THE **BACKYARD ASTRONOMER'S GUIDE**

THE BACKYARD ASTRONOMER'S GUIDE

FOURTH EDITION
COMPLETELY REVISED AND EXPANDED

TERENCE DICKINSON
AND ALAN DYER

FIREFLY BOOKS

A FIREFLY BOOK

Published by Firefly Books Ltd. 2021

First printing

Publisher Cataloging-in-Publication Data (U.S.): 2021934315

Library and Archives Canada Cataloguing in Publication
Title: The backyard astronomer's guide / Terence Dickinson and Alan Dyer.
Names: Dickinson, Terence, author. | Dyer, Alan, 1953- author.
Description: Fourth edition completely revised and expanded. | Includes index.
Identifiers: Canadiana 20210160179 | ISBN 9780228103271 (hardcover)
Subjects: LCSH: Astronomy—Amateurs' manuals.
Classification: LCC QB64 .D513 2021 | DDC 522—dc23

Published in the United States by
Firefly Books (U.S.) Inc.
P.O. Box 1338, Ellicott Station
Buffalo, New York 14205

Published in Canada by
Firefly Books Ltd.
50 Staples Avenue, Unit 1
Richmond Hill, Ontario L4B 0A7

Cover and interior design: Janice McLean

Printed in China

Canada

We acknowledge the financial support of the Government of Canada

To Susan, the center of my universe. —T.D.

For all the friends I've met under the stars. —A.D.

FRONT COVER: Comet NEOWISE, taken July 22, 2020, at Dinosaur Provincial Park, Alberta, Canada, by Alan Dyer, in a stack of seven 3-minute exposures at ISO 1600 and f/2.8 for the ground, blended with a single 30-second untracked exposure at ISO 6400 and f/2 for the sky, all with a 24mm Sigma lens and Canon EOS Ra camera.

BACK COVER: North America Nebula (NGC 7000) by Alan Dyer, in a stack of four filtered 16-minute exposures at ISO 1600 blended with four unfiltered 8-minute exposures at ISO 800, all with the Canon EOS Ra camera on a William Optics 51mm f/5 RedCat astrograph.

The Sky Is for Everyone

When I look up at the stars, I wonder about the kinds of planets that might be around each one. Every star is a sun, and astronomers have found thousands of planets orbiting other stars. These are known as exoplanets. Perhaps there are intelligent beings on a distant planet looking back at our Sun— a star to them—and wondering the same thing. The night sky is vast, mysterious and beautiful, and it is full of fascinating things if we know where and how to look.

What I love about astronomy is that no matter where we might be, there is always something to see. Even from a light-polluted city, we can spot Orion and a few other constellations, watch the phases of the Moon and monitor the bright planets Venus, Jupiter and Saturn as they move gradually across the sky over nights or weeks. With the privilege of a dark sky, we can see the spectacular Milky Way or observe a meteor shower. Some of my favorite parts of the fourth edition of *The Backyard Astronomer's Guide* are those which describe the naked-eye sky. Artfully laid out and organized to help us get to know the sky better, it is illustrated with striking images of the constellations, among other celestial targets, and offers tables listing transient events, such as planet conjunctions and lunar eclipses for the next decade or more.

As a small child, one of my life-defining moments was seeing the Moon through a telescope for the very first time. I was with my dad at a star party, which is not an event where Hollywood celebrities gather but where amateur astronomers set up their telescopes and invite the public along. Looking through the telescope, I couldn't believe my eyes—the Moon is an entire other world! Later, as a teenager with money from my first summer job, I bought a 4-inch reflecting telescope with an equatorial mount. I remember the incredibly clear winter night skies in Toronto—and the extremely cold weather— while I was outside trying to polar-align my telescope. Today, my family enjoys our 12-inch Dobsonian, an 8-inch Schmidt-Cassegrain and a 130mm refractor that, fostered by *The Backyard Astronomer's Guide*, my amateur astronomer husband Charles is an expert at setting up. This reference includes everything one might want to know about observing tools, from binocular options through traditional telescopes and their accessories, while not shying away from describing the newest and most sophisticated equipment available.

In my work as a professional astronomer, I am focused on exoplanets, a field of study made possible only by the advancements in technology, including computer capability and detector sensitivity. Impressive, too, are the technological advances for amateur astronomers. We can use apps to navigate the night sky, find out the latest hour-by-hour weather predictions and even sign up for alerts when solar activity indicates a display of northern lights might be visible. GoTo telescopes allow us, with a properly aligned instrument, to easily find and view specific objects. The advances in astrophotography, from hardware to software processing tools, help dedicated amateur astronomers acquire images that never cease to amaze.

In this latest edition of their enduring book, Terry and Alan continue to guide us with their own breathtaking images and commentary. They take us on an in-depth tour of all the things needed to make the night sky truly accessible, amplifying the phrase "the sky is for everyone."

—Professor Sara Seager, O.C.
Massachusetts Institute of Technology

CONTENTS

98

101

120

222

275

287

258

310

364

A New Look
at an Old Favorite

Since the publication of the first edition of *The Backyard Astronomer's Guide* in 1991, amateur astronomy evolved in many important areas. This prompted major rewrites and redesigns for the second edition in 2002 and the third edition in 2010. Now, at long last, after another decade of change, we are pleased to offer a greatly revised and expanded new edition, the fourth, adding another 48 pages to provide 416 pages of detailed instruction and information.

With this edition, we have taken the opportunity to restructure the content to reflect the steps we suggest people take when entering the hobby: Start by learning the naked-eye sky, then use binoculars. Gain a familiarity with the sky first, and look through a variety of telescopes at star parties. You'll then be better prepared to buy your own telescope. Just as we leave astrophotography to the last, so should you. Don't start your hobby there.

We've updated information throughout on what's in the sky, changing most of the images and illustrations and adding tables of events that are good for another decade and beyond. To expand our observing advice, we've added new chapters introducing you to the best features on the Moon and to some of the finest deep sky targets for binoculars and telescopes. We are pleased that expert observer Ken Hewitt-White agreed to author these chapters.

The popular equipment chapters surveying the marketplace of binoculars, telescopes and accessories and the tutorials on how to use this equipment have all been extensively revised. Recognizing that astrophotography is more popular than ever, we have expanded that topic into two chapters, with instructions on how to use everyday digital cameras to capture amazing images, supplemented by updated tutorials on image processing. Unless otherwise credited, the images in the book are our own, captured and processed using the techniques we describe.

As it has always been, this book serves as a sequel to author Dickinson's *NightWatch: A Practical Guide to Viewing the Universe. NightWatch* emphasizes material for the absolute beginner. Here, in *The Backyard Astronomer's Guide,* we provide more in-depth commentary, guidance and resources for the enthusiast.

For further advice and updates, particularly on telescopes and cameras, we invite readers to visit www.backyardastronomy.com.

—Terence Dickinson and Alan Dyer

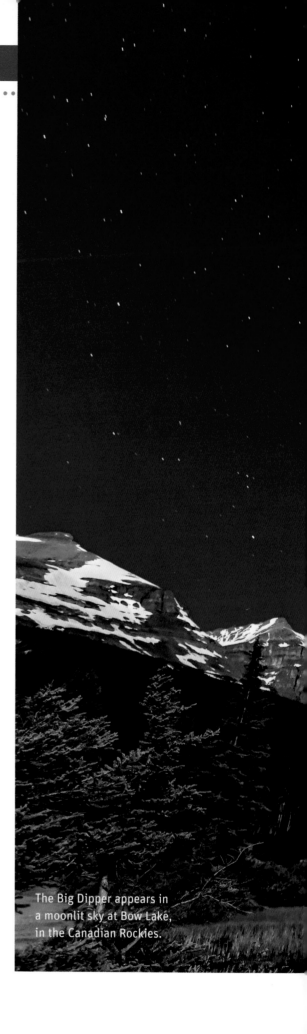

The Big Dipper appears in a moonlit sky at Bow Lake, in the Canadian Rockies.

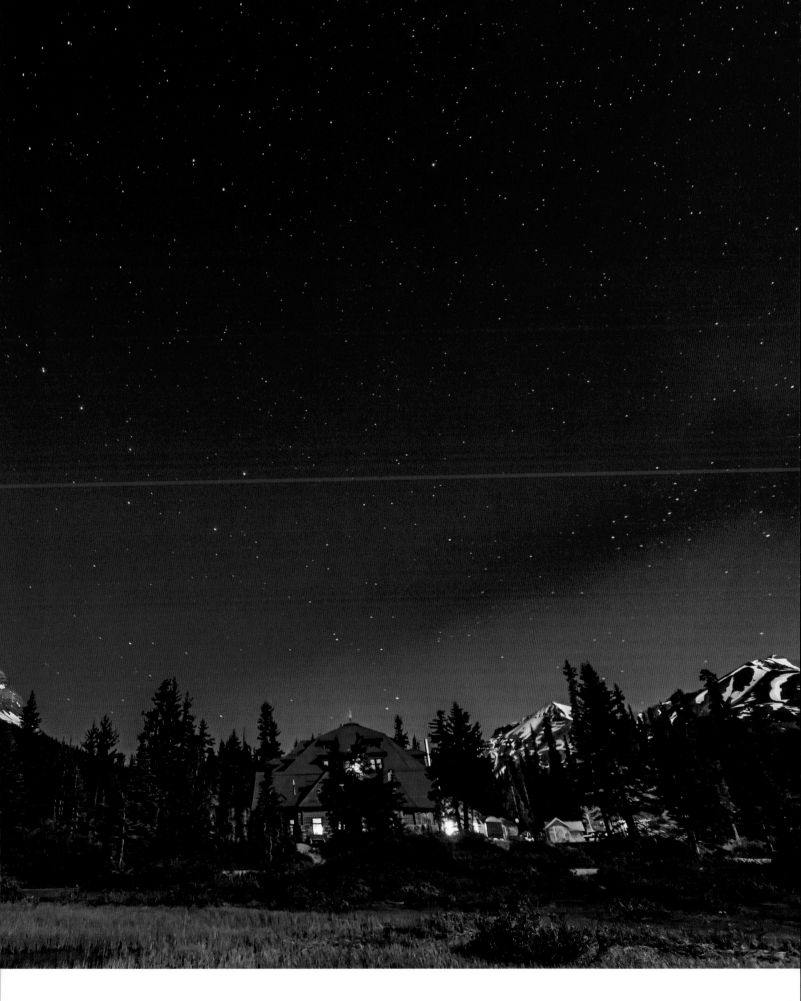

CHAPTER 1

Amateur Astronomy Comes of Age

There is something deeply compelling about the starry night sky. Those flickering points of light in the blackness beckon to inquisitive minds. So it was in antiquity, and so it remains in the 21st century.

Only recently have large numbers of people chosen to delve into stargazing—recreational astronomy—as a leisure activity. Today, more than a quarter of a million people in North America alone call themselves amateur astronomers.

The magic moment when you know you're hooked can come the instant you look through a telescope at Saturn's stunningly alien yet serenely beautiful ring system. Or the moment might be when you find yourself under a truly dark sky seeing the Milky Way for the first time.

The Milky Way shines over the Texas Star Party, a mecca for amateur astronomers. This photo, showing a monochrome Milky Way, simulates the scene as it would appear "live" to the unaided eye, with dark lanes of interstellar dust lacing the bright star clouds of the galactic center.

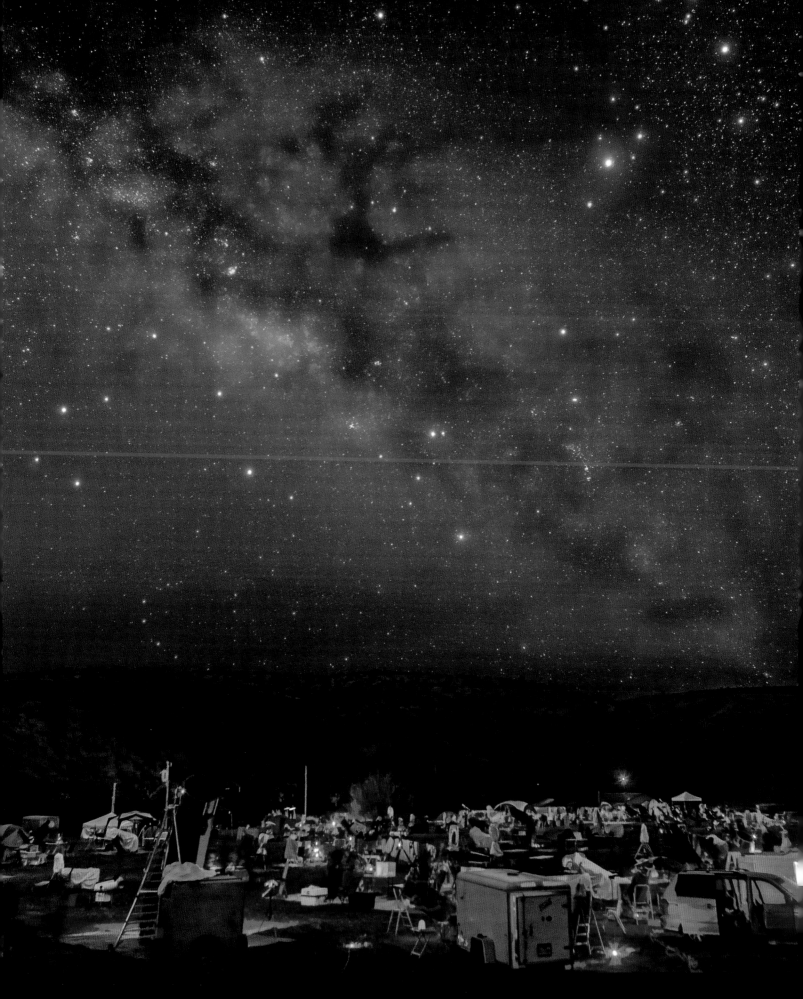

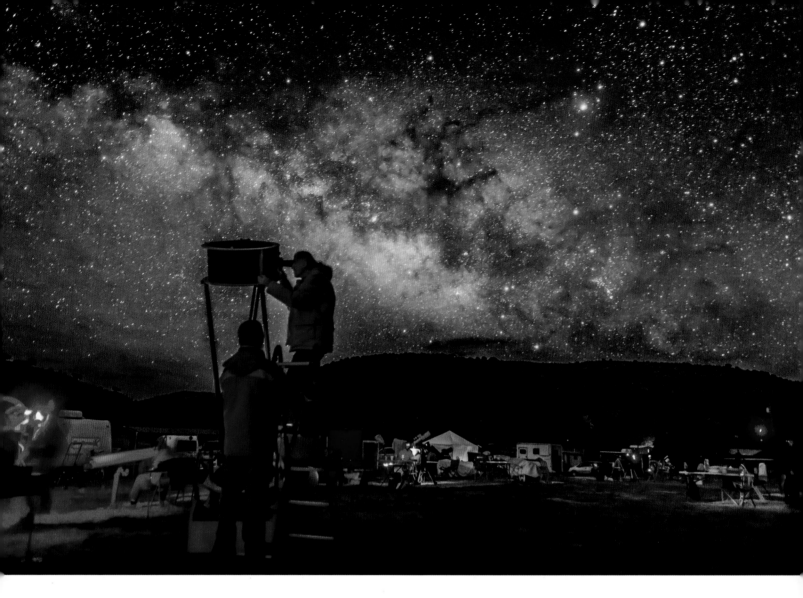

NATURALISTS OF THE NIGHT

American 19th-century poet and essayist Ralph Waldo Emerson once wrote: "The man on the street does not know a star in the sky." Of course, he was right then and now.

Well, almost. In recent years, a growing number of people have wanted to become acquainted with the stars. The selection and quality of astronomy books, software and telescopes are far greater now than they have ever been. Websites and Facebook groups devoted to the science and the hobby of astronomy attract huge numbers of hits and followers. High-profile science "media stars" fill auditoriums for their popular lectures. Print and TV ads feature images of families enjoying the night sky. There is no mistaking the trends: Astronomy has come of age as a mainstream recreational activity.

Not coincidentally, the growth of interest in astronomy has paralleled the rise in our awareness of the environment. The realization that we live on a planet with finite resources and dwindling access to wilderness areas has generated a sharp increase in activities for appreciating the natural world: birding, nature walks, hiking, camping, nature photography and visiting scenic wonders. Recreational astronomy is in this category too. Amateur astronomers are "naturalists of the night," captivated by the mystique of the vast universe that is accessible only under a dark sky.

Unfortunately, the darkness that astronomy enthusiasts seek has been beaten back by the ever-expanding domes of artificial light over cities and towns and by the increased use of LED lighting everywhere. Where many

of us live, the luster of the Milky Way arching across a star-studded sky has been obliterated forever. Yet amateur astronomy flourishes as never before. Why? Perhaps it is an example of that well-known human tendency to ignore the historic or acclaimed tourist sights in our own neighborhood while attempting to see everything when traveling to distant lands. Most people now perceive a starry sky as foreign and enchanting rather than something that can be seen from any sidewalk, as it was when our great-grandparents were young.

That is certainly part of the answer, but consider how much amateur astronomy has changed. The typical 1960s amateur astronomer was usually male and practiced his hobby alone. He had a strong interest in physics, mathematics and optics. He spent his weekends grinding a 6-inch reflecting telescope mirror from a kit sold by Edmund Scientific, following instructions in *Scientific American* telescope-making books. The four-foot-long telescope was mounted on what was affectionately called a plumber's nightmare—an equatorial mount made of pipe fittings. In some cases, it was necessary to haul out the telescope only under cover of darkness, to avoid derisive comments from suspicious neighbors.

Practical reference material was nearly nonexistent in the 1960s. The majority of what there was came from England, much of it written by one man, the late Sir Patrick Moore. Guidebooks of the day emphasized the useful "work" amateurs could do to contribute to science.

AMATEUR ASTRONOMY TODAY

Thankfully, that's history! Current astronomy hobbyists represent a complete cross section of society, encompassing people of all ages, occupations and levels of education. Amateur astronomy has matured as a legitimate recreational activity, not just the odd pastime of male science nerds and eggheads. Indeed, it has emerged as a leisure activity with a certain prestige.

Amateur astronomy has also become incredibly diversified, not only in who participates but in what they do. Today, no individual can master the field entirely. It is too large; it has too many activities and choices.

In general, though, we'll argue that amateur astronomers can be divided into four main groups: the armchair astronomers, the techno-enthusiasts, the photographers (or imagers) and the observers.

The armchair category refers to people who

STARGAZING THEN AND NOW
Bottom left: Old-timers who remember being geeky boys in the 1960s claim that kids today are only interested in video games. But in the '60s, the distraction was TV. This classic Unitron ad declared: "Johnny's traded the fleeting thrills of the 24-inch screen for the timeless excitement and majesty of the night sky." Nothing has changed!
Bottom right: In contrast to the loner of the '60s, stargazing today is often a family or group activity. Events such as this star party are attended by couples and family members of all ages, who enjoy a clear night as stars and planets appear in the twilight. Note the mobile apps in use on smartphones to help aspiring stargazers identify what's overhead.

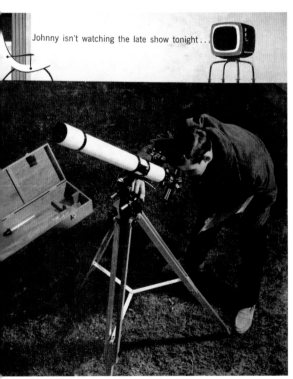

Johnny isn't watching the late show tonight...

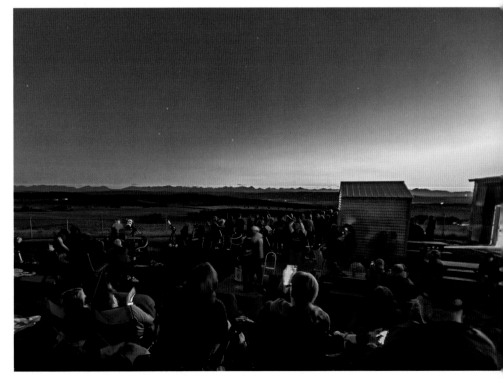

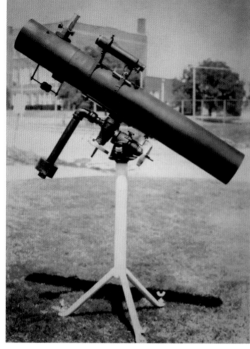

TECHNOLOGY NOW AND THEN

Above: The Galaxy Zoo project enables anyone to make real discoveries without leaving home, which is great for cloudy nights. **Above right:** In the 1960s, this was the classic telescope: a homemade 6-inch reflector with a mount fabricated from plumbing fixtures and salvaged car parts.

pursue the hobby mainly vicariously—through books, magazines, lectures and the Internet or perhaps by helping to organize club activities. Armchair astronomers are often self-taught experts on nonobservational subjects, such as cosmology or astronomical history.

The techno-enthusiast category was once the domain of telescope makers and craftsmen but now tends to be dominated by those who are skilled at programming and the use of computers for imaging and remote telescope operation. Just as with telescope makers in days gone by, the satisfaction is often in getting stuff to work, not necessarily in observing or even imaging the sky.

By comparison, the photographers spend most of their hobby time taking images. So much so, their telescopes might only ever have a camera attached, rarely an eyepiece. They may never actually observe the objects they shoot. (We count ourselves as partly guilty here!) And with the advent of remote robotic telescopes, photographers might not even see the telescopes they use, let alone the sky above them. Their goal is often to collect hours of so-called data.

To be clear, the hobby has room for everyone. We aren't about to discount anyone's interest or approach to the hobby.

Although we include chapters on pho-

tography, this book is written primarily for the fourth kind of amateur astronomer, the observer, whose prime interest is to explore the visible universe with eye and telescope. Observing is, for us, what it is all about. The exhilaration of exploring the night sky, of seeing for yourself remote planets, nebulas and galaxies—real objects of enormous dimensions at immense distances—is the essence of backyard astronomy.

AMATEURS AND PROFESSIONALS

Among the observers, amateur astronomy ranges from an occasional pleasant diversion to a full-time obsession. In the latter extreme, some amateurs fall into a fifth class: the researchers. They often devote more time and energy to astronomy than do all but the most dedicated—and paid—professional astronomers.

Such "professional amateurs" have focused on areas that professional astronomers have neglected, either by choice or through a lack of resources. This includes comet hunting, tracking asteroids, following the rise and fall of variable stars, searching for supernovas and, remarkably, even hunting for planets orbiting other stars.

While some research pursuits might be done visually, most are now carried out using

cameras and digital detectors, often with telescopes that rival what a small professional observatory might use. In 2019, for example, using a 0.65-meter telescope he built, amateur astronomer Gennadiy Borisov discovered Comet 2I, the first known interstellar comet.

Today, the researcher can also be an armchair astronomer, making valuable contributions by mining data through the popular zooniverse.org programs that offer up reams of data which professionals can't analyze, even with the aid of computers. As it turns out, human eyes can detect the subtle traces of an exoplanet in a star's light curve or classify a galaxy, to name just two projects, better than any automated machine-learning routine.

Whether using a telescope or a desktop computer, the researcher is the true amateur astronomer: an unpaid citizen scientist doing astronomy for the love of it, exactly what the word "amateur" means—one who loves. Astronomy is one of the few areas of science where citizen scientists can make meaningful contributions, if not outright discoveries, worthy of publication in academic journals.

Nevertheless, however laudable their work, this book is neither about nor for the researchers. It is for the vast majority of stargazers, who are more accurately described as recreational astronomers. Just as 99 percent of the millions of birdwatchers, or birders, would never describe themselves as amateur ornithologists, so it is with 99 percent of amateur astronomers. We aren't discovering new stars or planets, as much as our friends might think that's what we do. We aren't gathering data. We aren't doing science. So what are we up to under the stars? To quote a phrase in *AstroNotes*, the newsletter of the Ottawa Centre of The Royal Astronomical Society of Canada, our goal is "to boldly look where no human has looked before...and mainly to have fun."

A PASSION FOR THE SKY

Fun might be the object, yet the lengths some of us will go in pursuit of that happiness can baffle those not afflicted with the bug. To illustrate this, we recount a story we have included in every edition of this book because it is a classic example: the Great Comet Chase.

In March 1976, one of the brightest comets

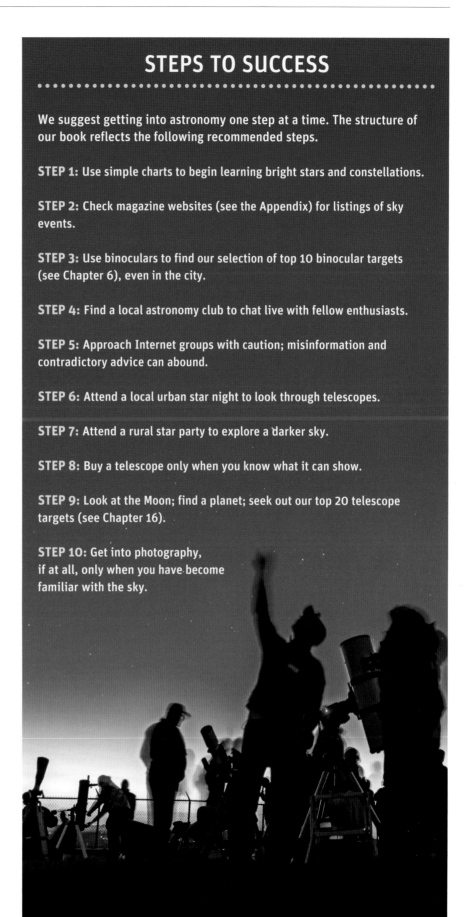

STEPS TO SUCCESS

We suggest getting into astronomy one step at a time. The structure of our book reflects the following recommended steps.

STEP 1: Use simple charts to begin learning bright stars and constellations.

STEP 2: Check magazine websites (see the Appendix) for listings of sky events.

STEP 3: Use binoculars to find our selection of top 10 binocular targets (see Chapter 6), even in the city.

STEP 4: Find a local astronomy club to chat live with fellow enthusiasts.

STEP 5: Approach Internet groups with caution; misinformation and contradictory advice can abound.

STEP 6: Attend a local urban star night to look through telescopes.

STEP 7: Attend a rural star party to explore a darker sky.

STEP 8: Buy a telescope only when you know what it can show.

STEP 9: Look at the Moon; find a planet; seek out our top 20 telescope targets (see Chapter 16).

STEP 10: Get into photography, if at all, only when you have become familiar with the sky.

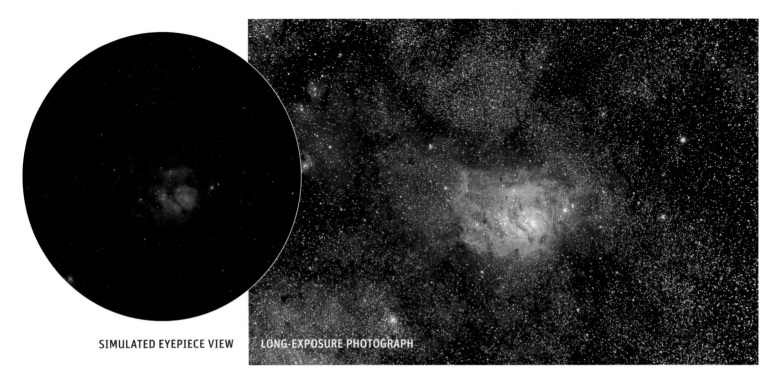

SIMULATED EYEPIECE VIEW LONG-EXPOSURE PHOTOGRAPH

REALITY CHECK

While views of vividly colored nebulas might be what you would expect to see through the eyepiece, the reality is that with very few exceptions, nebulas appear in subtle shades of gray. It takes a camera to reveal the colors. But there's still a thrill in seeing any cosmic object live at the telescope eyepiece.

of the 20th century, Comet West, was at its best. Of course, the weather over much of North America was terrible. Astronomy addicts were having withdrawal symptoms as they stared at the clouds each night, knowing that the comet was out there, just beyond reach. In Vancouver, several enthusiasts decided that they had had enough. "The comet was peaking in brightness. We had to do something," recalls our guest author, Ken Hewitt-White.

They rented a van and began driving inland over the mountains, which the forecast predicted would be clear of cloud cover by 4:30 a.m., the time when the comet was to be in view. The outlook for Vancouver was continued rain. "There were five of us with our telescopes, cameras and binoculars all packed in the van," says Ken. "A sixth member of our group had to get up early for work and reluctantly remained behind.

"It was a nightmare from the start—a blinding snowstorm. 'It's got to clear up,' we told one another. We drove 200 miles, and it was still snowing. After a few close calls on the treacherous mountain road, we finally turned back. Then, as we crossed the high point in the Coast Mountains, the sky miraculously began to clear. It was exactly 4:30. We pulled over and immediately got stuck. But we had not gone far enough—a mountain peak blocked our view.

"Five comet-crazed guys in running shoes started scrambling up the snowdrifts on the nearest cliff to gain altitude. By the time we reached a point where the comet should have been in view, twilight was too bright for us to see it. Half frozen and dripping wet with snow, we pushed the van out and headed back to Vancouver. Within minutes, we drove out of the storm and saw cloudless blue sky over the city. When we got home, we heard the worst: The guy who stayed behind had seen the comet from a park bench one block from his home."

ARE YOU READY?

While we devote several chapters of this book to choosing and using equipment, please make no mistake—it is *not* possible to buy your way into astronomy. Indeed, many of the sky sights on our scale of "Aah! Factors" are best enjoyed for free using no more than your unaided eyes, the observing technique we begin with in our next chapter.

But even appreciating the naked-eye sky requires knowledge and experience that take time to gain. Backyard astronomy is not an instant-gratification hobby. However, as you acquire knowledge and experience, astronomy will become a lifelong passion that will enrich your life as few hobbies can.

THE AAH! FACTOR

We offer our **Aah! Factor**, a 1-to-10 scale of celestial exclamation. Factor 1 sights evoke a detectable smile. Factor 10 targets inspire speechless rapture. It is nice to log a 2 or 3 on our scale each night. Factors 8 through 10 are bucket-list life goals!

1
Any celestial view through binoculars or a telescope; a faint meteor

2
Finding Mercury; seeing the Moon through a telescope; seeing the cloud belts on Jupiter; sighting the International Space Station

3
Seeing the Orion Nebula through a telescope; enjoying the starry dome from a dark rural site; seeing Jupiter's Red Spot or a colored double star

4
Finding the Andromeda Galaxy for the first time; a partial eclipse of the Moon; a conjunction of the Moon and Venus or of two planets; Earthshine in binoculars

5
Identifying Jupiter's moons through binoculars for the first time; a moderately bright comet in binoculars; telescopic detail on Mars; a good meteor shower

6
Recognizing your first constellation, such as Orion; a big-scope view of a globular cluster; watching a Jovian moon-shadow transit; a bright horizon aurora

7
Your first view of Saturn through a telescope; the center of the Milky Way from a truly dark site; a total eclipse of the Moon

8
An exploding fireball meteor; a naked-eye comet, such as 1997's Comet Hale-Bopp; a rare meteor storm

9
A multicolored all-sky aurora

10
A total eclipse of the Sun!

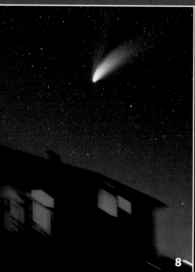

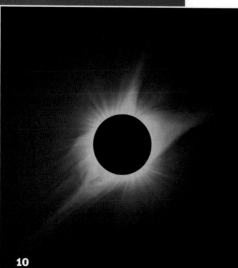

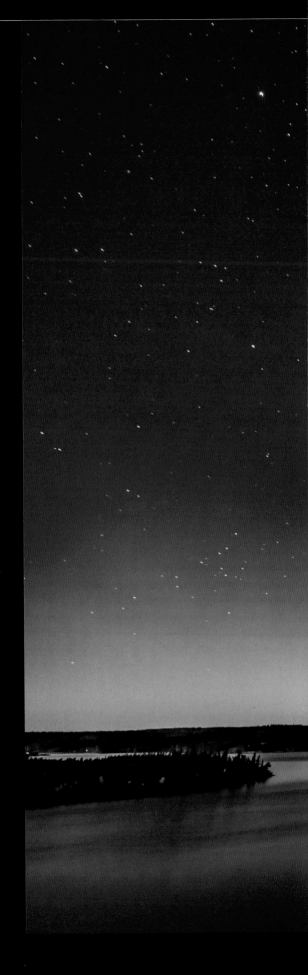

CHAPTER 2

The Naked-Eye Sky

We begin our exploration of the stargazer's universe with that most accessible of skies, the one you can see with no more than your unaided eyes.

You know you're an amateur astronomer when…well, there are many signs. But the key symptom that you've caught "the bug" is whenever you step outside, you look up to check the sky. Backyard astronomers learn to see amazing sights that almost everyone else misses. You soon gain a lifelong awareness of the sky's wonders.

The play of light and shadow in the day sky along with nighttime glows, both subtle and dramatic, provide a never-ending sky show. You just need to know what to look for. And that's what this chapter is all about.

This is naked-eye astronomy at its best, as an arc of northern lights forms in the darkening twilight of a September evening. The site is Prelude Lake, near Yellowknife, in Canada's Northwest Territories.

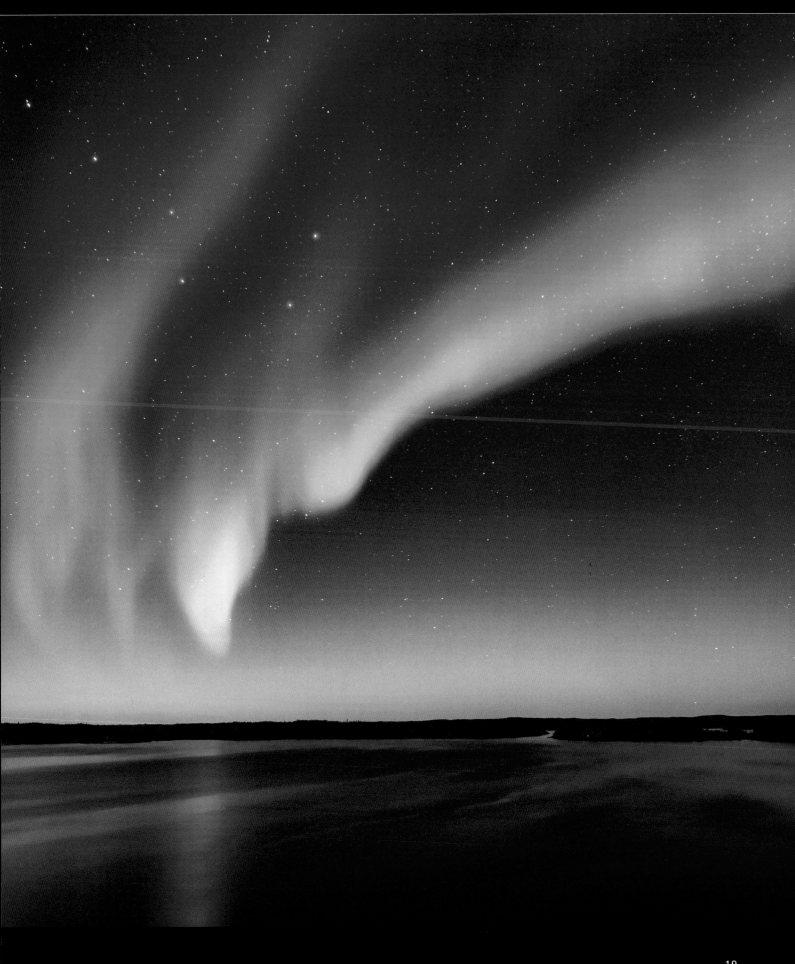

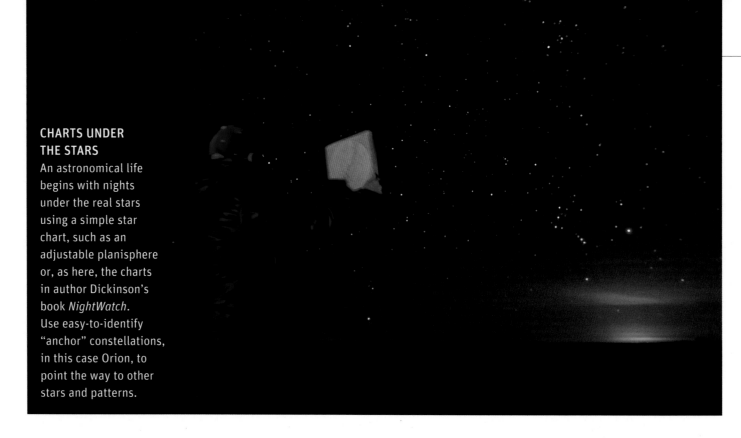

GETTING TO KNOW THE SKY

PLANISPHERE
This "star wheel" can depict the sky for any season but is made for a specific latitude range. Most planispheres are for 40 to 50 degrees north latitude. The Night Sky planisphere by David Chandler features a separate southern-horizon view on the back with less distortion than other designs.

Let's begin with advice for getting started under the stars. The first thing you should learn as an aspiring backyard astronomer is how to identify the bright stars and constellations using no more than your eyes and a star chart. It's an ongoing process, as the stars change through the seasons. Take the opportunity on clear, haze-free nights to get to know the sky, even in the city. In fact, an urban site is better than a dark rural site initially, as the urban sky doesn't overwhelm you with stars.

It's helpful, though, to find a location away from immediate streetlights glaring into your eyes, one that provides an open view of as much of the sky as possible. A nearby park or city skyline overlook might be perfect, assuming it is safe. We'll cover site selection in the next chapter and much more about sky motions and seasonal changes in Chapter 4.

USING SIMPLE STAR CHARTS

We've also included some basic seasonal star charts in Chapter 4 for both the northern and southern hemispheres, to serve as context to the binocular tours and telescope tours we provide in Chapters 6 and 16. While these seasonal charts can help you get started, we'll

admit it's not practical to hold up our hefty 416-page tome to the sky.

Instead, we suggest investing in lightweight charts that are easy to hold and use at night. One option is a planisphere, also known as a star wheel. Models from Firefly Books, Philip's, Miller, Ken Graun and David Chandler are excellent. To use one, turn the wheel to dial in the current date and time. What's shown in the window is what's visible at that time.

One drawback to most planispheres is that due to the mapping projection used, constellations get stretched out and distorted toward the horizon, around the perimeter of the chart.

An alternative we recommend—and we are biased here!—is author Dickinson's popular book *NightWatch*. Intended for absolute beginners, it has some of the best naked-eye sky-dome charts you'll find. The book's spiral binding makes it easy to hold open and utilize in the field.

Another option is the current issue of any astronomy magazine. Available in many countries, these magazines include all-sky charts of that month's sky, usually showing the planets as well, a feature book charts and planispheres can't include, as the planets keep moving.

USING MOBILE APPS

We delve into apps and high-tech aids in detail later in this book. We mention them here because people often turn first to one of the many free or low-cost planetarium apps for mobile phones and tablets. Search for "stargazing" in your app store, and dozens of titles will pop up. While some of these apps are free, watch out for in-app purchases and ads that take over your screen.

For beginners, we recommend the basic (and free) version of SkySafari or the paid app Sky Guide, with its attractive-looking sky. The advantage to an app is that it can also show the Moon and planets for that night and perhaps even comets and satellites. You can tap on an object and call up more information and images. And using your device's GPS, inclinometer and compass, the app presents an interactive view of what's in that part of the sky as you move the device around. It's like a magical window onto the sky.

The disadvantage is that it can be hard to relate the size of the constellations shown on your small screen to the real—and big!—sky overhead. And you are staring at a bright screen, creating your own personal light pollution.

SEEKING STAR TOURS

While apps and charts are great, you might find it helpful to take a guided tour of the sky. If there is a planetarium in your community, we suggest you attend one of its star shows, where a presenter uses the optical or digital projection system to re-create the night sky on the domed screen. The advantage of a planetarium is that it can demonstrate the motion of the sky overhead. While any mobile or desktop planetarium software can do that too, a planetarium theatre presents the sky and its motion as if you were standing under the real sky, in an immersive environment. A show can be an afternoon outing for the family. If the planetarium offers a stargazing course, you might find it a good way to learn from an expert.

But nothing beats being under the actual sky. Planetariums, apps and charts all suffer from a problem of scale. It is difficult to relate their artificial depiction to the real night sky. Even in a planetarium, constellations don't

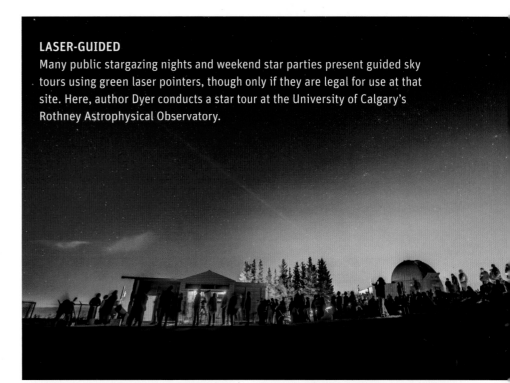

LASER-GUIDED
Many public stargazing nights and weekend star parties present guided sky tours using green laser pointers, though only if they are legal for use at that site. Here, author Dyer conducts a star tour at the University of Calgary's Rothney Astrophysical Observatory.

SKYSAFARI

SKY GUIDE

always appear as large as they do in real life.

As per our list of "Steps to Success" in Chapter 1, seek out a local urban stargazing event or one at a nearby rural park or conservation area. It might be staged by an astronomy club, planetarium or nature center. You will be able to look through telescopes, and the host amateur astronomers will probably be conducting tours of the sky, pointing out what's up and guiding you around the constellations of the current season.

APPS FOR ASTRONOMY
Mobile apps can show the area of sky your smartphone is aimed at. Here, we illustrate how two of our favorite apps depict the Orion region: SkySafari (iOS and Android; free in its basic edition) and the paid Sky Guide (iOS only).

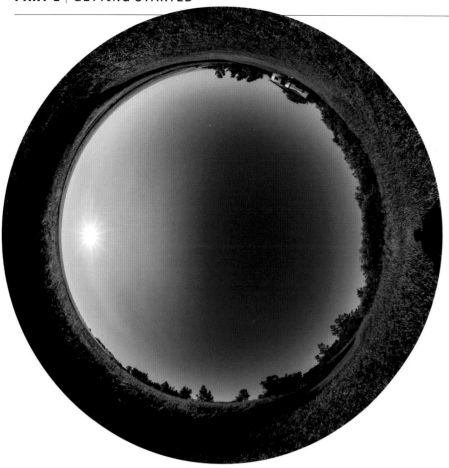

THE DAY SKY

POLARIZATION BAND
A fish-eye view of a clear morning sky shows the Sun to the east (at left) and, 90 degrees away from it (at right), the darkest blue sky along the band of polarization. Within the band, you can see the last-quarter Moon, which is always 90 degrees from the Sun. On a clear day, the darkening effect is visible even without the aid of a polarizing filter on your camera (none was used here) or polarized sunglasses.

While, yes, amateur astronomy *is* about learning the stars by night, your enjoyment of the sky can begin by day, when a roster of light and shadow effects often plays out overhead. All are naked-eye phenomena, and many can be seen from the city.

THE BLUE SKY

A deep blue sky gladdens the hearts of all amateur astronomers, as it promises spectacular stargazing. But a blue sky can be appreciated for its own sake.

The sky is blue because blue and purple light waves have the shortest wavelengths of all the colors of the visible spectrum. Short-wavelength light is most easily scattered by the air molecules of our atmosphere. Think of a group of bantamweight wrestlers trying to force their way through a line of heavyweight sumo champions. The hapless bantamweights get scattered at random in a wild melee. So it is with blue light waves, in a process called Rayleigh scattering.

How blue the sky appears depends on how clean and dry the air is and how much air lies above you. Water vapor whitens a sky by scattering all wavelengths equally. Dust and pollution also turn a day sky pale blue, if not brown or gray. Lower-altitude sites are likely to have more contaminants in the air than mountaintop sites.

On a cloudless early morning or late afternoon, look around the canopy of blue. Where is the sky bluest? You might think it would be directly overhead, where light passes through the least amount of water vapor and contaminants. But look carefully, and you'll see the bluest sky lies along a band 90 degrees from the Sun. Scattered light from the sky is naturally polarized (the light waves all vibrate in the same direction), and the degree of polarization is greatest at right angles to the Sun.

RAINBOWS

If a rainstorm has just passed by and sunlight is breaking through, look for a rainbow. A sunbeam shining through a raindrop will, after one reflection within the drop, head back in roughly the same direction as it entered. In the process, the beam of light is split into its component colors by the prismlike qualities of the raindrop. Multiply this effect by millions of raindrops, and the result is a curving swath of color around the point in the sky directly opposite the Sun. To be precise, rainbows always lie at a radius of 42 degrees from the antisolar point. To find the antisolar point, stand with your back to the Sun and imagine a line extended from the Sun through your head toward the ground in front of you.

From ground level, the antisolar point always lies below the horizon. So we never see a rainbow as a complete circle—we get only the upper part, as a multihued arc. The closer the Sun is to the horizon, the longer the arc. From an aircraft or a mountain peak, however, it is possible to see a rainbow as a full circle. For a rainbow to be visible against the sky, the Sun cannot be more than 42 degrees above the horizon. For that reason, rainbows are a late-afternoon or an early-morning phenomenon.

Double rainbows occur when the sunlight is particularly strong and the air is saturated

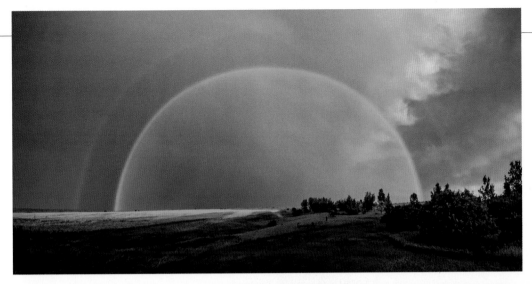
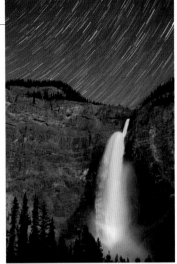
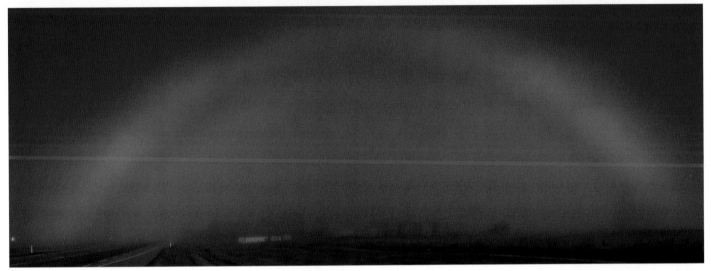

with raindrops. A second rainbow appears as a result of light bouncing through two reflections inside the raindrops. The fainter secondary bow shows up outside the primary bow at a radius of 51 degrees from the antisolar point, with its colors in reverse order—red on the inside of the arc rather than the outside, where it appears in the main rainbow.

Other rainbow-related effects to watch for in a double rainbow are the brightening of the sky inside the main bow and the darkening of the sky between the primary and secondary rainbows, an effect called Alexander's dark band, named for the Greek scientist who first described it in 200 AD. Also watch for the appearance of supernumerary arcs—purple and green bands on the inside edge of the main bow. Created by interference effects among the various beams of light exiting the raindrops at slightly different angles, supernumerary arcs appear only when the main rainbow is especially intense.

HALOS AND SUNDOGS

Planetariums and observatories often receive calls from people reporting a ring, or halo, around the Sun or the Moon. Halos are caused by light refracting through hexagonal ice crystals, each of which acts as a tiny prism. Unlike rainbows, most halo phenomena are centered around, not opposite, the Sun or Moon. Halos can occur any time the sky is covered with high-altitude cirrus clouds or icy haze in summer or winter.

The most common halo is a ring of light 22 degrees from the Sun or Moon. A larger, fainter circle can sometimes be seen 46 degrees from the Sun. Sundogs (officially called parhelia) appear as bright spots, occasionally colored, on either side of the Sun. When the Sun is low, as it is in winter, sundogs show up as intense areas on the inner halo. When the Sun is higher in the sky, sundogs appear just outside the inner halo. (At night, look for rare moondogs.)

BOWS IN THE MIST

Top left: Only when the Sun is close to the horizon is a rainbow nearly a semicircle. Note the brighter sky within the inner bow and the darker sky between the primary and secondary bows.

Top right: Moonlight can create a rainbow at night. This long-exposure photo by Yuichi Takasaka reveals the colors of a moonbow that the eye can't see.

Bottom: When the air is filled with fine droplets of mist, look for a white "fogbow." Smaller than a rainbow, a fogbow also appears opposite the Sun or other bright light source.

ICE-CRYSTAL AND WATERDROP EFFECTS

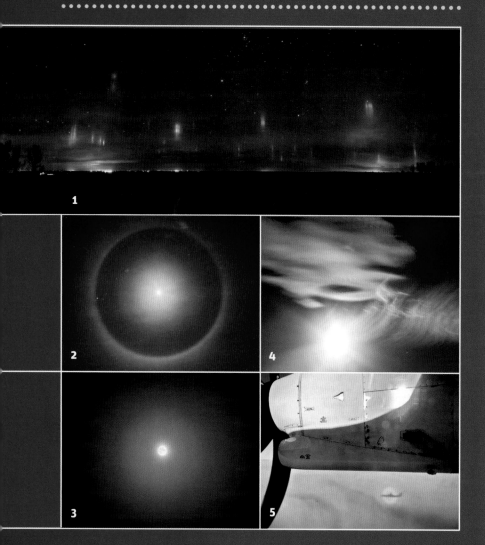

1 Light can reflect off flat ice crystals in haze and clouds, creating light pillars that rise from bright lights below; in this case, distant town streetlamps and farmyard lights.

2 Ice crystals at night can add halos around the Moon. Although a bright full Moon is usually required, this was around a first-quarter Moon. The colors are not visible to the eye.

3 Fine droplets of water in thin clouds diffract moonlight, adding colorful rings called lunar coronas close to the Moon's disk.

4 During the day, a diffraction effect created by waterdrops can form colorful clouds near the Sun. To see these at their best, wear dark sunglasses. Similar-looking but rarer nacreous clouds form in the stratosphere at high latitudes and can be seen shining after sunset or before sunrise.

5 On the shadowed side of an aircraft and with a low Sun, look for the shadow of the airplane on nearby clouds surrounded by the colorful diffraction rings of the glory effect.

The next most common halo phenomenon is what has become erroneously known as a "fire rainbow." More properly called a circumzenithal arc, it is a colored arc high in the sky that curves away from the Sun. It is part of a circle centered on the zenith and often appears tangent to the large 46-degree halo.

A parhelic circle, created by reflections off the vertical surfaces of ice crystals, can sometimes be seen passing through the Sun, running parallel to the horizon around the sky. Bright spots can appear on this horizontal arc at 90 or 120 degrees to the Sun or even directly opposite the Sun. Other arcs are occasionally visible tangent to the sides, bottoms or tops of the inner or outer halos. Light reflecting off the horizontal faces of ice crystals produces vertical light pillars. For a full explanation of the many and varied halo effects and much more, see Les Cowley's superb website www.atoptics.co.uk.

GLORIES AND CORONAS

Glories and coronas are colored rings that form when light is diffracted by water droplets, ice crystals or even pollen grains in the air.

A corona is a circular glow surrounding the Sun or Moon, usually with a diameter of no more than 10 degrees. It might be plain white or, at times, develop into a series of colored rings—diffraction rings—much like those found around star images in a telescope. In order for a corona to form, the Sun or Moon must be embedded in a light haze. When distinct clouds are nearby, they may be fringed with iridescent colors, which are part of the corona. Dark sunglasses are helpful for picking out coronas and iridescent clouds in the bright sky around the glaring Sun.

A similar effect, the glory, occurs around the point opposite the Sun. Your best chance of seeing a glory is from an aircraft. Sit on the side of the plane away from the Sun. As you break through nearby clouds, look for the plane's shadow on the clouds below. The shadow may be surrounded by colored rings.

A form of glory known by its German name *heiligenschein* appears as a soft glow of light around the shadow of your own head when it is projected onto a dewy lawn or low-lying fog in the early morning.

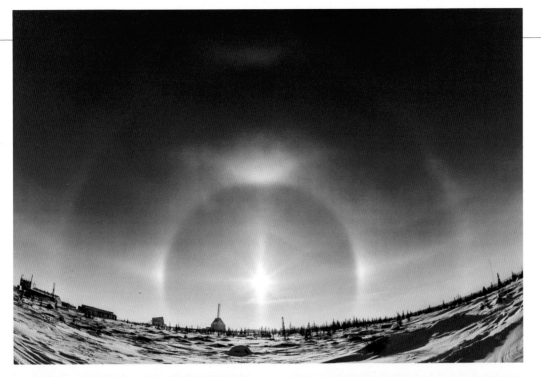

COLD AND COMPLEX

Left: On this bitterly cold day at the Churchill Rocket Research Range, in northern Manitoba, "diamond dust" ice crystals filled the air. The nearby crystals created an elaborate display with inner 22-degree and outer 46-degree halos, sundogs, a horizontal parhelic circle, a vertical light pillar, an upper tangent arc off the inner halo and a circumzenithal arc off the outer halo, at top.

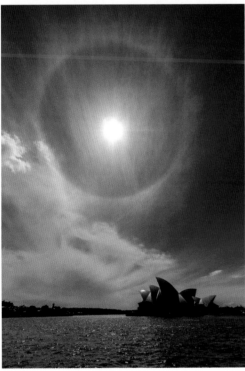

DAYTIME SIGHTINGS

A popular misconception is that the Moon comes out only at night. Yet the Moon can be seen in the day sky about 15 days a month. For example, on a late afternoon around first-quarter phase, look 90 degrees east of the Sun, and you'll see the rising Moon in the blue sky. At last-quarter Moon in the early morning, look 90 degrees west of the Sun for the setting Moon. Both quarter Moons make fine daytime telescope targets. Use a red filter or, better yet, a polarizing filter to darken the sky and increase the contrast.

When Venus is near one of its greatest elongations, roughly 45 degrees east or west of the Sun, the brilliant planet becomes another daytime target. The challenge is finding it. While you could use a prealigned GoTo telescope, a low-tech method is to wait for a day when the crescent Moon is nearby. Find the Moon first, and let it lead you to Venus. The trick is getting your eyes to focus. Once your eyes "auto-focus" to infinity, Venus suddenly becomes obvious.

Far more challenging is Jupiter. When it is 90 degrees away from the Sun (at quadrature), the giant planet lies in the sky's dark polarization band. Find it by using binoculars first, then try spotting it with your unaided eyes for a unique life-list sighting.

MOON AND VENUS BY DAY

Above: The waning crescent Moon shines to the right of Venus in a very clear daytime morning sky. First, find Venus with binoculars. Once you've located it, the planet will be obvious to the naked eye.

SYDNEY SOLAR HALO

Above left: Proving that solar halos don't require winter weather, this one appeared over Sydney, Australia, on a warm autumn day. What matters is the state of the atmosphere high above us.

THE SUNSET SKY

You have driven to a hilltop site for a night under the stars. The Sun is going down, and you are busy setting up your telescope gear. But take a moment to watch the sunset. Close inspection can reveal beautiful effects beyond the familiar red undersides of clouds.

THE GREEN FLASH

As the Sun sets, its disk can dim and redden enough to permit us to safely observe it with binoculars or a telescope—sometimes. Exercise extreme caution. If you find yourself squinting at the Sun, then it is too bright.

Often, as the Sun sinks below the horizon, its disk becomes red and flattened and displays

a boiling upper edge. Watch this edge—you will likely see it turn blue or green. In the last moments before the Sun disappears, a vivid green blob of light sometimes appears at the top of the disk and breaks off. It lasts only a second or two. This is the green flash.

The flash is caused by a prismlike dispersion of colors created by our atmosphere. The bottom of the setting Sun's disk becomes red, while the top turns blue. Well, not quite. The short-wavelength blue light normally at the top of the Sun becomes so scattered, it disappears, leaving the top edge tinged with green. If the Earth's atmosphere is layered into regions of varying temperatures, as in a mirage, that thin green rim can stretch and detach into a short-lived green blob at the top of the Sun's disk.

Under such conditions, a separate patch of red light can appear at the bottom of the Sun, creating an extremely rare red flash. While the same effects can be seen at sunrise, they are easy to miss, as the rapidly rising Sun takes observers by surprise.

CREPUSCULAR RAYS

When the Sun shines from behind clouds or distant hills, another effect can appear: crepuscular rays. The rays are typically seen as shafts of sunlight beaming down through holes in a cloud deck. Crepuscular rays are especially evident with the setting or rising Sun. The rays then appear as bands of sunlight and shadow spreading out from the sunset or sunrise point and arcing across the sky. They sometimes converge opposite the Sun, where they are called anticrepuscular rays. The diverging and converging effect is due to perspective, as the rays and shadows are actually parallel beams.

TWILIGHT COLORS AND THE EARTH'S SHADOW

Once the Sun has set, watch for changing colors in the west. If the atmosphere is clean and cloud-free, you will see the sky painted with the entire spectrum, from reds and yellows near the horizon through green-

SUNSET EFFECTS
Right: Seeing a green flash requires a cloudless view of the true flat horizon, over either land or water. In this image, the last bit of the Sun appears green before it sinks into the Caribbean Sea.
Below: A gibbous Moon rises into the evening twilight above the pink Belt of Venus and the deep blue shadow of Earth, while dark crepuscular shadows cast by clouds to the west converge on the antisolar point. The location is the Chiricahua Mountains, in Arizona.

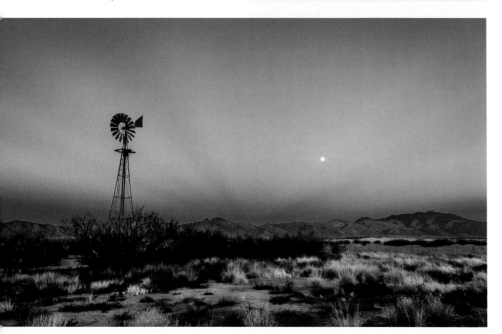

blues a few degrees up to deep blue-purples at 20 degrees altitude or more. If the sky is crystal-clear, this twilight purple can linger for up to 30 minutes.

Now face east. Look for a dark blue arc rising along the horizon. This is the Earth's shadow cast onto our atmosphere, the same shadow that intersects the Moon's orbit to create a lunar eclipse. The oddly named Belt of Venus, a pinkish glow lining the top of the shadow, is caused by the last red rays of the Sun lighting up the high atmosphere.

Soon after the Sun disappears in the west, the Earth's shadow climbs in the east. The shadow is easier to notice when the Sun is about five degrees below the horizon. As the sky darkens, the boundary of the shadow becomes invisible, but it is still there, evidenced by its effect on orbiting satellites (see page 30).

THE RISING MOON

On full-Moon nights, the Moon rises embedded in the blue shadow of Earth. The full Moon comes up as the Sun goes down, rising at a point on the horizon directly opposite the Sun. Like the low Sun, the rising Moon often looks flattened by atmospheric refraction and reddened by atmospheric absorption of the shorter blue wavelengths. If the lunar disk is rippling like a layer cake, look for green and red flashes.

While any rising full Moon is dramatic, a couple make headlines every year. The full Moon closest to the autumnal equinox is the Harvest Moon. Because of the low angle of the ecliptic in autumn, the Moon rises only 20 minutes or so later each night (compared with as much as an hour later at other times of the year). For two or three nights in a row, we see a golden Moon rising nearly due east in the early evening. Dust or smoke in the atmosphere at harvesttime also contributes to the Moon's golden hue.

At least once a year, one full Moon is a little closer and larger than the others. This is the so-called supermoon, a term coined by astrologers and disliked by most astronomers. A supermoon occurs when the full Moon coincides not only with perigee—the point where the Moon is closest to Earth in

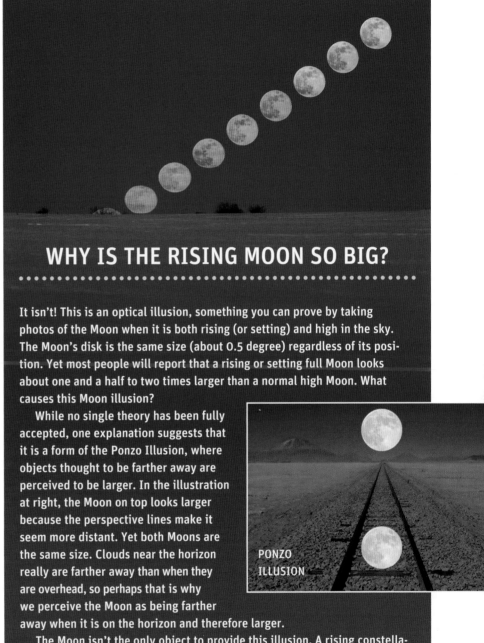

WHY IS THE RISING MOON SO BIG?

It isn't! This is an optical illusion, something you can prove by taking photos of the Moon when it is both rising (or setting) and high in the sky. The Moon's disk is the same size (about 0.5 degree) regardless of its position. Yet most people will report that a rising or setting full Moon looks about one and a half to two times larger than a normal high Moon. What causes this Moon illusion?

While no single theory has been fully accepted, one explanation suggests that it is a form of the Ponzo Illusion, where objects thought to be farther away are perceived to be larger. In the illustration at right, the Moon on top looks larger because the perspective lines make it seem more distant. Yet both Moons are the same size. Clouds near the horizon really are farther away than when they are overhead, so perhaps that is why we perceive the Moon as being farther away when it is on the horizon and therefore larger.

PONZO ILLUSION

The Moon isn't the only object to provide this illusion. A rising constellation also looks larger than it does several hours later, when it is at its highest altitude. It's as if we perceive the sky above us not as a spherical dome but as a flattened arc—close to us overhead but far away at the horizon.

its monthly orbit—but with the closest perigee of the year. However, the difference in apparent size between a perigean full Moon and a normal full Moon is so slight (about 7 percent), you can't detect the difference with your eye. People think the Moon looks bigger because they've been told it should.

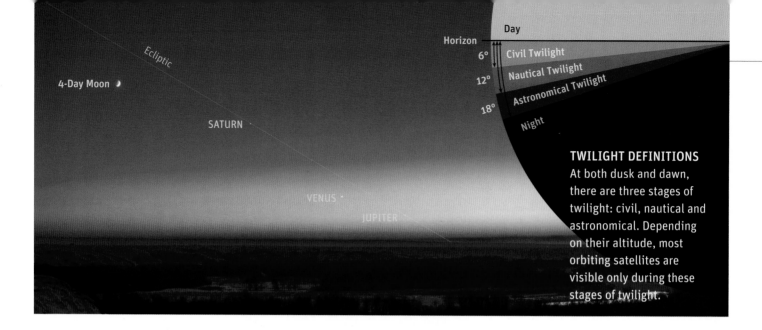

Horizon
Day
6° Civil Twilight
12° Nautical Twilight
Astronomical Twilight
18° Night

Ecliptic

4-Day Moon

SATURN

VENUS

JUPITER

TWILIGHT DEFINITIONS
At both dusk and dawn, there are three stages of twilight: civil, nautical and astronomical. Depending on their altitude, most orbiting satellites are visible only during these stages of twilight.

THE DARKENING SKY

ECLIPTIC IN THE TWILIGHT
Fading from red to deep blue, the twilight colors are punctuated by a row of three planets (from right to left): Jupiter, Venus and Saturn. The waxing Moon, illuminated by Earthshine, is farther along the line that defines the ecliptic, the path of the planets.

Cinematographers refer to early twilight as the magical "blue hour." For astronomers, the magic continues well into the deeper twilight. And, as astronomers, we are more familiar than most with the three stages of twilight.

TYPES OF TWILIGHT

The time when the Sun is between 0 and 6 degrees below the horizon is considered civil twilight. After sunset, at the end of civil twilight, streetlights typically switch on. Civil twilight coincides with the photographer's blue hour, when most of the natural light comes from the "cool" blue sky.

The period when the Sun is between 6 and 12 degrees below the horizon is nautical twilight. At the end of nautical twilight, the sky is too dark to distinguish it from the sea, making it impossible for navigators to sight the horizon to take traditional sextant readings.

And when the Sun is between 12 and 18 degrees below the horizon, we have astronomical twilight. Lots of stars are visible and maybe even the Milky Way, but the sky is not yet fully dark. A deep blue remains, perhaps apparent only in photographs. For true astronomical darkness, the Sun must be more than 18 degrees below the horizon. The night is then as dark as it will get, and long-exposure photography can begin.

In summer at high latitudes, astronomical darkness never arrives. The Sun is always less than 18 degrees below the horizon. The farther north you are, the longer this period of perpetual twilight and the brighter your night sky. From 49 degrees north (or south), for example, the sky is never astronomically dark during the two weeks on either side of summer solstice. From above the Arctic Circle, at 66.5 degrees north (or below the Antarctic Circle, at 66.5 degrees south), even twilight doesn't arrive at summer solstice, as the Sun remains visible all night, skimming across the horizon as the Midnight Sun.

EARTHSHINE AND THIN MOONS

A crescent Moon hangs in the west. Only a thin sliver of the disk is illuminated by the Sun, yet the entire disk of the Moon is visible. The "dark side" of the Moon appears faintly, an effect known as the old Moon in the new Moon's arms, or the Da Vinci Glow, after Leonardo da Vinci, who first explained it in 1510.

The dark portion of the lunar disk is experiencing nighttime on the Moon. In the lunar night sky, a large and brilliant Earth displays a nearly full phase. Sunlight reflecting off our oceans, clouds and polar icecaps lights up the nightside of the Moon with a blue-white light. Some of this Earthshine reflects back to Earth, enabling us to see the "dark side" of the Moon. Contrary to popular misuse, the face of the Moon we never see from Earth receives just as much sunlight as the side we do see and is correctly called the far side, not dark side, of the Moon.

Spring is the best season for admiring Earthshine on a waxing evening Moon. In springtime, the crescent Moon reaches its highest point above the western horizon, placing it in clearer air and allowing it to hang in the sky well after the sky becomes fully dark.

Spring is also the best season for seeing the youngest Moon. A young Moon appears low in the west as an ultrathin crescent embedded in the bright twilight, making it a challenge to locate. According to the U.S. Naval Observatory, the record for a naked-eye sighting of a young Moon is only 15.5 hours after the official moment of a new Moon. For a telescopic sighting, the record is 11.6 hours. Most of us would consider sighting any Moon less than 24 hours old an accomplishment. Use binoculars to find the Moon, then try it with your unaided eyes.

CONJUNCTIONS AND LINEUPS

As the planets wander against the starry background, they occasionally appear to meet up with one another, at least from our point of view on the moving Earth. These close approaches are called conjunctions. In common usage, as in our table on page 42, the term conjunction refers to any close gathering of planets or of the Moon and planets. (Technically, two worlds are not officially in conjunction unless they lie along a north-south line, sharing the same coordinate in right ascension or ecliptic longitude.)

The naked-eye outer planets—Mars, Jupiter and Saturn—can meet in conjunction high in a dark sky. Meetings between slow-moving Jupiter and Saturn are rare, occurring only once every 20 years, as happened in 2020.

However, most conjunctions, and certainly any involving Mercury or Venus, occur in twilight, at dawn or dusk. Twilight conjunctions of Venus and Jupiter, the two brightest planets, are the most spectacular.

Occasions when three, four or, rarely, all five naked-eye planets are clustered in the same region of the morning or evening sky are newsworthy events. Although not a conjunction, the planets can create a line of worlds strung along the path of the planets, the ecliptic, in the twilight. Add the Moon to the lineup, and you have a memorable night, indeed.

SATELLITES AND THE ISS

Since the launch of Sputnik 1 in 1957, humans have rocketed thousands of payloads into space, with a launch rate expected to increase from 100 satellites a year to hundreds, as private companies embark upon their mega-constellations of Internet satellites. To the working payloads add the spent rocket boosters that often remain in orbit as officially classified debris, and we now have an orbiting population of tens of thousands of objects bigger than four inches across being tracked by NORAD. Space has become so crowded that satellites have collided, raising fears of a chain-reaction Kessler effect, dramatized in the 2013 movie *Gravity*.

Managing the booming satellite population is an issue of great concern among amateur and professional astronomers. Even so, most of us enjoy sighting infrequent bright objects such as the International Space Station (ISS) and other satellites we can identify with apps and websites. For local ISS predictions, check NASA's spotthestation.nasa.gov or heavens-above.com and enter your location. The Heavens Above site provides predictions for many other bright satellites.

Being by far the largest object in orbit,

DARK SIDE OF THE MOON
Earthshine is often obvious on a waxing Moon up to five or six days old. On this night, our planet would have displayed the opposite phase in the lunar sky, appearing as a brilliant gibbous Earth lighting the nightside of the Moon. From sites on the lunar near side, Earth remains nearly stationary in the sky as it goes through a monthly cycle of phases.

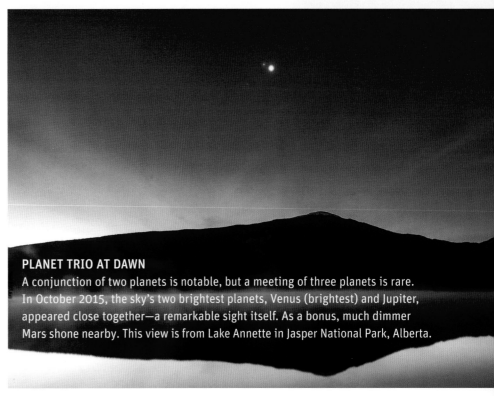

PLANET TRIO AT DAWN
A conjunction of two planets is notable, but a meeting of three planets is rare. In October 2015, the sky's two brightest planets, Venus (brightest) and Jupiter, appeared close together—a remarkable sight itself. As a bonus, much dimmer Mars shone nearby. This view is from Lake Annette in Jasper National Park, Alberta.

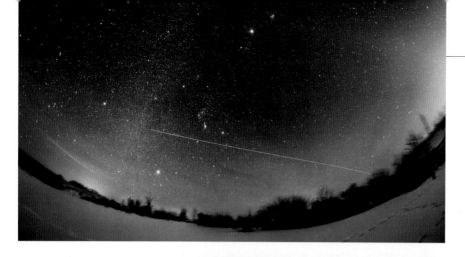

ISS SIGHTINGS

Above: In this long exposure taken on February 10, 2013, the space station appears as a streak across the evening sky, fading at left as it enters the Earth's shadow and experiences one of its 16 sunsets per day.

Above: The ISS can pass directly overhead from sites between latitudes 51 degrees north and 51 degrees south, as it did here on December 2, 2019. **Above right:** An app we recommend for space station predictions is GoSatWatch Satellite Tracking. It shows the times and the path of the ISS—in this case, previewing the pass captured above.

the ISS is the most reflective, often peaking at a magnitude of –3 to –4, between Jupiter and Venus in brilliance but with a yellow tint from its wide gold-colored solar panels. (See page 62 for more on the magnitude scale.) With an orbital inclination of 51.6 degrees and an altitude of 400 kilometers, the ISS can be seen from anywhere on Earth between 60 degrees north and 60 degrees south latitude.

At times, we can see the ISS accompanied by an unmanned resupply craft (such as the Russian Progress, the Japanese HTV and the U.S. Dragon and Cygnus vehicles) or by one of the manned Soyuz, SpaceX Crew Dragon and Boeing Starliner capsules. For a day before docking or after undocking, these appear as fainter dots preceding or following the ISS across the sky. If you can train a telescope on the ISS and follow it, you will see its shape.

Even binoculars will show an H-shape from its solar-panel wings.

While the ISS outshines any other satellite, hundreds of satellites can brighten enough to be visible to the unaided eye. They shine by reflecting sunlight, not by emitting light of their own, so you won't see satellites all the time. They are best observed during the 90 minutes after sunset or before sunrise. The Sun is then below the horizon for earthbound observers but is still shining at the satellite's altitude.

Satellites in low Earth orbit (below 2,000 kilometers) can appear as bright as first- or second-magnitude stars. How quickly a satellite crosses the sky depends on its altitude. The higher the altitude, the slower it moves. Satellites in low Earth orbit complete one circuit of our planet in 90 to 200 minutes and take only two to five minutes to traverse your local sky. Most objects travel from west to east (never east to west), but polar-orbiting objects, such as Earth-observing and spy satellites, move from north to south or south to north.

Satellites occasionally brighten as they head east and become more fully illuminated, just like a full Moon opposite the Sun. Sometimes, they flash briefly as sunlight flares off a reflective surface. If you see a satellite pulsing in brightness, it's likely a tumbling rocket booster or a derelict satellite. For many years, stargazers enjoyed catching predictable flares from the Iridium communications satellites, with their mirrorlike antennas. But the last of those flaring first-generation Iridiums was de-orbited in 2019.

A satellite might redden and fade out halfway down the eastern sky as it enters the Earth's shadow. It has orbited into our planet's nightside and has just experienced a sunset. As the night goes on, the shadow rises higher to engulf the entire sky, so no satellite can be in sunlight. However, people who live at high latitudes (above 45 degrees north or below 45 degrees south) can see satellites crisscrossing the sky all night in summer, when the Sun illuminates high-altitude objects even at local midnight. On short summer nights, it is possible to witness as many as three consecutive passes of the ISS, 90 minutes apart.

SATELLITE MEGA-CONSTELLATIONS

If light pollution weren't enough of an issue, astronomers became concerned in 2019 when Internet billionaire Elon Musk's SpaceX corporation began launching the first of a planned mega-constellation of tens of thousands of satellites into low Earth orbit. Each set of 60 Starlinks can be seen parading across the night sky as a line of bright dots in the nights that follow the launch. A novelty at first, but imagine the sky filled with hundreds of these satellites at any one time, all the time, a requirement to deliver Internet coverage worldwide.

Private companies are unilaterally changing the appearance of the night sky, and not for the better, as the satellite trails threaten to clutter every astrophotograph, both amateur and professional, let alone our naked-eye view of a pristine starry sky. In response to worldwide protests, SpaceX promised to mitigate its satellites' reflective surfaces, and efforts seem to be working, as later sets proved much less visible.

STARLINK TRAIN
Left: On this moonless night, some newly launched Starlink satellites appear in a pack traveling from right to left. **Top left:** An illustration of a SpaceX Starlink satellite.

NOCTILUCENT CLOUDS

Also known as polar mesospheric clouds, noctilucent clouds are seen at night, as the name suggests. They resemble silvery blue cirrus clouds across the northern horizon, glowing with an opalescent quality unlike any other clouds. Noctilucent clouds are usually confined to latitudes between 45 and 60 degrees north (or south, for observers Down Under), although they have been seen from as far south as Colorado. Noctilucents appear only around summer solstice when, from high latitudes, the Sun is just 6 to 16 degrees below the horizon even at midnight and can illuminate them.

Noctilucent clouds form at an altitude of 80 kilometers, five times higher than 99 percent of our planet's weather systems. This amazing height puts them at the fringes of the Earth's atmosphere. These are not normal clouds.

They may be made of ice crystals precipitated around dust from incoming meteors or from pollutants wafted into the mesosphere and trapped in cold polar regions. If you are at a high northern latitude near the end of June or through July, be sure to look north between midnight and 4 a.m. for the slowly moving waves of eerie noctilucent clouds.

NIGHT SHINING CLOUDS
An impressive display of noctilucent clouds shines across the northern sky on June 19, 2019. While they may appear to be glowing internally, noctilucent clouds shine by reflecting sunlight. Time-lapse movies reveal their slow, undulating motion.

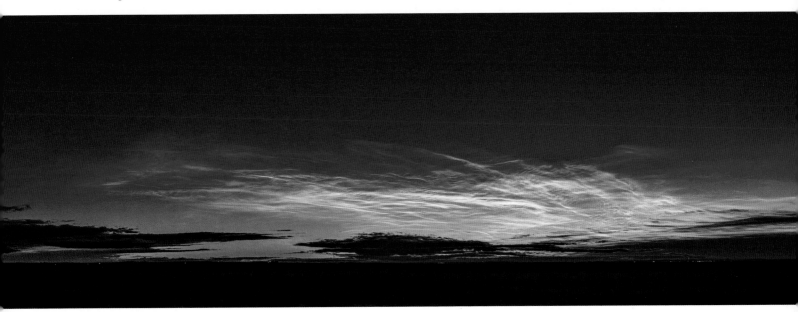

THE DARK SKY

Once the sky is completely dark, a new set of glows and lights is on display in the heavens for the watchful observer. Some are dramatic "Wow!" events. Others are subtle and serene.

METEORS

About 1,000 tons of dust and rock enter the Earth's atmosphere every day. What we call a meteor (or a falling or shooting star by non-astronomers) is created when a particle no bigger than a grain of sand incinerates in the atmosphere. The light we see is actually from the glowing atmosphere around the grain, not from the particle itself.

An object the size of a baseball can create a brilliant, shadow-casting meteor slashing across the starry dome for a few seconds. These celestial showstoppers are so rare and short-lived, you will be fortunate, indeed, to be outside looking in the right direction to see one more than once or twice in your lifetime.

During a prolonged watch on any given night, you will inevitably see a handful of sporadic meteors appear randomly across the sky. Most will be dim. The rare bright meteor, at about magnitude –1, often leaves an ionized trail that glows long after the meteor itself has faded, the trail slowly twisting in high-altitude winds.

Most meteoric material comes from old comets shedding streams of dusty debris throughout the solar system. When a comet approaches the Sun to within the orbit of Mars, solar radiation begins to vaporize its icy surface. Dust and debris encased in the ice since the solar system formed 4.6 billion years ago are released to drift into space. Some of those particles eventually collide with Earth and burn up in our atmosphere.

METEOR SHOWERS

Next to eclipses and bright comets, the celestial event that receives the most publicity is a meteor shower. Meteor showers are predictable annual events when, for one or two

RAINING GEMINIDS
The Geminids of 2017 put on a particularly good show. This composite image illustrates how meteors close to the radiant point appear shorter (and move slower) than those farther from the radiant; in this case, in Gemini.

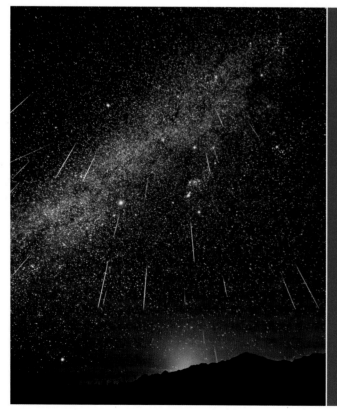

MAJOR ANNUAL METEOR SHOWERS

	PEAK	METEORS/HOUR
Quadrantid	January 3	10–50
Lyrid	April 21	5–25
Eta Aquarid*	May 4	5–20
South Delta Aquarid*	July 27-29	10–20
Perseid	August 11-12	30–70
Orionid*	October 20	10–30
Leonid*	November 16-17	10–20
Geminid*	December 13-14	30–80

The rates are a reasonable estimate of how many you might see under a dark, moonless sky, not the unrealistic zenith hourly rates (ZHR) often quoted.

Showers visible from the southern hemisphere

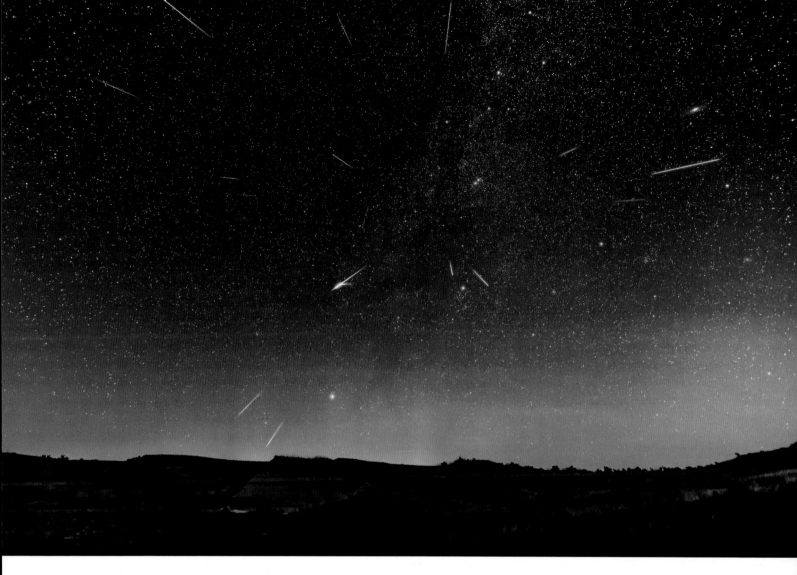

nights, the normally sparse count of meteors jumps to around 20 to 80 meteors per hour. About eight major meteor showers can be seen from the northern hemisphere each year. Observers in the southern hemisphere have just five major showers a year.

During a meteor shower, Earth crosses the orbit of a comet, passing through the dust left in the wake of the comet's previous trips around the Sun. The Perseids are thought to be the flotsam left behind by Comet Swift-Tuttle, last seen in 1992. The Geminids are debris from the asteroid Phaethon, which is more likely a tailless, fizzled-out comet.

Meteor showers can disappoint many first-time viewers. Hit-hungry news and social-media feeds hype every shower with headlines promising "dazzling displays" that will "light up the sky" sometimes despite a glaring full Moon. Sorry! Even the best showers peaking near full Moon will show scant numbers of meteors compared with a favorable dark-of-the-Moon phase.

Under moonless country skies, major showers like the Perseids (August 11-12) and the Geminids (December 13-14) produce only one meteor per minute, on average. Of course, meteors never appear on a one-per-minute schedule. At the peak of a shower, several minutes might go by without any meteors; then there may be a flurry of four or five within a minute or two. Enjoying a meteor shower demands patience.

The Geminids currently provide the best annual show, with the Perseids a close second. But for any shower to be seen at its best, your observing site must be dark, with no Moon present. Your equipment is simple: a lawn chair, a blanket or sleeping bag, a hot beverage and some favorite music. Just lie back and look up. And stay awake!

Plot the meteors on a star chart, and you'll see that all meteor shower trails point back to the same spot in the sky. For the Perseids, this radiant point is in the constellation Perseus, hence the name. For the Geminids, it is

RADIATING PERSEIDS
During the annual Perseid shower, all the member meteors radiate from a point in the constellation Perseus. But don't expect to see a fireworks display like the one shown here. This is a composite of images selected from hundreds taken over three hours, with 15 meteors recorded during that time.

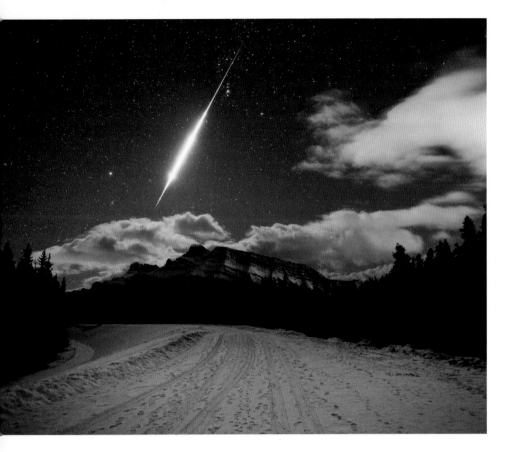

BOLIDE BY CHANCE

On December 20, 2014, while shooting winter nightscapes in Banff National Park, Alberta, Brett Abernethy fortuitously captured a ground-lighting bolide slashing across the constellation Orion. Seeing such a random bolide is rare; photographing one is truly a once-in-a-lifetime achievement. If you see or, better yet, photograph a bolide, report it to the American Meteor Society (amsmeteors.org). Triangulating reports can help track down where meteorites might have fallen.

in Gemini. The Quadrantids of early January are named for the now obsolete constellation Quadrans the mural, a pattern once charted in the Draco-Boötes area.

The apparent convergence of meteor trails is due to perspective. Earth actually passes through a parallel stream of meteor particles. But because a meteor's path in the sky can be more than 160 kilometers long and its end point is closer to the Earth's surface—and you—than its beginning point, meteor paths exhibit the same perspective effect as do railroad tracks or any parallel lines stretching off into the distance. A meteor entering head-on at the radiant appears as a brief starlike flash.

A common practice of veteran meteor watchers is to wait until after midnight (or 1 a.m. when daylight time is in effect). More meteors, both shower and sporadic, grace the skies of the postmidnight hours. At that time, the side of Earth we are on is turned in the direction of our planet's orbital motion around the Sun. Therefore, we are facing "into the wind." Any meteoric debris we run into hits the atmosphere with greater speed and produces a brighter, hotter trail.

METEOR OUTBURSTS AND STORMS

Every few years, predictions of a rare meteor outburst make the news, when a normally quiet shower experiences an unusual increase in meteor rates. Researchers are now able to accurately model the location of meteor streams and the Earth's passage through regions of increased density. For example, astronomers successfully predicted a brief outburst of the Aurigid meteors on September 1, 2007, and a minor outburst of the Alpha Monocerotids on November 21, 2019.

However, none of these occasional outbursts is ever likely to match the storm years of the November Leonids from 1998 to 2001. In 1998, the Leonids produced a fireball shower, a display of unusually bright meteors. And in 2001, observers watched in amazement as a storm of up to 20 meteors *per minute* rained down. Anyone who experienced the 2001 Leonids still raves about the night.

Yet even the 2001 display pales in comparison to the great Leonid storms of 1833, 1866 and 1966, when the sky became a dazzling canopy with hundreds to thousands of meteors per minute. The Leonid meteor shower can ramp up when its parent comet, 55P/ Tempel-Tuttle, returns to the Earth's vicinity every 33 years. Unfortunately, the next Leonid storm is not expected until 2099.

FIREBALLS AND METEORITES

A night spent watching a meteor shower inevitably prompts the question: "Do meteors ever hit Earth?" The answer is, no. No meteor shower debris has ever been known to strike the Earth's surface. Since shower particles are made of fine, crumbly comet dust, they all burn up at altitudes of 60 to 120 kilometers.

Of course, everyone has heard of meteorites, the correct name for objects that do hit Earth. These rocky chunks have a different origin than do most meteors. They are fragments of asteroids that have collided somewhere between the orbits of Mars and Jupiter.

Any meteor brighter than magnitude –4, the brightness of Venus, is called a fireball. Very few produce meteorites. A meteor that appears to explode in a fireworkslike display is a bolide. If a bolide produces several glowing pieces that carry on past the main explosion,

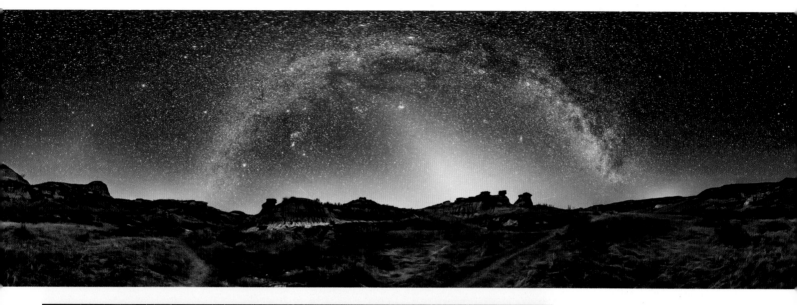

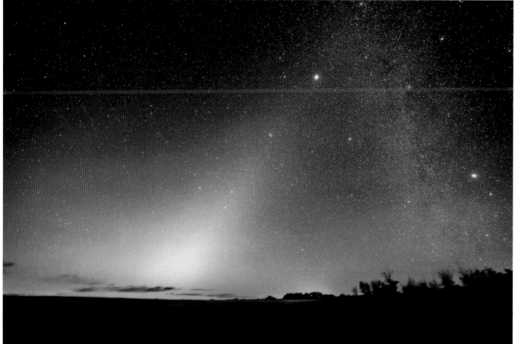

it's possible that some small fragments will survive to the Earth's surface. Report such a sighting to your local planetarium, observatory or college astronomy department. Note the meteor's direction of travel, its height above the horizon in degrees (or in hand widths at arm's length) and the cardinal directions of the start and end points. Record the time and your location.

Many bolide sightings are made from moving cars (so note your location and direction of travel) or, better yet, are recorded on video by dashcams and outdoor security cameras. In the latter case, even videos of moving shadows can provide useful information. For eyewitness sightings, report any sounds, such as hissing, rumbling, whistling or sonic booms, and any time delay between sight and sound.

Keep in mind that while the bolide might appear to have fallen just a few hundred meters away, bolides explode at altitudes of 12 to 25 kilometers, far into the stratosphere. What looks as if it were just over the next hill could be in the next state.

How do you distinguish a natural bolide from a reentering artificial satellite? Satellites

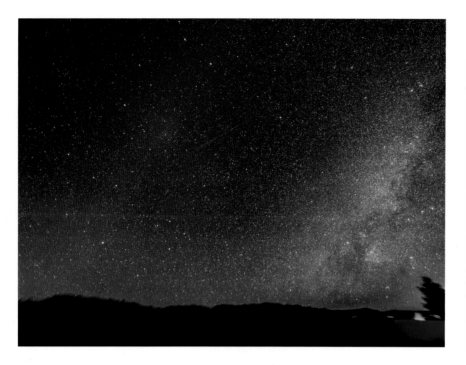

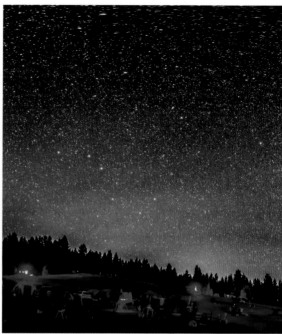

ELUSIVE GEGENSCHEIN
The faint glow of gegenschein (at left) is easiest to see in autumn or spring, when it is against an area of sky away from the Milky Way, as seen here in March 2013, when it was in the constellation Leo. Look for a large, diffuse brightening of the sky at the point opposite the Sun.

and space debris burn up more slowly than bolides, last longer (at least 30 seconds) and traverse a greater angle (100 degrees or more). Because bolides enter the atmosphere at a far greater velocity than artificial satellites, most of them exhibit an explosive terminal burst and a quick burnout.

ZODIACAL LIGHT AND GEGENSCHEIN

A far more subtle effect of interplanetary dust can best be seen on spring evenings and autumn mornings (true for both northern and southern hemispheres). On a moonless night in spring, for example, wait until twilight has left the western sky. If your site is dark, with little light pollution from distant cities, look for a faint pyramid-shaped glow stretching 20 to 30 degrees above the western horizon. (See page 93 for more on measuring degrees.) Fainter than the brightest parts of the Milky Way, the zodiacal light is often mistaken for the last vestiges of atmospheric twilight.

The glow is actually sunlight reflecting off comet-strewn dust orbiting in the inner solar system. It is called zodiacal light because it appears along the ecliptic, the region of the zodiac. The closer you live to the equator, the better your chance of seeing this light pyramid, both morning and evening, because the ecliptic is angled up higher at low lati-

tudes. On clear, moonless nights, however, attentive observers as far north as 60 degrees latitude can pick out the zodiacal light.

Much tougher to see are the other zodiacal light effects: the gegenschein and the zodiacal band. The gegenschein appears as a large (about 10 degrees wide), very subtle brightening of the sky at the point directly opposite the Sun (*gegenschein* is German for counterglow). It is produced by sunlight scattering off meteoric dust beyond the Earth's orbit. February, March and early October are the best times for detecting the gegenschein, since it is then projected onto star-poor regions well away from the Milky Way. Seeing this elusive glow is a naked-eye challenge. Even more difficult is the zodiacal band, a stream of light connecting the eastern and western zodiacal pyramids to the gegenschein. It is more imagined than seen!

AIRGLOW

Although recognized since the 1860s, airglow has only recently become better known among amateur stargazers because it now shows up so easily in our digital images. We routinely capture slowly moving bands of red and green tinting the sky, even from low latitudes, where auroras would rarely, if ever, occur. Visually, however, airglow is usually too faint for the naked eye to see, except as a

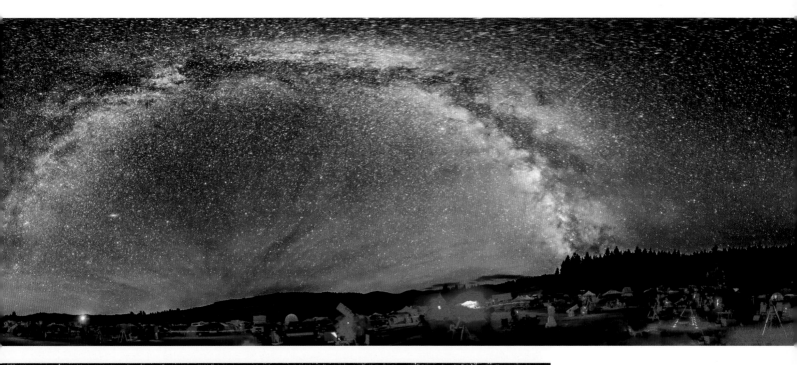

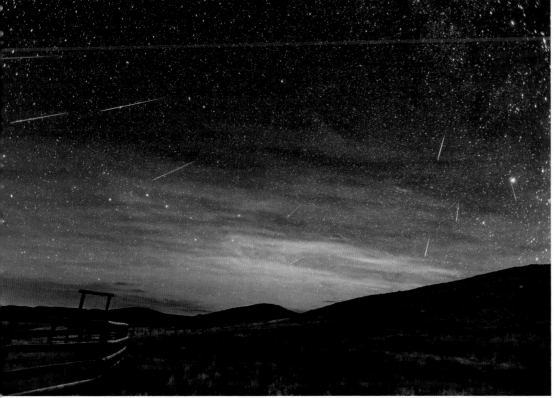

SUBTLE AIRGLOW

Above: The bright August Milky Way arches over the Table Mountain Star Party in Washington State, framing faint bands of green airglow. On this night, only cameras revealed the airglow; to the eye, it was invisible.

NOT SO SUBTLE AIRGLOW

Left: On the night of the 2016 Perseid meteors, the airglow over Grasslands National Park, in Saskatchewan, was so bright that it was easily visible to the eye, with the rare yellow airglow from sodium prominent, as well as the normal green from oxygen.

general impression that the sky is not as dark as you think it should be, despite your site being very dark and the air clear.

Airglow is not an aurora. It is a chemical fluorescence created by oxygen, nitrogen and hydroxyl molecules emitting light as they release energy by night that they absorbed under sunlight by day. A green airglow layer from oxygen at 90 to 100 kilometers is usually the most prominent, but the sky can be dominated by a red oxygen-emission layer at 150 to 300 kilometers. Occasionally, glowing sodium at 80 to 105 kilometers adds a yellow tint.

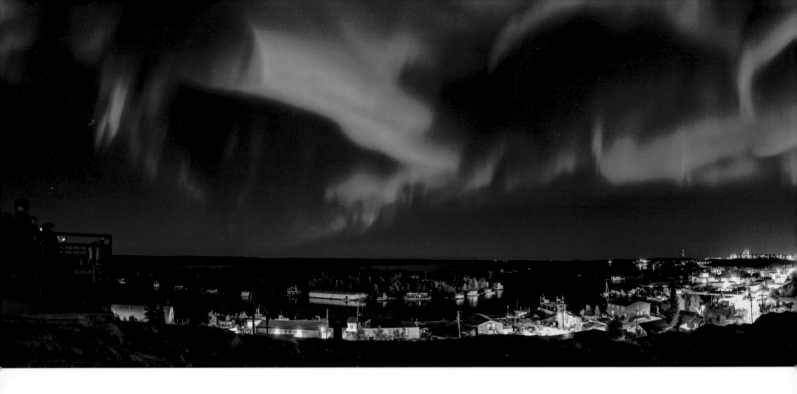

AURORAS

AURORA CITY

Destinations under the auroral oval, such as Yellowknife, in northern Canada, enjoy auroras covering some or all of the sky on most clear nights. This 300-degree panorama showcases a substorm, when the sky went wild with auroral curtains for a few minutes on September 6, 2019.

High-latitude observers are often treated to displays of northern or southern lights —aurora borealis or aurora australis. Auroras can be the most entertaining of all naked-eye phenomena, providing jaw-dropping light shows that are on the bucket lists of not just avid stargazers but also those who might otherwise have only a passing interest in skywatching.

WHERE AND WHEN TO GO

Indeed, aurora tourism has boomed in recent years. Locations in North America, such as Fairbanks, Alaska; Whitehorse, Yukon; Yellowknife, Northwest Territories; and Churchill, Manitoba, cater to aurora tourists, who happily endure winter nights to watch the lights.

On the other side of the Atlantic, Iceland, northern Norway, Sweden and Finland are hugely popular destinations. Aurora chasers at those European longitudes have to travel much farther north (to above the Arctic Circle) than they do in North America. This is because the northern lights occur most frequently along an oval band roughly 2,400 kilometers south of and centered on the north geomagnetic pole—*not* the geographic pole and *not* the magnetic pole, the latter being the pole to which your compass points. That pole is rapidly moving away from North America.

However, the north geomagnetic pole has been located in Canada's High Arctic for decades and, unlike the magnetic pole, isn't moving fast or far. Reports claiming that the northern lights are moving north, away from North America, are mistaken.

The auroral oval dips much farther south over North America, particularly over western Canada, than it does over Europe. Author Dyer frequently sees auroras from his rural site in Alberta; author Dickinson in southern Ontario, to the south and east, much less so.

In the southern hemisphere, the aurora australis forms an oval band around the south geomagnetic pole, in Antarctica. Because few populated landmasses lie underneath the southern auroral zone, most displays of southern lights go unseen. However, when the aurora australis becomes active and moves north, the South Island of New Zealand, as well as Tasmania and the south coast of mainland Australia can be treated to displays low on the southern horizon. The southernmost regions of South America and Africa rarely see the southern lights; they lie too far from the southern auroral oval.

A common misconception about auroras is that they occur most often or only in winter. In fact, the best auroral displays are usually around the equinoxes in March and Septem-

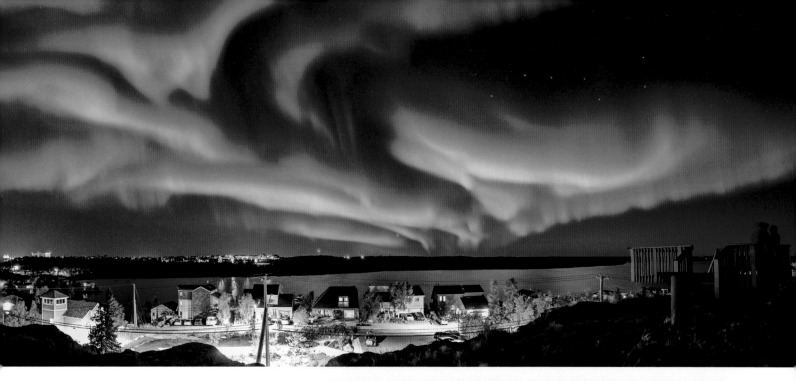

ber, when the Earth's magnetic field seems to connect better to the solar wind streaming from the Sun.

Brilliant auroras can also appear in summer, though not from high latitudes where the sky never gets dark. For example, from one of Dyer's favorite sites in Yellowknife, at 62 degrees north, dark sky aurora season is from late August to late April. From Tromsø, in northern Norway, at 69 degrees north, the dark sky season is October to March.

THE SOLAR CONNECTION

Other than clouds blocking our view, auroras have nothing to do with weather on Earth, in either cause or effect. Their trigger is electrons from the Earth's magnetic tail raining down on our atmosphere. This tail stretches for thousands of kilometers downwind from the Sun. Like an airport wind sock, our planet's magnetic tail is constantly waving and flapping in the solar wind, the stream of electrons and protons flowing out from the Sun.

When the solar wind intensifies, auroras can too. The solar wind varies with solar activity, which waxes and wanes over a roughly 11-year cycle, marked by the number of visible sunspots. The last solar maxima were in 1991, 2002 and 2013. The last minima, in 2009 and 2019, were long and deep, with the Sun spotless for weeks or months at a time. During peak years of solar activity, flares on the Sun's surface are more likely to blow part of the Sun's atmosphere, the corona, into space

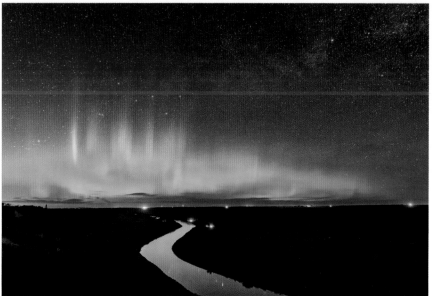

in a coronal mass ejection. At other times, a long-lived hole in the corona can also ramp up the solar wind.

Either way, the enhanced solar wind moving past Earth imparts energy to the electrons trapped in the magnetic fields surrounding our planet. The energized electrons accelerate from the magnetic tail on the nightside of the planet and move back toward Earth, following the magnetic field lines emanating from the Earth's molten outer core. The electrons intercept our atmosphere in an oval band around the Arctic and the Antarctic. And, like an old-fashioned cathode-ray television screen, the atmosphere glows when hit by these beams of electrons.

AURORA RIVER

From locations equatorward of the auroral oval, displays of aurora borealis typically appear as arcs of light on the northern horizon or, for aurora australis, on the southern horizon. Green curtains are often topped with red or magenta spires of light usually visible only to the camera, with both colors produced by glowing oxygen atoms.

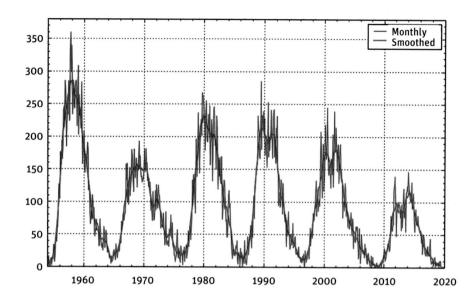

LIGHT SCIENCE

Above: Plotting sunspot numbers as the primary proxy for solar activity shows the Sun's 11-year cycle since the late 1950s. According to one set of predictions, the peak of the next cycle, Cycle 25, is expected for the mid-2020s at a level similar to the low peak of Cycle 24.

Top right: Much to the disappointment of many an aurora tourist, the colors are often visible only to the camera. The eye will see colors if the display gets bright, with green being the most obvious tint.

Bottom right: While there are many aurora apps, Aurora Forecast 3D, from The University Centre in Svalbard, Norway, provides a unique 3D visualization of the current auroral oval. The small sky icon at top left shows whether the lights will be visible from your chosen site, marked by the orange dot; in this case, Churchill, Manitoba. Yes, they will, despite a Kp of just 2 on this night.

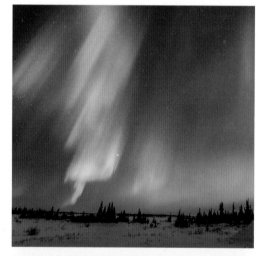

Auroras typically form as vertical curtains extending from 500 kilometers (higher than the space station) down to no lower than 80 kilometers. Even from high latitudes, an aurora usually appears first as a greenish band along the northern horizon. During an active display, luminous shafts climb high into the sky, filling the heavens with rapidly rippling curtains and streamers. When the streamers converge at the zenith, directly overhead, they form a coronal outburst, one of the finest sky sights you can witness. After such an outburst, the display often evolves into patches of light pulsing on and off all over the sky.

The predominant green color, at a wavelength of 557.7 nanometers, is from glowing oxygen atoms at an altitude of 80 to 200 kilometers. Energetic displays exhibit blood-red tints from a fainter emission line of atomic oxygen, at 630.0 nanometers, that occurs at the tops of the curtains, 200 to 500 kilometers up. A combination of blue-green and red light emitted by ionized nitrogen molecules can add a pink fringe to the bottom of an auroral curtain at 80 kilometers altitude.

AURORA FORECASTING

The prime measure of when we are likely to see aurora displays, a number provided by aurora forecast apps and websites, is the Planetary Kp Index, a measure of the disturbance in the Earth's magnetic field on a scale of 0 to 9. Sites under the usual location of the auroral oval can get good displays even with a Kp of 1 or 2. Southern Canada and the northern United States can as well if the Kp reaches 4 to 5. When the Kp shoots up to 6 to 9, even observers in the southern United States (and in Australia and New Zealand) should be on the lookout. It takes a rare Kp as high as 7 to 9 for auroras to expand down over southern England and most of Europe.

However, the Bz Index is also important. This measures the direction of the magnetic field streaming from the Sun. To connect best with the Earth's magnetic field and spark an aurora, the Bz should be south, or negative. The Bz can flip direction within minutes, triggering a sudden brightening of an aurora.

Despite a fleet of satellites that keeps constant watch on the Sun and the interplanetary

magnetic field, mysteries remain. In January 2016, scientists and members of the Alberta Aurora Chasers Facebook group gathered for beers at The Kilkenny Irish Pub, in Calgary. Examining the group's photos, the researchers identified a unique phenomenon: a pink arc equatorward of the main auroral oval. This has been dubbed STEVE (Strong Thermal Emission Velocity Enhancement). Satellite measurements suggest that STEVE events are caused by hot, horizontally flowing gas, not by electrons raining vertically, as with normal auroras. But STEVE's exact nature is a matter of ongoing research, aided by reports and images from amateur citizen scientists. You can contribute observations by tweeting sighting reports to @TweetAurora. For more details, go to aurorasaurus.org.

Most of us, however, are happy to see and shoot auroras just for fun. For aurora-viewing prospects, a good place to start is the website spaceweather.com or search for one of many aurora forecast apps for mobile devices.

FRINGES AND OUTBURSTS

Above right: Bright auroral curtains are often fringed by pink along the lower edges, a color visible to the naked eye. The effect, frequently accompanied by a rapid rippling motion only videos can properly record, is caused by glowing nitrogen molecules. This fish-eye view is from the Churchill Northern Studies Centre, in Churchill, Manitoba.
Right: When they fill the sky, auroral curtains can appear to converge and swirl at the zenith. You gaze up with dropped jaw and eyes wide in amazement. Note the green towers topped with oxygen reds. The reds become obvious to the naked eye only during the brightest and most spectacular displays, usually requiring high Kp values.

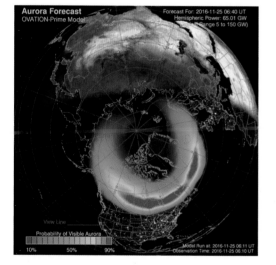

RED ALERT!

Above: Most aurora forecast apps and websites include this OVATION plot of the auroral oval. When it lights up red like this, cross your fingers for clear skies and head out. Even observers at lower latitudes may see something, though perhaps only a glow along the horizon.

CLASSIC STEVE

Right: Exhibiting its trademark pink and white bands, with green fingers below, a STEVE event was captured by Monika Deviat in this superb panorama taken at Peyto Lake, in Alberta, in September 2017. The green picket-fence formation is from raining electrons; the flowing band of pink and white is not. So this is not an aurora per se. The image also shows STEVE's usual location, south of the main auroral oval. Such displays are briefly active for no more than an hour, typically after the aurora to the north has subsided.

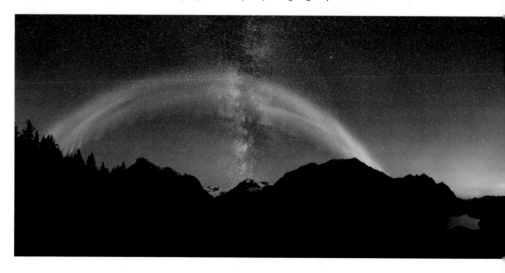

THE BEST PLANETARY CONJUNCTIONS 2020 – 2030

A list of noteworthy planetary conjunctions, both recent and upcoming

DATE	YEAR	PLANETS INVOLVED
December 21	2020	Jupiter and Saturn an amazing 6 arc minutes apart in evening sky
January 10	2021	Mercury, Jupiter and Saturn in a 2°-wide triangle low in evening sky
April 30	2022	Venus and Jupiter ¹/₂° apart low in dawn sky
March 1	2023	Venus and Jupiter ¹/₂° apart in evening sky; Moon nearby on February 16
August 14	2024	Mars and Jupiter ¹/₃° apart in dawn sky
June 9	2026	Venus and Jupiter 1¹/₂° apart in evening sky, with Mercury nearby
November 26	2026	Mars and Jupiter 1° apart in dawn sky, with Mercury and Venus below
March 18	2027	Mars, Jupiter and Moon within a binocular field all night and again on April 15
November 24	2027	Venus and Mars ¹/₄° apart low in evening sky
February 28	2028	Venus, Saturn and Moon within a binocular field in evening sky
November 9	2028	Venus and Jupiter 1° apart in morning sky
July 17	2029	Mars, Jupiter and Moon within a binocular field in evening sky
September 5	2029	Venus, Jupiter and Spica in a 4°-long line low in evening sky
November 8	2029	Venus, Mars and Moon within a binocular field in evening sky
November 25	2029	Venus and Mars 2° apart low in evening sky
June 25	2030	Venus and Saturn ¹/₂° apart in morning sky below Pleiades
August 5	2030	Venus and Mars ³/₄° apart in morning sky

LIFE LIST
TOP 10 NAKED-EYE SIGHTS

We present the first of several life lists of celestial sights (in this case, all visible with the unaided eye) roughly in order of increasing rarity.

1
The galactic center overhead

2
The gegenschein

3
A luminous display of noctilucent clouds

4
A complex halo display

5
An all-sky aurora

6
A grouping of three or four planets and the Moon

7
A brilliant bolide

8
A naked-eye nova (or supernova!)

9
A naked-eye comet

10
An intense meteor storm

THE MILKY WAY

Only one other sky-spanning phenomenon can compare to an aurora for spectacle. Unlike displays of northern lights, this wonderful sight appears almost every night of the year, yet sadly, it can't be seen from most astronomers' backyards. But from a site away from light pollution, little can surpass the naked-eye view of the Milky Way.

OUR HOME IN THE GALAXY

The Milky Way appears as a delicate, misty band of light punctuated by bright, glowing clouds of stars and split by dark, obscuring lanes of interstellar dust. Aim any optical aid at the Milky Way, and as Galileo discovered in 1609, it resolves into thousands of stars too faint and far away to be seen as individual stars with unaided eyes.

When you look at the Milky Way, you are observing a giant spiral galaxy—ours—viewed edge-on. All the stars you see at night with your unaided eyes belong to our Milky Way Galaxy and lie relatively close to us, within a few thousand light-years of the Sun. But the entire galaxy stretches 100,000 light-years from side to side. It is the light of the more distant stars lining our galaxy's spiral arms that blends together to form the hazy band we call the Milky Way.

Our solar system lies about 26,000 light-years from the center of our galaxy, roughly halfway from the galaxy's hub to the visible edge. When you picture our solar system in the galaxy, the image that likely comes to mind is of Earth and the rest of the planets orbiting the Sun in the same plane as the galaxy's pinwheel disk. It's a neat picture, but there is no cosmic requirement that the planes of the solar system and galaxy line up.

In fact, the solar system is tilted about 60 degrees to the disk of the galaxy. This is why the ecliptic (the line that defines the plane of the solar system) crosses the sky from west to east, while on northern midsummer and winter evenings, the band of the Milky Way (marking the disk of the galaxy) bisects the sky from north to south, almost at right angles to the ecliptic.

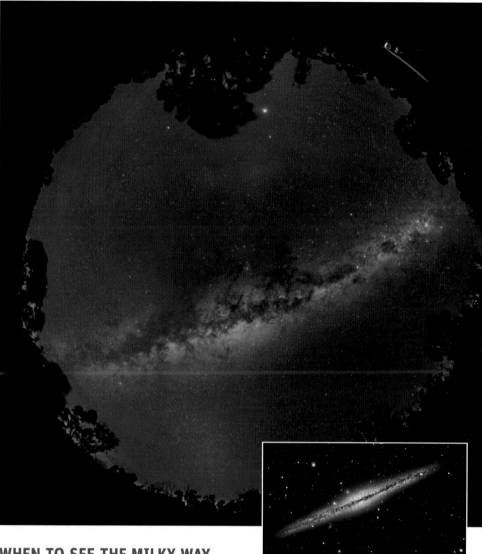

WHEN TO SEE THE MILKY WAY

As the Earth's revolution carries us around the Sun, we look in different directions into the Milky Way's spiral arms, as if gazing out from a spinning carousel. From June to August, our planet's nightside is turned toward the galactic center. We see the glowing core of the galaxy in the constellation Sagittarius, due south in the middle of the night from northern latitudes but high overhead from the southern hemisphere.

Because we are then looking toward its densest collection of stars, the Milky Way appears at its brightest. Many of the star clusters and nebulas visible at this time of year belong to the Carina-Sagittarius Arm, the next spiral arm inward from our galactic home in the Cygnus-Orion Arm or Spur.

Six months later, from December to Febru-

OUR EDGE-ON GALAXY

From the southern hemisphere, we see the Milky Way for what it is, a spiral galaxy viewed edge-on, complete with dark dust lanes. It is similar to galaxies observed in telescopes, such as NGC 891 (inset), but with the Milky Way, we see it spanning the sky. Its true nature becomes apparent when the galactic core appears overhead, as in this scene from Australia, which has been processed to simulate a naked-eye view.

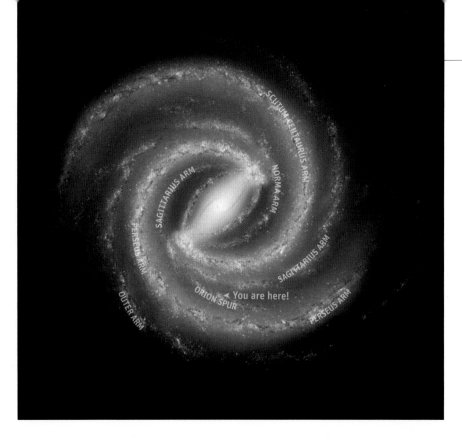

MAP OF THE MILKY WAY
Decades of observations with radio telescopes and infrared satellites have produced this map of the Milky Way, showing our galaxy as a barred spiral with two main arms emanating from either end of the central bar. While the details are still debated, it seems we live in a minor arm segment between the two main arms. Most of what we see in our night sky with unaided eyes and even with a telescope lies in the Orion Spur region of the galaxy. From June to September, we gaze toward the galactic center; from December to March, we look toward the outer edge of the Milky Way. In northern spring, we look out the top (off the page), while in northern autumn/ southern spring, we look out the bottom of the Milky Way, at right angles to the plane of our disk-shaped galaxy.

ary, the nightside of Earth faces the opposite direction, toward the outer edge of the galaxy and the constellations Orion and Gemini. Because we live in an outer spiral arm, there isn't as much galaxy between us and the dark depths of intergalactic space in this direction. The Milky Way in this region of the sky appears fainter. The bright stars in and around Orion all lie close to us, within 1,500 light-years or so, the product of active regions of star formation in our local arm. Many of the nebulas and star clusters, from Monoceros to Perseus, belong to the next arm out from ours, the Perseus Arm.

Between these two seasons, in spring and autumn, Earth is oriented to look at right angles to the Milky Way. We look out the top of the galaxy from March to May and the bottom of the galaxy from September to November. In autumn, we never lose sight of the Milky Way completely. As the sky turns, the Milky Way twists to become a band oriented east-west across the sky. For sessions of nonstop exploring along the spiral arms of our galaxy, autumn nights are best, true in either hemisphere (from September to November in the north, March to May in the south).

In springtime from either hemisphere, however, we do lose sight of the Milky Way. On spring nights, it lies along the horizon, wrapping around us in a 360-degree pano-

rama. We look straight up toward a galactic pole: the north galactic pole in northern spring and the south galactic pole in southern spring. It is around these galactic poles, far from the Milky Way's obscuring dust clouds, that we can peer farthest into space. Here, we find the richest collection of galaxies beyond ours. For telescope owners, spring is galaxy-hunting season, whether you live in Sydney, Nova Scotia, or Sydney, Australia.

To plan your Milky Way expedition, see Chapter 4 for more on how the Milky Way's position changes through the year.

WHERE TO SEE THE MILKY WAY
To see the Milky Way at its best, head as far from city lights as you can, perhaps to a local dark sky preserve (see the next chapter). Under the darkest August skies, for example, our galaxy's subtle glow can be seen extending far from the main star clouds into constellations such as Delphinus and Lyra. The Great Rift of interstellar dust that splits the Milky Way through Cygnus and southward becomes obvious. Diagonal dark lanes in southern Ophiuchus and Sagittarius form what looks like a prancing "Dark Horse." Under superb conditions, the lane delineating one of the horse's front legs can be traced as far as Antares, in Scorpius.

The Milky Way is most spectacular through Sagittarius and Scorpius, home of the center of our galaxy. From Canadian and northern European latitudes, these constellations crawl along the southern horizon, denying northerners decent views of the best part of our galaxy. To see this area of the sky well, go south. From the southern United States or Mediterranean latitudes, the glowing star clouds of Sagittarius climb high enough that they shine as the dominant naked-eye feature of a dark summer sky.

Even a trip to the tropics, however, gets you less than halfway to a full view of the southern sky. The magic latitude is 30 degrees south: central Chile, Australia and southern Africa. From there, under dry desert skies, the center of the galaxy passes overhead on winter evenings (June to August), glowing so brightly, it can cast a shadow. Lie back, gaze up at the galactic core, and enjoy a three-dimensional

experience unlike any other in astronomy. As we look up at the galactic core, our location on the outskirts of a spiral galaxy seen edge-on becomes obvious. (We provide more southern-sky tours in Chapters 6 and 16.)

And yet, burdened as many astronomers had been with their northern-hemisphere viewpoints, it was not until early in the 20th century that the question of the Milky Way's size and shape and our position in it was settled. For all northerners, we highly recommend a trip Down Under to put the Milky Way, and our place in the galaxy, in its true perspective. This is naked-eye astronomy at its finest. That change of latitude can change your attitude—and your life.

GALAXY VS. ECLIPTIC

Because of the 60-degree tilt of the solar system with respect to the plane of our galaxy, we see the Milky Way intersecting the ecliptic (marked by the line through Jupiter and Saturn) at that same angle, 60 degrees. This image was taken in June 2019, when the two gas giant planets flanked the Milky Way.

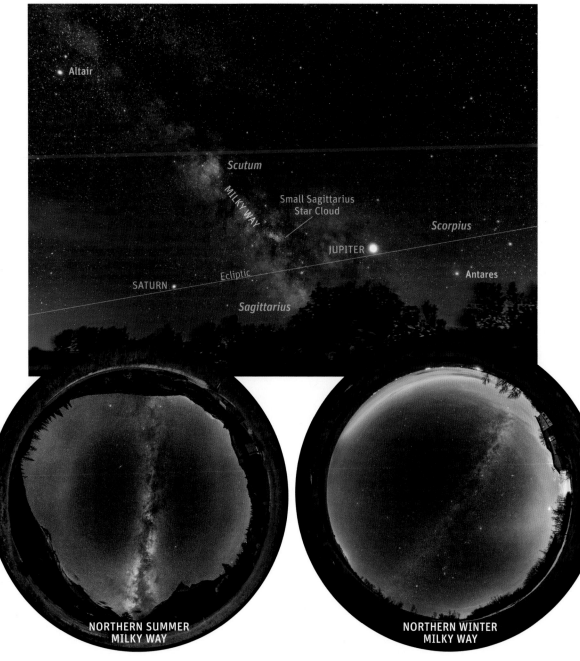

THE MILKY WAY: NORTHERN SUMMER VS. NORTHERN WINTER

Bottom left: In northern summer, we are looking into our galaxy, with the glowing galactic center to the south. Overhead, the Milky Way is bright through Cygnus, where we look down the spiral arm fragment in which we live. This August view is from the dark sky preserve of Waterton Lakes National Park, in Alberta. The 360-degree fish-eye image also captures the faint gegenschein and zodiacal band at left.

Bottom right: Six months later, we are looking in the opposite direction, toward the outer edge of our galaxy and the outer Perseus spiral arm. Although dimmer, the Milky Way of northern winter is populated by many bright stars in and around Orion's nearby star-forming regions. On this February night, we see the zodiacal light to the west (right) and an aurora along the northern horizon (top).

NORTHERN SUMMER MILKY WAY

NORTHERN WINTER MILKY WAY

Rasalhague

Ophiuchus

Dark Horse

Serpens

NAKED-EYE SPECTACLE

The richest region of the Milky Way, from Aquila
(at left) to Crux (at right), flanks the galactic hub, in
Sagittarius and Scorpius. This photographic panorama
simulates a largely monochromatic naked-eye view, with
dark dust lanes framing bright star clouds. From a dark
site, all these features can be seen with unaided eyes,
though from midnorthern latitudes, the right side of the
Milky Way, to the right of Scorpius, will be below your
horizon. Head to the tropics to see Alpha Centauri and
Crux, the Southern Cross.

Coathanger

Great Rift

Binocular Field

M23

Pipe Nebula

Scutum

Galactic
Center

Small
Sagittarius
Star Cloud

M8

Sagitta

Aquila

Scutum
Star Cloud

M25

Sagittarius
Star Cloud

M22

Altair

The Teapot

Sagittarius

Delphinus

Field of Nothing

Corona Australis

DARK FEATURES

Splitting the Milky Way through Aquila and Ophiuchus is the
Great Rift of interstellar dust, or carbon soot. Dust lanes
superimposed on the galactic core form a "Dark Horse," with
tendrils reaching from its front legs toward Antares, in Scorpius.
The horse's back end is known as the Pipe Nebula. One sign
of a dark sky is when you can see these dust lanes well. Being
nearby and lacking stars, they look darker than the rest of
the starry sky, which is gray due to distant starlight.

STAR CLOUDS

The large and small star clouds in Sagittarius stand out
as the brightest features of the Milky Way. The galactic
center lies just above the main Sagittarius Star Cloud.
Symmetrically positioned on either side of the galactic
center lie the star clouds of Scutum and Norma. They
are created by dust-free windows into the Scutum-
Sagittarius Arm and the Norma Arm, both inward of ours.

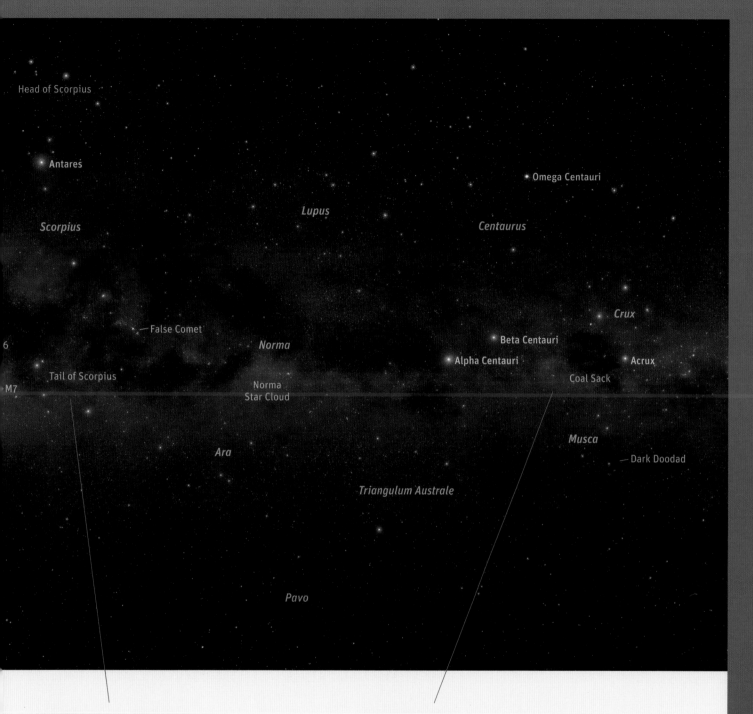

Head of Scorpius

Antares

Omega Centauri

Lupus

Scorpius

Centaurus

Crux

False Comet

Beta Centauri

Norma

6

Alpha Centauri

Acrux

Tail of Scorpius

Norma
Star Cloud

Coal Sack

M7

Musca

Dark Doodad

Ara

Triangulum Australe

Pavo

ARCHER AND THE SCORPION

Scorpius, here turned vertically, is one of the few constellations that looks like what it is supposed to be, a scorpion. Reddish yellow Antares marks the scorpion's heart. Below Scorpius, on the other side of the Milky Way, lies Sagittarius the centaur archer. We see this constellation as a teapot, with the bright Milky Way star clouds as the steam rising from its spout.

THE DARK EMU

From Australia, the dark outline of the aboriginal constellation of the Emu is obvious. The Coal Sack Nebula beside the Southern Cross is the bird's head and beak. Her neck is the obscuring dust lane through Centaurus that arcs up into Lupus and Scorpius. The glowing core of the galaxy is her body, while her legs are the dust lanes on either side of the Scutum Star Cloud. In South America, the Incas saw these dust lanes forming a dark llama across the sky.

CHAPTER 3

Your Observing Site

Purchasing a telescope might be the first thing that comes to the mind of an aspiring backyard astronomer. Not so fast! An often-neglected consideration is your observing site. Where are you likely to conduct most of your stargazing? And what will you be able to see from there? Your answers will have the biggest impact on which telescope you buy. As we emphasize in Chapter 7, it is best to choose a telescope (especially a *first* telescope) that is well suited to your main site, rather than one that can be used only rarely at a seldom-visited remote location.

Of course, the main reason to consider your site is the scourge of light pollution that brightens our night skies. Yet a great deal can be seen from the city, provided you can see the sky at all. In this chapter, we discuss factors to take into account when selecting your observing site, urban or rural.

From the best sites, the Milky Way exudes a textured appearance to the naked eye, with many levels of intensity and obvious rifts etched by dark nebulas. This image was taken in August 2019 from Grasslands National Park, in southern Saskatchewan, which was established as a dark sky preserve in 2009. Note bright Jupiter to the right of the Milky Way core and dimmer Saturn to the left, above the handle of the Teapot form of Sagittarius.

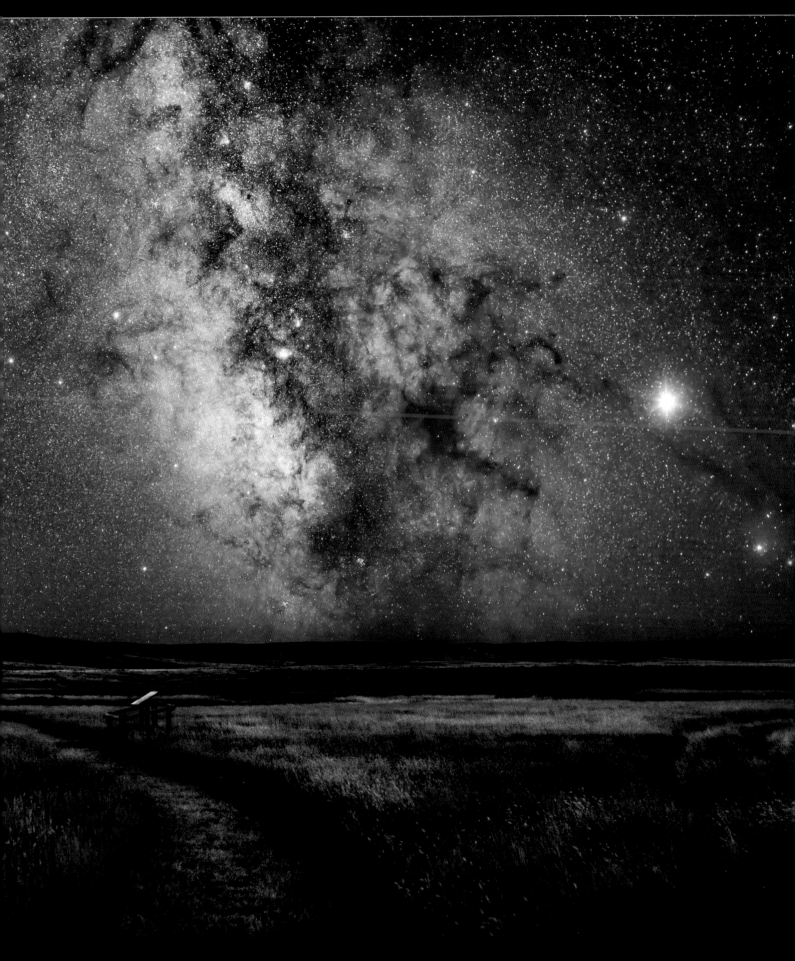

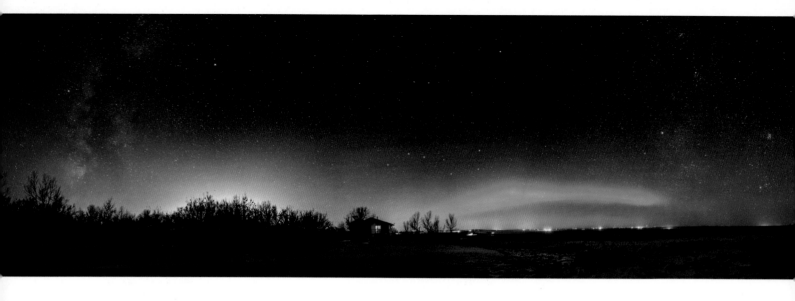

THE ERODING NIGHT SKY

AURORA COMMERCIALIS

AURORA COMMERCIALIS
From 60 miles away, a city of a million people to the west casts a dome of LED-white into the sky, washing out the Milky Way and competing with the natural sight of the aurora borealis at right. No wonder people say they don't see as many auroras now as they did in their childhood.

When our grandparents were young, the splendor of a dark night sky filled with stars and wrapped in the silky ribbon of the Milky Way was as close as their back door. Not anymore. Giant domes of light cover every city at night. Major metropolises are visible from 100 miles away as glows on the horizon. From a distance of 40 miles, they ruin most of the sky.

THE FIGHT FOR THE NIGHT

We are not suggesting that night lighting isn't needed in modern society. The problem is waste lighting. It's everywhere: Empty parking lots are floodlit all night; security lights pour into neighbors' windows, rather than being confined to the target area; and glaring streetlights spill their output sideways and upward.

In response to environmental concerns and a desire to improve the aesthetics of their cities, some "dark sky communities" have implemented strict lighting ordinances. Flagstaff, in northern Arizona, is the model, being declared a Dark Sky Place by the International Dark-Sky Association (IDA, at darksky.org).

The city passed bylaws regarding outdoor lighting (to quote from their preamble) "to help assure that dark skies remain a resource to be enjoyed by the Flagstaff community and its visitors and to provide safe and efficient outdoor lighting regulations that protect Flagstaff's dark skies from careless and wasteful lighting practices. Dark starry nights, like natural landscapes, forests, clean water, wildlife and clear unpolluted air, are valued in many ways by the residents of this community." We could not have said it better.

Residents and officials of most other communities would likely agree, yet they seldom recognize waste lighting as an environmental issue. More and brighter light is considered desirable "progress."

If stargazing were the only casualty of waste lighting, calls for action from astronomers would be ignored. But the impact on the night sky is only part of the issue. In the United States alone, the IDA estimates that 30 percent of all outdoor lighting (street, parking lot and security lighting) is wasted, with light shining upward. That equates to $3.3 billion wasted annually, resulting in 21 million tons of CO_2 per year added to the atmosphere from waste lighting alone. Offsetting that level of greenhouse gases would require planting 875 million trees.

Fortunately, communities wanting to trim budgets and combat climate change are shifting to more environmentally friendly lighting. All over the world, cities and towns are replacing inefficient, yellow sodium-vapor lights with energy-efficient LED lights, and most of the new fixtures are full cutoff designs that minimize light wasted up to the sky.

That's the good news. The bad news is that in the rush to convert to LED lighting, most municipalities opted for cheaper, more efficient white or blue-rich fixtures—and more of them —turning night into day. This lighting might save energy, but not the sky. Thus light pollu-

tion continues to grow worse each year. What were yellow glows over cities are now white.

URBAN ASTRONOMY

Of course, we prefer to remain optimistic. Newer, less glaring LEDs with a warmer color are becoming more common as residents object to blinding-white LEDs. And there's much you can see under bright skies *if* you make the effort. If you plan to stargaze only on dark-of-the-Moon weekends at remote sites, you might never see the sky anyway, and not because of light pollution. The problem is that your schedule and clouds will rarely agree.

The cruel reality is that the clearest nights often occur during the week or when the Moon is in the sky. The key is to accept the weather and sky conditions and make the best of them…from where you can, despite the light pollution. To succeed at "opportunistic" urban stargazing, you must first find a site with little in the way—no buildings, trees or nearby lights shining in your eyes.

Apartment dwellers might be limited to observing from balconies, with most of their building in the way. And yet seeing the Sun, Moon and planets is still possible, at least from a south-facing apartment (for northern-hemisphere observers). If you have access to your building's roof, all the better. The height puts you above the worst glare of the street-lights below.

If your urban or suburban home has a yard, position your telescope where it will be shielded by fences or bushes from surrounding streetlights and porch lights. After a few minutes, when your eyes have adapted to the semidarkness, there is lots to see. Typically, fourth-magnitude stars are visible over the suburbs of a large city, and fifth-magnitude stars can be seen above the outer reaches of a smaller metropolis. Of course, it depends on moonlight and on the clarity of the sky each night, but if you can shield yourself from nearby lights, the results will surprise you.

Choosing your site and your targets wisely

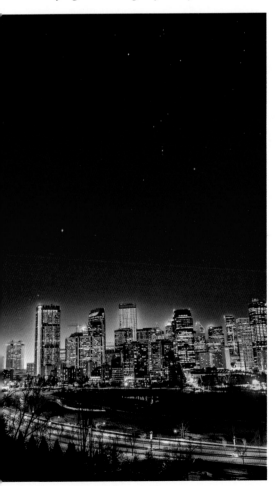

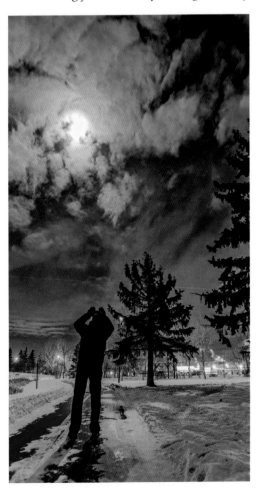

URBAN STARGAZING

Far left: Despite the lights, it is possible to see stars from an urban site on clear, dry nights, when constellations like Orion are visible. The key is getting away from the glare of nearby lights.
Left: Moonlight, streetlights and clouds…oh, my! When the only thing you can see is the Moon, look at the Moon! Here, it is nestled in clouds, creating a colorful lunar corona, a fine binocular target.

will determine the success of your urban stargazing experience. The Moon and planets are unaffected by urban lighting. Indeed, an atmospheric inversion layer over cities sometimes steadies the air so that the seeing is occasionally better in the city than in the country. The steadier air produces a sharper view. (We explain how to ensure the sharpest lunar and planetary views in Chapters 10 and 14.)

While a small telescope might be the most practical for city use, a bigger scope does have its advantages. For example, an 8-inch (200mm) aperture telescope under a bright suburban sky is limited to roughly the same non-solar-system targets as a 3-inch (80mm) telescope under a dark rural sky. However, the big scope's better ability to resolve fine detail is unhampered by light pollution. What you can see in the city looks just as sharp as it does in the country. Planets can look stunning. Double stars are another good class of urban objects, requiring resolution and a steady sky more than a dark sky.

While urban glow washes out diffuse nebulas and galaxies, the brightest star clusters make good suburban targets. Special filters that reduce light pollution (discussed in Chapter 8) can enhance some of these deep sky objects. However, they cannot transform a bright urban sky into a dark rural sky. Sorry!

EVALUATING YOUR SITE

Unless there is absolutely no alternative, we suggest not relying exclusively on a remote, albeit ideal, site. You'll see much more from an imperfect site you use often than from a perfect site you seldom visit. The convenience of a site at or near home is immense, as is the ability to grab time under the sky at a moment's notice on any night the clouds clear. For an urban site, consider the following:

◆ Is it limited to binoculars, or is there room for a telescope to be used in privacy? If you will be visible to neighbors or passersby "doing something" with a suspicious tubelike device, don't assume the first thing people (such as the police!) will think of is astronomy.

◆ How safe is the area? An urban park near

EARTH AT NIGHT
Showing the signature we humans have written on our planet by lighting up the night, NASA's Black Marble image from 2016 uses data from the Suomi National Polar-orbiting Partnership satellite to compile a composite global view of Earth at night.

CITY FROM SPACE
In January 2020, astronaut Jessica Meir snapped this image of Calgary, Alberta, from the International Space Station. As with many communities, the conversion to LED lighting from yellow sodium-vapor lights, for better or worse, was almost complete when this photo was taken.

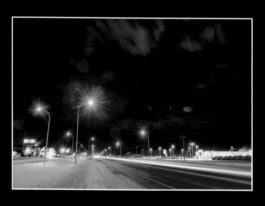

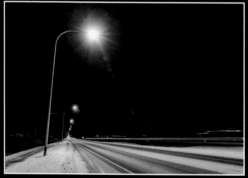

BEFORE AND AFTER
Left: Old cobra-head sodium-vapor lights glare in all directions, and the lamps are visible from far away. These fixtures are being replaced everywhere with shielded LEDs, but often not the best LEDs.
Bottom left: With cutoff shielding, the light is directed downward and the lamps themselves are not visible from a distance. The best LEDs, as here, shine with a "warm" color temperature of no more than 3,000 K (kelvin).

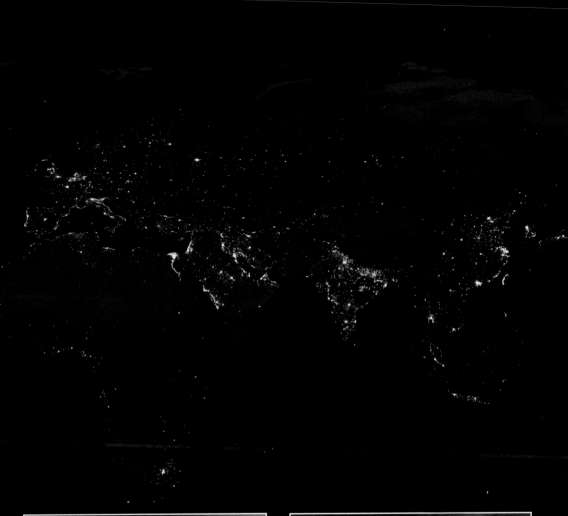

THINK GLOBAL, ACT LOCAL

While you might want to change the world, your battle for better lights is likely to begin at home, by convincing City Hall to remove or shield a glaring light in your street or back lane or by persuading a neighbor to turn off outdoor security lights. Invite your neighbor over for a backyard star party, and offer to switch those security lights to shielded fixtures at your expense. Share your views of what can be seen in the sky when the lights are off. For the science of the effects of poor lighting, model bylaws to help you implement local changes, listings of approved fixtures and more, see the International Dark-Sky Association's website at darksky.org.

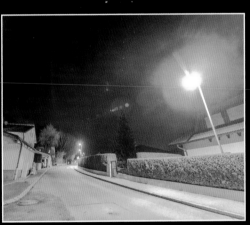

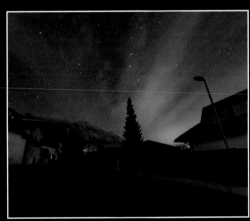

I CAN SEE CLEARLY NOW

Two views of the same street with unshielded lights ablaze (far left) and during a power outage (left) reveal just how much we are missing by hiding under the glare of ugly, wasteful lighting.

SHIELDED LIGHTS

While lighting fixtures are often shielded, many municipal engineers select fixtures with a blue-rich color temperature of 4,000 to 5,000 K. White LEDs disrupt the natural diurnal rhythms of plants and animals, with potential health consequences to humans. Ensure that your own home has dark-sky-friendly exterior lighting, with shielded "warm" 3,000 K LEDs. Here are a few examples of shielded fixtures approved by the International Dark-Sky Association.

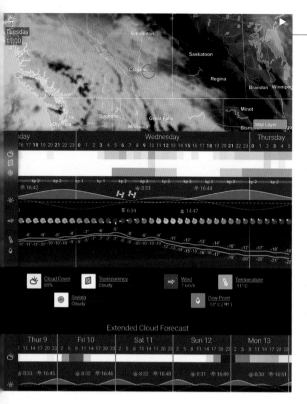

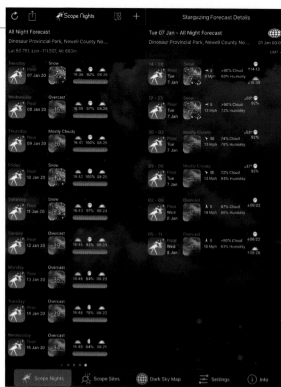

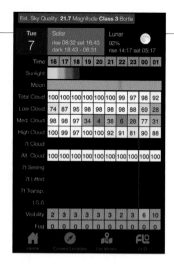

CLEAR OUTSIDE APP

Above: This U.K. app (here displaying the same night as the Astrospheric app at far left) gives hourly forecasts of low-, medium- and high-level clouds.

WEATHER APPS

Above left: The Astrospheric app provides hourly wind, temperature and cloud-cover forecasts (not good ones for the week shown here!), plus transparency and seeing values and even predictions for Auroral Kp Index and passes of the International Space Station.

Above middle: The Scope Nights Astronomy Weather app shows observing prospects for the current night in five-hour blocks and for the next week. Again, the sky doesn't look good here! "Poor" is all too often the reality.

home might provide an open view of the sky but could attract nefarious activities at night.

◆ If a telescope is useful at your site, even if it is at home, how far will you have to carry it?

◆ For a typical setup, how many trips will you have to make to and from the car or house?

◆ Can your equipment be left unattended while you assemble and disassemble the telescope? If not, can everything be carried in one trip?

That said, the question becomes: Can one telescope suit both a local and a remote site? A telescope that can be carried outside without being disassembled (what we generally call a "grab-and-go" scope) will be used more frequently than one requiring multistep assembly and disassembly. You might not think so now, but once the initial euphoria of the big new telescope has worn off, the prospect of setting it up and breaking it down looms large. You will find every reason not to use it—even from home.

Thus the best telescope for home use might be a small, even basic model, not a fancy dream scope. Or the solution could be two telescopes: a simple one suited for the less-than-ideal local conditions and a larger-aperture "bells-and-whistles" telescope that is best used under the dark skies of a rural site. In Chapter 7, we offer lots of choices.

PREDICTING CLEAR SKIES

Of course, even the best site is for naught if the sky is cloudy. Sources for weather forecasts abound, but many are not as precise as we like for astronomy, where we want hourly indications, even maps, of cloud cover. Fortunately, a number of services are aimed specifically at astronomers. For North America, the Clear Sky Chart (cleardarksky.com/csk) provides predictions for cloud cover on an hourly basis and for humidity (to judge the potential for dew or frost), transparency (valuable for glimpsing faint deep sky objects) and seeing (for sharp views of the Moon and planets). The data come from Environment Canada's forecasts for astronomy (weather.gc.ca/astro/index_e.html).

The superb Astrospheric mobile app (iOS and Android) and website (astrospheric.com) employs this same source for its underlying data. We check it daily to plan our observing sessions. Users elsewhere in the world can try Clear Outside, an app (iOS and Android) and a website (clearoutside.com). The Scope Nights Astronomy Weather app, shown above (eggmoonstudio.com), and the very comprehensive Xasteria (astro.ecuadors.net) are for iOS only. Australians can go to the SkippySky website (skippysky.com.au/Australia/) to view maps of multilevel cloud cover and plots of seeing and transparency.

RATE YOUR OBSERVING SITE

We present our checklist to rate your observing site on a scale of 0 to 40 points.
A site next to your home, at a dark location, with little chance of mosquitoes or snow earns
the maximum possible score of 40 points. Any score over 20 is well suited for regular use.

General Light Pollution: +10 Points
Score 10 if you can see 6.5-magnitude stars overhead and the light dome from the nearest city rises less than 10 degrees (Class 4 or better on the Bortle Dark-Sky Scale). Score 0 if you cannot see any star fainter than magnitude 4.0 (Bortle Class 8 or 9). See pages 59 and 60.

Local Light Pollution: +5 Points
Give yourself full points if there are no local lights visible at your site; 4 points if the brightest unobscured light is fainter than Venus. Score 2 for a site that requires moving around to remain in the shadows; 0 points if you cannot avoid a local light as bright as the Moon.

Horizon: +5 Points
A clear, flat horizon to the south earns full points. South obstructions higher than 30 degrees rate just 2 points. Similar obstructions in all directions score 0.

Convenience: +5 Points
Full marks if you can observe in comfort from your own yard; 3 points for a short walk; 2 for a short drive; 0 for a drive of an hour or longer.

Ground Level: +5 Points
If your equipment is stored in a ground-level room, you win! Score 5 points. Take 3 points if car loading is required, but score 0 if any full flights of stairs are involved.

Amenities: +5 Points
Score 5 for a washroom and warm-up room at your site; if your site is basic and rustic, score 0.

Privacy: +5 Points
No possibility of surprise interruptions by people, animals or unwanted headlights (or police searchlights!) scores you another 5. Score 0 if you feel nervous at the site.

Insects: −5 Points (or more!)
Mosquitoes are your enemy. Subtract 1 point for each month they are predictably annoying.

Snow: −5 Points (or more!)
Snow reflects light and increases light pollution. Subtract 1 point for each month of snow cover.

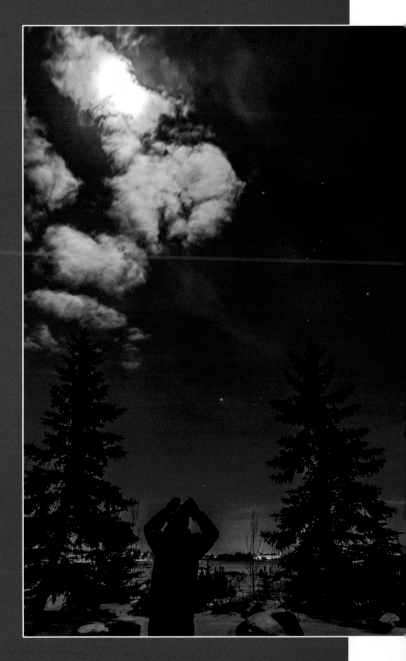

STARGAZING, IN SPITE OF...
Despite the poor viewing conditions on this night in early 2020, it was still possible to gaze at Orion with binoculars and to check on Betelgeuse, then at a record dim magnitude.

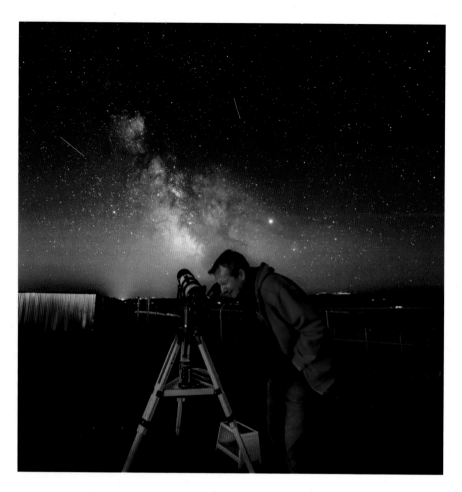

SEEKING DARKNESS

LOOKING SOUTH

As long as you can get out from under the light dome of your home city (assuming another city isn't adjacent), it is possible to see the Milky Way. A site southeast to southwest of the city is preferred so that the darkest sky lies to the south, allowing the best views of the Milky Way. Even in the southern hemisphere, this same advice applies.

Few people live where sixth-magnitude stars (the faintest the naked eye can usually see) are visible from their backyards. Most amateur astronomers must hunt for such a site, and reaching it can be an expedition if you live in or near a city of more than a million people. A 90-minute drive to get a reasonable view of the Milky Way is, unfortunately, a commonplace experience. In this section, we present tips and advice for seeking such a site under dark skies.

SEEKING A DARK SITE

Even outside the city, obstacles remain. Homeowners like to install dusk-to-dawn security lights that pump light into astronomers' eyes from up to two miles away. But beyond the aggravation of rural lighting is the question of where to go once you are in the country.

Stopping on a backcountry road is fine for binocular gazing, but it's not ideal for setting up a telescope and mount that can't be put back in the car in seconds. There is the real possibility of being mistaken for a trespasser with ill intent. Amateur astronomers tell horror stories about being confronted by suspicious landowners, sometimes at gunpoint, or by a carload of troublemakers.

Heading out on your own in search of a dark site to observe an aurora, a meteor shower or a bright comet is always a gamble. Yet sometimes it is the only choice, especially in the case of a comet or a rare conjunction of planets near the horizon demanding a specific viewing direction.

For long-term use, you'll want to seek out a dark location that is safe from intruders. If you have friends or family with a cottage or rural acreage, you might be all set. Otherwise, inquire at the local astronomy club or on a social-media page for stargazers in your area. Find out where they go to observe the night sky. Clubs might have a private members-only observatory at a secure location, or perhaps they have found a public park or conservation area they have been given permission to access and use after hours.

What constitutes a good observing site? The Milky Way should be distinct. Third-magnitude stars should be visible less than five degrees above the horizon, and binoculars should reveal stars right down to the true horizon. It is almost impossible not to have at least one dome of light somewhere on the horizon from a nearby town or more distant city. But if the largest dome is toward the north, it will be least annoying—unless it is an aurora borealis you are after. From northern-hemisphere sites, objects to the north are visible nearly overhead two seasons later, so the site should be south of the nearest major city. Go north, and you will be looking back toward the city glow for most targets. However, sites east or west of a major city can also work well.

While location is important, so is terrain. Snow cover is bad, not just because it is cold but because it reflects light back up to the sky, exacerbating whatever light pollution there is. Skies over snow-covered sites can be at least half a magnitude brighter because of reflected light. Cold, crisp nights might look good at

first glance, but the brilliance of northern winter nights is partly an illusion caused by the brightness of Orion and its star-rich neighbor constellations.

The ideal site is an isolated, elevated clearing in an area with dark vegetation, such as dense grass, scrub shrubbery or trees—the latter is also helpful for blocking distant lights. Coniferous trees are preferable to deciduous, not only because they block light year-round but because they release less moisture (i.e., dew) into the atmosphere. To that end, avoid low areas near open water or boggy ground where dew and fog will cut your sessions short. Higher sites are usually drier sites.

SEEKING THE PERFECT SITE

Here are a few other factors we look for when seeking out that perfect remote site and peak observing experience:

First, the location must be accessible. If you can't get there with your telescope, the perfection is moot. Ideally, we want to avoid lengthy treks on dirt or rough roads. Dust coats optics and works its way into mounts and drives, while shaken telescopes can arrive with mirrors rattling around inside the tube.

Altitude is good. But not too much! While you may have the clearest of conditions near sea level, the atmosphere itself absorbs at least 0.3 magnitude, even when looking straight up. At an altitude of 7,000 feet, however, it absorbs only 0.15 magnitude. We call this "atmospheric extinction."

Why not go higher? Besides feeling dizzy and experiencing difficulty breathing, you'll find that the reduced oxygen above 9,000 feet impacts dark adaptation—you lose the ability to detect faint objects at night. For instance, on the 14,000-foot summit of Hawaii's Mauna Kea, which is dotted with giant observatories, the sky looks less starry to the naked eye than it does at the 9,000-foot Visitor Center level.

Dry is also good, but not dusty. Dust particles scatter light and can make a mess of optics. Water vapor is worse, and not just because of dew. Places in eastern North America lose at least 0.2 magnitude to high humidity. It is this extinction factor that dims stars toward the horizon, where we peer through a much greater depth of atmosphere than when we

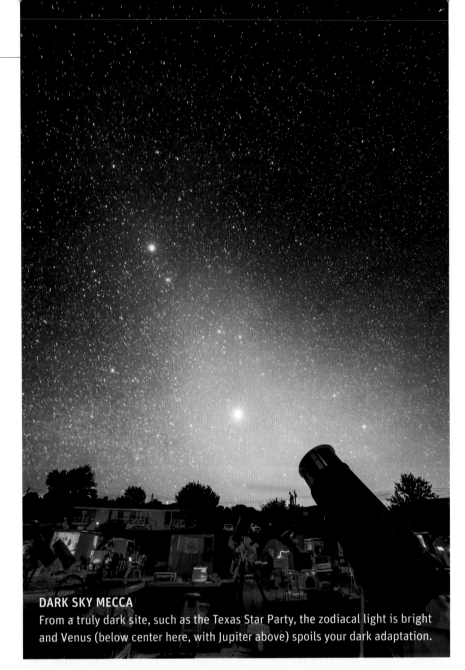

DARK SKY MECCA
From a truly dark site, such as the Texas Star Party, the zodiacal light is bright and Venus (below center here, with Jupiter above) spoils your dark adaptation.

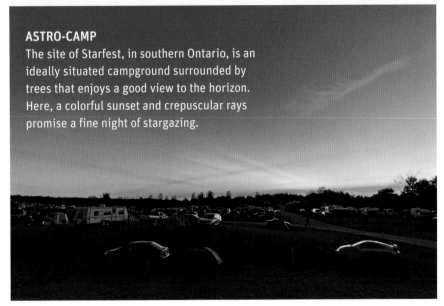

ASTRO-CAMP
The site of Starfest, in southern Ontario, is an ideally situated campground surrounded by trees that enjoys a good view to the horizon. Here, a colorful sunset and crepuscular rays promise a fine night of stargazing.

STAR PARTY ETIQUETTE

1 Arrive Before Darkness Don't arrive after dark with your headlights blazing while you seek a parking spot.

2 Park to Minimize Lights If you'll be leaving in the dark, park near the exit facing out.

3 Turn Interior Lights Off Make sure your vehicle's interior lights—and alarms—won't come on when you open doors.

4 Dim Red Lights Only Most important, all flashlights should be red light only, and aim them down and not at people.

5 No Pets, No Music Keep the night quiet, filled with only the sounds of delighted observers.

6 No Lasers Rules vary, but some events ban the use of green laser pointers once it gets dark.

7 Watch Your Step Power cords, tripods, tent ropes and other gear can be trip hazards.

8 Respect Others' Telescopes Always ask whether you can look, and don't touch unless shown how to focus.

9 Watch Out for Astrophotographers Be mindful that some people will be busy taking images and can't share views.

10 Keep Mornings Quiet When camping overnight, respect that others will want to sleep in.

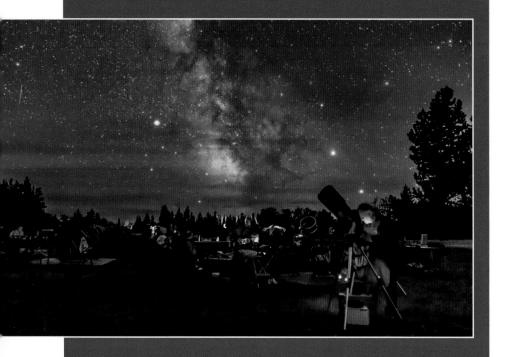

look straight up. Barring dust or smoke, the drier the sky, the less the extinction.

Thus our perfect dark sky site is one that's at an altitude between 2,000 and 7,000 feet, in an arid, low-humidity climate, well away from sources of light pollution and accessible by paved road. Locations that fit this description include most of Australia, the deserts of Chile, much of the American West and Southwest and parts of Hawaii. In Canada, there's southern British Columbia, Alberta and Saskatchewan. From farther north, skies are dark but often lit by pesky auroras.

Observers who venture to a truly dark site are often surprised that the sky doesn't look black. From the best sites, the night sky appears gray. That background luminance, even well off the Milky Way, is natural light from distant unresolved stars. Under good skies, naked-eye dark nebulas along the Milky Way (illustrated in Chapter 2) are darker than the rest of the sky because they lie closer to us and hide distant starlight.

And airglow, also described in Chapter 2, often adds a natural background glow. Sites in Chile close to the South Atlantic Anomaly region—a "hole" in the Earth's magnetic field—are particularly prone to massive airglow outbreaks that turn the sky red in photos. From our favorite sites in Australia, airglow is rare. But bushfires and floods are not!

STAR PARTIES

A popular way to enjoy the sky is in the company of others at a site well suited for stargazing. Known as star parties, these events can be a single night at a nearby park or a weekend or even a weeklong campout where people set up their gear for an extended run under the stars.

The agenda is to have fun observing and chatting with fellow amateur astronomers. In North America alone, there are at least a dozen major star parties (those with an attendance of over 300) and another three dozen that each attract 50 to 200 enthusiasts. One of them should be within a day's drive. Europe, the U.K. and Australia also have star parties and astro-camps at dark sky sites.

By contrast, until the 1970s, there was only one main convention, in southern Vermont:

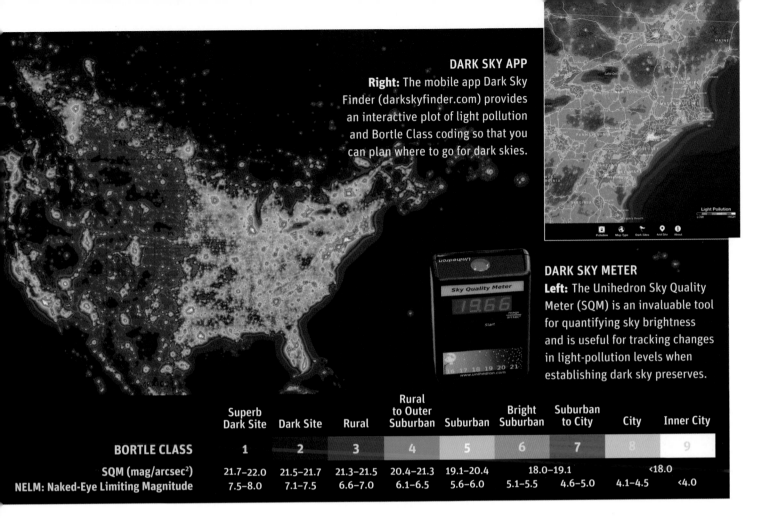

	Superb Dark Site	Dark Site	Rural	Rural to Outer Suburban	Suburban	Bright Suburban	Suburban to City	City	Inner City
BORTLE CLASS	1	2	3	4	5	6	7	8	9
SQM (mag/arcsec²)	21.7–22.0	21.5–21.7	21.3–21.5	20.4–21.3	19.1–20.4	18.0–19.1		<18.0	
NELM: Naked-Eye Limiting Magnitude	7.5–8.0	7.1–7.5	6.6–7.0	6.1–6.5	5.6–6.0	5.1–5.5	4.6–5.0	4.1–4.5	<4.0

Stellafane. It was the first and is still the best-known meeting of amateur astronomers in North America. Each summer, they assemble to spend a weekend atop a granite knoll named Stellafane ("shrine to the stars"). The convention has grown from a core of 20 telescope makers at its first meeting in 1926 to crowds of several thousand, who clamber over the rocks, bulge out of the lecture tent and devour thousands of hamburgers and hot dogs while examining the handcrafted telescopes with gem inspectors' eyes and, undoubtedly, a certain amount of envy.

Another annual astronomy gathering is the weeklong Texas Star Party, held in May at the Prude Ranch in southwest Texas, near Fort Davis. A 2½-hour drive from Midland or El Paso, the nearest good air services, it is *the* party for dark-sky-hungry backyard astronomers. The southern latitude (31 degrees north) and the site's isolation from urban areas provide some of the best skies on the continent. An added bonus is its proximity to the McDonald Observatory.

Other major star parties in the United States are the Winter Star Party in the Florida Keys in February; the Black Forest Star Party in north-central Pennsylvania; the Nebraska Star Party; the Oregon Star Party; the Okie-Tex Star Party and the Table Mountain Star Party in northern Washington. In Canada, Starfest, near Mount Forest, Ontario, and the Saskatchewan Summer Star Party draw large crowds. Attending a local star party is often the astronomical highlight of any stargazer's year.

Indoor astronomy trade shows have come and gone in recent years, but one remains as another mecca for enthusiasts. The annual Northeast Astronomy Forum (NEAF) presents a weekend of vendors who fill a hall with tempting toys to try and buy, as well as talks and workshops. The Rockland Astronomy Club stages NEAF each April in Suffern, New York.

In the U.K., in addition to astro-camps at dark sites such as the Brecon Beacons and Kielder Forest, several indoor astronomy trade shows, such as AstroFest in London, and outdoor science festivals, such as Bluedot at the Jodrell Bank Observatory, attract hundreds to thousands of attendees. Details on astro-events worldwide can be found in astronomy magazines or on their websites, or Google the event name to find its own website.

LIGHT-POLLUTION MAP
Top: Much of the land in western North America is dark, with islands of light from cities. In the more densely populated eastern half of the continent, the land is bright, with oases of darkness remaining.
Legend: The Bortle Class regions are color-coded on light-pollution maps and apps, with black to dark gray representing the darkest Bortle Class 1 and 2 skies. Blue and green are rural Bortle Class 3 and 4. At Bortle Class 8 and 9, inner-city cores are bright gray and white. The ranges of the Sky Quality Meter (SQM) and the naked-eye limiting magnitude (NELM) values for each Bortle Class are also indicated.

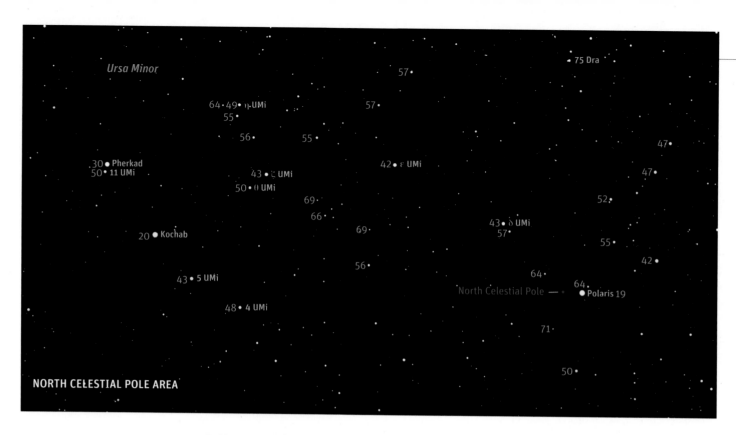

Ursa Minor

75 Dra

57

64·49· η·UMi
55·
57·

56· 55·

47·

.30 ● Pherkad
50· 11 UMi

42·ε UMi

47·

43 · ζ UMi

50· θ UMi
69·
66·
69·

52·

43· δ UMi
57·

20 ● Kochab

55·

56·

42·

43 · 5 UMi

64·

North Celestial Pole — 64·
64· ● Polaris 19

48· 4 UMi

71·

50·

NORTH CELESTIAL POLE AREA

ESTIMATING YOUR LIMITING MAGNITUDE: NORTH

Using these charts for the regions around the two celestial poles (areas visible year-round), you can estimate the faintest stars you can see from your site with the naked eye—your naked-eye limiting magnitude (NELM). The chart above is for the northern sky around Polaris, in Ursa Minor. In both charts, the numbers are stellar magnitudes with the decimal point omitted to avoid confusion with stars. Thus 64 = magnitude 6.4, close to the typical naked-eye limit. The field of view of both charts is about 25 degrees in width, roughly four binocular fields.

RATING YOUR SKIES

The darkness of the sky is commonly judged using a scale from 1 to 9, which was devised in 2001 by American astronomer John Bortle.

♦ **Bortle Class 1** is the darkest site, with the gegenschein visible and possibly even airglow. Zodiacal light is bright, perhaps with a yellow tint. The core of the galaxy casts shadows, and Venus ruins your night vision.

♦ **Bortle Class 2** is almost as good, with clouds visible only as dark masses obscuring the stars. Reaching such skies might require a cross-country or an overseas flight.

♦ **Bortle Classes 3 and 4** are more typical of the rural locations we frequent as our local dark sites, either on our own or at most star parties. Zodiacal light is obvious, and the Milky Way appears structured, but light domes dot the horizon as distinct glows. Any clouds in the distance appear bright, as they reflect light from towns. Enjoying Bortle Class 3 or 4 skies might demand a weekend or weeklong getaway.

♦ **Bortle Classes 5 and 6** are the skies of acreages near cities and of outlying suburbs. On a clear night, the Milky Way is visible but only as a pale glow overhead. The sky lower down is bright, and any clouds drifting through appear bright. The Andromeda Galaxy, however, is visible

to the naked eye, while most deep sky objects look impressive through a telescope. Deep sky photography is possible, especially when aided by light-pollution filters. Such a site makes a good destination for a "one-nighter."

♦ **Bortle Class 7** is likely where many of us live: the suburbs and outer areas of urban cores. Even a clear sky is gray, with no Milky Way. Stars to magnitude 4 or perhaps 5 are the naked-eye limit. While the brighter deep sky objects show up in a telescope, they lack the contrast of views from even a notch better Bortle Class. Star clusters are viewable; galaxies are not.

♦ **Bortle Classes 8 and 9** are urban and inner-city skies. Even on a good night, only the brightest first- and second-magnitude stars are visible, while most constellation patterns are not. The Moon and planets are the prime targets for telescopes.

Sky brightness is also rated by a factor that has become known as SQM, Sky Quality Meter, after the popular devices made by Unihedron (unihedron.com) to quantify sky brightness. They provide readings in terms of "magnitude per square arc second" of sky. The darkest skies, Bortle Classes 1 and 2, have SQMs of 22 to 21.5 (the smaller the number, the brighter/worse the sky). Sites within a modest drive from cities, Bortle

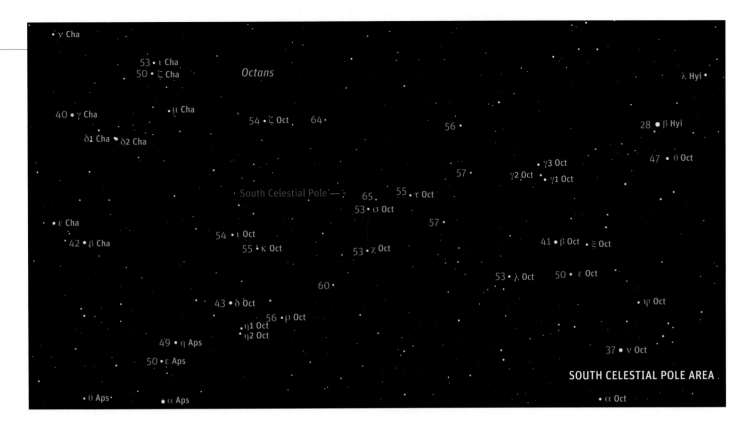

Classes 3 to 5, have SQMs of 21.5 to 19. The brightest urban skies have SQMs of 18 or less.

DARK SKY PRESERVES

A movement we have applauded and supported over the past two decades is the establishment of dark sky preserves that encompass an existing state, provincial or national park. Preserving the natural night sky meshes well with the goals of the park. Often, the park is already dark, and all that's needed is to shield the few existing lights and then have its "dark sky" status added to the park's mandate by legislation. With this recognition, the park is usually required to present outreach events, adding stargazing sessions to its schedule of interpretive programs and promoting that "half the park is after dark."

The International Dark-Sky Association (IDA) awards the status to candidate sites in the United States and worldwide, with categories ranging from Dark Sky Communities that have implemented night-sky-friendly lighting to Dark Sky Sanctuaries that are among the darkest sites in the world. In between are Dark Sky Parks and the more stringent Dark Sky Reserves. As of late 2020, the IDA had recognized 130 dark sky places.

In Canada, The Royal Astronomical Society of Canada (rasc.ca/lpa) pioneered the establishment of dark sky preserves and awards official dark sky status to applicant sites. Categories include Nocturnal Preserves, where public access is not required; Dark-Sky Preserves, which include public parks; and Urban Star Parks, where lighting is controlled though skies are not necessarily dark. More than two dozen sites in Canada have been recognized.

As increasingly more people seek out memorable night sky experiences, parks and communities see their dark status as a draw for tourism. For example, Jasper National Park in Canada, a huge dark sky preserve, hosts an annual Dark Sky Festival (jasperdarksky.travel) in October, with world-renowned speakers, concerts and a major star party. At an otherwise slow time between the peak of summer and the winter ski season, hotel rooms and restaurants are full. Local businesses love it. Dark skies mean money. Many other parks and resorts are following suit with dark sky festivals and sky-tour programs of their own, even adding small planetariums for those cloudy nights.

ASTRO-TOURISM

Dark sky festivals form the core events of the growing business of astro-tourism. As we stated in Chapter 1, the more that people are unable see the natural night sky, the more they want to see it. Yes, our grandparents could see the Milky Way from their city backyards, but chances are, they never bothered to look.

ESTIMATING YOUR LIMITING MAGNITUDE: SOUTH

This chart for the southern hemisphere depicts the area around the south celestial pole, in Octans. No matter your hemisphere, under at least Bortle Class 5 skies, the NELM for most people is sixth magnitude. In rare instances, under Bortle Class 3 and better skies, people with abnormally good vision can see to 7.0 and even 7.4, but it depends on sky conditions. Dry skies reveal more stars than can be seen in humid skies. Suburban skies may be limited to magnitude 4 or worse.

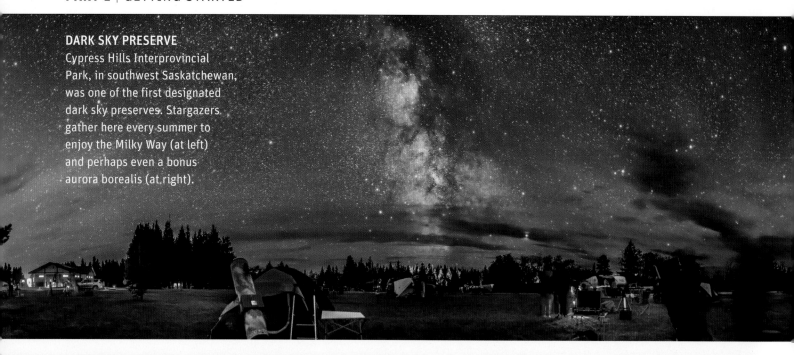

DARK SKY PRESERVE
Cypress Hills Interprovincial Park, in southwest Saskatchewan, was one of the first designated dark sky preserves. Stargazers gather here every summer to enjoy the Milky Way (at left) and perhaps even a bonus aurora borealis (at right).

THE MAGNITUDE SCALE

The brightness, or magnitude, of a star is rated on a scale that runs backward to what might be expected. The brighter the star, the lower its magnitude number. A difference of five magnitudes is equal to a brightness difference of 100 times. The faintest stars visible to the naked eye are magnitude 6.

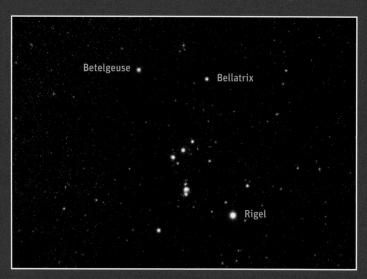

BRILLIANT ORION
The two brightest stars in Orion (reddish Betelgeuse and blue-white Rigel) are between magnitude 0 and +0.5, though in early 2020, when this image was taken, Betelgeuse had dimmed to +1.4, almost equal to Bellatrix, at upper right. The three belt stars of Orion are all about magnitude 2.

BRIGHT

MAGNITUDE	CELESTIAL OBJECT
–27	Sun
–13	Full Moon
–4.7	Venus at its brightest
–2.9	Jupiter at its brightest
–1.4	Sirius (brightest star after Sun)
0 to +1	The 15 brightest stars
+1 to +6	The 8,500 naked-eye stars
+6 to +8	Deep sky objects for binoculars
+6 to +11	Bright deep sky objects for amateur telescopes
+12 to +14	Faint deep sky objects for amateur telescopes
+15 to +17	Objects visible in large amateur telescopes
+18 to +22	Objects visible in large professional telescopes
+24 to +28	Faintest objects imaged by largest ground-based telescopes
+31	Faintest objects imaged by Hubble Space Telescope

DIM

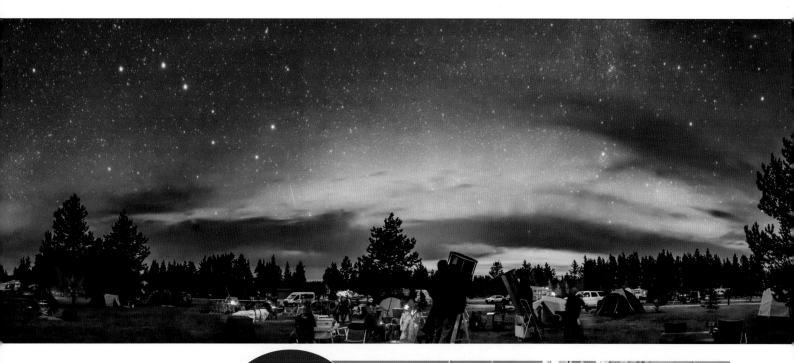

Now, just seeing the Milky Way is a bucket-list experience that can draw people from around the world to dark sky preserves.

To attract clientele, many resorts, B&Bs and cottages at dark sites now offer astronomy programs and telescopes to rent. Even professional observatories seek to draw tourists not just by day but by night. For example, at Kitt Peak National Observatory (noao.edu/kpvc/), near Tucson, Arizona, visitors can book guided sessions or reserve a 20-inch telescope for a night of personal viewing and imaging. In 2019, the Lowell Observatory (lowell.edu/visit/), in Flagstaff, Arizona, completed a major upgrade to its outreach facilities, with the Giovale Open Deck Observatory filled with dream telescopes that impress even the most seasoned amateur astronomer.

Around the world, many tour companies specialize in science and astronomy travel, catering, in large part, to the booming market of active older travelers keen to pursue new interests and see the world. Two sky attractions are the main draws: auroras and eclipses. As described in the previous chapter, tourists now brave winter conditions to travel to the Arctic and subarctic in hopes of sighting the northern lights. They usually do. In the U.K. and Canada, there are even one-night aurora flights that take you above the clouds for a sighting from the stratosphere. The southern lights, however, are tougher to deliver on demand.

Since the 1970s, solar eclipse trips have been the anchor programs of astro-travel agencies. Today, no matter how remote the path of the Moon's shadow, no total or annular eclipse goes unwatched, even those over the most distant sites, such as Antarctica. (Chapter 12 has more on eclipses.) Eclipses are a great way to combine the trip of a lifetime to an exotic locale with the experience of a lifetime: the sight of the Sun being suddenly extinguished from the daytime sky. For the totally addicted, maps of future eclipse paths serve as lifetime vacation planners. To see those maps, go to greatamericaneclipse.com.

SEEKERS OF DARKNESS BY DAY
Every total solar eclipse attracts thousands of "umbraphiles" seeking a special form of darkness, one that descends suddenly at midday when the Moon covers the Sun. These photos were taken in the mid-Atlantic on board the m/v *Star Flyer* sailing ship on November 3, 2013.

CHAPTER 4

Getting to Know the Sky Better

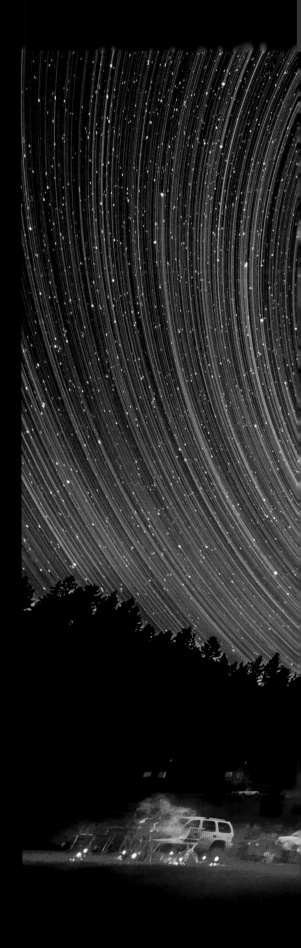

The circumpolar stars wheel about the north celestial pole over the red lights of the Table Mountain Star Party, in Washington State. Learning how the sky moves like this through the night and over the seasons is key to enjoying the sky and your telescope.

We got you started looking at the sky, by night and by day, and we've discussed picking an observing site. The next step is finding your way around the sky more thoroughly and learning how the sky changes through the night and through the year. After all, becoming familiar with the night sky's geography and motions is what being an amateur astronomer is all about.

While our book can serve as a guide, such knowledge can be gained only through the practical experience of observing the sky, usually with no more than your unaided eyes, and understanding what you see *before* you buy a telescope.

We have seen this advice ignored all too often. People buy telescopes that can point on command to thousands of objects, yet they cannot identify a single constellation. Without understanding what the sky has to show or how it works, you may spend a few frustrating nights with the new telescope, then neglect it. We'd like you to stay in the hobby, not dabble.

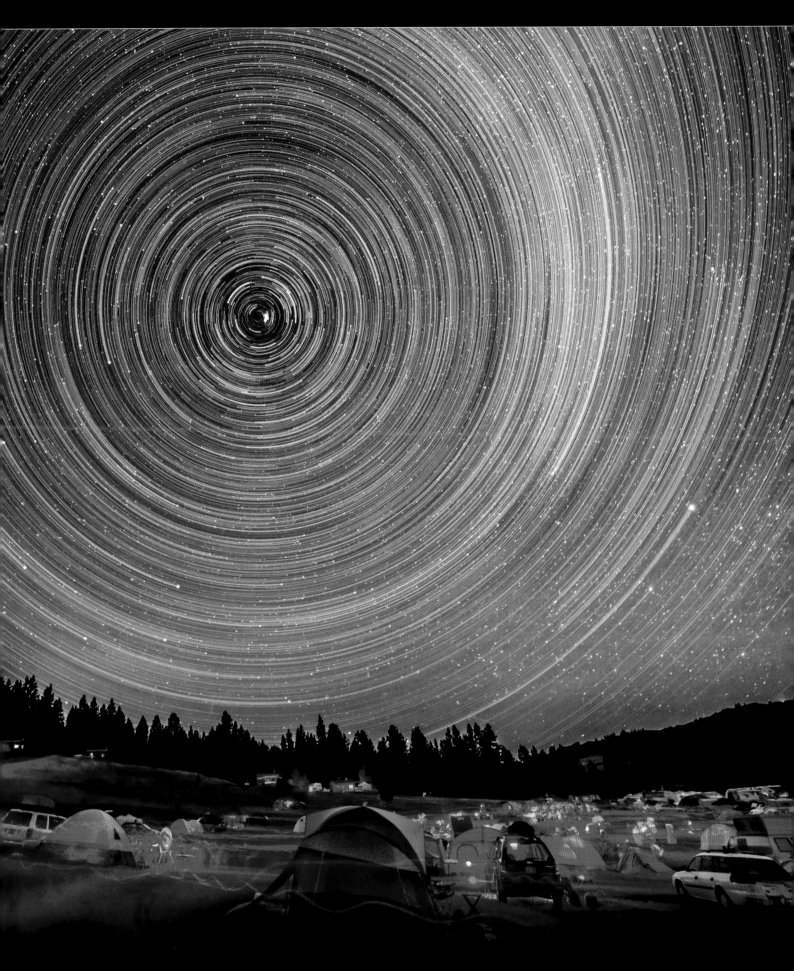

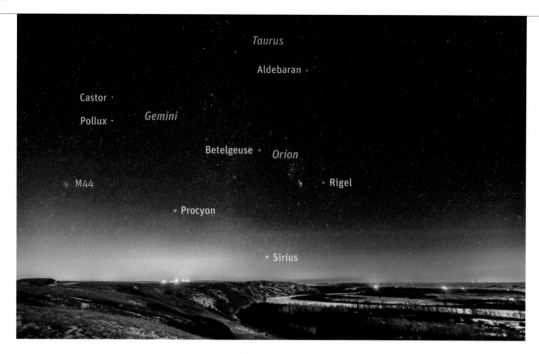

A SIGN OF WINTER
Orion and his retinue rising in the east on a December evening herald the arrival of winter. By February, Orion shines due south, as shown in the chart.

USING THE CHARTS
Our all-sky charts are like fish-eye views of the sky, with the 360-degree horizon around the perimeter. The zenith—straight up—is at center. South (S), the direction we usually face when stargazing, is at bottom. To look in another direction, simply hold the chart so that the direction you are facing is at bottom. For example, when facing north (N), turn the chart upside down.

LEARNING THE CONSTELLATIONS

On the following pages, we present seasonal all-sky charts, created with Stellarium software: four for the northern hemisphere for 45 degrees north and four for the southern hemisphere for 30 degrees south. With only one chart per season, not per month, they can be only roughly accurate for your particular night and time. However, we offer them to show how you can learn the sky by hopping from a key "anchor" constellation to others surrounding it.

THE NORTHERN WINTER SKY

The brightest stars in the night sky shine to the south, all in or surrounding Orion. It is a sparkling canopy.

◆ The Big Dipper (or Plough in the United Kingdom), in Ursa Major the great bear, lies in the northeast (NE), with the "Pointer" stars in the bowl pointing to Polaris, due north (N).

◆ Due south (S) is Orion the hunter, with his distinctive belt of three stars in a row. Above and below the belt are two famous stars: red Betelgeuse and blue-white Rigel.

◆ A line from Orion's belt points down to the brightest star in the night sky, Sirius, in Canis Major the large hunting dog.

◆ Another line from the belt points up to Aldebaran, in the face of Taurus the bull. Extend that line to the northwest, above Aldebaran, to find the naked-eye Pleiades star cluster.

◆ A line through Rigel and Betelgeuse points up to Castor and Pollux, paired in Gemini the twins.

◆ Between the twins and Sirius is Procyon, in Canis Minor the small hunting dog.

◆ Directly overhead is Capella, in the pentagon-shaped Auriga the charioteer. The two top stars of the Big Dipper's bowl point to Capella.

◆ You can join these bright stars to form a large pattern called the Winter Hexagon.

◆ Now try for small Lepus the hare and obscure Monoceros the unicorn.

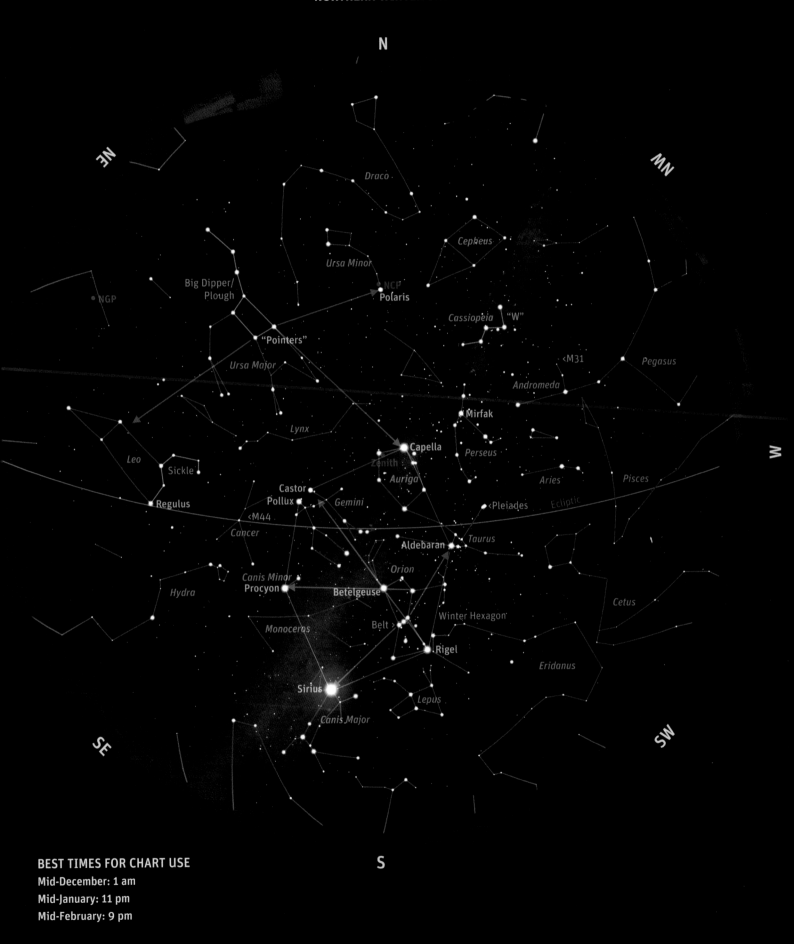

NORTHERN WINTER SKY

N

NE

NW

Draco

Cepheus

Ursa Minor

"W"

Big Dipper/
Plough

NCP

• NGP

Polaris

Cassiopeia

"Pointers"

<M31

Pegasus

Ursa Major

Andromeda

Mirfak

Zenith

Capella

Perseus

Aries

W

Lynx

Auriga

Pisces

Leo

Sickle

Castor

Pollux

Gemini

<Pleiades

Ecliptic

Regulus

<M44

Aldebaran

Taurus

Cancer

Orion

Cetus

Canis Minor

Procyon

Betelgeuse

Hydra

Monoceros

Belt >

Winter Hexagon

Eridanus

Rigel

Sirius

Lepus

Canis Major

SE

SW

S

BEST TIMES FOR CHART USE
Mid-December: 1 am
Mid-January: 11 pm
Mid-February: 9 pm

THE NORTHERN SPRING SKY

As Orion and his hunting scene with dogs, bulls and hares sink into the west, the Milky Way also disappears from view. In spring, we look out of the plane of our galaxy toward its north galactic pole (NGP), in Coma Berenices.

- The Big Dipper/Plough is now overhead. Use its Pointer stars to find Polaris in the Little Dipper, aka Ursa Minor the little bear.
- But the Pointers also point the other way, down to Leo the lion and its bright star Regulus. Leo's face is marked by the Sickle asterism.
- The handle of the Dipper arcs down to Arcturus, in Boötes the bear herdsman, which we often picture as a Kite. Arcturus is the brightest star of spring; indeed, it is the brightest star in the northern half of the sky, beating both Capella and Vega by a tiny margin.
- Speeding down the same arc brings you to Spica, in Virgo the goddess of the harvest.
- Continue on to find the quadrilateral shape of Corvus the crow southwest (SW) of Spica.
- Go back up to Boötes, then go east (E) to find the semicircle of Corona Borealis the northern crown.
- Farther to the east is H-shaped Hercules the hero, a transition constellation between the spring and summer skies.
- Across the southwest (SW) sprawls dim Hydra the water snake, with its lone bright star Alphard.
- Below the handle of the Big Dipper sit the hunting dogs of Boötes, Canes Venatici, and below them, between Leo and Arcturus, is Coma Berenices, the hair of Queen Berenices.
- Coma Berenices contains a large naked-eye star cluster and the north galactic pole (NGP), the realm of other galaxies.

WHERE'S THE NORTH STAR?

Stargazers soon learn the trick: The two stars in the pouring edge of the Big Dipper's bowl point to Polaris, the North Star. Locate that star, and you have found true north and the north celestial pole (NCP). As the night hours go by, Polaris never moves off its position in the sky. But where you find Polaris depends on how far north or south you are on Earth. The altitude of Polaris above your northern horizon equals your latitude.

SIGNS OF SPRING

Arcturus and Regulus rising signals the coming of spring, as the Big Dipper swings high above Polaris. Look for the Beehive (M44) and Coma Berenices star clusters on either side of Leo.

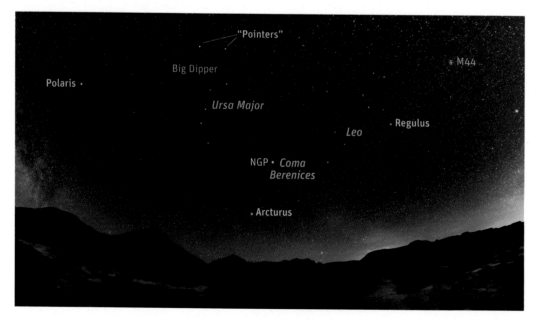

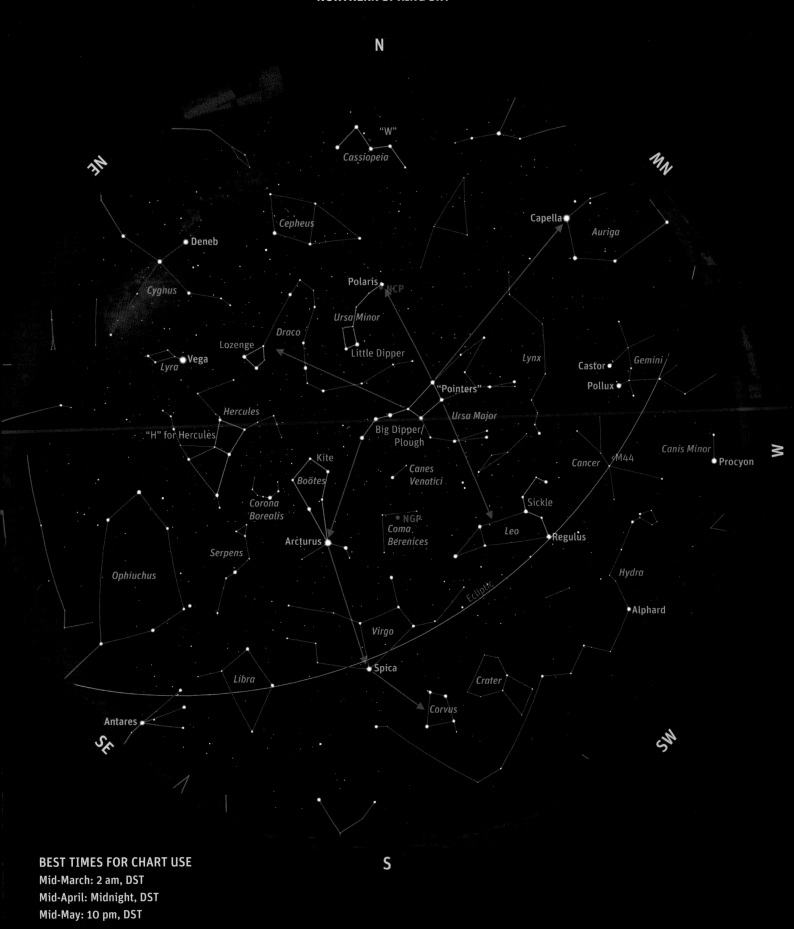

N

NE

NW

"W"
Cassiopeia

Cepheus

Deneb

Cygnus

Polaris •NCP

Ursa Minor

Capella

Auriga

Draco

Lozenge

Little Dipper

Lynx

Castor
Gemini

Pollux

Vega

Lyra

"Pointers"

Ursa Major

Hercules

"H" for Hercules

Big Dipper/
Plough

Canis Minor

W

Procyon

Kite

Boötes

*Corona
Borealis*

*Canes
Venatici*

•NGP

*Coma
Berenices*

Cancer

M44

Sickle

Leo

Regulus

Serpens

Arcturus

Ophiuchus

Hydra

Alphard

Virgo

Ecliptic

Spica

Crater

Libra

Corvus

Antares

SE

SW

S

THE NORTHERN SUMMER SKY

The hallmark of the evening summer sky is the Milky Way at its best. It is brightest to the south, toward the galactic center, in Sagittarius.

◆ Find the Big Dipper/Plough in Ursa Major, now to the northwest (NW). Its Pointer stars still point to Polaris, due north (N) in Ursa Minor, aka the Little Dipper.

◆ Continue that line to pass by the W of Cassiopeia the queen.

◆ Between the Dippers winds Draco the dragon, with his Lozenge-shaped head, found by extending a line up from the back two stars of the Dipper's bowl.

◆ Go back to the Big Dipper and follow the arc of its handle down to Arcturus in Boötes, now sinking into the west (W).

◆ Look overhead for the other three bright stars now visible, which form the Summer Triangle: Vega (the brightest), Deneb and Altair (farthest south).

◆ Identify their constellations: Vega belongs to the small parallelogram of Lyra the harp; Altair is the eye of Aquila the eagle; while Deneb is the tail of the long-necked Cygnus the swan, containing the pattern of the Northern Cross.

◆ Now fill in the gaps by identifying large rectangular Ophiuchus and the "Serpens" he is bearing, split into two (head and tail) on either side of Ophiuchus.

◆ Below Cygnus, look for the little constellations of Sagitta the arrow and diamond-shaped Delphinus the dolphin—both actually look like what they are supposed to be!

◆ Look low in the south (S) in the Milky Way for the Teapot shape of Sagittarius the archer and the distinctive curl of Scorpius the scorpion, with red Antares as his heart.

STARS OF SUMMER

From a summer campsite, look straight up to see the three stars of the Summer Triangle shining among the trees, with blue-white Vega the brightest.

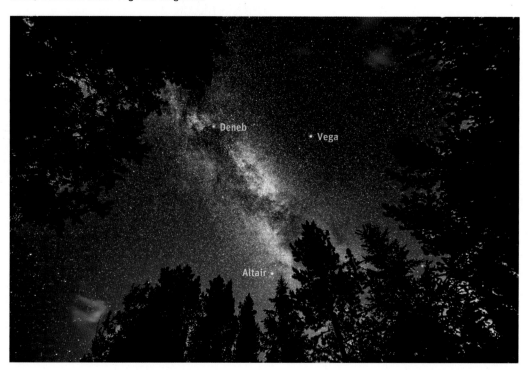

AREN'T THE STAR CHARTS BACKWARDS?

No, they aren't. In these and all such sky-dome charts, you are looking up at the sky not down at the ground, as with maps of Earth. When you are outside facing south (S is at bottom on all these charts), which way is east? It is to your left, while west is to your right. So on the all-sky charts, east (E) is at left and west (W) is at right, the opposite of Earth maps. To better match the sky and aid in identifying stars and constellations, turn any such chart so that the direction you are looking is at the bottom.

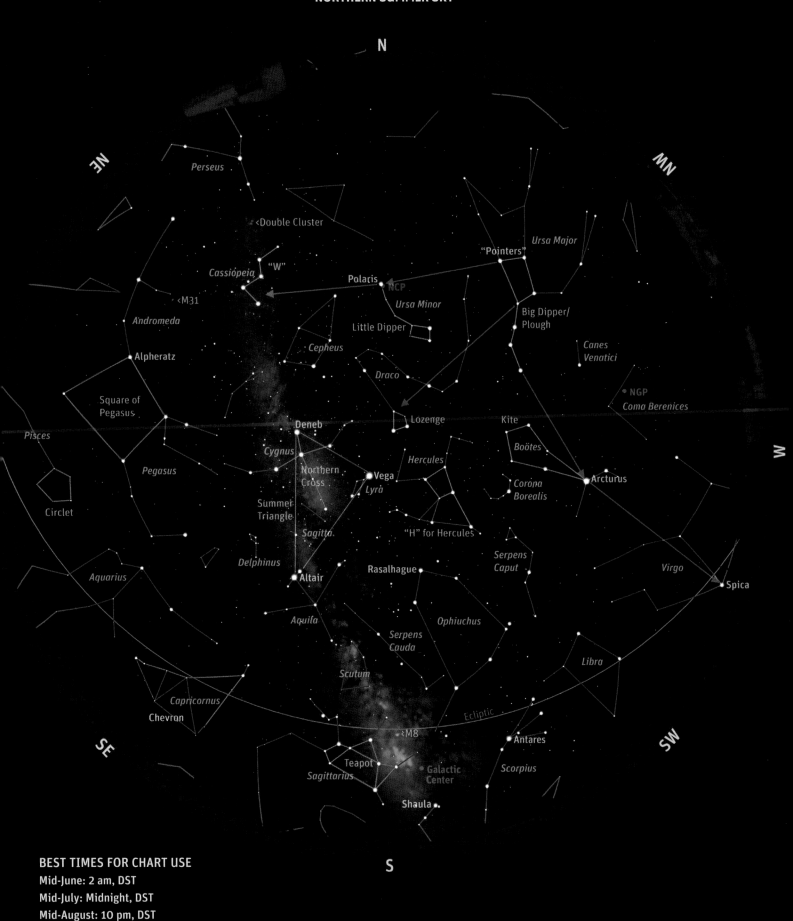

N

NE

NW

Perseus

<Double Cluster

"W"

Cassiopeia

<M31

Andromeda

Alpheratz

Square of
Pegasus

Pisces

Pegasus

Circlet

Aquarius

Capricornus

Chevron

SE

Cepheus

Little Dipper

Draco

Deneb

Cygnus

Northern
Cross

Summer
Triangle

Sagitta

Delphinus

Altair

Aquila

Scutum

<M8

Teapot

Sagittarius

Galactic
Center

Shaula

S

Polaris

NCP

Ursa Minor

Lozenge

Vega

Lyra

Rasalhague

Serpens
Cauda

"Pointers"

Ursa Major

Big Dipper/
Plough

Kite

Hercules

"H" for Hercules

Serpens
Caput

Ophiuchus

Libra

Ecliptic

Antares

Scorpius

Canes
Venatici

NGP

Coma Berenices

Boötes

Corona
Borealis

Arcturus

Virgo

Spica

SW

W

BEST TIMES FOR CHART USE
Mid-June: 2 am, DST
Mid-July: Midnight, DST
Mid-August: 10 pm, DST

WHERE ARE THE PLANETS?

Star charts in books can't show the planets because the planets move from month to month and year to year. But you'll always find the planets somewhere along the green ecliptic line, marking the plane of the solar system. For the early 2020s, Jupiter and Saturn, the slowest-moving, naked-eye planets, are located in the northern-hemisphere summer and autumn sky. Jupiter won't climb up into the northern winter sky until 2024 on.

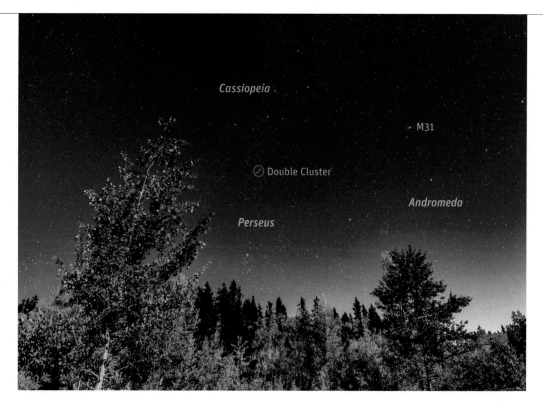

AUTUMN SKY SCENE
Nothing signifies celestial autumn better than Queen Cassiopeia and her daughter Andromeda, seen here rising above golden aspens on a moonlit evening.

THE NORTHERN AUTUMN SKY

With each passing night, the Summer Triangle sinks lower, but it also gets dark earlier, keeping the last of the summer stars in view until well into December. However, to the south lies a panorama of famous mythological figures.

◆ While you usually start with the Big Dipper/Plough, it is now low in the north (N). From a southerly latitude, it might be below your horizon. But Polaris lies at its constant altitude.

◆ Cassiopeia the queen, marked by her well-known W of five stars, is now overhead.

◆ One side of the W points to the Square of Pegasus, the flying horse that figures in the legend of Andromeda, the daughter of Cassiopeia.

◆ Andromeda is the arc of stars off the top left corner of Pegasus, marked by the star Alpheratz.

◆ Keep going left, and you come to an upside-down Y of stars below the left side of the W of Cassiopeia. That's Perseus, who rescued Andromeda.

◆ Now fill in the small constellations of Aries the ram, with its bright star Hamal, and faint but triangular Triangulum.

◆ Pisces the fish (with its Circlet asterism), Cetus the whale and Aquarius the water carrier are sprawling patterns of faint stars.

◆ To the southwest (SW), look for the chevron shape of Capricornus the sea goat. All the constellations to the south in autumn have a watery connection in mythology.

◆ The lone bright stars in the south (S) are Diphda, in Cetus, and Fomalhaut, in Piscis Austrinus the southern fish. To find them, follow lines down from either side of the Square of Pegasus.

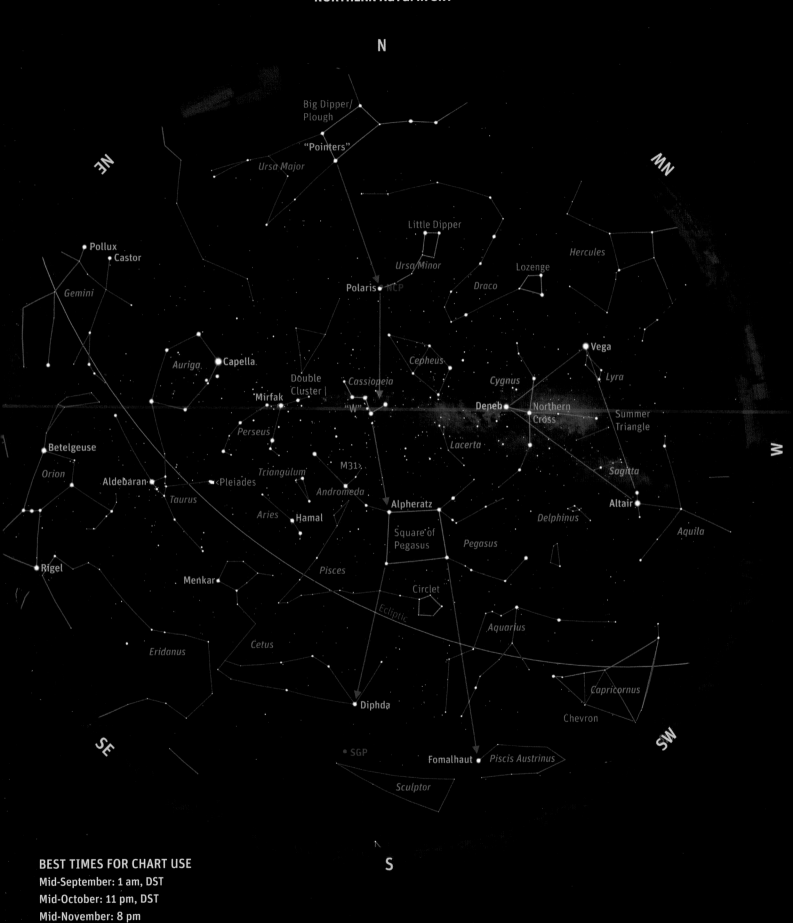

N

NE

NW

Big Dipper/
Plough

"Pointers"

Ursa Major

Little Dipper

Hercules

Pollux

Castor

Gemini

Ursa Minor

Lozenge

Polaris NCP

Draco

Cepheus

Vega

Auriga

Capella

Double
Cluster |

Cassiopeia

Cygnus

Lyra

Mirfak

"W"

Deneb

Northern
Cross

Summer
Triangle

Perseus

Lacerta

W

Betelgeuse

M31

Sagitta

Orion

Aldebaran

Triangulum

Andromeda

Altair

<Pleiades

Alpheratz

Taurus

Aries

Hamal

Square of
Pegasus

Delphinus

Pegasus

Aquila

Pisces

Rigel

Menkar

Circlet

Ecliptic

Cetus

Aquarius

Eridanus

Capricornus

Diphda

Chevron

SE

SW

• SGP

Fomalhaut

Piscis Austrinus

Sculptor

S

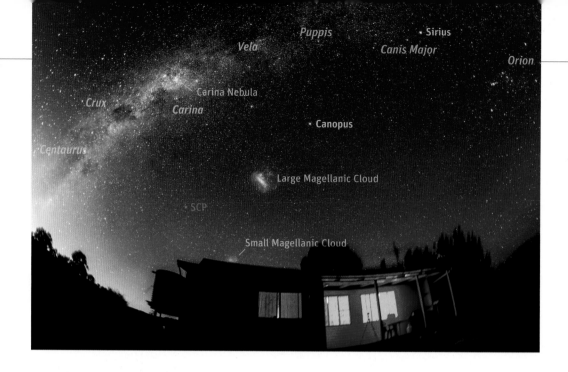

Image labels: Puppis, Sirius, Vela, Canis Major, Orion, Carina Nebula, Crux, Carina, Canopus, Centaurus, Large Magellanic Cloud, SCP, Small Magellanic Cloud

SUMMER DOWN UNDER
Late on an austral summer night, Orion sinks into the west as Crux and Centaurus rise in the east. The Magellanic Clouds start high but soon turn below the south celestial pole.

ANTIPODAL SEASONS
Just as in the northern hemisphere, Orion is best seen from Down Under from December to February—except that's summer. Travelers sometimes think that if they are on the other side of the world, they will see Orion at night in June or July. That doesn't happen. Earth is turned so that its dayside faces Orion during those months, no matter which hemisphere you are in. So, yes, Orion is a summer constellation in the southern hemisphere, but that's January!

LEARNING THE SOUTHERN SKY

To match the northern set, here are four seasonal charts from Stellarium to help you get oriented to the southern-hemisphere sky, drawn for a latitude of 30 degrees south, good for southern Australia and central Chile. The seasons are austral. Spring is September to November. Autumn is March to May. As we show here, Orion is highest in the middle of summer. The next section (page 82) explains why the sky looks different from the southern hemisphere.

THE SOUTHERN SUMMER SKY

On the hot nights of an austral summer, start by identifying the bright stars in and around Orion, now high in the north with his head closest to the horizon.

◆ Orion's belt points down toward the horizon to Taurus and the reddish star Aldebaran and up away from the horizon to Canis Major and the star Sirius, the brightest in the night sky.

◆ However, in Orion's upside-down orientation, the stars of his belt and sword take on the appearance of a Saucepan (see photo on page 76), an asterism unnoticed up north.

◆ The stars of the austral Summer Hexagon are all above the horizon, with Capella low in the north (N).

◆ A line down the back of Canis Major points along the Milky Way to Puppis, the stern of the ancient constellation of the ship Argo Navis.

◆ The other parts of Argo—Vela the sail and Carina the keel—don't have distinctive patterns.

◆ Indeed, a pattern that does look obvious to the eye, the False Cross, is split across two constellations, Vela and Carina.

◆ Below Sirius and the Milky Way lies bright Canopus, an outlier star in Carina and the night sky's second brightest star after Sirius.

◆ The Large and Small Magellanic Clouds (LMC and SMC) are high in the south near Achernar. This star lies at the mouth of winding Eridanus the river, which starts at the feet of Orion.

◆ Faint triangular Octans the octant contains the south celestial pole (SCP).

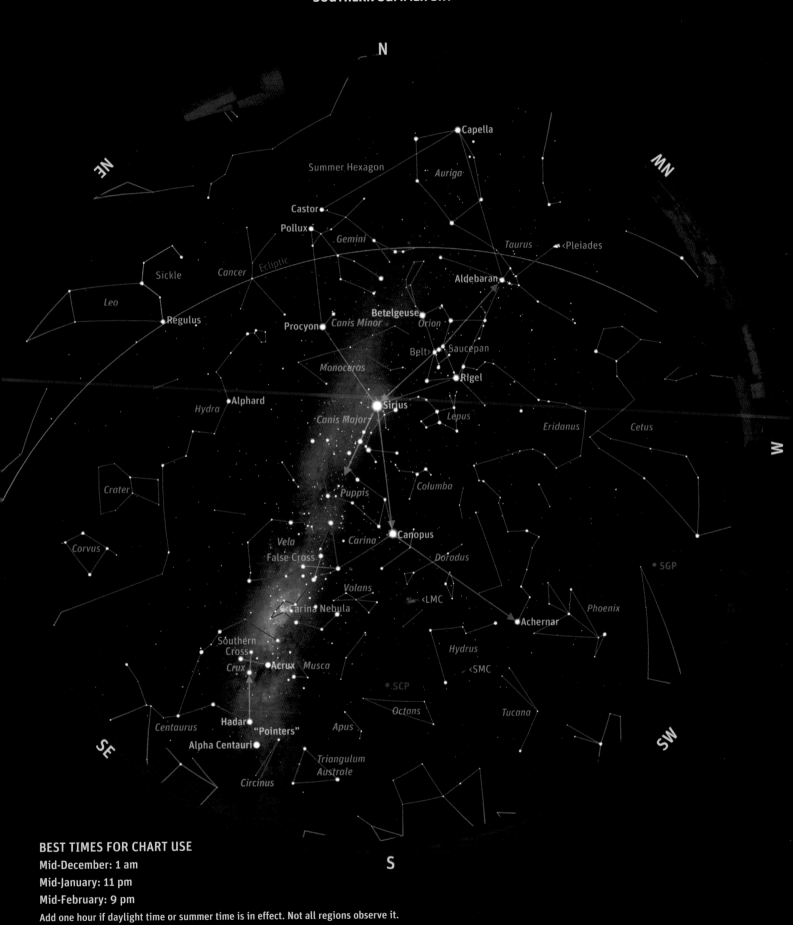

SOUTHERN SUMMER SKY

N

NE

NW

Capella

Summer Hexagon

Auriga

Castor

Pollux

Gemini

Taurus

<Pleiades

Sickle

Cancer

Ecliptic

Aldebaran

Leo

Regulus

Procyon

Canis Minor

Betelgeuse

Orion

Belt>

Saucepan

Alphard

Hydra

Monoceros

Rigel

Lepus

Sirius

Eridanus

Cetus

W

Canis Major

Crater

Puppis

Columba

Canopus

Corvus

Vela

Carina

Doradus

SGP

False Cross

<LMC

Volans

Phoenix

Carina Nebula

Achernar

Southern
Cross

Hydrus

<SMC

Crux

Acrux

Musca

SCP

Tucana

Octans

Hadar

Apus

Centaurus

"Pointers"

SW

SE

Alpha Centauri

*Triangulum
Australe*

Circinus

S

BEST TIMES FOR CHART USE

Mid-December: 1 am

Mid-January: 11 pm

Mid-February: 9 pm

Add one hour if daylight time or summer time is in effect. Not all regions observe it.

HOW DO WE JOIN THE DOTS?

In 1930, the International Astronomical Union officially defined where the constellation *boundaries* lie. But there is no standard for how we should "join the dots" to draw the constellation *patterns*. The method used in these charts from Stellarium is what the program calls "Western." However, astronomy magazines and star-chart publishers all have their own standard.

In 1952, author H.A. Rey published *The Stars: A New Way to See Them*, in which he presented nontraditional ways of joining the dots to make the patterns better resemble what they are supposed to be. Some work. Some are just strange. As such, programs like Stellarium (as with Gemini here) and magazines such as *Sky & Telescope* use a few of Rey's patterns, but not all.

THE SOUTHERN AUTUMN SKY

We are now presented with the finest sights of the southern sky. From a dark site, the Milky Way is the most obvious feature, not any bright constellation. The exception is Crux, the Southern Cross, standing upright high in the south. It is small but bright.

◆ Use Crux as your starting point. The Pointer stars of Alpha Centauri and Beta Centauri (aka Hadar) to the east (E) point to it and ensure that you have the right cross in view and not the impostor False Cross farther along the Milky Way to the west (W). It is larger but dimmer than the true cross. The long axis of the Southern Cross points down toward the south celestial pole, in Octans.

◆ Sirius is now sinking in the west (W), followed by Canopus in the southwest (SW).

◆ Now spend an evening on a dark night tracing the irregular patterns of Puppis the stern, Vela the sail, Carina the keel and Centaurus the centaur. If you can!

◆ They each contain remarkable objects for binoculars and telescopes, so getting to know them is worth the effort, though many of the best star clusters and nebulas are visible to the naked eye from a dark site.

◆ Early on autumn evenings, Orion is still up, setting on his side in the west (W). Opposite him in the east (E) lies his nemesis, Scorpius the scorpion, rising on its side. From up north, these two enemies never appear together in the sky.

◆ Above Scorpius is Lupus the wolf, whose stars mingle with those of northern Centaurus.

◆ Below Crux, try to pick out the small constellations of Musca the fly and Circinus the compasses, and below Alpha and Beta Centauri, look for Triangulum Australe.

ORION OVER AUSTRALIA'S TWELVE APOSTLES

Early on austral autumn evenings, Orion and the Saucepan asterism in his belt and sword sink into the west, marking the coming of cooler nights.

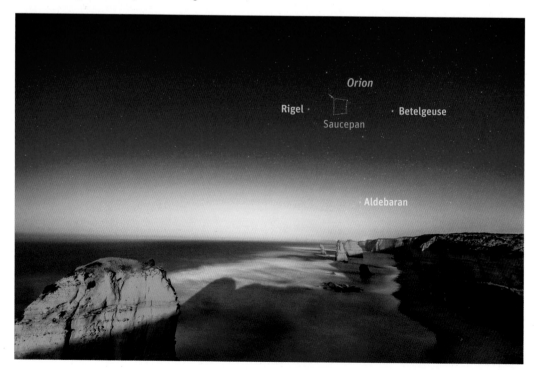

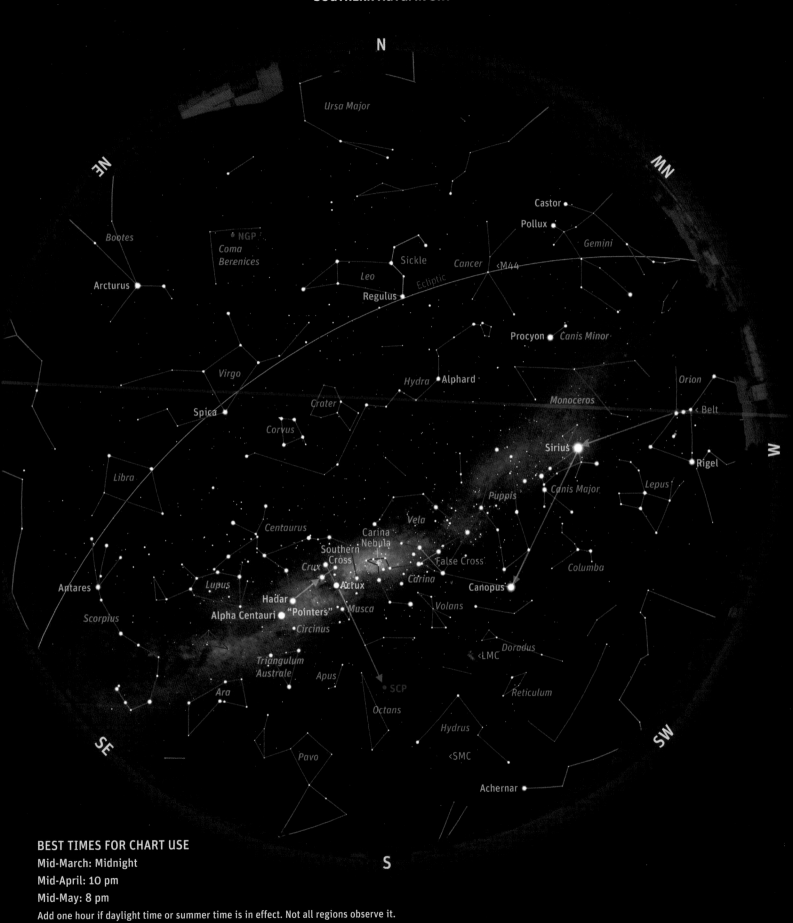

N

NE

NW

Ursa Major

Castor

Pollux

Gemini

Bootes

NGP

Coma Berenices

Sickle

Cancer

<M44

Leo

Ecliptic

Arcturus

Regulus

Procyon

Canis Minor

Virgo

Hydra

Alphard

Orion

< Belt

Monoceros

Spica

Crater

Sirius

Rigel

Corvus

Libra

Canis Major

Lepus

Puppis

W

Centaurus

Vela

Carina Nebula

False Cross

Columba

Southern Cross

Crux

Carina

Acrux

Lupus

Musca

Volans

Canopus

Antares

Hadar

"Pointers"

Alpha Centauri

Scorpius

Circinus

<LMC

Doradus

Triangulum Australe

Apus

Reticulum

Ara

SCP

Octans

Hydrus

SE

Pavo

<SMC

SW

Achernar

BEST TIMES FOR CHART USE
Mid-March: Midnight
Mid-April: 10 pm
Mid-May: 8 pm
Add one hour if daylight time or summer time is in effect. Not all regions observe it.

S

THE SOUTHERN WINTER SKY

This is the most spectacular sky. While it can be seen before dawn in autumn, this breathtaking panorama is overhead during the evening hours of a chilly winter night. The center of the galaxy, in Sagittarius and Scorpius, now lies at the zenith.

◆ To start, find the Pointer stars of Alpha Centauri and Beta Centauri (aka Hadar) high in the south (S).

◆ They point down to bright Crux, the Southern Cross, now sinking into the southwest (SW).

◆ High in the sky west of the galactic core, the rest of Centaurus the centaur and adjoining Lupus the wolf are sprawling patterns without obvious shapes.

◆ Not so for Scorpius, now also overhead. Its curling shape, with reddish Antares, does look like a scorpion.

◆ But Sagittarius to the east (E) doesn't look like a centaur archer. Look for its Teapot asterism. The center of the galaxy lies between the spout of the Teapot and the "stinger" stars of Scorpius.

◆ Below the Teapot, look for the tiara-shaped Corona Australis the southern crown.

◆ The two sides of the Teapot point down—a long way—to Grus the crane and Pavo the peacock, two bright southern constellations, drawn here to look like birds.

◆ One celestial bird that is obvious is made mostly of dark lanes in the Milky Way. Look for the Dark Emu across the sky, with her head as the Coal Sack near Crux, her neck the dust lanes arching up through Centaurus and her body the bright star fields in Sagittarius and Scorpius. Her feet are the dark lanes in Scutum.

DARK EMU OVERHEAD

On winter nights, the form of the Dark Emu stretches across the sky, her body etched in the glowing star clouds around the center of the galaxy, now overhead.

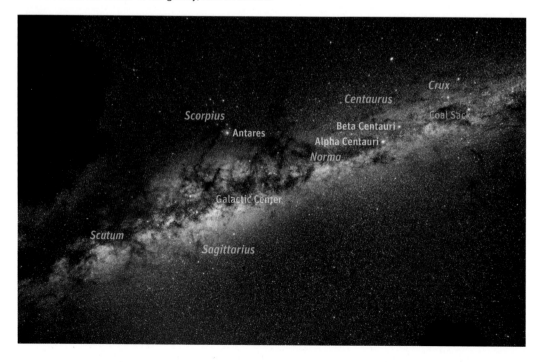

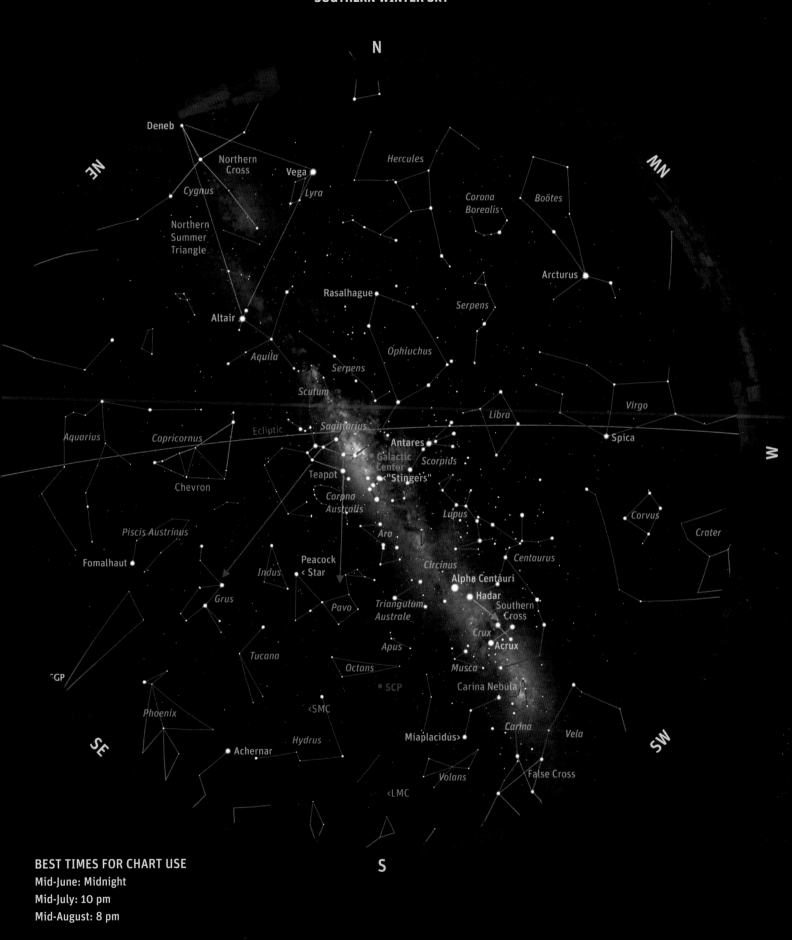

N

NE

NW

Deneb

Northern
Cross

Vega

Cygnus

Lyra

Hercules

Corona
Borealis

Boötes

Northern
Summer
Triangle

Rasalhague

Serpens

Arcturus

Altair

Aquila

Serpens

Ophiuchus

Scutum

Libra

Virgo

Aquarius

Capricornus

Ecliptic

Sagittarius

Antares

Spica

W

Galactic
Center

Scorpius

Teapot

"Stingers"

Chevron

Corona
Australis

Lupus

Corvus

Piscis Austrinus

Ara

Crater

Fomalhaut

Peacock
< Star

Indus

Circinus

Centaurus

Alpha Centauri

Grus

Pavo

Hadar

Triangulum
Australe

Southern
Cross

Tucana

Apus

Crux

Acrux

Octans

Musca

Miaplacidus>

Carina Nebula

SCP

GP

<SMC

Carina

Vela

SW

Phoenix

Hydrus

Achernar

False Cross

Volans

<LMC

SE

S

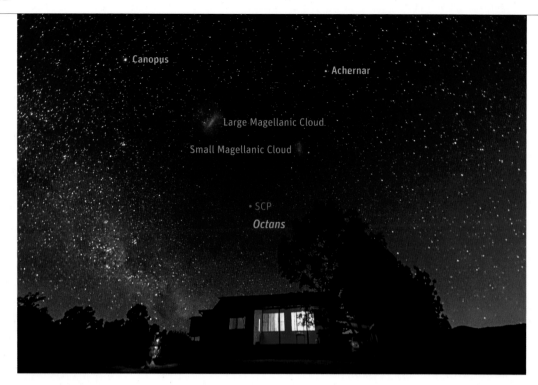

GALAXY SEASON
The Magellanic Clouds are now at their highest, each containing a rich collection of clusters and nebulas suitable for any binoculars or telescope. See Tours 17 and 18 in Chapter 16.

THE SOUTHERN SPRING SKY

The great southern Milky Way is gone as we look out the plane of the Milky Way toward our galaxy's south galactic pole (SGP), in Sculptor, now overhead. As in northern-hemisphere spring, binoculars or a telescope can reveal showpiece galaxies in the southern spring sky.

◆ Apart from Fomalhaut and Achernar at the mouth of Eridanus the river, both now high in the sky, the austral spring sky contains few bright stars.

◆ Start with Fomalhaut and identify the oblong shape of Piscis Austrinus the southern fish.

◆ Pavo the peacock is faint, with one bright star called the Peacock Star (aka Alpha Pavonis).

◆ We show the Peacock Star forming a "Southern Spring Triangle" (our term) with Fomalhaut and Achernar. It encloses much of Grus the crane, looking reasonably birdlike.

◆ North of Achernar rises the mythical bird Phoenix, with its brightest star Ankaa.

◆ South of Achernar lies Hydrus, another water snake, not to be confused with Hydra.

◆ Start with Achernar and wind your way along Eridanus, with its source near Orion, here rising on his side.

◆ Low in the southeast (SE) shine Sirius and Canopus, the first and second brightest stars in the night sky.

◆ Under dark skies, the two fuzzy patches of the Large and Small Magellanic Clouds (LMC and SMC), west of Canopus and south of Achernar, are easy with the naked eye.

◆ The SMC lies mostly in Tucana the toucan, while the LMC straddles the border between Doradus the goldfish and Mensa, named for Table Mountain in South Africa. This is the best season for exploring the Clouds and other southern galaxies, but not the Milky Way.

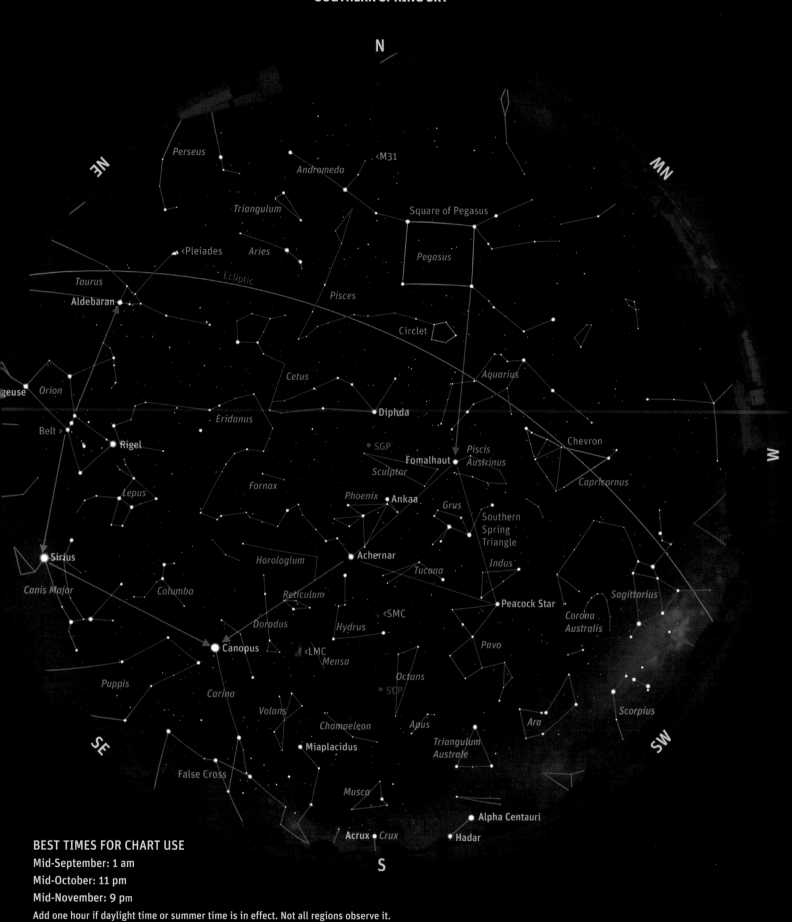

N

NE

NW

<Pleiades

Perseus

Triangulum

Andromeda

<M31

Square of Pegasus

Aries

Pegasus

Taurus

Ecliptic

Aldebaran

Pisces

Circlet

Aquarius

Orion

geuse

Cetus

Diphda

Chevron

Belt >

Eridanus

SGP

Piscis
Austrinus

W

Rigel

Fomalhaut

Capricornus

Lepus

Fornax

Sculptor

Phoenix

Ankaa

Grus

Southern
Spring
Triangle

Sirius

Horologium

Achernar

Indus

Canis Major

Columba

Reticulum

Tucana

Sagittarius

Doradus

<SMC

Peacock Star

Corona
Australis

Canopus

<LMC

Hydrus

Pavo

Puppis

Mensa

Octans

SUP

Scorpius

Carina

Volans

Apus

Ara

SE

Chamaeleon

Triangulum
Australe

SW

Miaplacidus

Musca

Alpha Centauri

False Cross

Acrux • Crux

Hadar

S

BEST TIMES FOR CHART USE
Mid-September: 1 am
Mid-October: 11 pm
Mid-November: 9 pm
Add one hour if daylight time or summer time is in effect. Not all regions observe it.

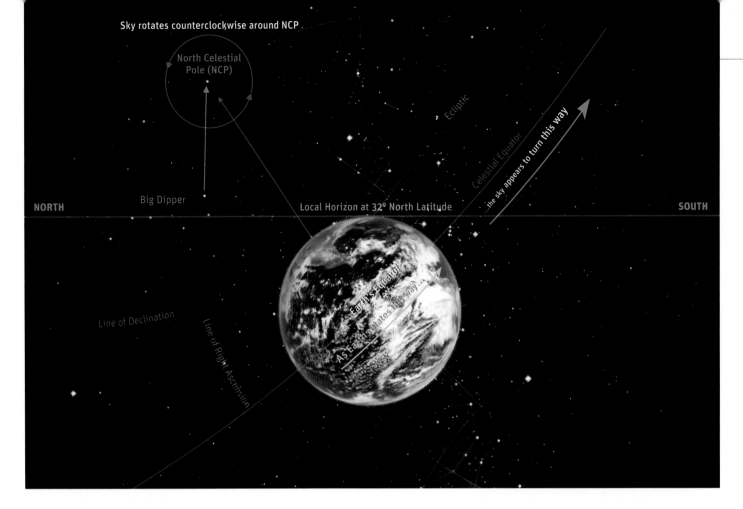

Sky rotates counterclockwise around NCP

North Celestial Pole (NCP)

Ecliptic

Celestial Equator

...the sky appears to turn this way

NORTH

Big Dipper

Local Horizon at 32° North Latitude

SOUTH

Line of Declination

Line of Right Ascension

Earth's Equator

AS Earth rotates this way

HOW THE SKY MOVES

YOUR SKY IN THE NORTHERN HEMISPHERE

Imagine the sky as a dome rotating above our heads. From northern-hemisphere sites, that dome appears tilted so that the north pole of the dome lies due north; in this example, 32 degrees in altitude above the northern horizon. Your local horizon is formed by a line tangent to the Earth's surface. Anything in the sky below that horizon line to the south is always out of sight from that latitude.

Your personal exploration of the cosmos certainly begins with the identification of the Big Dipper, Orion, Leo, Scorpius and patterns such as the Summer Triangle, the Square of Pegasus, the Teapot of Sagittarius and the Southern Cross. Use them, as per the previous charts, to point the way to the less obvious constellations.

But any night under the stars or a year spent becoming familiar with the stars reveals that the sky moves. Indeed, the point of backyard astronomy isn't just to learn how to find things but to see and appreciate the sky's motion. As the months of your astronomy apprenticeship pass, you begin to sense the cyclical change of the celestial panorama. You see and understand the celestial sphere that turns above us each night. Until you know the basics of how the sky moves over time, attempting to navigate a telescope around the sky will only invite confusion. So in this step of getting to know the sky, we explain "night moves."

UNDER THE CELESTIAL SPHERE

Feeling at home under the sky happens when a mental picture clicks in: You are standing under a large dome that appears to be spinning around an axis. In your sky, the celestial dome is tilted at an angle that depends on where you live. From a latitude of 32 degrees north, as in the example above, the celestial sphere is tipped so that the rotation point of the sphere (the north celestial pole) lies 32 degrees above the northern horizon. As Earth turns on its axis from west to east, the dome of the sky appears to turn about this pole from east to west. Looking north, the sky spins counterclockwise.

The dome is divided into northern and southern halves by the celestial equator, a projection of the Earth's equator into space that arcs across the south. The sky is also gridded with coordinate lines. Lines of declination measure how far an object is north or south of the celestial equator, similar to latitude on Earth. Lines of right ascension are the celestial equivalent of longitude, measuring an object's position east of a prime meridian line that runs through the point where the Sun crosses the celestial equator on the March equinox. For more on celestial coordinates, see page 197.

NIGHT MOVES: NORTHERN HEMISPHERE (32°N)

The daily motion of the sky from east to west is obvious by day: We see the Sun rise in the east and set in the west. This motion occurs because Earth spins on its axis. We see the same motion at night, as the starry dome rotates above our heads. This set of long-exposure star-trail images shows the sky's motion from southern Arizona, at 32 degrees north.

Looking North: The sky rotates about the celestial pole, here 32 degrees above the horizon. The celestial sphere appears to turn counterclockwise around Polaris, which is almost stationary near the pole. Stars and constellations around Polaris are circumpolar—they never set below the horizon but circle endlessly about the pole.

Looking South: As we gaze due south from anywhere in the northern hemisphere, stars move from left to right (east to west) across the sky. This region of the sky contains the seasonal constellations, which change through the year, unlike the circumpolar patterns that can be seen all year.

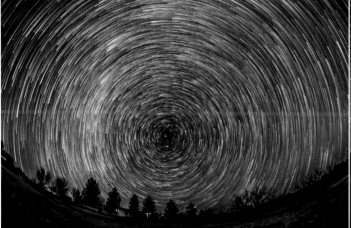

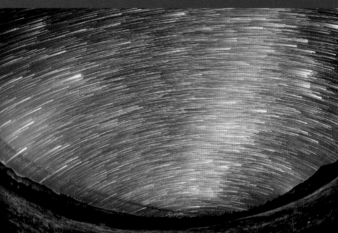

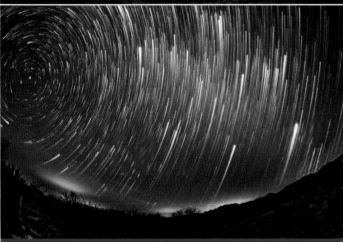

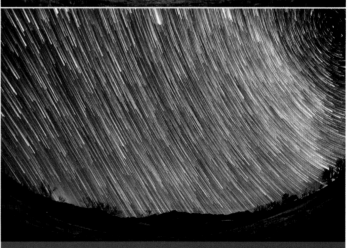

Looking East: Turning our gaze to look east, we see stars rising at an angle to the horizon, moving to the right as they climb higher. This fish-eye view takes in enough sky to show Polaris at left. The angle at which stars rise depends on your latitude. From the equator, at 0 degree latitude, the stars—and the Sun—rise straight up, perpendicular to the horizon.

Looking West: Celestial objects set in the west, moving to the right as they sink toward the western horizon. This view also takes in the north celestial pole, at upper right. As you travel south in latitude, stars rise and set at a steeper angle; as you travel north, stars do the opposite, rising and setting at a shallower angle.

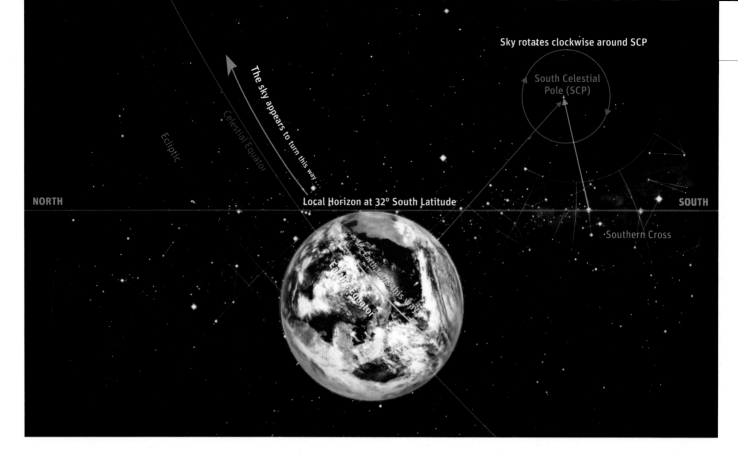

Sky rotates clockwise around SCP

South Celestial Pole (SCP)

The sky appears to turn this way

Ecliptic

Celestial Equator

NORTH

Local Horizon at 32° South Latitude

SOUTH

Southern Cross

Earth's Equator

YOUR SKY IN THE SOUTHERN HEMISPHERE

From 32 degrees south, Polaris is forever below the horizon. The sky turns clockwise around the blank south celestial pole (the Southern Cross points to it), which lies due south at an angle above the horizon equal to the site's latitude below the equator, 32 degrees in this case. The celestial equator and ecliptic now arc across the northern half of the sky. Southerners look north to see the Sun, Moon and planets.

CHANGING YOUR LATITUDE

Now here's where it takes a little mental gymnastics. What if you lived at the North Pole? How would the sky move? The north celestial pole (and Polaris) would be overhead at the zenith. The entire sky would turn parallel to the horizon. What about at the equator? The two poles of the sky would lie opposite each other on the horizon due north and due south. The sky would turn perpendicular to the horizon, rising straight up in the east and setting straight down in the west. That's why twilight in the tropics is short and night falls fast.

As you travel south of the equator, the north celestial pole dips farther below the northern horizon, while the south celestial pole rises higher into the south. You see less of the northern sky and more of the southern sky. In our chart above and the photos at right, we have placed ourselves at 32 degrees south. The motions look similar to the view from 32 degrees north but are opposite in direction. Go to the ends of the Earth at the Amundsen-Scott South Pole Station, and the south celestial pole lies overhead. As it does at the North Pole, the sky turns parallel to the horizon but in the other direction.

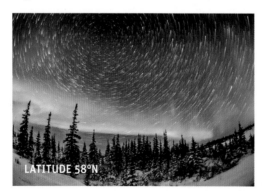

LATITUDE 58°N

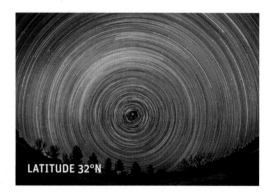

LATITUDE 32°N

POLAR ALTITUDE

From a latitude of 58 degrees north, Polaris and the north celestial pole lie high in the sky, at an altitude of 58 degrees due north. From a latitude of 32 degrees north, the pole is lower, only 32 degrees high but still due north. Both images were taken with the same fish-eye lens, so the image scale is identical.

NIGHT MOVES: SOUTHERN HEMISPHERE (32°S)

In the southern hemisphere, the world spins in the same direction, so the sky still turns from east to west. But from sites below the equator, the pole of the sky lies to the south, not north. We look south to see the circumpolar stars and north to see the seasonal stars. This set shows the spinning sky from Australia, at a latitude of 32 degrees south.

Looking South: The sky rotates about the celestial pole, here 32 degrees above the horizon, just as at the same latitude in the northern hemisphere. But from Australia or any southern-hemisphere site, we look south to the pole, with the sky rotating clockwise through the night around a relatively blank area of sky.

Looking North: As we gaze north from anywhere in the southern hemisphere, stars still move from east to west, but that's now from right to left. The Sun does the same by day, moving the opposite direction to what northerners are used to. And it is in the northern half of the sky we find the seasonal constellations that change through the year.

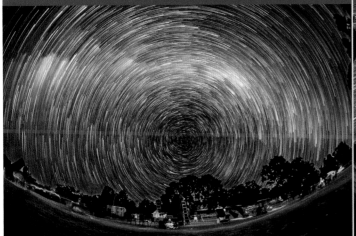

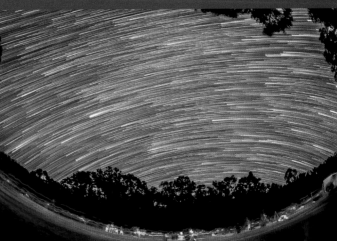

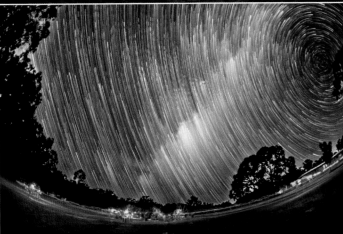

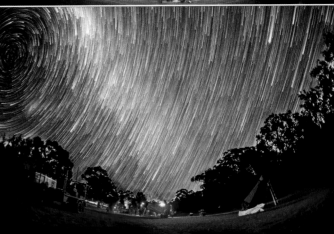

Looking East: Turning to look due east, we see stars rising at an angle to the horizon, the same angle as from 32 degrees north. But here in Australia, stars are moving to the left as they climb higher. This fish-eye view takes in enough sky to show the south celestial pole at upper right. The star clouds of the galactic core, in Sagittarius, are the bright area at center, here rising on an autumn evening.

Looking West: Celestial objects still set in the west from Down Under but in arcs moving to the left as they sink toward the horizon. In this fish-eye view, we see the south celestial pole and circumpolar stars at upper left. This set of photos was taken at the OzSky Star Safari star party, near Coonabarabran, New South Wales, thus the foreground of big telescopes.

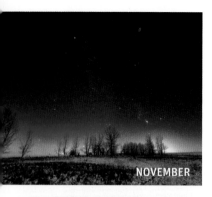

NOVEMBER

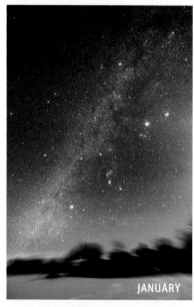

JANUARY

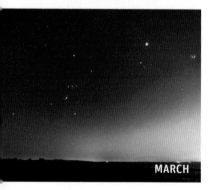

MARCH

ORION ON PARADE

On November nights, Orion rises in the east around 9 p.m. By January, he rises at 5 p.m. (before sunset) and shines due south about 10 p.m. By March, Orion is due south at 6 p.m. in broad daylight and appears setting into the western twilight as night falls.

THE MARCH OF THE CONSTELLATIONS

The rotation of Earth produces the daily—and nightly—turning of the sky. The Earth's revolution around the Sun produces the sky's other great motion, the seasonal parade of constellations. We can't see Orion in June or Sagittarius in December. Every constellation has its season. Indeed, the constellations quickly become familiar signs of the seasons.

In the illustration below, we gaze down on Earth at its orbital position for December 21. Looking past Earth toward the Sun, we see the Sun apparently sitting in Sagittarius. Its stars and the galactic center lie out of sight in our daytime sky, no matter where you live on Earth.

However, as Earth revolves around the Sun, the Sun appears to move eastward against the background stars by about one degree per day. From Sagittarius, the Sun moves along the ecliptic into Capricornus, then Aquarius. Over the course of a year, the Sun travels through the 12 constellations that make up the zodiac—plus a thirteenth, Ophiuchus.

The annual motion of Earth (and the resulting eastward trek of the Sun) sets old constellations out of sight behind the Sun in the western sky and brings new constellations into view in the east. In fact, stars and constellations rise about four minutes earlier each night. This adds up to two hours per month, or 12 hours after six months. Sagittarius, for example, home of the center of the Milky Way, rises about 5 a.m. by March 1 but, by April 1, is coming up at 3 a.m., standard time. By late June, Sagittarius and the galactic center shine due south at midnight. Six months later, in December, Sagittarius is back behind the Sun in the noonday sky.

After 12 months, the advance of the constellations adds up to 24 hours, and we have gone full cycle—the same constellations that were due south at midnight in June, such as Sagittarius, will be there again a year later. Learn the constellations one year, and you're all set for every year after that.

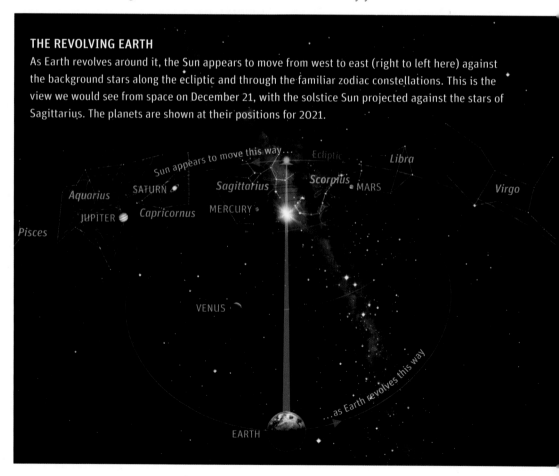

THE REVOLVING EARTH

As Earth revolves around it, the Sun appears to move from west to east (right to left here) against the background stars along the ecliptic and through the familiar zodiac constellations. This is the view we would see from space on December 21, with the solstice Sun projected against the stars of Sagittarius. The planets are shown at their positions for 2021.

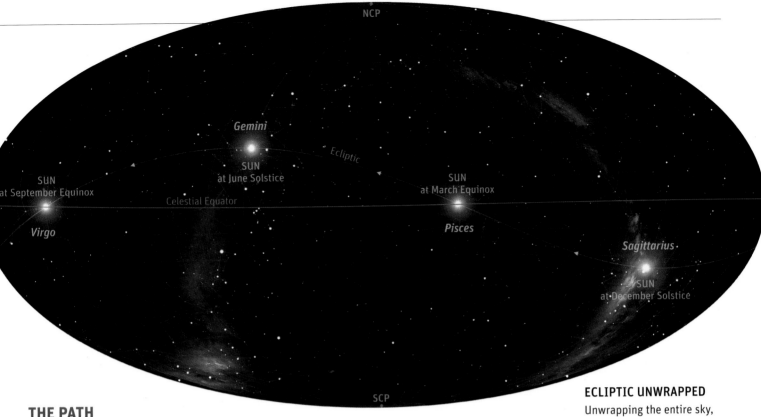

Labels on image: NCP, Gemini, *Ecliptic*, SUN at June Solstice, SUN at September Equinox, Celestial Equator, Virgo, SUN at March Equinox, Pisces, Sagittarius, SUN at December Solstice, SCP

THE PATH OF THE PLANETS

While the stars and constellations return to the same place in the sky each year, the planets do not. Just as Earth revolves around the Sun, so do the other planets—each at its own rate. Of the five naked-eye planets, Mercury travels the fastest around the Sun and Saturn is the slowest.

The orbital motion of the planets carries them against the background stars; this motion can be seen even after a few days. Jupiter, for example, takes 12 years to orbit the Sun (and our sky) and therefore spends about a year in each zodiac constellation, with its motion within that constellation obvious over weeks.

The inner planets, Mercury and Venus, never get far from the Sun, so they appear only in the morning or evening twilight sky. The planets beyond the Earth's orbit, from Mars outward, can all appear opposite the Sun in our midnight sky. But all the major planets (not Pluto!) are always found within a few degrees of the ecliptic, an artifact of our solar system's formation from a flattened disk of gas and dust. For more on the movement of the planets and how to find them, see Chapter 14.

However, Earth is tipped on its rotation axis with respect to the ecliptic, as most planets are. Our planet's tilt is 23.5 degrees. For this reason, the ecliptic does not coincide with the celestial equator. As the Sun travels along the ecliptic through the year, it reaches a maximum of 23.5 degrees north of the celestial equator on June 21 (with the Sun in Gemini) to 23.5 degrees south of the celestial equator on December 21 (with the Sun in Sagittarius). Those are the two solstices. The Sun crosses the celestial equator going north on March 21 (in Pisces), then going south on September 22 (in Virgo), the two equinoxes, all give or take a day due to leap years.

ECLIPTIC UNWRAPPED

Unwrapping the entire sky, we see the celestial poles at the top and bottom and the celestial equator bisecting the map. Due to the Earth's 23.5-degree tilt, the ecliptic (the plane of the Earth's orbit) is a line that swings 23.5 degrees above and below the equator. The Sun appears to move eastward (right to left here) along the ecliptic through the year.

SHIFTING OF THE SETTING SUN

One effect of the Sun's motion north and south along the ecliptic is to swing its rising and setting points (the latter shown here) along the horizon. At summer solstice in the northern hemisphere, the Sun rises and sets far to the north, but at winter solstice, it sets to the south, as this composite shows. The Sun rises due east and sets due west only on the two equinoxes.

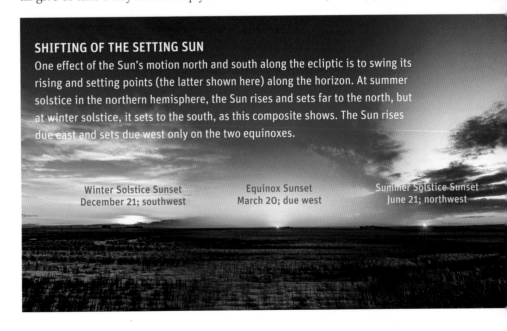

Winter Solstice Sunset
December 21; southwest

Equinox Sunset
March 20; due west

Summer Solstice Sunset
June 21; northwest

ECLIPTIC ANGLES

The Sun's changing altitude north and south of the celestial equator causes the seasons. When the Sun is high, we get more solar energy, longer days and summer. When the Sun is low, the days are short and cold.

But the Moon and planets also follow the ecliptic. When the Moon is opposite the Sun (as it is at full Moon) and when any planets lie opposite the Sun, they appear in our night sky at the place on the ecliptic where the Sun appears by day in the opposite season.

For example, the full Moon and outer planets at opposition appear farthest north from November to January and farthest south from May to July. Full Moons of winter are high, while full Moons of summer are low. If Mars reaches opposition (see page 265 for details) from June to August, it is low in the south for northern-hemisphere viewers, whereas Mars oppositions that occur during the winter months of November to January place Mars high in the sky for observers in the northern hemisphere.

EVENING ECLIPTIC IN SPRING

On spring evenings, the section of the ecliptic above the celestial equator is now in the west. This swings the evening ecliptic to its highest angle above the horizon for the year, placing twilight planets at their highest altitude, as Mercury and Venus are in this image taken in May 2015. Waxing crescent Moons are also at their highest in spring, making this the best season for sighting very thin young Moons and Earthshine.

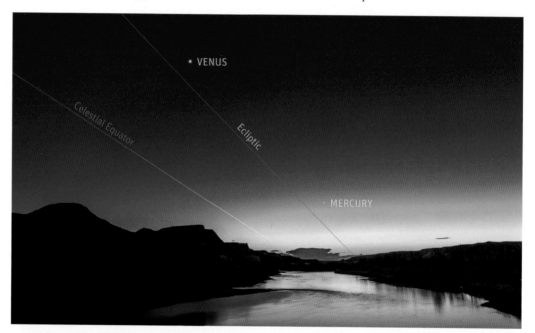

MORNING ECLIPTIC IN AUTUMN

The ecliptic arcs low across the evening sky in autumn (as in the photo on the facing page), but just the opposite occurs at dawn. The section of the ecliptic above the celestial equator is now in the east, swinging morning planets up to their highest, as in this image taken in November 2015, when Venus, Mars and Jupiter formed a line along the ecliptic.

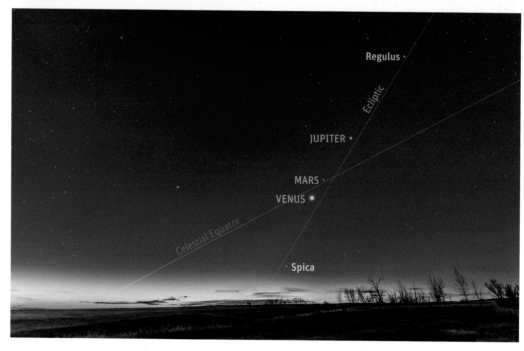

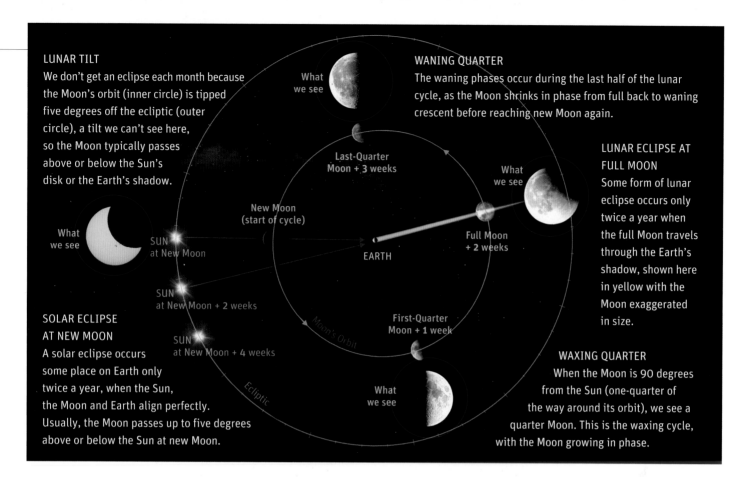

LUNAR TILT

We don't get an eclipse each month because the Moon's orbit (inner circle) is tipped five degrees off the ecliptic (outer circle), a tilt we can't see here, so the Moon typically passes above or below the Sun's disk or the Earth's shadow.

What we see

WANING QUARTER

The waning phases occur during the last half of the lunar cycle, as the Moon shrinks in phase from full back to waning crescent before reaching new Moon again.

Last-Quarter
Moon + 3 weeks

What we see

New Moon
(start of cycle)

LUNAR ECLIPSE AT FULL MOON

Some form of lunar eclipse occurs only twice a year when the full Moon travels through the Earth's shadow, shown here in yellow with the Moon exaggerated in size.

What we see

SUN
at New Moon

Full Moon
+ 2 weeks

EARTH

SUN
at New Moon + 2 weeks

First-Quarter
Moon + 1 week

SOLAR ECLIPSE AT NEW MOON

A solar eclipse occurs some place on Earth only twice a year, when the Sun, the Moon and Earth align perfectly. Usually, the Moon passes up to five degrees above or below the Sun at new Moon.

SUN
at New Moon + 4 weeks

Moon's Orbit

Ecliptic

What we see

WAXING QUARTER

When the Moon is 90 degrees from the Sun (one-quarter of the way around its orbit), we see a quarter Moon. This is the waxing cycle, with the Moon growing in phase.

MOON MOTIONS

Moon phases are caused by the changing angle between the Moon and the Sun as the Moon revolves around Earth. When the Moon comes between us and the Sun, the nightside of the Moon faces us. This is new Moon, a phase invisible to us except when the Moon crosses in front of the Sun in a solar eclipse, as we show above. When the Moon lies 180 degrees opposite the Sun, the side of the Moon facing us is fully lit by the Sun. We see a full Moon rising at sunset and setting at sunrise. If it travels through the Earth's shadow, we see a lunar eclipse, also depicted above.

In between, when the Moon is 90 degrees away from the Sun, we see the Moon half lit in a first- or last-quarter phase. While the Moon takes 27.3 days to orbit Earth with respect to the stars (its sidereal period), the month is longer than that. By the time the Moon returns to the same spot where it was at new Moon 27 days earlier, the Sun has traveled nearly 30 degrees farther east in the sky (one-twelfth of 360 degrees), as illustrated above. It takes the Moon another two days to line up again with the Sun. Thus we get the familiar lunar cycle: the 29.5-day synodic period from new Moon to new Moon.

LUNAR CYCLE

Above: Here, we look down on Earth, keeping it centered as the Moon goes around it. At new Moon, the Sun, the Moon and Earth lie in a straight line. A week later, the Moon has moved counterclockwise around Earth so that it lies 90 degrees away from the Sun. A week after that, the three worlds line up a second time for the full Moon, though the Sun has also moved east against the background stars. A week after full Moon, the Moon is again 90 degrees away from the Sun. The cycle begins anew when the Sun, the Moon and Earth align at new Moon once more after 29.5 days.

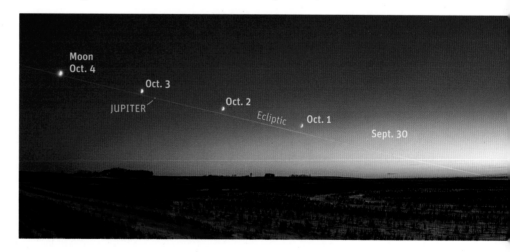

Moon
Oct. 4

Oct. 3

JUPITER

Oct. 2

Ecliptic

Oct. 1

Sept. 30

THE WAXING MOON

This composite shows the crescent Moon growing in phase (waxing) over five autumn nights. The Moon's orbital motion around Earth carries it about 13 degrees farther east each night. Here, it shines in the evening twilight. By full Moon, it will rise at sunset opposite the setting Sun. Note that the Moon lies above the ecliptic but is approaching it.

WHERE IS THE MILKY WAY?

While the ecliptic is where we find the Sun, the Moon and the planets, the Moon travels as much as five degrees above or below the ecliptic. Its path crosses the ecliptic twice a month, but we get an eclipse only when that crossing happens near new or full Moon, which occurs at least twice a year. (For more on eclipses, see Chapter 12.)

The ecliptic generally runs east-west across our sky. However, the plane of the solar system does not line up with the plane of the flat galaxy in which we live. The solar system, and therefore the ecliptic, is tipped by 60 degrees off the plane of our galaxy. Because of that 60-degree tilt, the Milky Way band often lies north-south across the sky, at nearly a right angle to the ecliptic.

The visibility of the Milky Way and which part we see change a lot through the year, as they do if we travel south, below the equator. The views below and on the facing page show the changing aspect of the Milky Way through the seasons, with the northern-hemisphere view (left image in each set) paired with a southern-hemisphere view at the same time of year but the opposite season.

JUNE–AUGUST

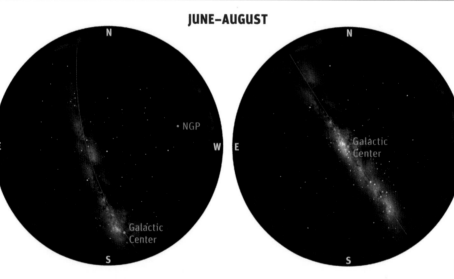

NORTHERN SUMMER
The Milky Way shines at its brightest as we gaze toward the galactic center in the south and the star clouds of Cygnus overhead. The Milky Way runs vertically across the sky. The purple line is the galactic equator. The north galactic pole (NGP) is 90 degrees away from the equator.

SOUTHERN WINTER
From a latitude of 30 degrees south, the bright galactic center that was just above the southern horizon from "up north" now shines overhead at the zenith. In this classic view, the true nature of the Milky Way as an edge-on spiral galaxy becomes obvious.

SEPTEMBER–NOVEMBER

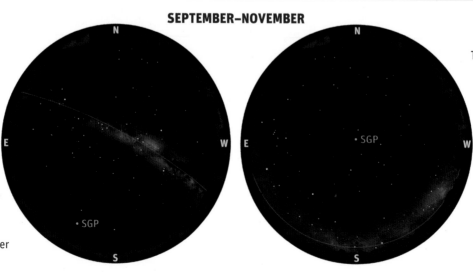

NORTHERN AUTUMN
The galactic center is sinking into the southwest, leaving the northern half of the Milky Way to arc across the sky from southwest to northeast. Overhead, we look down our local spiral arm in Cygnus and, in the northeast, toward the dimmer outer spiral arm in Perseus.

SOUTHERN SPRING
The Milky Way now runs along the horizon in austral spring, with the south galactic pole (SGP) of our galaxy overhead. We are looking out the plane of the galaxy at a right angle toward a myriad of other galaxies in the southern sky, including the Magellanic Clouds.

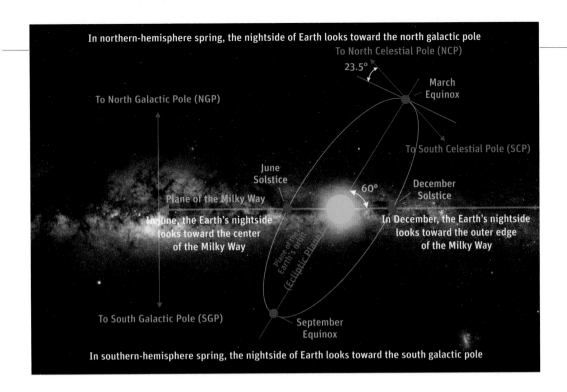

In northern-hemisphere spring, the nightside of Earth looks toward the north galactic pole

To North Celestial Pole (NCP)

23.5°

March Equinox

To North Galactic Pole (NGP)

To South Celestial Pole (SCP)

June Solstice

December Solstice

Plane of the Milky Way

60°

In June, the Earth's nightside looks toward the center of the Milky Way

In December, the Earth's nightside looks toward the outer edge of the Milky Way

Plane of the Earth's orbit (Ecliptic Plane)

To South Galactic Pole (SGP)

September Equinox

In southern-hemisphere spring, the nightside of Earth looks toward the south galactic pole

SEASONAL DIRECTIONS

The plane of the Earth's orbit—the ecliptic—is tipped 60 degrees off the plane of the Milky Way. From June to August, the nightside of Earth faces the galactic center. From December to February, it faces toward the outer edge of the galaxy. In northern spring, we look toward our galaxy's north pole (NGP), while in southern spring, we look toward its south pole (SGP).

DECEMBER–FEBRUARY

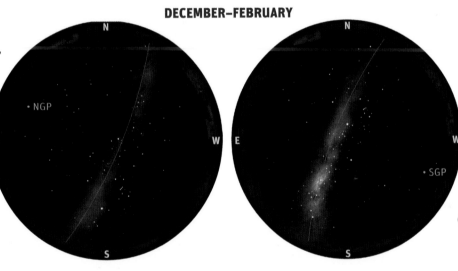

NORTHERN WINTER

Six months after summer, Earth has orbited 180 degrees to the other side of the Sun, so we are looking toward the outer edge of the Milky Way, opposite the galactic center. The Milky Way is now dimmer but contains the bright stars of the Orion region of our local spiral arm.

SOUTHERN SUMMER

Note how Orion, to the south in the northern view at left, is now not just overhead but in the northern half of the sky. South of Orion lie the bright Milky Way regions in Puppis, Vela and Carina, toward the Centaurus Arm, opposite the Cygnus region of a northern summer.

MARCH–MAY

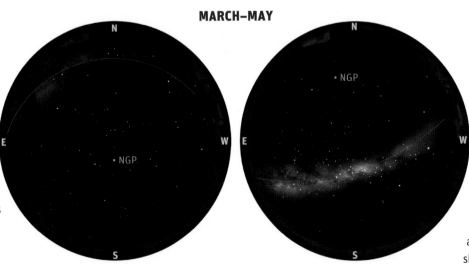

NORTHERN SPRING

In spring, northerners look out the plane of the galaxy toward its north galactic pole (NGP). The Milky Way now lies around the horizon. Overhead, the sky contains the rich telescopic galaxy fields of Coma Berenices and Virgo. This is galaxy-hunting season.

SOUTHERN AUTUMN

By contrast, March to May is when the brightest part of the southern Milky Way in Crux, Carina and Centaurus arcs across the sky from east to west. The galactic center is rising in the east. It's the best season to see as many of the southern-sky wonders as possible.

STAR-HOPPING GUIDES

We provide sample star-hop tours, but to explore the sky further, we recommend one of the following titles. Brother Guy Consolmagno's *Turn Left at Orion* is a best-selling classic. *Celestial Sampler* and *Deep-Sky Wonders* by Sue French are both excellent. We also like the pocket-sized *Objects in the Heavens*, self-published by Peter Birren (birrendesign. com), as it's easy to use at the scope and has extensive lists of top objects for each constellation. And beginners are well served by John Read's self-published series, above, of *50 Things to See...*, available through Amazon.

STAR-HOPPING

Nights spent under the stars with no more than a planisphere or simple star charts (as we advised in Chapter 2 and presented earlier in this chapter) begin to reveal the layout of the sky, as well as its nightly and annual cycles of motion. But even with no more than binoculars in hand (the topic of our next chapter), the prime question is, How do I find things?

The quick answer is star-hopping. This technique, one every amateur astronomer masters, requires learning to read star charts, the maps of the night sky we discuss in the next section. To become comfortable reading star charts, we recommend spending a few months stargazing with binoculars first, to gain experience using charts to hop to targets.

Learning to star-hop first with binoculars makes interpreting charts at the telescope (with its narrow field and inverted view) a small step, instead of the giant leap many newcomers find it to be. And it's why, in Chapter 6, we conclude the "Getting Started" portion of our book with a curated collection of binocular sky tours.

HOW TO STAR-HOP

The key to finding objects such as the Andromeda Galaxy and the Orion Nebula is hopping from bright guide stars to your target. And the key to that is pattern recognition. In our sample tours of binocular and telescope targets (Chapters 6 and 16), we provide tips for using patterns to home in on the object. Our tours help you learn the process.

But once you venture off on your own tours, you'll use a star atlas (see pages 94-97) to pick a bright star near the target, then identify a pathway of stars leading from that guide star to your destination. Look for chains or triangles of stars that serve as signposts.

The trick is transferring that mental picture of your route to the sky. This is where being familiar with the sky, the size of constellations and angular distances is important, as is the basic skill of knowing which way to turn the chart so that its orientation matches the sky. This comes with an understanding of how the dome of the sky is oriented above your head—knowing that when you look east, for example, the north celestial pole is to the left.

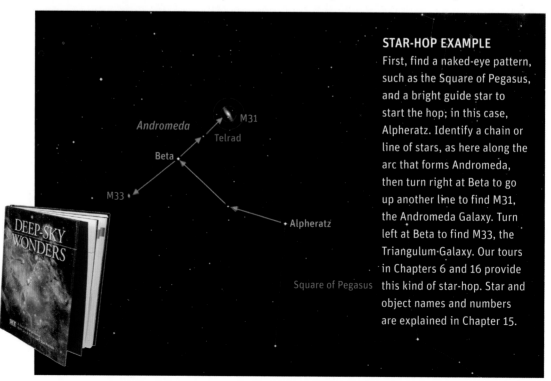

STAR-HOP EXAMPLE
First, find a naked-eye pattern, such as the Square of Pegasus, and a bright guide star to start the hop; in this case, Alpheratz. Identify a chain or line of stars, as here along the arc that forms Andromeda, then turn right at Beta to go up another line to find M31, the Andromeda Galaxy. Turn left at Beta to find M33, the Triangulum Galaxy. Our tours in Chapters 6 and 16 provide this kind of star-hop. Star and object names and numbers are explained in Chapter 15.

1° 5° 10° 15° 25°

Therefore, star charts with north up must be turned counterclockwise to match the naked-eye sky.

Star-hopping might sound like work. As such, many beginners think they can circumvent this technique by buying a computerized telescope. Don't. Not at first. Learn your way around the sky with binoculars. Star-hop routes to objects like the Andromeda Galaxy will soon become as familiar as the backstreets of your hometown.

By practicing first with the right-side-up views of binoculars, you'll soon be centering many targets in a telescope with no more than a small finderscope or red-dot finder, much to the amazement of your friends and family—and you! This skill is far more satisfying than just seeing an object the computer found for you and having no idea where it is.

FINDER AIDS

We will discuss these again in Chapter 9, when we survey telescope accessories, but suffice to say for now that when star-hopping with a telescope, a good low-power finderscope is essential. However, many beginner scopes come with a simpler alternative called a red-dot finder, or RDF. Hunters use these on their rifles. With an RDF, you look through a window to see a red dot superimposed on the unmagnified sky.

An alternative is a reflex-style finder, such as the popular Telrad and Rigel QuikFinder, which present a red bull's-eye pattern in the window. In a dark sky, this is all you need to locate most targets by star-hopping. But in a bright sky, a 6x30 or 7x50 optical finderscope might be needed to pick out star patterns. However, most finderscopes present views that are upside down or mirror-image, making translating the star-atlas view to the finder-scope view much more challenging.

THE DIPPER SCALE

The Big Dipper provides a constant gauge to angular distances in the sky. The Pointer stars of the Dipper's bowl are just over five degrees apart, one to two degrees smaller than the field of most binoculars and finderscopes. The two top stars of the bowl are 10 degrees apart, larger than typical binocular and finderscope fields.

HANDY SKY MEASURES

Finding targets is easier if you learn to gauge angular sizes and distances in the sky. Just how big is a seven-degree binocular-field star-hop? One convenient measure is your own hand at arm's length. The various configurations above mark off standard units of distance typical of the leaps in most star-hops.

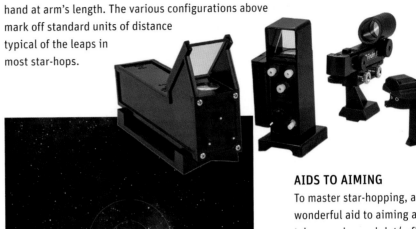

TELRAD PATTERN

Telrad

AIDS TO AIMING

To master star-hopping, a wonderful aid to aiming a telescope is a red-dot/reflex finder, such as one of the four shown above. The Telrad and QuikFinder are on the left; two popular red-dot finders are on the right. Some scopes have a version of these finders as standard.

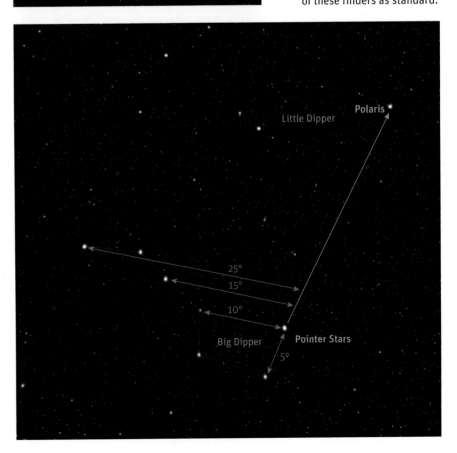

Polaris

Little Dipper

25°

15°

10°

Big Dipper Pointer Stars

5°

PRINTED STAR ATLASES

Regardless of whether you plan to use a computerized GoTo telescope, we suggest that you have a star atlas. Or two! A star atlas is as essential to the backyard astronomer as a road atlas is to the highway traveler, even in this age of GPS satnavs. And, like the traveler, the astronomer can become lost by not selecting the right atlas for the journey.

Planning a cross-country trip requires, first, a national map for an overview, then a state or provincial map for more detail and, finally, regional or city maps for information about congested areas or sites of special interest. Astronomers use the same procedure when exploring the night sky with binoculars or a telescope.

For the initial overview, the entire sky must be on one map. We've included such maps at the start of this chapter, one per season. However, as we mentioned in Chapter 2, the center star chart in astronomy magazines or a planisphere are also good options. Mobile apps will work, but they generally don't show the entire sky in one view.

But for homing in on specific targets, even with just binoculars, you need a more detailed star atlas. A digital atlas might do, but a print atlas is indispensable. It divides the sky into separate charts that plot the sky's contents in impressive detail. Printed star atlases are categorized by their limiting magnitude—the

faintest stars plotted. Each increase of one magnitude more than doubles the number of stars and other celestial objects shown but produces a substantially bulkier atlas. More detail also demands a higher level of experience to use the atlas. Don't buy the most detailed atlas to start.

FIFTH-MAGNITUDE STAR ATLASES

For those just beginning their tour of the night sky, several introductory books provide excellent fifth-magnitude star atlases along with plenty of support material. Of course, we recommend author Dickinson's *NightWatch* (Firefly Books). It contains excellent seasonal maps as well as charts of selected regions of interest and has a practical spiral binding.

Other favorites we can suggest are *The Monthly Sky Guide* by Ian Ridpath and star-chart cartographer Wil Tirion (Cambridge) and *The Night Sky Month by Month* by Will Gater and Giles Sparrow (DK/Dorling Kindersley). Less well known but recommended is *A Walk through the Heavens* by Milton Heifetz and Wil Tirion (Cambridge), which takes you through the stars step-by-step. Their *Walk through the Southern Sky* does the same for southern-hemisphere stargazers.

Smaller volumes, such as the *Backyard Guide to the Night Sky* by Andrew Fazekas (National Geographic), are attractive and contain lots of useful

FIFTH- AND SIXTH-MAGNITUDE ATLASES

These guidebooks all present useful background information as well as seasonal or monthly charts to help you become familiar with the sky and basic constellation identification. Any one of these is a great way to start your sky explorations. In all the examples of atlas interior pages here, we show the same region of sky around Orion to illustrate how each atlas depicts the sky and the depth of objects plotted.

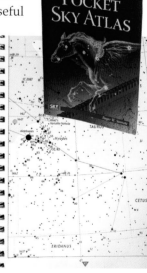

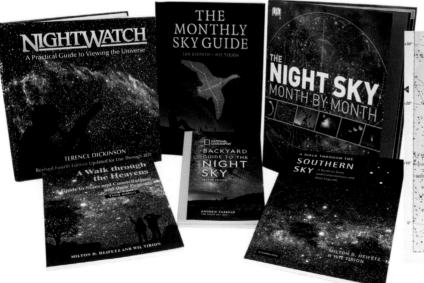

information. But in small-format books and night sky "field guides" (often in the same series as birding guides), the sky charts are small and harder to use in practice.

SIXTH- AND SEVENTH-MAGNITUDE STAR ATLASES

Every backyard astronomer needs a star atlas from this category. Our favorite is the *Pocket Sky Atlas*, published by *Sky & Telescope* magazine. A larger Jumbo Edition is not so easy to pack but is easier to read in the field with aging eyes! Both Pocket and Jumbo Editions include pairs of 80 charts, plus 10 close-up charts of selected regions, formatted in a spiral-bound atlas that lies flat. Stars are plotted to magnitude 7.6 and deep sky objects to magnitude 11 or 12, including the Herschel 400 objects and 55 red carbon stars. It's all the atlas most telescope owners are likely to need and, at $20, one everyone should own.

Another favorite of ours is the full-color *Cambridge Star Atlas* by Wil Tirion (Cambridge; $30), with 20 charts to magnitude 6.5 and 900 deep sky objects plotted. It is available in a general edition and in specialized versions by James Mullaney for observers of double stars and of Herschel deep sky objects labeled in William Herschel's original catalog system, for those wishing to complete the Herschel 400 (explained on page 290).

For decades, *Norton's Star Atlas* was a popular choice. First published in 1910, it is still in print. Although revised in recent years, the charts and listings of deep sky objects are surpassed by more recent publications.

EIGHTH-MAGNITUDE STAR ATLAS

Astrocartographic genius Wil Tirion produced the definitive eighth-magnitude star atlas with his *SkyAtlas 2000.0* (Sky Publishing and Cambridge). This is a big atlas—the 26 charts are each 12 by 18 inches. Swatches of the sky, roughly 40 by 60 degrees, are presented. If they were smaller, they wouldn't include enough of an individual constellation to provide the context for the portion of sky being shown.

The atlas is available in three formats: a spiral-bound Deluxe Edition ($40) with color-coded charts; a smaller Desk Edition with black stars on a white background; and a Field Edition with white stars on a black background to help preserve night vision at the telescope. We both use the Deluxe Edition frequently at home. For use at the telescope, we suggest the Field Edition in a plastic-laminated version ($80) that will withstand dew and abuse.

NINTH-MAGNITUDE STAR ATLASES

Compiling an atlas of stars down to magnitude 9.75 was a monumental undertaking. To accommodate the popularity of large-aperture reflectors and the more demanding observing agenda of amateurs from the 1980s on, more than 280,000 stars had to be plotted, along with 30,000 deep sky objects to 14th magnitude. The task was com-

SIXTH-, SEVENTH- AND EIGHTH-MAGNITUDE ATLASES

Bottom left: *The Cambridge Star Atlas* is available in several versions, but the general star atlas is the best one for most observers. All are spiral-bound to lie flat at the telescope, with one chart per page plus tables of objects on the facing page.
Bottom right: The smaller Field and Desk Editions of *SkyAtlas 2000.0* with monochrome charts (top) are sold in plastic-laminated versions, while the large-format Deluxe Edition (bottom) has full-color charts on foldout pages for use at home.

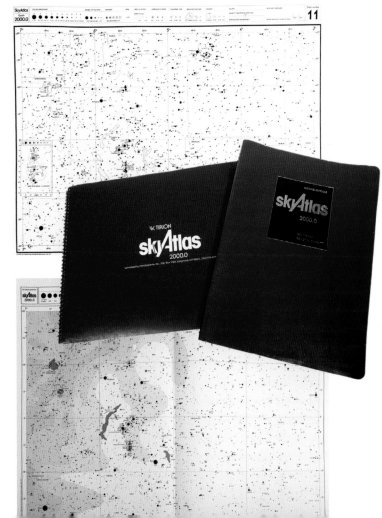

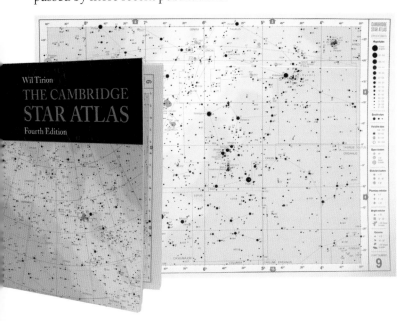

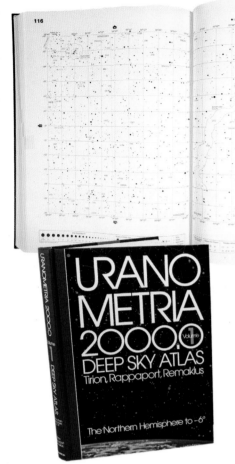

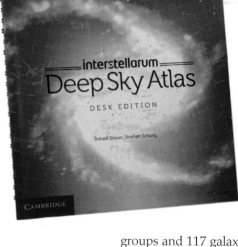

NINTH-MAGNITUDE ATLASES

Above: Now sold in a single volume of charts, *Uranometria 2000.0* is the deepest and most detailed printed star atlas. Monochrome charts are in side-by-side pairs over two pages. However, as of early 2021, *Uranometria 2000.0* is out of print and might be available only on the used-book market.

Above right: Color-coded charts over two spiral-bound pages depict objects by their visibility class, a unique feature of the new *interstellarum Deep Sky Atlas*. It's become our favorite atlas for desk use at home, particularly for helping to identify faint nebulas and galaxies recorded in our photographs.

pleted in 1987 with the publication of *Uranometria 2000.0* by Wil Tirion, Barry Rappaport and George Lovi (Willmann-Bell). The scale of detail meant that showing an entire constellation on one chart would require a chart the size of a tablecloth.

Obviously, that was impractical. Instead, the sky is divided into 220 double-page charts plus 29 close-up charts on 9-by-12-inch pages, first printed in two volumes. The latest edition combines the northern and southern books into a single all-sky volume ($60). A companion *Field Guide* ($60) contains reams of data tables of all the objects plotted.

It is hard to imagine a star atlas more advanced than *Uranometria*, but for many years, the *Millennium Star Atlas* was it. Now out of print but still prized by atlas aficionados, this atlas covered the sky down to an incredible 11th magnitude, in 1,548 charts in three 9-by-13 inch volumes. It was costly and posh enough that no one wanted to use it outside!

As the *Millennium Star Atlas* was published in 1997, digital atlases such as Earth Centered Universe, MegaStar Sky Atlas and Project Pluto (all Windows only) were becoming popular, threatening to replace print atlases, though as of 2020, none of those once popular programs has received an update in years.

Luckily, print survives! And with a new contender for the best advanced star atlas. Created originally in German by Ronald Stoyan and Stephan Schurig and now published in English by Cambridge, the *interstellarum Deep Sky Atlas* plots 200,000 stars down to magnitude 9.5 and 15,000 deep sky objects, including 526 dark nebulas, 58 star clouds, 500 galaxy

groups and 117 galaxy clusters, as well as 2,950 double stars, 371 stars with exoplanets and 536 asterisms. Popular object nicknames are plotted as well. For example, NGC 7479 is labeled as the Superman Galaxy and NGC 6905 as the Blue Flash Nebula. Most atlases don't do this.

With the exception of the two circumpolar charts, each of the 114 atlas charts in the Desk Edition spans two 10-by-11-inch pages in a spiral-bound format. One superb feature of this atlas is that objects are plotted in a font which indicates their suitability for viewing in four classes of telescopes: 4-inch, 8-inch, 12-inch and larger. You can tell at a glance whether something is a faint, challenging target or a bright showpiece.

The companion *interstellarum Deep Sky Guide* provides data, images and sketches of 2,362 of the deep sky objects plotted. Each volume costs about $80, though prices vary a lot on Amazon. Together, the *Deep Sky Atlas* and *Deep Sky Guide* are a great two-volume reference for the serious deep sky observer. We highly recommend them—but only when you really dive into deep sky observing, following our advice in Chapter 15.

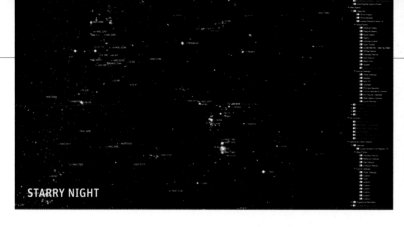

STARRY NIGHT

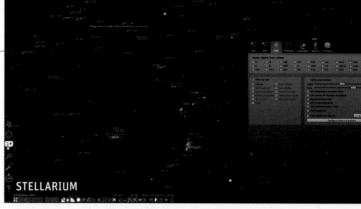

STELLARIUM

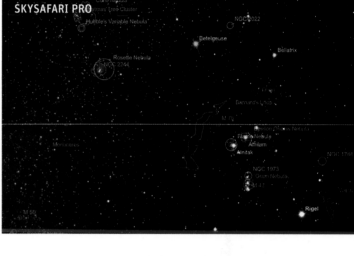

SKYSAFARI PRO

DIGITAL STAR ATLASES

While the *Deep Sky Atlas* proves that print atlases are very much alive and well, digital star atlases are excellent. And by "atlas," we mean programs that plot stars and objects to a deep limiting magnitude and can present charts with a north-up equatorial view and not just zenith-up, as in sky-simulation planetarium apps.

These more advanced star-atlas apps have several advantages over a print atlas. They can be zoomed in for more detail, showing stars as faint as 15th magnitude, if desired, and can be filtered to display only objects of interest or above a certain magnitude. Mobile versions on tablets can connect to telescopes—tap on a target, and your scope slews to it. We discuss computer control in Chapter 11.

FOR THE DESKTOP

For decades, the program we have used for the desktop through its many iterations and publishers is Starry Night Pro (starrynight.com). It has a good array of databases and the ability to add field-of-view (FOV) indicators to display the fields of your favorite eyepieces, telescopes and camera lenses. These are immensely helpful in planning photo shoots and observing sessions. We used Starry Night to create many of the charts in this book.

For advanced imagers controlling robotic and remote telescopes, TheSkyX Professional (bisque.com) is popular. The lower-cost SkyX Serious Astronomer Edition also offers telescope control and all the power most users will need. As of 2020, all versions of TheSkyX, from Serious to the advanced Imaging Edition, require a onetime payment plus an annual subscription.

Stellarium (stellarium.org) is a free open-source program for all platforms that offers numerous expandable databases and an attractive sky. We used it to create the all-sky charts in this book. Many observers use it as their main program, and its developer community adds plug-ins to increase its functions, such as FOV indicators.

FOR MOBILE

Digital atlases come into their own at the telescope, as they allow you to zoom in and frame the field to match your eyepiece view, even flipped over or upside down, for ease of identification of every faint fuzzy.

TheSky Mobile (bisque.com) and Luminos (wobbleworks.com/luminos) atlas programs, both for iOS only, have deep databases, equatorial modes and telescope control. The program we turn to almost daily is SkySafari Pro (skysafariastronomy.com). It offers a rich array of individually selectable databases, FOV indicators and the ability to display observing lists, either downloaded from a library or your own. So if you plan to observe all 110 Messier objects or author Dyer's 110 Finest NGC Objects, you can highlight just those. You can even log your observations.

SkySafari and StarryNight come from the same publisher, so via their LiveSky cloud syncing function, the two programs can share data such as FOV indicators and observing lists and logbooks you create. All very powerful, bug-free (mostly!) and well supported.

ADVANCED DIGITAL APPS
Clockwise from top left:
With digital atlases such as Starry Night, you can select the classes of objects to show and even how they are labeled. Stellarium for desktop can also filter its display from a vast array of object catalogs and object types. SkySafari in the Plus Edition for iOS and Android offers telescope control and all the detail most mobile users need. Serious observers will want the Pro Edition for its larger databases.

CHAPTER 5

Buying Binoculars for Astronomy

Veteran backyard astronomers always have binoculars within easy reach. Why? Binoculars are midway between the unaided eyes and a telescope in power, field of view and convenience. Of all the equipment an amateur astronomer uses, we feel binoculars are the most versatile and the most essential. Yet binoculars are often underrated by backyard astronomers, especially beginners. This is a pity, because binoculars are so much easier to use than a small telescope.

While binoculars can be found in most homes, many beginners ignore them for celestial observing. They assume that to start out in the hobby, they must purchase a telescope, often a complex computerized model, without first turning the binoculars they already own to the night sky.

Our next chapter presents curated tours of celestial sights using binoculars to enjoy and learn the sky. But in this chapter, we offer advice on *choosing* binoculars, both for beginners buying a first pair and for veterans upgrading those well-used faithful companions.

In all your experiences as an amateur astronomer, few will surpass the simple pleasure of standing under a truly dark sky with no more than binoculars in hand to scan along the Milky Way. Binoculars allow skilled observers to get back to basics and beginners to learn the basics.

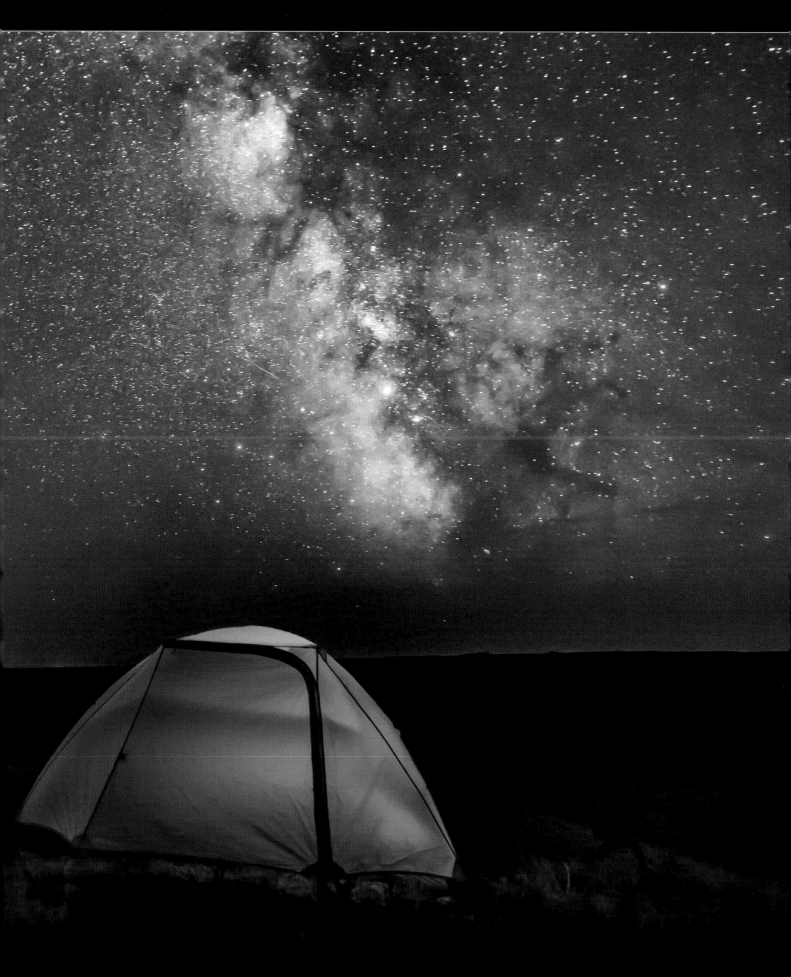

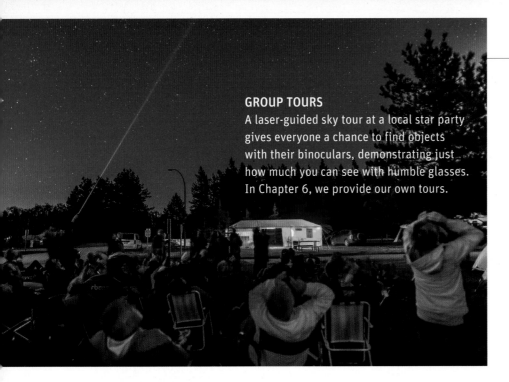

GROUP TOURS
A laser-guided sky tour at a local star party gives everyone a chance to find objects with their binoculars, demonstrating just how much you can see with humble glasses. In Chapter 6, we provide our own tours.

CONSIDER THE HUMBLE BINOCULAR

PRISM PAIR
Porro prism binoculars (left), named for 19th-century optician Ignazio Porro, have the familiar N-shaped light path. Roof prism binoculars (right) are distinguished by their straight tubes. Most utilize the Schmidt-Pechan prism design invented in 1899. Porro prism models all use external focusing, while roof prism binoculars have an internal focusing system.

When you use even ordinary birding binoculars under a dark sky, the hazy band of the Milky Way breaks up into countless thousands of stars—one of the great treats in amateur astronomy. About 4,000 stars are visible to the naked eye over the entire sky, but binoculars can pick up more than 100,000.

Binoculars have several advantages over a telescope:

- They are simple and intuitive to use. Just hold them up to your eyes and look.
- Images are right side up, matching your naked-eye view and star charts.
- Their field of view is wide, making it easier to locate objects.

- Binoculars require no setup. There's no waffling about whether the night is good enough to warrant the effort to cart your telescope outside.
- Finally, using two eyes for celestial viewing allows you to see more. Your brain is accustomed to receiving messages from both eyes, registering faint images as real. How much more can be seen? Experts estimate 40 percent above single-eye viewing.

BINOCULAR TYPES AND TERMS
Binoculars come in a bewildering array of sizes, magnifications, models and prices—from plastic toys for kids and pocket models for hikers to monster 150mm dual telescopes made to mount on a battleship, literally! But all share common specifications and features.

Aperture and Power
Binoculars have two numbers engraved on the body, such as 10x50 (pronounced "10 by 50"). The first number is the magnification; the second is the diameter of the front lenses in millimeters (mm). Thus 10x50 means a magnification of 10 and a lens diameter of 50mm.

Otherwise commendable websites, such as bestbinocularsreviews.com and optics-trade.eu, often assume that astronomy binoculars must have 70mm or larger lenses and lots of power. Not at all! That's the myth of magnification we will encounter again when selecting a telescope. Big, overpowered binoculars defeat the very advantages we just listed.

Out of all the available combinations of power and aperture, the binoculars we use and recommend most for astronomy have lenses from 42mm to 56mm and powers from 7x to 10x. They offer the best balance of light-gathering power versus magnification versus ease of use and weight.

Roof vs. Porro Prisms
Binoculars contain prism systems with a dual purpose: to reduce the length of the optical system by folding the light path and to produce a right-side-up image for convenient viewing.

Porro prism binoculars are the classic design, and they are now largely restricted to entry-level models in those brands that still offer Porros. The exception is premium marine

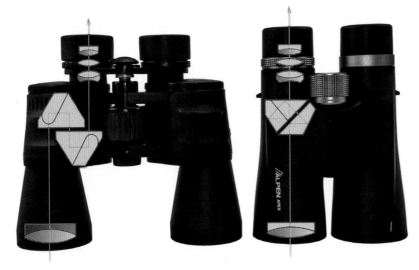

BINOCULAR SHOWCASE

Here is a sampler of celestial sights suitable for or even best viewed in humble binoculars.

SOLAR SYSTEM

Moon with Earthshine
(near Beehive star cluster; May 10, 2019)

Conjunctions (thin Moon below Venus
and Mercury; May 23, 2020)

Moons of Jupiter (above
gibbous Moon; February 23, 2016)

CELESTIAL EVENTS

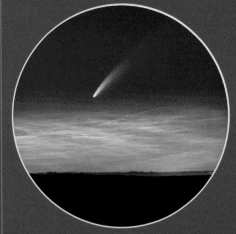

Bright comets
(Comet NEOWISE; July 2020)

Lunar eclipses
(near Messier 35; December 20, 2010)

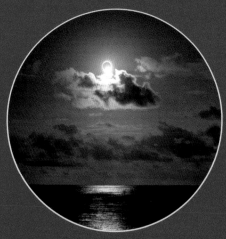

Solar eclipses
(total eclipse of July 21, 2009)

DEEP SKY OBJECTS

Milky Way star fields (such as the
Lagoon and Trifid Nebulas)

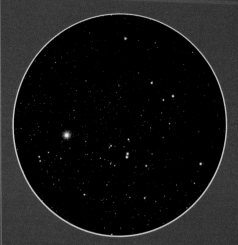

Bright star clusters
(such as the Hyades)

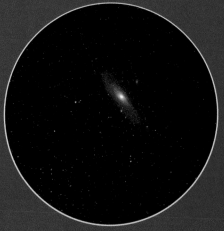

Andromeda Galaxy,
Messier 31

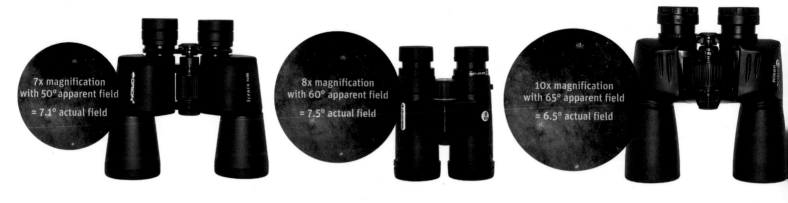

7x magnification
with 50° apparent field
= 7.1° actual field

8x magnification
with 60° apparent field
= 7.5° actual field

10x magnification
with 65° apparent field
= 6.5° actual field

COMPARING FIELDS OF VIEW

From left to right:

A simulation of what a 7x50 binocular with a 50° apparent field will show: 7.1° of sky within a small circle of light. An 8x42 with a 60° field provides a wider circle of light and a wider 7.5° actual field. A 10x50 (or 10x42) with a 65° apparent field presents a slightly wider circle, but due to its higher power, it shows less actual sky (6.5°).

CALCULATING FOV

Actual fields of view (FOV) are sometimes expressed in feet or meters at 1,000 yards or meters.

◆ Convert feet @ 1,000 yards into actual FOV in degrees by dividing by 52.5.

◆ Convert meters @ 1,000 meters into actual FOV in degrees by dividing by 17.5.

binoculars from makers such as Steiner, which dominates the marine market, where a 7x50 Porro is preferred for use in twilight on a rolling ship. For astronomy, either a 7x50 or 10x50 Porro can provide excellent performance at low cost.

Roof prism binoculars are far more popular because they are more compact. But they are more expensive than Porro prism models, often starting in price where Porros leave off. In theory, Porro prisms have higher light transmission, but the excellent coatings and optics in most roof prism binoculars make any difference in image brightness slight.

Exit Pupil vs. Age

For the brightest images at night, many references state that the light cone exiting the binocular eyepieces—called the exit pupil—should be the same size as that of the dilated and dark-adapted pupil of the eye, which is 7mm in young people.

How do you calculate the exit pupil? Simple. Just divide the aperture in millimeters by the magnification. For example, 7x50 glasses have 7.1mm (50 ÷ 7) exit pupils; thus the long-standing preference by mariners and stargazers for 7x50 binoculars.

After age 30, however, we generally lose one millimeter every 20 years or so as our eye muscles become less flexible. So applying the 7mm rule to all observers ignores age variations. Furthermore, the outer edges of the lens of everybody's eyes have some inherent optical aberrations.

For these reasons, borne out by our testing, the glasses that we have found reveal the most detail on all kinds of celestial objects have exit pupils in the 4mm to 5mm range. That would include 10x42s and 10x50s.

Power vs. Steadiness

Most people find that 10x is the limit for comfortably holding binoculars, because every quiver of the arms is also magnified by 10. A steadier view can be had with 7x or 8x glasses. In addition, the bigger exit beams from a 7x50 or 8x42 make it easier to position your eyes at the eyepieces. If your head or hands shake, stay with a 7x or 8x model.

Eye Relief

Binocular users who must wear eyeglasses for correction of astigmatism or who prefer to keep their glasses on while observing will benefit from binoculars with long eye relief; typically, at least 15mm for eyeglass use, if not 18mm to 20mm. Years ago, you had to seek out and pay a premium price for so-called high-eyepoint models.

Not so today. With one or two exceptions, all the binoculars we tested for this edition, including the lowest-cost models, had excellent eye relief. Even if you don't wear eyeglasses, long eye relief makes it more comfortable to look through the binoculars. Your eyes are not jammed against the eyepiece lens but can rest on the soft upraised eyecups.

Apparent and Actual Field of View

The diameter of the circle of light that can be seen through binoculars is called the *apparent field of view* (FOV), measured in degrees (°). The apparent FOV depends on the eyepiece design and has nothing to do with the diameter of the main lenses. The wider that circle of light, the more impressive and panoramic the view. The trade-off is that in wide fields, stars toward the edge of the field can look distorted and fuzzy.

Even many entry-level binoculars now

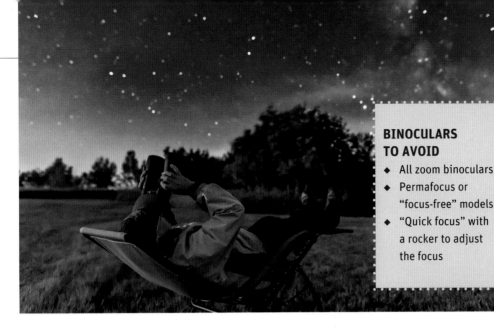

HOLDING STEADY

The best accessory for binoculars is a "zero-gravity" lounge chair that allows you to tilt back and scan around freely.

have wide apparent FOVs of 60° to 65°. What distinguishes the better models is that the stars are sharper across a greater proportion of the field. While binoculars with standard 45° to 50° FOVs can be quite sharp to the edges, they produce a tunnel-like viewing experience.

The apparent FOV is not always stated. What is given is the *actual* FOV, meaning how much of the sky, also in degrees, the binoculars show. That number depends on both the apparent field of the eyepieces and the power. The formula is: Actual FOV = Apparent FOV ÷ Power.

So a 10x binocular with a 65° *apparent* FOV shows 6.5° (65° ÷ 10) of actual sky. A binocular that shows 7° of sky does include slightly more sky. But if it has a power of only 7, then its apparent FOV is a narrow 49° (7° x 7), typical of 7x50 binoculars, even in the few premium models that are still being made.

Aperture vs. Weight

While binoculars with bigger-aperture lenses gather more light and present brighter images, they also weigh more, making them harder to hold up to the sky for any length of time. For this reason, we excluded rugged marine binoculars for being too heavy.

In our survey, the binoculars with 42mm lenses weigh in at only about 25 ounces (700 grams), one of their great benefits. The 50mm

models are in the next weight class, between 30 and 35 ounces (850 to 1,000 grams). The larger 56mm binoculars are a touch heavier, at 37 ounces (1,050 grams). Most people can hold this weight long enough for a satisfying look before having to rest their arms.

Mechanical Features

Better binoculars are weather-sealed and filled with dry nitrogen or argon, to keep out dust and moisture. The prisms in low-cost Porro binos are merely glued in place, which is not as durable as prisms held in metal cages, as in most roof prism models. All roof prism binoculars have precise internal focusing; Porro prisms use an external mechanism that is prone to flexure between the two sides. Roll-up eyecups on low-cost binoculars can eventually degrade and split. Eyecups that twist up and down are more durable and convenient and are now common.

Price vs. Performance

Acceptable-quality binoculars, all Porros, can be purchased for about $100. A jump up to a $400 roof prism gets you a noticeably better binocular in all respects. Pay four times more yet again for a top $1,600 model, and the improvements are much more subtle. Avid birders whose main optics are binoculars and perhaps a spotting scope are happy to pay top dollar for optics they will use for a lifetime.

But we astronomers also have telescopes to buy! So our binocular budget is likely to be more modest, thus the restriction of our market survey to models under $500, with a couple of notable exceptions.

COMPARING COATINGS

Better binoculars (top) are multicoated on all optical surfaces for the greatest light transmission and contrast. The glass looks dark, with deeply colored reflections. Glasses with poor coatings (revealed by the white reflections, bottom) provide dimmer views, with ghost images or lens flares when looking at the Moon.

GETTING FOCUSED

All binoculars have a fine diopter adjustment on one eyepiece to accommodate focus differences between the left and right eyes. For the sharpest views, cover the *right* lens and adjust the main focus wheel so that the *left* image looks sharp. Now reverse the process. Cover the *left* lens, and use the diopter adjustment to make the *right* image look sharp. Note that setting, and don't touch it. Focus by using just the center focus wheel.

OUR BINOCULAR BUYER'S GUIDE

7x50 PORRO PRISM MODELS

We begin our survey with the most affordable models. All prices are approximate U.S. "street prices" as of 2020, not suggested retail prices.

ENTRY-LEVEL PORROS

Older guidebooks debated between 7x50 and 10x50 binoculars. These days, the choice of 7x50s is relegated to those who wish to spend the least, perhaps buying the binos for a young astronomer. With the exception of costly marine binoculars, the few 7x50s left (all using Porro prisms) are entry-level, with narrow 45° to 50° apparent fields. The models here all have 18mm of eye relief.

The **Celestron Cometron** suffers from a dim, vignetted field because of its low-cost BK7 prisms, rather than the better BaK4 prisms, and from its basic coatings. Stars are sharp only in the central 50 percent of the narrow 48° field. But it's only $40!

With its eyecups rolled down, eye relief in the **Orion Scenix** ($100) is just enough for use with eyeglasses. Edge-of-field

LOW-COST 7x50 PORRO PRISMS
From left to right: Celestron Cometron; Orion Scenix; Nikon Aculon A211.

sharpness isn't as good as in the Nikon Aculon A211, but the Scenix has a wider 50° apparent field, yielding an actual field of 7.1°, typical of 7x50s.

The **Nikon Aculon A211** ($110) features twist-up eyecups far better than the roll-ups of the Cometron and Scenix. The Aculon's edge-of-field is brighter and more cleanly defined than in the Scenix but is a tunnel-like 45°, the smallest of any unit tested. At 32 ounces (920 grams), it is also the heaviest of the 7x50 trio.

TESTING TIPS IN THE SHOP AND AT HOME

☑ **Weight and Focusing:** Will they be too heavy to hold? Can you reach the focus knob easily? Does the focuser feel mushy and greasy?

☑ **Focus Stability (Porro):** Does the bridge connecting the eyepieces seesaw up and down easily? If so, the eyepieces will not maintain the same focus.

☑ **Prisms:** When held up to the light, eyepieces with a squared-off image (shown here) have inferior, dimmer BK7 prisms.

☑ **Sharpness:** The center should be pin-sharp. If the image gets fuzzy less than 50 percent from the center to the edge, pick another model.

☑ **False Color:** On dark tree branches against a bright sky, look for a blue or green color fringe, called a chromatic aberration. In better binoculars, this is minimal.

☑ **Collimation:** If, after a few minutes, you feel eyestrain and have to force the images to merge, the two halves of the binoculars are out of collimation. Reject them.

☑ **Star Testing (On-Axis):** A bright star should appear nearly pointlike, with small, irregular spikes. The fewer spikes, the better; but they must be symmetric. If you see asymmetric flaring even with your eyeglasses on, the binoculars are at fault.

☑ **Star Testing (Off-Axis):** Move the bright star toward the edge of the field of view. It will begin to grow wings, indicating astigmatism, which is always present to some degree. However, the better the binocular, the lower this off-axis aberration.

42MM ROOF PRISM MODELS

If you are looking for a binocular that can serve both astronomy and daytime uses, consider a 42mm roof prism. In testing, there was nothing we could see in a 50mm binocular that didn't show in a 42mm, with the benefit of a lighter 25-ounce (700 gram) weight. All these models have at least 15mm to 17mm of eye relief. An 8x42 gives a steadier image and wider actual field, but a 10x42 can resolve small objects better when held firmly.

8x42 ROOFS

Wisconsin-based Vortex Optics is well known to hunters and birders. The **Vortex Crossfire HD** ($140) is its entry-level series. The 62° apparent field is slightly wider than the 60° Nature DX ED, but both are similar for good edge-of-field sharpness.

Celestron's Nature DX ED ($160) features an extra-low dispersion (ED) lens for reducing false-color fringing around bright targets. At 8x, however, we saw little difference in color between the Nature DX ED and the non-ED Crossfire. Both were excellent and very sharp.

Hawke, a U.K. company, is another name not known to most astronomers. But the **Hawke Frontier ED X** ($450) is a top-class glass, with phase-corrected and dielectric coatings on the prisms for the sharpest and brightest images. Stars are sharp across 80 percent of the 65° field.

Zeiss is a name astronomers do know, yet few can afford. But its made-in-China **Zeiss Terra ED** 8x42 ($450) offers 20mm of eye relief and tack-sharp images across 80 percent of the 60° field. The Terras look and feel high-class, but without the high price.

10x42 ROOFS

Meade's Rainforest Pro series is a terrific value. The 10x42 ($160) has a 62° apparent field that's sharp over the central 60 percent and with little false color, despite not having ED glass.

Oregon-based Leupold offers its **Leupold BX-2 Alpine** ($250), a non-ED glass with a 62° field sharp over 70 percent and magnesium construction for a light 24 ounces (685 grams).

Vanguard is a name known to birders. Made in Myanmar with Japanese optics, the **Vanguard Endeavor ED II** ($400) uses an open-bridge design, which makes them easy to grip. Images are sharp across 75 percent of the generous 65° field. At 27 ounces (775 grams), this is the heaviest of the 42s but is the only model tested with a lockable diopter setting, shown on page 103.

The **Nikon Monarch 7** ($500) is a cut above the $300 Monarch 5 10x42. While both have brighter dielectric coatings on the reflective prism surfaces, the Monarch 7 adds ED glass. Stars are pinpoint over 80 percent of the 67° field. These are solidly built binoculars, with a silky smooth focus.

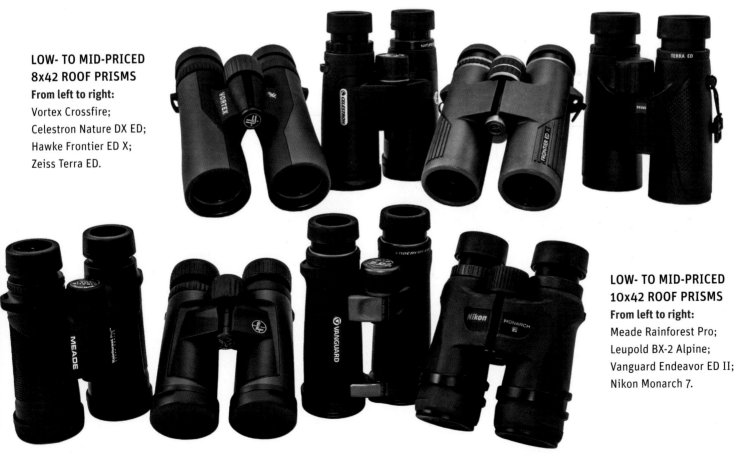

LOW- TO MID-PRICED 8x42 ROOF PRISMS
From left to right:
Vortex Crossfire;
Celestron Nature DX ED;
Hawke Frontier ED X;
Zeiss Terra ED.

LOW- TO MID-PRICED 10x42 ROOF PRISMS
From left to right:
Meade Rainforest Pro;
Leupold BX-2 Alpine;
Vanguard Endeavor ED II;
Nikon Monarch 7.

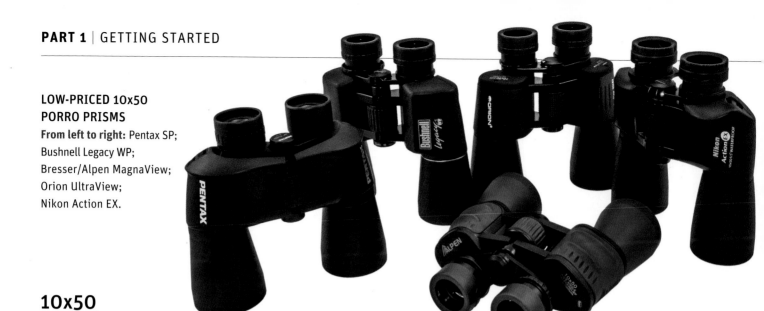

LOW-PRICED 10x50 PORRO PRISMS
From left to right: Pentax SP; Bushnell Legacy WP; Bresser/Alpen MagnaView; Orion UltraView; Nikon Action EX.

10x50 PORRO PRISM MODELS

The 50mm aperture gathers 40 percent more light than a 42mm, and the 5mm exit pupil of a 10x50 is a good match for the eyes of older stargazers. These Porro prism models all have apparent fields of 63° to 65°. With 10 power, they therefore show 6.3° to 6.5° of actual sky, only a little less than the 7x50 Porros but with a more panoramic view and the benefit of the extra resolution. The higher power also darkens the sky background, revealing fainter stars. In all, we feel a 10x50 Porro offers the best combination of pleasing performance versus affordable price.

ALL FOR UNDER $200

The **Pentax SP** ($80) has a wide 65° field, but the shallow eye-cups don't roll down easily, making it difficult to see the entire field when wearing eyeglasses. But the short 12mm eye relief is sufficient for good views without glasses, and they are economical. The waterproof (WP) version is $190 and has only a 50° field.

Of Bushnell's many binoculars, the **Bushnell Legacy WP** 10x50 ($110) stands out for astronomy. The eyecups twist up and down, and the eye relief is excellent. Stars are sharp in the central 50 percent of the 63° field. We'd recommend the Legacy over any of the budget 7x50s.

The **Bresser/Alpen MagnaView** ($120), sold in the United States through Explore Scientific, is the lightest of the 10x50 Porros, at 29 ounces (836 grams). It has great ergonomics, with molded thumb and finger rests, 17mm eye relief, twist-up eye-cups and a 65° field, with stars sharp over the central 50 percent. The MagnaViews are a good, affordable choice.

The **Orion UltraView** 10x50 ($140) has a similar field of view as the Legacy, but with stars sharper over 60 percent of the field. Excellent coatings suppress ghost images from internal reflections when looking at the Moon.

The **Nikon Action EX** ($180) is a waterproof version of Nikon's Aculon series, with longer eye relief. While the EX's apparent field is similar to the UltraView's, stars are sharp over 70 percent of the field, the best of the 10x50 Porros tested. Overall, the UltraView and Action EX are a close tie and worth the extra cost for an astronomy binocular that can serve you for years.

Note: In the U.K., the Opticron and Helios brands are popular, but their binoculars are not widely available in North America. Also, Celestron introduced its new Ultima line of Porro prism binoculars in early 2021, with the 10x50 (not shown) retailing for $140. In our tests, we found it a fine, affordable binocular.

CANON IMAGE-STABILIZED BINOCULARS

If it's a premium binocular you're after, you *must* test a Canon image-stabilized (IS) model. Press a button, and the IS optics magically dampen out all the hand-held vibrations. Many favor Canon's 10x42 L IS WP ($1,500) as the best for astronomy, but at 36 ounces (1,040 grams), it's hefty for a 42mm. The 12x36 ($800), at right, weighs 25 ounces (700 grams) and is great for eclipse trips. But the benefit of IS really shows itself with the original 15x45, at far right, and the current 15x50 and 18x50 models ($1,300 to $1,500), which offer magnifications that are impractical in non-IS binoculars. The optics are razor-sharp, and the apparent fields are an impressive 66° to 68°. At 41 ounces (1,180 grams), they are moderately heavy to hand-hold. Even so, we both love our Canon IS binoculars.

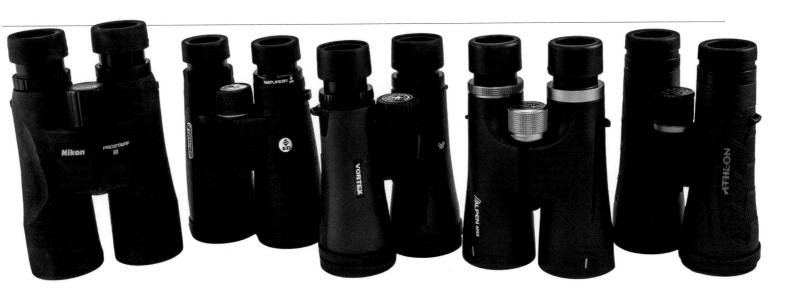

10x50 ROOF PRISM MODELS

Roof prism 10x50s, though more expensive, offer optics that are just that much sharper. Stars appear more like points, lacking the spikiness from residual aberrations in lesser optics. Internal focusing is smooth and precise, with the central wheel easier to reach with gloves on. As you go up the price range, the field of view widens, as does sharpness across the field.

For the very best 50mm-class binocular, check out the Kite Lynx HD+, Leica Ultravid HD, Swarovski EL, Vortex Razor HD or Zeiss Conquest HD. If money is no object, Nikon makes its 10x50 WX binoculars just for astronomy, with special Abbe-Koenig prisms and a 76° apparent field sharp to the edge. Image quality is astonishing, but so is the price: $6,400!

In the less stratospheric price range, we can recommend these 10x50s from firsthand use. **Note:** While companies revise their lines every two or three years, our survey should get you started in picking a brand and model that's best for you.

LOW- TO MID-PRICED 10x50 ROOF PRISMS
From left to right: Nikon Prostaff 5; Celestron Nature DX ED; Vortex Diamondback HD; Bresser/Alpen Apex; Athlon Midas G2 UHD.

ALL FOR $200 TO $500

The **Nikon Prostaff 5** ($200) is from Nikon's entry-level roof prism line. The body is durable polycarbonate, making it the lightest of all the 10x50s we tested, at 29 ounces (830 grams). Without ED glass, some color fringing is apparent, but stars are sharp in the central 60 percent. Eye relief is a superb 20mm. However, the eyecups collapse too easily when pressed.

The 10x50 version of **Celestron's Nature DX ED** ($220) has a similar 56° field as the Prostaff 5 but with less false color and with stars sharp in the central 70 percent of the field. We're impressed with the Nature EDs as a great value in roof prism binoculars.

The **Vortex Diamondback HD** ($250) is a step up from the Crossfires. Stars are sharp across 70 percent of the 65° apparent field. These binoculars are not ED, but false color is minimal. The smooth focusing mechanism snaps into precise focus. For Vortex, the next 10x50 in line is from its Viper HD series with low-dispersion glass ($550).

New in 2020, the **Bresser/Alpen Apex** ($370) has phase-corrected coatings but not ED glass, so it did show some false color on either side of focus on Venus. Images are very sharp; the phase of Venus was crisp. Stars remain pinpoint across 70 percent of the 65° field.

The second-generation **Athlon Midas G2 UHD** ($400), also new in 2020, offers better coatings to protect the outer lens surfaces. The 66° field is sharp across 80 percent. Constructed of a magnesium alloy, these binoculars are argon-filled and waterproof. The objectives are ED, and the prisms have dielectric coatings for maximum light transmission. They proved to be our favorite 10x50.

56MM MODELS

Binoculars with 56mm lenses are about the limit for handhold-ability. Even so, stay with 8x or 10x. The 12x to 18x models with 50mm and 56mm lenses are popular with hunters and touted as great for astronomy, but in practice, they really aren't, certainly not when hand-held.

Years ago, for his adult astronomy classes, author Dickinson selected the **Celestron SkyMaster DX** 8x56 Porro prism binoculars ($220) for his students. Still being made, the SkyMasters have a long 20mm eye relief and sharp star images clean to the edge. The downside is their narrow 46° apparent field, for a 5.7° actual field.

For about $220, Celestron also offers its **Nature DX** 10x56 roof prism binoculars with a wider 60° field and phase-corrected coatings. Without ED glass, some false color is apparent. Stars also get quite soft in the outer 40 percent of the field, but eye relief is 18mm.

CELESTRON 56MM BINOS
Assuming good coatings, binoculars with 56mm lenses can collect 25 percent more light than a 50mm. The SkyMaster DX 8x56 Porro (left) also provides a full 7mm exit pupil for the brightest field. But the Nature DX 10x56 has a wider apparent (60°) and actual (6°) field of view, despite its higher power.

BINOCULARS BIG AND SMALL

Binocular fans may wish to diversify their two-eyed tours of the sky by using one of these specialty models.

CONSTELLATION BINOCULARS

Rather than offering more power and aperture, these binoculars do the opposite, providing what can best be described as an enhanced naked-eye view. The power is low, and the actual field of view is wide enough, at 18° to 25°, to take in an entire constellation.

As with similar binoculars by Kasai, Orion and Vixen, the **Omegon** 2.1x42 ($180) uses no prisms but employs a variation of Galilean optics that are, let's say, "quirky" to look through.

HOW LOW CAN YOU GO?
The primary purpose of the Omegon (left) and the Orion Super-Wide (right) is to forgo magnification to provide as wide a field as possible, while showing stars at least a magnitude fainter than can be seen with the naked eye.

There is no well-defined field edge; you can move your eyes and head around to see more beyond the central area. In the Galilean design, the field of view *is* governed by the size of the front lenses. But with an exit pupil of nearly 21mm, you aren't getting 42mm of light-gathering power; more like just 10mm to 12mm. Rather, it's sheer field of view you're after.

Orion's **Super-Wide-Angle** 4x21 ($80) is a more conventional Porro prism binocular that is easier to look through and offers a cleanly defined 18° actual field, enough to take in most constellations in one big gulp. It's all plastic, but cheap, unique and fun to use.

BIG BINOCULARS

These binoculars represent the other extreme of size and power. Most backyard astronomers eventually acquire a 70mm or an 80mm binocular, with a power of 11x to 20x. While the views through big binoculars are wonderful, hand-held convenience is lost. To keep them steady, big binos must be mounted on a tripod, ideally with a smooth panning head made for cine use.

The 15x70 **Celestron SkyMasters** weigh 48 ounces (1,380 grams) and, at $90, are a terrific buy. The **SkyMaster Pros** ($200), weighing 58 ounces (1,670 grams), feature better optics and construction, though the focusing mechanism becomes tough to turn in winter, as the grease freezes.

With straight-through eyepieces, however, looking at any object above a 45° altitude is a neck-craning exercise, even if the binocular is on a special parallelogram mount, such as Orion's Paragon-Plus or Starlight Innovation's Para-Light.

PREMIUM 56s

Hunters, not astronomers, are the market for low-light 56mm binoculars. Indeed, Steiner in Germany has the 8x56 **Nighthunter** ($1,000), a rare premium Porro. Top-class roof prism 56s are available from Blaser and German Precision Optics. Swarovski offers the SLC; Vortex has the Razor UHD; and Zeiss makes the Victory HT (all $1,500 to $3,000). These binoculars employ Abbe-Koenig prisms, named for the Zeiss opticians who invented this roof prism design, which was patented in 1905. Costly Abbe-Koenig prisms are longer, heavier and more difficult to manufacture than Schmidt-Pechan prisms, but they transmit 5 to 10 percent more light.

If that sounds intriguing, check out Maven (mavenbuilt.com), a small company based in Wyoming. It sells its high-end optics only factory-direct, reducing markups. Its B.2, B.4 and B.5 binoculars have wide 65° to 67° apparent fields and use Abbe-Koenig prisms, ED or fluorite glass and four-element objectives. The optics are from Japan, but the binoculars are assembled in California. They tick all the boxes yet sell for one-half to one-third of the competition.

At 51 ounces (1,440 grams), the **Maven B.4 10x56** ($1,100) is certainly hefty, but the mass does dampen out fine jittery vibrations. And one glance shows how sharp it is, almost right to the edge of the 67° field. Author Dyer tried a demo model and was so impressed he bought it.

MAVEN 10x56

The Maven B.4 is shown here in its standard gray and orange livery. But for an extra charge, you can order your Maven as a bespoke binocular with custom body armor and trim colors, as well as personalized engraving.

Orion Telescopes, Oberwerk, Explore Scientific and Vixen sell big binoculars ($1,300 to $5,000) with 45° or 90° angled and interchangeable eyepieces that are more practical to look through when aimed up high. With 70mm to 125mm apertures, they are effectively twin telescopes and must be placed on a very heavy-duty tripod and panning head, like the Orion U-Mount. This is a serious investment, not only in dollars but in the effort required to set up each night. Yet the reward is unique, almost 3D views.

BIG GLASS

Below: When tripod-mounted, a 70mm binocular, such as Celestron's 15x SkyMaster Pro, can provide excellent views of Milky Way star fields, the Andromeda Galaxy, bright comets and much more. Even the Moon is superb, looking three-dimensional. The red-dot finder mounted on top aids in centering targets in the 4.3° field.

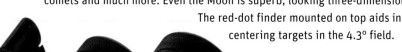

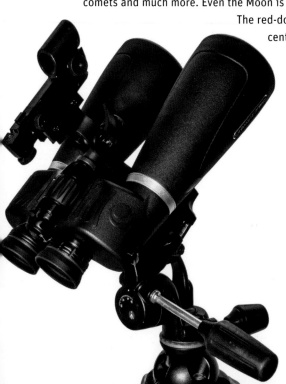

TAKING A STAND

Right: Counterweighted parallelogram mounts (such as the wood Para-Light and matching tripod by the Canadian company Starlight Innovation) cantilever the binoculars away from the tripod so that you can get underneath them to look up more easily. As you raise the binoculars up and down in height, as shown here, they stay aimed at the same object, handy for public viewing by kids and adults. While fun to use, parallelogram mounts can be as much work to set up as a telescope and require as much space to store and transport.

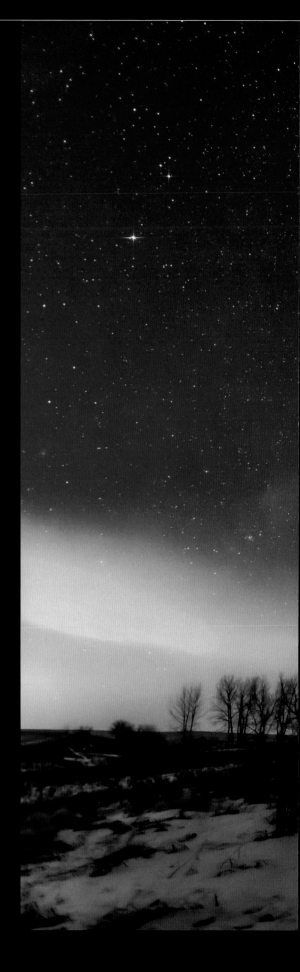

CHAPTER 6

Binocular Sky Tours

Following our advice to learn the sky first using binoculars *before* you invest in a telescope, we conclude our "Getting Started" section with tours of our picks for the top 10 targets for binoculars.

Here, and later in Chapter 13 ("Moon Tours for Telescopes") and Chapter 16 ("Telescope Sky Tours"), we're delighted that our colleague and sky-tour master Ken Hewitt-White agreed to serve as our guide to his favorite destinations in the night sky.

We'll let Ken explain why he's picked the objects he has, but suffice to say that all are relatively easy to find and are rewarding sights for any binoculars, with many suitable for suburban skies. Tracking down this "starter set" of objects will hone your star-hopping and observing skills, which will serve you well once you get a telescope. And you'll learn to identify constellations in the process, all by spending very little money—just time! But there is no time better spent than under the stars.

We begin our binocular tours with the northern winter sky and one of the most popular objects for binoculars and telescopes, the Orion Nebula (M42), visible even from suburban sites. But a rural site, as here, will always enhance any sky touring.

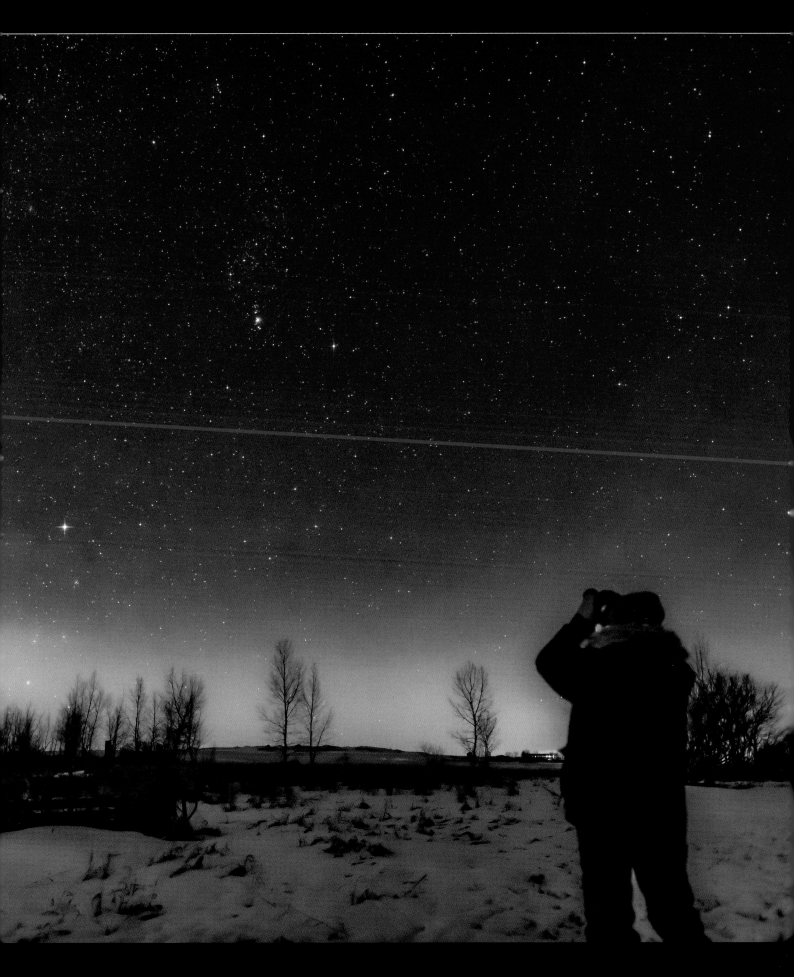

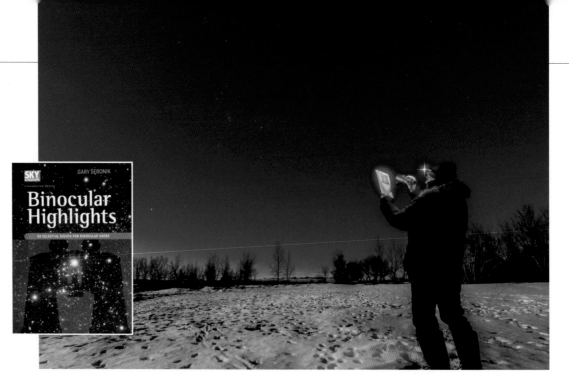

OUR SAMPLE BINOCULAR TOURS
BY KEN HEWITT-WHITE

Welcome to our binocular sky tours, a feature created especially for this edition of *The Backyard Astronomer's Guide*. I've designed these exercises in casual skywatching (with more to come in Chapter 16 for telescopes) to help novice observers apply the star-hop method we introduced in Chapter 4 to some actual stargazing.

You'll learn to navigate the heavens before splurging on a telescope. I say this as a lifelong observer who remembers being a young astronomy buff with a boundless interest in space—but no telescope. While I saved the profits from my newspaper route to purchase an "expensive" 60mm refractor, I used my dad's 7x35 binoculars to teach myself how to locate all sorts of sky objects. My savings plan took a full year, but after four seasons of 7-power probing, I was ready for that scope —and Dad let me keep the binoculars!

GETTING FOCUSED

I'm often asked what I think are the best binoculars for skywatching. My answer is that almost any are better than none. The previous chapter provided lots of choices for anyone buying a pair of binoculars, but my personal favorite is a 10x50. In my experience, 10 power is sufficient to pull in a large selection of celestial objects, and the 50mm aperture ensures a reasonably bright view.

Another factor is weight. My Nikon Aculon 10x50s (the inexpensive Porro prism model I used to compile these tours) aren't too heavy to hold. Moreover, they boast a 6.5-degree-wide field of view, which is generous for 10-power binoculars.

The most serious downside to all but the most expensive binoculars is that stars look distorted near the edge of the field. The distortion isn't always noticeable when viewing terrestrial objects, but stars have a way of exposing the "soft" side of any optical system. For night work, I keep my chosen object close to the middle of the binocular field. And when I focus my Nikons at the beginning of an observing session, I start by placing a bright star in the center of the field of view. After that, it's a two-step process.

First, with the right lens covered, I look through the left eyepiece and turn the central focus wheel to make the star as sharp as possible. Because the focus can be slightly different for each eye, I then cap the left lens and check the focus in the right eyepiece. The right eyepiece usually has an independent diopter adjustment that you only have to set once. I adjust the diopter until the star is now

pinpoint-sharp for my right eye. Then, with the eyepieces spread far enough apart (but not too far!) so that both eyes can see the entire field, I'm ready for stargazing.

TRIPOD TIPS

Well, not *quite* ready. For sweeps of the night sky or quick peeks at bright objects, hand-holding the glasses works fine. But if I'm going to concentrate on a small area of sky or a specific object, I prefer to mount my binoculars on a sturdy tripod. I use an L-shaped binocular tripod adapter, similar to those we show at right. With my binoculars on a tripod, I enjoy rock-steady stargazing.

Tripod-mounted binoculars work most easily on objects 20 to 30 degrees above the horizon. (Bear in mind that faint objects are hard to detect if they're not well above the horizon haze.) I like to sit in a small chair to ensure comfortable viewing. I extend the tripod legs to an appropriate height, keep one of the legs pointed away from me and pull the other two spread-apart legs over my chair, with the 10x50s at eye level.

For higher objects, I extend the tripod legs and center post to their maximum height, lean back in my chair, grab those two nearest tripod legs and carefully tip the whole works toward me until the binoculars are tilted steeply enough. My binocular-balancing act is steadier than holding the glasses by hand, and it allows me to aim as high as I like—almost. The straight-up zenith region remains out-of-bounds. I get a painful reminder from my neck every time I forget this rule!

DESIGNING THE TOURS

The destinations for our binocular tours are what we call "deep sky objects"—those which lie beyond the solar system. These objects are dozens or hundreds of light-years away in our Milky Way Galaxy. I've even included a few other galaxies that are *millions* of light-years distant *beyond* the Milky Way. Yes, it is amazing what humble binoculars can show.

If you are unsure what these kinds of objects are, please refer to Chapter 15, which contains much more about the nature of deep sky objects and the distances involved. But diving deeply into the science now isn't

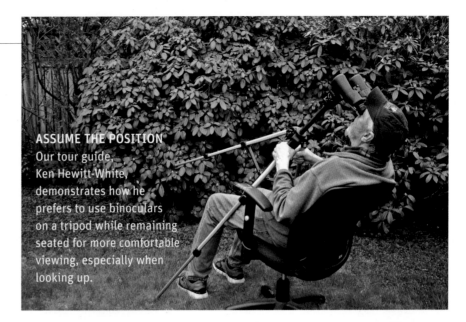

ASSUME THE POSITION
Our tour guide, Ken Hewitt-White, demonstrates how he prefers to use binoculars on a tripod while remaining seated for more comfortable viewing, especially when looking up.

necessary to get started enjoying the views binoculars can reveal.

I've organized the tours into winter, spring, summer and autumn sets, one pair per northern season, plus a pair for the southern sky contributed by globe-trotting author Dyer.

In designing these tours, I wanted to highlight top-tier objects from many categories: double stars, open star clusters, globular star clusters, bright nebulas and distant galaxies. I hope this selection of more than two dozen objects over 10 tours will give you a sampling of what the binocular sky can offer and a taste of backyard observing that will make you salivate for more.

Finally, a comment about city versus country stargazing: It's no contest! A truly dark starscape beats light-polluted city skies every time. Whenever you can, especially during the summer months, get out of town—and take your binoculars with you. The tour targets will certainly look better amid pollution-free conditions, even on moonlit nights.

Having said that, it's still worth getting outside whenever we're presented with a clear night over our balconies, patios and suburban yards. There's lots to see in a city sky, even with ordinary binoculars. Now, on with the tours!

TRIPOD MOUNTS

Most binoculars have a central threaded ¼-20 hole to accept a tripod mounting bracket, which has a base with a ¼-20 hole that can screw onto any tripod head. Some roof prism binoculars (such as the Vortex 10x50s at center) require a special thin bracket to fit between their closely set barrels.

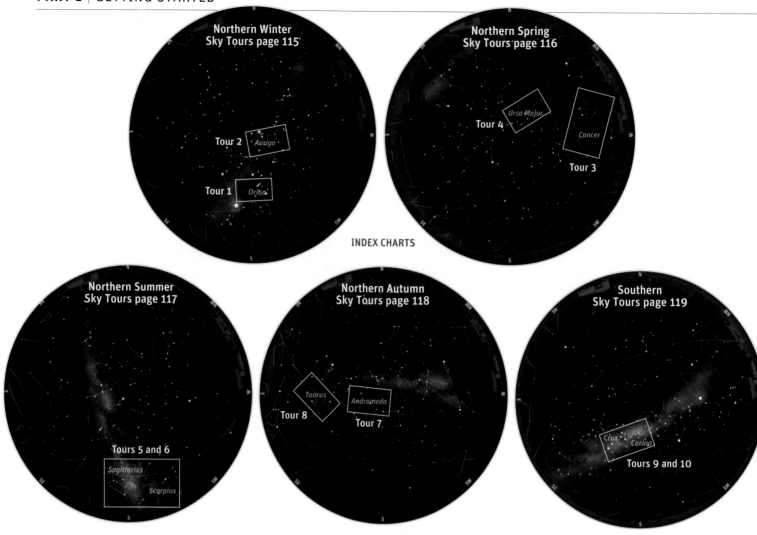

Northern Winter
Sky Tours page 115

Tour 2 *Auriga*

Tour 1 *Orion*

Northern Spring
Sky Tours page 116

Ursa Major
Tour 4

Cancer

Tour 3

INDEX CHARTS

Northern Summer
Sky Tours page 117

Tours 5 and 6

Sagittarius

Scorpius

Northern Autumn
Sky Tours page 118

Taurus

Andromeda

Tour 8

Tour 7

Southern
Sky Tours page 119

Crux *Carina*

Tours 9 and 10

WHERE WE ARE GOING

**A TYPICAL
BINOCULAR VIEW**

Right: In these tours, we present a number of images that simulate the appearance of key objects in binoculars. As with telescope views, don't expect to see vivid colors in nebulas and galaxies. However, bright stars can and do appear with noticeable color contrasts, as in this view of the area around the red-giant star Antares, in Scorpius.

Each of our 10 binocular tours involves mostly short star-hops: We begin with stars visible to the naked eye, progress to stars easily visible in binoculars and end at the chosen sky target(s). On many tours, we encounter more than one object along the way.

Each tour's chart covers an area of sky 20 to 30 degrees wide, about three to five binocular fields. A typical binocular field is five to seven degrees wide; the distance between the "Pointer" stars of the Big Dipper's bowl is about 5.5 degrees, as we illustrated in Chapter 4.

You can locate each tour's area via one of

**Typical 6.5°
binocular view**

the index charts above, versions of the star maps presented at the start of Chapter 4. To find the tour area, it's helpful to use those seasonal charts first to pick out the bright stars and major constellations (or use an aid such as a planisphere or a mobile app).

On our finder charts, "M" objects are from Charles Messier's 18th-century catalog of bright objects that serve as a popular "hit list" for beginners. NGC objects are from the 19th-century New General Catalogue. Most stars are indicated by their Greek letter, such as Alpha (α), Beta (β), etc. For more on celestial names and catalogs, see Chapter 15.

NORTHERN WINTER SKY

TOUR 1 ORION'S GLEAMING SWORD

Emblazoned with brilliant **Rigel** and Betelgeuse, the constellation **Orion** the hunter is the most recognizable winter pattern. Just south of Orion's tri-star belt is his fainter but more fascinating sword—a two-degree-long row of celestial glitter worth exploring, top to bottom. At the north end of the sword is **NGC 1981**, a star cluster whose seven brightest stars form a rough letter W. Below it is a smaller clump called **NGC 1977**. Farther down is the Orion Nebula, or Messier 42 (**M42**), a cauldron of hydrogen gas incubating newborn suns. Steadily held binoculars reveal three stars (more, for the eagle-eyed) within this misty stellar nursery. The brightest point on the sword is 2.8-magnitude **Iota** (ι) **Orionis**, at the south end. Near Iota is a fifth-magnitude double star, **Σ747**, which my tripod-mounted 10x50s resolve into a pair of pinpoints. All this in one binocular view!

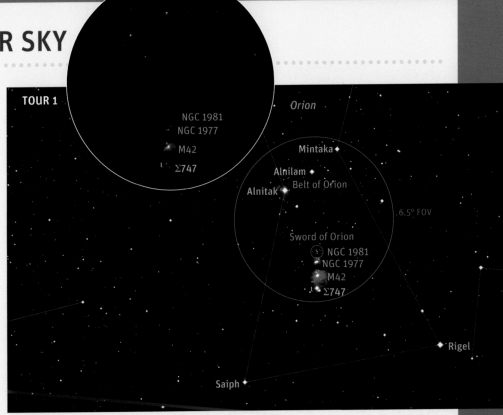

TOUR 2 COMPARING CLUSTERS

Far above Orion, the constellation **Auriga** the charioteer harbors three celebrated star clusters. The trio forms a slightly bent line, nearly six degrees long, in the winter Milky Way, which splashes across Auriga's pentagon-shaped star pattern, dominated by zero-magnitude **Capella**. Although the clusters are all the same type of object—open star clusters—they definitely aren't identical in appearance. Each exhibits its own shape, size and brightness, and I enjoy comparing them. The easiest (because it's compact) is Messier 36 (**M36**), located on the eastern side of the pentagon. Its fainter cousin, **M37**, lies just outside the pentagon's eastern border. The third cluster, **M38**, is a diffuse glow deep inside the pentagon. Whenever I have difficulty sighting M38, I let a nearby asterism, a group of stars dubbed the **Little Fish**, point the way. I can usually spot all three clusters from my suburban yard using 7-power binoculars, though 10x50s are better—especially for M38.

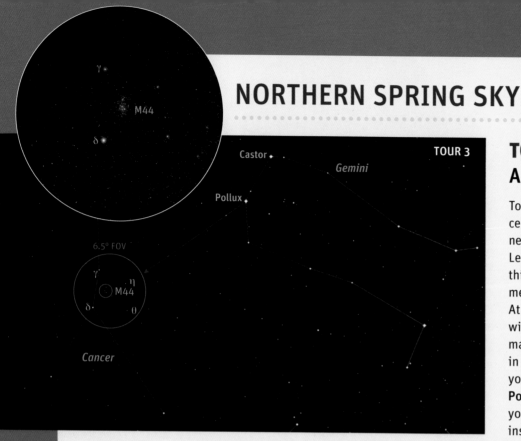

TOUR 3
A HIVE OF STARS

To suburban skywatchers, the stretch of celestial real estate between the prominent zodiacal constellations **Gemini** and Leo seems almost devoid of stars. Yet this barren area officially houses another member of the zodiac: **Cancer** the crab. At its center is a roughly three-degree-wide quadrilateral of fourth- and fifth-magnitude stars that's barely noticeable in a light-polluted city sky. But if you aim your binoculars two-fifths of the way from **Pollux**, in Gemini, to Regulus, in Leo, you'll see the little squashed square and, inside it, the impressive Beehive Cluster (**M44**). About two full Moons in diameter, the sprawling Beehive buzzes with several dozen stars, 10 of which shine between sixth and seventh magnitude. Those leaders combine with several other cluster members to form eye-catching pairs and triangles in my tripod-mounted 10x50s. Observing M44 carefully on a moonless night, I count up to three dozen "bees." How many can you see?

TOUR 4 HOP OVER TO THE BEAR PAIR

Gazing straight up on spring evenings, you can't miss the iconic pattern of the **Big Dipper**. Its seven stars are part of the huge constellation **Ursa Major** the great bear. North of the bear's head are two of the sky's grandest galaxies: **M81** and **M82**. M81 is a wide-open, two-armed spiral; M82 is an irregular edge-on system. Some 12 million light-years away, these galaxies are relatively close yet are a challenge for binoculars. If yours are powerful enough (10 power will do; 15 power is better) and your sky isn't too gray, you can glimpse these "island universes." The bigger and brighter of the two is 6.9-magnitude M81. In my 10x50s, I can usually see 8.4-magnitude M82 about two-thirds of a degree northward. To catch the "bear pair," follow our star-hop from the bowl to Upsilon (υ), up to the star labeled **23**, then to the triangle of Rho (ρ), Sigma1 (σ1) and Sigma2 (σ2) and across to **24**.

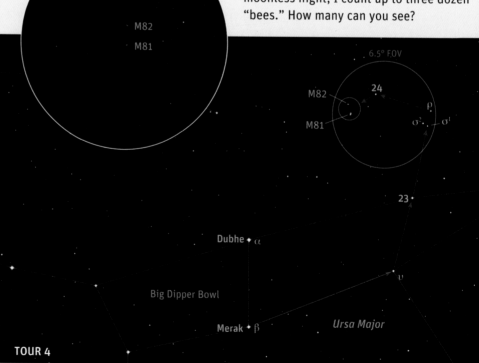

NORTHERN SUMMER SKY

TOUR 5 STEAM ABOVE THE TEAPOT

East of distinctive **Scorpius** the scorpion lies the large **Teapot** asterism within **Sagittarius** the archer. Viewed far from city lights, the Sagittarius Milky Way billows like steam above the Teapot's spout. One especially luminous patch of "steam" is **M24**, better known as the Small Sagittarius Star Cloud. In binoculars, the star cloud is a two-degree-long blizzard of faint stars. Flanking the glittery mass are two sixth-magnitude open clusters, **M23** and **M25**— the former a dense powder west of the cloud; the latter a sparse scatter eastward. Above the star cloud, my 10x50s pick up a faint, fuzzy streak called the Swan Nebula (**M17**). Closer to the Teapot's spout is the Lagoon Nebula (**M8**). And balanced on the Teapot's lid is the fifth-magnitude globular star cluster **M22**. I can detect all of these steamy showpieces from home, but a country view is far better.

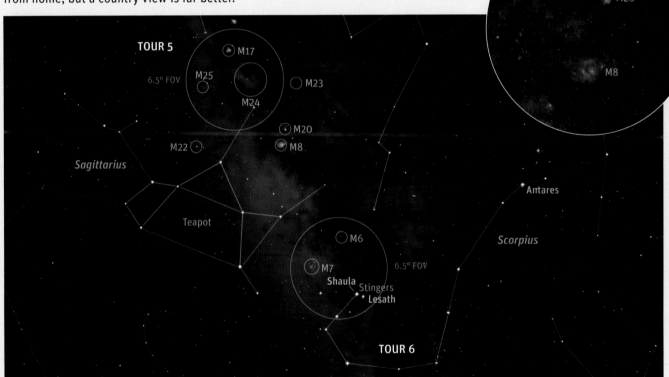

TOUR 6 STINGER STAR SWEEP

Viewed from my British Columbia home near the 49th parallel, **Scorpius** the scorpion drags its curving tail across the southern horizon (part of it curls *below* the horizon). I rarely see the scorpion's brightest "stinger" star, 1.6-magnitude **Shaula**, or its close neighbor, 2.7-magnitude **Lesath**. A rural hilltop solves that problem. From there, I have no difficulty seeing both stars. And in the Milky Way, northeast of the Stingers, I can spot a grainy lump of light —the third-magnitude open cluster **M7**, or Ptolemy's Cluster. I love making a slow sweep from Shaula over to M7 with my 10x50 binoculars. Inside the one-degree-wide dazzler, I can trace a dozen sixth- to eighth-magnitude stars resembling a ragged letter X, plus many dimmer stars blending into the Milky Way. A few degrees northwest lies the smaller but still impressive fourth-magnitude Butterfly Cluster (**M6**). Both starry treasures are visible in a single binocular view.

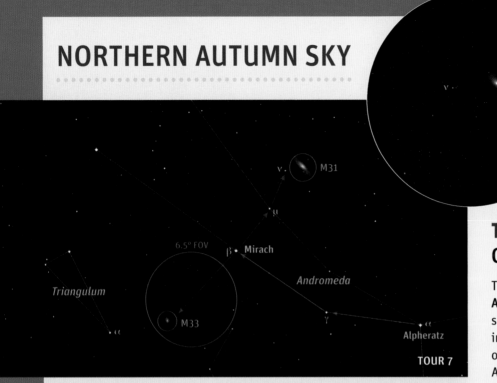

TOUR 7

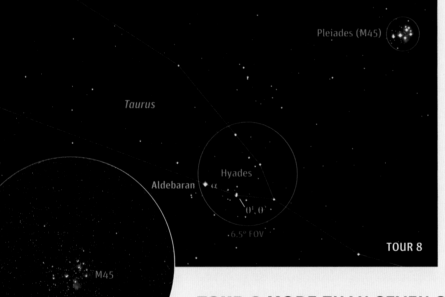

TOUR 7
COSMIC NEIGHBORS

The slender figure of the constellation **Andromeda** the princess is shaped like a slim letter V that fans out from **Alpheratz** in the northeast corner of the Great Square of Pegasus. A short star-hop through Andromeda leads to **M31**, the Andromeda Galaxy. M31 is 2.5 *million* light-years away, yet it's the nearest major spiral galaxy to our own. I get a special feeling whenever I sight the great galaxy in a truly dark sky. M31 is somewhat inclined to our view; it appears strongly elliptical, not round. My 10x50 binoculars reveal the fourth-magnitude hub flanked by tapering "wings" spanning at least two degrees of sky. A slightly farther cosmic neighbor is **M33**, the Pinwheel Galaxy. M33 lies 15 degrees southeast of M31, in the constellation **Triangulum** the triangle. The sixth-magnitude pinwheel is a lovely face-on spiral, smaller than M31 and diffuse. Away from city lights, my 10x50s show it as a pale, oval smudge.

TOUR 8 MORE THAN SEVEN SISTERS

The constellation **Taurus** the bull (easily found northwest of Orion) is home to a pair of huge clusters best appreciated in binoculars. Most famous is **M45**, the **Pleiades**—often called the Seven Sisters. Its main stars form a miniature dipper, but those third- and fourth-magnitude jewels are just the brightest of dozens of blue-white stars in the one-degree-wide group. With my tripod-mounted 10x50s, I count at least 20 "Pleiads" in addition to the sisterly seven. Two binocular fields southeastward is the V-shaped **Hyades** that out-lines the face of the celestial bull. The big V barely fits in my 6.5-degree-wide binocular field. Dominating the Hyades is first-magnitude **Aldebaran** (though the orange giant is a fore-ground star not related to the cluster). Aldebaran's side of the V is decorated with several star pairs. Especially pretty in binoculars is the red and blue duo of **Theta¹** (θ^1) and **Theta²** (θ^2) **Tauri**. The bottom line: Both Taurus clusters are binocular beauties!

SOUTHERN-HEMISPHERE SKY

TOUR 9 CROSSES AND COAL SACKS

The spectacular Carina-Crux area is well placed to the south on February to May evenings from tropical or southern-hemisphere latitudes. **Crux**, the icon of the southern sky, fills a 6.5-degree binocular field, one of the few constellations small enough to do so. Note the orange color of **Gamma Crucis**, or **Gacrux** (γ), the top star in the Southern Cross, which contrasts with white **Acrux** (α) at bottom and blue-white **Becrux** (β) and **Delta** (δ) **Crucis**. The fainter fifth star of the Southern Cross, **Epsilon** (ϵ), looks reddish. Bright Crux contrasts with one of the darkest regions of the Milky Way, the **Coal Sack**, made of interstellar dust blocking our view of what's behind. To the eye, the Coal Sack looks like a solid mass, but in binoculars, it breaks up into three main dark streaks separated by islands of faint stars. It's a wonderfully textured field. Between the Coal Sack and Becrux, look for the tiny star cluster **NGC 4755**, the **Jewel Box**.

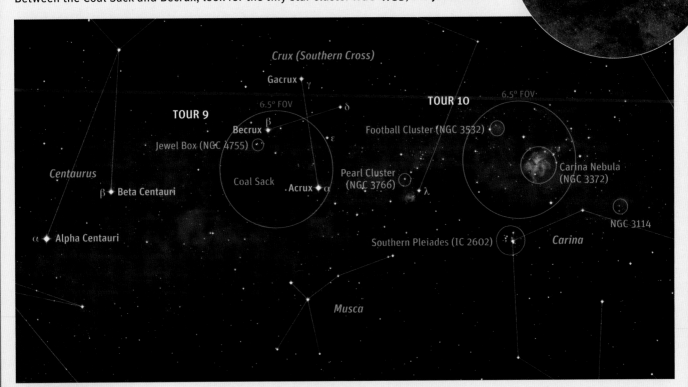

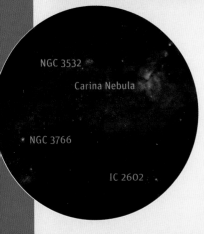

TOUR 10 CARINA AND COMPANY

Carina contains the most southerly section of the Milky Way. Within it, visible to the naked eye from a dark site, is the **Carina Nebula** (**NGC 3372**). Binoculars reveal a gray mist split by three dark lanes radiating from the golden yellow star Eta (η) Carinae. The nebula is flanked by a trio of naked-eye star clusters. To the west lies **NGC 3114**, with two bright stars amid a rich cluster in an already rich field. Below the nebula shines the bright blue **Southern Pleiades** (**IC 2602**), featuring five stars in an X beside nine stars in a C, all set in a dark region of the Milky Way. To the northeast of the nebula sits the oval-shaped **Football Cluster** (**NGC 3532**), the best of the cluster trio. Below it lies another Coal Sack-like dark nebula, itself to the west of the just resolvable **Pearl Cluster** (**NGC 3766**), set in a beautiful field around **Lambda** (λ) **Centauri**. Binocular observing doesn't get any better!

CHAPTER 7

Choosing a Telescope

As we described in Part 1, binoculars or even just your unaided eyes can reveal a lot in the sky. But, of course, a telescope provides a magical portal into a new universe, as everything it shows is beyond what your eyes alone can see. Everyone who views the Moon through a telescope is amazed at the alien landscape that unfolds at the eyepiece. And that first glimpse of Saturn always elicits a "Wow!"

The more you are wowed when you look through your telescope, the more you'll want to continue to explore the night sky. The secret to telescope happiness is buying not the biggest or most elaborate telescope but one that is easy and fun to use.

To help you make your purchase, we've included not only general information on telescope designs but also our opinions and recommendations gleaned from our use and testing of dozens of telescopes. We report on what we know from our experience to assist you in choosing a telescope in what has become a complex market.

A 90mm refractor on a good equatorial mount is a classic beginner telescope, capable of presenting wonderful views of the planets (Venus here) and hundreds of objects in the Milky Way and beyond. The key to success is knowing the sky.

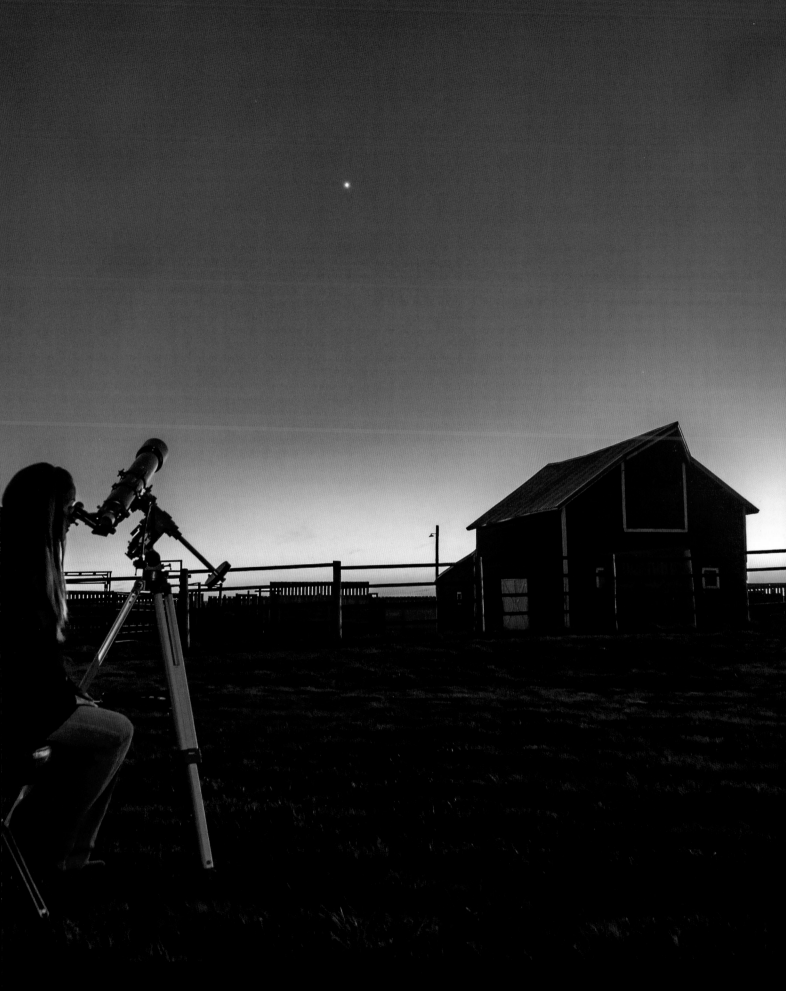

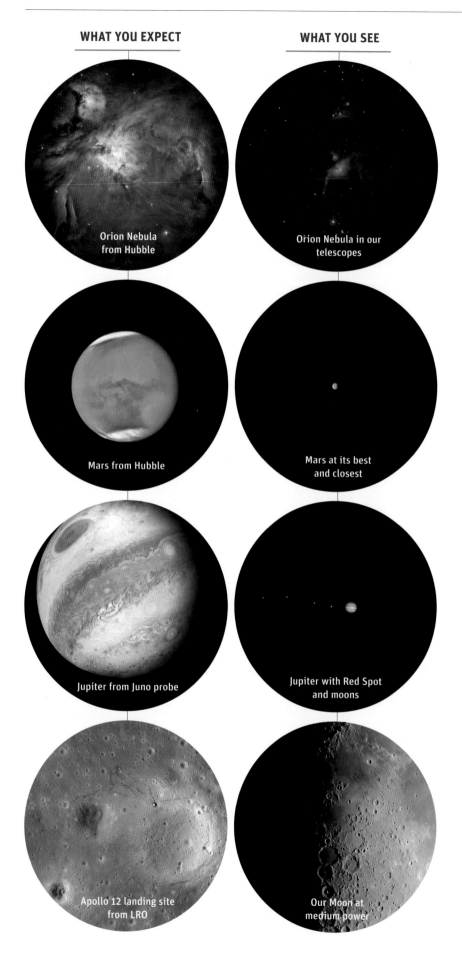

WHAT YOU EXPECT

WHAT YOU SEE

Orion Nebula
from Hubble

Orion Nebula in our
telescopes

Mars from Hubble

Mars at its best
and closest

Jupiter from Juno probe

Jupiter with Red Spot
and moons

Apollo 12 landing site
from LRO

Our Moon at
medium power

WHAT CAN YOU SEE?

Before we dive headlong into the marketplace in our quest for *the* best telescope, we think it wise to first address the question of what a telescope can actually show you. And it's a lot! Even a modest beginner telescope can reveal enough for a lifetime of sky exploring, including all the major planets and hundreds of star clusters, nebulas and galaxies. However, enjoying a telescope might require tempering your expectations of what you can, and cannot, see with it.

WHAT YOU EXPECT VS. WHAT YOU GET

In Part 3, we devote entire chapters to viewing each of the various classes of celestial objects with telescopes. So there's lots more to come on observing.

But as we've already mentioned, and will do so again, many people buy a telescope with the expectation that it will show much more than any backyard telescope, perhaps even any earthbound telescope, possibly can.

The reality is that planets appear sharp but small. Nebulas and galaxies appear in monochrome, with subtle details that require dark skies and trained eyes to see. And no matter how much magnification you apply, stars do not appear as giant glowing spheres but as pastel points of light. It's fair to say that only the Moon measures up to the level of impressive detail new users are likely expecting, though not to the extent of showing the flags the astronauts planted!

EXPECTATIONS VS. REALITY

What you might be expecting to see in your new telescope are nebulas and planets filling the field in glorious technicolor. And close-ups of the Moon revealing flags and landing modules. Sorry! It takes NASA's Lunar Reconnaissance Orbiter (LRO) to show the Apollo landing sites. Nor can our backyard telescopes compete with Hubble or NASA planet probes. But the details are there to be seen—they simply require the patience to learn to see them. (Courtesy NASA/STScI and JPL)

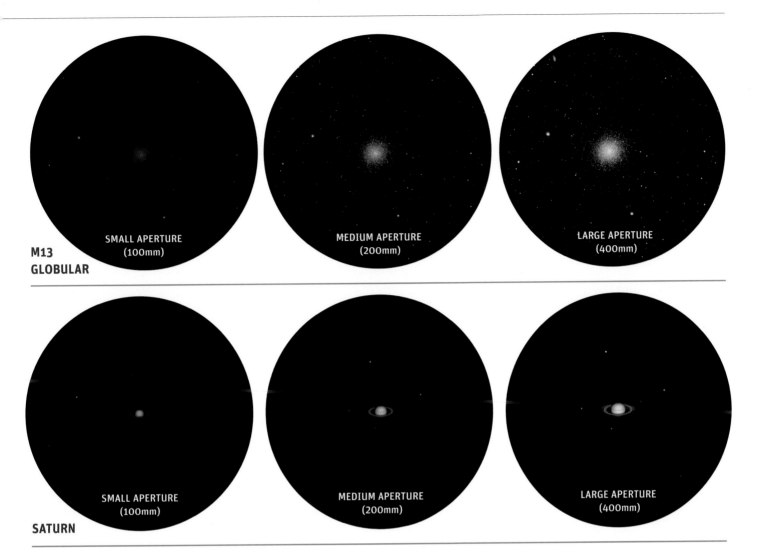

M13 GLOBULAR

| SMALL APERTURE (100mm) | MEDIUM APERTURE (200mm) | LARGE APERTURE (400mm) |

SATURN

| SMALL APERTURE (100mm) | MEDIUM APERTURE (200mm) | LARGE APERTURE (400mm) |

ARE YOU READY FOR A TELESCOPE?

Opinions from veterans differ on this. Some say, yes, satisfy the urge and buy a telescope right now if that's what you want, then grow into it. That might work. Too often, we find it does not.

We are of the school of thought that says, no. Buy later. As wonderful as all telescopes are, even a high-tech computerized model (in fact, *especially* a computerized scope) will be understandable and enjoyable only once you have taken the time to follow our guidance in Part 1 (Chapters 1 through 6). Learn to identify the brightest stars and major constellations with just your unaided eyes, then find some of the choice targets in our Chapter 6 tours using no more than humble binoculars.

Backyard astronomy isn't a race to buy stuff. The telescopic wonders of the night will wait while you get to know the grand layout of the sky and how it works and moves. The following are good tests of whether you are ready for a telescope:

- ◆ Do you know where the planets are currently located and when they are visible?
- ◆ Do you know when and where in the sky the Moon will be during its different phases?
- ◆ Can you identify the brightest stars of each season, such as those in Orion or the Summer Triangle?
- ◆ Can you point out the Orion Nebula, the Beehive star cluster, the Lagoon Nebula and the Andromeda Galaxy? (These are popular targets from each northern-sky season.)

If you can pass these tests, you're ready. But before we go shopping together in the telescope mall, indulge us while we first partake in some nostalgic fun putting the modern telescope market into historical perspective.

APERTURE IS KEY

The larger the diameter of a telescope's lens or mirror (its aperture), the more light it collects, and objects are brighter. As aperture increases, deep sky objects, such as the M13 globular star cluster, appear more obvious and detailed. With the planets, bigger telescopes resolve finer details, such as divisions in Saturn's rings, and reveal fainter moons. With more light, bigger scopes also allow the use of higher power. The chapters in Part 3 contain more simulations of what objects really look like in telescopes.

A BRIEF HISTORY OF TELESCOPES

Life used to be so simple. In the past, one type of telescope dominated the hobby, making the choice of which instrument to buy downright easy: You bought what everyone else was buying. Indeed, you had little choice.

Observing tastes also followed in lockstep fashion. Whatever type of observing the telescope in vogue excelled at was what most people concentrated on. It has long been our opinion that the history of amateur astronomy can be divided into periods during which a single type of telescope—and observing—defined the backyard astronomer's universe.

BEFORE 1950: SMALL-REFRACTOR ERA

If you wanted a telescope before 1950, chances are you made your own, typically a 6-inch reflector on a "plumber's nightmare" mount made of pipe fittings. If you could afford to buy a telescope, it was likely a 2- to 3-inch brass-fitted refractor that looked good in a study beside an oak bookcase. Larger refractors were available, but at a very high price. Commercial telescopes were expensive relative to the wages of the working person. They were made for the genteel astronomers of wealth and leisure.

The chief observing activities of such amateurs were viewing the Moon and planets and logging descriptions of the colors of double stars. A few advanced observers engaged in the more technical work of measuring the positions of double stars and the brightnesses of variable stars—tasks that were well suited to a small refractor.

1950 to 1970: NEWTONIAN ERA

After World War II, small telescope companies in the United States, such as Cave/Astrola, Criterion, Optical Craftsman and Starliner, began to offer high-quality Newtonian reflectors at a more reasonable price. With relatively large apertures of 6 to 12 inches and costs well below that of 4- to 5-inch refractors, the Newtonian became the most popular instrument of the day.

The Newtonians of the 1950s and 1960s were medium- or long-focal-length telescopes (f/7 to f/10). With the requisite equatorial mounts, they were so big they rarely traveled. But they didn't need to, because long-focus Newtonians were, and are, excellent for high-resolution planetary observing, which can be done from cities. And so we entered the golden era of planetary study by backyard astronomers, who charted features on planets in sketches that are still exceptional for their detail.

Deep sky objects remained a sideline. The books of the day bear this out. *Norton's Star Atlas*, the observer's bible of the 1950s and 1960s, lists only 75 deep sky objects in

THE BRASS AGE
A down payment of just 27 shillings sixpence gets you this lovely 3-inch brass refractor, right, to see all the objects referred to in Hutchinson's *Splendour of the Heavens*, above, a popular guidebook of the 1920s and 1930s, including "the hills and valleys of the Moon, the marvellous rings of Saturn, mysterious Jupiter with its unique lunar system, and most of the double stars."

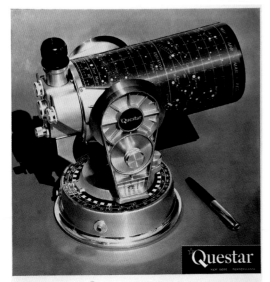

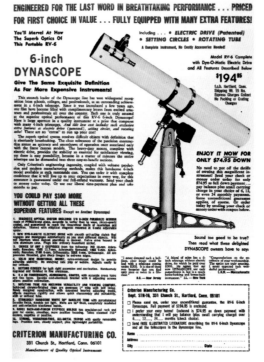

REFRACTOR ENVY

Who wouldn't want such an arsenal of refractors, complete with medium- and large-format film cameras and that newest of features: an electric motor instead of a weight-driven clockwork drive. Unitrons were the dream scopes of the 1950s and 1960s. Just $61 down!

QUESTAR LOVE

Far left: From the 1950s to the 1980s, every issue of *Sky & Telescope* had a full-page ad for Questar. In this ad, Miss Julia Wightman writes that her "Questar... so outmodes other telescopes that it is like a leap from the Stone Age to the present time." And that it was.

THE MODEL T OF REFLECTORS

Left: Many amateurs of the 1960s honed their observing skills with this classic 6-inch f/8 Newtonian, the Criterion RV-6 Dynascope on a German equatorial mount. The optics were superb at the breakthrough price of $195. Or $74.95 down.

the descriptive tables of the 1959 edition. The realm of nebulas and galaxies was all but ignored, despite the low levels of light pollution at the time.

Then, in 1965, NASA's Mariner 4 became the first interplanetary probe to return close-up images of a planet, Mars, revealing a cratered surface unlike anything telescopic observers had seen or imagined. The space age effec-

tively removed the Moon and planets as rich targets of opportunity for amateur astronomers. Planetary observing as a primary activity plummeted.

Yet, at the same time, the 1960s space race heightened public interest in astronomy. The hobby evolved from a fringe pursuit by lone males into a mainstream pastime, setting the stage for the next era.

SCT AND REFRACTOR REVOLUTION

Below left: In the 1970s, the Celestron C8, then the C5, came with sand-cast fork mounts and tubes finished with a velvety textured paint. They looked great for a while but soon showed dirt and grime.

Below right: The refractor renaissance began in the mid-1980s with Tele Vue's homage to the brass telescopes of old, but now with new glass types to eliminate chromatic aberration.

THE 1970s: SCT BREAKTHROUGH

The many Apollo-era converts to astronomy increased telescope sales to the extent that telescope companies could introduce mass-production techniques. At that time, Californian Tom Johnson was a pioneering telescope maker. Lured by the theoretically near-perfect star images of a Schmidt-Cassegrain (SCT), Johnson built a 19-inch unit for himself. In 1964, he renamed his electronics company Celestron Pacific and began making telescopes.

In 1970, Celestron introduced a compact 8-inch f/10 Schmidt-Cassegrain, the original orange-tube "C8" (even the color was novel). The retail price for the basic telescope was $795. Considering that 8-inch Newtonians cost $600 at the time, the C8 was expensive. But because of its compact size and ease of use, many amateurs flocked to the new style of instrument, dubbed a catadioptric, or "cat," a hybrid of a reflector and a refractor.

In many ways, the hobby as we know it today began with this telescope. The portability of Schmidt-Cassegrains enabled amateur astronomers to take telescopes of significant aperture to dark sky sites, an uncommon practice prior to the spread of light pollution in the 1970s. Observing deep sky objects soared in popularity.

THE 1980s: NEWTONIAN REBORN

The new interest in deep sky observing created a hunger for even more aperture. How could enthusiasts move to bigger telescopes yet retain portability?

The solution: Return to the Newtonian, but sacrifice the automatic tracking of equatorial mounts by using simple, squat altazimuth mounts. Popularized by California amateur astronomer John Dobson, these telescopes are now universally called Dobsonians. Beginning in 1980, Coulter Optical in California offered classic Dobsonians for as little as $500. Aperture fever swept the land.

Once again, the instrumentation led observers into new territory. Objects that were barely perceptible smudges in an 8-inch Schmidt-Cassegrain became impressive spectacles in the 13- and 17.5-inch Coulter Dobsonians popular in the early 1980s.

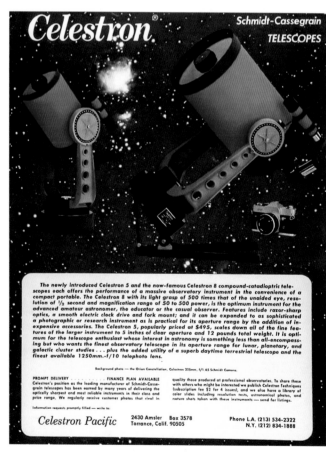

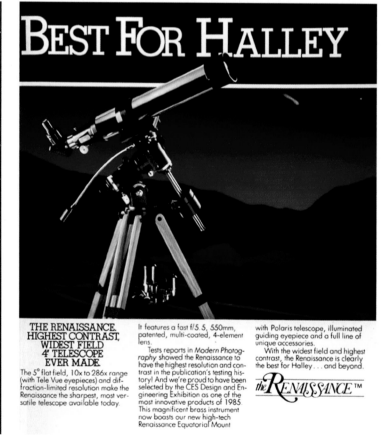

DOBSONIAN DEBUT

At the 1980 Riverside Telescope Makers Conference in California, Coulter Optical unveiled the first commercial Dobsonian, the 13-inch Odyssey 1, made in John Dobson's classic design.

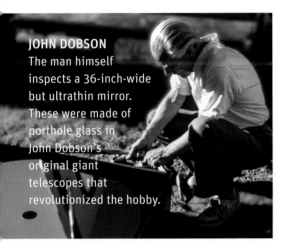

JOHN DOBSON
The man himself inspects a 36-inch-wide but ultrathin mirror. These were made of porthole glass in John Dobson's original giant telescopes that revolutionized the hobby.

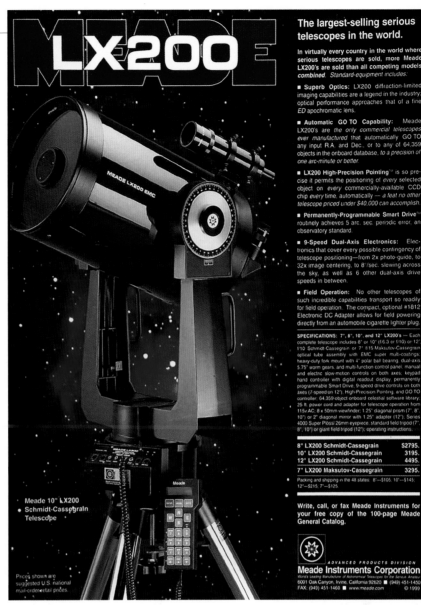
THE 1990s: REFRACTOR REBORN

The Schmidt-Cassegrains and Dobsonians did not win over everyone. Observers complained of the fuzzy views offered by the large but low-cost "light-bucket" reflectors. Others were disappointed by a spate of poorly made Schmidt-Cassegrains during the Comet Halley boom of the mid-1980s. Two telescope designers, working independently, revolutionized the refractor for recreational astronomy.

Former NASA optical designer Al Nagler developed ways to reduce the length of the refractor without increasing chromatic aberration, or false color, the traditional flaw of refractors. His Tele Vue Renaissance and Genesis models were instrumental in reestablishing the refractor.

Aerospace engineer Roland Christen also attacked chromatic aberration. Beginning in the late 1980s, Christen's firm, Astro-Physics, marketed the first affordable triplet-lens apochromatic refractors. The race for bigger telescopes gave way to the desire for better telescopes.

THE 2000s: COMPUTERS TAKE OVER

By the close of the 20th century, the three classes of telescope optics—refractor, reflector and catadioptric (the Schmidt-Cassegrain)—shared equal billing in popularity. Similarly, amateur astronomers pursued eclectic observing interests for the first time, enjoying a wide range of celestial targets, from the nearby Moon to distant clusters of galaxies. We still do.

With optics perfected to such a high art and available in a diverse array of telescope designs, what was next? In a word, computers.

While Celestron had introduced a comput-

HIGH-TECH TELESCOPE

Meade's original 8-inch LX200 sold for $2,795 in the late 1990s. These GoTo telescopes, as they are called, have since evolved to include features such as WiFi to control the telescope with your smartphone. Who could have predicted that?

HIGHER-TECH TELESCOPE
The eVscope presents only digital images to the eyepiece or smartphone. Is it observing or astrophotography? Will the next generation of telescope buyers care about the difference? (Image courtesy Unistellar)

erized telescope as far back as 1987, with its CompuStar, the first high-tech scopes to make an impact were Meade Instruments' LX200 models, introduced in 1992 (LX stood for Long eXposure). However, computerized telescopes remained high-end models throughout the 1990s, aimed at enthusiasts willing to spend thousands of dollars.

In 1999, Meade broke the price barrier for computerized telescopes by introducing the ETX-90EC and its hand-held Autostar computer ("ET" was short for Everyone's Telescope). For $750, you could own a telescope that aimed itself, solving the problem that discourages so many beginners: how to find celestial objects.

THE 2020s: EYEPIECE NOT REQUIRED

So what's next in telescope technology? The $3,000 eVscope from Unistellar is surely a sign of things to come. It and crowd-funded competitors such as the Vaonis Stellina and Vespera go one better in GoTo technology, promising to self-align at the switch of a power button, then find targets selected from a wireless app. They present views that are strictly electronic, built up by digitally stacking lots of short exposures. Images are beamed to your smartphone for instant sharing on social media. You see nebulas in color—but on a screen.

While the eVscope has an eyepiece, what you see through it is the same digital image your smartphone receives. You aren't looking at the "real object" but at a picture of your target, exactly what many visitors to telescopes suspect they are seeing anyway.

Despite what us old-timers might think (after all, GoTo scopes were once despised by traditionalists), telescopes will continue to evolve with exciting new features and capabilities. We will have an even greater array of choices. Now on to making that choice.

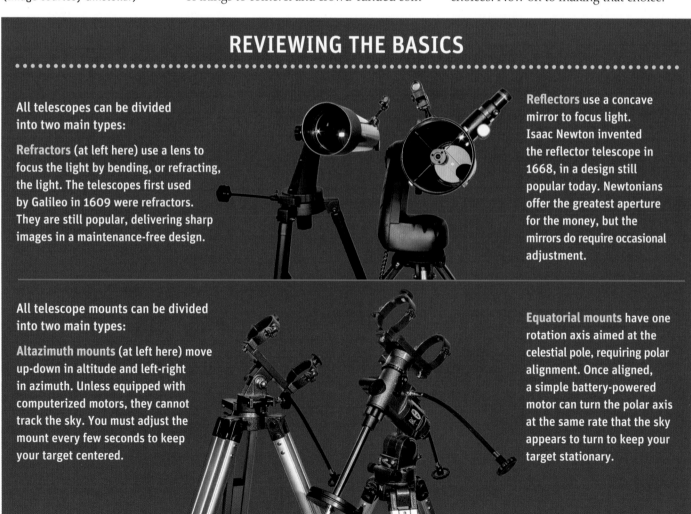

REVIEWING THE BASICS

All telescopes can be divided into two main types:

Refractors (at left here) use a lens to focus the light by bending, or refracting, the light. The telescopes first used by Galileo in 1609 were refractors. They are still popular, delivering sharp images in a maintenance-free design.

Reflectors use a concave mirror to focus light. Isaac Newton invented the reflector telescope in 1668, in a design still popular today. Newtonians offer the greatest aperture for the money, but the mirrors do require occasional adjustment.

All telescope mounts can be divided into two main types:

Altazimuth mounts (at left here) move up-down in altitude and left-right in azimuth. Unless equipped with computerized motors, they cannot track the sky. You must adjust the mount every few seconds to keep your target centered.

Equatorial mounts have one rotation axis aimed at the celestial pole, requiring polar alignment. Once aligned, a simple battery-powered motor can turn the polar axis at the same rate that the sky appears to turn to keep your target stationary.

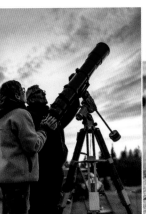

CHOOSING THE BEST TELESCOPE

TELESCOPE DIVERSITY
Refractors, reflectors and catadioptrics...you'll see every type of telescope represented at star parties, owned and operated by friendly stargazers happy to tell you what they love (and perhaps don't like) about their telescopes.

EMPTY MAGNIFICATION
These views simulate what Jupiter looks like at high power in a small telescope pushed beyond its 50x-per-inch limit, yielding a dim, fuzzy image. What we can't simulate is the constant motion of the image from turbulence in our atmosphere and shakes in the mount. A large telescope provides enough light to allow high powers, but only on the steadiest nights.

Time and again, we are asked, "What is the best telescope?" or "Which telescope would you buy?" Because no single telescope dominates the market anymore, the choices can be daunting. Furthermore, a telescope we would choose for ourselves is not likely to be best suited to your needs.

We provide specific recommendations later in this chapter. But it has to be a wide range of recommendations as *there is no single best telescope*. After all, there is no single best car. And telescopes can be just as varied, offering the astronomical equivalent of everything from a small, nimble sports car to a large, load-hauling truck. Which one is best? It depends.

Our advice is to make your decision based not on refractor versus reflector or altazimuth versus equatorial but on other factors far more important for ensuring enjoyable nights under the stars. We will outline these first, then dive into our survey of models.

FACTOR 1: IGNORE THE MAGNIFICATION SCAM

First, there is one telescope trait you can ignore: how much the telescope magnifies. *Magnification is a meaningless specification.* With the correct eyepiece, any telescope can magnify hundreds of times. The question is, How does the image look at 450x? Or even 300x. Probably dim and fuzzy. Why? There are two reasons:

◆ **Not Enough Light** The telescope simply is not collecting enough light to allow the image to be magnified to that extent. When an image is enlarged, it is spread out over a greater area and becomes too faint to be useful. The telescope has been pushed beyond its limits.

How much can a telescope magnify? The general magnification limit is 50 times the aperture in inches or 2 times the aperture in millimeters. For example, the maximum usable power for a 60mm telescope is only 120x. Claims that such a telescope can magnify 450x are misleading, intended solely to lure the unsuspecting buyer.

◆ **Blurry Atmosphere** The Earth's atmosphere is always in motion, distorting the view through a telescope. Some nights are worse than others. At low power, the effect may not be noticeable, but at high power, atmospheric turbulence (what we call poor seeing) can blur the image badly.

On most nights, a magnification of about 300x is the practical upper limit, even for an expensive large-aperture telescope. People do not buy big telescopes to obtain highly magnified images but, rather, to get brighter, sharper images and to see fainter objects.

FACTOR 2: AVOID APERTURE FEVER

The most important specification of a telescope is its *aperture*. When amateurs speak of a 90mm or an 8-inch telescope, they are referring to the diameter of the main lens or mirror.

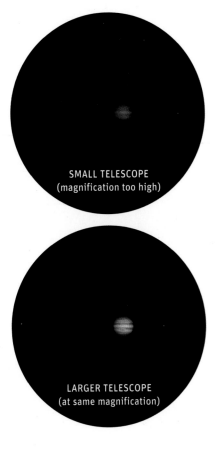

SMALL TELESCOPE
(magnification too high)

LARGER TELESCOPE
(at same magnification)

The larger the aperture, the brighter and sharper the image.

With the magnification myth dispelled, you might think you need as much aperture as you can afford. That is true to a certain extent and does guide some of our recommendations. But if you are not careful, you might become afflicted by "aperture fever." We have seen just as many people give up the hobby for buying too much telescope as buying too little.

Big telescopes do not always foster cosmic contentment for several reasons:

♦ **Portability** One often-overlooked fact is that large telescopes do not fit into small cars. It is surprising how many amateur astronomers buy a huge instrument without considering how to transport it—or carry it. For a first telescope, in particular, any instrument you cannot easily carry out to the backyard in one or, at most, two pieces is unlikely to be used after the novelty wears off.

♦ **The Shakes** Another problem with big telescopes is the shakes. A large-aperture telescope on too small a mount might be more portable, but the images will dance about with every puff of wind and every touch of a hand, discouraging use. Yet a mount sturdy enough to steady the telescope might also be too heavy and cumbersome. Again, the scope will fall into disuse.

♦ **Price** Big telescopes can be expensive, and lots of beginners lose interest in the hobby. The reasons can often be traced back to big scopes that are awkward to set up. Now you've got a sizable investment tied up in a telescope that only takes up valuable storage space. And, depending on its age, a big scope might also be tough to sell.

Our advice? The beginner should resist any temptation to buy a first telescope larger than 8 inches (20 cm) in aperture. Think twice about that 10-inch Schmidt-Cassegrain or Newtonian.

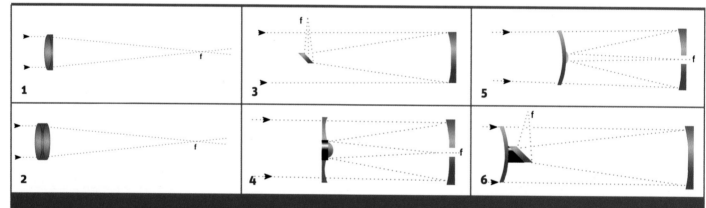

TYPES OF OPTICS

1 Achromatic Refractor The classic refractor uses a doublet lens with elements made of crown and flint glass. In f/10 to f/15 focal ratios, chromatic aberration (blue halos) is negligible. It becomes noticeable in f/5 to f/7 models.

2 Apochromatic Refractor "Apos" use lenses with at least one element made of ED glass to eliminate colorful halos around bright objects.

3 Newtonian Reflector Named for its inventor, Isaac Newton, this timeless design uses a concave primary mirror (it should be made with a parabolic curve) with a flat secondary mirror. The eyepiece is at the top of the telescope.

4 Schmidt-Cassegrain (SCT) An aspherical corrector plate compensates for aberrations in the f/2 spherical mirror. A convex secondary folds the light path down the stubby tube.

5 Maksutov-Cassegrain This uses a steeply curved corrector lens. The secondary is often a reflective spot on the inside of the corrector. As with all Cassegrains, light exits out a hole in the primary mirror.

6 Maksutov-Newtonian Usually made in fast focal ratios, this design boasts a view free of aberrations across a wide field at low power and crisp images at high power.

FACTOR 3: CONSIDER YOUR SITE

Perhaps your most important consideration when picking the best telescope is your observing site. Can you observe from home? Are views restricted by trees, houses or streetlights? How far will the telescope have to be carried from your home to the yard? Will you need to negotiate stairs? And once outside, will you have to move the scope around the yard to sight different areas of the sky?

If you are plagued with light-polluted skies at home, f/6 to f/15 telescopes are preferred. As a general rule, they have better optical quality than most ultrafast f/4 to f/5 telescopes, while yielding higher powers with a given set of eyepieces. Both characteristics will provide more pleasing images of the Moon and the planets, the best targets under light-polluted skies.

If there is little possibility that your telescope will be used at home, then base your decision on portability and ease of transportation. A 3.5- to 5-inch Maksutov-Cassegrain, a 5- to 8-inch Schmidt-Cassegrain, a 6- to 8-inch Newtonian or a 3- to 4-inch refractor will probably be used far more than a bulkier instrument. With a big scope, you'll transport it to a rural site only if conditions look ideal.

If, on the other hand, you are fortunate enough to live under dark rural skies and can conveniently store a large telescope for quick setup, then by all means consider a larger-aperture reflector, perhaps a 10- to 16-inch Dobsonian or a 9.25- to 12-inch Schmidt-Cassegrain.

FACTOR 4: DON'T CATCH PHOTO FEVER

A common demand of the first-time telescope buyer is, "I want to be able to take pictures through my new telescope." By that, the prospective buyer usually means images of colorful nebulas and galaxies. However, this type of photography requires a minimum of $3,000 in telescope gear alone, and the best scope for imaging is not always the first choice for visual use.

Some types of astrophotos can be taken easily and inexpensively (as we instruct in Chapter 17), but close-up images of nebulas and galaxies aren't among them.

FACTOR 5: CONSIDER YOUR AGE

Many buyers ignore this, but it's a definite consideration. Will your knees and back withstand lifting and carrying a 40- to 50-pound telescope out to the yard or car? The arc of a typical telescope-buying life goes like this: You start young with a small low-budget scope, as it's all you can afford. As disposable income increases, you buy that bigger and better dream scope, often a succession of them. As you age, your willingness to handle hefty scopes declines and you buy a small scope again, but one with very

LIFT AND FIT

Consider the reality of transporting a big telescope to a dark sky site. Can you lift it onto and off the mount or tripod? Will the packed telescope fit into the family vehicle? And still leave room for the family? This 12-inch Schmidt-Cassegrain will not!

RULES TO BUY BY

To summarize our advice in this chapter, we propose five rules that we think will serve most beginners well when buying a first telescope.

1 Bypass Power-Mad Models Avoid any telescope sold on the basis of its magnification. This Bushnell scope even includes its 565 power in its name! Such claims are sure signs that the telescope is a junky toy in disguise.

2 Mind the Mount A good mount is just as important as good optics. And more important than how many dials it has is how sturdy it is.

3 Portability Is Paramount The best telescope for you is the telescope you will use most often. A small instrument that is easy to set up is better than a big scope that remains in storage.

4 Keep It Simple Telescopes needing more than 5 to 10 minutes to load into a vehicle or to set up suffer a steady decline in use after the first year.

5 Keep It Visual We suggest beginners ignore astrophotography. Buy the sharpest, sturdiest telescope for the pleasure of observing by eye.

high quality. In this chapter, we are encouraging you to start with that latter class of scope.

FACTOR 6: PRICE

What might be your first consideration is our last. But clearly, most buyers have a budget in mind. For a good starter scope for an adult or a child, expect to pay at least $200. For $400 to $800, you can get a telescope that will serve you for years. A $1,000 to $2,000 telescope will have all the latest high-tech features. In short, telescopes are incredible bargains. Try spending that little to get into any other outdoor pursuit or sporting pastime.

DECODING TELESCOPE SPECS

The following terms, and *not* magnification, represent the most important optical specifications of any telescope.

Aperture and Light-Gathering Power
A telescope is rated by its aperture, measured by diameter. As shown below, an 8-inch (20 cm) telescope has twice the diameter but *four* times the surface area—and therefore light-gathering power—of a 4-inch (10 cm), making its images four times brighter.

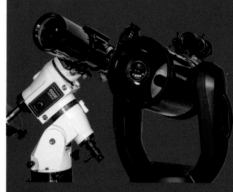

Resolution An 8-inch telescope can resolve twice as much detail as a 4-inch. The resolving power of a telescope is given by the empirical rule devised by William Dawes in the 19th century: Resolving power (in arc seconds) = 4.56 ÷ aperture (inches); or 116 ÷ aperture (mm). A 4-inch can resolve details or double stars 1.14 arc seconds apart; an 8-inch can resolve 0.57 arc second, making it twice as sharp.

Focal Length The length of the light path from the main mirror or lens to the focal point (the location of the eyepiece) is the focal length and is almost always given in millimeters, as with camera lenses. With Maksutov-Cassegrains and Schmidt-Cassegrains, the optical path is folded back on itself, as shown, making the tube shorter than the optical focal length.

Focal Ratio The focal ratio, or f/ratio, = focal length ÷ aperture. For example, a 100mm (10 cm or 4-inch) telescope with a focal length of 800mm has a focal ratio of f/8. For photography, "faster" f/4 to f/6 systems yield shorter exposure times. But when used visually, image brightness depends only upon the aperture and the magnification used, not the focal ratio.

Diffraction-Limited A promise of "diffraction-limited" means the image quality is limited by the wave nature of light and not by errors in the optics. This is achieved if the optics provide a final error at the eyepiece of only one-quarter of a wavelength of light (the wavefront error), meeting the so-called Rayleigh criterion, a minimum standard. Premium telescopes can do better, with RMS (not the more forgiving peak-to-valley) wavefront errors of 1/8- to 1/20-wave, but the performance edge is subtle and comes at a high cost.

Strehl Ratio A spec often given with premium optics is the ratio of an optic's measured surface accuracy compared with what is theoretically possible. A Strehl ratio of 0.80 or higher is superb.

Central Obstruction While a reflector's secondary mirror blocks some light, the loss is not significant. What is noticeable is the smearing of contrast caused by the diffraction of light from the obstruction. This effect is proportional to the *diameter* of the secondary mirror, not by the area it obstructs, and so should be stated by diameter. An 8-inch scope, shown here, with a 2.75-inch-diameter secondary mirror has a central obstruction of 34 percent. A central obstruction of 20 percent or lower by *diameter* produces a negligible effect.

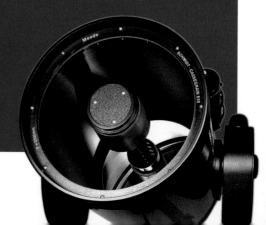

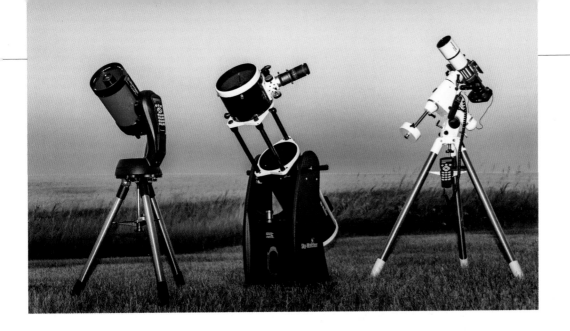

SURVEYING THE TELESCOPE MARKET

Ignore Facebook advisers who might tout one particular telescope design or even one particular telescope as "the best." There isn't one. Picking the right telescope requires weighing the factors we listed earlier against what the market has to offer. Here's our survey, sorted by optical design, with the focus on models available in North America.

ACHROMATIC REFRACTORS
70mm to 120mm (2.8-inch to 4.7-inch)
Refractors with 60mm (2.4-inch) lenses populate every big-box store and camera shop for the holidays. Most are what we call "trash scopes." Their flaw is not so much the main lens but everything else: poor eyepieces, dim finderscope, lack of slow-motion controls and a shaky mount. Over the years, we've seen few 60mm telescopes we could recommend.

With the jump to an 80mm (3.1-inch) or a 90mm (3.5-inch) refractor, the quality of the telescope improves greatly. Most f/7 to f/11 refractors in this aperture league are worthy beginner telescopes. Color correction of the doublet lens, made of crown and flint glass, is very good, as false color diminishes with longer focal lengths and slower f/ratios of

f/7 and greater. The telescope is portable, durable and largely maintenance-free, a prime consideration for a child's scope.

In telescopes we tested for this edition, we found the quality excellent, considering the low price of $200 to $250. Look for models with slow-motion controls on the altazimuth mount and two good Kellner or Plössl eyepieces (see Chapter 8) that provide no more than 100x to 150x, not excessive magnifications.

A just acceptable notch down in quality from the 80mm to 90mm models is a smaller 70mm (2.8-inch) refractor ($150), but only if it is fitted to a sturdy mount, again an altazimuth with slow-motion controls. An example is Meade's StarPro 70mm.

A fine choice is a step up to a 4-inch (100mm) refrac-

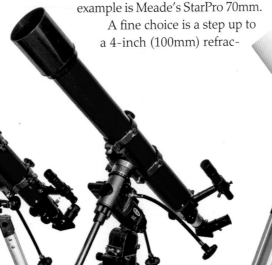

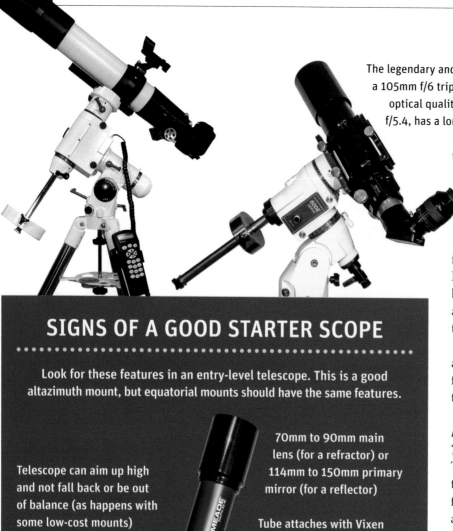

4-INCH APOS PAST AND PRESENT
The legendary and long-discontinued Astro-Physics Traveler (right), a 105mm f/6 triplet, has rarely been matched for compactness and optical quality. Tele Vue's superb NP101is (left), while faster at f/5.4, has a longer tube due to its unique Nagler-Petzval design.

SIGNS OF A GOOD STARTER SCOPE

Look for these features in an entry-level telescope. This is a good altazimuth mount, but equatorial mounts should have the same features.

Telescope can aim up high and not fall back or be out of balance (as happens with some low-cost mounts)

Slow-motion controls (one on each axis)

Large red-dot finder or 6x30 optical finder (not 5x24)

1.25-inch focuser (not 0.965-inch)

25mm Kellner, Modified Achromat or Plössl eyepiece

Ideally, an astronomical prism diagonal, not an erect-image Amici prism diagonal, as here

70mm to 90mm main lens (for a refractor) or 114mm to 150mm primary mirror (for a reflector)

Tube attaches with Vixen dovetail bar for quick disassembly and packing

Solid altazimuth mount for a refractor, as here, or a Dobsonian mount for a reflector (for ease of use)

Adjustable full-height tripod, not a tabletop mini-tripod

One or two other eyepieces, such as a 10mm, but providing no more than 150x (forget any included Barlow lens!)

tor, though long-focus f/8 to f/10 models are increasingly rare; a pity. Examples are Explore Scientific's FirstLight 102mm and Celestron's Omni XLT 102, both f/9.8 designs on EQ3-style mounts for $300 to $350. Some 102mm achromats sold now are fast f/5 designs that are best for low-power views. Models with f/6.5 focal ratios perform much better, though at high power, false-color halos around bright objects are still noticeable, though not objectionable.

Larger achromats with 120mm (4.7-inch) aperture, usually f/9, have been excellent performers but are now less common, partly due to the decreasing cost of apochromats.

APOCHROMATIC REFRACTORS
76mm to 150mm (3-inch to 6-inch)
Technically, the term "apochromatic" means that the lens brings three colors to the same focus rather than just two, as in a standard achromat. But in practice, a good apo reduces all false-color halos below the eye's threshold of detection. This level of performance is achieved by two- or three-element apos using fluorite or extra-low-dispersion (ED) glass in one or more elements of the main lens.

As a rule, apo refractors with triplet lenses provide color correction a notch better than doublet apos, though at a higher cost. Apos employing the lowest-dispersion Ohara FPL-53 ED glass, in either a doublet or a triplet design, also usually provide better color correction than models with FPL-51 ED glass.

In our "Brief History of Telescopes" (page 124), we mentioned that this class of telescope was pioneered by the American firm Astro-Physics, which offered refractors from 92mm to as large as 180mm, usually with focal ratios of f/6 to f/7. Between the two of us, we have owned Astro-Physics refractors of every size and prize them. But finding an owner willing to part with one is now the only way to get an "AP," as telescope production has effectively stopped. The company is now making pre-

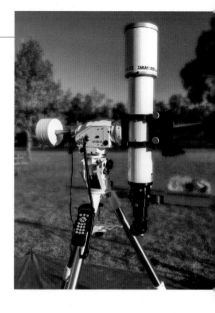

mium mounts only. Even used, Astro-Physics apos command high prices.

The other American company that pioneered apo refractors is Tele Vue Optics, which offers ultraportable 60mm, 76mm and 85mm refractors ($850 to $2,200). These use doublet lenses for very good color correction—only a tad below that of the best apos. Its top-of-the-line f/5.4 NP101is ($4,000) and f/5.2 NP127is ($7,000) employ a unique Nagler-Petzval design with a front doublet coupled to a rear sub-diameter doublet to flatten the field and eliminate chromatic aberration. Both are superb visual and photographic instruments.

In part taking over from Astro-Physics in supplying domestically produced large-aperture apos for the purist is the Telescope Engineering Company (TEC), based in Colorado and headed by master optician Yuri Petrunin. Models range from the 140mm f/7 ($7,500) to the monster 200mm ($30,000!). Views we've seen through TEC scopes are every bit as good as through any Astro-Physics.

The other U.S. domestic supplier of premium apos is Stellarvue, headed by Vic Maris, who supervises the finishing and testing of its foreign-made lenses in California. While its models change frequently, the Stellarvue line usually ranges from an 80mm ($1,800) to a 152mm ($9,000), most available with only modest wait times. The Stellarvue refractors we have tested have been excellent.

Looking overseas, the leading name in prestige apo refractors is the Japanese firm Takahashi. In all sizes, from the diminutive FS-60 ($900), a 60mm we can recommend, to the giant TOA-150 ($13,000), Takahashi refractors provide outstanding images. Although pricey, they have the advantage that many are available from stock.

Also from Japan, but much more affordable than Taks, are refractors from Vixen Optics. Construction quality doesn't match a Takahashi but is still very good. Apos are offered from the ED80Sf ($750) to the SD115S ($2,700), most with doublet ED lenses, providing very good color correction.

In recent years, we have seen a profusion of apos enter the market, with optics made in China or Taiwan. They are sold around the world under a variety of brand names. Paying $1,000 to $1,500 per inch of aperture used to be the norm for apos, but new Chinese imports have dropped that to $250 to $500 per inch. Although none have the prestige of apos from the likes of Takahashi, TEC or Tele Vue, all the new-generation apos we tested have been first-rate, with color correction in triplets every bit as good as the top-end "boutique" apos.

For an affordable apo that's good for both visual and photo use, look at units from Astronomics (under its Astro-Tech house brand), Explore Scientific, Omegon, Orion Telescopes and Synta/Sky-Watcher. We've tested Explore Scientific's FCD100 and Sky-Watcher's Esprit line, aimed at astrophotographers, and were very impressed. All showed textbook images with no chromatic aberration.

Apos from Taiwan-based William Optics are popular, and earlier models we've owned and tested were excellent. As with Stellarvue, the models change frequently but typically include 60mm to 150mm telescopes across its ZenithStar, Fluorostar and Gran Turismo series.

A line of Chinese-made apos introduced in 2020 under the SharpStar brand and sold worldwide under other house brands includes 61mm to 140mm triplet apos at attractive prices. In our tests, we found their color correction and sharpness compete with the best from the prestige brands, while the focuser, fittings and finish are also superb.

Despite plummeting prices, an apo refractor remains the most costly type of telescope per inch of aperture. At the other end of the price-per-aperture scale is the Dobsonian.

DREAM APO

For refractor fans, this is a dream combo: the Takahashi TSA-120 on the Sky-Watcher AZ-EQ6 dual-configuration alt-az/ equatorial GoTo mount. The views of Mars through the Tak on this night were fabulous!

APO ARRAY

Here, we see the relative sizes of the 76mm, 100mm and 140mm SharpStar apos. The small and medium sizes are easy to carry, but the 140mm is a hefty beast requiring a large equatorial mount, which is true of most apos larger than 127mm.

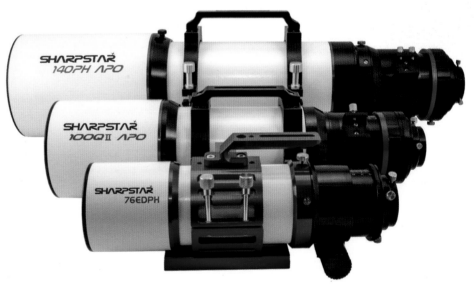

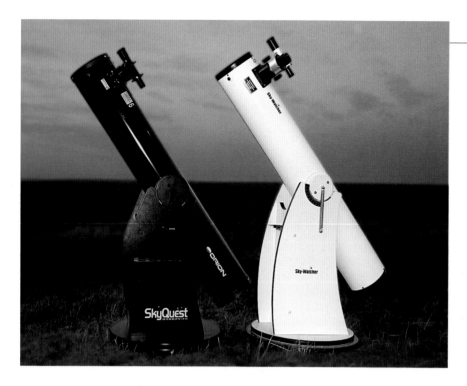

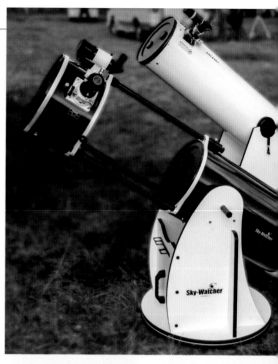

DOBSONIAN CHOICES AND TUBE DESIGNS

Above: The Orion SkyQuest (left) and Synta/Sky-Watcher 6-inch (150mm) Dobsonians are terrific values. Although amateur astronomers praise these telescopes as great choices for beginners, many buyers ignore them in favor of small reflectors on shaky and confusing equatorial mounts. **Above right:** In smaller apertures, some brands of Dobsonians offer a choice of the more economical but bulkier solid-tube design or an open-tube model, like the Sky-Watcher Flextube in the foreground that collapses for easier transport and storage. **Right:** Truss-tube Dobs such as this Meade Lightbridge break down into smaller components than the Flextube models. But they require attaching the pairs of truss poles to the base, then attaching the upper tube assembly to the poles. Minor mirror collimation may be needed.

DOBSONIAN REFLECTORS
150mm to 0.63 m (6-inch to 25-inch)

For our personal choice of "the best" telescope, we feel this design offers the most outstanding value in a telescope, providing generous aperture, excellent optical quality, good fittings and solid mounts for not a lot of money. What more could anyone want?

Our favorite Dobs continue to be the models made in China by Synta, sold under the Sky-Watcher brand as its Classic series, and Orion's SkyQuest XT Dobs. The mirrors are well made and mounted, and the focusers and finderscopes are excellent. The altitude tension control and Teflon bearings provide the essential smooth motions. For about $300, the 6-inch (150mm) is a great starter scope capable of showing far more than any 70mm or 80mm refractor or 4.5-inch equatorial reflector of comparable price.

At $450 to $550, the 8-inch (200mm) Dob is perhaps the best telescope deal in the history of the hobby. For previous editions of our book, we bought a Classic solid-tube Sky-Watcher Dobsonian and commented, "Right out of the box, it was in perfect collimation after traveling all the way from China." For this edition, we purchased a Sky-Watcher Flextube 200P and found the same—spot-on collimation and textbook-perfect star images. It has become one of author Dyer's favorite telescopes, a keeper!

The 10-inch (25 cm) models ($600 and up) from Sky-Watcher and Orion are also incredible bargains, providing even more aperture for hunting deep sky denizens. But now the tube is getting big and long. So in this size, and certainly for 12.5-inch (32 cm) and larger Dobs, we recommend a truss-tube unit, such as an Explore Scientific Generation II, an Orion SkyQuest or a Meade Lightbridge, or a collapsible Flextube model from Sky-Watcher.

Beyond the mass-market reflectors, we enter the realm of the high-end Dobsonian, with furniture-grade wood construction and handcrafted mirrors made by the top names in optics, such as Galaxy Optics; Optical Mechanics, Inc./James Mulherin; Ostahowski Optics, Inc./Terry Ostahowski; and Zambuto Optical Company.

Boutique companies come and go in this

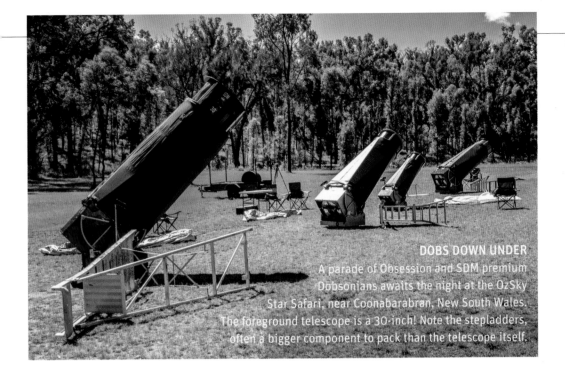

DOBS DOWN UNDER
A parade of Obsession and SDM premium Dobsonians awaits the night at the OzSky Star Safari, near Coonabarabran, New South Wales. The foreground telescope is a 30-inch! Note the stepladders, often a bigger component to pack than the telescope itself.

DON'T ASK!
Telescope owners are frequently asked two questions:
◆ How much does it magnify?
◆ How far can you see?

To avoid appearing too ignorant, never ask those! This chapter dispels the magnification myth. And with telescopes, it isn't how far you can see but how faint. For more questions commonly asked by new telescope owners, see page 212.

category. However, the unquestioned leader in premium Dobs is Wisconsin-based Obsession Telescopes. Owner Dave Kriege pioneered the truss-tube Dobsonian. Prices to satisfy your obsession for big aperture start at $4,500 for a 12.5-inch and go up to $20,000 for 25-inch Classic models. The UC (Ultra Compact) models (15-inch to 22-inch) feature minimalist structures for minimum weight and maximum portability. We've looked through many Obsessions over the decades, and all have been superb, in both optics and mechanics.

PROS AND CONS OF TELESCOPE TYPES

No telescope design guarantees superb images. Only quality craftsmanship can guarantee quality images. But these are the principal plus and minus points of each design.

TYPE	ADVANTAGES	DISADVANTAGES	STARTING PRICE WITH MOUNT
Achromatic refractor	Low cost; sharp, contrasty images; rugged and durable design	Chromatic aberration, especially in fast f/5 to f/6 designs	$150
Apochromatic refractor	Freedom from most aberrations; excellent for deep sky imaging	Highest cost per inch of aperture; limited aperture	$1,200
Newtonian reflector	Lowest cost per inch of aperture; adaptable to Dobsonian mount	Coma at field edge; requires occasional collimation	$300
Schmidt-Cassegrain	Compact; good for some imaging	Large secondary obstruction	$700
Maksutov-Cassegrain	Compact; sharp optics; long focal length good for planetary viewing	Slow focal ratios and narrow field; long cool-down in large apertures	$400
Maksutov-Newtonian	Wide, flat field; fast focal ratio	Long cool-down time; heavy	$2,000

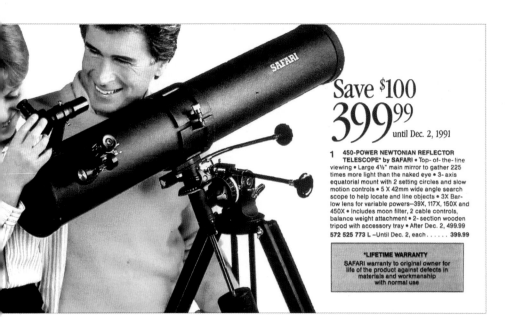

Save $100
399⁹⁹ until Dec. 2, 1991

**1 450-POWER NEWTONIAN REFLECTOR
TELESCOPE* by SAFARI** • Top-of-the-line
viewing • Large 4½" main mirror to gather 225
times more light than the naked eye • 3-axis
equatorial mount with 2 setting circles and slow
motion controls • 5 X 42mm wide angle search
scope to help locate and line objects • 3X Bar-
low lens for variable powers—39X, 117X, 150X and
450X • Includes moon filter, 2 cable controls,
balance weight attachment • 2-section wooden
tripod with accessory tray • After Dec. 2, 2,499.99
572 525 773 L –Until Dec. 2, each **399.99**

***LIFETIME WARRANTY**
SAFARI warranty to original owner for
life of the product against defects in
materials and workmanship
with normal use

CLASSIC EQUATORIAL NEWTONIANS

A Sears catalog page from
1991, above, shows the
Newtonian telescope
that has been around for
decades: the 4.5-inch on
the venerable EQ2 mount.
But can you identify how
many things are wrong
with how it is set up?
See Chapter 10.
No wonder people
have problems using an
equatorial mount. The
Celestron AstroMaster
130mm, right, is a decent
modern successor on a
similar mount, and here,
it is set up correctly. It
sells for $300 with motor
drive. The Sears Safari was
$400—in 1991.
But, hey, it was
450x!

COLLIMATION

The primary and secondary mirrors in a
Newtonian reflector and the secondary
mirror in a Schmidt-Cassegrain require
occasional adjustment to ensure
the images remain sharp.
This is called collimation.
The process is illustrated
in the Appendix.

EQUATORIAL NEWTONIANS
114mm to 25 cm (4.5-inch to 10-inch)

The standard instruments of the 1960s—
6-inch f/8 or 8-inch f/7 Newtonians on Ger-
man equatorial mounts—have largely disap-
peared from the market. Dobsonian-mounted
versions remain the more popular choice.

However, smaller Newtonians on light-
weight German equatorial mounts continue
to populate the entry-level market. Tens of
thousands of amateur astronomers started
their astronomical lives with a Tasco 4.5-
inch (114mm) Newtonian, the 11TR, sold for
decades. Largely replacing the Tasco-style
4.5-inch is another ubiquitous telescope,
the Synta 5.1-inch (130mm) reflector, usually
offered in an f/5 version ($250 to $300) and
sold under various brand names, such as the
Orion SpaceProbe, Celestron's AstroMaster
and the similar Meade Polaris. The quality of
the f/5 parabolic mirror is very good. (Avoid
any Newtonian with just a spherical mirror;
the images will not be sharp.)

This telescope's mount is the EQ2 style that
has been on the market for more than half a
century (see Chapter 10). The mount is just
adequate, but the other fittings and accesso-
ries of these 130mm reflectors are usually fine
and, if equipped with the optional motor drive,
will provide hands-off tracking (but not GoTo).

Larger 6- and 8-inch f/5 Newtonians on
Chinese-made mounts, such as the Orion
AstroView and SkyView models ($450 to
$600), also provide good-quality choices for
the visual observer, though neither is a GoTo
telescope. The Orion Sirius 8-inch and Atlas
8- and 10-inch Newtonians ($1,600 to $2,200)
have much sturdier GoTo mounts. In the same
league, Meade has its competing LX85 6- and
8-inch Newtonians ($1,000 to $1,200).

Such equatorial f/5 Newtonians appeal to
aspiring deep sky astrophotographers. But we
think there are better choices, as we describe
in Chapter 17. Even for visual use, we suggest
avoiding equatorial Newtonians larger than
6 inches, as the big tubes tend to be shaky and
wind-prone. Even in smaller sizes, the eye-
piece can be hard to reach because its orien-
tation changes as the telescope moves around
the sky. In a Dobsonian, the eyepiece stays at
a consistent angle.

MAKSUTOVS
90mm to 180mm (3.5-inch to 7-inch)

A form of reflector, the catadioptric telescope combines a mirror with a front lens, or corrector, that serves to eliminate optical aberrations. The designs are usually named after their inventors.

The Maksutov-Cassegrain was invented in the 1940s by Dmitri Maksutov. Most "Maks" are f/13 to f/15 Cassegrain systems, in which the light is directed out the back of the telescope through a hole in the primary mirror.

The legendary Maksutov of this style is the 3.5-inch f/14 Questar, introduced in 1954 as a top-of-the-line compact telescope, defying all the trends over the decades to big aperture and computers. Remarkably, the legendary Questar 3.5 is still available—for $5,000 to $6,500. Judging by its longevity, it is the right "prestige" telescope for a very select market.

Maksutov-Cassegrains are available as tube assemblies or as fully mounted telescopes in 90mm to 180mm apertures. Examples include Orion's Apex and StarMax lines, Sky-Watcher's Skymax units, Explore Scientific's FirstLight models and Celestron's Nex-Star series.

However, the trendsetting Mak was, and to some extent still is, the Meade ETX-90,

MAKSUTOV GLASS

This older-model 150mm Sky-Watcher Maksutov shows the design's characteristic steeply curved front corrector lens, which holds the secondary mirror. Celestron, Meade, Orion and Sky-Watcher typically have 3.5- to 7-inch (90mm to 180mm) Maks in their lines.

THE MOUNTING MENAGERIE

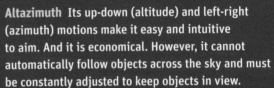

Just as there are many types of optics, there are many types of mounts, creating endless mix-and-match possibilities. No one type is best. The key factor is that the mount be steady yet easy to move and aim.

Altazimuth Its up-down (altitude) and left-right (azimuth) motions make it easy and intuitive to aim. And it is economical. However, it cannot automatically follow objects across the sky and must be constantly adjusted to keep objects in view.

Dobsonian Like any alt-az mount, the Dobsonian cannot track the stars, at least not without a computerized motor system. While it lacks slow-motion controls, a Dob's simple Teflon bearings make it easy to move and nudge to follow objects. And it is inexpensive.

German Equatorial (GEM) This classic design was invented in Germany in 1824 by Joseph von Fraunhofer, thus the name "German." One axis aims at and rotates around the celestial pole; a simple motor is all you need to track objects so that they stay fixed in the eyepiece. A computer is not required.

Chinese Equatorial This GEM variation is proprietary to China-based iOptron. Its center-balanced equatorial mount (CEM) reverses the location of the declination axis to place the weight of the scope over the center of the tripod for better load-handling characteristics. (Courtesy iOptron)

Fork Suitable for stubby-tubed telescopes, such as Maksutov- and Schmidt-Cassegrains, a fork mount can be set up as an alt-az mount or, as shown here, can be turned into an equatorial mount by tipping it over on a wedge so that the fork tines point to the celestial pole.

GoTo Some altazimuth mounts, such as the Sky-Watcher AZ-GTi (far left) and the Orion StarSeeker (left), can be used only as a GoTo mount under computer control. Other than small beginner mounts, most GEMs and CEMs are also equipped with GoTo systems.

HAVE MAK, WILL TRAVEL
Like refractors, Maksutovs are mostly maintenance-free, with collimation of the mirrors not even possible. In small sizes, they are rugged and highly portable telescopes, like this Celestron NexStar 4SE f/13 Mak, left, with the solid GoTo mount for $500. In sizes under 150mm, Maks like Meade's ETX-90 and ETX-125, right, meet our criterion for portability. Their f/13 to f/15 optics are well suited to lunar and planetary observing, making them great for urban sites. Their small secondary obstruction gives them refractorlike sharp, contrasty images.

introduced in 1996 as a low-cost Questar clone. Meade ETXs have consistently offered excellent optics, though inevitably, at $500 for the 90mm, the mounts and fittings are plastic. The plastic gears emit the odd creaking noises characteristic of ETXs. But with their reliable Autostar computers, they do slew to and track objects very well.

While excellent for lunar and planetary observing from urban sites, Mak-Cassegrains are not so ideal for deep sky viewing from dark sites, as their long focal length and slow focal ratios make it hard to achieve the low power and wide fields that are best for some objects. The other caveat is that large Maks

(150mm and up) take a long time to cool down. While they can provide superb planetary images, they do so only after they cool for an hour or more to eliminate thermal currents inside the closed tube.

A variation is the Maksutov-Newtonian, usually made with a faster f/5 focal ratio that is better for deep sky viewing and imaging. Explore Scientific's 152mm Comet Hunter is a Mak-Newt, as are specialized 190mm imaging reflectors from Sky-Watcher and Orion (about $1,600). Mak-Newts sound ideal, but they, too, suffer from long cool-down times and also high weight, demanding a large mount. Mak-Newts have never caught on.

TO GOTO OR NOT TO GOTO?

In some brands, telescopes with identical optics might be available on either manually operated mounts or computerized GoTo mounts. Which version should you buy? It depends…

For example, Orion's StarSeeker IV 130mm Newtonian comes on a very capable altazimuth GoTo mount with WiFi app control ($450). Essentially the same f/5 optics are available in the Orion German equatorial SpaceProbe 130ST ($300). The optional single-axis motor ($100) adds tracking, but not GoTo. In this instance, the choice is clear: Go for the GoTo. Don't buy the equatorially mounted version thinking it'll be better for astrophotography—the EQ2 class of mount and drive are simply not good enough.

In other cases, the premium for "going

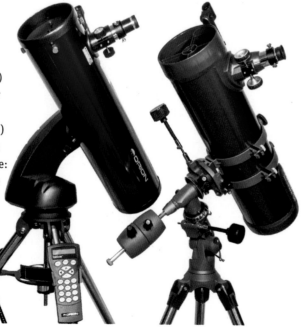

COMPUTERIZED OR MANUAL?
The Orion StarSeeker (left) and Celestron AstroMaster both feature similar and excellent 130mm (5.1-inch) f/5 Synta-made Newtonian optics. But it is your choice: Save money by getting the basic equatorial mount with the AstroMaster ($300 with drive), or spend more for the StarSeeker's full GoTo system ($450).

GoTo" is much higher. Adding the GoTo motor and SynScan computer to a Sky-Watcher Flextube Dobsonian essentially doubles its cost, for example, putting the 8-inch at over $1,000.

With some exceptions, you'll get more aperture for the dollar—and better views—by purchasing a manual telescope. But *you'll* have to do the finding. To buy a GoTo scope within your budget, you usually have to sacrifice aperture. But you might see more because you'll find more. That's especially true under bright suburban skies, where star-hopping even to bright deep sky objects can be tough. Yet you *can* see them, if only you can find them.

THE REMARKABLE SCHMIDT-CASSEGRAIN
20 cm (8-inch)

For more than 50 years, the telescope that has been, and continues to be, at the technological forefront of amateur astronomy is the Schmidt-Cassegrain telescope, or SCT, a variation of a design invented by Bernhard Schmidt in the 1930s. Since 1970, the 8-inch model has been the top-selling serious recreational telescope for its good combination of aperture, portability and features. We've both owned several SCTs over the years.

Ignoring the much-reviled Criterion Dynamax of the late 1970s, Celestron's first serious competition came in 1980, when Meade Instruments introduced its Model 2040 4-inch and Model 2080 8-inch SCTs. Meade started out in the early 1970s selling telescope accessories and good-quality Newtonians but soon realized that the future lay with the SCT.

For the past few decades, Meade and Celestron have battled with advertising and feature wars. Despite their success and perhaps because of the stiff competition over the years, both companies have faced financial crises, near closures and attempted mergers. Although they are based in California, both are owned by offshore companies, with most of the manufacturing now in China, Taiwan or Mexico.

We've divided our survey of the popular 8-inch SCTs first into models with German equatorial mounts, then into the fork-mounted units by price class. All are GoTo telescopes. Basic manual SCTs went extinct in the 1990s,

with the last noncomputerized models being Meade's LX5, LX6 and Premiere and Celestron's Super C8, Powerstar and Ultima C8.

German Equatorial Models ($1,800 and up)

Both companies offer 8-inch Schmidt-Cassegrains on compact but sturdy German equatorial mounts. Celestron has its Advanced VX (AVX) C8 and Meade its LX85, both with GoTo systems for about $1,800. The mounts are fine, and the optics are identical to what's in fork-mounted units.

If you think you might get into astrophotography, an AVX model might be a good choice, as it has a very solid, small mount that can accept a variety of tube assemblies, such as an apo refractor that we recommend as the best astrophoto scope (see Chapter 17). For a telescope intended just for visual use, however, we suggest one of the lower-cost fork-mounted models.

Entry-Level Fork Models ($1,200)

This category introduces the fork mount that works so well on stubby-tubed telescopes like the Schmidt-Cassegrain. These GoTo instruments operate in altazimuth mode, making them easier to set up than the German equatorial models, as there is no need for polar alignment and no counterweights.

In this price class, Celestron has the Nex-Star 8SE, while Meade offers the LX65 (each $1,200). While we call this class "entry-level," either model can serve you well for many years for visual use and for easy-to-shoot images of the Moon.

For GoTo alignment, Celestron employs its SkyAlign system, in which you level the tripod, then slew the scope to any three bright objects in the sky. It works very well, allowing you to align a GoTo scope even if you can't identify any bright star.

Meade has its Level North Technology (LNT), which requires that you level the tube and aim it either due north or to magnetic north. The scope then slews to two alignment stars it selects. (Chapter 11 has more details.)

While their single-arm forks are solid enough, the light tripods of both models tend to be somewhat vibration-prone for the mass

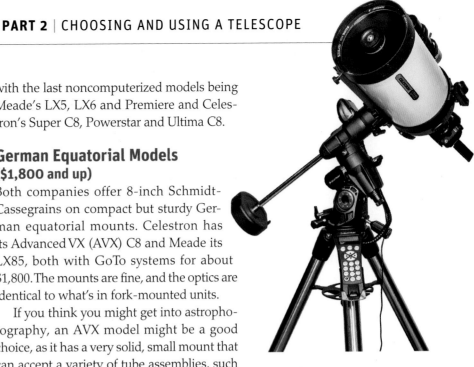

SCT ON A GEM
The Celestron 8-inch EdgeHD on its small but solid AVX mount is a combination suitable for astrophotography. While Celestron offers the same tube on the larger CGEM II ($2,400) and massive CGX mounts ($3,000), they are overkill for a C8. They would be good only if you intend to upgrade to an even bigger optical tube in the future.

SLEWING A GOTO TELESCOPE
Computerized telescopes that can find targets for you are called "GoTo" telescopes: When you press a button, they go to the object. We call this movement of the telescope slewing to the object. In astronomical parlance, slew = move.

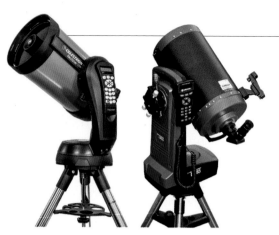
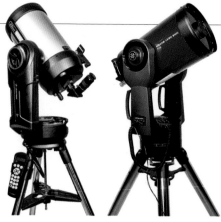
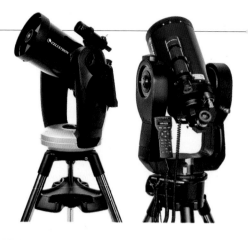

ENTRY-LEVEL SCTS

At the lower end of their lines, Celestron has its long popular NexStar SE (left) and Meade its newer LX65 (right), both on sturdy single-arm forks. These telescopes weigh about 30 pounds for tube and mount, but the LX65's fork mount can accept a second tube assembly, such as a small refractor, for complementary viewing.

MIDPRICED SCTS

Celestron's newer Evolution series (left) has WiFi. Meade's older LX90 (right) adds the two-arm fork mount. Also midpriced but not shown is Meade's LightSwitch ($2,000), which includes a camera that performs auto-alignment. Celestron offers that feature in the StarSense camera, which can be added to any of its SCTs and is bundled with some.

PREMIUM SCTS

Celestron's CPC 800 (left; courtesy Celestron) and Meade's LX200 ACF (right) include features for astrophotography—all very nice, but be warned: The Celestron CPC 800 with tripod weighs 61 pounds, while the Meade 8-inch LX200 is 73 pounds. Unless you can leave the scope assembled and wheel it out on a dolly (see Chapter 9), stay with the lighter models.

THE SCHMIDT-CASSEGRAIN SHOP

In the "old days," Celestron and Meade each offered only one 8-inch Schmidt-Cassegrain. As of 2020, Celestron has 11 models, while Meade has five. The gallery above depicts the major models of 8-inch SCTs in each of three price categories.

of telescope they are supporting. The tripods are best matched to the 6-inch versions of the NexStar SE or LX65 models. But for visual use, they work well enough.

Midpriced Fork Models ($1,800)

Moving up the price range brings us to Celestron's recent NexStar Evolution 8 ($1,700) and Meade's venerable LX90 ($1,800). Both offer a sturdier mount and tripod for a steadier image with less vibration when you touch the telescope.

The optics are the same as in the entry-level models, with Celestron also offering an EdgeHD version of the Evolution 8. While EdgeHD optics are good for deep sky photography, this is not a telescope we would recommend for that purpose. So forget the EdgeHD option.

The Meade LX90 includes periodic error correction and a GPS receiver for automatic detection of your site, date and time for ease of GoTo alignment. By 2020, however, the LX90 was a little old and in need of an upgrade to WiFi and app control, which negates the need for GPS, as your smartphone provides that information.

Celestron's Evolution 8 introduced built-in WiFi to Schmidt-Cassegrains and a recharge-able lithium battery that is good for a night or two of operation. With WiFi, the telescope is controlled by Celestron's free SkyPortal mobile app (see Chapter 11), for a user experience more in keeping with 21st-century expectations for a high-tech telescope compared with a classic hand controller.

Top-End Fork Models ($2,000 to $2,700)

At the top end as of 2020, Celestron has the CPC Series ($2,000 for the 8-inch CPC 800) and Meade has its LX200-ACF ($2,700). Both have been on the market for many years as reliable and well-established units but are perhaps destined for replacement.

With the optics the same across the lines, what sets the top-end SCTs apart are features designed for astrophotography. For Celestron, the CPC 800 offers even more solid fork arms (needed when the telescope is tipped over on an equatorial wedge, as it must be for long-exposure imaging), a heavier tripod, GPS (but no WiFi), an auto-guider port and periodic error correction. Meade's LX200-ACF adds the more advanced Autostar II computer with GPS (but not WiFi), a much sturdier mount than the LX90, an auto-guider port and mirror locks.

While neither scope would be our first choice for an astrophoto rig, many people do get great results with them. But for primarily visual use, the massive weight of each of these scopes will make you think twice about setting one up for a casual backyard stargazing session. In an 8-inch SCT, we advise staying with the entry-level or midrange models.

Larger and Smaller SCTs
($700 to $19,000)
While the 8-inch models are the most popular Schmidt-Cassegrains, Meade and Celestron manufacture other sizes. In smaller scopes, Celestron has its NexStar 5SE ($700) and 6SE ($800), both with great optics and rock-solid mounts and tripods. To compete at the entry level, Meade has a 6-inch f/10 ACF-optics version of the single-fork LX65 ($1,000). These SCTs are more portable and easier to set up than their bigger 8-inch cousins. We recommend the 6-inch SCTs for your prime consideration for their good blend of aperture, light weight and ease of use.

At the other end of the scale, Celestron has 9.25-inch models in its Evolution ($2,200) and CPC series ($2,500) and the 11-inch CPC 1100 ($3,000). Meade has 10-inch ($2,400) and 12-inch ($2,900) scopes in its midrange LX90 ACF series. However, the tall, light fork mounts of the big LX90s are not a good match for the larger tubes.

Meade's LX200 ACF series is a better choice for the aperture-hungry buyer. The 10-inch ($3,500) is just portable, while the 12-. 14- and 16-inch models ($4,600 to $16,000) rank as observatory instruments. Ditto on Meade's even more massive LX600 series of 10- to 16-inch SCTs ($4,700 to $19,000).

Celestron vs. Meade
So which is better, Meade or Celestron? We have examined images in dozens of their SCTs. In units we have tested and owned in recent years, all have contained excellent optics with no consistent difference in optical quality. It's a toss-up.

In mechanics, the focusing mechanisms in Celestrons we've used tend to be more precise, though still with some image shift from the moving mirror. In some Meades, the focus has

had a greasy feel, making it hard to nail the focus. Meades also tend to be noisier when slewing than Celestrons but are accurate. Chapter 11 has more details on each of their GoTo systems.

SCHMIDT-CASSEGRAIN OPTICS

Much has been written about the quality of Schmidt-Cassegrain optics. Detractors maintain that the 33 to 38 percent obstruction of the secondary mirror degrades images unacceptably. In our experience, an SCT with well-made optics, as they have been for many years, provides images sharp enough to please the vast majority of users. With its central obstruction, an 8-inch SCT can deliver contrast and sharpness equal to those of a 5-inch refractor.

We're convinced that the reason many SCTs don't perform well is that their optics are not properly collimated. With these telescopes, the slightest miscollimation of the critical secondary mirror softens planetary detail and degrades contrast. (See the Appendix.)

Celestron now offers the option of EdgeHD optics in many of its models, while Meade has Advanced Coma Free (ACF) optics in all its models. Both are designed to provide sharper stars over a wider field of view when imaging than conventional Schmidt-Cassegrain optics.

For visual use, we've found no significant differences between classic SCT and ACF optics in side-by-side tests. Celestron's EdgeHD design includes an extra field-flattener lens system in the baffle tube that can reduce light transmission. For purely visual use, the EdgeHD option is not needed. Save your money.

BIG CATS
Big-aperture Schmidt-Cassegrains, such as Celestron's 11-inch CPC (left) and Meade's 10-inch LX200 (right), are as close to dream scopes as most people will want. But these are also the telescopes that are soon offered for sale by owners who overbought and find they rarely use the telescope. Just saying!

RECOMMENDED TELESCOPES

TELESCOPE PARADISE
Happy stargazers ready a diverse array of telescopes for a night of celestial exploration. Annual star parties are wonderful, but by choosing a portable telescope that's easy to use, you'll be able to enjoy its views on more than just one special weekend a year.

We should emphasize again that the best telescope isn't necessarily the biggest or the one with the fanciest technology. *The best telescope is the one you will use most often.* To that end, our list of recommended models is biased toward those with sharp optics, a steady, jitter-free mount, convenient portability and ease of use, all at an attractive price.

Everyone nods in agreement that these are the important traits of a good telescope. Yet all too often, prospective buyers we talk to ignore our advice, making their purchase based on other reasons, such as what was on sale at the local big-box store, which had the splashiest magazine ad or YouTube endorsement or which was cheaper on Amazon Prime.

A common desire of many new buyers is a telescope that will also allow them to take images with their DSLR camera. It is certainly possible, but those choices are complex enough that we cover them in Chapter 17. Here, we deal with telescopes that are best suited for visual use, which is what we suggest you start with anyway.

No one can be an expert in the 1,500+ models now on the market. But of the telescopes we've used in recent years and tested specifically for this edition, the following are our favorites.

GETTING STARTED: REFLECTORS ($200 to $450)
The following Newtonian reflectors represent our first choices for your first telescope. None require a major outlay, and all will retain good resale value. In this price class, we suggest staying with a manual telescope and avoiding low-cost GoTo scopes. But that means you have to find objects by star-hopping, as per our tours in Chapters 6 and 16. Topping our list is…

6-inch f/8 Dobsonian (Orion SkyQuest; Synta/Sky-Watcher Classic)
Depicted on page 136, these well-made $300 scopes provide great optics on a stable mount and represent our first choice for a starter scope. In a side-by-side test, an Orion SkyQuest beat a cumbersome 6-inch achromatic refractor for sharp planetary images.

Orion StarBlast 6
This compact Dobsonian ($280) uses 6-inch f/5 optics on a one-arm mount. While it is more compact than the f/8 Dobs, the StarBlast must be placed on a table to be operated. The optics are sharp, the mount is sturdy, and the fittings and accessories are excellent. For a young child, consider the smaller StarBlast 4.5

or SkyQuest XT4.5, both unbeatable values at $200 and able to show far more than any 60mm "450x" trash scope.

Sky-Watcher 130mm Heritage

This tabletop Dobsonian ($220) uses a minimalist collapsible tube that works surprisingly well. The open design will be prone to glare from lights, so it might not be the best choice for use in a light-polluted urban backyard. But from a darker site, both the 130mm and the larger 150mm Heritage are fine portable starter scopes for an adult or a child.

130mm f/5 Equatorial Reflector (Celestron AstroMaster; Explore Scientific FirstLight; Orion SpaceProbe; Meade Polaris)

We'll admit that our first-choice Dobsonians aren't for everyone. They may be too big, too long or impractical to use at locations such as apartments and condos. While equatorially mounted Newtonians are popular, these beginner models are not suitable for most astrophotography, even with the motor drive.

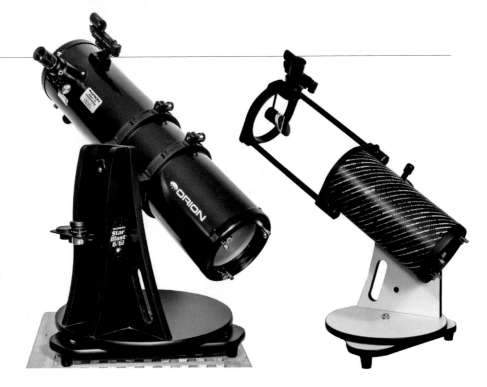

TABLETOP STARBLAST AND HERITAGE

Orion's 6-inch StarBlast, left, is a great example of a Dobsonian reflector that delivers the most bang (i.e., maximum aperture and best views) for the buck. Its solid mount moves smoothly, the included Plössl eyepieces and focuser are good, and the f/5 mirror is excellent. Sky-Watcher's Heritage 130mm, right, and larger 150mm are minimalist reflectors but work well, providing good aperture and sharp optics at low cost. The upper end collapses down to make a compact package for storage and transport. But like all tabletops, both Heritage models must be placed on a sturdy platform.

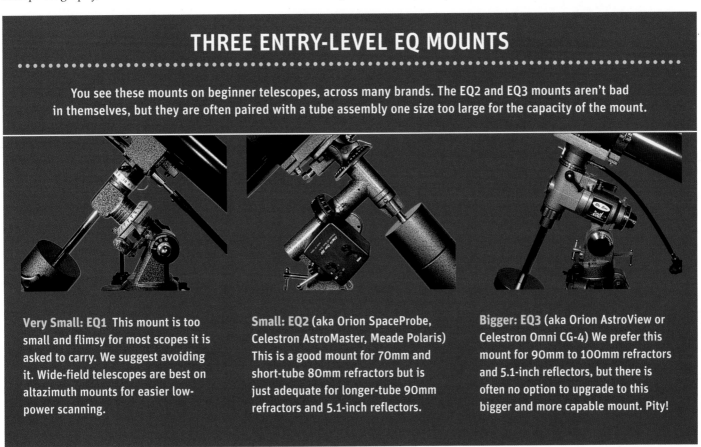

THREE ENTRY-LEVEL EQ MOUNTS

You see these mounts on beginner telescopes, across many brands. The EQ2 and EQ3 mounts aren't bad in themselves, but they are often paired with a tube assembly one size too large for the capacity of the mount.

Very Small: EQ1 This mount is too small and flimsy for most scopes it is asked to carry. We suggest avoiding it. Wide-field telescopes are best on altazimuth mounts for easier low-power scanning.

Small: EQ2 (aka Orion SpaceProbe, Celestron AstroMaster, Meade Polaris) This is a good mount for 70mm and short-tube 80mm refractors but is just adequate for longer-tube 90mm refractors and 5.1-inch reflectors.

Bigger: EQ3 (aka Orion AstroView or Celestron Omni CG-4) We prefer this mount for 90mm to 100mm refractors and 5.1-inch reflectors, but there is often no option to upgrade to this bigger and more capable mount. Pity!

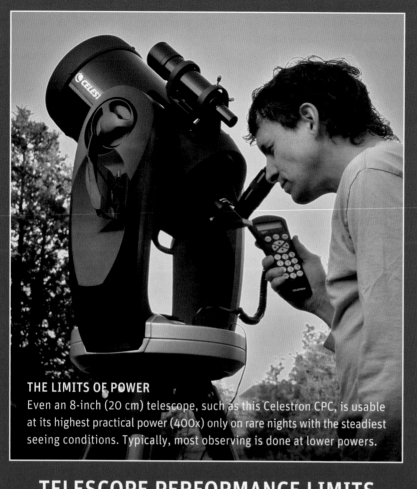

THE LIMITS OF POWER
Even an 8-inch (20 cm) telescope, such as this Celestron CPC, is usable at its highest practical power (400x) only on rare nights with the steadiest seeing conditions. Typically, most observing is done at lower powers.

TELESCOPE PERFORMANCE LIMITS

These figures are commonly quoted in a telescope's specifications and are what any telescope of each aperture is capable of achieving in theory, if not in practice.

Aperture (inches)	Aperture (mm)	Faintest Stellar Magnitude Visible	Theoretical Resolution (arc seconds)	Highest Usable Power
2.4	60	11.6	2.00	120x
3.1	80	12.2	1.50	160x
4	100	12.7	1.20	200x
5	125	13.2	0.95	250x
6	150	13.6	0.80	300x
8	200	14.2	0.65	400x
10	250	14.7	0.50	500x
12.5	320	15.2	0.40	600x
14	355	15.4	0.34	600x
16	400	15.7	0.30	600x
17.5	445	15.9	0.27	600x
20	500	16.2	0.24	600x

Even large scopes can rarely use magnifications over 600x or resolve better than 0.4 to 0.5 arc second.

In this class, we like the ubiquitous 130mm f/5 units sold under various brands, as they have good optics. For this edition, we tested Celestron's AstroMaster 130EQ (depicted on page 138). While its main optics were good, the included erect-image 20mm eyepiece was among the worst we have seen. The Astro-Master version of the EQ2 mount, while fairly steady, proved awkward to use, as controls and lock knobs collided or were hard to find and reach. The tube was difficult to rotate in the cradle to place the eyepiece at a convenient angle. Struggling with it confirmed our opinion that a Dob is so much easier to use.

GETTING STARTED: REFRACTORS ($150 to $300)

A refractor can certainly be more appealing than any reflector. It's what a child expects a telescope to look like and is rugged and low-maintenance, good traits for a child's scope. Some of these models are generic and are sold under different brands. Others are unique to a specific brand.

70mm f/10 Alt-Az Refractor (Meade StarPro)

Provided it is on an altazimuth mount with slow-motion controls, a 70mm f/10 refractor provides sharp optics and ease of use. It is the lowest-priced telescope of quality on the market. No other scope for $150 or so is worth considering, even for a child keen on the stars and planets.

80mm/90mm f/6.7 Alt-Az Refractor (Explore Scientific FirstLight; Meade StarPro; Orion VersaGo E)

The step up in aperture gets you a much better telescope. We tested and were impressed by this trio of achromatic refractors from Explore Scientific, Meade and Orion ($180 to $200). They are not the same telescope rebranded; each is unique. While all are f/6.7, color correction is good and the main lenses are sharp. The mounts are a little shaky, but all three are good starter scopes that look like "real telescopes" and so should delight any child. Yet these are not toys to be used once or twice then set aside; they can each serve an aspiring astronomer for many years.

90mm f/10 Equatorial Refractor (Celestron AstroMaster; Meade Polaris; Orion AstroView)

These long-focus 90mm refractors have amazed us with the sharpness of their optics at any price, let alone the $300 these models cost. Because of their long tubes, they are best on an equatorial mount, with the EQ2 class of manual mount the usual offering. Add the single-axis DC motor drive, and you have a fine astronomical instrument for high-power lunar and planetary viewing from urban sites or any location.

Celestron StarSense Explorers

Introduced in early 2020, these remarkable telescopes include a cradle for your smartphone, which rides along with the scope, allowing the StarSense app to take images of the night sky using the phone's camera. It then uses those images to figure out where things are, to guide you to targets as you move the scope around. It is very clever and works amazingly well, even under poor sky conditions.

As of late 2020, the StarSense line includes two fine refractors: the 80mm f/11 LT ($180) and the 102mm f/6.5 DX ($380), both with sharp lenses, though hampered by low-grade eyepieces and a fuzzy erect-image star diagonal. Of the two reflectors in the StarSense series, the 130mm f/5 DX ($400) is the best optically. All are good telescopes for an older child.

CELESTRON'S STARSENSE SERIES

With Celestron's StarSense Explorer refractors (shown here are the 80mm LT, left, and 102mm DX, right), you download the free app and enter your unique code to unlock it. Clamp your smartphone into the adjustable bracket, perform a simple alignment of the phone, and it will then accurately guide you to targets as you move the telescope around the sky following the app's direction arrows (shown at far right). To an extent, the StarSense scopes make all other beginner scopes obsolete, so these rank high on our list of telescopes for your consideration. However, the technology is almost certain to migrate to other models, such as Dobsonian reflectors.

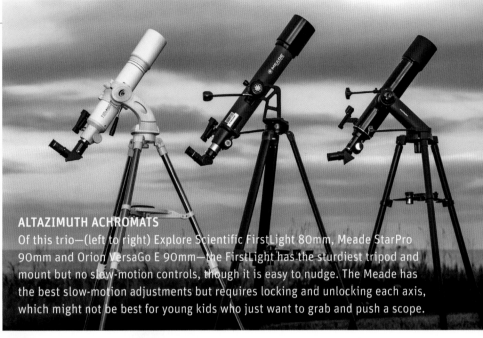

ALTAZIMUTH ACHROMATS
Of this trio—(left to right) Explore Scientific FirstLight 80mm, Meade StarPro 90mm and Orion VersaGo E 90mm—the FirstLight has the sturdiest tripod and mount but no slow-motion controls, though it is easy to nudge. The Meade has the best slow-motion adjustments but requires locking and unlocking each axis, which might not be best for young kids who just want to grab and push a scope.

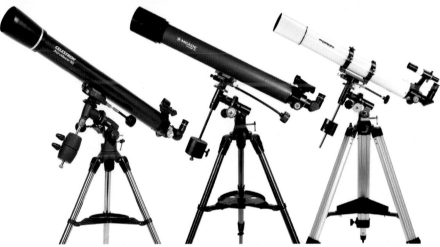

EQUATORIAL ACHROMATS
Above: The 90mm f/11 refractors from Celestron (left), Meade (center) and Orion (right) are all similar on the EQ2-style mount. This class of telescope is a good starter scope for an older child or a teen who can sort out the use of an equatorial mount—it confounds many adults! (Photos courtesy Celestron, Meade and Orion)

 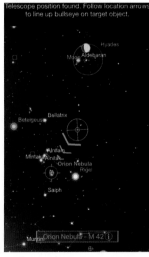

All provide computerized finding without the fuss of having to enter site information and aligning on stars—and at little extra cost, because the computing power is in the phone you already own. We were impressed. Should the technology fail, you still have a good manual beginner scope.

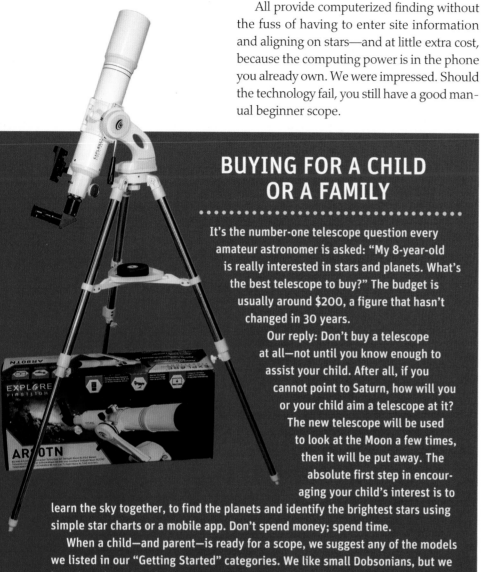

BUYING FOR A CHILD OR A FAMILY

It's the number-one telescope question every amateur astronomer is asked: "My 8-year-old is really interested in stars and planets. What's the best telescope to buy?" The budget is usually around $200, a figure that hasn't changed in 30 years.

Our reply: Don't buy a telescope at all—not until you know enough to assist your child. After all, if you cannot point to Saturn, how will you or your child aim a telescope at it? The new telescope will be used to look at the Moon a few times, then it will be put away. The absolute first step in encouraging your child's interest is to learn the sky together, to find the planets and identify the brightest stars using simple star charts or a mobile app. Don't spend money; spend time.

When a child—and parent—is ready for a scope, we suggest any of the models we listed in our "Getting Started" categories. We like small Dobsonians, but we have heard stories of youngsters bursting into tears after receiving a Dob as a gift. "That's not a telescope!" they blubber. For them, the only "real" telescope is a long tube atop a tripod.

That's fine. There are some good 70mm to 90mm refractors from which to choose, such as Meade's StarPro series or Explore Scientific's FirstLight scopes (the well-mounted 80mm FirstLight is shown above with its attractive gift box, a definite plus for delighting a child).

That said, if you wish to take advantage of a family vacation to a dark sky site to do some stargazing with your child, we suggest you do so by simply lying back, talking about what the Milky Way is, how far away the stars are and some of their names. Look for satellites and meteors. Pick out some constellation patterns and tell their stories. Or have your child imagine constellations and name them. The result is a memorable night of stargazing, instead of a frustrating hour trying to use an unfamiliar and uncooperative piece of equipment in the dark to aim and focus on something, anything!

STARTER SCOPES TO AVOID

Inevitably, we are asked: "But what about…?" Or readers point out a favorite telescope of theirs that we missed. While there are certainly other fine telescopes out there, we refrain from recommending models that we haven't used or seen.

However, here are types we suggest you *avoid* for a beginner scope, for the reasons stated. To protect the guilty, we have not named specific models, but you will find examples of these from all manufacturers.

◆ Small refractors and reflectors on mounts that are essentially light camera tripods lacking slow-motion controls; they simply have a "pan" handle. They do not work when aimed up, nor can they precisely follow celestial objects.

◆ In fact, dismiss most altazimuth mounts (except a Dobsonian) without the slow-motion controls that are so necessary to aim at and follow targets.

◆ Short-tube 80mm refractors, with f/4 to f/5 focal ratios. At these fast focal ratios, achromatic refractors exhibit gobs of false color and soft images, hampering views of the planets.

◆ Ditto on 100mm and 120mm f/5 achromatic refractors and 114mm f/4 reflectors. All of these instruments are fine for low-power scanning of star fields but not for the range of objects most beginners want to look at, such as high-power views of the Moon and planets.

◆ 114mm (4.5-inch) short-tube Newtonians with f/9 focal ratios. These use a built-in Barlow lens but have poor main mirrors, so images are fuzzy.

◆ 76mm (3-inch) reflectors, especially those on tabletop Dobsonian mounts. They have spherical, not parabolic, mirrors, so images do not come into focus. We tested one and found it to be even worse than a 60mm "trash scope." In a reflector, buy at least a 4.5- or 5.1-inch model.

◆ Just about any telescope on an EQ1 class of equatorial mount. It's too light and flimsy to steadily hold most of the telescope tubes it is paired with, and an equatorial mount is unnecessarily complex to use, especially for a child.

GETTING SERIOUS, BUT STAYING SIMPLE ($400 to $750)

In this price range, you have a choice between basic telescopes with more aperture or smaller telescopes with GoTo functions. First, here are our favorite no-frills telescopes.

Classic Solid-Tube Dobs: 8- and 10-inch (Explore Scientific FirstLight; Orion SkyQuest; Sky-Watcher Classic)

These classic Dobsonians give you serious aperture without costing a bundle. They are well made, with excellent optical quality for the price ($400 to $750). The tubes are four feet long, so keep that in mind when planning on packing your car for a family vacation.

For about $300 more, Orion offers its Sky-Quest models with the IntelliScope option. However, we can foresee that the StarSense technology on your smartphone will make such digital setting circles obsolete.

ORION INTELLISCOPE

An option with some Orion Dobsonians is the IntelliScope, which adds an encoder to each axis and a Computerized Object Locator (inset) that directs you to targets. IntelliScopes we've tested have worked well and are a good hybrid of manual simplicity with computer-aided pointing.

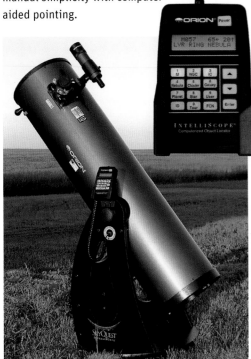

Sky-Watcher Flextube Dobs

While more costly than their solid-tube counterparts, the sliding truss tubes of the 8- and 10-inch Sky-Watchers ($550 and $750) make this scope more compact for transport. We like and highly recommend these telescopes for their superb optics, which provide both bright images of deep sky objects and sharp views of the planets, and for their solid mount with good fittings. What more could you want? Of course, the answer is GoTo.

GETTING SERIOUS—AND MORE COMPLEX ($450 to $1,000)

If GoTo technology is appealing, you'll have to spend at least $450 to get an accurate and reliable system on a telescope with good optics. Inevitably, adding the technology while staying within a budget usually means sacrificing aperture. But the compact size of these telescopes might be a better fit for your observing site and need for portability.

130mm Orion StarSeeker IV

With fine optics identical to those in other Synta 130mm f/5 Newtonians, this $450 telescope has a solid single-arm fork mount and superb GoTo system with built-in WiFi that operates from the SynScan Pro mobile app (see Chapter 11). We bought and tested a unit for this edition and found it works very well. We suggest Orion's StarSeeker series as the minimum "buy-in" for a good GoTo scope, with the 130mm far superior to a traditional equatorial non-GoTo Newtonian.

Celestron's Astro Fi series offers a 90mm f/10 refractor ($410), a 102mm f/13 Mak-Cass ($410) and a 130mm f/5 Newtonian ($425) on a single-arm fork similar to the StarSeekers but on a lighter and less sturdy tripod.

ORION STARSEEKER IV

Right: In North America, these Synta WiFi scopes are sold by Orion as its StarSeeker line. In the series, we particularly like the 130mm f/5 Newtonian for its blend of aperture, portability and price. The optional hand controller (shown) is a worthwhile backup in winter. when mobile devices can die.

SKY-WATCHER FLEXTUBE
Above: Unlike full truss-tube Dobs, Flextube Dobs, such as this 8-inch we really like, collapse for more compact storage but provide quick setup with no assembly or recollimation required. However, they do not break down into as small a set of components as truss-tube telescopes.

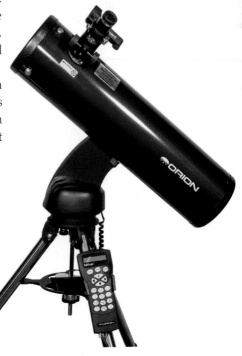

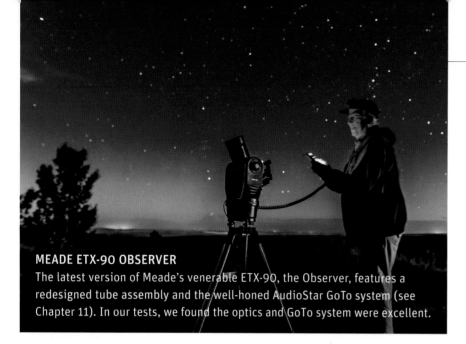

MEADE ETX-90 OBSERVER
The latest version of Meade's venerable ETX-90, the Observer, features a redesigned tube assembly and the well-honed AudioStar GoTo system (see Chapter 11). In our tests, we found the optics and GoTo system were excellent.

CELESTRON NEXSTAR 6SE

Although on the market for many years, the SE series from Celestron remains one of its most popular lines. The 6SE, in particular, is a solid, portable scope for a good price, and with the right accessories, it can be upgraded to WiFi and StarSense.

Meade ETX-90 and ETX-125 Observer

For portability and sharp f/14 optics, the ETX-90 Observer ($500; shown in use above) can't be beat. A sturdy field tripod is included, as is a case for the telescope and a bag for the tripod, along with two good eyepieces, making a complete portable package. The larger ETX-125 Observer ($700) gets you more aperture, still with excellent portability and sharp f/15 Mak-Cass optics. Either makes a fine urban telescope.

Celestron NexStar 5SE and 6SE

For their good blend of aperture and portability in a GoTo scope, Celestron's NexStar 5SE ($700) and 6SE ($800) f/10 Schmidt-Cassegrains have long impressed us. Their solidness, crisp optics, smooth focuser and reliable NexStar computer make them a pleasure to use, and they are easy to carry into the yard and align.

6-inch Meade LX65 ACF

Our guest author Ken Hewitt-White tested the 8-inch version of the LX65 and found that "the superb ACF optics and GoTo capability enabled me to enjoy a wealth of sky objects in my light-polluted city sky." The tripod proved a little light for the weight of the 8-inch scope but is ideal for the 6-inch LX65 ($1,000), the version we are recommending.

GETTING MORE SERIOUS ($1,200 to $3,000)

This price range represents the top dollar that most first-time buyers will likely want to spend, though there is a soaring stratosphere of instruments above this.

8-inch Celestron SCT or Meade ACF

Unless you are a refractor fan or a Dobsonian diehard, the first choice in this price range has to be an 8-inch Celestron Schmidt-Cassegrain or a Meade ACF. All models feature the same optics regardless of price, and the GoTo systems from both companies are excellent.

As we described earlier, Celestron's entry-level NexStar 8SE or Meade's LX65 models are more than adequate for strictly visual use, with the benefit of lower cost in a lighter telescope that is easier to carry and set up. However, you might like the WiFi capability and rechargeable battery in Celestron's Evolution 8 or the astrophoto features of the Celestron CPC 800 or Meade LX200 ACF, if you are willing to handle the weight.

CELESTRON GEM

A German equatorial mount, like Celestron's CGEM, is preferred for astrophotography because of its stability, ease of accurate polar alignment and ability to accept a variety of optical tubes, such as this EdgeHD 8-inch.

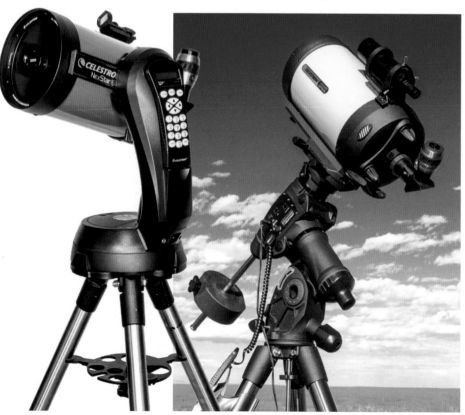

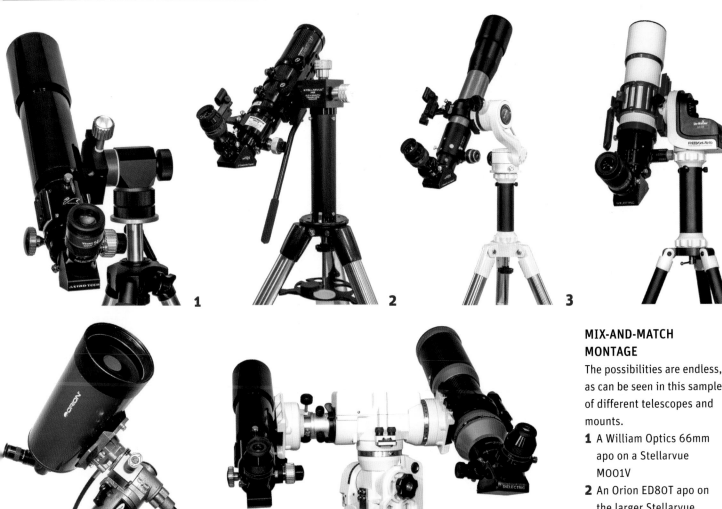

MIX-AND-MATCH MONTAGE

The possibilities are endless, as can be seen in this sample of different telescopes and mounts.

1 A William Optics 66mm apo on a Stellarvue MO01V

2 An Orion ED80T apo on the larger Stellarvue MO02C

3 A Tele Vue TV-85 on the Sky-Watcher AZ5

4 A SharpStar 76EDPH on the Sky-Watcher AZ-GTi GoTo mount

5 An Orion Apex 127mm Mak on an EQ3 mount

6 A dual-scope rig on a Sky-Watcher AZ-EQ5 mount in altazimuth mode

Of these mounts, the AZ-GTi would work well as an airline-friendly package for overseas travel, providing GoTo and tracking. To mate tubes to mounts, most models use the Vixen-standard of dovetail bars and plates for small scopes.

CUSTOM MIX AND MATCH

In the "getting more serious" price class, many experienced stargazers prefer to buy the mount and optics separately, usually from different suppliers. This is a great way to get a top-class telescope that will work for both visual observing and astrophotography. In Chapter 17, we offer our suggestions for an astrophoto rig.

The advantage when you mix and match is you get a mount that is best suited to your needs, with features you like, which can then be used with a variety of optical tube assemblies (OTAs). For example, a small refractor for wide deep sky views can be complemented by a larger Maksutov-Cassegrain for lunar and planetary viewing. While Maks and Schmidt-Cassegrains can be purchased as just tube assemblies for custom mounting, apo refractors are the usual choice for the optics in a mix-and-match combo, since many apos are available only as OTAs.

OPTICAL TUBE ASSEMBLIES

Excellent 70mm to 150mm apo refractors are available from the manufacturers we listed on pages 134 and 135. You can pick a refractor from Astro-Tech, Explore Scientific, Stellarvue, SharpStar, Tele Vue, Vixen and William Optics, among many others.

As an example, the Sky-Watcher Evostar doublet apos are a great value at $480 for the little f/5.8 72ED up to $3,200 for the big f/8 150DX. Explore Scientific's ED127 has an excellent f/7.5 triplet ED lens, dual-speed

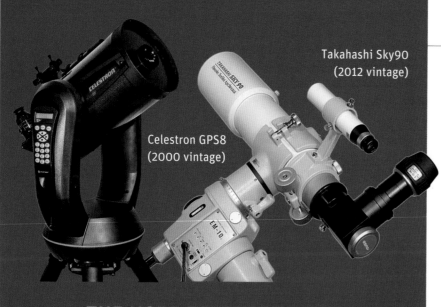

Takahashi Sky90
(2012 vintage)

Celestron GPS8
(2000 vintage)

THE USED-TELESCOPE LOT

A telescope can last a lifetime. It is the high-tech telescopes that lose value the most. Even though they might still work, people don't want old GoTo technology. Indeed, on old scopes, such as the 2000-vintage Celestron GPS8, above, any included GPS receiver will not function, as old systems cannot read the current date correctly. But in most cases, if it was a good telescope in its day and has been well cared for, a used scope can be an excellent buy today.

Check the classifieds on websites such as www.astrobuysell.com, www.astromart.com or, in the southern hemisphere, www.iceinspace.com.au. Buy and sell groups on Facebook are another source. A caution on telescopes on eBay or Kijiji: Most will be trash scopes that remain junk at any price.

GOOD SCOPES OF THE PAST

- ◆ Celestron C5
 (almost any vintage)
- ◆ Celestron/Vixen fluorite apo refractors (early 1990s)
- ◆ Early-model Meade ETX90 and ETX105
- ◆ Any Questar 3.5 (but at a price!)
- ◆ Rare Quantum 4- and 6-inch Maks
- ◆ Hiper APOs made by Officina Stellare (formerly A&M)
- ◆ Apos designed/made by Thomas M. Back/TMB Optical
- ◆ Any Astro-Physics refractor (again at a price!)
- ◆ Any Takahashi or Tele Vue refractor
- ◆ Any Starmaster premium Dobsonian (the Carl Zambuto optics and construction by Rick Singmaster were superb)

USED TELESCOPES TO AVOID
(poor optics and/or mounts)

- ◆ Any Criterion or Bausch & Lomb Schmidt-Cassegrain
- ◆ Almost any Schmidt-Cassegrain produced in the mid- to late 1980s
- ◆ Any Celestron C90 Maksutov
- ◆ Any Coulter blue- and red-tube Dobsonian
- ◆ Any of Meade's MTS fork-mounted scopes
- ◆ Any of Meade's Schmidt-Newtonians
- ◆ Most low-cost GoTo scopes, such as Meade's older DS series
- ◆ Meade and Celestron non-GoTo SCTs from the 1990s

(An older SCT might be a good buy if it's in excellent condition and cheap. But test the optics and drive.)

focuser, great finderscope, tube rings and a 2-inch star diagonal, all for $1,900. Image quality is stunning.

For most backyard astronomers, apos over 140mm aperture exceed the practical limit for an easily portable telescope and are likely best in an observatory. On the other hand, if you are looking for an airline-portable scope to take on your travels, consider a 60mm to 90mm apo on an altazimuth mount, either manual or GoTo.

In reflectors, OTAs from Guan Sheng Optical (GSO), which are sold under various house brands, offer good value in Newtonian and Cassegrain systems, the latter in both niche-market Classical Cassegrain and photo-friendly Ritchey-Chrétien designs.

MOUNTING CHOICES

For a lightweight alt-az mount, the Stellarvue M001V ($150) is about as compact as they get, ideal for a small travel scope on any sturdy camera tripod. It uses Dobsonian-like Teflon bearings. Explore Scientific's Twilight I and the Astronomics Astro-Tech Voyager 2 are larger and nearly identical alt-az mounts (each $200), with slow-motion controls and a solid tripod capable of handling up to a light 4-inch refractor or a 5-inch Mak. For an even bigger alt-az mount, look at the elegant DiscMount DM-4 or DM-6 or the dual-saddle Losmandy AZ8, though all are serious money.

Our favorite affordable alt-az mount for grab-and-go observing is the Sky-Watcher AZ5 ($320), with a hefty tripod and head that can also nicely handle a light 4-inch refractor or a 5-inch Mak. But for not much more, Sky-Watcher's compact AZ-GTi mount ($380) offers full GoTo via WiFi control and the SynScan Pro app. The tripod is light, but the package is surprisingly sturdy and capable of handling OTAs up to 11 pounds (5 kg).

In German equatorial mounts, the choices are many, with some described in Chapter 17, and all serve as good astrophoto platforms. But for a versatile option, consider the Sky-Watcher AZ-EQ5 or bigger AZ-EQ6, superb GoTo mounts that can be set up as a German equatorial for photography or, for visual use, in dual-saddle altazimuth mode not requiring polar alignment.

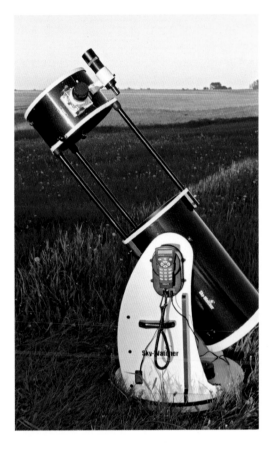

DEEP SKY EXPLORERS ($1,800 and up—way up!)

If aperture fever has you in its grip, the only antidote is to purchase a big Dobsonian. There are a number from which to choose, from no-frills to fancy.

12.5- to 20-inch Explore Scientific, Orion and Sky-Watcher Dobs

We'd class any Dob with a 12.5-inch (32 cm) or larger mirror as large aperture and aimed at the deep sky enthusiast. In these sizes, we recommend a truss-tube unit. The SkyQuest XX12i comes with the IntelliScope "push-to" computer for $1,700, while the full XX12g GoTo version is $2,100. But factor in the cost of the light shroud, the accessory bags you'll need for transport and the shipping costs.

Explore Scientific has truss-tube Dobs in 10-inch ($1,000) to 20-inch ($8,600) apertures that feature a lightweight upper tube assembly (UTA) and a low-profile wood ground board that accepts the UTA for compact storage. However, we simply mention them here, as we have not used one to comment firsthand on their performance.

Sky-Watcher has a basic Flextube in a 12.5-inch (32 cm) aperture for $1,250. Adding the SynScan GoTo system ups the price to $2,100. Its big 16-inch (40 cm) Flextube with GoTo is $3,400. Copying Obsession's Ultra Compact design, Sky-Watcher's StarGate 18 and 20 are low-profile Dobs with GoTo for $9,000 and up, though, again, we only mention them as options; we have not used one.

12.5- to 25-inch Obsession Dobs

These premium truss-tube telescopes have long ruled the big-aperture universe. We particularly like the Classic 15- and 18-inch models ($5,700 and $7,700) as manageable and satisfying one-person telescopes that don't require a large ladder.

The Ultra Compact 15 ($5,900) and 18 ($7,200) are especially attractive, as they collapse into packages that can fit into any vehicle, and the fast f/4.2 mirrors and low-profile designs lower the eyepiece still farther. Adding the full Argo Navis and ServoCAT GoTo and tracking systems costs an extra $4,000. Any Obsession is a lifetime investment no true deep sky devotee will regret.

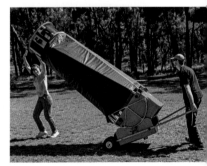

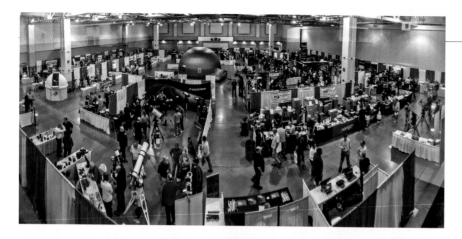

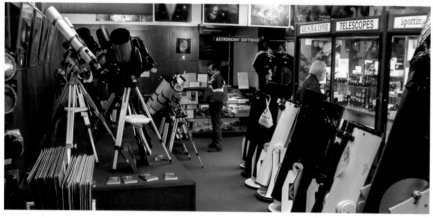

MAKING THE PURCHASE

SHOPPING SPREE!

Top: Indoor trade shows in our hobby are rare. This show in Tucson, Arizona, in 2014 was the last in the area. The annual Northeast Astronomy Forum (NEAF) in Suffern, New York, features a show floor like this, packed with the latest gear, helpful sales reps and tempting bargains.
Bottom: Nothing beats being able to see a telescope in person before you buy. If you are fortunate to have a shop near you, support it. If you have a star party near you, attend it. You'll discover firsthand what a telescope can show and which one might be best for you.

After making your selection, or at least narrowing down the choices, the questions are, "Where can I learn more?" and "Where can I buy the telescope?"

WHERE TO LEARN MORE

Attending star parties to talk to owners in person about their telescopes is the best way to learn more. What we do not recommend is finding a Facebook group and asking, "What telescope should I buy?" You will provoke so many conflicting answers, many of them wrong, that you'll be no further ahead. If you wish to post a question on forums and Facebook groups, make it as specific as possible, such as "Is Brand X Model Y suitable for deep sky astrophotography?"

However, a simple rule applies: No matter how bad the telescope, someone will defend it as the best value on the planet! The corollary: No matter how good the scope, someone will dislike it or the company that makes it.

Yet amid the web dross are thorough reviews written by observers who know telescopes and whose expert opinions can be trusted. Reviews on astrogeartoday.com and by Ed Ting on scopereviews.com stand out as among the best on the web. The reviews on cloudynights.com are of varying quality and authority. When a reviewer states, "This is the best telescope I've ever used!" ask yourself, How many has the reviewer actually used? Ditto on YouTube reviews. Keep in mind, some are endorsements in disguise from company ambassadors, or the hosts earn revenue from affiliate sales commissions.

Magazine reviews (we write them ourselves) typically provide more thorough tests, meeting a higher editorial standard than crowd-sourced web reviews. Magazine websites usually have reviews archived for download for free or to paid subscribers.

DIRECT FROM THE MANUFACTURER

So where to buy? Boutique manufacturers of high-end refractors and Dobsonians often sell only direct. Their small production runs can mean a wait of weeks or months before your scope will be shipped. Ninety-nine percent of the time, there is no risk.

However, this is where you might want to query the Internet to ask whether the company in question has shipped products on time. If reports reveal that people are waiting long past promised delivery dates, exercise caution. But if delivery dates have been adhered to, even if the wait times are long, it is probably safe to proceed.

ORDERING ON-LINE

Brick-and-mortar telescope shops, as with so many retail stores, are becoming a rarity. The vast majority of telescope sales are now through on-line purchases, especially after the COVID-19 pandemic. We suggest buying from dealers who sell only astronomy products and who have knowledgeable staff who can assist in your purchase and offer after-sale support. They generally ship anywhere, perhaps with shipping included or at competitive rates that are no more than what you might pay if buying from a big New York discount house or from Amazon. Buying cross-border might not be the bargain you hoped for, as you can be hit

with duties and brokerage fees. Support your own country's dealers if you can.

We strongly urge you not to "showroom," seeking the advice of a local or national telescope dealer by visiting in person or having a lengthy discussion over the phone, then taking that advice and purchasing from Amazon because the price is a few percent lower. We feel that is unethical. When the product arrives and there's an issue or you simply do not understand how the telescope works, do not expect the local dealer to help you. Call Amazon for help. Good luck!

PURCHASE FROM A LOCAL DEALER

If you are fortunate enough to have a local dealer, support that business. Buying locally, either in person or via the dealer's website, is by far the safest method. You can get expert presale advice and after-sale service and support. Local dealers often inspect products before they sell them to ensure they are not defective out of the box.

Should a product need to be repaired or exchanged, the dealer will take care of it. The alternative is having to fuss with packing and shipping the product back to the manufacturer yourself, often at your own expense, then trying to deal with customer-service personnel by phone or e-mail.

Local dealers are also a good source for advice on the best eyepieces and accessories you might need and will certainly want— the topics of our next two chapters.

SUMMARY: SELECTING BY SITE

At the start of this chapter, we listed several factors to consider when making your telescope choice. We will end by emphasizing the key factor few buyers think about and most well-meaning advisers on Facebook fail to ask: Where will you use the telescope?

♦ For an urban apartment or condo, a small, high-quality 70mm to 90mm alt-az refractor might be best. A 3.5- to 5-inch Mak-Cass or SCT might work, but if you cannot see much sky, aligning the GoTo system will be impossible.

♦ For a suburban backyard, a 6- to 8-inch no-frills or GoTo Dob could work very well, as would a 6- or 8-inch SCT.

♦ If you live under dark, rural skies, a larger Dobsonian or SCT would be worthwhile.

♦ But if getting to good skies requires a drive of an hour or more, consider scopes that can be packed and set up quickly, even if that means sacrificing aperture.

♦ If the telescope will be used on family vacations, make sure that packing it still leaves room for the family!

♦ If you are setting up a permanent observatory, even one in a suburban backyard, then you can go for the biggest dream scope that will fit. Have fun!

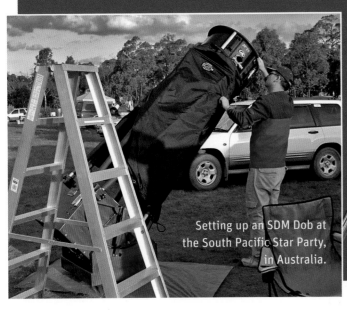

Setting up an SDM Dob at the South Pacific Star Party, in Australia.

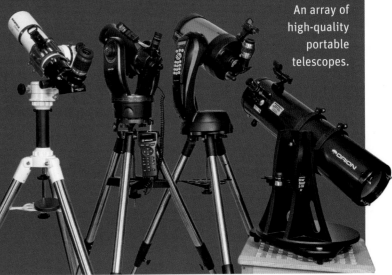

An array of high-quality portable telescopes.

CHAPTER 8

Choosing Eyepieces and Filters

Both of us have taught many introductory courses for recreational astronomers. During each session, one or two class members ask why they are having trouble using their telescopes. Invariably, their instruments are the standard "450-power" beginner's model —the same type we unwittingly purchased as our own first telescopes.

Apart from their rickety mounts, these telescopes are notorious for their poor-quality eyepieces. Our suggestion to the disappointed owner is to use only the low-power eyepiece and forget the high-power ones and any included Barlow lens. Upgrading to a better class of eyepieces is the best improvement a new owner can make to a starter telescope.

Eyepieces represent the first and foremost accessories every telescope owner needs to consider, thus our chapter dedicated to their selection. As with the cost of lenses for a quality camera, a good set of eyepieces can cost as much as your telescope. But just as with lenses, you will hold onto eyepieces even as your telescopes come and go.

While you can add many accessories for photography and observing convenience, none is as essential to the happy enjoyment of a telescope as a set of good eyepieces. They are half the telescope's optical system and can make a huge difference to your viewing experience.

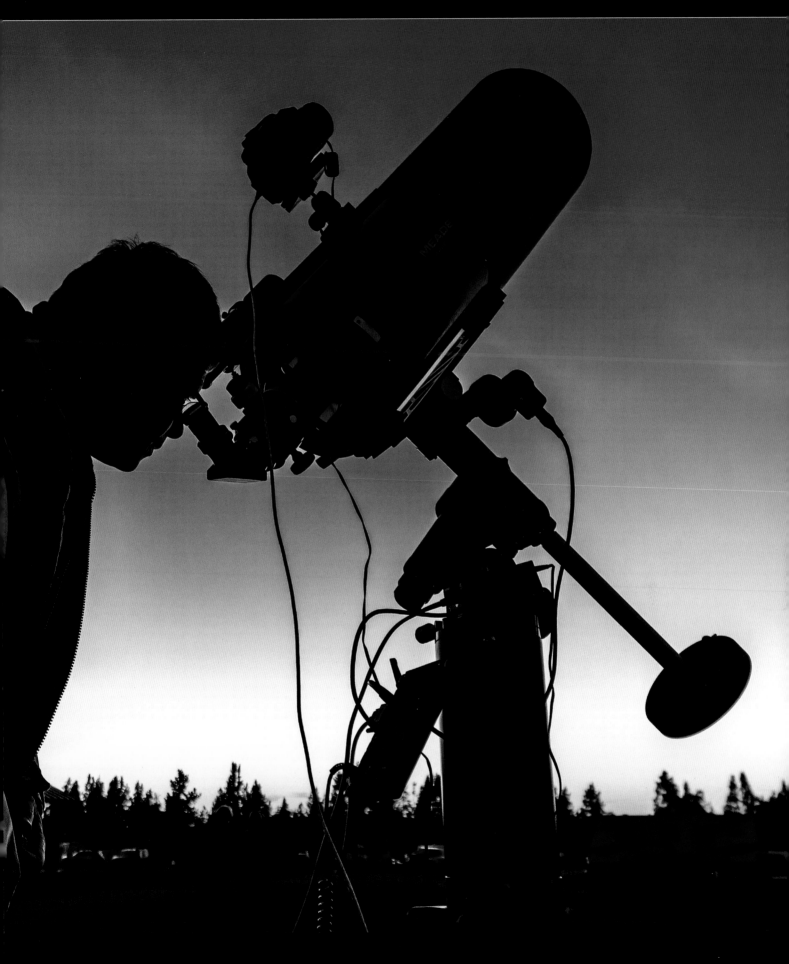

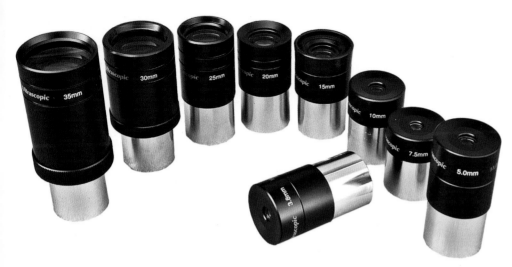

EYEPIECE BASICS

EYEPIECE LINEUP
A typical series of eyepieces, like these now discontinued Orion Ultrascopics, comes in focal lengths from long (35mm) to short (3.8mm). The shorter the focal length, the higher the power, but often the smaller the eye lens and shorter the eye relief, making high-power eyepieces harder to look through.

On all astronomical telescopes, the eyepieces (sometimes known as oculars) are interchangeable. Switching them is how you change magnification, or power. High-quality eyepieces are as essential to sharp views as is a good primary mirror in a reflector or an objective lens in a refractor. While it is a telescope's main mirror or lens that gathers the light and forms the image, the eyepiece magnifies that image and is critical to providing sharp and satisfying views. Eyepieces come in a bewildering variety. But it is not necessary to collect an entire series; a set of three or four will suffice.

WHY BUY?
To keep costs down, many entry-level telescopes come with low-grade eyepieces or eyepieces of just acceptable quality. Fuzzy images are often the fault of the eyepieces, not the main optics.

Before long, beginners on a budget see the need for better eyepieces, while buyers of more expensive telescopes often have to purchase eyepieces, as upscale scopes might come with no eyepieces at all or with only a bare minimum 25mm eyepiece. Like buying a camera with a kit lens, it'll get you started. But just as you'll soon lust after a greater range of camera lenses, so it is with telescope eyepieces.

Selecting a set of eyepieces best for your telescope and budget requires understanding the merits of various eyepiece designs. How-

ever, the most important specification of any eyepiece is simply its focal length.

FOCAL LENGTH
Like any lens or mirror, an eyepiece has a focal length, indicated in millimeters and marked on the side of the unit. In general, we recommend that every telescope owner should have one good eyepiece from each of the three main focal-length groups:

- **Long Focal Length (55mm to 25mm):** An eyepiece in this range provides low power and covers a large region of sky, good for finding targets and for viewing large objects, such as the Andromeda Galaxy and star fields in our Milky Way.
- **Medium Focal Length (24mm to 11mm):** An eyepiece in this range will be used more often than the other two, so you should invest the most to acquire this one. It provides medium power and takes in a smaller area of sky (typically less than one Moon diameter) but is generally best for most deep sky objects plus many double stars and tours of the Moon.
- **Short Focal Length (10mm to 3mm):** This eyepiece produces high power and shows only a tiny region of sky but is ideal for close-ups of lunar features, viewing the planets and resolving close double stars.

While good beginner scopes, such as those we featured in Chapter 7, come with two or three eyepieces covering the range, they usually have very narrow and fuzzy-edged fields of view and poor eye relief, two other key specifications in an eyepiece.

APPARENT FIELD OF VIEW
How much sky is seen through the eyepiece depends on the magnification it provides and on its apparent field of view (AFOV). The AFOV, in turn, depends on the optical design of the eyepiece. If you hold an eyepiece up to the light and look through it, you will see a circle of light. The diameter of that circle, measured in degrees (°), is the eyepiece's AFOV, a concept we encountered when surveying binoculars in Chapter 5. Unlike with binoculars, all eyepiece manufacturers state the

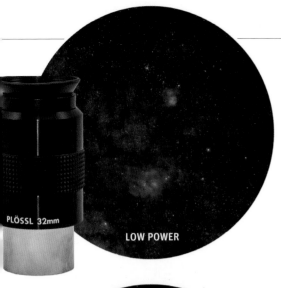

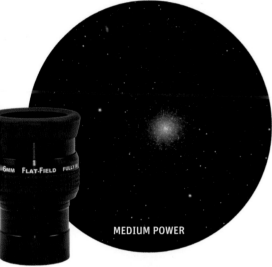

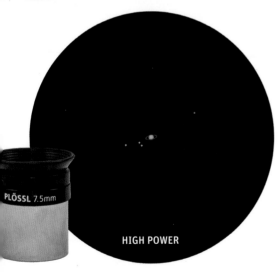

PLÖSSL 32mm

LOW POWER

6MM FLAT-FIELD FULLY

MEDIUM POWER

PLÖSSL 7.5mm

HIGH POWER

EYEPIECE POWER TRIO

A starter set of three eyepieces will provide a range of low, medium and high magnifications sufficient to handle most astronomical targets, from taking in large regions of nebulosity to resolving smaller deep sky targets and seeing tiny details on the planets.

CALCULATING POWER

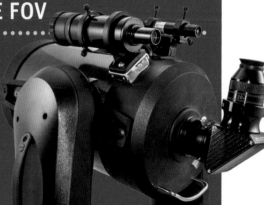

The magnification any eyepiece provides depends on the telescope you use. The formula is:

MAGNIFICATION = TELESCOPE FOCAL LENGTH (mm) ÷ EYEPIECE FOCAL LENGTH (mm)

For example, for an 8-inch Schmidt-Cassegrain with a 2,000mm focal length yielding an f/ratio of f/10:

◆ A 40mm eyepiece yields (2,000 ÷ 40) = 50x (low power)

◆ A 20mm eyepiece yields (2,000 ÷ 20) = 100x (medium power)

◆ A 10mm eyepiece yields (2,000 ÷ 10) = 200x (high power)

Those same three eyepieces on a telescope with a 1,000mm focal length would yield only 25x, 50x and 100x, respectively. As you can see, the power an eyepiece provides depends not only on its own focal length but also on the focal length of the telescope with which it is used. That's why no astronomical eyepiece is marked with a magnification.

CALCULATING TRUE FOV

How much sky an eyepiece shows is called the actual or true field of view (TFOV), and it depends on the eyepiece's apparent field of view (AFOV) and the magnification that eyepiece gives on your telescope. The formula for calculating the approximate TFOV is:

TFOV = AFOV ÷ MAGNIFICATION

On our example 8-inch f/10 Schmidt-Cassegrain:

◆ A 20mm Plössl eyepiece with a 50-degree apparent field yields 100x. At that power, its TFOV is half a degree (50 degrees ÷ 100 = 0.5 degree), just wide enough to show the entire disk of the Moon.

◆ A 20mm wide-angle eyepiece with an 82-degree apparent field provides the same power but yields an actual field of 0.8 degree, enough to reveal lots of sky around the Moon.

Another way to determine TFOV is to measure the time it takes a star to drift across the eyepiece field with no tracking motors engaged. A star at the celestial equator takes four minutes to travel one degree.

**15mm
50° Eyepiece**

1° TFOV

**14mm
70° Eyepiece**

1.4° TFOV

**14mm
82° Eyepiece**

1.6° TFOV

**14mm
100° Eyepiece**

2° TFOV

NORMAL, WIDE, WIDER, WIDEST

Here, we compare the fields of view of four classes of eyepieces, from a standard-field 50° Plössl to a 100° extreme wide-angle. With nearly identical focal lengths, all four eyepieces provide similar magnifications. How much sky each eyepiece shows (the true field of view, or TFOV) depends on its apparent field of view. Our simulated fields are for a 4-inch (10 cm) f/7 telescope, but the same relative difference in TFOVs would apply to any other scope. The 100° eyepiece provides the most impressive field, but at a high price. While a similar true field of 2° can be obtained using a low-cost 32mm Plössl, you don't have the panoramic viewing experience or the benefit of resolution from the higher magnification of the 14mm eyepiece.

AFOV in the specifications. In general, eyepieces fall into one of the following three classes for field of view:

- **Standard-Field (AFOV = 40° to 60°):** Any eyepieces included with telescopes will be from this class. While standard-fields are usually the lowest-cost eyepieces, some premium models can go for up to $250. So they aren't necessarily cheap or poor performers. Indeed, avid planet observers prize this class for the minimum number of optical elements (i.e., lenses) yielding high contrast.
- **Wide-Angle (AFOV = 65° to 75°):** These provide an impressive porthole onto the sky and are excellent for panoramic views of the Moon and for many deep sky objects. Once a specialty eyepiece, most high-quality eyepieces over $80 now fall into this class. A set from this league would serve you very well for a lifetime.
- **Extreme Wide-Angle (AFOV = 80° to 100°):** If wide-angle eyepieces are impressive, extreme wide-angles are even more so. The 100° models are sometimes labeled as ultra- or mega-wides. But as you might expect, these are also the most costly. As

a rule, the wider the apparent field, the higher the price. In addition, as the field widens, eyepieces are more prone to optical aberrations that distort stars toward the edge of the field into blobs, V-shaped seagulls, multicolored streaks or all three. The best wide-angle eyepieces ($300 to $800) can reduce these aberrations to a minimum.

BARREL DIAMETER

The lens elements that constitute an eyepiece are mounted in a barrel that slips into the focuser or into the star diagonal of the telescope. During the 20th century, eyepieces evolved into three standard barrel diameters:

- **0.965-inch (24.5mm):** Developed by Zeiss, this small barrel size was adopted by Japanese, then Chinese, manufacturers for use on low-cost beginner scopes. Once common, the 0.965-inch size for eyepieces and focuser fittings is becoming rare. The selection and quality of eyepieces in this small barrel diameter was always poor. As we advised in Chapter 7, any telescope with eyepieces of this diameter is an inferior-quality instrument.

UPGRADING THE STAR DIAGONAL

UPGRADING ERECT-IMAGE DIAGONALS

Many beginner refractors come with erect-image star diagonals (at left above), which are good if the scope is used for land viewing. However, the Amici prisms employed by these diagonals introduce diffraction spikes and a fuzziness to high-power images of celestial objects. Buying even a low-cost astronomical diagonal ($40; at right above) can greatly improve image sharpness.

UPGRADING TO A PREMIUM 1.25-INCH DIAGONAL

The best star diagonals of any size use mirrors with high-reflectivity coatings. Upgrading to a premium diagonal ($80 to $120) can improve image sharpness and brightness. However, many premium diagonals have longer bodies than standard-issue prism star diagonals, requiring the focuser to rack in farther. Some refractors might not reach focus with such a diagonal.

UPGRADING TO A 2-INCH DIAGONAL

Schmidt-Cassegrain telescopes 8 inches (20 cm) and larger can be upgraded to use 2-inch eyepieces by purchasing a 2-inch star diagonal (shown at rear; $150 to $300) with a lock ring that screws onto the rear of the instrument in place of the standard 1.25-inch visual back. A better choice is to buy a 2-inch visual back that will then accept any 2-inch accessory.

◆ **1.25-inch (31.7mm):** This barrel size is by far the most common in all price classes and designs. As such, a set of eyepieces purchased now will fit any other telescope you are likely to buy in the future. However, the barrel size does impose restrictions on the maximum field of view. Thus we have even bigger eyepieces.

◆ **2-inch (50.8mm):** This larger barrel size is used by eyepieces that offer both long focal length and a wide field of view, something not physically possible in a smaller barrel size. Many telescopes in the midpriced class and up are now equipped with focusers that accept 2-inch eyepieces. A step-down adapter, shown in foreground at right, allows the use of 1.25-inch eyepieces as well.

BARREL-SIZE TRIO
With rare exceptions (there are a few 3-inch eyepieces), eyepieces come in one of three barrel sizes: the now largely disused 0.965-inch (above left) introduced by Zeiss; the common 1.25-inch "American standard" (above middle); and the larger 2-inch (above right) used to achieve a wide field in a low-power eyepiece.

EYE RELIEF

The distance your eye must be from the eyepiece to view the whole field is called the eyepiece's eye relief, an amount that depends on the eyepiece design. With many eyepieces, the higher the power, the shorter (and therefore less comfortable) the eye relief. For example, most standard-field Plössl eyepieces (explained in the next section) have eye-relief values of about 70 percent of their focal

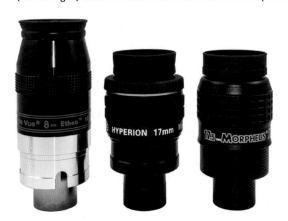

DOUBLE BARRELED
A few eyepieces come with dual-sized barrels, allowing them to be inserted in either a 1.25- or a 2-inch focuser, though the focus point is quite different between the two uses.

SHORT AND LONG EYE RELIEF

Right: Which would you rather look through? All are high-power 7mm to 9mm eyepieces. Traditional Plössls (top pair) have small eye lenses and short eye relief. Longer eye relief models (bottom pair) have large eye lenses and eyecups that place your eye well back from the eyepiece.

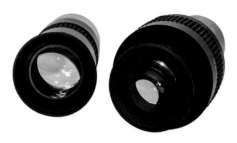

COATINGS COMPARED

Lower-cost eyepieces have just a blue single-layer lens coating (left). Better eyepieces use multicoatings, indicated by the darker reflections (right), which provide brighter images and freedom from ghost images.

EYE COMFORT

Much of the experience in using an eyepiece comes from the comfort of eye guards. **Left trio below:** Some have none (left), use an add-on that can fall off (middle) or have an eyecup that folds up and down (right). **Right trio:** The best style is a twist- or pull-up mechanism that allows precise positioning of the eyecup.

lengths. A typical 17mm Plössl has an eye relief of roughly 13mm, a decent value. However, 4mm to 8mm eyepieces have an eye relief of only a few millimeters, forcing you to touch your eye to the eyepiece to peer through a small pinhole lens.

While long eye relief allows the observer to wear glasses when viewing, only people with significant astigmatism need to keep their glasses on while observing. A quick refocus of the telescope corrects for normal near- or farsightedness.

But even without the need to wear glasses, we find that eyepieces with at least 13mm to 15mm of eye relief are a lot more comfortable to look through. Most models include some form of extendable eyecup to help position the eye. As with the binoculars we looked at in Chapter 5, long eye relief in telescope eyepieces has become more common, even in modestly priced eyepieces. Just as they are with binoculars, long eye relief and large eye lenses are certainly hallmarks of the best eyepieces. Once you have used a set, you won't go back to squinting through the tiny lenses of the classic eyepieces of yesteryear. We certainly haven't!

LENS COATINGS

Like camera lenses, all modern eyepiece lenses are coated to improve light transmission and to reduce flare and ghost images. The minimum coating is a single layer of magnesium fluoride applied to the eyepiece's two exterior lens surfaces, giving them a bluish tint. These days,

all but the lowest-cost eyepieces have several layers of coating material applied to all the lens surfaces to boost light transmission.

That's particularly important in extreme wide-angle eyepieces that use up to eight or nine lens elements. Without top-class multicoatings, they would exhibit flares and ghost images off bright objects, dim images from poor light transmission and a lack of contrast. Old-school purists still accuse wide-angle eyepieces of suffering from these faults, but we've not found that to be the case, certainly not in top-class models with modern coatings.

MECHANICAL FEATURES

Some eyepiece brands are parfocal, which means that every eyepiece in the series focuses at the same point. So provided you stay within a manufacturer's series, switching eyepieces does not require significant refocusing, a convenient feature.

All but vintage eyepieces are threaded to accept filters, which are described in the last section of this chapter. Ideally, the inside fittings should also be blackened as a precaution against lens flares from bright objects outside the field. Better eyepieces also have a cleanly machined field-stop ring inside the barrel for defining the edge of the field. Low-cost eyepieces lack such a ring (yielding an ill-defined field edge) or have field stops with rough edges marred by metal burrs and nicks.

Most eyepieces are now supplied with rubber eyecups, which are good for blocking stray light and for keeping the eye properly positioned. In the best eyepieces, the eyecups are adjustable and are integrated into the design, rather than being loose-fitting add-ons that can fall off, get lost in the dark and be hard to replace.

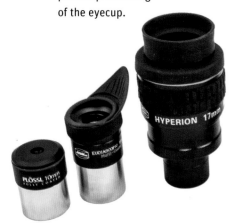

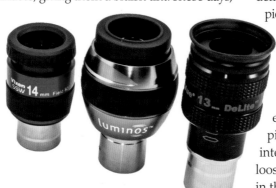

EYEPIECE DESIGNS

After stargazers debate the merits of refractors versus reflectors, discussions of equipment inevitably turn to which eyepieces are best.

STANDARD-FIELD EYEPIECES (40° to 60°)

An eyepiece design employs a particular combination of lens elements of a specific shape. The design determines the field of view and the eye relief. With exceptions noted, manufacturers do not have exclusive license to a design. Plössl eyepieces, for example, are sold by nearly every telescope manufacturer. Many eyepiece designs are named for the pioneering opticians who invented them.

- **Kellner and Modified Achromat:** Since its invention by Carl Kellner in 1849, the Kellner was the standard workhorse eyepiece design until the 1980s. An economical three-element type, it produces average images in a fairly narrow field of view by today's standards—typically 40°. It works best on long-focal-ratio telescopes (f/10 or longer) and suffers from chromatic aberration, or false color. Some manufacturers sell the Modified Achromat, a variation included with entry-level scopes.

- **Orthoscopic:** In 1880, Zeiss optical designer Ernst Abbe invented a four-element eyepiece with a triplet lens matched to a single lens. Orthoscopics have a 45° apparent field and less chromatic aberration and ghost imaging than a Kellner. Many observers still consider the Abbe Orthoscopic to be the best eyepiece for planetary observing. Now largely replaced by Plössls, a few classic Orthos are still offered by Baader Planetarium. Others, like the Pentax XO, University Optics Abbe and original Zeiss Abbe Orthos, are sought after by planetary purists. Check eBay!

- **Plössl:** Devised in 1860 by Georg Plössl, this design enjoyed a resurgence in the late

ECONOMY KELLNER CLASS
Above: Often included with beginner telescopes, Kellner and Modified Achromat eyepieces like these are perfectly fine to use.

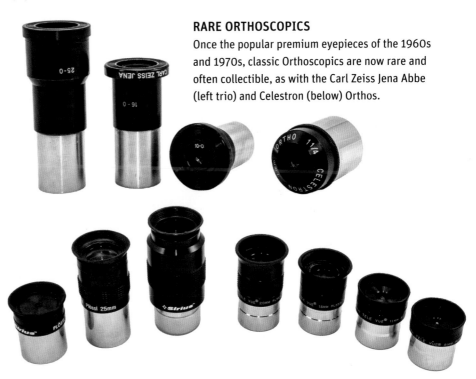

RARE ORTHOSCOPICS
Once the popular premium eyepieces of the 1960s and 1970s, classic Orthoscopics are now rare and often collectible, as with the Carl Zeiss Jena Abbe (left trio) and Celestron (below) Orthos.

POPULAR PLÖSSLS
Classic four-element Plössls are available in good budget models, such as the Orion Sirius line (left; $40 to $50) and the premium Tele Vue series (right; $100 to $150).

1970s with the French-made Clavé Plössls then, from 1980 on, with Tele Vue's series. The Plössl remains the most popular standard-field eyepiece. A true Plössl is a four-element design consisting of two nearly identical pairs of lenses. Compared with Orthoscopics, the Plössl has a slightly wider field (about 50°), works better on f/6 or faster telescopes but has a shorter eye relief. The best Plössls are good for all observing, with planet viewing their forte, although eye relief is poor in 13mm and shorter models.

The 45° Vernonscope Brandon ($240), originally designed by Chester Brandon in 1949, sold for over 50 years with Questar telescopes. It is similar to a Plössl in having two pairs of lens elements. Like Orthoscopics, Brandons work best on slower f/ratio telescopes.

LONG EYE RELIEF VARIATIONS

Celestron's X-Cels (left; $85) and Tele Vue's DeLites (right; $260) offer a consistent 20mm of eye relief across the series due to the use of an integrated Barlow lens.

◆ **Plössl Variations:** Many manufacturers now market five- to seven-element Plössl variations carrying various trade names, such as Super Plössl, Ultrascopic or Eudiascopic. In some cases, the design is more akin to a five-element wide-angle eyepiece with 55° to 60° fields. Some models include a built-in Barlow lens that increases power while retaining an excellent eye relief of 16mm to 20mm, even at the shortest focal lengths. Examples include Celestron's excellent X-Cel LX ($85), Explore Scientific's 52° series ($70 to $140), Meade's UHD ($120 to $200), Orion's Edge-On Planetary ($100) and Vixen's SLV ($170).

In a higher-priced league and featuring a 62° field bordering on wide-angle is Tele Vue's DeLite series, introduced in 2015, with focal lengths from 3mm to 18.2mm ($260 each). Like the earlier 60° Radian series these replace, eye relief is also a consistent 20mm. While we've included the DeLites in this design category, their lens configuration, as with the Delos series, remains a Tele Vue secret. However, the DeLites are, indeed, a delight for planetary and general-purpose viewing.

WIDE-ANGLE EYEPIECES (65° to 76°)

Tele Vue first popularized the Plössl in the 1980s, then introduced its Wide-Field eyepieces. These six-element eyepieces had apparent fields of 65°, less ghosting and more pinpoint stars across the field than the awful Erfle eyepieces that had been the wide-angle mainstay for decades. A plethora of new 65° to 75° eyepieces followed.

Among the best current competitors are Baader's Hyperions (3.5mm to 36mm; $150 to $220), a fine affordable choice in wide-fields. (Orion's Stratus series is very similar.) Edge performance is good, with images blurring in the outer 30 percent of the 68° to 72° field. When used on slower f/8 to f/10 telescopes, edge sharpness improves, as it does for all wide-angle eyepieces.

Explore Scientific's 68° series (16mm to 40mm; $160 to $330) directly competes with Tele Vue's Panoptics (19mm, 24mm, 27mm, 35mm and 41mm; $250 to $525). The six-element "Pans" replaced the old Wide-Fields in 1992, with star images tack-sharp across the 68° field, even on fast focal-ratio telescopes (the toughest test). No one has beaten venerable Panoptics for image quality across a wide field, especially on fast scopes.

Except Tele Vue itself. Introduced in 2009, its Delos series (3.5mm to 17.3mm; $350 each) features a 72° field and 20mm eye relief. The huge eye lens and adjustable eyecup afford a very comfortable viewing experience. These

DESIGNS TO REPLACE

Old amateur-astronomy handbooks regale the reader with references to exotic eyepiece designs. Some, such as the Hastings, Monocentric, Steinheil and Tolles, are praised by planetary observers but are so rare, few amateurs will ever encounter them. Others are so poor, they deserve mention so that they can be replaced immediately. Or avoided altogether.

Huygenian: This two-element design from the 17th century is often supplied with poor-quality telescopes. These are marked with an H, AH (Achromatic Huygenian) or HM (Huygens Mittenzwey).

Ramsden: Variations add a third lens element to produce an Achromatic Ramsden or a Symmetrical Ramsden. All give fuzzy tunnel-vision views with little eye relief.

Poor Barlows: To provide hyped high power, beginner scopes often come with a "Powerful 3x Lens" or, worse, "Zoom Eyepieces." All are junk.

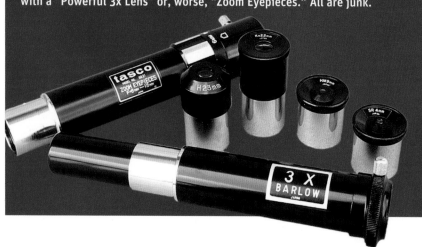

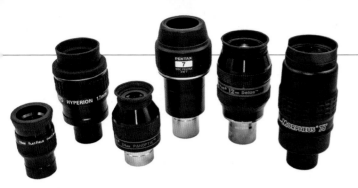

GOING WIDE
Wide-angle eyepieces range in apparent fields (from left to right): Orion EF (65°), Baader Hyperion (68°), Tele Vue Panoptic (68°), Pentax XW (70°), Tele Vue Delos (72°) and Baader Morpheus (76°).

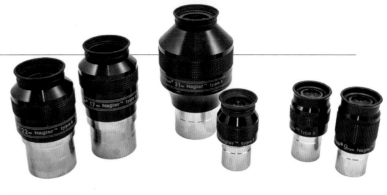

GOING WIDER...
Tele Vue's Nagler series includes the Type 4 models with 2-inch barrels and long eye relief (left), the Type 5 series with the giant 31mm and compact 16mm (center) and the even more compact Type 6 series with modest eye relief (right).

are among the very best eyepieces you can buy, but they are available in only medium to high powers.

Baader Planetarium competes directly with Delos with its Morpheus line of eight-element, flat-field eyepieces ($250 each) in a comparable range of focal lengths, from 4.5mm to 17.5mm, and all with a similar large eye lens and 20mm eye relief. Image quality comes close to matching Panoptic and Delos perfection across its wide 76° field, almost as wide as the next class of eyepieces, making them a great value.

EXTREME WIDE-ANGLE EYEPIECES (80° to 90°)

The heart of the Tele Vue line remains the series that bears company founder Al Nagler's name. The original 13mm Nagler caused a sensation when it was introduced in 1982, after Tele Vue had established brand credibility with its conventional Plössls. Other Nagler focal lengths followed, each with seven steeply curved lens elements providing an impressive 82° apparent field unheard of at the time.

To create his revolutionary eyepiece, Nagler took an exotic, extremely wide-angle eyepiece design and placed a Barlow lens in front of it. The eyepiece and Barlow operate as a single unit—the aberrations of one cancel out the aberrations of the other—producing exquisitely sharp images edge to edge, despite the extreme field of view. The original Type 1 and 1986-vintage Type 2 Naglers were a hit, even though they cost two to four times more than the best eyepieces of the day.

From 1998 to 2001, Nagler introduced new 82° Nagler designs labeled Types 4, 5 and 6, which are still sold today. The Type 4s ($450 each) have increased 18mm eye relief. The

six-element Type 5 models include the "holy hand grenade" 31mm Nagler ($680) that provides the most outstanding panoramic views we've ever seen. The seven-element Type 6 series ($330 each) has a compact, lighter design with modest 12mm eye relief and focal lengths from 13mm to as short as 3.5mm. Why combine a short focal length with an ultrawide field? Such an eyepiece is useful for telescopes that lack tracking, like Dobsonians. The object stays in the field longer for high-power inspection.

EVEN MORE EXTREME EYEPIECES (100° to 110°)

Stepping up its game in 2007, Tele Vue introduced the Ethos design, first in a 13mm (as with the Naglers), then expanding to 6mm, 8mm, 10mm, 17mm and 21mm focal lengths ($600 to $850). Ethos eyepieces provide an amazing 100° field that has to be seen to be believed. The eyepiece truly gets out of the way for the ultimate spacewalk experience.

The 3.7mm and 4.7mm Ethos-SX (Simulator eXperience) offer an even greater 110° field ($650 each). And yet despite the enormous field and complex glass, star images are pinpoint right to the edge and contrast is superb. Any Ethos eyepiece is a serious investment, but if you want the best, especially for fast focal-ratio telescopes, look no further.

For this edition, however, we were curious as to how the Nagler and Ethos clones and competitors from Explore Scientific, Meade, Omegon, Orion, Stellarvue, Vixen and others would stack up against the industry standard. Could they match Tele Vue performance while bettering Tele Vue prices? See "Our Eyepiece Shoot-Out" on page 168 for the results.

...AND EVEN WIDER

Tele Vue's Ethos line introduced the first widely available 100° eyepieces, a design now copied by 100° models from Explore Scientific and Stellarvue. The history of modern eyepieces is very much the history of innovations by one company, Tele Vue and its founder Al Nagler, seen here at the Texas Star Party in 2007 introducing his prototype Ethos 13mm eyepiece.

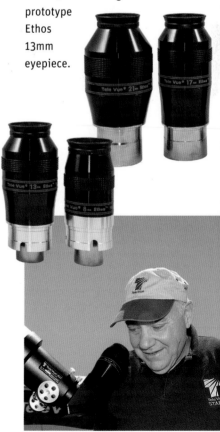

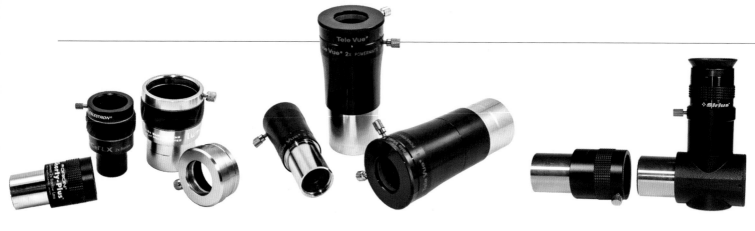

BEVY OF BARLOWS

The Orion Shorty-Plus and Celestron X-Cel 2x Barlows are for 1.25-inch eyepieces. A 2-inch Barlow like the Celestron Luminos can multiply the power of panoramic 2-inch eyepieces.

HYPERION PREMIUM ZOOM

Baader's Hyperion Zoom, now in a Mark IV version ($300) with a lighter and more compact design than the Mark III shown here, is among the best of the 8mm to 24mm zooms.

NAGLER HIGH-POWER ZOOM

Despite its Nagler designation, this 3mm to 6mm zoom has a standard field of 50°. Click stops define focal-length positions at 1mm increments.

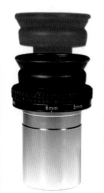

POWERFUL POWERMATES

Tele Vue's Powermates are offered in 1.25-inch and 2-inch sizes and in magnification factors up to 4x. However, with the greater availability of long eye relief eyepieces, there is less call now for a Powermate or Barlow in every eyepiece case.

BARLOW LENSES

Many wide-angle eyepieces integrate a Barlow lens into their designs, often to increase eye relief. But a Barlow can be purchased as a separate item to use in conjunction with individual eyepieces.

Barlows are concave, or negative, lenses that increase the effective focal length of a telescope and multiply the power of any eyepiece. The name stems from Peter Barlow and George Dollond's 1834 scientific paper that first described this style of lens. Barlows are available in magnifications from 1.8x to 5x. With a 2x Barlow, the most common, a 24mm eyepiece effectively becomes a 12mm. If you plan carefully to avoid duplicating powers, Barlows can double your eyepiece set. For example, if you have a 24mm eyepiece with a 2x Barlow, there's no need for a 12mm eyepiece. A 2x Barlow with a 24mm and a 15mm eyepiece gives the equivalent of a 12mm and a 7.5mm eyepiece, four useful powers with three lenses.

The advantage of Barlows is that they produce high power with longer-focal-length eyepieces that are easier to look through because of their better eye relief. Compare this with the eye-squinting views of traditional 8mm to 4mm eyepieces. For owners of fast f/4 to f/5 telescopes, Barlows are a recommended method of achieving high power. In our testing, we've found that today's high-quality Barlows introduce no detectable aberrations or light loss compared with single eyepieces of equivalent magnification.

BARLOW IN FRONT

When placed between the diagonal and the eyepiece, a 2x Barlow doubles the power. But it can also be placed between the focuser and the diagonal, as here, for approximately 3x power—effectively two Barlows for the price of one.

A good Barlow, sometimes called a "focal extender," can also improve eyepiece performance. The negative lens increases the effective focal ratio by reducing the steepness of the light cone entering the eyepiece. A 2x Barlow reduces the cone's angle by half, so an f/5 telescope becomes, in effect, an f/10—a combination in which any eyepiece will show sharper images across the field.

Barlows come in tube lengths ranging from less than three inches to nearly six. The so-called Shorty Barlows, usually with 2x amplification, are suitable for use when inserted into star diagonals. The Shorty Barlows we've tested and used have proven excellent, but expect to pay $80 to $150 for a good three- or four-element Barlow of any type.

Tele Vue offers a series of four-element 2x to 4x Powermates ($220 to $330). With a more advanced optical design than the classic negative-lens Barlow, the Powermate has the advantage of being parfocal with the eyepiece used on its own, requiring no major refocusing when you insert the Powermate, unlike when you insert a Barlow.

ZOOM EYEPIECES

Why buy three or four eyepieces (or even two and a Barlow) if one eyepiece will do it all? That is the promise of zoom eyepieces, which use a sliding Barlow lens to vary their effective focal length. Most units ($80 to $200) offer a focal-length range of 8mm to 24mm. But their apparent field of view is restricted, narrowing to a tunnel-vision view of only 40° at the low-

est power, just where you want wide-field. While convenient for public viewing sessions, zooms have failed to win us over for serious observing—we prefer the higher quality of separate fixed-focal-length eyepieces.

Tele Vue's $420 Nagler Zoom eyepiece is the exception. With a focal-length range from 3mm to 6mm, this specialized eyepiece is for high-power planetary viewing with fast apo refractors. Image quality is superb, and the 50° apparent field and focus stay constant throughout the zoom. Even though the 10mm eye relief is generous for a 3mm focal length, it is still a bit cramped in practice.

COMA CORRECTORS

While optical aberrations can be reduced to near zero in modern eyepieces, they are still present in the main optics. Therefore, a premium eyepiece on a fast f/4 Newtonian telescope still shows some edge-of-field aberrations that make stars resemble tiny comets, the result of coma inherent in the parabolic primary mirror itself.

The solution is a coma corrector lens inserted into the optical path of a Newtonian, usually in the manner of a 2-inch Barlow that can then accept any eyepiece. Models include the Baader Multi-Purpose Coma Corrector ($220), the Explore Scientific HR ($300) and the Tele Vue Paracorr Type-2 ($500). Coma correctors are popular for use with f/3 to f/5 Newtonians to suppress off-axis aberrations. Anyone who spends serious money for a large Dobsonian telescope will want to have one for low-power panoramic viewing.

COMA-FIXING PARACORR
Tele Vue's Paracorr has an adjustable top for dialing in the best correction. Not all Newtonian focusers will accept such a long tube. It also requires 6mm of inward travel for eyepieces to reach focus and adds 15 percent in magnification.

EYEPIECES: A SUMMARY COMPARISON

TYPE	APPARENT FIELD OF VIEW	ADVANTAGES	DISADVANTAGES	PRICE	
Kellner (three-element)	35° to 45°	Low cost. Good for long-focal-length scopes.	Narrow field. Chromatic aberration.	$30 to $50	
Orthoscopic (four-element)	45°	Freedom from ghost images and most aberrations.	Narrow field for deep sky viewing.	$50 to $250	
Classic Plössl (four-element)	50° to 60°	Excellent contrast and sharpness. Wider field than most Orthos.	Less eye relief than Orthos. Slight astigmatism at edge of field.	$40 to $250	
Wide-Angle (five- to eight-element)	62° to 75°	Wide field of view. Minimal edge aberrations.	Moderate to high cost.	$80 to $550	
Nagler- and Ethos-class (six- to nine-element)	80° to 110°	Extreme field of view with few edge aberrations.	Expensive. Low-power models are heavy and large.	$180 to $850	

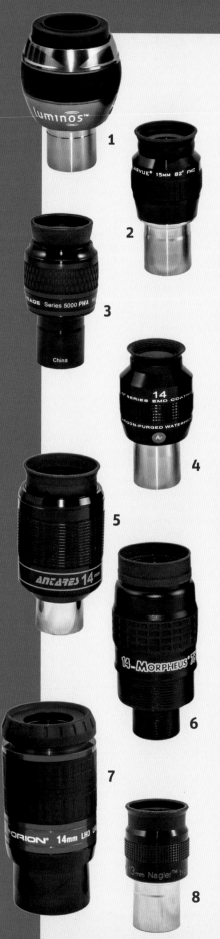

OUR EYEPIECE SHOOT-OUT

For this edition, we purchased a set of popular eyepieces in the 82° and 100° classes, all with focal lengths between 13mm and 16mm, a sweet spot for magnification. We tested them on f/6 apo refractors and on an 8-inch f/6 Dobsonian reflector. Tele Vue eyepieces work well on even faster telescopes where off-axis sharpness is most challenging. We present our mini-reviews in each class in order of increasing U.S. retail price.

82° EYEPIECES

1 CELESTRON 15MM LUMINOS ($120)

Although advertised as 82°, the 15mm Luminos has an apparent field between 82° and the 76° field of the Morpheus. Stars start to bloat 50 percent out from the center and get quite distorted at the edge. The eyecup is extendable, and the eye relief is an excellent 17mm. It's a good eyepiece for the price.

2 STELLARVUE
15MM ULTRA WIDE ANGLE ($150)

The Stellarvue 82° Ultra Wide Angle is well made, with solid construction, good 14mm eye relief and a fold-up eyecup. However, stars begin to bloat 50 percent from the center and are quite distorted at the edge. But of the low-cost 82° models, this was the best overall for both optics and mechanics.

3 MEADE
16MM PREMIUM WIDE ANGLE ($200)

In 2020, Meade introduced its Premium Wide Angle 82° series, in part replacing the older Series 5000 Ultra Wide Angle. The lower-cost UWAs had good optics but a stiff eyecup mechanism. The new PWA is very similar to the Stellarvue 82° in design and optical performance.

4 EXPLORE SCIENTIFIC
14MM 82° SERIES ($200)

This eyepiece is solidly made and fairly comfortable to use, despite its short 11mm eye relief. The eyecup nicely places your eye where it needs to be. Stars are sharp across all but the outer 10 percent of the field, so it is very close to Nagler performance. A superb eyepiece for the money.

5 ANTARES
14MM SPEERS-WALER SERIES 4 ($200)

The name comes from Canadian designer Glen Speers and "Wide Angle Long Eye Relief." Stars are sharp across all but the outer 20 percent. Eye relief is a good 16mm. However, with your eye where it needs to be to see the whole field, the field partially blacks out, with squirming kidney-bean shadows. It's uncomfortable to use; we can't recommend it.

6 BAADER
MORPHEUS 14MM 76° ($280)

While not quite as wide as the others, the Morpheus comes close, so we included it. With 20mm of eye relief, this is a very comfortable eyepiece to use. Stars are sharp across all but the outer 15 percent of the field and are still tight at the edge. It fits 2-inch focusers but requires only 1.25-inch filters. The Morpheus series is a new favorite.

7 ORION
14MM LHD LANTHANUM 80° ($280)

A long 20mm of eye relief, screw-up eyecup and large eye lens make the Lanthanum a pleasure to use. Although advertised as 80°, the apparent field matched a Nagler's 82° field. Stars are Nagler-class sharp to the edge. At 580 grams (20 ounces), it's the heaviest of the 82° bunch, and its 2-inch barrel requires 2-inch filters. But this is a superb eyepiece.

8 TELE VUE 13MM TYPE 6 NAGLER ($320)

Type 6 Naglers are small, light and tack-sharp across the field, even on fast f/ratio telescopes. They set the standard. The rubber eyecup can fold down but is stiff and is best left up. The eye has to be a little above the eyecup for best position, and eye relief is just 12mm.

9 VIXEN 14MM 83° SSW ($350)

Stars do bloat a little at the very edge, but the Vixen SSW comes close to matching a Nagler, with the benefit of a slightly longer 14mm eye relief and a more comfortable, adjustable eyecup. And the color-coded cosmetics of the SSW series are attractive. Highly recommended.

100° EYEPIECES

10 OMEGON PANORAMA II 15MM ($260); 600 GRAMS (21 OUNCES)

Based in Germany, Omegon offers many unique products, including the Panorama 100° eyepieces. While the least expensive of the 100s, consider import fees. Performance is excellent, with stars sharp across all but the outer 10 percent of the field. Eye relief is a long 20mm. However, the Omegon and Meade both have apparent fields less than the others, closer to 90° as measured.

11 MEADE 15MM MEGA WIDE ANGLE SERIES 5000 ($270); 638 GRAMS (22 OUNCES)

Like twins separated at birth, Meade's mega-wide looks nearly identical to the Omegon. Optical performance is also identical. The knurled grip rings and construction of both are superb. Either model represents an excellent value in a mega-wide eyepiece. Note their middle-weight mass.

12 STELLARVUE 13.5MM OPTIMUS ($350); 564 GRAMS (20 OUNCES) WITH 2-INCH ADAPTER

Stellarvue's Optimus is the lightest of the 100° set, a consideration for balancing small telescopes and many Dobsonian telescopes. Like the Ethos, it can be used as either a 2-inch or a 1.25-inch eyepiece. Stars begin to distort in the outer 25 percent of the field, so it's worse than the Explore Scientific and Ethos but still very good, especially for the price. Eye relief is a comfortable 13mm, and there's no annoying kidney-bean shadowing of the exit pupil, also true of the other 100s.

13 EXPLORE SCIENTIFIC 14MM 100° SERIES ($550); 833 GRAMS (29 OUNCES)

The Explore 100° comes a very close second to Tele Vue in sharpness, with stars sharp across 90 percent of the field and still well contained at the edge. Eye relief seems a little tight due to the eye lens being more deeply recessed than it is in the others. While you are not likely to submerge your eyepieces, their waterproof and argon-filled construction prevents moisture from fogging the internal optics, which can happen at very humid sites. The main drawback is the weight, by far the heaviest of the bunch. But it is an excellent eyepiece.

14 TELE VUE 13MM ETHOS ($630); 586 GRAMS (20 OUNCES)

This is the original 100° eyepiece and is still the standard of excellence. Eye relief is 15mm, a little longer than the Explore Scientific and Stellarvue competitors. And stars are tack-sharp across 95 percent of the field, flaring only slightly at the very edge. It performs well on fast telescopes.

CONCLUSIONS

For the most part, performance was commensurate with price in both the 82° and 100° series. The Stellarvue Optimus, with its full 100° field, stood out as a great value for performance versus price. Both Explore Scientific eyepieces came very close to matching their Tele Vue counterparts but at a lower price. The Orion and Vixen 82° eyepieces are also superb in all aspects, though at prices similar to the Tele Vue Nagler.

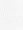

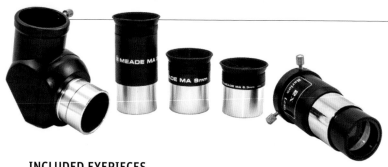

INCLUDED EYEPIECES

Shown in Chapter 7, the Meade StarPro AZ 90 refractor's complement of Modified Achromat eyepieces and accessories is typical—fine to start with, but upgrading is recommended.

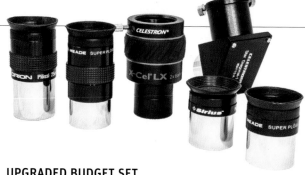

UPGRADED BUDGET SET

Upgrade on a budget by replacing the Modified Achromat eyepieces and Amici prism diagonal with Plössl eyepieces, an astronomical prism diagonal and perhaps a better Barlow.

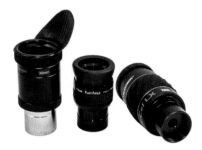

EXPANDED AND IMPROVED SET

Expand your collection at a modest cost by adding a low-power 32mm or 35mm Plössl (left), a midpower wide-angle, like an Orion 19mm EF (center), or a long eye relief high-power eyepiece (right).

KNOW YOUR LIMITS!

The rules of thumb are:

- Avoid eyepieces that yield a power less than four times the telescope's aperture in inches (to keep the exit pupil below 7mm).
- Avoid eyepieces that yield a power more than 50 times the aperture in inches (the maximum useful power).

EYEPIECE RECOMMENDATIONS

As we can attest, eyepieces are easy to collect. Buy one of a series, and you might long to own the whole set. In truth, six or seven eyepieces are not needed. A set of four will do well, as will just two or three to start. Here are our recommendations, in order of increasing price and decreasing priority.

UPGRADED BEGINNER SET

Most good entry-level telescopes, like those we discussed in Chapter 7, are now supplied with 25mm and 9mm Modified Achromat or Kellner eyepieces. This is a decent starter set for a small telescope. For improved views on a budget, consider a set of 25mm, 12mm and 7mm Plössls (such as those in Meade's Series 4000 or Orion's Sirius lines) to provide low, medium and high powers. Or buy 25mm and 17mm Plössls with a good-quality 2x Shorty Barlow for a complementary range of four powers.

That means replacing the generic bargain Barlow; we have yet to see an included Barlow that works as well as an $80 to $100 unit from Celestron, Explore Scientific, Orion or other name brands.

EXPANDED BUDGET SET

For telescopes that accept only 1.25-inch eyepieces and already come with good 25mm and 9mm or 10mm Plössl-class eyepieces, a top priority should be an ultra-low-power eyepiece. For a budget price, we recommend a 32mm to 35mm Plössl. Regardless of brand, this will provide the maximum possible field of view for a 1.25-inch system.

For an economical midpower eyepiece with a wider 65° field, consider either a 16mm or a 19mm Orion EF Widefield for just $80. Both models have excellent eye relief and comfortable twist-up eyecups. They are among the best in an affordable wide-angle eyepiece and represent the lowest price you can pay and get decent performance. Avoid $50 "house-brand" or generic wide-angles; they are typically pretty bad even at a bargain price.

For improved high-power views, the 2x Shorty Barlow will work or upgrade to a long eye relief eyepiece such as a Celestron 60° X-Cel or an Explore Scientific 52° or 62° Series. Indeed, upgrading all your eyepieces to a set of long eye relief Plössl variations will make a big improvement at a reasonable price.

ADDING A PREMIUM PRIME EYEPIECE

The addition of any eyepiece from this class is likely to cost at least $200 to $400. If that's what you paid for your telescope, a premium eyepiece will be hard to justify. But keep in mind that any eyepiece you buy now can be used on bigger and better telescopes you'll acquire in the future. In addition, quality eyepieces tend to retain at least two-thirds of their value when sold as used equipment, so you can buy with some assurance.

If you can afford just one top-quality eyepiece, what should it be? In our experience, the eyepiece you'll use the most falls in the medium-power range. A rule of thumb says that the eyepiece which best matches the eye's ability to resolve detail is the one that yields a

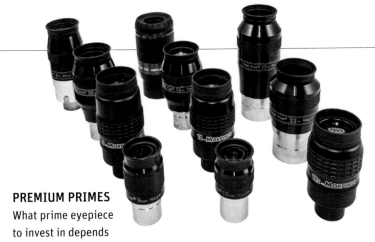

PREMIUM PRIMES

What prime eyepiece to invest in depends on your telescope's focal ratio. For fast f/4 or f/5 scopes, look at top-quality eyepieces with 8mm to 10mm focal lengths (left). For f/6 to f/7 instruments, we recommend a 12mm to 14mm eyepiece (center). For f/8 to f/11 scopes, an eyepiece in the 16mm to 22mm range (right) will be your most-used model.

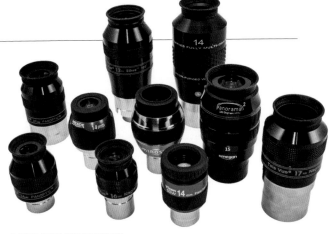

DEEP SKY DIVERSITY

Adding 82° and 100° eyepieces with longer and shorter focal lengths than your prime medium-power eyepiece will fill out your deep sky options. Choose a series you like and stay with it.

2mm exit pupil. To determine the focal length of this optimum eyepiece, multiply your telescope's focal ratio by 2. For example, the prime eyepiece for an 8-inch f/10 Schmidt-Cassegrain is a 20mm (10 x 2). It would provide 100x. We'd suggest a 19mm Panoptic for a 1.25-inch or a 20mm Orion LHD Lanthanum for a 2-inch, among many others.

This isn't a hard-and-fast rule and applies best to telescopes under 16 inches (40 cm) aperture. However, it serves to narrow the choice for which eyepiece should be your biggest investment. For recommendations, see "Our Eyepiece Shoot-Out" (page 168), as the 13mm to 16mm focal lengths we tested are in this prime medium-power range for f/6 to f/8 scopes. For the typical f/5 Dobsonian, a 10mm Ethos or Delos falls into this range—costly, but it will be used a lot.

ADDING MORE DEEP SKY EYEPIECES

Another prime slot for a premium wide-angle eyepiece is in the low-power range. We can recommend nothing better than a Tele Vue 24mm Panoptic for a 1.25-inch focuser or a 27mm Panoptic for a 2-inch focuser. A lower-cost alternative is Explore Scientific's 68° Series or a Celestron Ultima Edge. If your budget and f/5 to f/6 telescope can handle them, consider a 21mm Ethos, a 20mm Explore Scientific 100° Series or the more affordable and lighter 20mm Stellarvue Optimus.

In the medium-high range (120x to 200x), consider a shorter-focal-length Baader Morpheus 76°; Explore Scientific 82° or 100°;

HOW LOW CAN YOU GO?

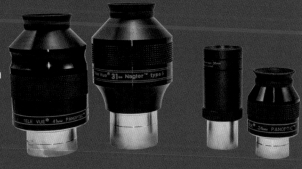

A 40mm to 42mm wide-angle (65° to 68°) eyepiece offers the maximum possible true field of view in the 2-inch format. While a longer-focal-length 55mm eyepiece offers lower power, it won't provide a wider actual field of view, as the barrel size limits such an eyepiece to a 50° apparent field.

For example, on an 8-inch f/10 Schmidt-Cassegrain, a 41mm 68° Panoptic eyepiece produces 50x and an actual field of 1.4°. On the same scope, a 55mm 50° Plössl produces a lower 36x but nearly the same 1.36° actual field.

The same is true in a 1.25-inch barrel (the right-hand pair here), where a 35mm Plössl-class 50° eyepiece doesn't give any wider field than a 24mm 68° eyepiece.

Seekers of the widest field possible must also be aware of another limit to how low you can go. If an eyepiece yields more than a 7mm exit pupil in an obstructed telescope, such as a reflector or catadioptric, you might see a field with a dark hole in the center. With a refractor, the penalty for exceeding the low-power limit is that not all the light collected by the telescope enters your eye. Your eye "stops down" the telescope's aperture. The low-power limit of any telescope is given by:

TELESCOPE FOCAL RATIO X 7MM
(diameter of a fully dark-adapted youthful eye)

For an f/5 reflector, for instance, the longest useful eyepiece is 35mm (5 x 7mm). A 40mm eyepiece is not recommended.

OCULARS OLD BUT GOOD

Some classic eyepieces of old, such as Zeiss Abbe Orthoscopics and TMB Monocentrics, are collectors' items. Other discontinued models, including several we highlighted in earlier editions of our book, might be easier to find on the used market. Here are a few we've used and can recommend.

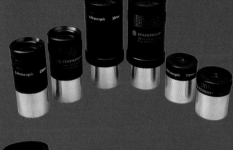

Orion Ultrascopic and Celestron Ultima: These Plössl variations (also Baader's Eudiascopics) differ only cosmetically and are sharp, though have traditional eye relief specs.

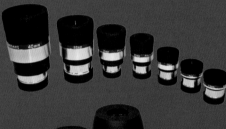

Meade Series 5000 60° Super Plössls: These excellent five-element Plössl variations preceded Meade's rebranded HD-60 and UHD versions.

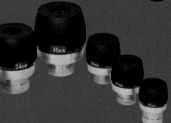

Meade Series 5000 68° Super Wide Angles (SWAs): Although never as sharp to the edges as Panoptics, the 68° SWAs were a fine series, as were the older yellow-labeled Series 4000 SWAs.

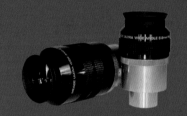

Meade Series 4000 82° Ultra Wide Angles (UWAs): These eyepieces, the first Nagler copies, came before the Series 5000 UWAs (current as of 2020). The 14mm and 8.8mm UWAs were excellent.

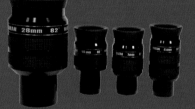

William Optics 82° UWANs: These Nagler wannabes fell short of matching Tele Vue but are a good value if obtained for a decent price.

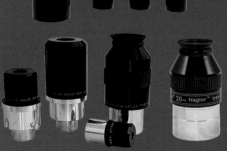

Older Tele Vue Naglers: The original Types 1 and 2 from the 1980s perform very well. We also like the 20mm Type 5 for its sharper stars at the edge compared with the 22mm Type 4.

Meade 100° Mega Wide; Orion 80° LHD Lanthanum; Stellarvue 100° Optimus; Tele Vue Nagler or Ethos; or Vixen 83° SSW. A 14mm to 7mm eyepiece from any of these lines can provide enough power to resolve star clusters and reveal faint galaxies without sacrificing field of view. These are perfect eyepieces for untracked Dobsonians, where their wide fields help keep objects in view.

ADDING A LOWEST-POWER PANORAMA EYEPIECE

For the widest field on a 2-inch system, Tele Vue's 41mm Panoptic can't be beat. If a 40mm eyepiece yields more than a 7mm exit pupil on your telescope (see "How Low Can You Go?" on page 171), opt for a Baader Hyperion 36mm or 31mm, an Explore Scientific 25mm 100°, a Meade 26mm Mega Wide, Tele Vue's 35mm Panoptic or its big 31mm Nagler, again assuming that your scope can handle the weight and your wallet the price.

Frankly, you can spend a lot on such an eyepiece and not use it that often. Don't forget to factor in the 2-inch nebula filter you'll also want, making for a pricey addition. But the views of big deep sky objects, such as the North America Nebula, Carina Nebula or Veil Nebula, are unforgettable.

ADDING A HIGHEST-POWER PLANETARY EYEPIECE

As mentioned, for highest-power viewing of planets, double stars and small deep sky targets, we've often used a good Barlow or Powermate paired with a long-focal-length eyepiece, rather than a standard 4mm to 8mm eyepiece. Eye relief is much better, and performance is not compromised.

An alternative is one or two short-focal-length but long eye relief eyepieces from Baader's Morpheus, Celestron's X-Cel, Orion's 55° Edge-On, similar Stellarvue Planetary or Tele Vue's DeLite or Delos series. While costly, a 4.7mm or 3.7mm Ethos SX works great too, with the 110° field good for Dobsonians.

But a caveat: While lowest- and highest-power eyepieces are great to have, your most-used eyepieces in practice will be the ones that provide magnifications in the range of 7 to 25 times your telescope's aperture in inches.

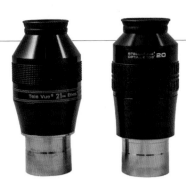

TOP OF THE LINE
The 21mm Tele Vue 100° Ethos (left; $850) is superb but costly and is very nearly matched in edge-to-edge sharpness by Stellarvue's 20mm 100° Optimus ($400) at less than half the cost.

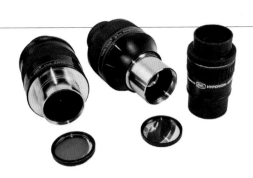

LOWEST-POWER PANORAMA
Under dark skies, the lowest-power eyepiece can give wonderful views of star clusters, dark nebulas and large emission nebulas, the latter best with a 2-inch UHC-class filter.

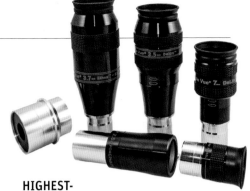

HIGHEST-POWER PLANETARY
Consider a Barlow or Powermate coupled to a longer Plössl (front) or a long eye relief eyepiece that incorporates a Barlow and gives a wider field.

OUR FAVORITE EYEPIECES

While we suggest you need only three or four eyepieces, if you're like us, you'll accumulate a caseload after a few years. From longest to shortest focal lengths, these eyepieces are currently on our most-used list.

1 Tele Vue 41mm Panoptic and 31mm Nagler Type 5: As you might have gathered, we love these for their widest field and edge-to-edge sharpness. But their weight can pose balance issues on Dobsonians. Not to mention their cost!

2 Baader 31mm Hyperion Aspheric: An affordable alternative author Dyer uses is the 31mm Hyperion. While soft in the outer 30 percent of the 72° field, its light weight works well on our small Dobs and refractors. The 36mm Hyperion also works very well.

3 Tele Vue 27mm Panoptic: "I notice it is often overlooked," says author Dickinson, "but many of my most awesome deep sky views have been with the 27mm Pan. It's an ideal combination of power, wide field and great optics."

4 Tele Vue 24mm Panoptic: This Pan provides the widest field in a 1.25-inch eyepiece and is sharper than any competitor. If there is one premium deep sky eyepiece to buy for 1.25-inch focusers, this is it.

5 Orion 14mm LHD 80° Lanthanum: Out of the eyepieces tested for our

Shoot-Out, Dyer decided to keep this one. "The Orion is almost Nagler-sharp to the edge and looks great on my red-anodized SharpStar refractor."

6 Tele Vue Ethos (17mm to 8mm): We've owned these for years and use them a lot. There is nothing better, though we have to admit that at today's prices (and our low Canadian dollar), it's tough to justify their cost.

7 Baader Morpheus (17.5mm to 9mm): In previous editions, Dyer said: "If I were restricted to owning one line of eyepieces, it would be the Pentax XWs." Now make that the Morpheus series. They outperform the XWs for less money.

8 Tele Vue Delos (6mm and 3.5mm): With a set of Ethos in our cases, there was little need to buy a set of Delos. But Dyer turns to a Delos when he needs a high-power, long eye relief eyepiece for planets and double stars.

9 Tele Vue Type 6 Naglers: These are excellent, but with aging eyes, we're less tolerant of their 12mm eye relief, especially with an Ethos, a Morpheus or a Delos at hand, all with better eye relief.

10 Tele Vue 4x Powermate: "On my short-focal-length apo refractors," says Dickinson, "the 4x Powermate makes a great planet-viewing combination when coupled with a 26mm to 20mm Plössl eyepiece."

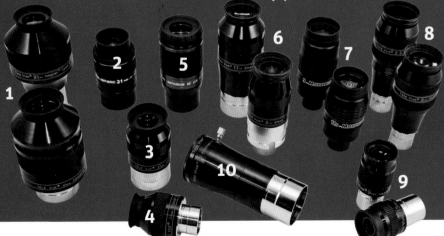

CHOOSING FILTERS

The best accessory for a telescope is a set of first-class eyepieces. The best accessory for the eyepieces is a good set of filters. However, be warned—while the difference a filter makes can be dramatic, it is more often subtle, requiring a trained eye to appreciate.

FILTER BASICS

There are three types of filters for amateur astronomy: solar; lunar and planetary; and deep sky. Although very different in construction, these filters have the same purpose—to reduce the amount of light that reaches the eye, which seems contrary to our quest for bigger telescopes and more light.

It is easy to understand why a filter is required for observing the Sun, and because solar filters are integral to that task, we deal with them separately in Chapter 12. But the planets? Here, the main purpose of a filter is to enhance planetary markings by improving contrast between regions of different colors.

On the other hand, nebulas and galaxies are faint. So how does a filter help? Nebula filters block unwanted sky glow wavelengths and admit the narrow range of colors from glowing nebulas, improving the contrast between nebula and sky.

Filters are made of plane-parallel glass and are available for 1.25- and 2-inch eyepieces. With the exception of the Vernonscope Brandon models, which use a proprietary thread, all eyepieces made since the 1980s use a standard filter thread, so any brand of filter can be used on any eyepiece. While a few manufacturers offer sliders or wheels for rapidly switching between filters, these require more back focus, which not all telescopes can provide.

PLANETARY FILTERS

Available in every color of the rainbow, planetary filters are inexpensive ($15 to $45 each; often bundled in sets of 4 to 20 filters). As with eyepieces, the temptation is to collect the whole set, but you don't need them all.

The most useful of all the colors are: #12 deep yellow; #23A light red, to increase the contrast between dark and light areas on Mars; #56 light green, to enhance features such as Jupiter's Great Red Spot and its dark cloud bands; and #80A light blue, for occasional glimpses of clouds on Mars. These constitute a basic set.

A #8 light yellow can be substituted for the #12, and a #21 orange or #25 deep red for the #23A light red. A specialized Mars filter ($40) lets through both red and blue light, improving contrast of Martian surface and atmospheric features. However, the improvements offered by all planetary filters are subtle. (See Chapter 14 for more on viewing the planets.)

THREAD-ON FILTERS

All filters thread onto the bottom of the eyepiece. By threading a filter onto the front of a star diagonal (most are threaded), it will work with whatever eyepiece is inserted into the diagonal.

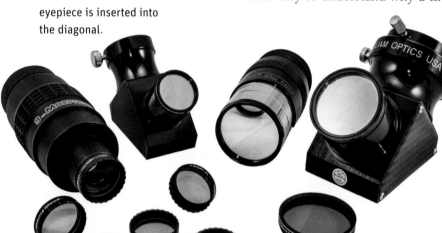

PLANETARY SET

Most planetary filters are labeled with the same Kodak Wratten numbers used in photography. A #80A blue filter for planetary observing is the same color as the photographer's #80A. However, these premium Baader filters are labeled by wavelength (nm).

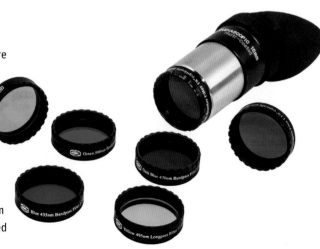

PLANETARY FILTERS: A SUMMARY COMPARISON

WRATTEN #	COLOR	OBJECT	COMMENTS
Minus Violet	mostly clear	Planets	Reduces violet chromatic aberration
8	light yellow	Moon	Cancels blue chromatic aberration from refractors; reduces glare
11	yellow-green	Moon	Same as #8 but deeper color
12 or 15	deep yellow	Moon	Increases contrast; reduces glare
21	orange	Mars	Lightens reddish areas and accentuates dark surface markings; penetrates atmosphere
		Saturn	May be helpful for revealing cloud bands
		Sun	Cancels blue color of some Mylar solar filters
23A	light red	Mercury, Venus	Darkens blue-sky background in daytime observations
		Mars	Same as #21 but deeper in color
25	deep red	Mars	For surface details with large-aperture scopes
		Venus	Reduces glare; may reveal cloud markings
30	magenta	Mars	Blocks green; transmits red and blue
38A	blue-green	Mars	Reveals clouds and haze layers
47	deep violet	Venus	Reduces glare; may help reveal cloud markings; a very dark filter
56	light green	Jupiter	Accentuates reddish bands and Great Red Spot
		Saturn	Accentuates cloud belts
58	green	Mars	Accentuates details around polar caps
		Jupiter	Same as #56 but deeper color
80A	light blue	Mars	Accentuates high clouds, particularly near limb
		Jupiter	Accentuates details in belts and white ovals
82A	very light blue	Mars	For Martian clouds and hazes
		Jupiter	Similar to #80A but very light tint
85	salmon	Mars	Similar to #21; for surface details
96	neutral density	Moon, Venus	Reduces glare without adding color tint
—	polarizer	Moon	Darkens sky background during daytime for observations of quarter Moon

LUNAR FILTERS

The Moon can be too bright in large telescopes. A neutral-density filter ($15) can cut glare and ease eyestrain. For achromatic refractors, a #8 light yellow or a #11 yellow-green filter is also helpful in canceling the chromatic aberration present in all but the finest models—most noticeable as a bluish fringe on the Moon, Jupiter and Venus.

An alternative is a filter such as Lumicon's Minus Violet or Baader Planetarium's Fringe Killer (each $80). These suppress the short-wavelength blue-violet and long-wavelength red that contribute to the false-color halos around bright objects.

Polarizing filters are also useful as neutral-density filters for viewing the Moon. Their ability to block light waves that vibrate in one direction makes them good for glare-reducing sunglasses. Their main application in astronomy is for observing the first- or last-quarter Moon in daylight or twilight. Light is most polarized in the region of sky 90 degrees from the Sun, where the quarter Moon (or Jupiter at quadrature) is found, so a filter darkens the sky. That said, we rarely use lunar filters.

LUNAR POLARIZER

A polarizing filter darkens the background sky, increasing contrast for daytime Moon views and lowering the brightness in nighttime views. (For the best effect, make sure it is rotated.)

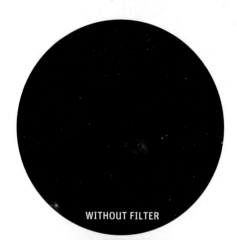

NEBULA FILTERS

Made of multiple layers of thin coatings, nebula filters are much more expensive than planetary filters. Prices range from $60 to $120 for 1.25-inch filters (left) or up to $250 for filters that fit 2-inch eyepieces. But all avid deep sky observers will want one. Or two or three!

NEBULA FILTERS

Introduced by Lumicon in the late 1970s, nebula, or light-pollution-reduction (LPR), filters are rightly considered a significant advance in amateur-astronomy equipment. These high-tech filters capitalize on the fact that nebulas emit light only at very narrow wavelengths, unlike stars, which emit across a broad spectrum of colors. Nebular light results mostly from ionized hydrogen atoms, which emit at 656nm (nanometers) red and 486nm blue-green wavelengths, and ionized oxygen atoms, which emit at 496nm and 501nm green wavelengths.

Mercury- and sodium-vapor streetlights emit only in the yellow and blue ends of the spectrum. Because nebulas emit in the red and green parts of the spectrum, filters can block at least some artificial light without affecting the natural light of nebulas. Unfortunately, nebula filters can only partially block the more continuous spectrum emitted by LED streetlights.

Three kinds of deep sky objects benefit from the use of a nebula filter: diffuse emission nebulas, planetary nebulas and supernova remnants, as explained in Chapter 15. All emit light at those narrow wavelengths. Some nebulas (seen as blue in photos) shine only by reflecting a broad spectrum of starlight and so do not benefit from nebula filters. Nor do most nebula filters help when viewing galaxies or star clusters; filters dim both the object and the sky.

Nebula filters can transform a poor, light-polluted sky into a moderately good location (at least for observing emission nebulas) and a good observing location into a great one. Indeed, their effect is most dramatic under dark skies, where nebula filters can reduce the omnipresent sky glow from weak auroral and airglow activity and background starlight. We feel a nebula filter is a must-have accessory for deep sky viewing. But which one to buy?

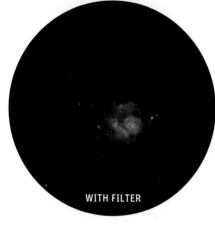

WITHOUT FILTER

WITH FILTER

FILTERING THE LAGOON

A typical narrowband UHC filter brings out more and fainter nebulosity while darkening the sky, as seen in the above simulations. The improvement varies with the object; the Lagoon Nebula, in Sagittarius, is a good filter target. One view of the Veil Nebula, in Cygnus, with a UHC or O-III filter will convince you of a nebula filter's value (see Chapter 15).

TYPES OF NEBULA FILTERS

With nebula filters, the critical specification is the bandpass. Some filters let a broad swath of light through in the all-important green band of the spectrum, as well as the red. However, the human eye is more sensitive to green, so that's the band that matters the most for visual astronomy. Broadband, or Deep Sky, filters are intended for mild light-pollution reduction. While they can darken the sky when viewing star clusters and galaxies, broadband filters offer only a mild enhancement of nebulas. A few examples of these filters are the Astronomik CLS, Lumicon Deep Sky, Orion Sky-Glow and Thousand Oaks LP-1.

The next class has a much narrower bandpass in the green that blocks unwanted light more effectively, significantly improving contrast, but only for emission nebulas. Other deep sky objects just go dark. The Lumicon Ultra-High Contrast (UHC) filter, now in its third generation from Farpoint Astro, is the original of a number of UHC filters. Among them are the Astronomik UHC, Optolong UHC, Orion UltraBlock, Tele Vue Bandmate Nebustar (made by Astronomik) and Thousand Oaks LP-2. Celestron's UHC/LPR falls between a broadband and a narrowband filter in contrast.

There are also "line" filters that use ultranarrow bandpasses tuned to the green emission lines of doubly ionized oxygen, called O-III (though it is more correctly labeled as "[OIII]" in physics terminology), and to the blue-green Hydrogen-beta emission line. H-beta filters enhance so few objects (mostly the Horsehead Nebula and the California Nebula), you might rarely use one. But O-III filters can provide an even more dramatic increase in contrast on some nebulas than a UHC filter. Line filters are offered by Astronomik, Celestron, Lumicon, Orion, Tele Vue and Thousand Oaks (its LP-3 and LP-4).

Note: Don't confuse *visual* filters with the narrowband hydrogen, oxygen and sulfur filters intended for monochrome *photography*. Don't buy those by mistake! And especially DO NOT buy a red Hydrogen-alpha filter designed only for deep sky photography and use it on the Sun. You could damage your equipment and your eyes.

NEBULA FILTERS: A SUMMARY COMPARISON

The main difference among nebula filters is their transmission of wavelengths in the blue-green band (around 500nm), from a wide bandpass (90nm) to a very narrow bandpass (9nm).

TYPE	BANDPASS[1]	COMMENTS
Broadband (CLS or Deep Sky)	90nm: 442nm–532nm	Widest bandwidth and brightest image but least amount of blocking of light pollution. Can be used on non-nebula deep sky objects. Good for slow focal-ratio telescopes.
Narrowband (UHC)	24nm: 482nm–506nm	Narrow bandpass darkens sky with more dramatic contrast. A good general-purpose filter for all emission nebulas. Suitable for urban sites.
Oxygen-III (Line Filter)	11nm, including 496nm and 501nm	Very narrow bandpass centered on green doubly ionized oxygen lines. Highest contrast. Good for planetary nebulas and supernova remnants. Best on fast focal-ratio telescopes.
H-beta (Line Filter)	9nm centered on 486nm	Very narrow bandpass centered on blue-green H-beta emission line. Useful for very few nebulas. Buy this filter last. You'll rarely use it.

[1] Measured in nanometers (nm)
1 nanometer =
10 angstroms =
1 millionth of
a millimeter

These charts are courtesy of Astronomik and show the passbands of Astronomik's visual filters, but other brands are similar. The vertical orange lines are the main red and green emission lines of nebulas.

We use UHC and O-III filters regularly but have found little use for the subtle improvement of broadband filters. If you are going to choose one filter, make it a UHC-class narrowband filter. If you get hooked on nebulas, add an O-III filter later, though it is best suited to fast f/4 to f/6 telescopes. On slow f/10 to f/15 telescopes, O-III filters darken the sky so much that users can have difficulty seeing the field of view. On fast scopes, however, the improvement to certain deep sky objects is like doubling the aperture of your telescope. Not bad for $200! Except, like eyepieces, you do tend to collect filters over the years. Why not?

CHAPTER 9

Our Accessory Catalog

A few key accessories can make stargazing sessions more comfortable and productive. Others are luxury items that can be added once your basic needs are met. We consider some items not as essential as ads and YouTube videos might have you believe.

Indeed, you don't need to leave the telescope shop with a cartful of gear just to get started. However, having some of these accessories on your wish list will make holiday gift giving easier for your family in years to come.

In preparing this edition of our book, we were surprised at how many items that we included in earlier editions are now obsolete or simply not on anyone's wish list. Electronic star pointers? Gone. Replaced by phone apps. Big and hefty lead-acid batteries for portable power? Gone. Replaced by compact lithium batteries. Bluetooth adapters? Replaced by WiFi. The same might happen to items we list in this edition. With that caveat, we offer our catalog of the accessories we think are worthy of consideration by backyard astronomers. Or not!

You don't realize how essential a simple red flashlight is until you forget it one night. How do you read star charts or set up your telescope without it? You can have the biggest and best telescope, with all the bells and whistles, and yet be lost under the stars for want of a $20 flashlight. So buy two. Or three!

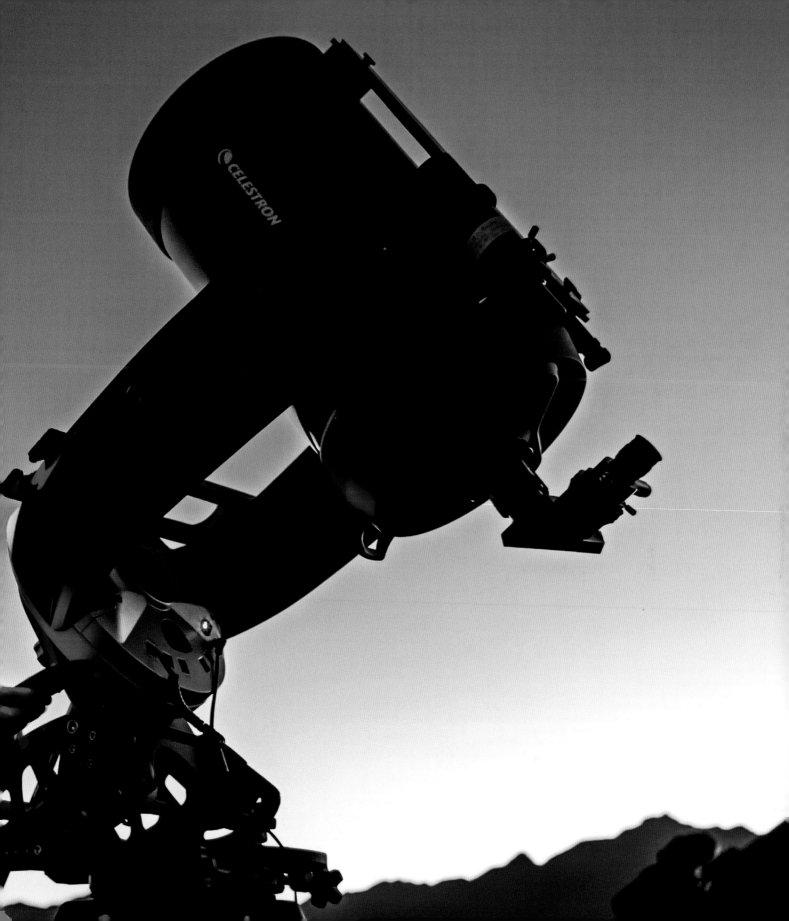

ALMOST ESSENTIAL

Star charts and eyepieces top the list of must-have accessories, so much so that we cover these items separately in Chapters 4 and 8, respectively. Astrophotography requires many specialized products, which are discussed in Chapter 17. However, we think the following accessories for visual astronomy should rank highest on your wish list.

RED FLASHLIGHTS

While a white-light flashlight is useful for setup and takedown, you'll need a red flashlight for most of your nighttime forays to preserve your night vision. Flashlights with both white and red LEDs are useful, with headlamps preferred to leave your hands free. Some use AAA batteries; others use lithium batteries that are rechargeable by a standard 5-volt USB charger.

Some headlamps, such as models from Coast, require you to switch through the white light to get to the red light, a poor design that will make you very unpopular at star parties. Look for units with separate switches for the red and white lights and selectable brightness levels. Dimmable red LED lights (or white lights covered with red gel) on flexible stalks are also useful for illuminating star charts, accessory cases and tabletops.

RED-DOT OR REFLEX FINDERS

We mentioned these in Chapter 4, but if your telescope doesn't already have a red-dot finder (RDF), adding one can make it much easier to aim your telescope than with the often poor optical finderscopes included with beginner scopes. Example RDFs are the Orion EZ Finder, Burgess MRF, Astro-Tech ATF and Celestron's StarPointer ($30 to $60). RDFs slide into the dovetail channel occupied by your existing finder or use a new dovetail base bolted to existing holes in your telescope tube.

Popular alternatives we like (each about

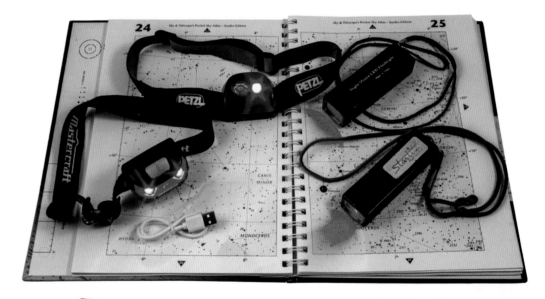

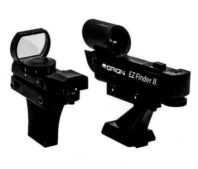
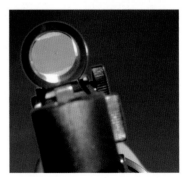

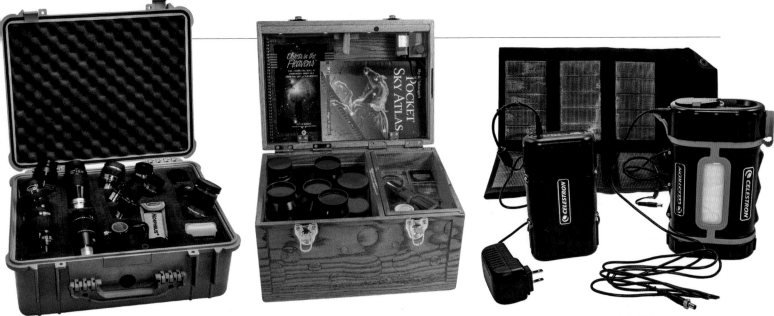

CARRYING A CASELOAD

A big Pelican case, left, holds some of the eyepieces we tested in Chapter 8. While you'll have fewer eyepieces, you will also have filters, tools, hand controllers, cables, star atlases and more. Forgetting a critical part can ruin your observing trip. The Wood Wonders case, right, can be customized in layout and exterior finish and include your personalized monogram.

$40) are the Telrad, designed by Steve Kufeld, and the Rigel Systems QuikFinder. Each projects a red bull's-eye pattern onto a reflex window and attaches using a plastic base that fastens with double-sided tape or screws.

POWER PACKS

GoTo telescopes need 12-volt power. Some have built-in batteries that are good for a night. Some might come with an AC adapter, which is fine for use at home. For use in the field, some scopes come with a cord that plugs into a car's 12-volt cigarette-lighter jack.

However, a separate battery is a better choice, as it allows you to set up your telescope anywhere, with no worries about running down your car battery. Sealed lead-acid batteries are a thing of the past. Most power packs are now lithium cells and come with a 5.5mm OD/2.1mm ID tip-positive jack and cord to plug into the same barrel-style jack most telescopes use for their power input.

The bigger the capacity, the more nights' use you'll get out of a single charge. Some GoTo scopes can draw up to 3 amps at 12 volts when slewing, draining a small power pack before a busy night is over. Add antidew heater coils, CMOS cameras and auto-guiders, and the modern observer quickly encounters an energy crisis in the field.

ACCESSORY CASES

The best accessory for all your accessories is a solid case to keep everything organized and within reach in the dark. Camera stores offer hard-shell cases such as the popular Pelican line. Some cases have compartments with

MORE POWER!

Above: We use and recommend these Celestron PowerTank batteries. The smaller Lithium LT is good for one or two long nights; the bigger Lithium Pro will work for several nights depending on your power demands. For long stays at remote sites, a third-party solar panel can recharge your batteries.

POOR FINDERSCOPES

First-time telescope buyers often don't realize how important the little finderscope is to enjoying a new telescope. A good finderscope makes it easier to find and center targets. Unfortunately, many low-cost telescopes purchased at big-box stores have atrocious finderscopes, sometimes no more than hollow tubes with crosshairs.

The common 5x24 finderscope, shown here, is poor. It often has an aperture stop inside the tube, cutting the advertised 24mm aperture down to an actual working diameter of 10mm to avoid awful lens aberrations. Such a small aperture makes it difficult to sight anything dimmer than the Moon. Upgrading a 5x24 junk finder to a good-quality 6x30 (i.e., 6 power and 30mm aperture) or adding a red-dot finder makes a vast improvement.

Actual aperture 10mm

Advertised aperture 25mm

TAKING CARE OF TELESCOPES

Cardboard boxes will last only so long. A soft-sided case, such as this Orion model for small refractors (below), or a hard-shell case, like this JMI unit for a Celestron NexStar 6SE (right), is almost essential if you'll be making lots of field trips with your telescope.

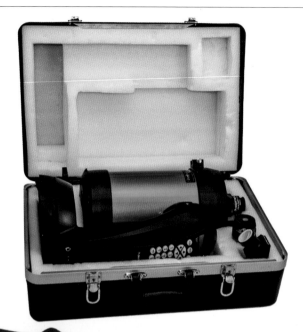

movable dividers; others have foam that can be cut out as needed. Specialized cases for astronomers from Wood Wonders (wood-wonders.com) provide built-in illumination, a place for your tablet and heater elements to keep your eyepieces dry and toasty—luxury!

TELESCOPE CASES

Many telescopes don't come with their own case. For taking your scope on the road, you'll want one. Dealers such as Orion Telescopes sell padded or soft-sided bags suitable for small telescopes. Some bags can also accommodate tripods and mounts. Hard-shell cases, often a manufacturer option, are better choices for large scopes, such as Schmidt-Cassegrains. Farpoint Astro sells the excellent JMI line of cases.

CLEANING AND TOOL KITS

A kit containing all the screwdrivers and wrenches your telescope might require can be an essential item. After a jostling road trip, parts come loose, optics must be collimated and bolts need tightening. "No tool kits" for some telescopes can replace screws and bolts with large knobs that are easy to adjust by hand, such as those from Bob's Knobs.

A packet of lens-cleaning tissue, cotton swabs, lens-cleaning fluid or a LensPen should also be included in every accessory case. And don't forget the bug spray! Apply it carefully, though. Repellents with high DEET content can eat into optical coatings and the vinyl on binocular bodies.

DEWCAPS

The first line of defense against dew or frost is a dewcap, a tube that extends beyond the front lens or corrector plate. Most refractors have built-in dewcaps. Yet the telescopes that most need dewcaps—Maksutov- and Schmidt-Cassegrains—rarely come with one. Exposed to the sky, the corrector lenses of these telescopes readily attract dew, quickly ending an observing session. Dewcaps in all sizes can be purchased from telescope manufacturers or small accessory companies, such as Astrozap, Farpoint Astro and Kendrick Astro Instruments. Or you can fashion one yourself out of poster board, foam or plastic.

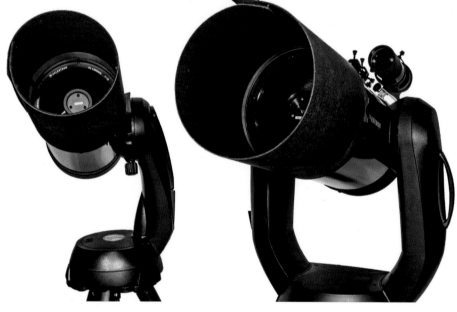

KEEPING CORRECTORS DRY

Schmidt-Cassegrains are notorious for attracting dew. These dewcaps from Astrozap are held in place with Velcro. Some telescopes, like the classic Celestron GPS8 at right, might need a specific dewcap cut to accommodate rails along the tube.

NICE TO HAVE

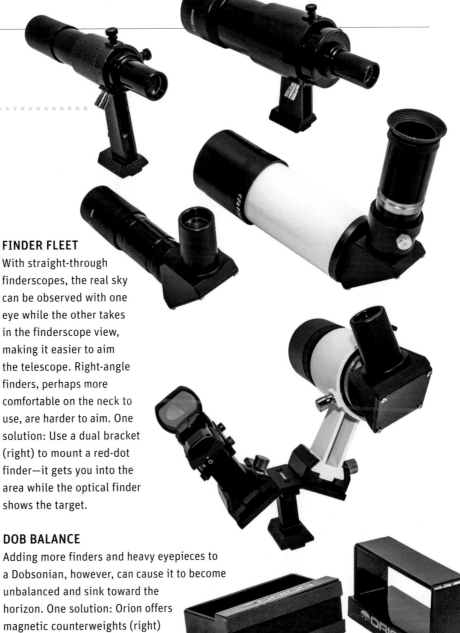

After the necessities of astronomical life have been met comes a list of items that aren't essential but can add enjoyment to your sessions under the stars.

50MM FINDERSCOPE
Some large telescopes, such as Schmidt-Cassegrains, come with only a red-dot finder or a small 6x30 optical finderscope. If it's a GoTo telescope, the assumption is that you need the finder only to perform the initial star alignment. That might be true, but for 8-inch (20 cm) and larger telescopes, a 7x to 9x50mm finderscope (for $60 to $120) is a nice upgrade, allowing you to see deep sky targets in context in the wide field of the finder.

A caveat: A big finderscope, not to mention large eyepieces, can cause a Dobsonian to sink out of balance. Magnetic counterweights or beanbags stuck to the bottom of the tube might be needed.

Some finderscopes have illuminated reticles. While also nice to have, it's easy to forget to turn off the light, so the illuminator is dead most of the time. Have a spare battery in your kit. Ditto for your red-dot finder. Without it, aligning your GoTo scope can be difficult.

POLAR-ALIGNMENT SCOPE
Equatorial mounts must be polar-aligned for accurate tracking, requiring some way of aiming the mount's polar axis at the celestial pole. On German equatorial mounts, a small polar-alignment scope, located in the mount and aimed up the polar axis, might be included, or it might be a worthwhile option. A polar scope makes it much easier to aim the polar axis at Polaris for an alignment good enough for visual use, if not photography (see the Appendix).

MOTOR DRIVES
Most first-time telescope buyers who purchase equatorial mounts do so because of the mount's ability to track

FINDER FLEET
With straight-through finderscopes, the real sky can be observed with one eye while the other takes in the finderscope view, making it easier to aim the telescope. Right-angle finders, perhaps more comfortable on the neck to use, are harder to aim. One solution: Use a dual bracket (right) to mount a red-dot finder—it gets you into the area while the optical finder shows the target.

DOB BALANCE
Adding more finders and heavy eyepieces to a Dobsonian, however, can cause it to become unbalanced and sink toward the horizon. One solution: Orion offers magnetic counterweights (right) to clamp onto the lower end of the metal tube.

SIGHTING THE POLE
Small sighting scopes (left) in the polar axis of German equatorial mounts make it easy to align on the celestial pole. All have reticles that indicate where to place key stars such as Polaris for precise alignment. (See the Appendix for detailed instructions.)

TRACKING MOTOR

The optional single-speed drive for the EQ2 mount we illustrate in detail in Chapter 10 is shown at right. Better units offer multiple speeds for electric slow motions. While either type is not essential, they do provide basic hands-off tracking (but not GoTo functions).

COLLIMATION AIDS

A low-cost Cheshire eyepiece (left) is helpful for eyeball alignment of Newtonian mirrors as per the steps we outline in the Appendix. A laser collimator (right) is popular for collimating truss-tube Dobsonians assembled for each night's use.

LINING UP BY LASER

A laser collimator at work shows the beam hitting the primary mirror off-center (meaning the secondary needs adjusting) and returning to the collimator off-center (meaning the primary is also off slightly).

the stars. Yet many never bother adding the optional motor drive needed to supply the very tracking the mount is capable of providing. The lowest-cost model (shown at left) offers tracking in the east-to-west motion at a fixed speed. Better models have override buttons for an instant 8x, 16x or 32x speed change. This is useful for panning around the Moon and centering objects. Chapter 10 has more details.

COLLIMATION TOOLS

Newtonian reflectors need collimation from time to time. Some Newtonians come with a collimating cap. A better choice is a collimating eyepiece (about $45), a tube with crosshairs and a diagonal surface to reflect light down into the telescope tube (one type is called a Cheshire eyepiece). Sighting through such an eyepiece makes it easier to center all the optical elements, especially if the secondary and primary mirrors are marked with a dot or a ring at the center (see the Appendix for collimation procedures).

LASER COLLIMATORS

A higher-tech solution is a laser collimator ($70 to $300). When placed in the focuser, the collimator projects a beam of red laser light down the Newtonian tube. You then adjust the tilt of the telescope's mirrors until the beam returns exactly onto itself. It works well, allowing accurate collimation by day. However, precise collimation might still require a star test by night. Laser collimators are available from CatsEye, Farpoint Astro, Hotech USA, Orion and Starlight Instruments, which offers the well-respected Howie Glatter line.

OBSERVING CHAIRS AND TABLES

Why not be comfortable? Treat yourself to a place to sit while observing. You can use an adjustable-height stool, such as those sold in music stores for drummers. A better choice is a specialized observing chair (either metal or wood), which offers a greater range in seat height as well as a back to rest against. Wood Wonders sells the handcrafted Catsperch models.

Large Dobsonians require an observing ladder. A small kitchen stepladder might suf-

COMFORT AND CONVENIENCE
An adjustable chair and a portable camp table make for a comfortable observing station, allowing you to get organized, then relax and enjoy the experience. Take your time and look. Sketch. Make notes. Observe!

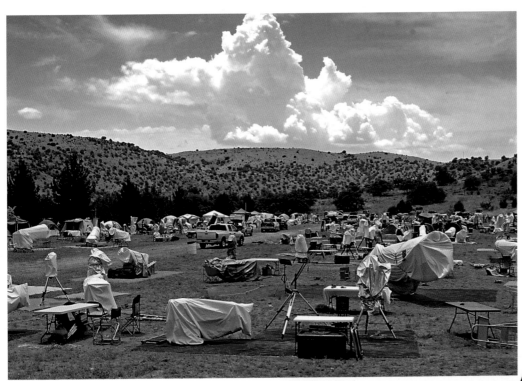

SCOPES UNDER COVER

A scene from the Texas Star Party shows the main observing field by day, with a sea of scopes under cool white covers to protect them from the Sun and the West Texas storms. For long-term stays at dark sites, covers such as these from TeleGizmos (below) are essential.

fice for 14- to 16-inch Dobs. Really big Dobs need a tall stepladder, a bigger component to pack and transport than the telescope itself.

Out in the field, a folding camp table is great for laying out star charts, cases and other stargazing paraphernalia. Without one, observers are forced to work off tailgates or out of car trunks.

SCOPE COVERS

At star parties and even in your own backyard, it's most convenient if you can leave your telescope or perhaps just the aligned mount set up for a few nights. Doing so requires a weatherproof cover, if only to keep off the Sun...and birds! Dealers such as AstroGizmos, Astro-Systems, Orion and TeleGizmos offer excellent sets of weatherproof covers to fit many sizes and styles of telescopes. Our TeleGizmos covers have lasted for years in all weather conditions; we can recommend them.

DEW GUNS

A dewcap usually keeps moisture off the lens for about an hour longer than would be the case without the cap. Then what?

The first attack of dew can be repelled with a hand-held hair dryer, blowing warm (not hot) air onto the affected lens. At home, a low-

DEW: THE VAMPIRE OF ASTRONOMY

Like a vampire, dew sucks the life out of a telescope late at night. As the temperature falls, moisture condenses out of the air onto the optics, forming droplets of dew or, in cold weather, frost. Every backyard astronomer has cursed the plague of glazed optics that ended a planet watch on an evening of excellent seeing or fogged an astrophoto midway through a night's worth of exposures.

Owners of Newtonian telescopes usually don't have to worry about dew, since the long tube protects the main mirror. Dew can still form on secondary mirrors in open truss-tube Dobs. However, Schmidt-Cassegrains, Maksutovs and refractors, like this little Meade ETX, are the telescope types most prone to dew.

On humid nights, a hand-held hair dryer is a stopgap measure. The optics always fog up again. Once the telescope has donated all its heat to the air, dew keeps re-forming. Furthermore, after many dew attacks, an optical surface can accumulate a sticky, hard-to-remove residue from heat-dried dust and moisture. The secret is to prevent the dew from forming at all. And that's what dew heaters can do.

DEW GUNS

At home with AC power at hand, we often use a hair dryer (right) to warm up camera lenses when dew unexpectedly begins to form. A low-power 12-volt unit (left) plugs into a car's cigarette lighter.

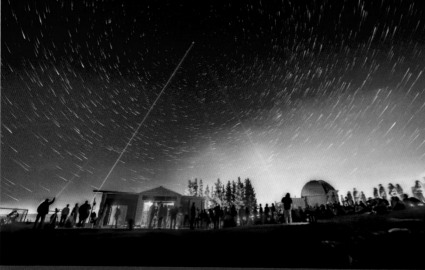

THE LEGALITY OF LASERS

Green laser pointers (GLPs) are favored by astronomers for outreach programs. However, the ready availability of GLPs in years past has led to their misuse by miscreants aiming them at aircraft, where they can blind pilots. The rise of such dangerous incidents has caused many jurisdictions to ban their import and sale outright or to restrict sales to low-power units under 5 milliwatts. (Really bright GLPs, now often illegal, rate as high as 50 milliwatts.)

In our country, The Royal Astronomical Society of Canada worked with Transport Canada to get a special dispensation that allows accredited members of the Society to use GLPs for outreach, but only away from airports and urban areas. And even then, we have "plane spotters" at public events looking out for aircraft in the area so that we can stop our laser pointing until the sky is clear. (See www.rasc.ca/laser-pointer-usage)

The rules and regulations are being debated and differ from country to country. But as amateur astronomers who value GLPs for our programs, adhering to the regulations that we can help write ensures that we can continue to use GLPs responsibly for public education.

wattage AC hair dryer has saved us on many a night. If you are running on 12 volts DC, use a heater gun sold in automotive stores for melting frost off windshields. It plugs into the socket of an automobile cigarette lighter.

DEW REMOVER COILS

The best way to eradicate dew and frost, however, is to prevent them from forming in the first place. The trick: a low-voltage heater coil. This provides just enough warmth to ward off dew without creating air currents that would degrade image sharpness.

Heater coils are available from Astrozap, Dave Lane Astrophotography, Kendrick Astro Instruments, Orion and Starfield Optics. There are models for all sizes of telescopes, finderscopes, Telrads, secondary mirrors, eyepieces, even laptop computers. Most systems use a 12-volt, variable-intensity controller to distribute power to several heaters. Starfield Optics has models that operate from a 5-volt USB power outlet, often a more convenient power source but one suitable only for small coils.

WHEELEY BARS

Inspired by TV studio gear, Jim's Mobile, Inc. (JMI), now owned by Farpoint Astro, designed Wheeley Bars, a set of rolling casters that fit under the tripod legs of large telescopes, such as 10- to 12-inch (25 cm to 30 cm) Schmidt-Cassegrains. Other companies, such as ScopeBuggy, followed suit. If you can store your telescope in a garage or shed that has clear access to your backyard site, a telescope dolly is a great solution for a no-fuss setup. It can make an otherwise unwieldy large-aperture telescope a practical choice for casual stargazing.

GREEN LASER FINDERS

A green laser pointer is superb for conducting public observing sessions. How did we ever point out stars and constellations without one? With difficulty! It can also be fitted to telescopes and used as a finder. Several companies, such Hotech USA, Farpoint Astro and Orion, offer laser finders and brackets. However, check with your local authorities or astronomy clubs on the legality of their use in your area.

ANTIDEW AIDS

Heater coils from Kendrick Astro Instruments (left) operate off a 12-volt source. The Dew Destroyer from Dave Lane Astrophotography (center) comes with its own long-lasting lithium battery. The Starfield Optics coil (right) can be powered by a 5-volt USB charger. As shown, a telescope can be outfitted with heaters for all optics for about $250 to $350 with the controller.

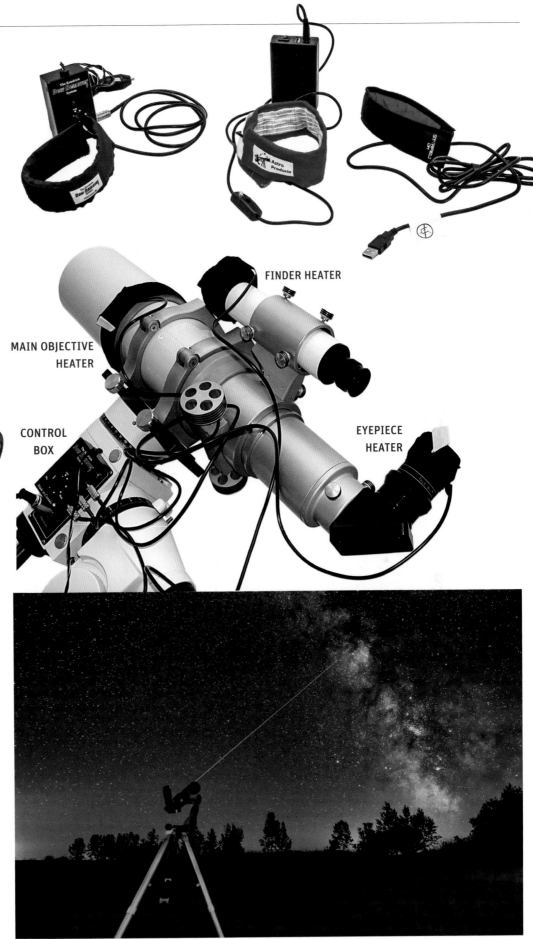

FINDER HEATER

MAIN OBJECTIVE HEATER

CONTROL BOX

EYEPIECE HEATER

SCOPE ON WHEELS

This JMI Wheeley Bar dolly makes it possible to keep a telescope assembled and ready to roll. Models are available for tripod-mounted scopes and for Dobsonians. (Image courtesy Farpoint Astro)

LASER-LIGHT POINTING

At a dark site, a green laser can work as a finder, with the advantage that you don't have to bend down to peer through a finderscope. But at star parties, other astronomers might not appreciate your laser beams. And lasers are illegal in many places.

LUXURY ITEMS

For the observer who has collected all the required toys, there is another realm of wonderful astronomical accessories, some with hefty price tags.

GPS DONGLES

Some GoTo telescopes come with a built-in GPS receiver. This circumvents the need to enter your site (usually a onetime requirement) and the date and time (often needed every night). While entering your local information is scarcely a hardship, small GPS dongles are available that plug into the hand controller and enter that information automatically. However, it can take a minute or more for the receiver to acquire the satellite signal.

WIFI DONGLES

GoTo telescopes can be controlled by astronomy software on an external computer, tablet or phone connected to your telescope via an ad hoc WiFi signal. Chapter 11 contains the details. Some telescopes have WiFi built in, but as with GPS, you can add WiFi connectivity to other GoTo scopes with an add-on dongle. This can work well but does involve more fuss over connecting gear that, in the case of the SkyFi unit, also needs its own battery power.

DIGITAL SETTING CIRCLES

Much of the computer-finding functionality of GoTo telescopes can be added to Dobsonians. Orion offers the $200 IntelliScope upgrade kit, while Sky Engineering (the Sky Commander unit) and Wildcard Innovations (the Argo Navis unit) have add-on computers and axis-encoder kits for a variety of telescopes (from $400 to $1,000).

All provide digital readouts of the telescope's position. Databases of objects allow you to find targets by dialing up the object's catalog number. Then, as you manually swing the scope, you watch the display. When the coordinates read 00 00, you are on target. Such devices are a particular favorite of users of big Dobsonians going after deep sky prey.

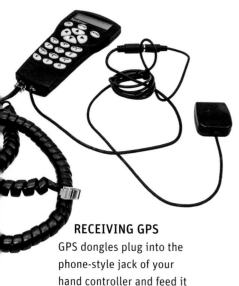

RECEIVING GPS
GPS dongles plug into the phone-style jack of your hand controller and feed it GPS satellite information for automatic entry of location and time. They don't require separate power.

TRANSMITTING WIFI
Celestron (left) and Sky-Watcher (middle) offer WiFi dongles for their telescopes, while the Starry Night SkyFi unit (right) works with most GoTo scopes using the Starry Night or SkySafari apps. Orion's StarSeek is a version of the SkyFi.

UPGRADING DOBSONIANS
Top: Popular with deep sky observers using premium Dobs, the combination of the Argo Navis computer and the StellarCAT motor drive can turn a giant Dob into a GoTo scope. Finding, then tracking, deep sky objects becomes a breeze.
Above: The alternative solution to adding tracking to a Dobsonian is to place it on a Poncet platform (named for its inventor, Adrien Poncet), which provides an hour or so of tracking before needing to be reset.

DOB PLATFORMS AND DRIVES

The major limitation of Dobsonian telescopes —no tracking—can be overcome with an ingenious device: the equatorial platform. The telescope rests on a small, ankle-high table that can swivel around one axis, driven by a motor. Equatorial Platforms offers drives for all sizes of Dobs ($1,400 to $4,000).

The alternative is adding computer-driven motors. The ServoCAT kits from StellarCAT are a popular solution for premium Dobs ($1,700 and up). When teamed with the Argo Navis, you get a full GoTo Dob. Once on target, objects stand still for detailed inspection. Big Dobs with premium optics turn into the finest planetary telescopes available.

TWO-INCH STAR DIAGONALS

If the focuser can accommodate it, a 2-inch star diagonal is a great addition to a refractor or a

Cassegrain-style telescope, allowing use of the panoramic 2-inch eyepieces we praised in Chapter 8. The best diagonals have mirrors with dielectric coatings that reflect 99 percent of the incident light, a sizable notch up from the 89 percent reflectivity of standard overcoated aluminum. If you get a 2-inch diagonal, get the best, but expect to pay $150 to $300.

BINOCULAR VIEWERS

Binocular viewers utilize a series of prisms to split the single beam from a telescope into twin collimated beams, one for each eye. The main caveat is that the added length of the light path through a binocular viewer typically requires four to five inches (10 cm to 13 cm) of extra in-focus travel of the focuser. Some premium refractors can accommodate this, as do most Schmidt-Cassegrains. But Newtonian reflectors cannot.

To get around this, binocular viewers are usually supplied with a small Barlow lens (often 1.5x to 2x), which extends the focal point out far enough that the eyepieces will

SHINY DIAGONALS

Two-inch diagonals allow the use of wide-angle two-inch eyepieces. These units feature enhanced coatings. There are special models for the threaded backs of Schmidt-Cassegrains. Two-inch visual backs that will accept any two-inch accessory are also available.

BEST BINOCULAR VIEWERS

Top-end binocular viewers are available from Baader Planetarium (below) and Tele Vue (right), each about $600 (for the Baader MaxBright II model, not shown) to $1,400. The Baader Großfeld premium viewer (below) can be fitted with a low-profile prism diagonal and one of several Glasspath Corrector lenses for correcting aberrations and allowing telescopes to reach focus.

THE TWO-EYED ADVANTAGE

Views through a telescope equipped with a binocular viewer, such as the Denkmeier, left, and the Baader Großfeld, bottom left, can be impressive. Objects appear to float in three-dimensional space. Planets seem to take on extra detail. The Moon looks like a real landscape just outside your spaceship window. And the comfort and ease of viewing are far greater than with one-eyed observing.

The obvious question with binocular viewers is the loss of light. Each eye can receive, at best, only 50 percent of the light that a conventional single eyepiece would provide. However, when the brain merges the two dimmed images back together, the result is a view that is nearly as bright as the same view with a single eyepiece. Even so, the extra optical elements do introduce some light loss, typically about 0.5 magnitude. For image brightness, an 8-inch scope performs like a 6-inch, a 10-inch like an 8-inch and a 12.5-inch like a 10-inch.

Binocular-viewer aficionados maintain that these drawbacks are offset by the additional detail all objects seem to display. Our experience confirms this. Images from both eyes present the brain with a view that has a greater signal-to-noise ratio. Views seem less grainy. Those dark and nasty eye floaters (dead blood cells in the eye) that drop in front of planets at high power are largely suppressed, allowing continuous and unimpeded views of the planets.

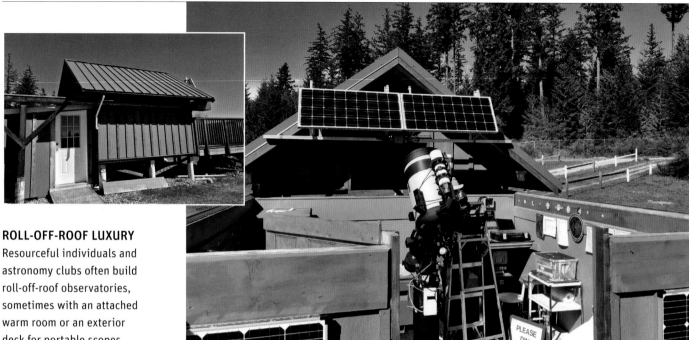

ROLL-OFF-ROOF LUXURY
Resourceful individuals and astronomy clubs often build roll-off-roof observatories, sometimes with an attached warm room or an exterior deck for portable scopes. The solar panels on this club's high-tech but off-grid observatory charge batteries for powering security systems and the telescope gear.

reach focus. But the extra power of the Barlow and the restriction to 1.25-inch eyepieces make it impossible to achieve low power and wide fields with binocular viewers. However, deep sky objects at moderate power and planets at high power become new experiences when viewed with both eyes wide-open.

The best binocular viewers from Baader, Denkmeier and Tele Vue start at $600. Lower-cost binoviewers are sold by a number of dealers. A $270 binoviewer we tested from William Optics provided sharp images with no added color or blurring of detail due to aberrations. The prime drawback was the vignetting of the field due to the undersized prisms. Of course, you have to factor in the cost of dual sets of eyepieces and filters. However, once you are satisfied with your telescope and eyepieces, you may find that no other accessory will provide as significant an improvement to the view.

HOME OBSERVATORIES

The ultimate accessory for any telescope is a house to put it in. Observatories can be either rotating domes or shelters with roofs that roll or flip off or fold down. While handy backyard astronomers often build their own structures (author Dickinson built two), commercial companies such as SkyShed offer kits for both roll-off-roof sheds and classic domes, starting at about $3,000. Even at less-than-ideal sites, there's much to be said for having your

DOMES AT HOME
The advantage of an observatory, such as this SkyShed POD dome, is that the telescope not only stays assembled but also remains close to outside temperature and is, therefore, ready to use with little cool-down time. However, in a humid climate, moisture can still attack optics. Antidew heaters, in place here, can be just as useful in an observatory as in the field.

telescope permanently set up and ready to go.

Other suppliers of home observatories include Astro Haven, NexDome, Sirius Observatories and Technical Innovations/HomeDome. Some offer options for fully motorizing and automating dome operation for observers who want to set up a completely robotic installation in the backyard or at a nearby dark site or anywhere in the world with power and high-speed Internet.

ANTIBOUNCE FOOTPADS
These $60 pads cut the time it takes vibrations to dampen by half or better, helping to stabilize otherwise shaky mounts. Yet we find few observers use them.

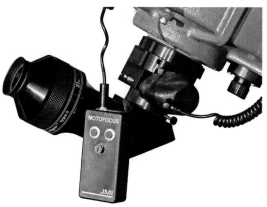

NOT ESSENTIAL

Although each of these products will have its champion (we'll get e-mail!), we feel all are accessories you can happily live an astronomical life without. The more gadgets you have, the more time it takes to set up and the more that can go wrong.

VIBRATION DAMPENERS

Placed under the legs of a telescope tripod, these small pads ($30 to $60) absorb vibrations, preventing them from being transmitted up the tripod leg. While the pads do work, most people prefer to set their telescopes onto solid ground, especially telescopes that need precise alignment, such as GoTo scopes and those intended for photography. For the latter, you really want a solid mount to begin with.

FOCUS MOTORS

Celestron, Meade, Orion and third-party suppliers, such as Farpoint Astro, make battery-operated motors ($100 to $300) for virtually every focuser and telescope on the market. While hands-off focusing reduces vibrations and image shake, we've found focus motors can suffer from hesitation, backlash and run-on, making it hard to home in on precise focus. We find the extra batteries and cables a nuisance. Some people love focus motors; we have managed to live without them.

POLAR-ALIGNMENT CAMERA

The QHYCCD PoleMaster camera and software (about $300) has proven to be popular

PUSH-BUTTON FOCUSER

Motorized focusers can be an aid to high-tech imaging, allowing automatic focusing of imaging cameras. But for visual use, they are another gadget that can go wrong.

and, indeed, does work very well, as we found in our testing. Other brands followed with similar units, such as iOptron with its iPolar. These dedicated cameras and software provide very precise polar alignment, which is useful when shooting through very long-focal-length telescopes, negating the need for drift alignment and other trial-and-error methods.

However, many camera-control devices, such as the ASIAIR, now come with polar-alignment routines that use the imaging and guiding cameras already at hand. (See the Appendix for the details.) So there is less need for a dedicated electronic polar-alignment camera. And no need for it at all if you're only doing visual astronomy or wide-field imaging.

STARSENSE CAMERA

Celestron's SkyProdigy telescopes have a dedicated camera that images the sky for automatic GoTo alignments using clever plate-solving routines built into the hand controllers. The same functionality can be added to most current Celestron GoTo scopes and some Sky-Watcher models by buying Celestron's add-on StarSense camera with the included hand controller (about $400). But you can live without it if you can aim and align your GoTo scope on two or three stars yourself, hardly an arduous task. If it's proving to be a challenge, we might politely suggest you need to learn the sky to better identify stars, rather than spend more money!

POLAR-AXIS CAMERA
Adapter kits are available to attach the PoleMaster camera to a variety of mounts so that it looks up the polar axis. It can be useful for aligning hard-to-align fork mounts.

STAR-ALIGNMENT CAMERA
Coupled with the StarSense hand controller, this add-on camera shoots the sky to map star positions for automatic GoTo alignments of Celestron and Sky-Watcher telescopes. (Photo courtesy Celestron)

CHAPTER 10

Using Your New Telescope

Whether you are unpacking your first purchase or the latest addition to a growing collection, setting up a new telescope is always a thrill. If you have never set up a telescope before, the anticipation of seeing your first celestial object through the sparkling new optics might make you toss the instruction manual aside.

Even if you are patient enough to read the manual, you might find the instructions more than a little baffling. We've seen telescopes packed with misleading or bizarrely translated manuals, manuals available only after some hunting on the manufacturer's website or no manuals at all!

To aid first-time telescope owners, we provide this chapter as our own "guide to using your new telescope," with tips prompted by the many questions we've handled over the years from puzzled owners.

In this chapter, we cover basic manual telescopes. Chapter 11 deals with GoTo telescopes, though many will also require completing the assembly steps we outline here.

An enjoyable night under the stars with your telescope first requires getting to know the fine points of its setup and operation. Equatorial mounts like this one can be particularly perplexing to a new telescope owner.

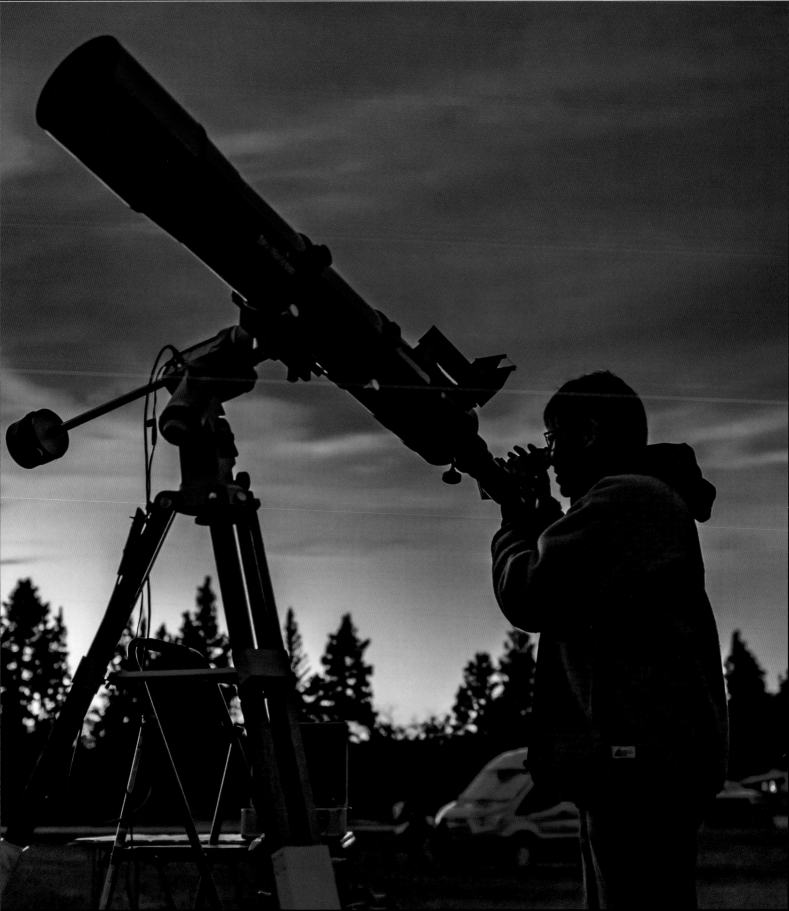

YOUR FIRST TELESCOPE

In this chapter, we present a guide to setting up and using your first telescope. For our examples, we selected two telescopes on commonly available equatorial mounts: an 80mm (3.1-inch) refractor and a 130mm (5.1-inch) reflector. However, consider this chapter a tutorial for the assembly and use of *any* beginner's telescope, because many of our tips apply to any instrument.

From our experience, telescopes such as these, although excellent buys, elicit the most cries for help from new owners. The scientific appearance of the equatorial mounts, while often attracting the novice in the first place, are also at the root of the "What's this for?" and "How does this work?" questions that these instruments always generate.

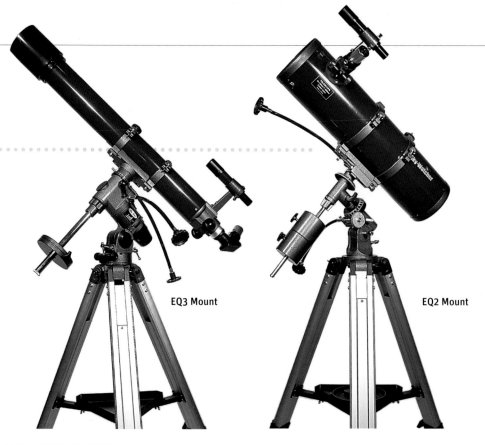

EQ3 Mount

EQ2 Mount

OUR EXAMPLE SCOPES

As of 2020, the Sky-Watcher telescopes depicted here on EQ2 and EQ3 mounts are no longer available in North America, but similar made-in-China models with identical or comparable mounts are offered by Celestron, Meade and Orion. Elsewhere in the world, these scopes might still be sold under the Sky-Watcher brand or under various dealer house brands.

HOW NOT TO SET UP A TELESCOPE

What's wrong with this picture? Lots! Yet this is how reflector telescopes are often shown and set up in big-box stores by staff who know little about telescopes.

1 The eyepiece is at the bottom of the telescope, where all eyepieces should be, right? Not on a Newtonian reflector. The tube on this scope is pointed at the ground.

2 The finderscope is mounted backwards, pointed 180 degrees away from where the main optics are aimed, rendering it useless as a finder. Worse, we've seen the Barlow lens installed here as if it were the finder.

3 The equatorial mount is polar-aligned for a location near the North or South Pole, near 90 degrees latitude. It will be impossible to find and track objects.

4 The counterweight shaft and its weights are missing, making for an unbalanced and unstable telescope.

5 The 2x Barlow and 4mm eyepiece are in place, under the misguided belief that more power is better. In all, this telescope is unusable.

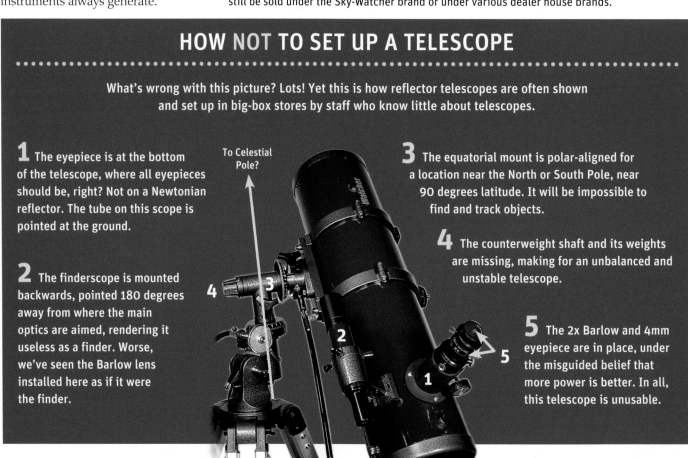

To Celestial Pole?

THE OPTICAL TUBE ASSEMBLY

Although we're showing the tube of a 130mm Newtonian reflector, refractors share many of the same components. Refractors also have a mirror or prism star diagonal for convenient right-angle viewing.

DUSTCAP
Remove the *whole* cap to use the scope. The off-axis hole is for viewing the Sun through a smaller aperture, with unsafe and now rare eyepiece solar filters. This hole (and the raised part for holding the removed cap) has no purpose today yet continues to be part of the design, to the confusion of new owners.

FINDERSCOPE
This is a low-power (usually 6x) scope for aiming at targets. Many clamp into a dovetail shoe for quick removal for packing. A red-dot finder is now common instead of an optical finder.

FINDER ADJUSTMENT SCREWS
Two bolts at right angles adjust the finder so that it points at the same place as the main telescope. In this unit, the third knob is a spring-loaded bolt that holds the finder tube in place.

CAMERA ATTACHMENT BOLT
This ¼-20 stud bolt allows you to attach a camera (or a tripod's ball head) for wide-angle tracked photography. It's normal that only one ring has this bolt.

SPIDER BOLTS
These three bolts hold the struts (called the spider), which in turn hold the secondary mirror in place. Don't loosen them.

FOCUSER
This is usually a rack-and-pinion type. The tension can be adjusted by the screws between the focus knobs. The black screw-on ring at the top is *essential*—it's the adapter for 1.25-inch eyepieces. If it is missing, as it can be in a secondhand scope, eyepieces have no place to sit. The adapter might be threaded for a camera T-ring.

EYEPIECE SETSCREW
One or two screws hold the eyepiece in place. Don't lose them!

TUBE RINGS
Loosen the clamps to slide the tube up and down within the rings for balancing in the north-south direction. In Newtonians, these clamps also allow you to rotate the tube to place the eyepiece at a convenient angle and height.

EYEPIECES AND BARLOW
At least one eyepiece is supplied with most telescopes. The lowest-power eyepiece is the one marked with the largest number (often 25mm). Inserted between the eyepiece and the telescope, a Barlow lens doubles or triples the power of any eyepiece. See page 166.

THE EQUATORIAL MOUNT

Many beginner telescopes are supplied with a German-style equatorial mount like this, commonly called the EQ2 model. The graduated setting circles look scientific and appear to be a great feature, but in practice, they are not accurate and you will rarely use them.

DECLINATION AXIS LOCK

SETTING CIRCLES AND INDEX POINTERS
These are for dialing in the coordinates of celestial targets. The right ascension (R.A.) setting circle (at bottom), marked 0 to 23 hours, can be turned independently of the mount; the declination (Dec.) setting circle (at top), marked 0° to 90°, should be fixed.

MOTOR-ATTACHMENT BOLT (under R.A. setting circle)
This is where an optional fixed-speed R.A. motor drive attaches (the lowest-cost motor option).

SLOW-MOTION CONTROL (right ascension axis)

FINE LATITUDE ADJUSTMENT (partially hidden at back)
Turning this moves the mount up and down slowly for fine-tuning the tilt of the mount. This is for ease of polar alignment.

AZIMUTH LOCK
Loosening this allows the entire mount head to swing in azimuth (i.e., parallel to the horizon). This lock and motion are for polar alignment only, *not* for turning the telescope to find targets.

SLOW-MOTION CONTROL (declination axis)
Once the axes locks are tightened, the slow-motion controls engage and can be used to fine-tune the pointing and to follow objects.

R.A. SETTING-CIRCLE LOCK SCREW
Tightening this little screw allows the R.A. setting circle to turn with the telescope when the R.A. lock is loose. This is unnecessary—leave this screw loose.

RIGHT ASCENSION AXIS LOCK
Loosen the R.A. and Dec. locks to allow the scope to turn freely to swing to a new target. Tighten them when you are close to the target.

MYSTERY WHEEL
This is a gear-and-clutch mechanism for older-style AC motors and one type of variable-speed DC motor.

MYSTERY SCREW
Does little. This is removed to attach the variable-speed motor. Can serve as a spare for the little setscrews on some focusers.

LATITUDE BOLT AND SCALE
This is where you adjust the angle of tilt of the mount for your latitude, a onetime adjustment. Loosen this bolt with caution, as the entire mount will flop down once it is loose.

EQUATORIAL HEAD
Comes as a single unit out of the box, but its angle of tilt needs to be set to your latitude north or south of the equator. Here, the mount is set for 45 degrees latitude. Your longitude doesn't matter.

COUNTERWEIGHTS
The number and size vary with the telescope. These slide up and down the screw-in counterweight shaft to balance the telescope around the R.A. axis.

HOW AN EQUATORIAL MOUNT MOVES

To move around the sky, a German equatorial mount swings around two axes. To follow objects accurately as they move from east to west, the mount's right ascension axis must be aimed toward the sky's celestial pole, a process called *polar alignment*. See "Time to Align" on page 207.

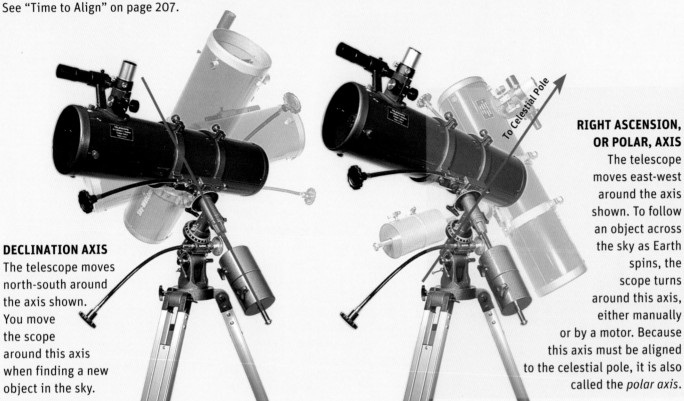

DECLINATION AXIS
The telescope moves north-south around the axis shown. You move the scope around this axis when finding a new object in the sky.

RIGHT ASCENSION, OR POLAR, AXIS
The telescope moves east-west around the axis shown. To follow an object across the sky as Earth spins, the scope turns around this axis, either manually or by a motor. Because this axis must be aligned to the celestial pole, it is also called the *polar axis*.

DECODING DIRECTIONS

Using an equatorial mount introduces the new telescope owner to the concepts of *right ascension* (R.A.) and *declination* (Dec.), the coordinates used to grid the sky. Every star and celestial object has its unique celestial coordinates. Declination is like latitude on Earth: Changing the declination moves the scope north or south in the sky. Right ascension is like longitude: Changing the right ascension moves the telescope east or west. Declination is measured in degrees, from 0° at the celestial equator (through Orion here) to +90° or −90° at the two celestial poles. Right ascension is measured in hours, from 0h to 23h.

Dialing in celestial coordinates is not the method we recommend for finding objects, but learning the terminology helps you understand how your equatorially mounted telescope moves on its two axes.

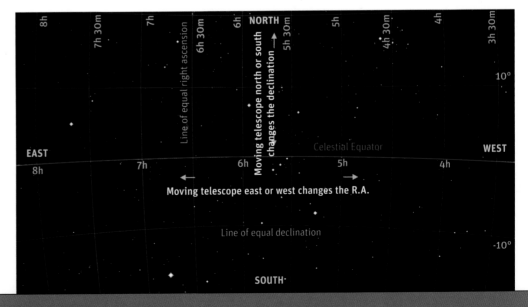

SOME ASSEMBLY REQUIRED

Inside hinge

Variation

Most entry-level telescopes require a similar assembly procedure for turning the box of assorted parts into a working telescope. Be sure to do this first-time assembly indoors, in the light, warmth and comfort of your home.

TELESCOPE ASSEMBLY: A 10-STEP PROGRAM

Here's how to put together the typical entry-level telescope on the venerable EQ2-style equatorial mount that has been offered in much this same form for more than 50 years. The steps apply to most small telescopes and often involve attaching the tripod legs to the mount head first. Only after you have a secure and solid tripod and mount (Steps 1 through 3) should you attach components such as the counterweights and tube to the mount (Steps 4 through 10).

STEP 1
BOLT LEGS TO MOUNT HEAD
On the EQ2 mount, each of the legs attaches directly to the mount head. Notice there's a hinge halfway down each leg. The hinge goes on the inside and is for holding the spreader bar.

Variation: On the EQ3 and most larger mounts, the legs attach to a separate top plate. The mount head then attaches to this plate with one large central bolt. This arrangement makes the scope easier to disassemble for transport. The legs and top plate might come preassembled.

STEP 2
ATTACH SPREADER BAR
On many telescopes, the legs now come with the spreader bar already attached. For scopes that do not, stand the tripod on a nonslip floor and attach each arm of the spreader bar to a tripod leg by pressing the bolt through the leg's hinge and the spreader bar's arm. A Phillips head screwdriver (likely not supplied) is required for the final tightening.

STEP 3
ATTACH ACCESSORY TRAY
Use the small wing-nut bolts to attach the tray to the spreader bar. This helps stabilize the telescope. On some beginner scopes, this tray is plastic and clips onto the spreader bar.

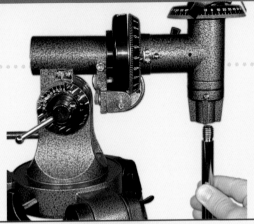

STEP 4
ATTACH THE COUNTERWEIGHT SHAFT
This screws into the head (leave the weight itself off for now). The shaft acts as a good handle for the next step, which is likely necessary, since most mounts come packed in the wrong orientation, often set to 0° or 90°.

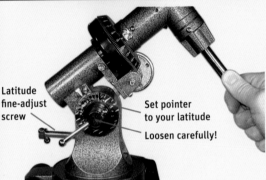

Latitude fine-adjust screw

Set pointer to your latitude

Loosen carefully!

STEP 5
ADJUST MOUNT ANGLE
Loosen the large latitude bolt (carefully!) while holding the mount head. Tilt the mount to your latitude (use the scale on the side of the mount as a guide). Just get it close at this point. Then lock that large bolt down good and tight. You won't need to adjust it again. Turn the latitude fine-adjust screw in until it pushes against the mount. This will help hold it in place.

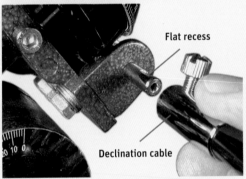

Flat recess

Declination cable

STEP 6
ATTACH SLOW-MOTION CABLES
Use a small flat-bladed screwdriver (or the little tool supplied) to attach each cable to its shaft on the mount. The setscrew in each cable's sleeve mates with the flat side of the D-shaped shaft. The long cable goes on the declination axis.

REFLECTOR
For a reflector, turn the head so that the declination slow-motion cable is at the top, closest to the eyepiece at the top of the tube.

REFRACTOR
For a refractor, turn the head so that the declination slow-motion control extends to the bottom to place it near the eyepiece.

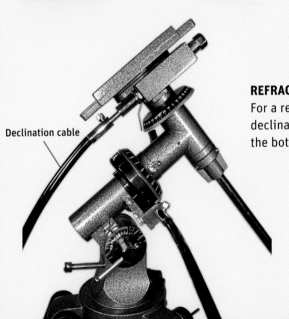

Declination cable

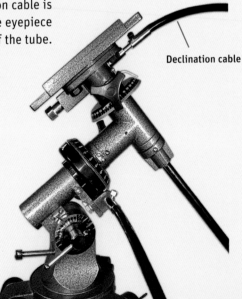

Declination cable

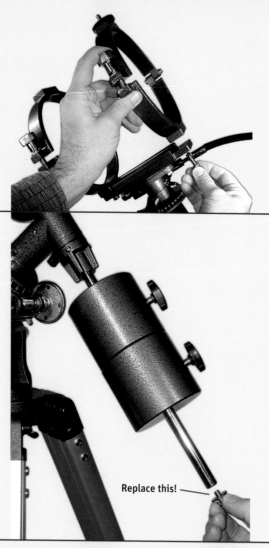

STEP 7
BOLT TUBE RINGS TO THE HEAD
With many new scopes, the tube and rings slide into a dovetail channel on the mount, so no tools are required. For those without a dovetail channel, use the supplied bolts and lock washers to fasten each ring to the head. The ring with the piggyback camera bolt should go at the top of the mount. Do this without the telescope tube—just fasten the rings on first.

STEP 8
SLIDE ON THE COUNTERWEIGHT
Undo the screw at the bottom of the shaft to slide on the counterweight. Most counterweights have a larger recess on one side —placing that side at the bottom allows the weight to extend a little farther down the shaft if needed. Replace the "toe saver" screw—it prevents the weight from sliding off the shaft and onto your foot!

Replace this!

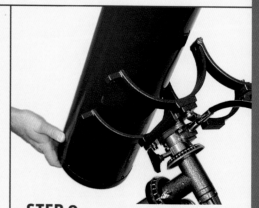

STEP 9
PLACE THE TUBE IN THE CRADLE
Remember, if it's a reflector, the eyepiece goes at the top. Place the rings near the center of the tube. Clamp the rings securely but not overly tight.

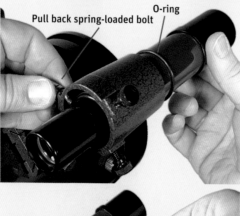

Pull back spring-loaded bolt O-ring

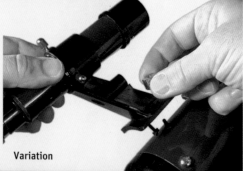

Variation

STEP 10
INSTALL THE FINDERSCOPE
First, insert the finderscope into the bracket. Many finders come with a small rubber O-ring (you might find it strung around the bracket). The O-ring goes into the recessed notch on the finder tube and acts as a spacer to hold it steady. (**Note:** Try not to lose the O-ring, as the finderscope will wobble in the bracket without it. After many years, the O-ring will dry out and break. Replace it with an elastic band or some tape.) To insert the finder, pull back the spring-loaded silver bolt (if your finder has that style of bracket). The bracket then clamps into the dovetail channel on the telescope tube.

Variation: Some finder brackets must be bolted directly to the tube.

MOTOR-DRIVEN

The most common option for an EQ2-style mount is a single-speed DC motor for the right ascension (R.A.) axis. Almost identical units are sold by Celestron, Meade and Orion, among others. The motor attaches to a bolt hole on the side of the polar axis and slides onto the shaft normally occupied by the R.A. slow-motion control. Attaching the motor forfeits the east-west slow-motion control and any ability to fine-tune the position of the scope manually in the east-west, or R.A., direction. But once on a target, the scope continues to track it automatically, a great convenience.

SPEED CONTROL
Turning this knob speeds up or slows down the motor. Getting it to move the scope at the right speed to track stars is trial and error on this model. Turn it to the highest setting as a start.

DIRECTION SWITCH:
SINGLE-SPEED MOTOR
Flicking the N-S switch to S makes the motor turn the opposite way for use in the southern hemisphere. If you live north of the equator, set it to N. If objects drift out of the field faster when the motor is turned on, it's set to the wrong direction.

BATTERY
All drives today operate with batteries rather than AC power. This one runs on a 9-volt battery that lasts, at best, for only a few nights of use. A rechargeable battery is a good choice here.

ANOTHER OPTION:
VARIABLE-SPEED MOTOR
A better, though more expensive, choice for the EQ2 mount—and the only choice for better-grade mounts like this EQ3 model—is a variable-speed motor drive. This particular unit has push-button controls for 2x and 8x speeds for fine centering of objects. Variable-speed motors also run off separate battery packs with multiple C or D cells for longer battery life. Better dual-axis units can control a motor on each axis for electric slow motions, an excellent option.

DAYTIME ADJUSTMENTS

Setting up at night is *not* the next step to using your new telescope. Take your scope out first during the day for some simple but crucial adjustments. This daytime check is a highly recommended procedure that many new telescope owners bypass, anxious to experience the thrill of first light with their telescopes under a starry sky.

But essential adjustments, such as lining up the finderscope and getting the telescope focused for the first time, are much easier to do during the day than at night. You can find suitable targets more easily, and you'll know what they are supposed to look like once you get them in view. If your scope will not focus, see "Why Won't It Focus?" (facing page) and the "First Light" section (page 210) for possible reasons.

Trying to make these initial adjustments at night "cold turkey" on targets you can't find (because the finder isn't lined up yet) or can't focus on (because the focuser is way off position) is inviting frustration and disappointment. This tip is key to successful first use of your new telescope.

UP TIGHT

First, ensure that all the tripod bolts are firmly cinched down. A loose tripod means a wobbly telescope and a jittery image. Then play with moving the telescope around by day. Learn where the locks are. Unlock the axes to swing the telescope close to a daytime target. Once there, lock the axes and use the slow-motion controls to center a target. As you do, you'll notice a couple of things:

1 LOCK THE AXES

The slow-motion controls probably won't do much as long as the axes remain unlocked. To engage the slow-motion controls, lock the axes with the levers shown here on this EQ3 mount.

2 PARTS IN COLLISION

The telescope tube will collide with the slow-motion cables or with the tripod itself when aimed in certain directions (mostly straight up). There is a trick to avoid this to some extent. Read on.

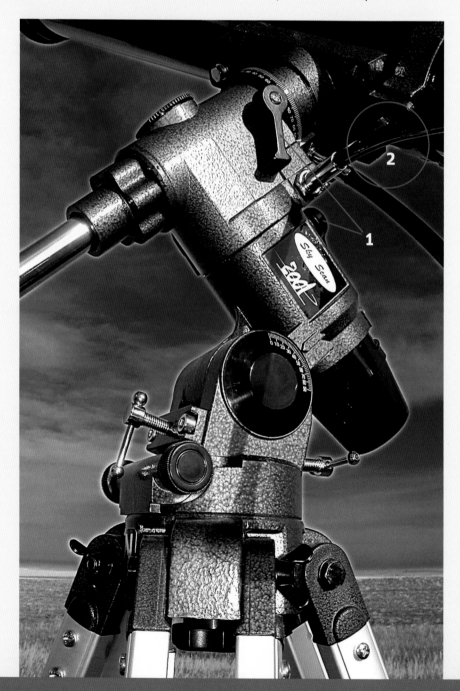

BALANCING ACT

Unlock the telescope, move it to point at a new area of the sky, then let it go. If the scope swings away on its own, it is out of balance. An unbalanced telescope tends to point wherever it wants to, which makes it hard to find the targets you'd like to observe. Motor drives might not work well either, as they labor to turn the telescope. To fix this:

ADJUST BALANCE IN DECLINATION

With the tube horizontal, loosen the cradle rings and slide the tube along the cradle until it is balanced in the north-south, or declination, direction. With the declination axis unlocked, the scope is balanced if it doesn't move. Reflectors can be bottom-heavy due to their main mirrors; refractors can be top-heavy and balance best with the main lens nearer the cradle.

ADJUST BALANCE IN RIGHT ASCENSION

With the right ascension lock loose and the counterweight shaft horizontal, slide the counterweight(s) along the shaft. The scope is balanced if it stays put when you let it go, no matter where it is pointed in the sky. When balancing any telescope, be sure the finderscope and the eyepiece are in place but the lens cap is not, as would be the case at night.

BECOMING FOCUSED

It's much easier to focus a new scope first during the day on a familiar landscape object, rather than at night on an unfamiliar stellar target. To do this:

1 Insert the low-power eyepiece. With most entry-level telescopes, that's the one marked 25mm or 20mm, not the ones marked 12mm, 9mm or 6mm. If you have a refractor, insert the star diagonal first, then slide the eyepiece into it. Don't use any Barlow lens that might have been supplied.

2 Swing the telescope to a distant target on the horizon (sight along the tube to get it close). It should be several hundred meters away, not just across the street.

3 Rack the focuser back and forth until the image sharpens to a crisp focus. With a daytime object, it should be obvious when you are getting close to focus.

4 Leave the focuser as is. You are now close to being perfectly focused for objects in the night sky. This is one less adjustment you'll have to make in the dark.

WHY WON'T IT FOCUS?

If you can't make the image sharp even in a daytime test, here are possible reasons:

◆ On a refractor, there's no star diagonal in place.

◆ On a reflector, a needed extension tube on the focuser is missing.

◆ Some scopes have extension tubes for both 2-inch and 1.25-inch eyepieces. Use one or the other but not both.

◆ If you bought the scope used, the owner might have disassembled the eyepiece or main lens and didn't put the lenses back right.

◆ With bargain scopes from big-box stores, it's possible the optics are defective.

◆ You are looking through a window. Don't! See the "First Light" section on page 210.

◆ If the image is just very dim, you didn't remove the entire lens cap.

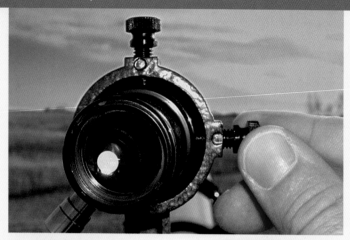

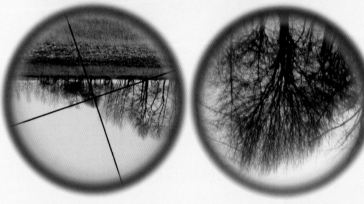

View through the finderscope View through the telescope

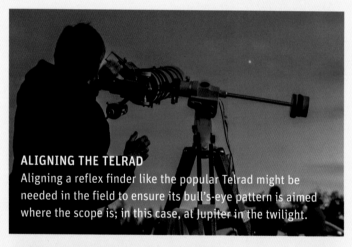

ALIGNING THE TELRAD
Aligning a reflex finder like the popular Telrad might be needed in the field to ensure its bull's-eye pattern is aimed where the scope is; in this case, at Jupiter in the twilight.

GETTING LINED UP

A low-power finderscope or a red-dot finder on the side of the tube is an essential aid to trouble-free telescope enjoyment. To be of value, however, the finder must be lined up so that it points to the same place as the main telescope. This is easiest to do during the day on a distant landscape target. To do this:

1 With the low-power eyepiece in place in the main telescope, find a recognizable object on the horizon (perhaps a power pole or treetop).

2 Now look through the finderscope, and locate the same object; it will likely be off-center.

3 Use the two to six adjustment bolts to tilt the finder's tube until your target object is centered on the finder's crosshairs. Red-dot finders have similar X- and Y-axis adjustments for centering the red dot onto the target. Turn its brightness up full in the daytime.

4 Once the finder is collimated, any object placed on the crosshairs or on the red dot is centered in the telescope. You might need to recollimate the finder occasionally.

SHARPENING THE FINDER

If the view through the finderscope is fuzzy, you'll need to focus it. Most units allow this, though it is not always obvious how to do so. Some finder eyepieces turn. As they twist, they slide in and out to focus. For other units:

1 The finder is focused by moving the main lens, not the eyepiece, up and down the finderscope's tube. This lens is in a metal or plastic cell screwed onto the tube. It is not glued and is designed to turn.

2 As you face it, turn the lens cell counterclockwise to unscrew it. A retaining ring behind the lens cell will also loosen. You might need to turn this ring to back it away from the main cell. This will expose the threads so that you can move the main lens.

3 Turning the lens cell moves the main lens up and down the tube, changing the focus. When distant objects look sharp, turn the retaining ring so that it locks back up against the lens cell. The finder is now focused for your eyes; do this with your glasses either on or off.

NIGHTTIME USE

Many entry-level telescopes are compact and light enough that they can be left assembled to be carried outside as a unit for a "grab-and-go" viewing session. That is the best arrangement. But attaching and removing the tube from the mount is often required each night.

When reassembling your telescope, you might need to rebalance it for proper operation of the mount. Once outside, all equatorial mounts must be aligned to the celestial pole,

a procedure with an undeserved reputation for being complex and intimidating. Yet for the accuracy needed for casual visual use, it can be accomplished in seconds.

Even when the mount is aligned, aiming at some areas of the sky might be awkward. This is a quirk of a German equatorial mount, but it's easy to work around, as per the tips we provide on page 209.

But first, advice on putting away your telescope.

TELESCOPE BREAKDOWN

If you do need to break down your scope after each night's use, keep the procedure as simple as possible.

1 Remove the tube. Unless your tube and rings attach to the mount via a quick-release dovetail plate (as many scopes now offer), the easiest method of removing the tube is to open the cradle rings and simply lift out the tube. Note where it sits for proper balance.

2 Remove the counterweights from the shaft. This makes the mount lighter and less cumbersome. If you leave them on, their weight might cause the latitude position to shift or the R.A. axis to swing around and hit something, like you!

3 If you need to break the scope down further, remove the tripod's accessory tray so that the tripod legs will fold in. A good accessory for transport by car or even safe storage at home is a padded case or cases for the tripod and tube assembly.

4 If you are packing the telescope in a car, remove the finderscope, slow-motion controls, star diagonal and eyepiece. Protruding as they do, they can get damaged or lost. Keep the counterweight well packed so that it can't bang against the tube.

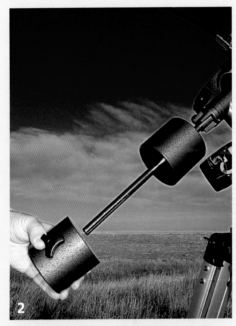

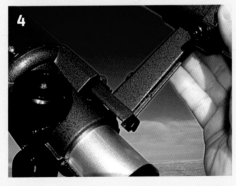

FINDER TIP
On some beginner scopes, the finder bracket is plastic and prone to breakage. Be careful when handling the scope and putting it away. And if you remove the finder, be sure not to lose it!

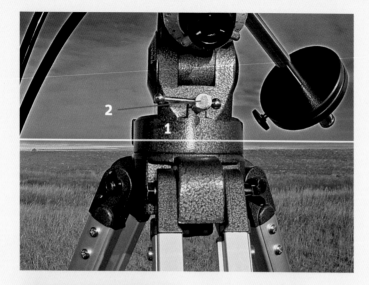

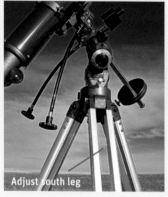

Adjust south leg

3

ON THE LEVEL

Fussing with precise leveling of a telescope mount isn't necessary for visual use, certainly not for manual telescopes. However, if you have the angle of the equatorial head preset for your latitude, then leveling the scope ensures that the polar axis of the mount is, indeed, pointed close to the altitude of the celestial pole (i.e., Polaris, the North Star).

Where leveling is more of a concern is with GoTo telescopes (covered in the next chapter). For their alignment process to work best, more accurate leveling is often required. But for less demanding manual scopes, here are some tips:

1 Use the height adjustments on the tripod legs to level the mount. Eyeballing it should be sufficient, though some tripods or mount heads have a bubble level, as we show on the facing page on the EQ3 mount.

2 You can also just turn the fine-latitude adjustment screws to shift the mount's angle up or down to aim at the celestial pole, Polaris. As long as the polar axis is aimed close to the celestial pole (however you accomplish that), the mount will track fine.

3 As an alternative to adjusting the head, simply raise or lower a north- or south-facing tripod leg (loosen the wing nut, but be sure to retighten it) to accomplish the same thing, effectively aiming the polar axis at the celestial pole.

A CHANGE OF LATITUDE

The only time you need to alter the mount's home position for the polar-axis angle is when you travel north or south in latitude; for example, from 50°N (Alberta) to 33°N (Arizona). Traveling east or west in longitude but staying at the same latitude makes no difference in how you set up your telescope.

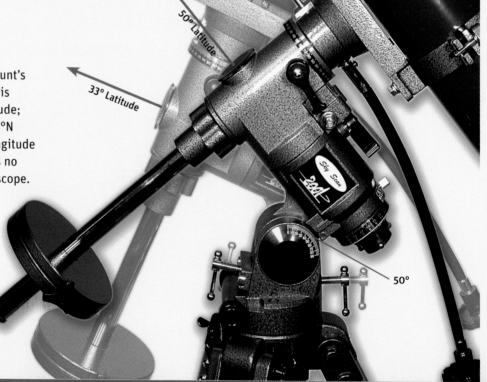

TIME TO ALIGN

To track objects properly (or at all!), every equatorial mount must be aligned so that its polar axis points at the celestial pole. The sky rotates around this point, and the mount must too. If you ignore polar alignment, you might as well have bought a cheaper altazimuth mount. For users in the northern hemisphere, polar-aligning a telescope requires only a few simple steps. With no bright pole star in the southern hemisphere, however, the task is tougher; see the Appendix for tips.

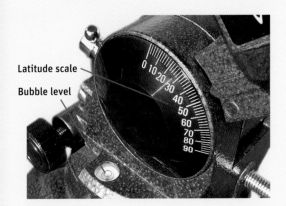

Latitude scale

Bubble level

1 If you have not done this earlier, adjust the polar axis so that its angle of tilt equals your latitude. You can look that number up in most atlases or with a GPS app on your smartphone.

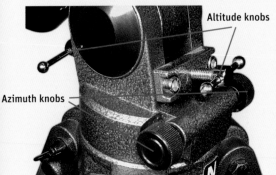

Altitude knobs

Azimuth knobs

3 Use the fine azimuth and altitude adjustments on the base of the mount head to tweak the aim of the mount at Polaris. This is easier than trying to shift the whole tripod to aim the mount due north.

2 Place the scope outside at night so that the polar axis aims due north, toward Polaris (that's true north, not magnetic north). Some mounts indicate which side should face north with a large N. Knowing which way is north and how to locate Polaris are essential to finding anything in the sky and to polar-aligning. See Chapter 4 for charts that show where Polaris is.

4 If your mount has a hollow polar axis with no polar scope installed (for example, the generic EQ3 we show or the Celestron Omni CG-4 and Orion SkyView Pro mounts), you can sight Polaris through the axis to achieve a more precise centering.

Variation: Sighting Polaris through an optional polar scope inserted into the polar axis allows for more precise alignment for mounts that offer such a polar scope. Instructions can be found in the Appendix. But for casual observing, roughly aiming the correctly angled polar axis due north will suffice; objects will stay in the eyepiece for several minutes with the R.A. tracking motor on.

TELESCOPE SETUP TIP

On subsequent nights, all you need to do is place the telescope at your favorite backyard spot, perhaps with markers for the legs so that the polar axis aims due north. For more precise polar-alignment methods needed for astrophotography, see the Appendix.

AIMING FOR THE SKY

Once you have polar-aligned your telescope, you do not need to use the azimuth or altitude adjustments again—they are *not* for finding objects. Instead, move the telescope around *only* by using the right ascension (R.A.) and declination (Dec.) motions. Here's the process:

1 To swing the tube around to where you want to look in the sky, first loosen the R.A. and Dec. axes locks. Once near a target (as sighted through the finderscope), lock the axes, then use the slow-motion controls to zero in on the spot.

2 To move the telescope north or south in the sky, move it around the Dec. axis, as shown here. Move the telescope in this direction only when you want to change targets.

3 To move the telescope east or west in the sky, move it around the R.A. axis, as shown here. You'll need to move the telescope slowly from east to west to follow objects across the sky during the night. A motor attached to this axis will do this tracking for you.

4 If you have a motor on the R.A. axis, you might find the slow-motion control in that axis no longer works (many entry-level scopes have no clutch mechanism). If that's the case, leave the R.A. axis unlocked but with a slight tension on it and nudge the scope by hand until the object is centered. Then lock up the axis, and the motor should engage and start driving.

5 If the motor has 4x or 8x speed controls, you can fine-tune an object's position by speeding up, stopping or reversing the motor, which makes a variable-speed drive a good choice.

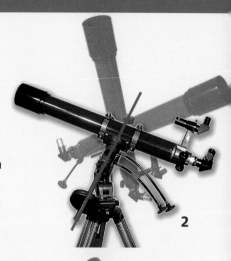

2

3

YOU CAN'T GET THERE FROM HERE

Swinging a German equatorial mount around the sky is where most people get tangled up. There are some places in the sky where such a mount simply won't point easily. For example:

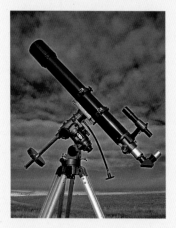

BANG!

1 Here, the EQ3 equatorial mount is aimed due north, at Polaris. That's not a big problem, though viewing Polaris can require a big shift in R.A. to center it in your eyepiece.

2 Now the scope is aimed at an object high in the southeast. This works fine provided the eyepiece is on the west side of the mount, as it is here, not on the east side.

3 But here's the same mount with the scope aimed high overhead. Oops! The tube hits the tripod. This is inevitable with most telescopes on this type of mount and tripod.

4 This EQ2 mount has a worse problem. The position of the motor drive makes it impossible to aim the scope high into the west or northwest—the tube collides with the motor casing.

DOING THE EQUATORIAL TANGO

One way to avoid the telescope collisions we've just described is to perform this "equatorial tango." All German equatorial mounts, even the best, share another limitation: They cannot track an object all the way across the sky in one uninterrupted arc. Here's the situation:

1 The telescope is aimed east and is following an object as it rises into the sky to a position due south. No problem.

2 If the telescope stays with the object as it moves across the meridian —the due south point—and into the west, the tube will eventually collide with the mount or tripod. What to do?

3 The solution is the "meridian flip"—flipping the tube to the other side of the mount, a dance all owners of German equatorial mounts must learn to perform with their mounts.

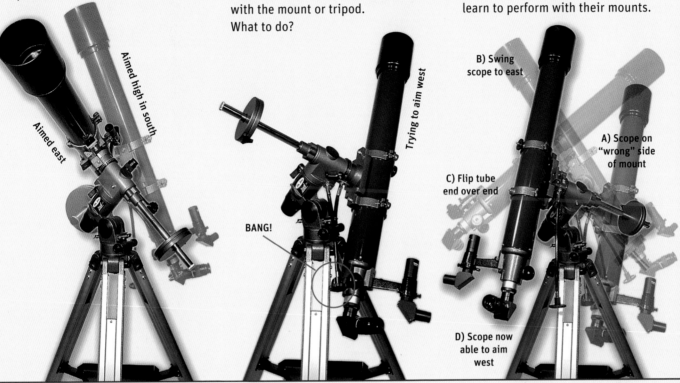

Aimed high in south

Aimed east

Trying to aim west

BANG!

B) Swing scope to east

A) Scope on "wrong" side of mount

C) Flip tube end over end

D) Scope now able to aim west

LOOKING WEST

After performing Step 3, above, the telescope is looking west, with the eyepiece on the east side of the mount. The telescope can now track objects well down into the western sky.

Telescope looking west

Eyepiece on east side of mount

LOOKING EAST

Conversely, when looking at the eastern sky, the eyepiece should be on the west side of the mount. Learning how and when to tango with your telescope will give you unimpeded observing of most of the sky.

Telescope looking east

Eyepiece on west side of mount

FIRST LIGHT

Even after assembling their telescopes and checking them out during the day, new scope owners often have disappointing first-light experiences at night. By heeding a few simple do's and don'ts, you should enjoy wonderful views your first night out under the stars.

DO'S

DO USE THE STAR DIAGONAL ON REFRACTORS Many refractors will not focus without the star diagonal in place. If you bought a used telescope and this part is missing, that's why it isn't focusing. It can be purchased separately. Reflectors often have various extension tubes for the focuser. Use the wrong one or none, and the eyepiece might not reach focus.

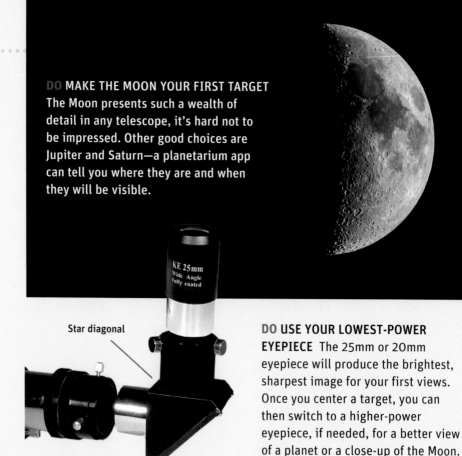

DO MAKE THE MOON YOUR FIRST TARGET The Moon presents such a wealth of detail in any telescope, it's hard not to be impressed. Other good choices are Jupiter and Saturn—a planetarium app can tell you where they are and when they will be visible.

Star diagonal

DO USE YOUR LOWEST-POWER EYEPIECE The 25mm or 20mm eyepiece will produce the brightest, sharpest image for your first views. Once you center a target, you can then switch to a higher-power eyepiece, if needed, for a better view of a planet or a close-up of the Moon.

DON'TS

DON'T LOOK THROUGH A WINDOW Window glass distorts views through telescopes. Opening the window

doesn't help either, because the warm air rushing out of the window blurs the image even more. Telescopes must be placed outside. If the night is cold, allow 15 to 45 minutes for the telescope to cool down, as warm air inside the tube can also blur images.

DON'T USE YOUR HIGHEST-POWER EYEPIECE Higher power isn't better. The 4mm and 6mm eyepieces supplied with many entry-level telescopes yield blurry views, not to mention fields of view so narrow that finding even the Moon becomes a challenge.

DON'T INSERT THE BARLOW LENS For the same reason, the 2x or 3x Barlow lens often supplied as standard equipment can be just as debilitating to sharp views. A good-quality Barlow can be a useful accessory; a poor-grade Barlow is a doorstop.

DON'T LOOK OVER A HEAT SOURCE Even a cooled-down telescope will be handicapped if it looks through warm air rising from a heat vent (as here), a nearby chimney or a warm car hood. Black asphalt that was searingly hot during the day also releases its warmth at night.

WHY IS THE VIEW UPSIDE DOWN?

Astronomical telescopes never present right-side-up views. The extra optics needed to flip the image the right way around would only add to the cost and detract from the image quality by dimming the light and distorting high-power views.

The upside-down views might seem confusing at first, but the only celestial object where the image is obviously flipped compared with the naked-eye view is the Moon. With the stars and planets, an erect image in the telescope has little value, since these objects look like points to the naked eye anyway. Far better to have the sharpest, brightest image at the eyepiece.

Where the inverted image can be confusing is in the finderscope. Straight-through finders provide inverted views but are easiest to orient: Just turn a star chart upside down to match the view. However, finders with right-angle eyepieces usually present mirror-image views. Matching these to a printed chart requires flipping the chart over and shining a flashlight through the paper, likely impractical.

An alternative is to use a planetarium app on a smartphone or tablet with the sky chart flipped, an option offered on many programs. Or you can purchase a finderscope that presents an erect image to begin with, such as a right-angle correct-image unit, aka a "RACI."

FINDER DUO

To find objects, a zero-power finder that projects a dot or bull's-eye onto a naked-eye view of the sky might be all you need to aim the telescope to the right area. However, a good 6x30 or 7x50 optical finder allows you to see brighter deep-sky targets (especially in bright skies) for more accurate pointing. The two complement each other.

Erect-Image View as in...
- Binoculars
- Terrestrial spotting scopes
- Finderscopes with a correct-image erecting prism

Inverted View as in...
- Newtonian reflectors or any telescope with an even number of reflections (i.e., two mirrors)
- Straight-through finderscopes with no erecting lens

Mirror-Image View as in...
- Refractors and catadioptric telescopes with a star diagonal or any scope with an odd number of reflections
- Finderscopes with a 90-degree right-angle star diagonal

To orient yourself at the eyepiece, remember:
- With no motor tracking, objects drift across the field from east to west.
- An object "preceding" another lies to the west and enters or leaves the eyepiece first.
- An object "following" another lies to the east and follows its companion across the field.
- Bump the scope up toward Polaris, and new sky appears at the north edge of the field of view.

TOP 10 FREQUENTLY ASKED QUESTIONS

Many of the usual questions that first-time telescope owners ask (i.e., How much does it magnify? Can I see the rings of Saturn?) are covered throughout this book. But here, we answer other FAQs from those new to using a telescope.

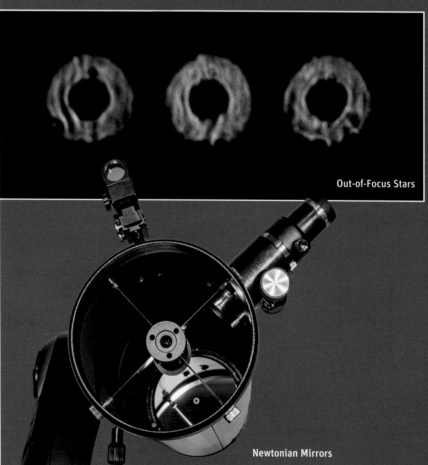

Out-of-Focus Stars

Newtonian Mirrors

1 HOW FAR CAN I SEE?

Even with the unaided eye, you can see the Andromeda Galaxy, 2.5 million light-years away. A telescope can reveal galaxies tens of millions of light-years away, so distant that their light has been traveling to us since long before the extinction of the dinosaurs.

2 CAN I SEE THE FLAGS LEFT ON THE MOON?

Flags, footprints and lunar modules on the Moon are too small to resolve in any earth-bound telescope, even by Hubble in Earth orbit. Sorry!

3 IS SOMETHING WRONG? STARS JUST LOOK LIKE POINTS...

When a telescope is in focus, stars *should* look like points. Beyond the Sun, no star is close enough to show itself as a disk. If stars look like large, shimmering disks or donuts (as at left), the telescope is out of focus.

4 ...AND PLANETS LOOK LIKE TINY DOTS

Don't expect a planet to fill your eyepiece with an image that looks as if it was taken by a space probe or Hubble. Even at 200x, planet disks remain small, but the detail is there. The trick is learning to see that detail, a skill that comes with practice. For tips on observing the planets, see Chapter 14.

5 IN A REFLECTOR, DOESN'T THE SECONDARY MIRROR BLOCK SOME OF THE LIGHT?

Yes, but not enough to dim the image noticeably (the secondary mirror blocks no more than 10 percent of the light). Only when you throw a star out of focus, as shown above left, do you see the secondary mirror's silhouette as a hole in the center of the donutlike image.

6 HOW DO I FIND OBJECTS?

For owners of noncomputerized telescopes, the best method is to star-hop. In Chapter 4, we provided instructions and recommended a number of star atlases and star-hopping guidebooks. Chapter 16 offers star-hopping tips and tours for telescopes.

7 WHY DO OBJECTS MOVE SO FAST ACROSS THE EYEPIECE?

Telescopes also magnify the effect of the sky's east-to-west motion. At low power, objects drift across the field in two to three minutes. At high power, it takes only 20 to 30 seconds. That's why slow-motion controls, smooth Dobsonian mounts or motor-driven mounts are so important.

8 WHY CAN'T I SEE COLORS IN NEBULAS?

We said it before, but we'll repeat the caveat here: Even through large telescopes, nebulas and galaxies are too faint to excite the color receptors in the eye. These deep sky objects (see Chapter 15) appear in monochrome, as depicted at right in this simulated eyepiece view of the Orion Nebula.

9 IS THE VIEW BETTER OUTSIDE THE CITY?

For faint objects such as nebulas and galaxies, yes. The darker the sky, the better. But the Moon and planets, being bright, can look just as sharp and clear in a light-polluted city sky as they do from the country. In Chapter 3, we offered advice on picking an observing site.

10 WHERE CAN I GET HELP?

A local astronomy club likely conducts stargazing sessions at an observatory or a park. These are great opportunities to learn more about telescopes and what they can show. As people did this night, at right, you can often BYOT—bring your own telescope—to seek assistance and advice.

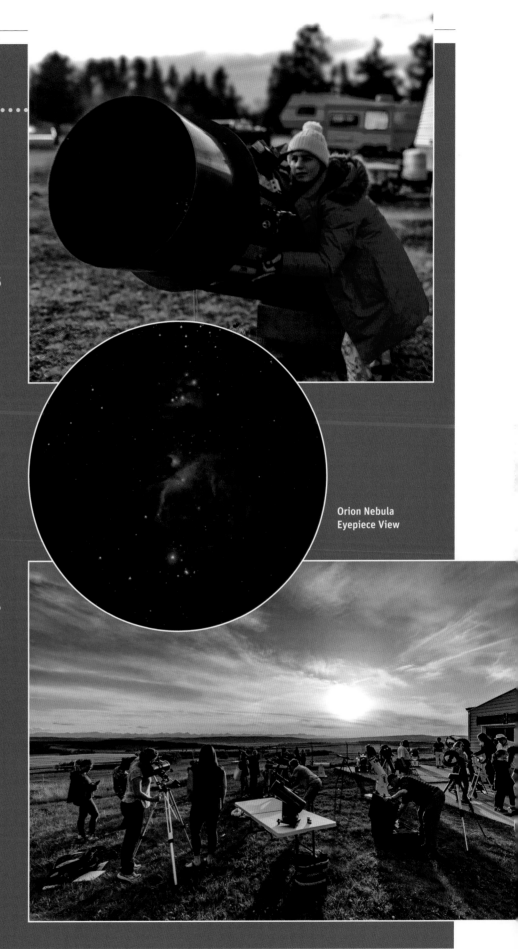

Orion Nebula
Eyepiece View

CHAPTER 11

Using Your GoTo Telescope

At one time, high-tech areas of the hobby were reserved for astrophotography. Today, even when practicing back-to-basics visual astronomy, computers are ever-present. They help us learn the sky and plan our observing sessions, and they aim our telescopes for us.

Since their introduction in the early 1990s, computerized telescopes have been sold by promising they will make the hobby more enticing and accessible for newcomers: "You don't need to know a star in the sky, yet you can still find hundreds of interesting objects." In reality, we find GoTo scopes often confuse rather than enthuse.

Instead of being presented with exciting views of deep sky wonders found at the push of a button, beginners are greeted by cryptic "Error" or "Alignment Failed" messages or by badly behaving telescopes that point to the ground not the sky.

But set up correctly, GoTo scopes do work and are wonderful. As such, we present our guide to getting your GoTo scope going and your apps aligning.

With the right hardware and software, it is possible to control a telescope with star-charting programs on a phone or tablet so that the screen shows a map of where the scope is pointed and will slew to targets you tap on. Just don't forget to actually look in the eyepiece!

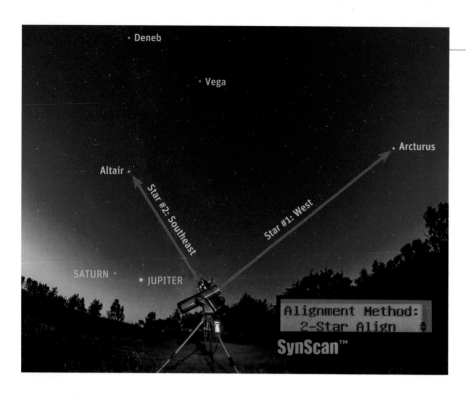

Deneb

Vega

Arcturus

Altair

Star #2: Southeast

Star #1: West

SATURN

JUPITER

Alignment Method:
2-Star Align

SynScan™

To North

ALIGN A GEM

All German equatorial mounts (GEM) require that you polar-align the mount first *before* performing a two- or three-star GoTo alignment. Even with only a rough polar alignment, most GoTo systems will find targets, though tracking may not be accurate. Home position to start a GoTo alignment is usually aimed north, with the counterweight shaft vertical, as shown, and the scope aimed at declination 90°.

ALIGN ON TWO STARS

Before they can find targets, most GoTo telescopes must initially be pointed toward at least two stars to align on them, as per the SynScan screen above. These target stars should be widely separated, as Arcturus and Altair are here. Aligning on Altair and Deneb or on Deneb and Vega would not work as well, if at all, for accurate pointing around the sky.

SET A SITE

With Meade's software, you can indicate your site by using a U.S. zip code or your city. Alternatively, as the Meade AudioStar does, all systems offer the option of adding and saving your own location by entering your latitude, longitude and time zone—steps that are prone to error!

GOTO TIPS

We find GoTo telescopes all too often collect dust, not starlight. After some initial alignment failures, the owner gives up and dismisses the telescope as a poor purchase.

In our testing over the decades, we have encountered a few units that were defective out of the box or failed early on, but the majority of GoTo telescopes work just fine. However, getting them set up right can be tricky.

HOW A GOTO SCOPE WORKS

Every GoTo telescope contains a virtual map of the sky programmed into its hand controller or companion wireless app, enabling it to point to and track thousands of objects. To match its virtual sky with the real sky, the scope must know where it is, what time it is and where key stars are. This process is called "GoTo alignment."

With most GoTo telescopes, you need to input your location only once—the hand controller defaults to that site upon start-up. Some models keep track of time (or get the time from a built-in GPS receiver), but most must have the date and time input each night.

All GoTo scopes then require an initial alignment, typically on two or three stars. The procedure is simple. Usually, you place the telescope in a starting position; for certain altazimuth models, that means the tube is level and aimed due north. From that position, the scope slews itself to the first alignment star. You can select that first star yourself from the computer's list or let the "auto" mode (included on most units) select it for you, based on your current location, date and time.

In Sky-Watcher and Celestron telescopes with altazimuth mounts, there is no starting position. You have to slew the telescope to the first star. So you must be able to identify that star. *That's absolutely critical!*

For telescopes that point themselves to the first star, they will get only close, maybe within a six-degree finderscope field at best. That's *normal*. We've seen people struggle for hours with exact leveling, entering latitude and longitude to the arc second or attempting to aim *precisely* true north, all in a wasted effort to get the telescope to aim *exactly* at that first star. Forget it—it will always be off.

AUDIOSTAR
Location Option
1-Zipcode 2-City

Site:
Add

Enter Lon:
112° 49' West

Time Zone:
-07.0

Now, using only the push-button motion controls, center that star first in the finder, then in the low-power eyepiece, and hit the Enter or Align button. This tells the computer how far off the star was from where it calculated it would be. That's what "alignment" means.

A good alignment requires sighting a second star. Most telescopes will move, or slew, to star #2, chosen either by the scope or by you. It will be off too, but closer. Center it, hit the Enter or Align button, and the alignment is done. (Some models, especially those with German equatorial mounts, need a third star.) The scope now knows how its virtual map deviates from the real sky, enabling it to accurately point to other objects. You're ready to observe.

ENTERING LOCAL INFORMATION

A main source of GoTo woe comes from entering local site information incorrectly.

◆ Celestron and Meade GoTo telescopes offer a list of cities from which to pick. If your hometown is not on the telescope's list, enter your latitude and longitude, available from mobile apps or from Google Earth. Entering to the nearest half degree (30 arc minutes) is fine.

◆ *But*…watch the sign or direction: A minus latitude is in the *southern* hemisphere; a minus longitude is *west* of England's Greenwich 0° meridian, which covers all of North and South America. Locations in Europe, Asia, Africa and Australia have a positive longitude east of Greenwich. Enter the longitude wrong, and the telescope will think you're in Asia, not North America. It will aim at the ground, not the sky.

◆ Enter the time zone correctly. In North America, Eastern time is Greenwich time *minus* five hours, not plus. Pacific time is minus eight hours.

◆ Don't correct for daylight time at this point; there is a separate choice for this.

◆ The question about daylight time is *not* whether your region observes daylight time (aka, summer time) but, rather, whether daylight time is in effect *now* (mid-March to early November for North America).

◆ If pointing at the Moon is consistently off, check that you entered the daylight-time setting and/or date correctly.

PHYSICAL SETUP

◆ While the tripod should be level, there's usually no need to be overly fussy.

◆ Ensure that the finderscope or red-dot device is aligned with the main optics. If it is not, you will have difficulty centering that first alignment star. See page 204.

◆ Some telescopes require a starting position aimed close to true north (the direction of Polaris). Don't aim at magnetic north (the direction a compass points; some Meades are an exception).

◆ When aligning, move the telescope *only* by using the electric motions. Do not unlock the scope to turn it by hand or lift it up to shift the whole tripod.

◆ When running off external power, check the plug. A loose connection or a brief loss of power will shut down or reboot the telescope, forcing you to realign from scratch.

PICKING STARS

◆ Aligning on the wrong star (for example, on Castor when the scope is asking for Pollux, 4.5 degrees away) will cause the telescope to miss targets by a wide margin.

◆ Aligning on stars due north and south of each other can throw off some systems. The telescope might accept the alignment but fail to find things well. If so, realign on different stars.

◆ If the telescope offers a three-star alignment, use it—it is more accurate. And make sure you select the third star from the other side of the sky.

WHEN ALL ELSE FAILS… Read the manual! It can provide more useful tips, step-by-step instructions and diagrams of the often complex menu trees of hand controllers. User groups on Facebook might be another source of helpful advice, or contact the dealer who sold you the telescope.

CHECK YOUR BATTERY

If the scope behaves badly (moving in fits and starts or failing to stop), check that the batteries are good and that the internal batteries are not corroded. For external power, use supplies and cables from the manufacturer, or you risk frying components if the voltage or polarity are wrong.

PARK YOUR SCOPE

Most telescopes offer a Hibernate or Park function that shuts down the scope but retains its alignment information. As long as the telescope is not moved, it can be powered up the next night to resume GoTo finding right away, though it will likely require that you input the current time.

FACTORY RESET

A new owner can sometimes get the hand controller in such a muddle that nothing works or all the menus are in a foreign language. Use the Factory Reset command to put the controller back to its default settings. This fixed a hand controller we tested that had seemed to be defective out of the box.

MEADE AUDIOSTAR/AUTOSTAR TELESCOPES

Many Meade GoTo telescopes, from the entry-level ETX-80 to the midrange LX65 and LX90 series, use the AudioStar hand controller, a well-refined system with the narrated "Astronomer Inside" audio tours. The higher-end LX200 and LX600 series forgo the audio tours aimed at beginners and add the Autostar II hand controller. Older scopes use the original Autostar hand controller.

Meade's LightSwitch telescopes use an Autostar III, with its built-in star catalog and plate-solving routines used by the alignment camera, similar to Celestron's StarSense system. We have not used the LightSwitch system, so it is not included here.

As with the other systems, the following tips are not intended to be a full instruction manual—you have that!—but can improve the performance of key functions.

AUDIOSTAR CONTROLLER

Meade's AudioStar hand controller offers narrated commentary on many objects, but Autostar hand controllers set up with similar steps and options.

AUDIOSTAR/AUTOSTAR SETUP

◆ Under **Telescope>Max Elevation**, you can reduce this number from 90° to 85° or less to prevent the scope from aiming straight up, causing anything attached to the rear port of an ETX to collide with the mount base. In fact, attaching anything to that port greatly restricts how high you can aim the telescope when in altazimuth mode. Also, objects directly overhead can be hard to slew to and track.

◆ **Telescope>Az Percent** and **Alt Percent** each add in some backlash compensation. Try 10%. But if moves seem jerky, then back this off—0% might be fine.

◆ **Telescope>High Precision** forces the telescope to slew to a nearby bright star first for centering before slewing to the desired object. For visual use, turn this off.

◆ **Telescope>Quiet Slew** reduces the maximum slew speed and motor noise. Your neighbors will appreciate this.

◆ **Telescope>Calibrate Motors** is advised only if the motions seem to misbehave, perhaps after suffering from a low battery.

◆ **Telescope>Train Drives** should be needed only as a last resort. Check the manual!

◆ Under **Setup**, do *not* change the **Az Ratio** or **Alt Ratio**. Why this option is even included is not clear.

◆ Under **Utilities**, set the **Brightness** and **Contrast** for the display. This may need to be adjusted in cold weather.

SITE INFORMATION

◆ **Setup>Site** provides options for choosing by: **1-Zip Code** (good only for the U.S.) or **2-Country**, then **City**. Choosing the city closest to you should be fine.

◆ You can **Add** a custom site by entering a **Name** and the **Latitude** and **Longitude**. **Time Zone** is minus (–) for North America. The added site will become the default.

◆ The AudioStar hand controller keeps track of the date and time. Nice! Older Autostar hand controllers require that you enter these each night.

CHOOSE THE SETUP: ALTAZIMUTH VS. POLAR

Fork-mounted GoTo scopes of any brand, such as this Meade ETX-90, can be set up either altazimuth, far left, or tipped over as an equatorial, or polar, mount, left. The latter then requires polar alignment and setting Meade's hand controller to **Mount>Polar**. For all visual use and even for lunar and planetary imaging, an altazimuth setup is much easier and is sufficient. These scopes are in Meade's start positions for each mode for the northern hemisphere.

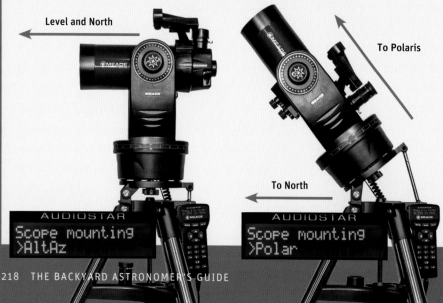

Level and North

To Polaris

To North

AUDIOSTAR
Scope mounting
>AltAz

AUDIOSTAR
Scope mounting
>Polar

ALIGNMENT

◆ The **Easy** alignment mode requires that the tube be level, but some models can use either **True North** or **Magnetic North** as a starting point.

◆ **Easy** alignment picks two stars and slews to them. Hit **Mode** to skip a star that is not visible, and go to the next star on the list.

◆ The **1-** and **2-Star** options require that you pick the stars, but the scope will slew to them from the Level-North starting position.

◆ Meade advises that you not align on stars overhead or near the celestial pole.

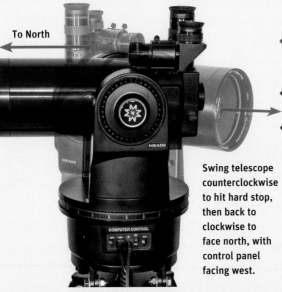

To North

Swing telescope counterclockwise to hit hard stop, then back to clockwise to face north, with control panel facing west.

◆ For Level-North (LNT) scopes, the **Automatic** leveling/finding-north dance can take a long time. This is normal. It's quicker to use a standard two-star align.

◆ Snugly lock the axes. A loose axis will slip and lose alignment under motor control.

◆ The creaking noise from the plastic gears when tracking is normal for ETX scopes, but they do find things accurately.

FINDING THINGS

◆ All object lists are accessed off the **Object** menu. Unlike other systems, there are no buttons for directly choosing objects from the Messier, Caldwell or NGC catalogs, etc.

◆ When choosing a deep sky object, hit **Enter** to put its name or catalog number on the lower line, or **GoTo** will not work.

◆ To exit a **Tour**, hold the **Mode** button down for a few seconds.

◆ While Meade's databases are good, they include invisible objects, such as black holes and quasars, which is useless information.

AVOIDING HARD STOPS

Older ETX telescopes require turning the scope counterclockwise until it hits a hard stop, then turning it back clockwise to place the fork arm over the control panel, which is positioned facing west. Failure to do this can result in the scope jamming into the hard stop during a GoTo slew. Newer ETX models have no hard stop, though the scrolling instructions might still mention it.

TIPS ON TIPS

For the three systems, we have organized tips into several categories:

◆ **Setup Functions:** Set-once-and-forget, if not correct, can result in bad behavior.

◆ **Initial Site Information:** Location and time/date that might need to be entered each night.

◆ **Alignment:** Tips on performing key alignment routines.

◆ **Finding Things:** Tips on navigating the databases.

AUDIOSTAR	AUDIOSTAR	AUDIOSTAR	AUDIOSTAR	AUDIOSTAR
Telescope Model >ETX-90	Current Targets: >Astronomical	Cord Wrap > ON	Audio Clip > OnDemand	Messier Object: 13

SCOPE CHOICE
Under **Setup>Telescope**, select the **Telescope Model** (the ETX-90 here), the **Focal Length**, the **Mount Type** (altazimuth or polar) and the **Tracking Rate** (to sidereal for astronomy use). These may be OK out of the box, but check.

TARGET CHOICE
Under **Setup**, **Targets** will be set to **Terrestrial** when powered up. **Targets** will switch automatically to **Astronomical** after an alignment. If it doesn't, the scope will not track the sky. If objects drift out of view, check this.

CORD WRAPPING
Under **Utilities>Cord Wrap**, select **ON** to prevent the battery cables from twisting around the mount as it turns. Most systems have this feature. When on, the scope may "take the long way round" when slewing.

AUDIO TOURS OFF
To turn off the narration on AudioStar units once the novelty wears thin, under **Utilities>Audio Clip**, choose **On Demand**. When it is playing, hit the **?** button to skip the cartoon-style intro aimed at kids and go to the main narration.

PAGING TO THE DEEP SKY
Under **Objects>Deep Sky**, hit the **Up** button to go straight to the **Messier** list. An object can be selected by entering its catalog number. In the list of **Named Objects**, some might be faint.

CELESTRON TELESCOPES

Celestron's NexStar hand controllers, while upgraded from time to time, all function in a similar manner. The exception is the StarSense version sold with the StarSense camera accessory and included with the Sky Prodigy telescopes. Since this camera takes care of much of the alignment process, it has different options to make it more automatic.

NEXSTAR SETUP

◆ Under the **Menu** button, set **Tracking** to **Altazimuth** (or **Equatorial**, as might apply to your scope).

◆ Under **Model Select**, choose your telescope by scrolling to it, and hit **Enter**.

◆ Under **Menu>Scope Setup**, the **Anti-Backlash** might need to be adjusted in each axis and direction. Try 10%. Too high, and the telescope will jump.

◆ Under **Menu>Scope Setup**, adjust the **Slew Limits**; 85° and −2° in altitude are good.

◆ Under **Menu>Scope Setup**, turn **Cord Wrap ON** if you are powering from an external source.

◆ **Utilities>Light Control** sets the brightness of the keypad and LCD display.

◆ **Utilities>Scrolling** allows you to adjust the speed of scrolling text for readability.

◆ **Utilities>Calibrate GoTo** is needed only if the scope is carrying extra weight.

SITE INFORMATION

◆ Under **Menu**, there is a **View Time-Site** option, but that's not where you set them. Instead...

◆ The hand controller might ask for site information out of the box. If the dealer already entered a site or if you did and wish to change it, go to **Menu>Scope Setup>Setup Time-Site**.

◆ Hit **Enter**, and the existing site should appear. Hit the **Undo** button to back out of the selection by three pages (!) to get to the **City Database**. Or use the **Up** or **Down** button to go to **Custom Site**. This nonintuitive navigation fouls up many new users.

◆ Under **Custom Site**, enter **Longitude**, then east or west (North America is west), and **Latitude**, then north or south.

◆ Enter the **Date** in the American style of month/day/year, true of most systems.

ALIGNMENT

◆ There is no special starting position such as Level-North. Meade owns that technology.

◆ For 1-2-3 SkyAlign models, the scope must be carefully leveled if it is to identify alignment targets in the **SkyAlign** mode. Other alignment modes, such as **Auto 2-Star**, are not so fussy.

◆ For **SkyAlign**, you must slew to three bright targets—any three, even if you don't know what they are. It's clever but is a somewhat tedious process.

◆ Better to learn to identify stars and use the **Auto 2-Star** or **2-Star** methods, as they require you to slew only to the first star; the scope slews to the second.

◆ **Solar System Align** is good for a rough alignment when all you can see is the Moon or a bright planet (or the Sun by day).

◆ German equatorial mounts like the AVX and CGEM models require a three-star alignment, with two stars on one side of the meridian and the third star on the other.

◆ When pressing one direction button, hold the opposite button down to momentarily speed up the slew to Rate 9—handy for quick moves when aligning.

FINDING THINGS

◆ You can enter a catalog from one of the direct-access keys only if the screen is back to the upper page (via **Undo**) with the Scope Name visible.

◆ After choosing a target, hit **Info** to get object details without slewing to it. Hit **Enter** to slew to it (there is no GoTo button per se).

NEXSTAR AND STARSENSE CONTROLLERS

The NexStar controller, top, is used on most Celestron GoTo scopes. The StarSense controller, above, contains the star catalog needed for its plate-solving alignment routines that automatically identify star fields.

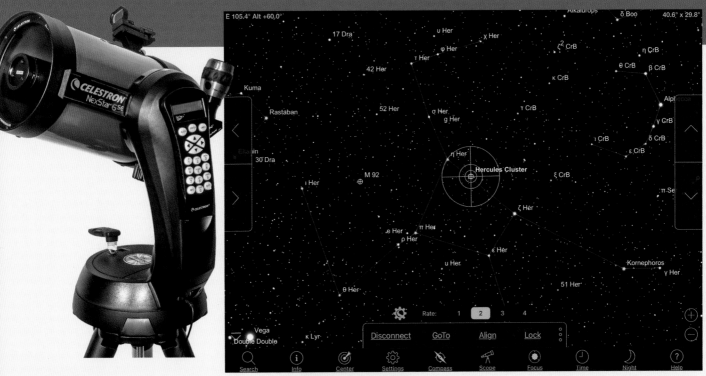

RELIABLE GOTO

The NexStar SE remains one of Celestron's most popular series. However, these telescopes must be used under motorized control, as they cannot be moved around the sky manually. But they can be upgraded to WiFi control by using the SkyPortal accessory (plugged into the base here) and free mobile app (shown above right).

- The **Tour** has a nice selection of targets, but as in most systems, they are all over the sky in no particular order.
- **Menu>Advanced** makes more options available for scope setup and filtering targets.
- For Messier and NGC objects, you must enter the leading zeros (i.e., M013 not M13).

STARSENSE HAND CONTROLLER

- This version offers combined menus for **View/Modify Site** and **View/Modify Time**.
- The main **Align** choices are **Auto StarSense** and **Manual StarSense** (where you aim at different areas of the sky).
- Under **StarSense Camera**, it might be necessary to **Calibrate** so that the camera and telescope are aligned electronically. Follow the manual's instructions.
- Under **Capture Settings**, you can adjust the sensitivity of the camera to suit various sky conditions.

PICK A CITY

In the **City Database**, choose **International** for non-U.S. cities, then your **Country** and **City**. A city within 100 kilometers or so of your location should work fine. Or you can choose **Custom Site** and enter your latitude, longitude and time zone.

STAY WITHIN A CONSTELLATION

Select **List>Constellation**, then pick a constellation to access a list of targets within that constellation—very handy for exploring all the Messiers in Sagittarius, for example.

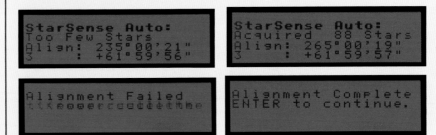

STAR SENSING

To perform an automatic alignment, Celestron's StarSense camera and controller slew the telescope around the sky to take images of three star fields. If, after several attempts, the camera does not see enough stars (perhaps due to cloud or obstructions), it will fail. The camera must see 20 to 50 stars in each field for the best results and a successful alignment.

IF YOU CAN'T SENSE STARS

Some form of alignment is needed to get most GoTo telescopes going and tracking. With StarSense scopes, there is no two-star alignment mode to fall back on. If all you can see is the Moon or a planet in twilight, the camera will not work. The alternative is **Solar System Align**, where you slew to and align on the object you choose.

SKY-WATCHER/ORION TELESCOPES

The GoTo scopes sold by Orion Telescopes and Binoculars (based in the U.S.) under its Star-Seeker brand are manufactured by Suzhou Synta Optical Technology in China, which makes the Sky-Watcher brand as well. Synta also owns Celestron, but Celestron's software, while similar to Synta's SynScan, differs enough that we've dealt with it separately. But we can describe the setup process for Sky-Watcher and Orion GoTo scopes together, as they're identical.

SYNSCAN CONTROLLER

While older SynScan hand controllers can be updated with new firmware, a new hand controller, with features such as the USB port on this V5 unit, might be a worthwhile upgrade.

SYNSCAN SETUP

◆ Under **Setup>Tracking**, select **Sidereal**. With German equatorial mounts, doing so will turn the R.A. tracking motor on even if you answer **NO** to **Begin Alignment?**

◆ **Setup>Elevation Limits** might be set to –15° by default, which could allow the tube to hit the mount. Reduce this to –5° or less.

◆ **Utility>Show Information>Power Voltage** displays the current battery level, the only system that does.

◆ When controlled by a laptop, the hand controller's **PC Direct Mode** can likely be left off, contrary to the vague instructions.

SYNSCAN SCOPES

Orion's StarSeeker IV mount, far left, and the Sky-Watcher AZ-GTi mount, left, offer built-in WiFi and can operate off the same hand controller, upper left, or the SynScan Pro app, below, that has all the functions of the hand controller plus an additional North-Level alignment mode.

SITE INFORMATION

◆ There is no city database. You must enter your **Site** by **Longitude** and **Latitude**, then add the **Time Zone** and **Daylight Time**. **Time Zone** is minus (–) for North America.

◆ You need to enter **Date** and **Time** each night, even after a restart from **Park**. The time must be entered in the 24-hour clock (e.g., 8 p.m. = 20:00).

◆ If you use the accessory GPS dongle, the hand controller will skip the location pages, but you must still confirm the **Time Zone** and **DST**, which is odd.

ALIGNMENT

◆ The hand controller offers **Brightest Star** (for altazimuth mounts only, where you select a region of sky and it picks a star), plus **1-** or **2-Star** methods. On equatorial mounts, a **3-Star** alignment is offered. Ignore the **NPError** and **ConeError** options. They are just to confuse you.

ALIGN WITH THE APP

To remove backlash when aligning on stars with the SynScan Pro app, left, the final move to center a star has to be up and right, as indicated by the highlighted buttons, before the process will proceed by tapping the then activated star (★) button.

- In all methods with altazimuth mounts, there is no preferred starting position. So you must slew to the first star, but the mount will slew to the second star.
- With **Aux Encoders Enabled**, you can loosen the axes and push the mount close to the first star, then lock the axes and do the final centering with the slew buttons, a unique feature (but see "Enable Encoders" below).
- **Daytime Alignment** allows aligning on the Moon by day or on a bright planet in twilight.
- When aligning, you might need to increase the speed (**Rate + 9**) to roughly aim at a star, then reduce the speed (**Rate + 5**) for fine centering in the eyepiece, an annoyance.
- After finishing an alignment, the controller returns to the **Alignment Method** page as if you need to repeat the process. No! Another potential point of confusion. Just hit one of the buttons to enter a database or **Tour**.

FINDING THINGS

- After selecting a target, you must hit **Enter**, then **Enter** again, to skip over object information and get to the **View Object?** page, where **Enter** now starts the GoTo slew, another quirk.
- There is no confirming beep when the telescope completes a GoTo slew.

- Nonintuitively, you must hit **Esc**, not **Menu**, to go back up the menu tree to an upper-level page.
- **Tour** takes you to a **Deep Sky Tour** with no solar system objects or double stars. The selection of targets is OK (some, like the Cocoon Nebula, are too faint to see), but they are presented in random order around the sky, not west to east as they should be.

SYNSCAN PRO APP

- Sky-Watcher and Orion WiFi mounts can be controlled with a hand controller or the SynScan Pro app, but not both.
- The app detects the type of mount and presents alignment options suited to that model.
- Under the app, a **North-Level** mode is offered (though only for altazimuth mounts) and requires a start position with the tube level and aimed north. The mount will slew to the first star, making alignment easier.
- To align, you pick stars from a list first, then hit **Begin Alignment**. The best choices are usually the stars at the top of the list.
- As of SynScan v1.19, the sky tours are under **Utilities**. Go to **Settings** for **Altitude Limit** and **Backlash**, with **Aux Encoders** located under **Advanced**.

TUNE BACKLASH

If the telescope runs on after you jog a motion button, go to **Setup>Backlash** and reduce the **Alt** and **Az** settings to zero or a low value such as two arc minutes (0° 02' 00"). By default, our test units were set to 30 arc minutes in altitude, far too high, causing a lot of runaway motion. Here, we show the settings for both the SynScan Pro app and hand-controller.

ENABLE ENCODERS

Mounts with Freedom Find encoders, which allow you to manually push the telescope around without spoiling the alignment, need to be **Enabled** *each night* under **Setup>Auxiliary Encoder**. They are off by default in both the hand controller and the app, defeating the very feature and selling point that make these mounts work well.

SKIP LOCATION PAGES

Your location needs to be entered only once by latitude and longitude. Set **Longitude** to west (**W**) for North America—it is easy to set it to east by mistake. Each night, you must still skip through these pages by hitting **Enter**, an annoying step.

FIRMWARE CHECK

For all systems, do *not* worry about updating hand-controller firmware. Any problems you encounter are likely not because of old firmware. The update process itself is fraught with risk and requires a Windows PC. None support MacOS.

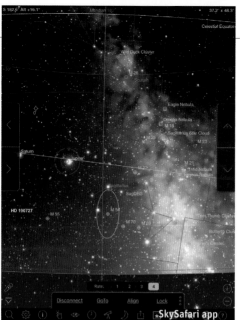

SynScan Pro app

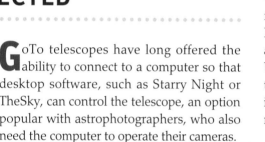

SkySafari app

Sky-Watcher and Orion WiFi telescopes can be controlled with the SynScan Pro app (left screen), which is text-based only.

APP CONTROL

Sky-Watcher and Orion WiFi telescopes can be controlled with the SynScan Pro app (left screen), which is text-based only. But it can link to the star-charting apps SkySafari (right screen) and Luminos when you select the SynScanLink option under the app's Scope Setup page, as shown at bottom of page 225. Using a star-charting program makes it easy to see and explore all that's in a specific area of sky, such as the rich Sagittarius region here.

WIRED CONNECTIONS

The traditional wired method of connecting a telescope to a computer uses the serial cable that comes with many GoTo telescopes. It connects from the hand controller (often with a telephone-style RJ11 port) to an old-fashioned RS232 DB9 (9 pin) serial plug. No computer made since the 1990s uses such a serial port, so users are left to acquire a USB-to-serial adapter, install its drivers, select the right COM port, then hope the planetarium software recognizes this port as a connection option.

The latest hand controllers now come with a USB port (at last!) to connect directly to a computer, a far better arrangement. Even so, for visual use at least, wired connections to laptops have now been largely replaced by WiFi connecting to mobile tablets or smartphones.

WIRELESS OPTIONS

An increasing number of telescopes come with built-in WiFi, and some don't even include a hand controller. Instead, they rely on the use of a mobile app to align and run the telescope.

Owners of other GoTo scopes can add WiFi to their telescopes with the aid of accessory dongles we showed in Chapter 9, page 188. Celestron's SkyPortal module ($120) and Sky-Watcher/Orion's SynScan module ($70) allow their brands of telescopes to connect to their respective SkyPortal or SynScan Pro apps. The dongles either augment or outright replace the traditional hand controller.

GETTING CONNECTED

EXPLORE STARS

Explore Scientific's WiFi-enabled mounts, such as the iEXOS-100 (below), have no hand controller and operate via the ExploreStars app for Android tablets and Apple iPads only. The alignment screen shows the stars it has selected, though the version we tested had a propensity to pick obscure stars, such as Thuban in Draco here, and often did not show their proper position.

GoTo telescopes have long offered the ability to connect to a computer so that desktop software, such as Starry Night or TheSky, can control the telescope, an option popular with astrophotographers, who also need the computer to operate their cameras.

For visual observers, using a laptop or a tablet to operate the telescope has the advantage of providing an interactive star chart showing where the scope is pointed. Here, we present control options that as of 2020, we find work best. But bear in mind that software changes rapidly, and new options might well become our favorites.

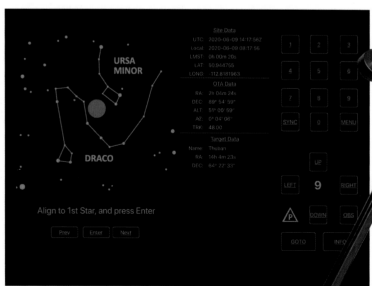

A solution for all telescopes is to use the SkyFi wireless box (in version III as of 2020) from Simulation Curriculum ($200). SkyFi works with SkySafari and Starry Night. Orion's StarSeek and Meade's Stella modules (the latter was discontinued in 2020) are similar.

We found that WiFi-enabled telescopes and add-on dongles connected to our devices easily and reliably, offering all the functions of a hand controller plus significant advantages:

◆ There's no need to input your site and time, as your device knows these.

◆ Comets and asteroids are included and can be readily updated via a download.

◆ SkySafari offers downloadable tours, such as a Messier Marathon, or you can configure your own sky tours.

◆ The SynScan Pro app has a clever Point-and-Go feature that commands the mount to slew to where your smartphone is aimed.

◆ Visitors to your telescope can see where it is aimed. You can pass your tablet around for family members to pick targets and tap on them to command the scope to go to them, a treat for children and adults alike.

◆ Once on target, the software provides images, audio narration and much more information than a hand controller can.

Indeed, hand controllers, with their crude alphanumeric displays, may soon be relegated to gadgets of quaint curiosity, like flip phones.

But the technology works best only when you are familiar enough with the sky to know what to look at. That's why we've included our deep sky tours in Chapters 6 and 16, to get you started on a sampler of celestial wonders that can be found either by traditional star-hopping or by high-tech tapping on a screen. It's your choice.

A final caveat: While the wireless technology is attractive, if the battery in your tablet or smartphone dies, as it might in cold weather, you are left with a useless telescope. In our tests, we found that apps can be power hogs, killing a device after two to three hours.

Call us old-fashioned, but we still like to have a hand controller as a more reliable wired option for our GoTo telescopes, especially on winter nights. And when we really want to simplify, we star-hop with our manual Dobsonians and grab-and-go refractors.

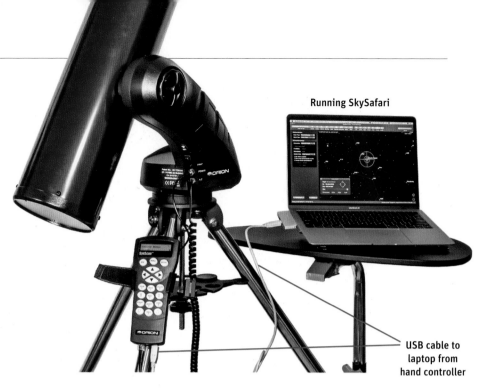

Running SkySafari

USB cable to laptop from hand controller

WIRED CONNECTION

Laptops running desktop programs such as SkySafari (shown here), Starry Night or TheSky can connect to telescopes via a serial connection or, with modern hand controllers, as here, directly via USB. Many people like Stellarium, though we find its connection process and use with telescopes arcane and unreliable. But it's free.

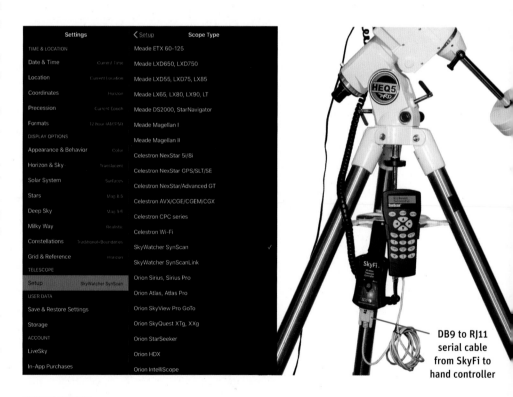

DB9 to RJ11 serial cable from SkyFi to hand controller

SKYFI SETUP

The SkyFi box connects to a hand controller via the serial cable that comes with GoTo telescopes, as here, or via a USB cable on newer controllers. Users must select the brand and model or series of telescope, as shown above, and the type of mount. Once connected, the telescope can be aimed with either the app (tap a target and hit GoTo) or the hand controller.

CHAPTER 12

Observing the Sun, Moon and Eclipses

The Moon was the first celestial object Galileo looked at with his telescope more than four centuries ago. The excitement he must have felt as he gazed at the Moon's rumpled face for the first time is part of the legacy of the telescope as an instrument of exploration. Even in his crude 3x refractor crippled by every optical aberration known, Galileo saw features never before observed or imagined. Galileo was also among the first to observe the Sun through a telescope, revealing that it, too, was blemished—with dark sunspots he tracked across the solar disk. We can do the same today, though far more safely than Galileo could in the 1600s.

While the Sun and Moon are interesting objects on their own, even non-astronomers pay attention to them when the two worlds align with Earth to create eclipses of the Sun and the Moon, two of the most memorable sights in the sky.

We live on a special planet where we can witness the spectacle of our lone, large Moon covering the Sun in a total eclipse. From no other planet in the solar system does a moon so precisely match the Sun in apparent size to create such a perfect eclipse. Author Dyer captured this scene in Idaho on August 21, 2017, looking toward Wyoming's Grand Tetons.

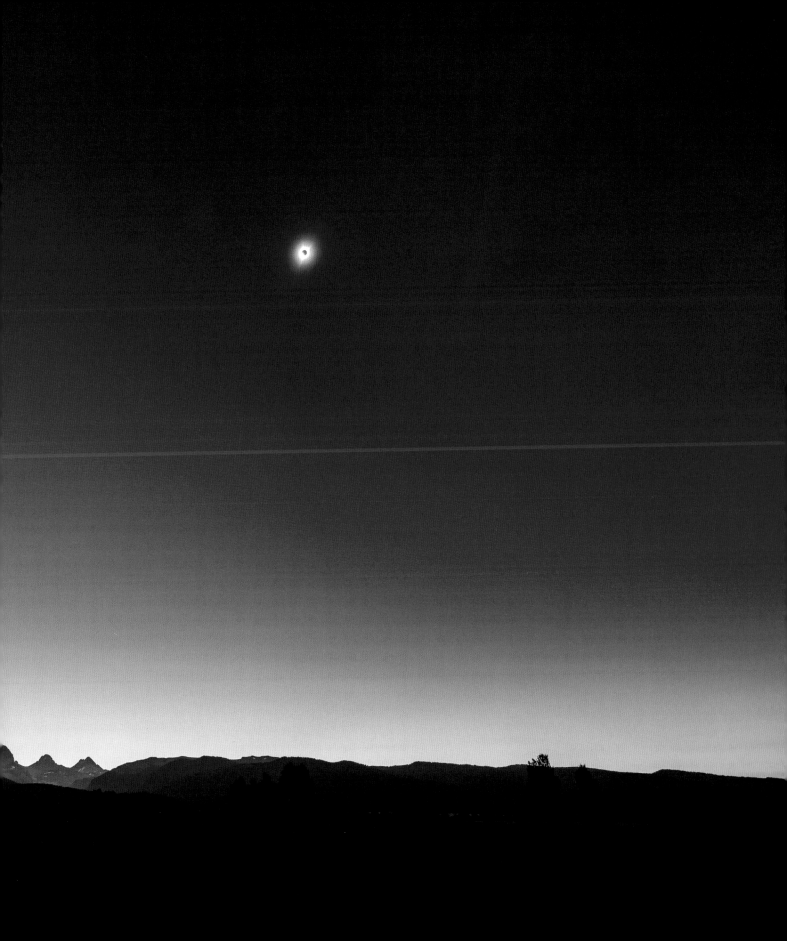

SIMULATED MOONS

This series uses simulated Moon images from the mobile app Moon Globe. For a free desktop program for Windows, try the Virtual Moon Atlas.

| 27-DAY-OLD WANING CRESCENT | 25-DAY-OLD WANING CRESCENT | 23-DAY-OLD WANING CRESCENT | 21-DAY-OLD LAST QUARTER | 19-DAY-OLD WANING GIBBOUS | 17-DAY-OL WANING GIBB |

RISES AT DAWN

WANING PHASES IN THE LATE-NIGHT SKY; RISING LATER EACH NIGHT

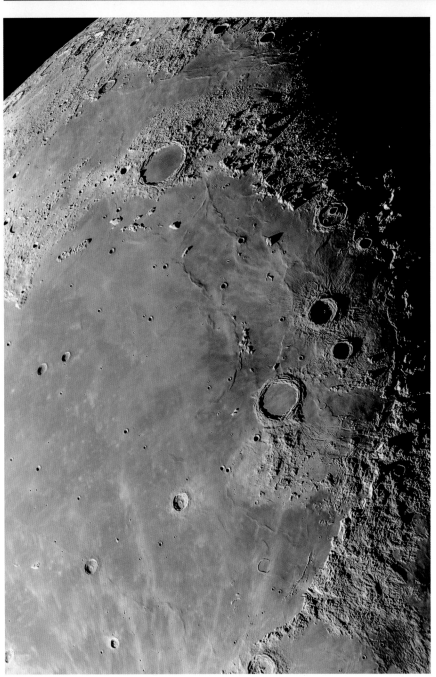

IMBRIUM PANORAMA

The huge impact basin Mare Imbrium is one of the most spectacular regions of the Moon, rimmed by arcs of mountain ranges and punctuated with giant craters such as Plato, at top, and Archimedes, at center. Lunar photographer Robert Reeves captured this panorama at a waning last-quarter Moon.

OBSERVING THE MOON

With his crude telescopes, Galileo discovered that the Moon was not an unblemished sphere or mirror in the sky, as had been thought, but another world with features not unlike Earth.

Today, craters and mountains on the Moon are usually the first details brought to focus in a new telescope. Those initial lunar views make a lasting impression. Indeed, the Moon presents such a variety of wonderful vistas, they alone would be worth owning a telescope to see.

Wrinkled plains, rugged fields of craters, sunlit mountain peaks and deep valleys all stand in stark relief, undistorted by any wisp of cloud or fog (on the Moon, that is). The Moon is so close, its features so easily visible and the detail so abundant, there is always something of interest to examine.

SHAPED BY IMPACTS

The evidence brought back by the Apollo astronauts and data from later unmanned missions to the Moon confirm that almost everything we see on the Moon was created and shaped by one primary force—impacts, large and small.

With no atmosphere to protect and affect it, the Moon has been subjected to countless impacts of comets, asteroids and meteoroids—debris left over from the formation of the solar system. However, with the exception of a few more recent craters—such as Copernicus and Tycho—most of what we see is the result of heavy bombardments that began to taper off about a billion years after the Moon formed.

Even the circular "seas," the maria (pronounced MAH-ree-ah; singular is mare, or MAH-ray), are basins created by giant impacts that were later flooded with eruptions of fluid

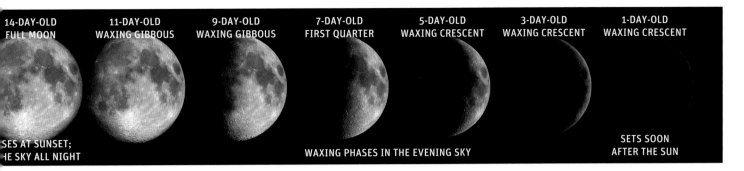

14-DAY-OLD
FULL MOON

11-DAY-OLD
WAXING GIBBOUS

9-DAY-OLD
WAXING GIBBOUS

7-DAY-OLD
FIRST QUARTER

5-DAY-OLD
WAXING CRESCENT

3-DAY-OLD
WAXING CRESCENT

1-DAY-OLD
WAXING CRESCENT

SES AT SUNSET;
HE SKY ALL NIGHT

WAXING PHASES IN THE EVENING SKY

SETS SOON
AFTER THE SUN

magma which filled the impact basins during a period from 3.8 to 3.2 billion years ago. So while there has been volcanism on the Moon, craters are not ancient volcanoes, contrary to what many lunar observers of the 1950s and 1960s stubbornly maintained.

When you look at the Moon, you are seeing a surface that Earth once had. But Earth gained and retained an atmosphere and oceans not of magma but of water. Earth also retained its internal heating and rapid rotation, leading to plate tectonics and the movement of landmasses that would change the face of our world. The Moon is a geological laboratory frozen in time, allowing us a glimpse at how Earth and the solar system once were.

WHAT CAN YOU SEE?

Lots! After years of post-Apollo neglect by backyard astronomers, the Moon has become a prime object of interest again. The reason is simple. Great views are possible with any telescope, even in the city. And what you see constantly changes in appearance, not because of erosion or weather but because of the lighting.

Our lunar tours in the next chapter imagine an ideal situation in which we observe the Moon virtually every night for two weeks, from new Moon to full Moon. The terminator, the line between day and night on the Moon, moves westward about 12 degrees of lunar longitude every 24 hours, revealing new vistas each successive evening of a waxing Moon.

GOING THROUGH A PHASE

The above sequence of images simulates the changing phase of the Moon from a young waxing crescent (at far right) to an old waning crescent, with the Moon moving from right to left here, as it does when it travels eastward in our sky from night to night. The age of the Moon is given in days from 0, at new Moon. The Moon is full 14 to 15 days after new Moon.

WHO NAMED THE FEATURES?

Sea of Nectar? Marsh of Decay? Bay of Rainbows? These and other fanciful names for prominent lunar features date from 1651 and this Moon map, produced by Giovanni Battista Riccioli, a Jesuit priest and astronomer.

Riccioli established the convention for naming the maria after weather and ocean conditions as well as states of mind. Seas on the Moon's eastern half, the phase we see during a waxing Moon, were named for pleasant conditions, since the waxing Moon was believed to bring fair weather. He named seas on the western half for stormy conditions, as the waning Moon was thought to bring bad weather.

Craters were named after notable figures in the history of science and astronomy. Starting in chronological order from the Moon's northern segment, Riccioli worked clockwise around the lunar disk. Plato and Aristarchus are at top, while Tycho and Copernicus are at bottom and top left, respectively. Riccioli adhered to the *Tychonic system* (thus Tycho's prominent crater), which held that the Sun orbited an unmoving Earth, although the other planets orbited the Sun. He placed astronomers Copernicus and Kepler, proponents of the then controversial heliocentric system, in the Sea of Storms.

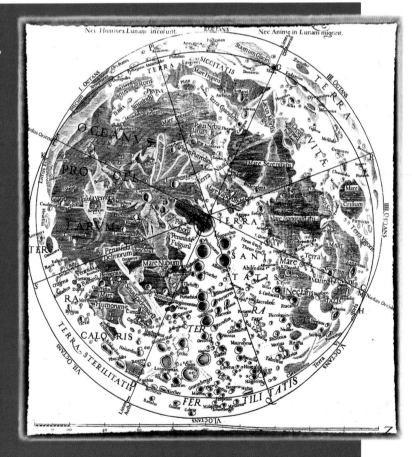

MOON MONTAGE

Despite being shaped by one main force—impacts—the face of the Moon presents such a variety of forms and features, you could spend a lifetime studying them. And some people have! All the images here are by Robert Reeves.

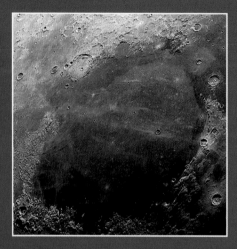

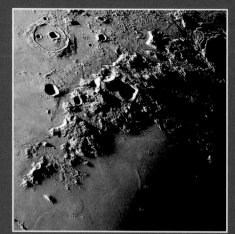

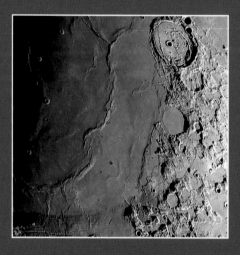

LUNAR SEAS Giant impacts created circular basins that were later flooded with magma flows. The Sea of Serenity, seen here, formed 3.7 billion years ago and filled with lava over the next 700 to 800 million years.

MOUNTAIN RANGES Unlike earthly mountains, which were created by the slow uplift of tectonic forces, lunar mountains, such as the Caucasus, above, were made in moments from the impacts that formed the basins the mountains border.

WRINKLE RIDGES Officially called dorsa, these features are only a few hundred meters high and snake across seas (this is the Serpentine Ridge). They formed as basins subsided and became wrinkled from compression.

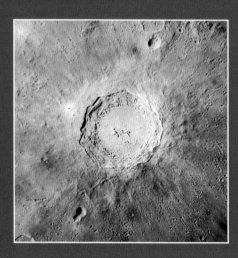

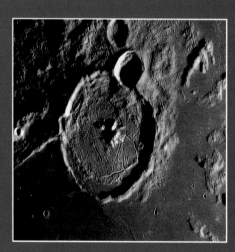

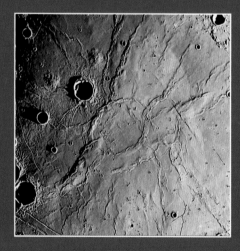

COMPLEX CRATERS Craters larger than about 20 kilometers across, such as Copernicus, shown here, often have central peaks and terraced walls created when rock layers were liquefied by the heat of the impact.

FLOOR-FRACTURED CRATERS Some large craters were flooded by lavas that formed either smooth-floored craters, such as Plato, or floor-fractured craters, such as Gassendi, above, if upwelling lava cracked the floor into fragments.

GHOST CRATERS Ancient craters on a mare, such as Lamont, shown here, in Mare Tranquillitatis, were almost entirely buried by encroaching mare magmas, creating subtle features visible only under low lighting.

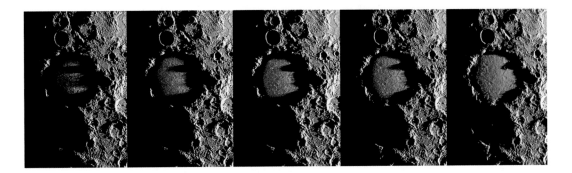

Even during a single night's backyard session, the terminator moves enough to subtly change the appearance of features, as crater rims and mountain peaks light up and shadows shorten across crater floors.

Also, due to differences in timing and a wobble of the Moon called libration, the lighting is never quite the same each month. Features along the terminator on a six-day-old Moon one month won't look the same as those on a six-day-old Moon the next month.

Under steady seeing conditions, when the image of the Moon looks sharp and unwavering, a 6-inch (150mm) telescope can resolve lunar features as small as one kilometer across. However, tiny domes and ridges only 100 to 300 meters high near the terminator can reveal their presence by casting shadows many kilometers long.

WHAT CAN'T YOU SEE?

Anyone who has offered views of the Moon to friends or the public has heard the question, "Can we see where the astronauts landed?" Yes. The *locations* can be pinned down by using a lunar map. But what the person really wants to know is whether it's possible to see the footprints, lunar landers and American flags. And the answer to that is…no.

The smallest crater visible under ideal

> ### DARK SIDE OF THE MOON
> There is no permanently dark side of the Moon. While there is a side we never see from Earth, the lunar far side experiences the same 29-day cycle of day and night as does the near side that faces Earth.

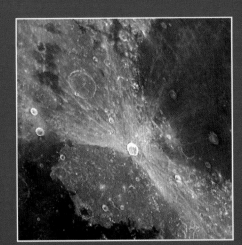

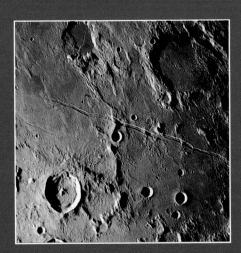

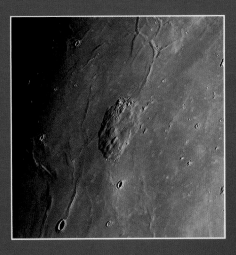

LUNAR RAYS Young craters exhibit bright rays from ejecta splashing across the surface. Age will eventually darken them. With the crater Proclus, below and right of center, the impactor hit at a shallow angle of less than 15 degrees.

RILLES Officially called rimae, these valleys are fault lines where the surface split and subsided in a classic example of a feature on Earth that is called a graben. This is Rima Ariadaeus, just west of Mare Tranquillitatis.

LUNAR DOMES While flowing and fountaining magma shaped some of the Moon, the only features that are likely ancient volcanoes are low domes such as these, the Rümker Hills in Oceanus Procellarum.

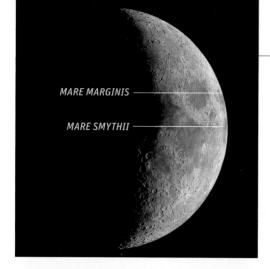

MARE MARGINIS —

MARE SMYTHII —

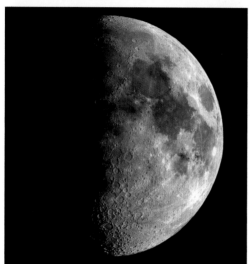

LUNAR LETTERS
For a few hours during a six-day-old Moon, sunlight illuminates the rims of certain craters to make an X and a V on the terminator. The Lunar X is formed by the rims of craters Blanchinus, La Caille and Purbach, while the Lunar V is formed by morning light on the rim of Ukert.

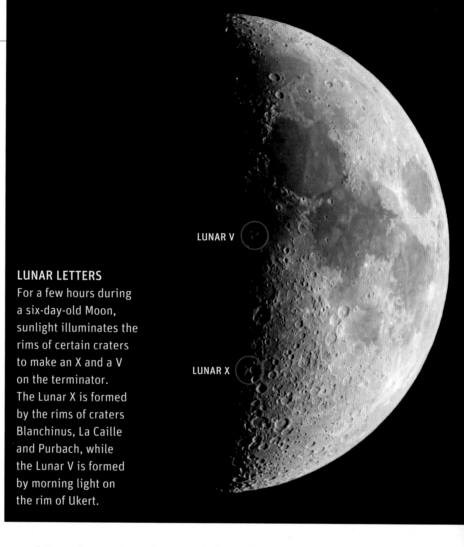

LUNAR V

LUNAR X

LIBRATION AT THE LIMB
As the Moon orbits Earth, a series of wobbles called libration tips the eastern, then northern, western and, finally, southern lunar limbs toward us each month. Note how the elusive Mare Marginis and Mare Smythii can just be seen on the limb in the top image, taken at a favorable eastern libration, but are not visible on the above image in this pair of photos by Robert Reeves.

conditions is several times larger than the biggest sports stadiums in the world, whereas the largest piece of hardware left behind by the Apollo astronauts is smaller than a garage. It took the high-resolution cameras of NASA's Lunar Reconnaissance Orbiter to reveal the hardware and rover tracks left by the Apollo missions.

LUNAR OBSERVING TECHNIQUES

The Moon's image is so bright that even small telescopes provide enough light to show features clearly. With telescopes larger than 6 inches (150mm), what can be seen is limited not by the telescope but by the steadiness of the atmosphere. Chapter 14 has more on rating your seeing conditions. As with the planets, try to observe the Moon when it is highest, above the worst turbulence and haze in our atmosphere. For a waxing crescent or quarter Moon, this dictum means observing as early in the evening as you can.

As a general rule, the Moon can be viewed at higher magnifications than any other celes-

tial object. For instance, we often use a 5-inch (125mm) refractor at up to 450x on the Moon. However, the most common magnification for detailed lunar observing is about 200x, providing views equivalent to looking out the porthole of a spacecraft orbiting the Moon at an altitude of 1,600 kilometers. Wide-angle (82- and 100-degree) eyepieces with good eye relief add to the spaceship effect.

In large telescopes, the Moon can be too bright. The solution to the unwanted glare is a neutral-density filter (about $20) that screws into the base of a 1.25-inch eyepiece just as deep sky and color filters do. A minus-violet or light yellow filter can lessen blue false-color halos in achromatic refractors. A light red filter or a polarizing filter can darken the sky for daytime or twilight observations.

Compared with the demands of deep sky observing, the Moon is an easy target. The exquisite beauty of its alien-looking surface will keep drawing you back. We are fortunate to have such a fascinating world next door to explore.

OBSERVING THE SUN

Examining the intensely brilliant surface of the Sun is possible only with proper filtration. *Never* look at the Sun through any optical device unless you are sure it is safely filtered. Astronomy is a benign hobby with few opportunities for personal injury. But this is one of them. Read the following carefully.

SAFETY FIRST: SOLAR FILTERS

Over the years, especially around solar eclipses, many materials have been promoted as suitable for use as solar filters. You might recall your father making a homemade filter to view an eclipse you remember from childhood. We can almost guarantee it was unsafe.

Contrary to your father's practice, do not use smoked glass, sunglasses, layers of color or black-and-white film, X-ray film, photographic neutral-density filters or polarizing filters. All these materials, while dimming the visible Sun, can pass harmful infrared or ultraviolet light. These invisible wavelengths can damage the retina of the eye and, in extreme cases, cause partial or complete blindness. *Do not take chances.* It is *not* sufficient to dim just the visible light your eyes can see.

For gazing at the Sun safely with unaided eyes, use "eclipse glasses" from a reputable supplier (see below). These are made with aluminized Mylar or black polymer. An alternative is a No. 14 welders' filter sold at welding-supply outlets. However, only the No. 14 grade is safe; the more common No. 12 welders' filter is too light.

To observe the Sun, place the filter or glasses over your eyes *before* you look at the Sun. With them, individuals with sharp eyesight can see sunspots that are Earth-sized or larger.

For telescopes, you need a solar filter made to fit snugly over the front of the telescope, where it safely reduces the intensity of sunlight by 99.999 percent *before* it enters the tube. The most durable solar filters are made with optical plane-parallel glass coated with a nickel-chromium alloy. Orion Telescopes, Seymour

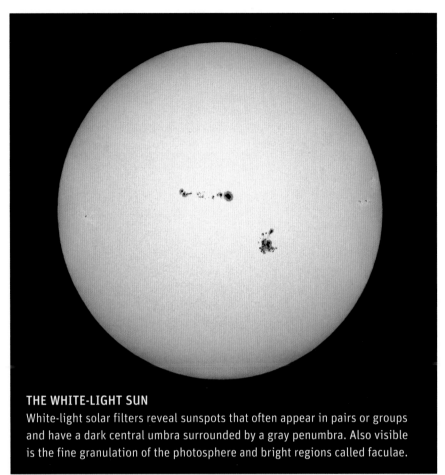

THE WHITE-LIGHT SUN
White-light solar filters reveal sunspots that often appear in pairs or groups and have a dark central umbra surrounded by a gray penumbra. Also visible is the fine granulation of the photosphere and bright regions called faculae.

HAND-HELD AND TELESCOPE FILTERS
Above: Eclipse glasses and hand-held viewers use aluminized Mylar or black polymer for safe views of partial solar eclipses but can also reveal large naked-eye sunspots.
Right: The only safe filters for telescopes (and binoculars) cover the front aperture. The Seymour Solar filter is a metal-on-glass type; the Kendrick filter is a Mylar type and comes with a handy Sun-spotter finder device.

FILTERED FAMILY ECLIPSE

Right: A family enjoys safe views of the solar eclipse of October 23, 2014, one that was visible only as a partial eclipse, with the Moon's umbral shadow missing Earth, as happens at many solar eclipses. A particularly large sunspot group marked the Sun that day.

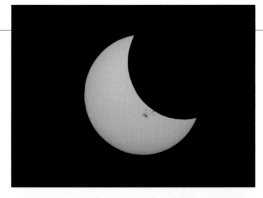

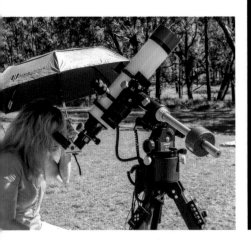

ARTIFICIAL SUNSPOT

For this remarkable view of the Sun in H-α, Rainee Colacurcio used a Lunt 80mm telescope to capture the International Space Station in transit in front of the Sun, a rare and fleeting sight. To calculate when you might see such a transit from your location, go to transit-finder.com.

SOLAR SHADING

Solar observing is the only time you need an umbrella in backyard astronomy! Being in the shade helps you see details through any H-α telescope, such as this 100mm model from Lunt.

SOLAR ROTATION

At the equator, the Sun rotates once every 25 Earth days, but near the poles, a "day" on the Sun lasts 34 Earth days. This differential rotation extends deep into the Sun and generates the 11-year solar cycle, as magnetic fields wind up, then release.

Solar and Thousand Oaks Optical are major suppliers of glass filters for any size telescope. Prices range from $50 for a pair for binoculars to $200 for a full-aperture 12-inch filter.

Metal-coated thin Mylar film, a sturdy plastic material about the thickness of shrink-wrap, is a popular and generally cheaper alternative. The Mylar must be in a cell that mounts securely over the front of the telescope. Models for all sizes of binoculars and telescopes are available from Baader Planetarium, Kendrick Astro Instruments and the companies noted in the previous paragraph. Rainbow Symphony is another well-known supplier of eclipse glasses.

We have found that Mylar filters equal the optical quality of glass filters. However, Mylar filters can impart an unnatural blue cast or present a white Sun, which is, in fact, its natural color. In most metal-on-glass types, the Sun is yellow, which is how we expect the Sun to appear. Black polymer filters also provide a yellow Sun, but their optical quality makes them suitable only for naked-eye and wide-angle camera use.

Another word of caution: Aluminized Mylar sold for use on van and camper windows and used for "space blankets" is unsafe for solar viewing. It is not dense enough and does not necessarily block infrared and ultraviolet. Use only filters sold specifically for astronomical applications by well-established dealers. For the 2017 eclipse, Amazon was flooded with unsafe impostor filters that had to be removed from the market. Be careful in 2023 and 2024.

Once a scope is filtered, finding the Sun can be tough! Aim the telescope by watching the instrument's shadow, *not* by gazing up the tube at the Sun and especially not by peeking into the finderscope. Indeed, always cap the front of the finderscope or remove it during any solar observing. When the telescope tube's shadow becomes circular, the telescope is aimed approximately sunward.

FILTER ALTERNATIVES

Solar projection involves using an unfiltered telescope to project the Sun's image onto a white card held a few inches away from a low-

power eyepiece, one you can afford to sacrifice, as it could get damaged by the Sun's heat.

While projection is suitable for group viewing, we offer it with caution. At a public event, there is always the danger of someone—a curious child perhaps—looking through the unfiltered telescope. The safer variation is to build a "sun funnel," where the telescope projects the image onto an enclosed rear-projection screen, with no way for anyone to look directly into the eyepiece. For instructions on making a sun funnel, see NASA's website at https://eclipse2017.nasa.gov/make-sun-funnel.

Small refractors are ideal for solar projection; large telescopes must be covered with an aperture stop. A hole in a piece of cardboard covering the aperture works fine for refractors or Newtonians, but never practice solar projection with a catadioptric telescope, such as a Schmidt-Cassegrain or Maksutov-Cassegrain. Heat builds up inside these instruments, which can damage the telescope. Use *only* a front-aperture filter for catadioptric telescopes.

The avid solar observer might wish to invest in a Herschel wedge, a costly form of star diagonal that reflects away most of the Sun's light and heat to present the eyepiece with an image at a safe level of brightness. The result is a white-light solar image with better sharpness and contrast than the image with front-aperture filters. With a Herschel wedge, however, the full force of sunlight passes through the telescope optics, so the same equipment precaution we've given for solar projection applies here.

WHAT CAN YOU SEE?

All of these methods present the Sun as seen in white light. The main features visible are dark sunspots. These are cooler regions of the Sun where magnetic fields have trapped gases and stopped the normal convection that heats the photosphere, the Sun's luminous surface. Sunspots are about 4,000 K (kelvin), compared with 5,800 K for the rest of the Sun's surface.

Sunspots wax and wane over an approximate 11-year-long cycle (see pages 39-40). The last maximum was in early 2014. The Sun dipped to a deep solar minimum in 2019-20,

THE CORONADO PST

The little H-α Personal Solar Telescope (PST) has only a 40mm aperture but reveals prominences on the limb and some surface detail. It requires no power and includes a small finderscope and a tuning adjustment.

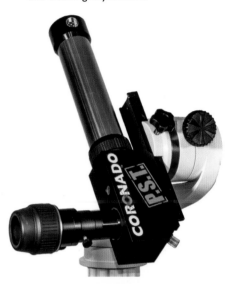

GALILEO'S SUNSPOTS

In 1610, Galileo in Italy and Thomas Harriot in England were the first to observe sunspots with a telescope, followed by Christoph Scheiner as well as David Fabricius and his son Johannes in 1611, though it was Johannes who, in autumn 1611, first published an account of these dark spots.

Galileo's first published accounts of sunspots did not appear until the summer of 1612, by which time Scheiner, a Jesuit mathematician, had also published his observations. (Galileo's drawings here show the rotation of the Sun over five days in July 1612. The north pole of the Sun is at upper right.)

Arguments broke out between Galileo and Scheiner over who had the priority of discovery as well as the nature of the spots, with Galileo maintaining, correctly, that they were blemishes on the Sun and Scheiner insisting that they were satellites of a perfect Sun. These pioneering observations were made just before the Sun entered the Maunder Minimum, a prolonged dip in solar activity from 1645 to 1715, when any sunspot was rare.

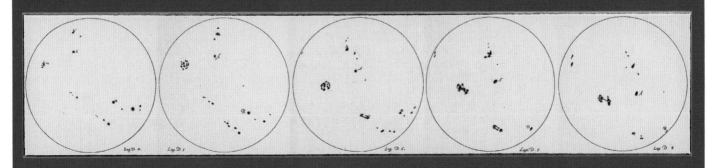

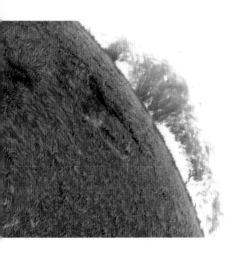

LEAPING OFF THE LIMB
Prominences can extend for thousands of kilometers into space and can change shape over just one to two hours. Jack Newton captured this giant prominence in 2015 using a Coronado H-α telescope.

SOLAR ROTATION
This series of H-α images by Fred Espenak shows the Sun at intervals of two days, with a giant dark filament first centered on the Sun's disk (left), then moving to the right as the Sun rotates. In the final frame, the filament juts into space to become a solar prominence.

when weeks went by with not a sunspot in sight. Activity should pick up in the mid-20s as the current Cycle 25 reaches a peak, but some predictions call for a weak maximum like the previous Cycle 24. Cycles are counted from the year 1755, when astronomers began to record sunspot numbers with accuracy.

Small spots may last for several days or grow into large spot groups and stay on the solar face for weeks. Because of the 25-day solar-rotation period (as measured at the equator), the scene changes a little every day and a great deal in a week.

Faculae, another white-light feature of note, are bright regions best seen near the edge, or limb, of the Sun, where limb darkening makes the solar disk appear dimmer. These are regions of concentrated magnetic field lines but are less intense than sunspots.

Under high power and with steady seeing conditions, the solar surface might look granulated. These granules are bubbling convection cells, each several hundred kilometers across—the size of Texas!

THE H-ALPHA SUN

All the solar filters discussed so far show the Sun in white light—they reduce the amount of light across the entire spectrum. A very specialized solar filter eliminates all light from the Sun except the main wavelength emitted by hydrogen atoms—at 656 nanometers (nm)—letting through light in a bandwidth only 1 Ångstrom (Å) wide or less (1 Å = 0.1 nm). All such filters provide some means of tuning the bandpass to reveal the best detail.

When you view the Sun in the red light of hydrogen atoms, you see a higher layer called the chromosphere and features such as solar prominences, filaments and flares. With a hydrogen-alpha (H-α) filter, prominences that are normally seen only during a total solar eclipse become visible arcing off the edge of the Sun.

A dedicated H-α telescope adds a new dimension to the hobby of astronomy, but it is expensive. The most affordable H-α scopes are the 40mm Coronado Personal Solar Telescope ($700) and the 60mm Daystar Solar Scout DS ($800). A top-end 100mm H-α scope can be upwards of $7,000.

H-α filters are also available to attach to existing telescopes, but even these cost from $1,000 to $6,000. Most go in front of the telescope. The Daystar Quark H-α filters (available in wider prominence and narrower chromosphere models for about $1,200 each) are placed at the eyepiece end and require a 5-volt power source to heat the internal filter.

Double-stacking front-mounted H-α filters (at some cost!) provides views with a bandwidth under 0.5 Å, resulting in more contrast, especially of disk details such as granules and filaments, which are prominences seen in silhouette in front of the Sun. Coronado (a division of Meade Instruments), Daystar Filters and Lunt Solar Systems are the principal manufacturers of H-α filters and telescopes.

Whether in H-α or white light, the Sun can be a fascinating target exhibiting changes from day to day, even hour to hour. And you don't have to lose sleep to observe it.

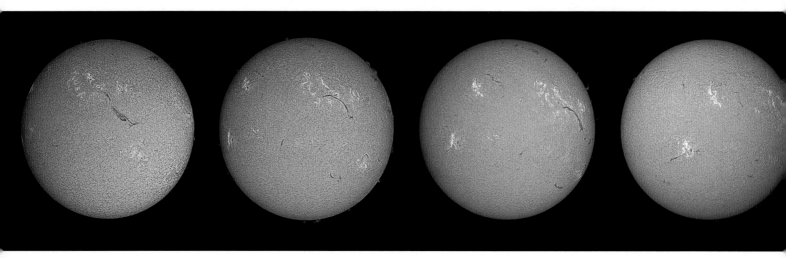

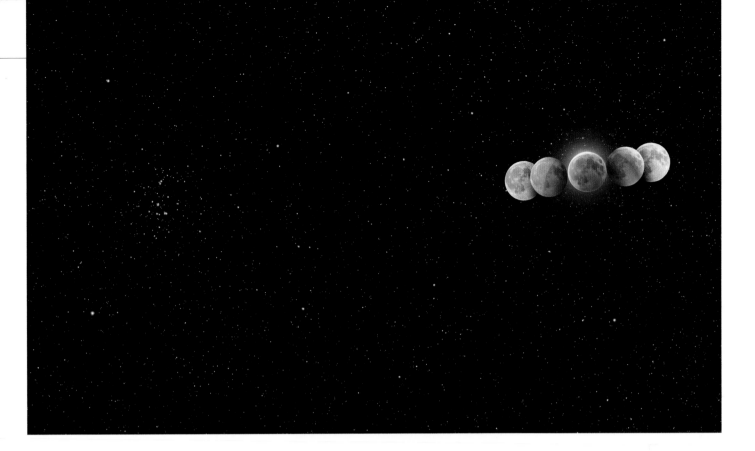

OBSERVING LUNAR AND SOLAR ECLIPSES

No celestial event sparks as much attention as does an eclipse, whether of the Sun or the Moon. (The two types of eclipses are illustrated in Chapter 4.) For many backyard astronomers, eclipses are the memorable milestones in a lifetime of observing the sky.

Adding them up over the centuries, partial and total solar eclipses taken together actually outnumber partial and total lunar eclipses by a factor of 3 to 2. Solar eclipses are more common. Yet in a lifetime of observing, you will see (and likely already have seen) many total lunar eclipses. But you will be fortunate to see a total solar eclipse once or twice, and even that achievement will take some effort.

The reason is that total eclipses of the Sun can be witnessed only along a narrow path on Earth, often crossing open ocean or remote regions of the globe. By contrast, total lunar eclipses can be seen over more than half the planet—from the entire nightside of Earth facing the full Moon on eclipse night.

ECLIPSES OF THE MOON

A lunar eclipse occurs only when the Moon's orbit, which is tilted five degrees off the eclip-tic, takes the Moon across the ecliptic at full phase, placing the Moon exactly opposite the Sun. The Moon then travels through at least some portion of the Earth's shadow.

Each year contains at least two and up to five lunar eclipses, though in the latter case, most are minor penumbral eclipses. Each year also has a minimum of two solar eclipses, always paired with a lunar eclipse two weeks earlier or later, but there can be as many as five solar eclipses in a calendar year. In that rare case, most are only partial eclipses.

Penumbral lunar eclipses occur when the Moon passes through the light outer portion of the Earth's shadow, the penumbra. An observer standing on the Moon would see a partial eclipse of the Sun by Earth. Penumbral eclipses are largely undetectable to the eye.

Only when the Moon enters the Earth's inner umbral shadow do we see an obvious dark bite taken out of the disk of the full Moon. Some umbral lunar eclipses are partial, with a portion of the lunar disk remaining brightly lit. However, for partials greater than about 70 percent, the hallmark feature of a

THROUGH THE SHADOW
This wide-field composite of the January 20, 2019, total lunar eclipse shows the Moon moving through the Earth's umbral shadow, which, at the distance of the Moon, is about three times the diameter of the Moon. For this eclipse, the Moon shone near the Beehive star cluster (at left).

ECLIPSE SEASONS
Eclipses of the Sun and the Moon usually come in pairs separated by six lunar cycles of 29.5 days each, giving us at least two "eclipse seasons" in every calendar year.

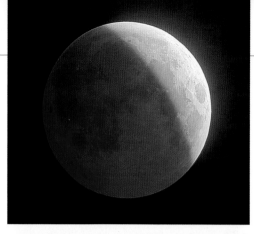

UMBRAL SHADING

During the partial phases of an umbral eclipse, the edge of the umbra can exhibit subtle color variations, such as blue tints caused by ozone high in the Earth's atmosphere absorbing red light and scattering blue light.

MOONSET ECLIPSE

Totality in twilight presents a beautiful contrast of the red Moon in a blue sky in this image taken on the morning of December 10, 2011.

LUNAR-ECLIPSE SEQUENCE

Totality lasted for only a few minutes on April 4, 2015, as the Moon skimmed across the northern edge of the Earth's umbra. From Monument Valley, Utah, totality occurred just before sunrise.

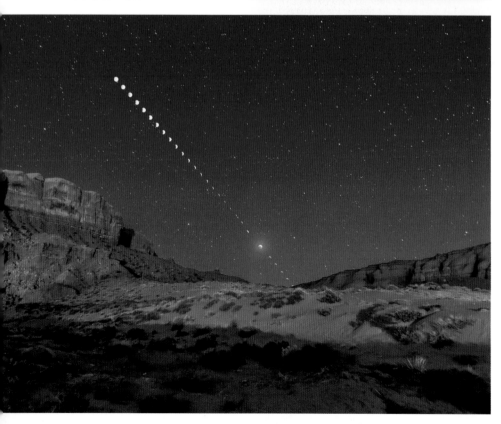

lunar eclipse begins to appear—the reddening of the eclipsed Moon.

The part of the Moon within the umbra sees a total eclipse of the Sun by Earth. The only light reaching that part of the Moon is sunlight that has passed through and been filtered by the Earth's atmosphere, and that's mostly red light. The totally eclipsed Moon turns deep red. How dark the Moon appears varies with how much cloud and high-altitude haze, often from volcanoes, are in our atmosphere. The Danjon scale rates a lunar eclipse from $L = 0$ (dark, almost invisible) to $L = 4$ (bright copper-red).

During a total lunar eclipse, the entire disk of the full Moon enters the umbra for as little as four minutes (for the April 4, 2015, eclipse) to as long as 104 minutes (for the July 27, 2018, eclipse, the longest of the 21st century).

If a lunar eclipse occurs in the middle of the night for your location, the Moon is high in the sky and you will see the entire eclipse, from the onset of the partial phase, through totality, to the end of the partial phase. Under these circumstances, try to view the event from a dark site. You will see the night transition from a bright moonlit sky to a dark, nearly moonless sky. The Milky Way (if it isn't a spring eclipse) will appear during totality, then fade away as the bright full Moon returns.

However, the timing is often such that the Moon rises or sets with some portion of the eclipse in progress, perhaps even the total phase. While you miss part of the event, you have the chance to see the eclipsed Moon low on the horizon, a potentially more photogenic sight than when the Moon is high in the sky.

Remember, a lunar eclipse occurs only when the Moon is exactly opposite the Sun, so an eclipsed Moon either rises as the Sun sets or sets as the Sun rises, with you in the middle of the celestial alignment.

ECLIPSES OF THE SUN

As dramatic as a total lunar eclipse can be, it pales in comparison to a total solar eclipse. But lifelong amateur astronomers who haven't experienced one often justify their unwillingness to travel to view the event by dismissing the sight as no different than seeing it get dark on any clear evening. No. A total solar eclipse

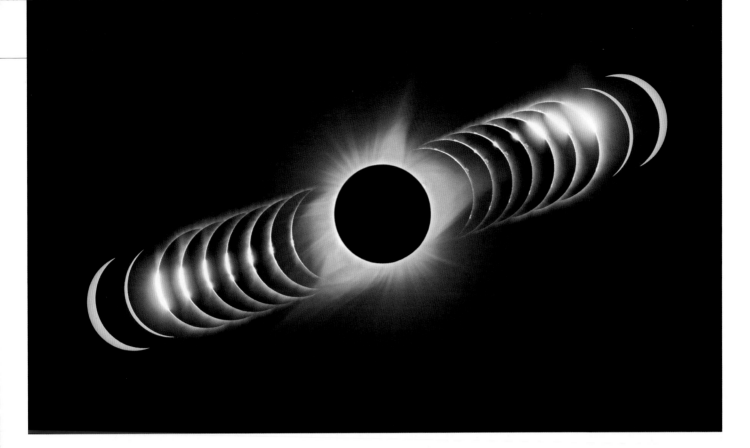

is the most powerful and moving sight you will ever witness in nature. It can bring even hardened observers and veteran "umbraphiles" to tears.

The fact that the disk of the Moon appears about the same size as the disk of the Sun in our earthly sky is one of the greatest cosmic coincidences. And in about 600 million years, this will no longer be the case, as the retreating Moon will be far enough away from Earth that its disk will no longer completely cover the Sun with the frequency it does now. We live in a special place and time.

Total solar eclipses (TSEs) inspire thousands of people—eclipse chasers—to travel around the world to stand in the shadow of the Moon. Most TSEs are remote events, requiring planning and the resources of a tour company to get you to exactly the right place at the right time.

However, on August 21, 2017, tens of millions of people in North America drove to the eclipse path that swept across the United States, jamming highways and making it possibly the most widely observed total solar eclipse in history.

The TSE of April 8, 2024, will be an encore performance, as the path of totality sweeps over Mazatlán, Mexico; Austin; Dallas-Fort Worth; Little Rock; Indianapolis; Cleveland; Buffalo; Montreal; and Fredericton, New Brunswick; and it just misses many other major North American cities. You want to be in the path. You really do!

See greatamericaneclipse.com for detailed maps of TSEs. For eclipse weather predictions, see meteorologist Jay Anderson's site at eclipsophile.com.

If you miss 2024—or you see it and want to relive the experience—then get to Spain in 2026, Egypt in 2027 (totality passes over Luxor!) or Australia in both 2028 and 2030.

A popular misconception (or rationalization for not traveling to the path of totality) is that a 90+ percent partial eclipse of the Sun provides 90+ percent of the experience of a total eclipse. Again, no! It is 10 percent of the experience. Only during a total eclipse do you witness the sudden drop in light level (in a matter of seconds) from an eerie bright twilight to darkness, with planets and bright stars visible above a horizon rimmed with an orange "sunset" glow all around you. The Sun's atmosphere, the corona, shines with an uncanny metallic light and shows intricate tracery and loops from twisting magnetic fields.

A total solar eclipse is not something you just see; it is something you feel and hear. It gets colder, and birds and animals grow quiet, responding to the fall of night at midday. The

SOLAR-ECLIPSE SEQUENCE

As the Moon covers the Sun (at left in this composite), the last bits of sunlight shining through lunar craters and valleys create the diamond ring effect and fleeting bright Baily's Beads. The start of totality is called second contact. The reverse happens as totality ends at third contact. Note the large pink prominence on the limb. The Sun's delicate corona appears only during the brief minutes or seconds of totality. You will not see it from sites outside the total-eclipse path. This was the total solar eclipse of August 21, 2017, shot from Idaho.

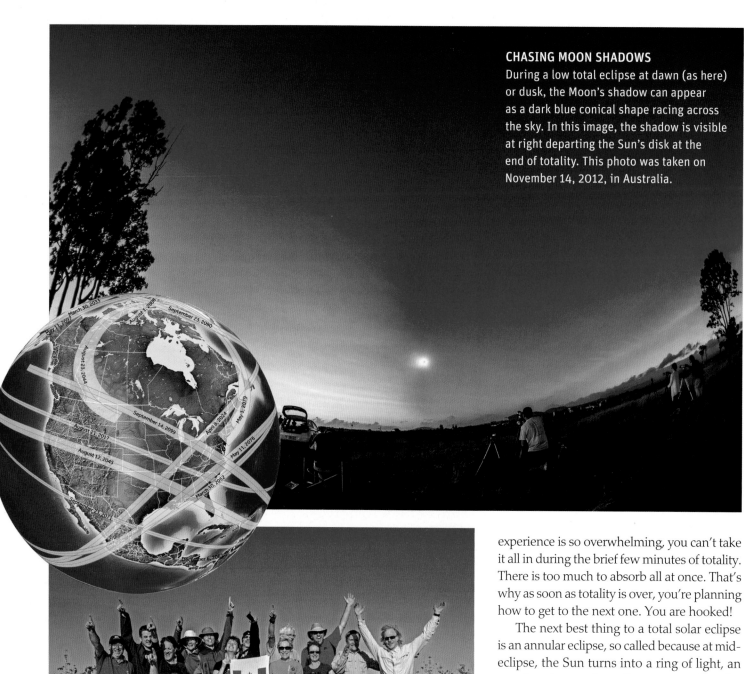

CHASING MOON SHADOWS
During a low total eclipse at dawn (as here) or dusk, the Moon's shadow can appear as a dark blue conical shape racing across the sky. In this image, the shadow is visible at right departing the Sun's disk at the end of totality. This photo was taken on November 14, 2012, in Australia.

HAPPY CHASERS
Happiness is a successful eclipse chase to the far side of the world. These Canadian chasers celebrate the Australian 2012 total solar eclipse under perfect skies.
Inset: A chart courtesy greatamericaneclipse.com plots the paths of all total solar eclipses across North America in the 21st century. Plan your life now!

experience is so overwhelming, you can't take it all in during the brief few minutes of totality. There is too much to absorb all at once. That's why as soon as totality is over, you're planning how to get to the next one. You are hooked!

The next best thing to a total solar eclipse is an annular eclipse, so called because at mid-eclipse, the Sun turns into a ring of light, an annulus. An annular eclipse occurs when the Moon is near the point in its orbit farthest from Earth—apogee—so its disk is not quite large enough to cover the disk of the Sun completely. During a rare hybrid eclipse (such as on April 20, 2023), the Moon appears large enough to just cover the Sun, but only in the middle of the path, where it is noon; at the ends of the path, toward sunrise and sunset, the eclipse is annular.

The annular eclipse across the U.S. on October 14, 2023, will be a fine warm-up and dress rehearsal to the big event six lunar months later.

TOTAL (AND NEAR-TOTAL) LUNAR ECLIPSES 2021-2030

YEAR	DATE	TOTALITY*	LOCATION
2021	May 26	15 m	Australia, Pacific, North America
2021	November 19	—	Deep 97% partial eclipse from Asia and Americas
2022	May 16	85 m	North and South America, western Europe
2022	November 8	85 m	Asia, Australia, North and South America
2025	March 14	65 m	North and South America
2025	September 7	82 m	Europe, Africa, Asia, Australia
2026	March 3	58 m	Asia, Australia, North and South America
2026	August 28	—	Deep 93% partial eclipse from Americas, Europe, Africa
2028	December 31	71 m	Europe, Africa, Asia, Australia, northwestern North America
2029	June 26	102 m	North and South America, Europe, Africa
2029	December 29	54 m	Eastern North and South America, Europe, Africa, Asia

*(m = minutes)

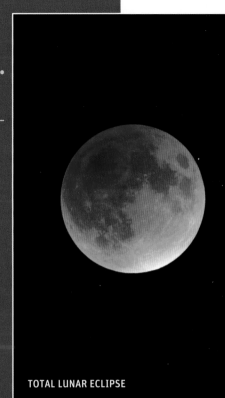

TOTAL LUNAR ECLIPSE

CENTRAL SOLAR ECLIPSES 2021-2030

YEAR	DATE	TYPE*	LOCATION
2021	June 10	A	Northern Ontario and Quebec and Nunavut, in Canada
2021	December 14	T	Antarctica
2023	April 20	H	Western Australia, Indonesia, Papua New Guinea
2023	October 14	A	Western U.S., Mexico, Central and South America
2024	April 8	T	Mexico, central and eastern U.S., eastern Canada
2024	October 2	A	South Pacific, southern Chile and Argentina
2026	February 17	A	Antarctica
2026	August 12	T	Greenland, Iceland, Portugal, Spain
2027	February 6	A	Southern Chile and Argentina, Atlantic
2027	August 2	T	Spain, North Africa, including Egypt, Saudi Arabia
2028	January 26	A	Northern South America, Portugal, Spain
2028	July 22	T	Australia, South Island of New Zealand
2030	June 1	A	North Africa, Greece, Turkey, Russia, China, Japan
2030	November 25	T	Southern Africa, Indian Ocean, southern Australia

*ANNULAR (A), TOTAL (T), HYBRID (H)—collectively called "central" solar eclipses

For maps and details on these and other eclipses, such as partials, see Fred Espenak's website at eclipsewise.com/eclipse.html

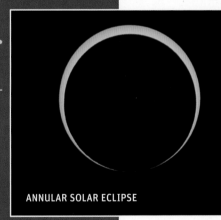

ANNULAR SOLAR ECLIPSE

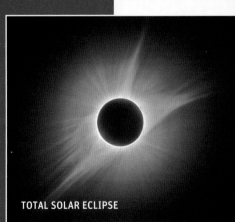

TOTAL SOLAR ECLIPSE

CHAPTER 13

Moon Tours for Telescopes

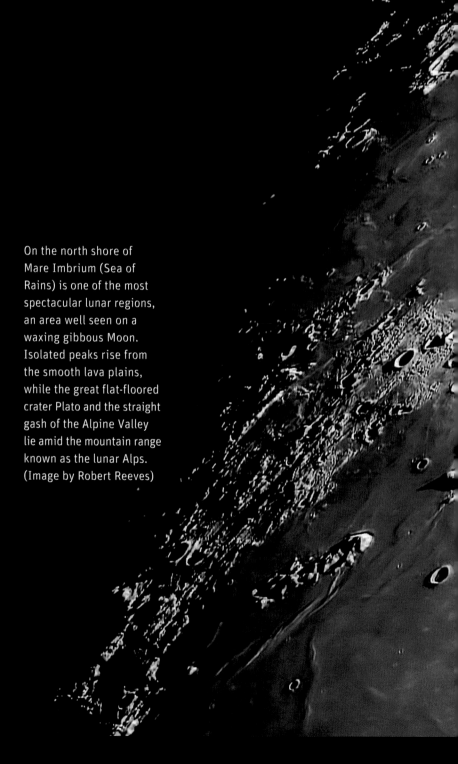

No other object in the sky presents as much detail as does the Moon —so much, in fact, that the view can be overwhelming. To get you started in your lunar exploration, we provide a sampler set of curated tours, as we did with the binocular sky in Chapter 6 and will do with the telescopic deep sky in Chapter 16.

We've enlisted our cohort Ken Hewitt-White to prepare the tours, each suitable for a small telescope. Along the way, however, we encounter some challenging features that will require a larger scope and excellent seeing conditions.

The tours step you along the terminator of a waxing Moon over two weeks and focus on representative examples of the kinds of features we discussed in Chapter 12. You'll visit seas, mountains, wrinkle ridges, rilles, rays, scarps, domes and, of course, craters of all types and sizes.

So no need to wait for the next Moon-landing mission to become more familiar with our nearest celestial neighbor. Get your telescope out and start exploring the Moon on the next moonlit night.

On the north shore of Mare Imbrium (Sea of Rains) is one of the most spectacular lunar regions, an area well seen on a waxing gibbous Moon. Isolated peaks rise from the smooth lava plains, while the great flat-floored crater Plato and the straight gash of the Alpine Valley lie amid the mountain range known as the lunar Alps. (Image by Robert Reeves)

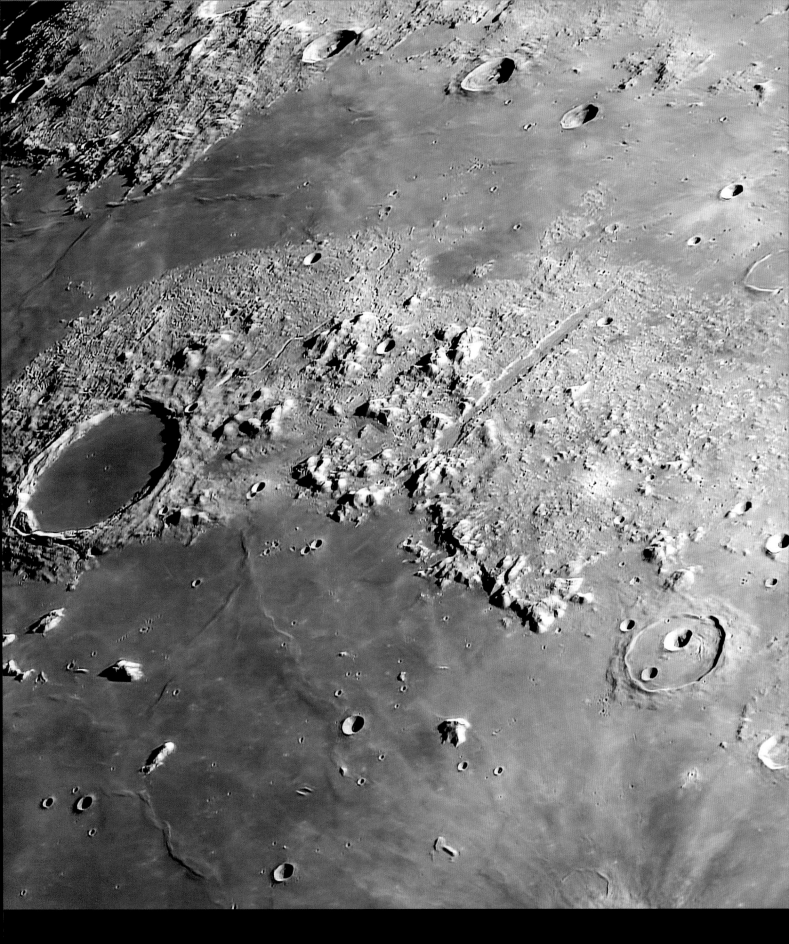

AIMING AT THE MOON
Moon gazing doesn't need dark skies or even night skies. The first-quarter Moon is a good target for an evening session in the twilight with any telescope or binoculars.

LUNAR LIBRARY

Robert A. Garfinkle's *Luna Incognita* is a massive three-volume encyclopedia. The *21st Century Atlas of the Moon* by Charles A. Wood and Maurice J. S. Collins is essential. Wood's earlier *The Modern Moon* and accompanying *Atlas of the Moon* by Antonín Rükl are out of print but are prized by lunaphiles.

OUR SAMPLE MOON TOURS
BY KEN HEWITT-WHITE

Welcome to the Moon! In the previous chapter, Alan and Terence commented that after the Apollo Moon missions, backyard astronomers began neglecting our nearest neighbor in space. Over the following decades, amateur astronomy increasingly featured larger telescopes deployed under moonless country skies. Our unloved Luna became *persona non grata* among deep sky observers.

I know, because I was one of them. Oh, I'd occasionally scan a waxing Moon, but aside from the main craters and mares, I rarely knew what I was looking at. I wasn't truly exploring.

That changed when I finally realized the incredible wealth of telescopic detail the Moon has to offer. I began to appreciate the number of lunar wonders I could examine in a span of sky only half a degree in diameter, the Moon's angular size. Moreover, those superb views are possible from my own backyard, using any telescope I choose. And since the lighting of the lunar surface is always changing, the scenery is subtly different each time I look.

I still observe the deep sky (for proof, see Chapter 16), but my interest in the Moon has grown a lot in recent years. I'd like to share some of my lunar explorations with you.

TWELVE TIDY TOURS

My dozen one-page Moon tours don't add up to a comprehensive atlas; they simply represent some of my favorite lunar hunting grounds. The tours are arranged chronologically, according to the time after new Moon when the terminator—the longitudinal demarcation between light and shadow—is closest to the tour region. Most lunar features look best when near the terminator.

The details I describe may or may not precisely match what you see in your telescope—it will depend on the exact hour of your observation. The conditions are forgiving; my descriptions are valid for many hours beyond the cited times, sometimes even a day

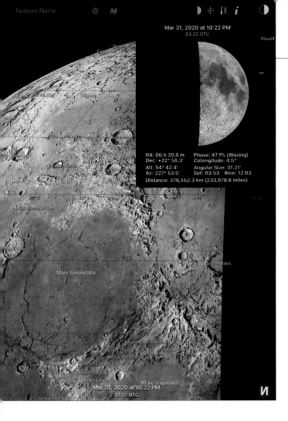

MOON APPS
Mobile apps on a tablet, such as Moon Atlas, above, and Moon Globe, can flip their charts mirror-image, as here, to match the view through a telescope with a star diagonal, making it easier to identify features.

or two. For example, I describe Mare Crisium as it appears three days after new Moon, but it looks almost as good a night or two later.

Where appropriate, I provide formal and English names (Mare Imbrium = Sea of Rains), plus the dimensions of maria, craters, rilles, faults, valleys and mountains. (You'll find a summary of lunar geology in Chapter 12.) As you explore, consider how the lunar sights you see compare in size with the terrestrial ones around you, such as your town, a nearby river or a surrounding valley. The crater Tycho, for example, could easily swallow up New York City, Toronto or Greater London, England.

When reading my location directions, note that east and west on the Moon are the *opposite* of sky directions. Our labeled Moon photos, all taken by expert astrophotographer Robert Reeves, are oriented with east on the right, west on the left and north up, as per most Moon atlases. However, bear in mind that Newtonian reflectors provide eyepiece views that are upside down, while refractors and Cassegrain reflectors with star diagonals present mirror-reversed views (see page 211).

If you enjoy these Moon tours, you'll likely benefit from books and apps dedicated to lunar observing. Some recommended resources are highlighted on these pages. More are listed in the Appendix. By the way, most of our tour images reveal considerably more than what I describe. As you become adept at observing the Moon, these images might inspire you to explore the selected regions more deeply.

LET'S EXPLORE
Time for some small-scope moonwalks. You will be impressed at how much detail modest optics can show. I worked up these tours using my 4¼-inch f/6 Newtonian reflector at between 50x and 200x. Pushing my little scope to 150x or 200x wasn't an extreme measure, provided the Moon was reasonably high and the atmosphere steady. Indeed, high magnification helped dull the glare of what was sometimes a brilliant orb. I didn't use any lunar filters (see Chapter 12), but they can be helpful.

Most of my observations were conducted during "prime time" evening hours. However, I also describe how some regions appear late at night at a waning phase, after full Moon, when the Sun is lighting features from the opposite direction. Regardless, you don't have to follow these tours in the order I present them—each one is designed to stand alone. If the sky is clear and the Moon is visible, simply turn to the tour that works best for that particular lunar phase.

Have fun and happy Moon touring!

ON-LINE MOON
For a superb interactive Moon map that uses imagery from NASA's Lunar Reconnaissance Orbiter probe, go to quickmap.lroc.asu.edu. This image zooms in to the area of the Apollo 11 landing site.

MOON MAPS
Laminated lunar maps from Orion Telescopes and *Sky & Telescope* magazine are handy for use at the telescope.

THE 3-DAY-OLD CRESCENT MOON

TOUR 1 FIRST MARE OF THE MOON

The first easily recognizable lunar feature to appear after new Moon is **Mare Crisium** (Sea of Crises). The mare slowly emerges as the Moon turns 2 days old, and it's all there on a 3½-day-old crescent.

Because it's located near the eastern limb, we see Crisium foreshortened by an amount that depends on lunar libration, as illustrated in Chapter 12. At an unfavorable libration, Crisium tips closer to the limb and seems strongly elongated north-south. At a favorable libration, it's tipped toward us and looks more circular. In truth, Crisium is elliptical—it measures 620 by 570 kilometers—but its major axis actually runs east-west.

Crisium's eastern rim is very uneven. For proof, slap on the power and observe the wedgelike cape known as **Promontorium Agarum**. The opposite rim draws our attention for a different reason. Occasionally, we see the terminator cutting across western Crisium, leaving that part of the mare's floor in shadow. However, the mountainous western rim is illuminated. Curving beyond the terminator, the mountain peaks seem to float in empty space.

Once the mare is fully visible, I can trace some wrinkly ridges, called dorsa, at 100x. **Dorsa Tetyaev** and **Dorsa Harker** lie on the eastern side, while **Dorsum Oppel** arcs along the floor's western edge. Close to Oppel are the still shadowed craters **Peirce** (18 kilometers) and **Swift** (12 kilometers). Southwest of center, a bigger "black hole" is 23-kilometer-wide **Picard**. Near Picard, beside Crisium's western wall, are the lava-flooded craters **Yerkes** and **Lick**. Both craters are bigger than Picard but tricky to spot. **Greaves** (14 kilometers) sits on Lick's north edge.

Some of these details get scrunched during an unfavorable libration. Even so, Crisium remains interesting until the shadows recede. Those shadows return after full Moon, as the terminator marches across the mare's eastern rim. The image here captures Crisium about two days after full, at a 16-day-old waning gibbous Moon.

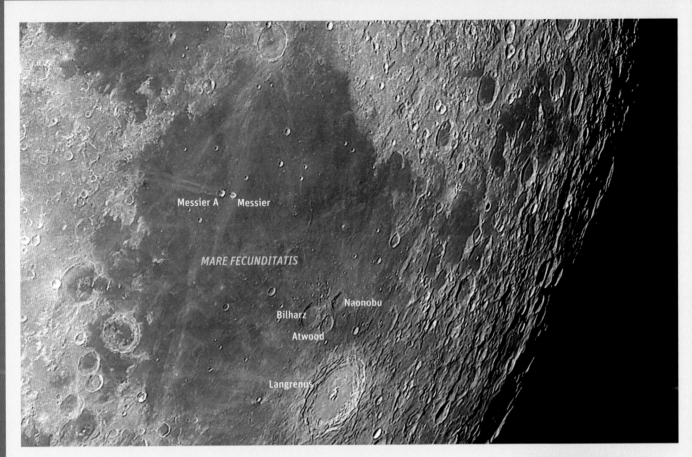

Messier A Messier

MARE FECUNDITATIS

Naonobu

Bilharz

Atwood

Langrenus

THE 4-DAY-OLD CRESCENT MOON

TOUR 2 COMET CRATERS

The side-by-side craters **Messier** and **Messier A** honor 18th-century French comet hunter Charles Messier. Appropriately, two long rays issuing from one of the craters are reminiscent of a comet sporting a two-part tail. The comet craters are located within **Mare Fecunditatis** (Sea of Fertility), which lies adjacent to smaller Mare Crisium (see Tour 1). The "comet" becomes visible as the Moon turns 4 days old.

These relatively youthful craters aren't identical. Inspecting them at 100x, I can tell that Messier, 12 by 9 kilometers in extent, is elongated east-west. Messier A is slightly larger (13 by 11 kilometers) and less obviously oval—and it's the source of the twin rays stretching to the western edge of Fecunditatis.

The rays comprise light-colored material that was sprayed out during the crater-forming crash. Astronomers believe both craters were created by a single incoming projectile. It struck at a low angle from the east, gouging out one highly elongated hole (Messier), then bouncing to make a second

oblong excavation (Messier A) and the rays. Ballistics experiments have proven that low-angle impacts produce elliptical craters.

In addition to the "comet," I can't help noticing **Langrenus**, a 133-kilometer-wide crater on the eastern shore of Mare Fecunditatis. Like Mare Crisium, Langrenus is strongly foreshortened and changes its appearance under different librations. Langrenus is graced with a massive central peak and terraced interior; however, its Earth-facing eastern wall is shadowed during this early crescent phase. Soon after full Moon (when this photo was taken), the eastern side is illuminated in spectacular fashion.

Finally, next to Langrenus on the Fecunditatis floor, are **Bilharz**, **Atwood** and **Naonobu**. Ranging from 30 to 43 kilometers across, these craters form a compact triangle. On a young Moon, they're a stark, dark triplet of "black holes."

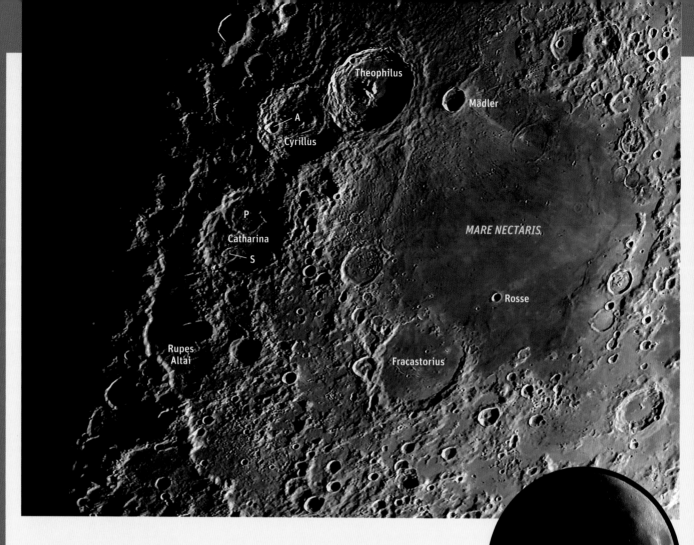

Theophilus

Mädler

A

Cyrillus

P

Catharina

S

MARE NECTARIS,

Rosse

Rupes Altai

Fracastorius

THE 6-DAY-OLD CRESCENT MOON

TOUR 3 PERFECT SEA AND FAULTY TERRAIN

All is calm on **Mare Nectaris** (Sea of Nectar), a smooth expanse nearly 350 kilometers in diameter. Curiously, the adjoining 124-kilometer-wide crater **Fracastorius** exhibits the same flat floor. Long ago, lavas in the Nectaris Basin welled up, breached Fracastorius's low-lying northern rim and flooded the crater. Visible to the north, in the Nectaris "sea," is a solitary "island" called **Rosse**. And on the mare's northwestern shore is **Mädler**, 28 kilometers in diameter.

From Mädler, we hop to three giant craters, each about 100 kilometers across, arranged in a north-south row. Best of the bunch is **Theophilus**, whose striking rim rises high above the crater's floor. Theophilus boasts a towering central peak of notable complexity. The tightly clustered multiple summits are enticing at 150x.

Theophilus partially overlaps older **Cyrillus** to the southwest. Cyrillus is severely degraded yet still rewards us with a well-spaced double central peak. On its uneven floor, southwest of center, is 17-kilometer-wide **Cyrillus A**.

Farther southward, past a rumpled highland, is low-profile **Catharina**. An examination of Catharina's floor reveals two semiflooded siblings: little **Catharina S** at the south end and larger **Catharina P**, which obliterates Catharina's crumbling northern rim.

Running east and south of Catharina is the 480-kilometer-long **Rupes Altai**, or Altai Scarp. This crescent-shaped lunar fault is the southwest portion of the main rim of the battered Nectaris Basin. The lunar surface east of the scarp is about 1,000 meters lower than the ground west of the scarp. Before first quarter, the sunlit Rupes Altai materializes as a bright, ragged curve, as shown here. Four days after full Moon, the escarpment becomes a dark arc as it casts a shadow onto the Nectarian lowlands.

Also appealingly accented again after full Moon are Mare Nectaris and our three giant craters. This whole area is well worth a late-night look on a waning gibbous Moon.

THE 7-DAY-OLD QUARTER MOON

TOUR 4 FINELY ETCHED LINES

As the Moon surpasses age 7.0 days, a flat region at the center of the lunar disk becomes visible. This moony midpoint is **Sinus Medii** (Central Bay), an elongated plain about 350 kilometers in length oriented northeast-southwest, just south of roundish **Mare Vaporum** (Sea of Vapors). The nonflat parts of Sinus Medii are worth careful inspection.

Spanning the northeast end of Sinus Medii is 220-kilometer-long **Rima Hyginus**, or Hyginus Rille. At low magnification, Rima Hyginus appears as a white line bent in the middle. A dimple dents the rille. Upping to 100x reveals that the dimple is located slightly east of the bend. It's the 10-kilometer-wide crater **Hyginus**. Rather than impact-related, Hyginus is of volcanic origin. Lining the inside of the rille, like peas in a pod, are numerous craterlets that are probably volcanic pits. I need at least 150x to pick up a few of those "peas."

Southwest of Hyginus, near the center of Sinus Medii, is **Triesnecker**, a steep-walled impact crater 27 kilometers in diameter. At this lunar phase, Triesnecker is a puddle of blackness, as shown here. A cluster of central peaks starts poking out of the shadows later. Meanwhile, the area around the crater deserves high-power scrutiny.

A spidery network of narrow channels called the **Rimae Triesnecker** stretches from southeast of Triesnecker northward almost to Hyginus, 200 kilometers away. The two or three thickest rilles are visible in my 4¼-inch scope at 175x or more. Of course, bigger scopes show more lines. Most of the rilles are still traceable on an 8-day-old Moon, though the finer lines disappear soon after. Indeed, essentially all these rilles are hairline-thin; none are more than 1.5 kilometers in width.

The rilles will challenge you. Several factors dictate whether you will be able to detect them: location of the terminator, telescope size, magnification, atmospheric seeing—and patience.

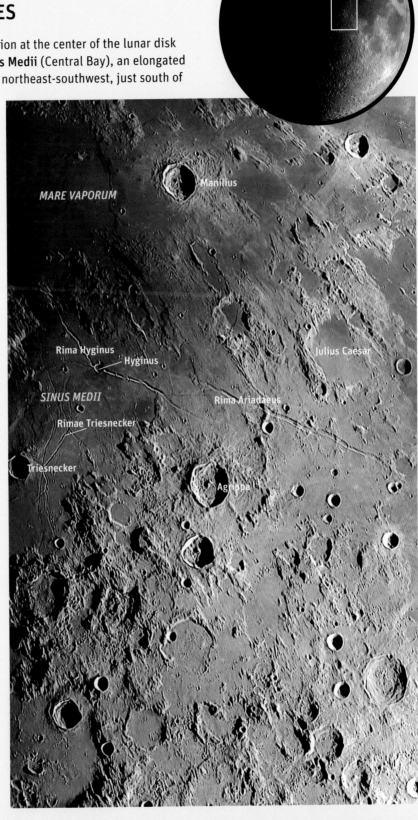

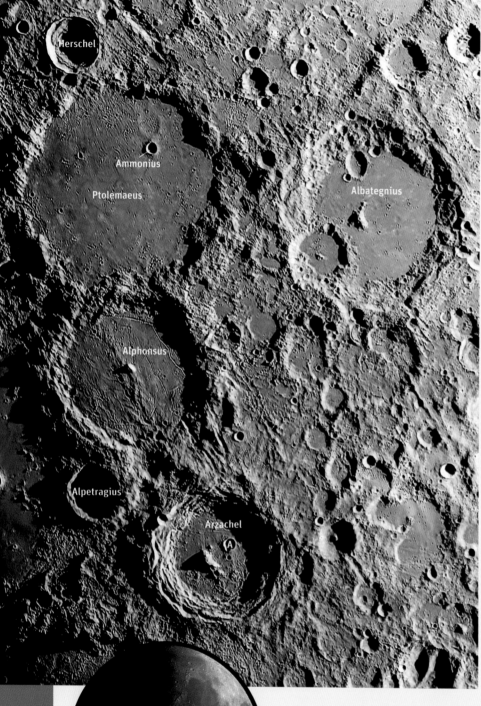

TOUR 5
DRAMATIC TRIO

Waxing through its 8th and 9th days, the Moon offers so many arresting sights, I've had to prepare four tours over two nights. We lead off with a dramatic trio of craters reminiscent of the group we saw in Tour 3: three-in-a-row monsters, north-south orientation and attention-grabbing at any magnification.

The most impressive specimen is **Ptolemaeus**, because it's so expansive, flat and smooth. It measures 154 kilometers from side to side but lacks a central peak. In this rugged region, Ptolemaeus exudes a placid, lakelike quality. At 100x, I can see nine-kilometer-wide **Ammonius** in the northeastern part of the crater.

Ptolemaeus is attended immediately northward by a relatively youthful friend named **Herschel**. Fully 41 kilometers in diameter, Herschel possesses steep, terraced walls and a sharp peak that's oddly off-center. These details are shadowed at first; however, the crater's appeal increases by the hour as the Sun rises over the crater walls.

Adjoining Ptolemaeus's southern rim is monster number two: **Alphonsus**. Outlined by a mountainous ring, Alphonsus is 118 kilometers across. This is another smoothy, except a pointed central peak interrupts its flat floor. In the photo here, the peak resembles an upright missile!

Hopping southward along a ridge of bumpy ground brings us to the third monster, **Arzachel**, 98 kilometers wide. Its high walls have multiple terraces. East of the prominent central peak is **Arzachel A**, a 10-kilometer-wide dent easily seen at 100x.

Just west of the rough ridge that runs between Alphonsus and Arzachel is a crater with the mouth-mangling moniker of **Alpetragius**. This fairly deep excavation (the size of Herschel and still in shadow in this image) has a major rounded central hump that shows well at high power.

After this dramatic trio, a gentle nudge of the telescope to the lunar southwest brings us to the amazing focal point of our next tour.

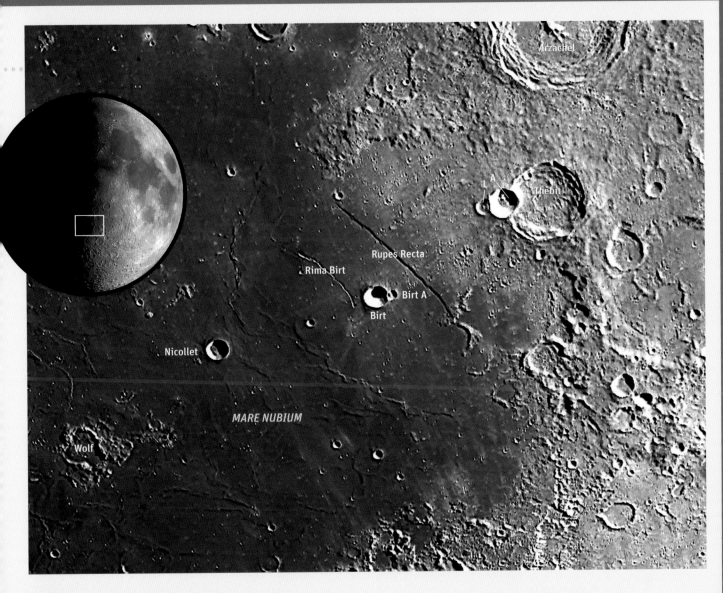

The image shows labels: Arzachel, L, A, Thebit, Rupes Recta, Rima Birt, Birt A, Birt, Nicollet, MARE NUBIUM, Wolf

TOUR 6 THE STRAIGHT GOODS

"Wow!" After a lifetime of backyard observing, my reaction is always the same when my telescope picks up the famous Straight Wall (officially **Rupes Recta**).

Located on the eastern shore of **Mare Nubium** (Sea of Clouds), the 110-kilometer-long Straight Wall is a classic surface fault that drops the mare's surface by several hundred meters. The Altai Scarp (see Tour 3) is higher and longer yet doesn't cut the same pristine line as the Straight Wall. Viewed soon after first quarter, the wall casts a well-defined shadow over the sunken surface to the west.

As the lunar terminator inches westward from day 8 to day 9, the terrain immediately west of the Straight Wall becomes illuminated. Here, we find 17-kilometer-wide **Birt**, a sharp-rimmed crater that's shadow-filled. On Birt's eastern flank, facing the wall, is a 6.8-kilometer divot called **Birt A**. Both Birts show in my reflector at 100x. Northwest of Birt is

your challenge of the day: a razor-thin rille called **Rima Birt** running roughly parallel to Rupes Recta.

Between the Straight Wall and Arzachel (see Tour 5) is **Thebit**, 58 kilometers in extent. Thebit is actually *three* overlapping craters of different sizes. A 20-kilometer-wide companion named **Thebit A** overlies Thebit's west rim, and Thebit A, in turn, contacts **Thebit L** (12 kilometers). Each successively smaller member of the Thebit family leads toward the Straight Wall. I can nab Thebit A at 75x; Thebit L sometimes needs 100x or more.

The shadow cast by the Straight Wall can appear even more stark than what the above image (taken later) suggests. While the wall's dark edge makes it look like a vertical cliff, it is, in reality, a gentle slope. By the way, just after last quarter, when Mare Nubium is lit by a setting Sun, the Straight Wall becomes a bright streak—and seems just as clifflike.

THE 9-DAY-OLD GIBBOUS MOON

TOUR 7 INCREDIBLE IMBRIUM

Mare Imbrium (Sea of Rains) spans a whopping 1,250 kilometers; its sprawling eastern half is ready for exploring 8½ to 9 days after new Moon.

Eastern Imbrium is outlined by three curving mountain ranges: **Montes Alpes**, **Montes Caucasus** and **Montes Apenninus**. The latter are immense. Very steep on their mare-facing side, the Apennines top out at approximately 5,000 meters. By contrast, an impressively deep feature is the 130-kilometer-long **Vallis Alpes** (Alpine Valley), which cuts through the Alp mountains.

Imbrium's major craters display obvious differences in my scope at 100x. At the western terminus of the Apennines, **Eratosthenes**, 60 kilometers in diameter, has terraced interior walls, a complex central peak and an apron of debris. At the far end of the Alps, 101-kilometer-wide **Plato** is filled with solid lava. Plato's surface is dinner-plate smooth. The lava plain is pitted by only a few craterlets big enough to show in backyard telescopes. They're visible in the image of Plato at the beginning of this chapter. I love the saw-toothed shadows cast by Plato's hilly eastern rim. The most northerly crater in my tours, circular Plato always looks elliptical due to foreshortening.

The Imbrium plain is a treasure trove of wrinkles, isolated peaks and partially flooded craters. Look for **Cassini**, whose rim, 58 kilometers edge to edge, barely noses above the Imbrium "sea." Cassini encloses two deep holes, **Cassini A** and **B**.

South of Cassini, we find the huge triangle of **Aristillus** (55 kilometers), **Autolycus** (40 kilometers) and **Archimedes** (83 kilometers). Aristillus exhibits three central peaks. Autolycus has a roughed-up floor, while Archimedes is steep-walled and exceptionally flat.

Pushing to 150x and nudging southwestward past an irregular jumble of lumps called **Montes Archimedes**, I pass 13-kilometer-wide **Bancroft**, then smaller **Beer** and **Feuillée** to **Timocharis**, a 35-kilometer-wide crater surrounded by a messy ejecta apron. Inside, a single craterlet is located exactly where the central peak should be!

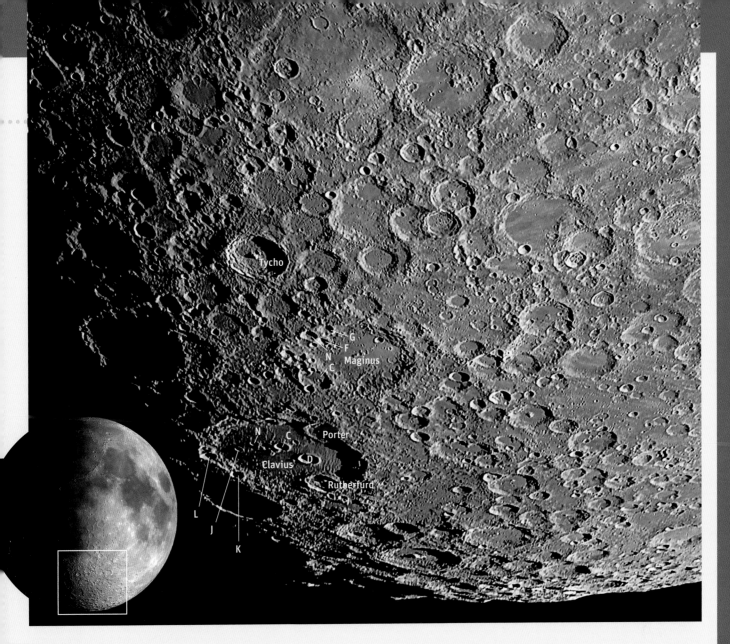

Tycho

G
F
N
C — Maginus

N C Porter
Clavius D
Rutherfurd

L
J
K

TOUR 8 SOUTHERN WONDERS

The crater-crowded neighborhood in the Moon's southern highlands is pure chaos. Packed in here are three well-known impact sites—if you can find them.

Famous **Tycho**, a high-walled beauty 85 kilometers wide, is surprisingly hard to identify amid the crater carnage. As the Moon reaches its 9th day, Tycho's rim is sharp but its eastern wall darkens the floor partway to the central peak. The peak, in turn, casts a shadow toward the terraced western wall. During this Moon phase, I can usually trace a few rays emanating from Tycho (they're faintly visible in the above image). Tycho's complete ray system awaits us on our final tour.

Southeast of Tycho is **Maginus**. This crumbling crater is 160 to 190 kilometers across, depending on how you measure its pulverized extremities. Maginus is an essentially flat-bottomed formation; its battered west end is what catches my eye. On the northwestern part of the beat-up rim is a

triangle of little craters itemized as **Maginus G, F** and **N**. Directly south of them is 42-kilometer-wide **Maginus C**.

To the southwest lies **Clavius**, which, at 225 kilometers, is one gigantic crash zone. In our photo, Clavius looks strongly elliptical due to the foreshortening caused by its proximity to the southern lunar limb. (During a favorable southern libration, Clavius is better positioned for inspection.) Several craters overlap Clavius. **Porter** (53 kilometers) straddles the north rim, while **Rutherfurd** (55 kilometers) does likewise on the south edge. The west and southwest portions of the rim are pocked by **Clavius L** (24 kilometers) and **K** (20 kilometers).

Clavius's elongated interior is decorated with a crescent of craters that's an engaging sight in my scope at 150x. Including Rutherfurd, I can spot five successively smaller, semishadowed holes named **Clavius D, C, N** and **J**. The whole set is gorgeous again at last-quarter phase.

THE 10-DAY-OLD GIBBOUS MOON

TOUR 9 GREAT BIG HOLE IN THE GROUND

Copernicus is the king of craters. The result of an impact that occurred possibly only a billion years ago (fairly recent in lunar terms), the big hole is 93 kilometers in diameter and nearly 3,800 meters deep, and it hosts two lofty central peaks. Its mountainous rim, rising 900 meters above the barrens of **Mare Insularum** (Sea of Islands), is surrounded by a massive slosh of disgorged debris.

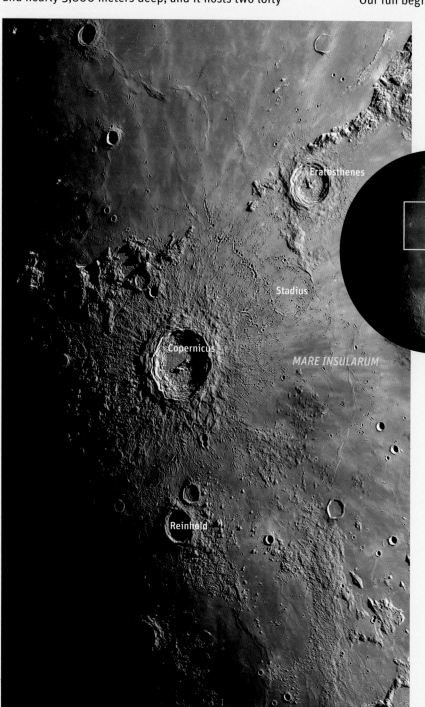

Our fun begins one night earlier (day 9) with an absorbing phenomenon: Copernican sunrise. Over a period of several hours, the crater's steep eastern rampart becomes illuminated, then the rim, then the two central summits. Nothing else shows. The illusion of a bottomless pit is amazing. (The effect plays out in reverse at Copernican sunset, a couple of nights after last quarter.)

As the Moon waxes into its 10th day, tiny ejecta features become apparent east of Copernicus, beyond its thick apron of excavated material. Look between Copernicus and **Eratosthenes** (introduced in Tour 7) for a string of Copernican craterlets that forms a sinuous path running north-south. In my reflector at 200x, I can trace the chain of pockmarks meandering around the west side of barely perceptible **Stadius**. This 70-kilometer-wide "ghost" crater is virtually full of Insularum lavas. Although the photo captures Stadius nicely, experienced lunar observers know the lighting has to be just right to detect it.

Many hours elapse before Copernicus's cavernous interior becomes completely visible—but it's worth the wait. By lunar age 10½ days, Copernicus is at its best. At 75x, I can admire the crater's rugged rim and finely terraced interior walls. Rising out of the bright white floor are the two peaks, plus a pinpoint—a small third peak—between them.

Copernicus also sprouts bright rays. I'll say more about them in Tour 12.

THE 11-DAY-OLD GIBBOUS MOON

TOUR 10
FUNNY HUMORUM

Only 380 kilometers in diameter, **Mare Humorum** (Sea of Moisture, not Sea of Laughter) is a relatively minor mare. Humble though it may be, Humorum is immensely interesting to explore in a telescope.

At Humorum's south end is 41-kilometer-wide **Vitello**, a flat-bottomed crater easily sighted at low power. West and a bit north of Vitello are a few partially submerged craters that, depending on the exact lighting, materialize in my scope at 100x. The two best are **Lee** (same size as Vitello) and **Doppelmayer**, at 65 kilometers across. Most of the northern half of Lee's rim is missing, while badly eroded Doppelmayer has a rumpled floor and big central mound. The northeastern portions of both craters are open to the Humorum "sea."

Humorum's western shore invites scrutiny because of **Rupes Liebig**, a fault running parallel to the mare's western edge. My scope picks up the scarp plus a craterlet, **Liebig F**, at its midpoint. The eastern shore is scarred by a set of parallel rilles called **Rimae Hippalus**. One rille arcs across the partially flooded, 58-kilometer-wide crater **Hippalus**. The southwest wall of Hippalus is submerged below the Humorum lavas.

An unnamed short, curved fault on Humorum's northwestern shore terminates at **Gassendi**. This distinctive crater, 110 kilometers in diameter, exhibits a well-defined rim, several central peaks and a broad floor etched by a maze of rilles named **Rimae Gassendi**. Under favorable lighting conditions and steady seeing, I can glimpse short rille segments along the southeastern part of the floor at 175x. **Gassendi A**, a substantive, 33-kilometer-wide crater, slightly overlaps its parent at the north end.

After observing Humorum and Gassendi on an 11½- or 12-day-old Moon, I shift my view northward, past showpiece crater Kepler (32 kilometers), with its terraced walls and a bright ray system, to a strange and exotic landscape—and our next tour.

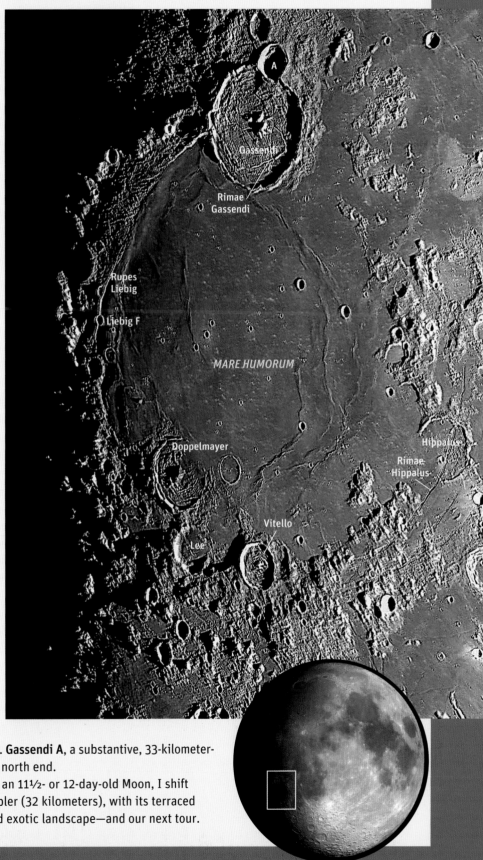

THE 12-DAY-OLD GIBBOUS MOON

Aristarchus
Plateau

Vallis
Schröteri

Aristarchus

Herodotus

OCEANUS PROCELLARUM

Marius Hills

Marius

Reiner
Gamma

Reiner

TOUR 11 STRANGE STUFF

In the vast space where **Oceanus Procellarum** (Ocean of Storms) and Mare Imbrium meet is the **Aristarchus Plateau**. This roughly rectangular formation involves a broad mountain, a deep valley and two dominant craters.

In my scope at 100x, 35-kilometer-wide **Herodotus** has a bright rim and a shallow, darkish interior. By contrast, slightly larger **Aristarchus** is deep and glaring. This lunar jewel gleams with an almost artificial brilliance, and it's a source of rays (see our final tour). Aristarchus exhibits both lateral terraces and vertical striations.

Equally noteworthy is **Vallis Schröteri** (Schröter's Valley). Once a conveyor of hot lavas, this enormous rille—up to 10 kilometers wide and 1,000 meters deep—originates at a volcanic vent north of Herodotus. That source, plus the swollen upper portion of Schröteri, has been dubbed the "Cobra Head." The valley snakes north and west for 160 kilometers.

Southward on the Procellarum plain is **Marius**, a flat-floored crater 41 kilometers across. Beside it is a field of volcanic domes called the **Marius Hills**. These lunar pimples—dozens of them—are up to several kilometers long and a few hundred meters high. When the waxing terminator runs west of Marius, the lumpy landscape unveils itself at around 150x.

Another curiosity is the cryptic-sounding **Reiner Gamma**. It's neither mare nor mountain nor crater. Measuring 40 by 30 kilometers, Reiner Gamma is the near side's solitary example of a lunar swirl, a no-frills flat spot shrouded in an intense magnetic field. Soon after lunar age 12½ days, you'll find this oval oddity west of the 30-kilometer-wide crater **Reiner**. Employing at least 100x, I perceive Gamma Reiner as a slender white "fish" that has swallowed a little gray "football." Go ahead; see for yourself.

Another opportunity to explore all this strange stuff occurs about halfway between the last-quarter and new Moon. Don't miss it!

MORE STARTER TOURS

For even more Moon tours, see John A. Read's excellent beginner's guide to the Moon's top 50 features, available in print and as an e-book.

THE 14-DAY-OLD FULL MOON

TOUR 12 BIG MOON RISING

Ever watch a moonrise in a scope or tripod-mounted binoculars? At full Moon, the rising orb—often orange-tinted and climbing behind distant trees—is big, bold and beautiful. (The "big" part is an optical illusion, for the Moon only *seems* larger when it hugs the horizon. See page 27.)

On my 4¼-inch reflector, I use low magnification so that the Moon fits easily in the eyepiece field. If the Moon is emerging during bright twilight (hours ahead of a precisely full Moon), the lunar disk isn't glaring—it's mesmerizing. I can identify numerous dark maria, appreciate many other subtle variations in texture and coloration and, best of all, admire the wondrous lunar rays.

There are a variety of ray systems, and no two are alike. As the image on this page attests, four are standouts. Gleaming **Aristarchus** (see the previous tour) is a source of rays radiating mainly southeastward, until they intersect the broad splash of rays emanating from **Kepler**. Some of Kepler's rays, in turn, mingle with those of giant **Copernicus** (see Tour 9). The Copernican ray system is a veritable spider's web of streaks. **Tycho** (Tour 8) isn't quite as large as Copernicus, yet it's special. In my scope, Tycho is a pure white depression surrounded by a dusky "collar." Its rays span hundreds of kilometers in all directions.

Other bright rays emanate from **Proclus** in the northeast, with its oddly asymmetric ray system, and from a crater

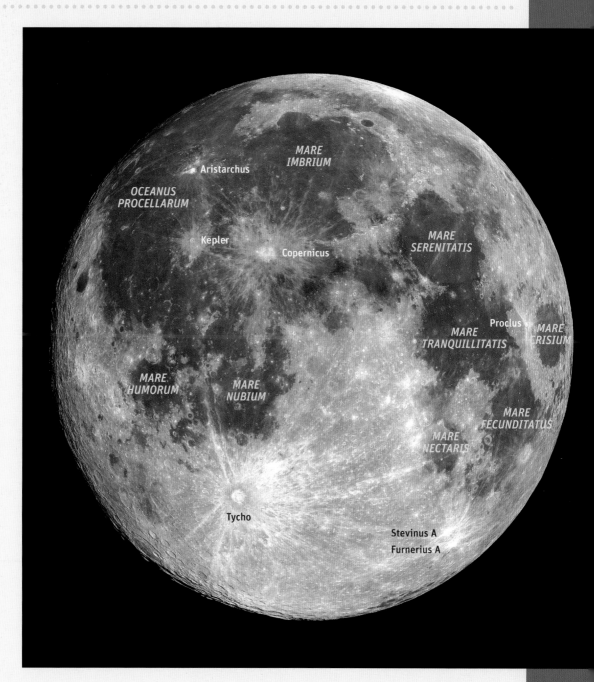

pair in the southeast called **Furnerius A** and **Stevinus A**. Their two ray systems seem out of proportion to the craters' 10-kilometer diameters.

Lunar rays are a relatively short-lived phenomenon. Over the eons, they darken and fade away. Tycho's rays dominate because the impact that created them occurred about 109 million years ago—very recent in lunar terms. Tycho's main competitor, Copernicus, is considerably older, so its rays are somewhat degraded by comparison.

CHAPTER 14

Observing the Solar System

Galileo first gazed at Venus, Jupiter and Saturn with his new telescope in 1610, discovering distinct phases on Venus, four moons orbiting Jupiter and strange appendages jutting out from Saturn that later observers realized were rings.

Now, in the 21st century, all the major planets, as well as dwarf planets Ceres and Pluto, have been imaged in detail by space probes. We know what these worlds and their moons look like up close. And yet seeing the members of the solar system for ourselves continues to be the major attraction to owning a telescope. Few celestial sights can match a live telescopic view of Saturn and its fascinating rings or Jupiter's cloud belts and intriguing Great Red Spot.

In this chapter, we focus on telescopic targets in the solar system: the Sun's family of planets, both major and minor, and comets. At least one planet is prominent every night, but a bright comet, such as Comet NEOWISE, is a rare treat.

To the delight of northern-hemisphere observers, Comet NEOWISE glided across the northern sky in July 2020. Sporting a classic blue gas tail and curving white dust tail, the comet was easily visible to the unaided eye from a dark site, such as here at the Columbia Icefield in Jasper National Park, Alberta. This image was taken on July 27, when the comet appeared below the Big Dipper. Airglow and aurora tint the sky.

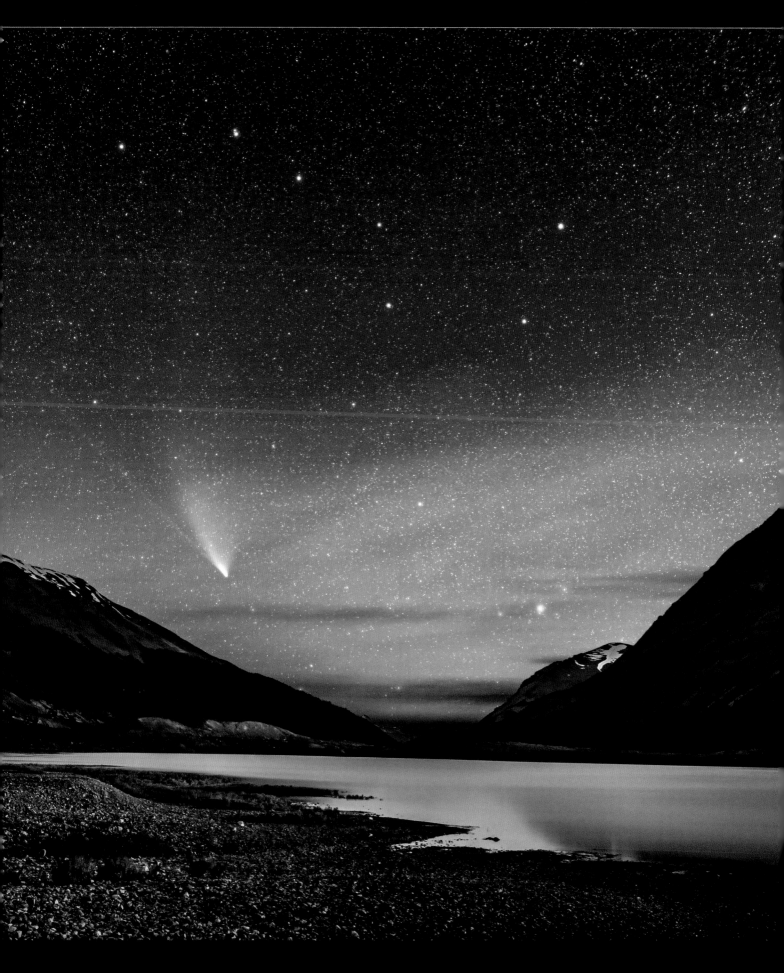

VENUS ✦ · Elnath

MERCURY ·

INNER-PLANET APPEARANCES
In early May 2015, Mercury was near its greatest elongation in the
evening sky. While brilliant Venus was still a month away from its
greatest elongation, this scene shows how much lower Mercury
usually appears compared with Venus, even though the innermost
planet is at its widest separation from the Sun.

OBSERVING MERCURY

> **TRANSIT SCHEDULE**
> Mercury transits the
> disk of the Sun 13 or 14
> times each century
> and always in early
> May or early November,
> when its orbit crosses
> the ecliptic going south
> or north, respectively.

In many ways, Mercury is similar to our next-door world, the Moon. At only 1.4 times the Moon's diameter, Mercury is a small, airless globe plastered with craters and volcanic plains. Being airless means that we are looking at Mercury's solid surface.

Unlike the Moon, however, we can see little evidence of Mercury's ancient history when we view the planet through our telescopes. For one, Mercury never appears farther than about 28 degrees from the Sun, placing it low in our dusk or dawn sky. And it

is small. Its disk is typically only 5 to 10 arc seconds in diameter, compared with Jupiter's average size of 40 arc seconds.

OBSERVING MERCURY IN TWILIGHT

The best sighting opportunities come at greatest elongations. Mercury reaches its maximum angle away from the Sun about six times a year, usually equally divided between morning and evening elongations. If only for convenience, observers often hunt down Mercury

during one of its two- to three-week-long appearances as an evening "star." At its best, Mercury can shine as bright as magnitude –1, making it surprisingly obvious to the unaided eye, if you know where to look.

Evening appearances in spring are best, as Mercury is then as high as it gets in our sky due to the steep angle of the springtime ecliptic with respect to the horizon. For temperate latitudes, each year typically offers one best window of opportunity in spring for an evening sighting. Autumn brings the most favorable time for a morning sighting.

Mercury can be seen with the naked eye or binoculars, but conditions for telescopic views could hardly be worse, even at favorable elongations. Mercury is generally less than 15 degrees above the horizon, swimming in bad seeing.

Moreover, false color plagues the planet—an effect caused by dispersion from atmospheric refraction, which is worse the lower the altitude of the target. Mercury appears with a red fringe on the lower edge of its tiny disk and a green or blue fringe on the upper edge, further smearing details on the disk.

Despite the challenges, superb observations were made a century ago by Eugène Antoniadi, a Greek-born French astronomer who became one of the greatest planetary observers of all time. Antoniadi did his best work during the 1920s with refractors ranging from 12 to 33 inches in aperture. Eventually, he produced a crude map and concluded that Mercury rotates once every 88 days, the same time it takes Mercury to orbit the Sun, and that one hemisphere must constantly face the Sun, just as one side of the Moon always faces Earth.

Antoniadi was partly right. Mercury's rotation *is* locked to its parent star, but not in the way he had thought. The planet actually makes half a rotation during one orbit around the Sun, so the same face returns to a sunward position after two orbits. We are looking at the same side of Mercury on every second evening or morning elongation. It matters little, as disk details are so elusive.

What is obvious is Mercury's phase. As Mercury rounds the Sun and approaches Earth over a typical three-week evening observing window, its disk grows in size and wanes from nearly full to a delicate, slender crescent that is similar to a three-day-old Moon. Following its changing phase is likely your best Mercury project.

OBSERVING MERCURY BY DAY

There is a way to see more of the little planet. For a sharp telescopic view, you must do what Antoniadi did: Observe Mercury by day. The same applies to Venus, which can also be viewed using the following techniques. The challenge is finding the two inner planets in a bright blue sky.

One way is to align a GoTo telescope the night before, then park or hibernate it. The next day, wake it up, and it should go to Mercury or Venus. However, do this only when the planets are at their greatest elongations from the Sun. If they are close to the Sun, you run the risk of the telescope sweeping over the Sun as it slews or the Sun's glare washing out the view.

A good time to look for Mercury is when it is near its greatest western elongation. That places it in the eastern sky as a morning object. Daytime seeing is often best in the morning, before the Sun has warmed the air to produce convection currents that spoil the seeing.

A useful homemade accessory for daytime planetary observing is an extended dewcap made of black construction paper. Fasten the paper around the telescope tube so that it extends at least a foot beyond the length of any existing dewcap. This prevents direct sunlight from falling onto a refractor's lens, a Schmidt-Cassegrain's corrector plate or a Newtonian's secondary mirror.

Under the best conditions of daytime or twilight viewing, Mercury is a sharply defined disk with hints of dark and light splotches just at the threshold of vision. It is paler than Venus, and its creamy surface has the appearance of being vaguely textured, like fine sandpaper. It is questionable whether observers are seeing craters on Mercury, but the planet certainly looks different than cloud-covered Venus.

EYEPIECE VIEW: MERCURY

As a reality check in this chapter, we present several drawings by artist Edwin Faughn depicting what you can expect to see at the eyepiece when looking at a planet through a small telescope. This is Mercury at its full phase, when it is at its most distant and smallest. Not much to see!

MERCURY AT ITS BEST

Under the very finest conditions—a large telescope in the Chilean desert—master planetary imager Damian Peach has recorded as much detail on Mercury as it is possible to see and capture from Earth: in this case, just a few dark and bright markings on a disk that was 10.2 arc seconds across. Unless otherwise stated, all the planet close-ups in this chapter are by Damian Peach.

OBSERVING VENUS

At a magnitude of −4 or brighter, Venus can so dominate the morning or evening sky that there is no mistaking it. No other planet or star gets as bright. The planet's brilliance is due to two factors: Venus comes closer to Earth and, therefore, appears larger than any other planet, and the sulfuric-acid haze at the highest levels in Venus's atmosphere is extremely reflective.

Sixty-five percent of the sunlight that falls on Venus is reflected back into space, the highest albedo of any planet in the solar system. Venus is dazzling to the eye but a disappointment in the telescope. It is as featureless as a cue ball; all we can see are its white clouds.

EVENING AND MORNING 'STARS'

Unlike the mercurial inner planet, Venus spends several months each as an evening or a morning 'star,' reaching one of its greatest elongations away from the Sun once or twice a year as it shifts back and forth from one side of the Sun to the other.

The period between successive evening or morning appearances, the so-called synodic period, is 584 days—1.6 Earth years. So an evening elongation in spring is followed by one in late autumn the next year, then in summer two years after that.

Due to an odd 13:8 synchronicity between Venus and Earth (Venus orbits the Sun almost

exactly 13 times over eight Earth years), Venus returns to the same place in our sky every eight years. So elongations eight years apart are similar. For example, the favorable elongation of March 2020, shown above, was a near copy of the one in March 2012 and will be similar to the elongation of March 2028.

Like Mercury, Venus passes through phases during its season of visibility, and for the same reason—the orbit of Venus is interior to the Earth's orbit. But Venus orbits at twice Mercury's distance from the Sun. Consequently, Venus moves more slowly and can appear twice as far from the Sun in our sky than does Mercury. The results are viewing windows (apparitions) lasting months and a higher position in the sky than Mercury ever attains.

And, to clarify the confusing terminology, an evening apparition is called greatest elongation east (GEE) because Venus is then east of the Sun, even though it appears in our western sky. It's vice versa for greatest elongation west (GEW) in the eastern morning sky.

The other date of note in each Venus apparition is greatest brilliancy, often called greatest illuminated extent. This always occurs with Venus at a crescent phase, about 36 days *after* greatest elongation in the evening or 36 days *before* greatest elongation in the morning. Although we see only a crescent illuminated, the disk is so large that the area lit by the Sun

VENUS AS AN EVENING 'STAR'

Top: When Venus is in the evening sky, it dominates the twilight scene, shining this night, March 25, 2020, below the Pleiades as the winter stars set. The thin Moon shines low above the horizon.

Above: While Venus looks spectacular to the naked eye, the best telescopic views are often by day, as in this photo taken by author Dyer three hours before sunset in early May 2020, capturing what the crescent planet looked like in the eyepiece.

is at maximum, peaking Venus at an amazing magnitude –4.6 to –4.8.

DAYTIME VIEWING

The thick layer of cloud and haze blanketing Venus is extremely uniform. Yet observers looking through a telescope can occasionally see dusky patches and brighter poles, subtle differences at the limit of visibility.

Visual observers have reported these features for more than two centuries, and their drawings have sometimes coincided with markings visible in ultraviolet photographs, where cloud features stand out best. However, when examining Venus against the darkness of deep twilight, the glare of the planet can make sighting any cloud features difficult.

As with Mercury, daytime viewing is preferred for Venus. At its brightest, Venus can actually be seen with the unaided eye in a clear, deep blue sky in late afternoon (near an evening elongation) or in early morning (near a morning elongation). On days when the crescent Moon is nearby, find it and let it guide you to Venus.

Through a telescope in a blue daytime sky, Venus is a beautiful suspended pearl. Daytime observation reveals the clouds' gradation in brightness from the bright limb to the darker terminator, the day/night boundary. The ter-

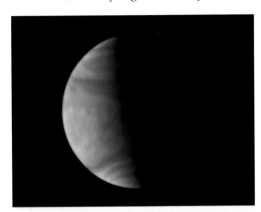

VENUSIAN CLOUDS
It required a 41-inch telescope at the historic Pic du Midi Observatory, in France, and imaging through ultraviolet and infrared filters to reveal structures in Venus's upper clouds. Visual observers with backyard gear will be fortunate to see any dusky markings.

RATING THE SEEING

Observers rate the steadiness of the seeing conditions using a 5-point scale devised by Eugène Antoniadi.

1
Perfect seeing, without a quiver

2
Slight quivering, with moments of calm lasting several seconds

3
Moderate seeing, with larger air tremors that blur the image

4
Poor seeing, constant troublesome undulations of the image

5
Very bad seeing, not stable enough to allow a rough sketch

Lunar and planetary observers cherish "Seeing 1" nights!

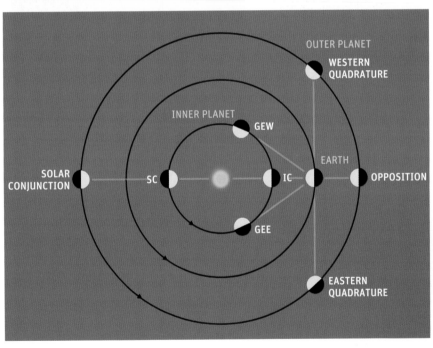

PLANET POSITIONS

When the inner planets, Mercury and Venus, are directly between Earth and the Sun, they are at inferior conjunction (IC). Superior conjunction (SC) is when they are out of sight behind the Sun. They are at their greatest elongations west (GEW) of the Sun in the morning sky and east (GEE) of the Sun in the evening sky. When Earth is between the Sun and an outer planet (Mars and beyond), the outer planet is in opposition, closest to Earth and at its brightest and largest. When an outer planet is 90 degrees away from the Sun, as viewed from Earth, it is in quadrature and can show a slight gibbous phase. Each of the outer planets disappears behind the Sun for a few weeks during a solar conjunction.

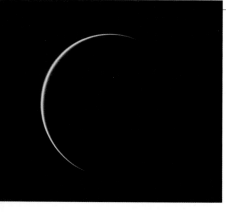

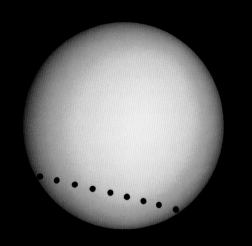

DAYTIME VENUS

Top: Near or at inferior conjunction, Venus can appear in the day sky as a thin crescent close to the Sun. Damian Peach captured this view on May 28, 2012, a week before Venus was at inferior conjunction and made one of its rare transits across the Sun. **Above:** Venus is bright enough that the infrequent occasions when the Moon covers it, called an occultation, can be observed even in broad daylight. Author Dyer took this sequence on August 13, 2012, as the pale crescent of the Moon passed in front of brilliant Venus.

TRANSIT OF MERCURY

On November 11, 2019, the transit of Mercury was in progress at sunrise from Dyer's home site, thus the missing first half of the transit in this composite taken over three hours.

TRANSIT OF VENUS

Rare Venus transits occur in pairs eight years apart. This was the transit of June 8, 2004, which was followed by one on June 5-6, 2012, the last for another 105 years.

PLANETARY TRANSITS

On rare occasions at inferior conjunction, Mercury or Venus passes directly across the disk of the Sun in an event called a transit.

The last transit of Mercury was on November 11, 2019. Before that, there was one on May 9, 2016. The next, however, is not until November 13, 2032. During a transit, you can see the tiny silhouette of Mercury moving across the Sun over several hours.

Even more rare are Venus transits. Venus appears so large, it is obvious to the filtered naked eye as a huge black dot on the Sun's disk. Transits of Venus played a key role in 18th-century history as expeditions, one led by Lt. James Cook, traveled the world to record the transits of 1761 and 1769. The next transit of Venus is not until December 10-11, 2117.

minator receives only grazing sunlight compared with the direct rays lighting the limb.

On its date of greatest elongation, Venus should appear half illuminated, like a quarter Moon. This is called dichotomy. Yet visual dichotomy at evening apparitions occurs four to eight days before it should according to orbital geometry. The reverse happens when Venus is in the morning sky, with visual dichotomy occurring a few days after the geometry suggests it should.

Backyard observers have recorded these variances for decades. German astronomer Johann Schröter noted this effect in the 18th century, and the discrepancy is sometimes called the Schröter effect. To observe it, examine Venus daily for the week on either side of greatest elongation east or west to note when you think Venus appears at exactly half phase.

The celestial clockwork brings Venus between Earth and the Sun, to inferior conjunction, every 584 days. When Venus is within days of inferior conjunction, its disk can expand to 60 arc seconds across, larger than any other planet, while its phase shrinks to a razor-thin crescent.

Observing the slender crescent of Venus in the day sky requires extreme caution, as the telescope must be aimed close to the Sun to view the planet. Attempts are best left to those inferior conjunctions when Venus passes up to eight degrees from the Sun, as it does in August 2023 and March 2025. The reward might be the sight of the lit crescent extending around the disk as a complete ring, an effect caused by the scattering of sunlight in the Venusian atmosphere. Conditions must be exceptional, but the sighting does not require a large telescope.

OBSERVING MARS

A part from the Moon, Mars is the only celestial object that readily reveals details on a solid surface when viewed through a telescope. Yet Mars is just far enough away that its features are difficult to observe with clarity.

Under good observing conditions, Mars looks like a familiar world similar to our own, with polar caps, dark "seas" amid the salmon-hued deserts, dust storms and the occasional clouds. With its Earth-like features, a 24.6-hour rotation period and an axial tilt only two degrees different from the Earth's, it's easy to see why 19th-century observers thought they were looking at an inhabited world.

The pinkish orange globe suspended in the black void of space is an enchanting and unforgettable sight. But be warned: Memorable views of Mars are not common. Mars always tantalizes.

OPPOSITION CYCLES

For only three to six months every 26 months, at its biennial oppositions, is the Martian disk large enough (over 10 arc seconds across) to reveal rich detail. Even then, some oppositions are better than others due to the elliptical orbit of Mars. Those which occur when Mars is near its perihelion point closest to the Sun place the red planet closest to Earth, and therefore, it appears at its largest in the eyepiece.

At perihelic oppositions, the apparent diameter of Mars can be as great as 24 to 25 arc seconds, while at aphelic oppositions, it may reach a maximum of only 14 arc seconds. The cycle is 15 to 17 years long. We enjoyed close perihelic oppositions in 2003 and 2018, but the next one is not until 2035. The opposition of October 2020 was almost as good, with a 22.6-arc-second disk and Mars reasonably high in the sky for northern-hemisphere observers. But the oppositions of the 2020s will be progressively more distant until 2029, when close-approach distances begin to improve again with each opposition.

How good a view we get depends not only on how close Mars is but also on how high it is. For northern-latitude observers,

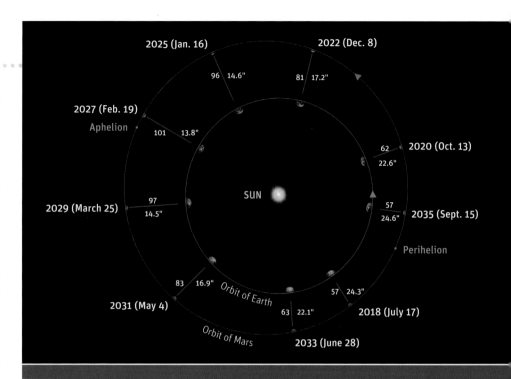

MARS OPPOSITIONS NEAR AND FAR
This chart plots the geometry for Mars oppositions, from the close perihelic approach of 2018 through the increasingly distant oppositions of the 2020s, as we pass Mars when it is farther from the Sun, back to the next perihelic opposition in 2035. The numbers represent the distance from Earth to Mars in millions of kilometers and its maximum disk size in arc seconds (").

OPPOSITIONS OF MARS 2020-2040

DATE	DECLINATION	DISK SIZE (")	DISTANCE (million km)
October 13, 2020	5°N	22.6	62
December 8, 2022	25°N	17.2	81
January 16, 2025	25°N	14.6	96
February 19, 2027	15°N	13.8	101
March 25, 2029	1°N	14.5	97
May 4, 2031	15°S	16.9	83
June 28, 2033	27°S	22.1	63
September 15, 2035	8°S	24.6	57
November 19, 2037	20°N	18.9	74
January 2, 2040	26°N	15.3	91

Oppositions of Mars are more northerly but more distant through most of the 2020s, then grow closer but more southerly in the early 2030s. Mars viewing takes patience!

Planet-wide dust storm

Opposition: July 2
Closest approach: Jul
Disk = 24.3 arc secon
Distance = 57.5 million k

MARS ATTACKS(!) AND RETREATS

Above: In 2018, Damian Peach recorded the entire perihelic opposition of Mars: from March through opposition and closest approach in late July to when Mars was once again distant in early 2019. However, a global dust storm in June and July obscured surface details.

Inset: By waiting for moments of good seeing and training your eye to see, subtle features should reveal themselves, as in this drawing that better represents what you can expect to see at the eyepiece at about 200x.

DUST STORM SEASON

Northern spring equinox on Mars, called Ls=0, marks the start of the Martian year. Ls=90 is northern summer solstice. At Ls=250, Mars is at perihelion, just before southern summer begins, at Ls=270. The higher level of heating makes global dust storms more likely.

Mars is highest and, therefore, least prone to poor seeing only during unfavorable distant oppositions. At the most favorable close approaches, Mars is usually low in the northern-hemisphere summer sky. Observers at southern latitudes or in the southern hemisphere get the best views of Mars when it is closest and located on the most southerly segment of the ecliptic.

TELESCOPES FOR MARS

Large telescopes are limited by turbulence in the Earth's atmosphere. A night of superb seeing yields a resolution of 0.5 arc second. One arc second is more typical and is the resolution of a 4-inch telescope; half an arc second is the theoretical capability of an 8-inch telescope; and 0.3 arc second is the limit of a 15-inch instrument. This tiny angle equals an 80-kilometer resolution on Mars, but only when the planet is at its closest.

Rarely does the Earth's atmospheric turbulence settle enough for a 15-inch-class telescope to show full resolution. But when near-perfect conditions do occur, the overwhelming detail visible on Mars in a high-quality, large-aperture telescope is astonishing. What large optics will do anytime, though, is make the planet appear brighter and enhance the color differences over the disk. So with Mars, larger is usually better, provided the optics are sharp.

The best magnification for Mars is about 35x per inch of aperture up to 7 inches (18 cm) and 25x to 30x for larger telescopes. This yields a pleasing image while avoiding the effects of irradiation, a phenomenon that originates in the eye and causes brighter areas to encroach on dark adjacent regions. On Mars, irradiation

produces an apparent enlargement of the polar caps and the loss of fine, dark details next to the bright desert areas. The effect is most troublesome at magnifications below 25x per inch of aperture.

WHAT CAN YOU SEE?

Regardless of the telescope and viewing conditions, experience is key to detecting the wealth of detail that Mars can present to backyard observers. At first glance, the planet appears so small, you might wonder how any features can be seen. The trick is to start observing Mars at least two months before the date of opposition to train your eye to discern the ever-so-subtle features that abound on our neighbor world. Then, around opposition, when the best views are possible, you will be ready to squeeze the most out of eye and telescope.

The clarity of Mars' surface features—its white polar caps and dark, irregular patches on a largely peach-colored sphere—depends, to a great extent, on the transparency of the Martian atmosphere. The dark areas can vary in size and shape from one opposition to the next or even during an opposition. As recently as the 1960s, these dark areas were thought to be tracts of vegetation changing with the seasons. We now know the changes occur as winds transport dark and light dust across the planet.

Major dust storms can lower the contrast across large sectors of the disk within days of a storm's onset. The planet can remain shrouded for weeks, as happened in July 2018, when a storm wiped out disk details just as Mars was reaching its closest point to Earth since 2003. The storm was so intense, it ended the life of the solar-powered Opportunity rover.

Experienced observers can detect emerging storms on Mars when desert areas brighten

and encroach on nearby dark regions. Amateurs are often the first to see Martian storms developing and to alert NASA to make observations with Hubble or orbiting Mars probes.

The Martian south pole is tipped Earthward at oppositions favorable for northern-hemisphere observers. The brilliant white polar cap shrinks during the prime observing window (90 days centered on opposition), sometimes revealing notches in the main polar cap or detached patches. Summer is then beginning in the Martian southern hemisphere.

However, the buttonlike polar caps are often obscured by large hazes, or polar hoods. In addition, bright icy clouds on the morning and afternoon limbs of the planet can masquerade as polar caps, making it difficult to pick out the real cap or polar hood.

Because Mars' rotation period is 24 hours 38 minutes (called a sol), the same features are visible from Earth 38 minutes *later* each night. Observe at the *same time* each night, and you see nine degrees farther east on the planet on each successive night. After 41 nights, you have looked entirely around the red planet and Earth and Mars are back in sync—you are seeing the same face at the same hour as you did when you started observing.

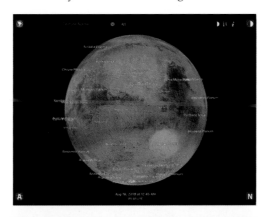

SIMULATED MARS

The simulation at left from the Mars Atlas app shows the view from August 16, 2018. Compare this with the Mars photo above nearest the word August—they are very close. The views show two prominent features on Mars: dark, triangular Syrtis Major and the bright circular Hellas Basin. To the left is Meridiani Planum, which marks the 0° longitude point for Mars maps. As with Moon apps, Mars apps can invert or flip the image to match the view in your telescope, making it easier to identify features on the red planet.

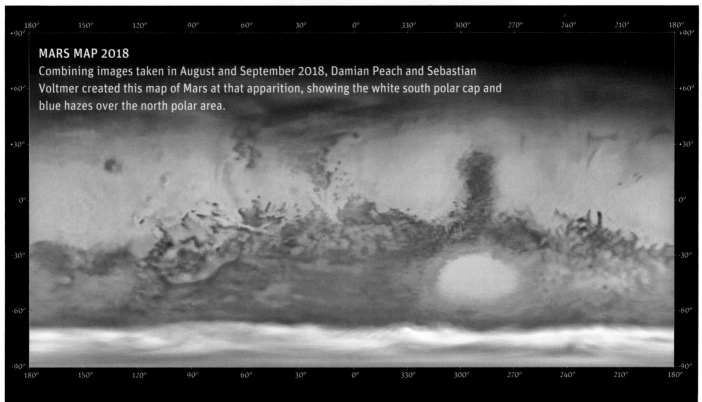

MARS MAP 2018
Combining images taken in August and September 2018, Damian Peach and Sebastian Voltmer created this map of Mars at that apparition, showing the white south polar cap and blue hazes over the north polar area.

FILTERS FOR MARS

Inexpensive color filters (see Chapter 8) can improve your views of Mars. A blue filter (Wratten #80A) can help reveal bright icy clouds. Orange (#21) and red (#23A) filters can enhance the contrast of the dark areas. A red filter may be too dark for instruments smaller than 8 inches (20 cm). A minus-violet filter ($40 to $100) can be useful for achromatic refractors, as it suppresses the blue halos from chromatic aberration.

A red filter can also improve seeing by eliminating the shorter wavelengths that are most affected by atmospheric turbulence. For telescopes greater than 8 inches, try a deep red #25 filter. Generally, telescopes larger than 5 inches (125mm) respond better to color filters than do smaller instruments. However, colored planetary filters offer subtle improvements at best. They are not a substitute for experience at the eyepiece training your eye to see fine detail.

And, for aesthetic appeal, nothing can match an unfiltered view of the Martian coral-pink deserts, pure white poles and gray-green dark regions. A sharp view of Mars at a favorable opposition under good seeing conditions is a night to remember in your lifetime of stargazing.

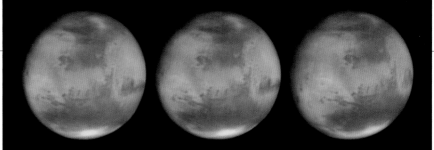

MARS' ROTATION

Taken over 90 minutes on June 8, 2016, these images show how the rotation of Mars brings new features into view on the morning limb (at left) while features rotate out of view on the afternoon limb (at right). The dark area in the north (at top) is Mare Acidalium; to the south is Mare Erythraeum. Thin clouds brighten the morning and afternoon limbs. Nudging the scope north-south can help you identify which way is north on Mars. With a telescope drive off, Mars will drift out of the field with its afternoon limb *preceding* and the morning limb *following*.

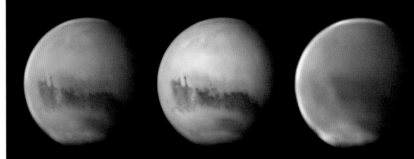

RED AND BLUE MARS

In these images taken on June 16, 2018, we see Mars in full color and as it appears through an infrared filter (center) and a blue filter (right). Visually, a red filter enhances contrast of dark surface features, while a blue filter brings out atmospheric hazes and clouds.

THE CANALS OF MARS

In 1894, Percival Lowell (1855-1916), a wealthy American diplomat-turned-astronomer, built an observatory in Flagstaff, Arizona, to study linear features ("canals") reported on Mars by Italian astronomer Giovanni Schiaparelli a generation earlier. Schiaparelli had used an 8.5-inch refractor, but Lowell's new instrument was a 24-inch refractor, a grand telescope lovingly restored by Lowell Observatory staff in 2015.

Examining Mars with the 24-inch, Lowell became convinced that the canals he observed and recorded in his drawings were constructed by a Martian civilization to preserve a dwindling water supply on a desert planet. With the publication of his book *Mars* in 1895 and two more books that followed, Lowell became the most famous astronomer of his day.

For the next two decades, Lowell continued his studies of Mars, making regular announcements about what he and his staff observed. The newspapers loved it. So did science fiction writer H. G. Wells: Soon after reading about Lowell's theories, Wells penned *The War of the Worlds*, about Martians invading Earth.

The canals proved to be the product of the brain's tendency to connect fine detail at the threshold of vision into linear features. There are no straight lines on Mars. But the seeds had been planted, and Martians have been part of our culture ever since.

OBSERVING JUPITER

Unlike Mars, which requires superb optics and relatively high magnifications to see much detail, Jupiter has features that are easily revealed by an 80mm refractor at about 100x: its main cloud belts, the Red Spot (usually) and the shadows of its four Galilean satellites.

While every increase in telescope size reveals more, aperture is definitely secondary to optical quality with all planetary observing. Jupiter is a bright object, so there is plenty of light. Focusing that light into a sharp, high-resolution image is the key. In good seeing, 25x to 35x per inch of aperture should be adequate for observing Jupiter. With well-collimated optics, Jupiter should snap into focus and appear sharp-edged.

JOVIAN WEATHER WATCHING

What can you expect to see with a 4-inch refractor or a 6-inch reflector? Because of Jupiter's constantly changing clouds, the amount of detail varies from one observing season to the next.

However, three or four dark belts are always visible and sometimes as many as eight, depending on how the wind circulation is divvying up the clouds. Loops, curving festoons and general turbulence can be seen along the edges of the dark equatorial belts. The light zones are at a higher altitude than the dark belts and consist mostly of ammonia haze; the dark belts are chiefly ammonium hydrosulfide.

The Equatorial Zone and the adjoining parts of the equatorial belts are known as System I, while the rest of the planet (except the polar regions) is System II. The polar regions are referred to as System III, but Systems I and II contain the most interesting and changing details.

System I rotates in approximately 9 hours 50 minutes; System II's general rotation period is about five minutes longer, fast enough that details shift in only a few minutes. The two cloud systems continually slide by each other inside the equatorial belts, making them the areas of greatest weather activity.

Overall, Jupiter's disk is creamy white, bright and distinct. Look closely, and you'll see an aspect called limb darkening—the edge of Jupiter's disk is about one-tenth as bright as its center. This is the result of solar illumination being absorbed by a thin haze in Jupiter's upper atmosphere, above the highly reflective clouds. Limb darkening subdues the visibility of the cloud features near the disk's edge.

Jupiter's Red Spot, for example, is not visible at the edge of the disk. Rather, it is seen clearly only when it has rotated one-quarter of the way around. The same is true of all Jovian features, which are seldom visible for more than 2½ hours before they rotate out of view.

North Polar Region
North Temperate Belt (NTB)
North Tropical Zone (NTZ)
North Equatorial Belt (NEB)
Equatorial Zone (EZ)
South Equatorial Belt (SEB)
Great Red Spot (GRS)
South Tropical Zone (STZ)
South Temperate Belt (STB)
South Polar Region

JOVIAN BELTS AND ZONES
While Jovian cloud features come and go, this image from March 18, 2016, shows Jupiter's characteristic twin dark equatorial belts and less prominent temperate belts bordered by brighter zones. The Great Red Spot lies on the south edge of the South Equatorial Belt. Note the turbulence "downwind" of the Red Spot.

Inset: Through a telescope, Jupiter presents the largest disk of any planet (except Venus at its closest). It is flanked by its four Galilean moons, which dance from one side of the planet to the other. They can be sighted even in binoculars.

RED SPOT CHANGES

This collage of images by Damian Peach from 2003 to 2016 illustrates how the Great Red Spot changes in appearance and intensity of color. In 2010, it was accompanied for a time by a new baby red spot.

THE GREAT RED SPOT

System II contains the famous Great Red Spot, a swirling maelstrom of clouds pumped up from a vortex that penetrates to a lower level of the planet. Its pinkish color (it rarely appears red to the eye) is usually quite distinct from the hue of any other feature on the planet, indicating that its source material is probably deeper than that of other features.

The apps SkySafari and Luminos provide times when the Red Spot will be centered on the disk (in transit). Select Jupiter, then Info. *Sky & Telescope* also lists the Red Spot's current longitude and provides the Universal Times (UT) when the Red Spot will be in transit, though Jupiter won't be visible from your location for most of those events. If you see the Red Spot one night, it will be visible two nights and one hour later (five Jupiter rotations).

Under excellent seeing conditions, it is possible to detect vague texture within the Red Spot. It certainly exhibits variations in its color over time—and size. In the past few decades, the Red Spot has shrunk from being big enough to contain three Earths to only as wide as 1½ Earths.

Even if the Red Spot fades in hue, its home—the Red Spot Hollow—should be visible as an indentation in the South Equatorial Belt (SEB). In late 1989, for instance, the SEB disappeared in just a few weeks and the Red Spot, after years of near invisibility, regained prominence. In 1990, the Red Spot faded as the belt returned. But in the late 2010s, the Great Red Spot again darkened and became more obvious.

As the SEB moves past the Red Spot and is disturbed by it, a churning swath of clouds is heaved into the wake (the region behind the Red Spot, in terms of the planet's rotation). This wake feature is usually more obvious than details within the Red Spot.

For many decades, several large, white ovals, one-quarter to one-third the size of the Red Spot, roamed in the South Temperate Belt (STB), the next belt south of the one occupied by the Red Spot. During the 1990s, the white ovals began merging, and by 2002, only one, about one-third the size of the Red Spot, remained. Then, in 2006, this white oval turned reddish, similar in hue to the Great Red Spot. It was dubbed the Little Red Spot. It survived for another decade, to be photographed by NASA's Jupiter-orbiting Juno probe in 2016.

TRACKING MOONS AND SHADOWS

A unique sight is the transit of one of Jupiter's four large Galilean moons across the planet's cloudy face. As one of the moons appears to touch the Jovian disk, it is transformed from a

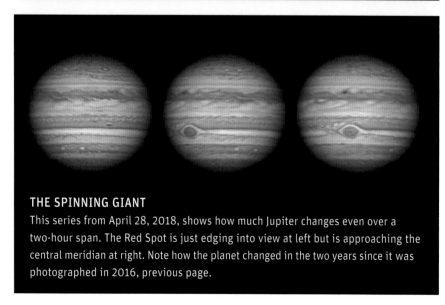

THE SPINNING GIANT

This series from April 28, 2018, shows how much Jupiter changes even over a two-hour span. The Red Spot is just edging into view at left but is approaching the central meridian at right. Note how the planet changed in the two years since it was photographed in 2016, previous page.

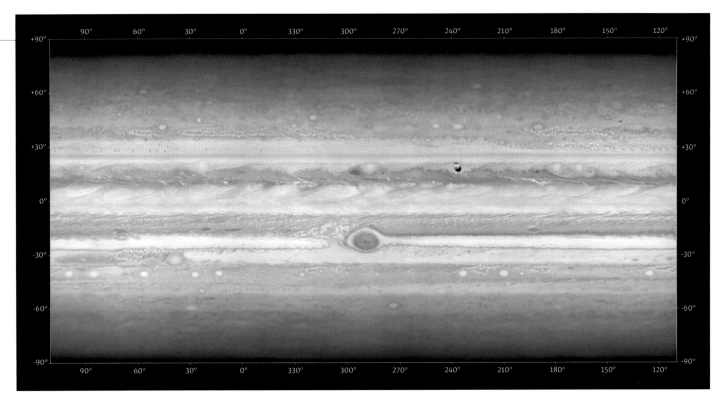

JOVIAN STRIP MAP

Combining images from May 4 to 10, 2018, Damian Peach created this map of the complex Jovian clouds. Io is on the disk casting its shadow directly behind it, as moons do when Jupiter is near opposition. Note the blue festoons hanging below the North Equatorial Belt and the white and red spots in the South Temperate Belt. Longitudes are for System II.

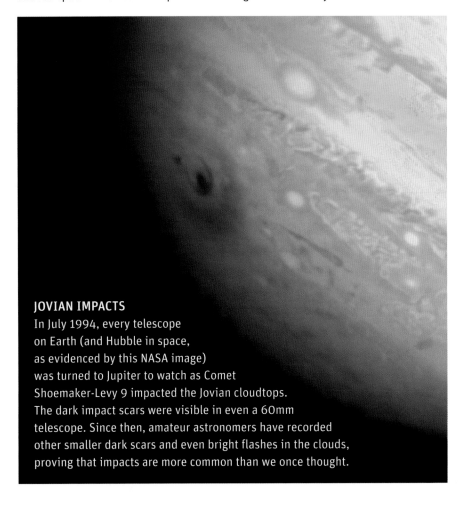

JOVIAN IMPACTS

In July 1994, every telescope on Earth (and Hubble in space, as evidenced by this NASA image) was turned to Jupiter to watch as Comet Shoemaker-Levy 9 impacted the Jovian cloudtops. The dark impact scars were visible in even a 60mm telescope. Since then, amateur astronomers have recorded other smaller dark scars and even bright flashes in the clouds, proving that impacts are more common than we once thought.

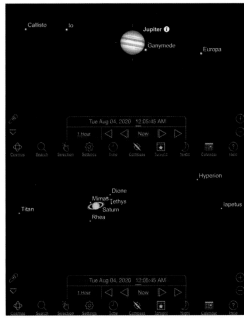

MOON FINDERS

Most planetarium apps, such as SkySafari, above, provide accurate depictions of the locations of the Jovian and Saturnian moons for easy identification at the eyepiece. Some programs also show moon and shadow transits. But watch that the simulated view matches the orientation of the image in your eyepiece—either inverted or mirror-image.

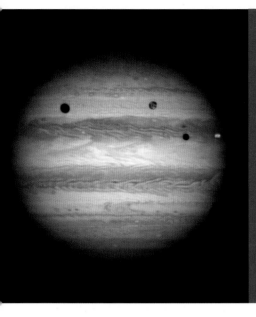

JUPITER'S FOUR MAJOR SATELLITES

Satellite	Diameter (km)	Visual Magnitude	Orbital Period (days)	Avg. Maximum Distance From Planet Center (arc sec.)	Apparent Diameter (arc sec.)	Shadow Diameter (arc sec.)	Effective Shadow Diameter* (arc sec.)
Io	3,643	5.0	1.77	138	1.2	1.0	1.1
Europa	3,122	5.3	3.55	220	1.0	0.6	0.8
Ganymede	5,262	4.6	7.16	351	1.7	1.1	1.4
Callisto	4,821	5.7	16.69	618	1.6	0.5	0.9

*Includes darker part of penumbral shadow

DUAL MOON DANCE

One moon shadow is of interest. Two is a treat. This is reddish Io (at right) and dusky Ganymede, each casting its black shadow onto the Jovian cloudtops in a dual moon and shadow transit on March 24, 2016. These dances don't last long —even a single transit might be only one to two hours.

UNIVERSAL TIME

The times of astronomy events are often given in Universal Time (UT), more correctly called Coordinated Universal Time (UTC). This is Greenwich Mean Time and is 5 hours ahead of Eastern standard time in North America; 4 hours ahead of Eastern daylight time in summer. So June 2 at 02:00 UT is 10 p.m., EDT, the evening before, on June 1.

dazzling spot against the dark sky to a tiny, fragile disk etched in the limb. Each moon has its own characteristic appearance as it crosses the planet.

Io, the innermost of the four big moons, has a light pinkish hue and high surface brightness. When it enters the disk, it is always a brilliant dot on the darker limb. As it begins its transit, Io can become lost in the white zones, which have similar reflectivity. When in front of the darker belts, the moon is typically a distinct bright spot.

Europa, the smallest of Jupiter's four major moons, has the most reflective surface. It is intensely white, especially as it enters the limb—a tiny white dot against the edge of the cloud-strewn giant. As Europa marches in front of the big globe, it usually encounters the white clouds of the zones and disappears from view. It is probably the most difficult moon to see throughout a complete transit. On the rare occasion when it tracks across a dark belt, Europa can be observed for its entire journey.

The largest satellite in the solar system, Ganymede is easier to follow across Jupiter's face because of its size and because its color is duller than the white clouds and brighter than the dark ones. Ganymede is light brown when transiting a white zone and resembles a washed-out satellite shadow. Superimposed on the limb, the reverse is the case: The limb is darker than Ganymede, so the moon appears as a bright dot. As with Io, there is a transition area in which Ganymede can disappear as its intensity matches the background between the limb and the brighter central part of the disk.

Outermost Callisto is probably the easiest moon to follow, because its dull surface makes it darker than almost anything it encounters, except at the very edge of the disk, when it enters or exits its transit. Callisto's crossings are the rarest of the four Galilean moons: It orbits Jupiter only once in 17 days, compared with 7 days for Ganymede, 3½ days for Europa and just 42 hours for Io. Also, for more than half of Jupiter's 12-year solar orbit, the planet's satellite system is angled so that Callisto passes above or below Jupiter as seen from Earth and misses transiting the disk altogether.

The shadows of Jupiter's moons are much easier to observe than a transit, because they appear as inky black dots, far darker than any of the planet's surface features. However, the shadows vary in size, with Ganymede's the largest, Io's the second largest and Europa's and Callisto's the smallest. Ganymede's shadow is visible in a 60mm refractor; the others usually require a 70mm refractor for a definite sighting.

When Jupiter is close to its annual opposition date, each moon shadow appears close to the disk of the moon itself as it transits the planet. On nights before and after the opposition date, the shadows are well separated from the moons casting those shadows. The moons are likely to be off the disk.

A special treat is seeing two moons and their shadows in transit at the same time. Even rarer is a triple moon-shadow transit, with three shadows on the Jovian disk at once. The last was on January 24, 2015. The next is March 20, 2032.

OBSERVING SATURN

No photograph, however detailed, can adequately portray the astonishing beauty of the ringed planet floating against the black-velvet backdrop of the sky. Of all the celestial sights available through a backyard telescope, only Saturn and our own Moon are sure to elicit exclamations of delight from first-time observers.

THE RINGS

Data taken by NASA's Cassini probe, which orbited Saturn from 2004 to 2017, suggest that Saturn's rings are less than 100 million years old, possibly created when an icy moon was hit by a large impactor and disintegrated. But how the rings formed is still a matter of debate.

Today, the icy particles that make up the rings range in size from tiny crystals, like those in an ice fog, to flying icebergs the size of small mountains. The ring system is truly enormous, as wide as two-thirds the distance between Earth and the Moon. Yet the rings are only a few tens of meters thick—yes, meters!—with local warps that raise ring particles a kilometer or two above the ring plane.

When Saturn is near one of its semiannual equinoxes (twice a Saturnian year, that is), the rings turn edge-on and, because they are so thin, disappear entirely. Or if they are still tipped slightly toward the Sun but edge-on to Earth, they appear as a gossamer string of light for a few nights. The next edge-on ring-plane passage, in March 2025, occurs with Saturn too close to the Sun for us to see. We have to wait another half a Saturnian year, until late 2038 and early 2039, for a favorable set of ring-plane crossings with Saturn well placed in our night sky.

Fortunately, for most of the 29.5-year-long Saturnian year, the rings are tipped toward us for a superb view. They were tipped to their maximum extent of 27 degrees in 2017, when it was midsummer in Saturn's northern hemisphere. The rings close up through the early 2020s, as Saturn moves toward its northern autumnal equinox, in 2025. After that, Saturn's southern hemisphere will tip increasingly toward us, exposing the south face of the rings through the rest of the 2020s.

Much to the surprise of first-time telescope owners, almost any telescope will reveal Saturn's rings. A 60mm refractor at 30x to 60x clearly shows them. The view is outstanding in 4-inch (10 cm) or larger telescopes. While the Voyager and Cassini spacecraft discovered hundreds of identifiable rings, only three components can be readily distinguished through backyard telescopes. They are known simply as rings A, B and C. The A and B rings are bright and obvious. They are separated by the Cassini

RING WORLD
An image taken at the Pic du Midi Observatory, in France, in June 2017 shows the incredible detail Saturn can display under the finest observing conditions. Even in less than ideal circumstances, however, the major A and B rings are obvious, separated by the dark Cassini Division. The C ring and Encke gap are threshold features, while the cloud belts are always subtle in color and contrast. **Inset:** This eyepiece sketch shows the rings tipped at the shallow angle that will be more typical of the views through the 2020s, when sighting the Cassini Division will become more challenging.

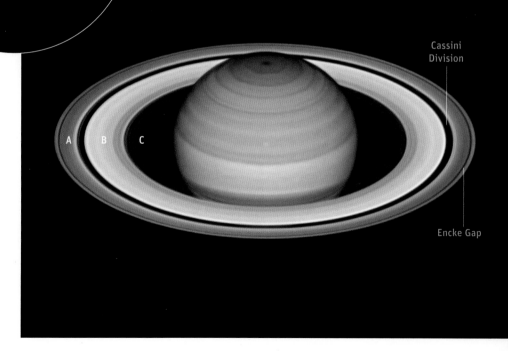

Cassini Division

A B C

Encke Gap

THE TILTING RINGS

A collage of images by Damian Peach presents the changing aspect of Saturn's rings from their maximum tilt in 2004, with the south face of the rings visible and that hemisphere of the planet turned toward us at southern summer solstice, through the edge-on views in 2009 and 2010, at the Saturnian equinox. The rings then opened up to reveal their northern face as summer came to the northern hemisphere of Saturn. The cycle reverses in the 2020s as the rings close up again to go edge-on in 2025 before opening up with the south face tipped toward us.

Division, a gap about as wide as the United States. This region was swept clear of most particles by gravitational tugs from Saturn's moon Mimas. An 80mm refractor will reveal it, but a good 5-inch (125mm) instrument is generally required to detect the dark line of the Cassini Division clearly all the way around.

The A ring, the outermost main ring, is less than half the breadth of the B ring and is not as bright, although the difference is subtle. However, the innermost C ring, also known as the crepe ring, is so dim that an experienced eye and at least a 6-inch (150mm) telescope are needed to distinguish it. The inner ring is a phantomlike structure extending about halfway toward the planet from the inner edge of the B ring. The C ring and the Cassini Division are best seen when the rings are wide open.

The mid-2020s will be lean years for sightings of both of these features.

One other division, called the Encke gap, lies near the outer edge of the A ring. The hairline-thin Encke gap is extremely difficult to detect with a backyard telescope. More obvious is the shadow cast by the planet onto the back side of the rings. The shadow disappears around opposition, as it then lies hidden behind the planet, but it increases in width in the weeks after opposition, giving the planet its 3D appearance.

THE PLANET

A night of steady seeing makes for a memorable evening at the eyepiece looking at Saturn. Take your eyes off the rings, and look at the planet's subtle cloud belts separating

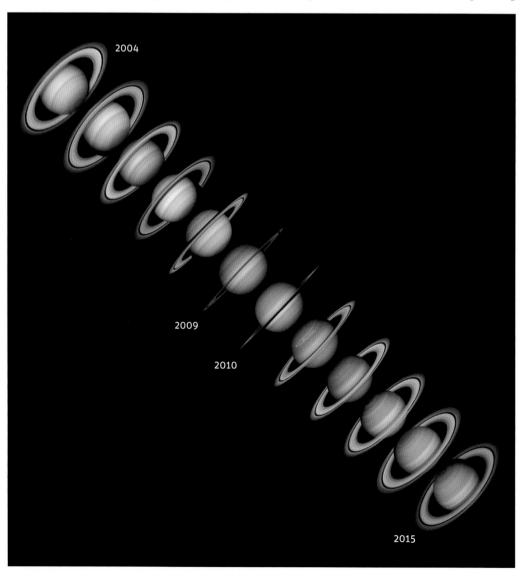

2004

2009

2010

2015

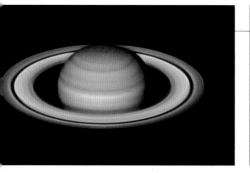
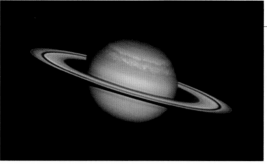
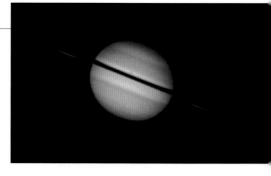

the creamy yellow equatorial region from the beige temperate zone.

You might also spy the shadow of the rings cast onto the planet. This is usually narrow but is not that difficult to see when you look for it. Depending on the geometry between Earth, the Sun and Saturn, the shadow can appear either above or below the rings as they pass in front of the planet and can be mistaken for the dusky crepe ring.

Saturn lacks the storms and spots that mark Jupiter's roiling atmosphere. However, white spots sometimes erupt to disturb the scene for a few weeks. It happened in 1933, 1960, 1990 and 2010. At maximum intensity, the white spots were visible in 4-inch (10 cm) telescopes.

THE SATELLITES

A small telescope also reveals several of Saturn's large family of satellites. Unlike Jupiter, whose major moons appear in a line on either side of the planet, the same tilt of Saturn that tips its rings wide open also scatters its moons not only beside but also above and below the planet. They appear as tiny "stars" around the rings, but all lie in the same plane as the rings. So only when the rings are edge-on every 13 to 15 years do we see Saturn's retinue of moons arrayed in a line on either side of the planet.

Seven of Saturn's moons are visible in an 8-inch (20 cm) telescope. Titan, an eighth-magnitude object orbiting Saturn in approximately 16 days, is by far the largest of Saturn's moons (second only to Jupiter's Ganymede for the title of biggest planetary moon in the solar system) and is easy in any telescope. When at its maximum distance from the planet, Titan appears to be five ring diameters from Saturn's center.

A 70mm refractor should reveal 9.7-magnitude Rhea less than two ring diameters from the planet. The next two moons inward

from Rhea are Dione and Tethys. At magnitudes 10.4 and 10.3, respectively, both are readily seen in a 6-inch (15 cm) telescope. Inward from Dione and speeding around the edge of the rings are Enceladus and Mimas, both more than a magnitude dimmer, making them difficult to detect close to the rings' glare.

Odd outer Iapetus has the peculiar property of being five times brighter (at magnitude 10.2) when it is to the west of Saturn than when it is to the east. One side of the moon is exposed bright ice, while the other—the side that faces the direction Iapetus orbits Saturn —is covered with a veneer of dark organic compounds that might have come from the tiny outer moon Phoebe. When at its brightest, Iapetus is about 12 ring diameters west of its parent planet, where it can look like any field star.

Now return to Titan. You are looking at orange clouds that rain methane. It is the only moon with a substantial atmosphere, a trait NASA plans to exploit in the 2030s by exploring this dynamic world using a helicopter drone probe called Dragonfly.

SHADOWS AND STORMS
Left: Three months before Saturn's opposition, an image taken April 7, 2019, shows the shadow of the planet projected onto the far side of the rings.
Middle: The remnants of a storm that erupted in Saturn's northern hemisphere in 2010 disturbed the normally smooth and subtle belts and zones, which can be seen in this image taken May 20, 2011. Major storms and spots on Saturn are rare.
Right: Nearly edge-on, the rings are slivers of light on either side of the planet in this image taken January 4, 2009. The shadow they are casting onto the cloudtops is a prominent black band across the disk.

SATURN'S MOST-OBSERVED SATELLITES

Satellite	Diameter (km)	Visual Magnitude	Orbital Period (days)	Avg. Maximum Distance From Planet Center (arc sec.)	Apparent Diameter (arc sec.)	Shadow Diameter* (arc sec.)
Titan	5,149	8.4	15.95	197	0.85	0.7
Rhea	1,529	9.7	4.52	85	0.25	0.2
Dione	1,123	10.4	2.74	61	0.17	0.15
Tethys	1,066	10.3	1.89	48	0.16	0.15

*Titan's shadow is seen only when the rings are nearly edge-on. Other satellite shadows are exceedingly difficult to see.

OBSERVING URANUS AND NEPTUNE

For most observers, just finding the outer "ice giant" planets to check them off a life list is reward enough. Both appear only as tiny blue-green disks.

FINDING URANUS

Uranus was discovered in 1781 by English astronomer William Herschel, profiled on page 291. Using his 6.2-inch Newtonian reflector, Herschel observed a sixth-magnitude "star" that did not look like a point of light. As Herschel described it: "From experience, I knew that the diameters of the fixed stars are not proportionally magnified with higher powers, as the planets are. Therefore, I now put on powers of 460 and 932 and found the diameter of the comet increased in proportion to the power, while the diameters of the stars...were not increased in the same ratio." Herschel thought he had discovered a comet, but it soon became clear that his find was a planet orbiting beyond Saturn, the first found since antiquity.

Usually at magnitude 5.7, Uranus is technically visible to the unaided eye but is an easy target for binoculars. And any telescope will reveal Uranus's pale aquamarine disk—the top layer of the planet's thick atmosphere. About 100x is needed before the 3.7-arc-second disk ceases to resemble a star.

Five of Uranus's 27 moons (the count as of 2020) were known before the 1986 flyby of the Voyager 2 probe, and 10 more were uncovered by the spacecraft's cameras. But even the brightest moons—Ariel, Titania and Oberon—are just under 14th magnitude.

GREEN PLANET URANUS
Revealing remarkable detail for an Earth-bound telescope, this image taken with the robotic Chilescope on November 27, 2018, shows a bright polar region on Uranus.

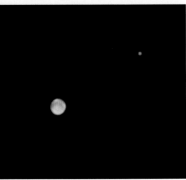

BLUE PLANET NEPTUNE
Subtle atmospheric features and Neptune's major moon Triton can be seen in this image taken by Damian Peach on September 25, 2010. Neptune's disk was its usual 2.3 arc seconds across.

EYEPIECE VIEWS: ICE GIANTS
It takes high power and steady seeing just to reveal the tiny disks of Uranus (left) and Neptune (below), let alone any surface details. However, each exhibits its unique color, as in these eyepiece renderings by Edwin Faughn.

FINDING NEPTUNE

For the backyard astronomer, Neptune is more interesting in some ways than Uranus. It is certainly more challenging. The most distant major planet was discovered in 1846 based on predictions that a planet existed beyond Uranus that was affecting its orbital motion. Since its discovery, Neptune has completed only one orbit of the Sun.

For the binocular observer, Neptune appears starlike, at about magnitude 7.8, creeping eastward from Aquarius into Pisces and Cetus through the 2020s. Use star-charting software to locate the current position of the planet, or slew a GoTo telescope over to its location. Bumping up the power to 200x unmistakably reveals Neptune's 2.3-arc-second disk. It definitely looks blue in 6-inch (15 cm) or larger telescopes. Occasionally, Venus or Mars passes close to Neptune for a contrasting conjunction. Saturn appears near Neptune in July 2025 and February 2026.

Neptune has one large satellite and 13 small ones as of 2020. Voyager 2 discovered six of the small moons when it encountered the planet in August 1989. Triton, the biggest moon, is 13th magnitude, making it visible in moderately large telescopes and an easier catch than any of the Uranian moons.

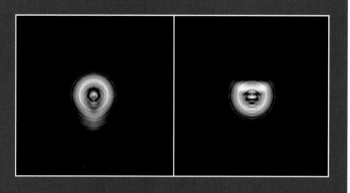
OBSERVING DWARF PLANETS AND ASTEROIDS

With its controversial ruling in 2006, the International Astronomical Union demoted Pluto from full planet-hood to the status of a dwarf planet. Pluto fans still object and continue to lobby for its reinstatement. However, we think it is fair to say that if Pluto were discovered today, and not as it was in 1930 (by Clyde Tombaugh at the Lowell Observatory), it would not be considered the ninth planet. We now know it is the largest (just barely!) of many such icy worlds in the region beyond Neptune known as the Kuiper belt.

Planet or not, Pluto remains a challenging target for any amateur telescope. Since its perihelion in 1989, Pluto has continued to recede from the Sun in its 248-year orbit. It has faded from its maximum possible magnitude of 13.6 in the late 1980s to about 14.5 in the 2020s. But Pluto is slowly moving away from the star-rich region of the Milky Way into eastern Sagittarius, then into Capricornus (after 2023), where the decrease in star density will make it easier to pick out.

However, easy is a relative term. You will need a printout of a digital chart that plots stars down to 15th magnitude and Pluto's position. Even then, you can't be sure of a sighting until you observe the field over several nights, as Tombaugh did, to see the dim world's motion against the stars. A 10-inch (25 cm) telescope is the likely minimum for Pluto hunting.

The largest object in the other zone of minor worlds—the asteroid belt between Mars and Jupiter—is easier to spot. Also classified as a dwarf planet, 1 Ceres varies in brightness from fainter than ninth magnitude to as bright as 7.7, when it is near opposition and closest to Earth. With a diameter of 964 kilometers, Ceres does exhibit a one-arc-second disk, so it might not look starlike at high power under the best seeing conditions.

With the exception of Ceres, all asteroids appear as their name suggests: little stars. The other members of the "big four"—2 Pallas, 3 Juno and 4 Vesta—can all be tracked down among the stars, with Vesta shining at magnitude 5 when it is closest to Earth, making it the brightest "minor planet" of the hundreds of thousands that have been cataloged.

ASTEROID STREAK
On April 24, 2020, author Dyer captured asteroid 3 Juno, then approaching opposition in the constellation Virgo. It was moving fast enough that its starlike image turned into a streak over the 90 minutes of exposure. Asteroids at opposition can move enough in one night to reveal their identity.

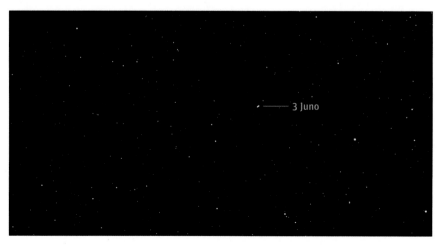

3 Juno

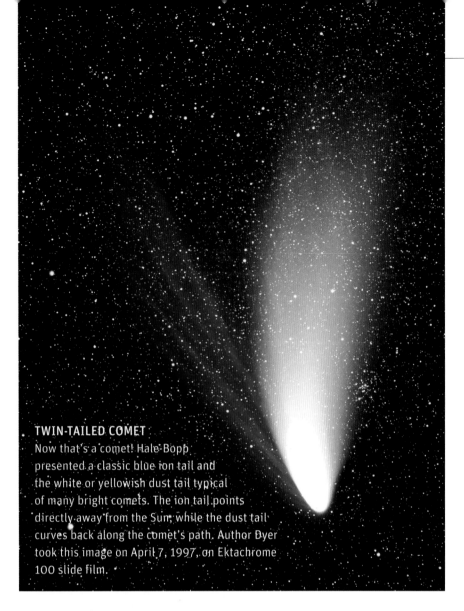

TWIN-TAILED COMET
Now that's a comet! Hale-Bopp presented a classic blue ion tail and the white or yellowish dust tail typical of many bright comets. The ion tail points directly away from the Sun, while the dust tail curves back along the comet's path. Author Dyer took this image on April 7, 1997, on Ektachrome 100 slide film.

OBSERVING COMETS

KEEPING UP ON COMETS
For current comet news, go to the websites of astronomy magazines or check spaceweather.com. Comet expert Seiichi Yoshida maintains a detailed site at http://aerith.net.

Comets are agglomerations of ice impregnated with dust, like dirty snowballs the size of a small city. Comets orbit the Sun in strongly elliptical paths, spending most of their time in the deep-freeze far from the Sun. Some have had their orbits shaped by Jupiter's gravity and travel strictly within the realm of the major planets. Called short-period comets, they all have orbital periods under 200 years. Even during a favorable appearance, however, most remain binocular objects at best (in the range of magnitude 5 to 10).

Of the comets that do brighten to naked-eye visibility (brighter than magnitude 5 for a fuzzy object like a comet), many come from the Kuiper belt, the zone beyond Neptune inhabited by Pluto and other dwarf planets.

These are known as long-period comets and take hundreds or thousands of years to complete one orbit, putting on their brief show perhaps only once in recorded history.

As a general rule, comets become active only when they venture within the orbit of Mars. At this distance, sunlight heats the comet's icy surface enough to release gas and dust that are swept into tails by the solar wind and the pressure of sunlight in the vacuum of space. If a comet comes close to Earth and the Sun *and* if it emits a lot of reflective dust, it can become bright enough to attract the attention of even casual stargazers. But a naked-eye comet, such as NEOWISE in 2020, is rare.

THE NAMING OF COMETS
Comet Halley, a member of the short-period comet club, is by far the best-known comet. Its fame stems from its 76-year orbit, closely matching a human life span, making the feathery cosmic visitor truly a once-in-a-lifetime sight. It made its best appearance in modern times in April 1910, when it reached first magnitude and sported a 30-degree tail. At its return in 1986, Halley never got brighter than magnitude 3.5, resulting in millions of disappointed viewers who were anticipating a spectacle in the sky.

Comet Halley is named for Edmund (or Edmond) Halley who, in 1705, calculated that the comet would return in 1758 by using the then new laws of gravity formulated by Isaac Newton, which Halley helped publish in Newton's *Principia* in 1687. This was the first time a comet's orbit had been plotted and its return predicted.

While a few historic comets are named for the scientist who determined the orbit of the comet, most are named for the person(s) who first saw the comet. Comet Hale-Bopp, for example, was spotted on the same night in July 1995 by New Mexico comet hunter Alan Hale and amateur astronomer Tom Bopp of Arizona.

By the 1990s, however, discoveries of comets by amateur astronomers sweeping the skies were becoming rare, which is even more true today. Most comets now carry the names of automated survey telescopes, not the name of any person associated with the search pro-

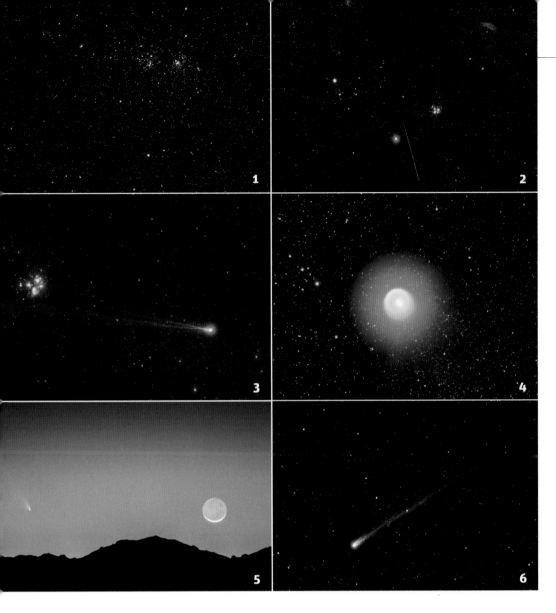

1 SMALL FUZZBALL
Comet PanSTARRS, C/2017 T2, is typical of many of each year's batch of comets, appearing only as a faint fuzzball in a telescope and recording with a characteristic green glow.

2 LARGER FUZZBALL
In December 2018, Comet 46P/Wirtanen passed unusually close to Earth, becoming just bright enough to see with the naked eye. But even in wide-field images, it was a green, tailless glow.

3 PHOTOGENIC TAIL
Discovered by Australian comet hunter Terry Lovejoy, Comet C/2014 Q2 became naked eye, but its blue ion tail remained a photographic target as it passed by the Pleiades in January 2015.

4 TAILLESS COMET AT MIDNIGHT Comet 17P/Holmes delighted all when it blossomed into naked-eye brilliance in late 2007. But the comet appeared opposite the Sun in the sky, so its tail was pointed away from us and appeared short.

5 TWILIGHT COMET
Another Comet PanSTARRS, C/2011 L4, was at its best low in twilight, as are many comets. March 12, 2013, was a memorable night, as the comet appeared close to the thin Moon. Wow!

6 GREAT COMET OF 1996
As Comet Hyakutake passed Earth 15 million kilometers away, its tail stretched for more than 45 degrees, from the Big Dipper to Coma Berenices, as shown in author Dyer's image taken March 25, 1996, on Fuji Super G 800 film with a 28mm Nikkor lens.

gram. Thus we have many comets named ATLAS (Asteroid Terrestrial-impact Last Alert System), LINEAR (LIncoln Near-Earth Asteroid Research), LONEOS (Lowell Observatory Near-Earth-Object Search) and PanSTARRS (Panoramic Survey Telescope and Rapid Response System), to name a few of the robotic telescopes that scour the skies for asteroids and supernovas. Comets are a bycatch.

The ability of these systems to pick up comets when they are still faint and far away has put most amateur comet hunters out of business. Amateurs used to find four to eight comets a year. Now it is only one or two at best. Even so, we have enjoyed recent comets from dedicated observers such as Terry Lovejoy and Don Machholz.

Once a comet is discovered, it is given a designation such as C/2020 F8, with the second letter indicating the half-month period it was found that year (A = first half of January,

B = second half, and so on) and the number signifying the order the comet was found during those two weeks. So Comet C/2020 F8 (SWAN) was the eighth comet found during the last half of March 2020. It is named for the instrument on board the SOHO Sun-observing satellite that was used to detect it.

A comet with a well-established orbit that is observed on more than one visit to the inner solar system is designated P/ with a number for the chronological order in which it was discovered. Thus Comet Halley, the first to be calculated, is 1P/Halley. As of 2020, about 400 comets have these permanent designations.

FIZZLES VS. FABULOUS

Comet discoverer David Levy has an oft-quoted saying that "comets are like cats—they have tails, and they do what they want." How bright a short-period comet will appear *can* be predicted with some assurance based

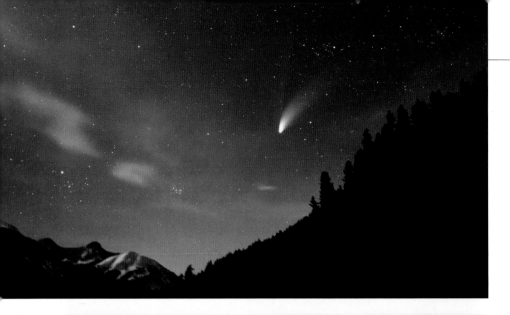

GREAT COMET OF 1997
A year after Hyakutake, Comet Hale-Bopp shone so brightly that it was visible from cities and in moonlight. Note its twin tails, looking very much like Donati's Comet of 1858. This 1.5-minute tracked exposure was taken April 12 on Fuji Super G 400 film with the same 28mm Nikkor lens used for Hyakutake (see page 279) to compare the apparent sizes of the two comets.

GREAT COMETS OF THE PAST

Comet observers long for the glory days of the 19th century, when brilliant comets were frequent. "Great Comets," to use a loosely defined term, appeared in 1807, 1811, 1819, 1825, 1830, 1843, 1854, 1858, 1860, 1861, 1874, 1881 and in June *and* September of 1882.

The latter, simply called the Great September Comet (officially C/1882 R1), was a sungrazer in the same "Kreutz group" that produced Comet Ikeya-Seki in 1965. It also has the distinction of being the first comet to be photographed in an image that survives. Before that, we rely on artist depictions, such as William Turner's fine 1858 painting *Donati's Comet*, shown below, recording a classic curving dust tail similar to that of Comet Hale-Bopp in 1997.

Most adults who later recounted having seen a comet as a child in 1910, the year of famed Comet Halley, actually saw the Great Daylight Comet (C/1910 A1) that appeared in late January, before Halley, peaking at magnitude –5 and growing a tail some 50 degrees long.

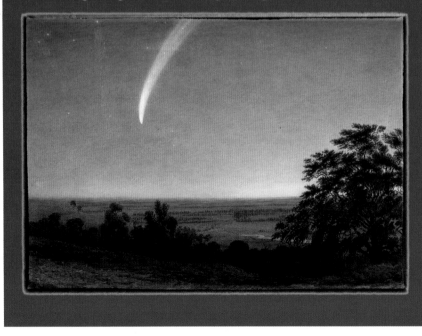

on past performance and its distance from Earth and the Sun. A good example is Comet Halley's lackluster but accurately predicted showing in 1986.

But familiar comets can surprise us. In October 2007, Comet 17P/Holmes, a normally faint comet, exploded in brilliance by a factor of 500,000, shooting up from magnitude 17 to 2.8 in a few days, bright enough to be visible to the unaided eye even from city limits.

A comet coming in for the first time, however, or one that has not been close to the Sun in thousands of years can fail to live up to expectations. The most infamous example is Comet Kohoutek (C/1973 E1), billed in late 1973 as the Comet of the Century. Its initial rate of brightening declined sharply. Rather than being a spectacular Christmas comet, it fizzled.

Other comets break up as they are warmed by the Sun, their pieces disintegrating into dim clouds. High hopes for a good show in May 2020 from Comet C/2019 Y4 (ATLAS) were dashed when its nucleus split into at least six fragments that all faded. In November 2013, Comet C/2012 S1 (ISON) completely vaporized as it grazed close to the Sun.

Making up for the fizzles are the fabulous comets. "Old-timers" might remember the two naked-eye comets that made back-to-back appearances in 1957: Comet Arend-Roland (C/1956 R1) in April and Comet Mrkos (C/1957 P1) in August. The brightest comet of the 20th century was Comet Ikeya-Seki (C/1965 S1), a member of the rare class of sungrazers that swoop to within one or two solar diameters of our star's surface. In late October 1965, Ikeya-Seki was visible to the unaided eye in broad daylight, at an astounding magnitude of –10.

Comet Bennett (C/1969 Y1), discovered in December 1969 by John Bennett of South

Africa, was a conspicuous second-magnitude object in the evening sky in April 1970. It was one of the first comets to be photographed in color. Imagine!

Then along came Comet West (C/1975 V1), discovered by Richard West in November 1975 at the European Southern Observatory. Comet West did the opposite of Kohoutek, far surpassing its predicted brightness. In early March 1976, the cosmic visitor moved out from behind the Sun to appear in the morning sky at magnitude –1, sporting a dust tail 30 degrees long. With the Kohoutek fiasco still fresh in their minds, news editors ignored Comet West, leaving it to be enjoyed only by avid amateurs, such as our guest author Ken Hewitt-White, who recounted his comet-chasing tale in Chapter 1. After West, bright comets were scarce for 20 years.

RECENT COMETS

In early 1996, the comet drought ended. Comet hunter Yuji Hyakutake of Japan picked up a small comet that came within 14 times the distance to the Moon. On a cosmic scale, that's close. In late March and early April, Comet Hyakutake (C/1996 B2) displayed a 60-degree tail and reached first magnitude as it moved quickly across the northern sky.

Then came the undisputed king of the comets: Comet Hale-Bopp (C/1995 O1). Many readers will remember this magnificent object, which reached first magnitude in March and April 1997. Hale-Bopp was probably the most impressive comet seen in the northern hemisphere since the 1880s.

Both comets were poorly placed for viewers in the southern hemisphere. Austral observers got their comet in January 2007. After rounding the Sun and moving into the southern-hemisphere sky, Comet McNaught (C/2006 P1), discovered by Robert McNaught, became a stupendous sight, flaunting a huge fountain-like tail. Then, in July 2020, Comet NEOWISE (C/2020 F3), discovered by a NASA infrared satellite, became the brightest comet seen from the northern hemisphere since Comet Hale-Bopp.

Great comets such as NEOWISE often appear with only a few months' warning, so we can only hope for another one soon.

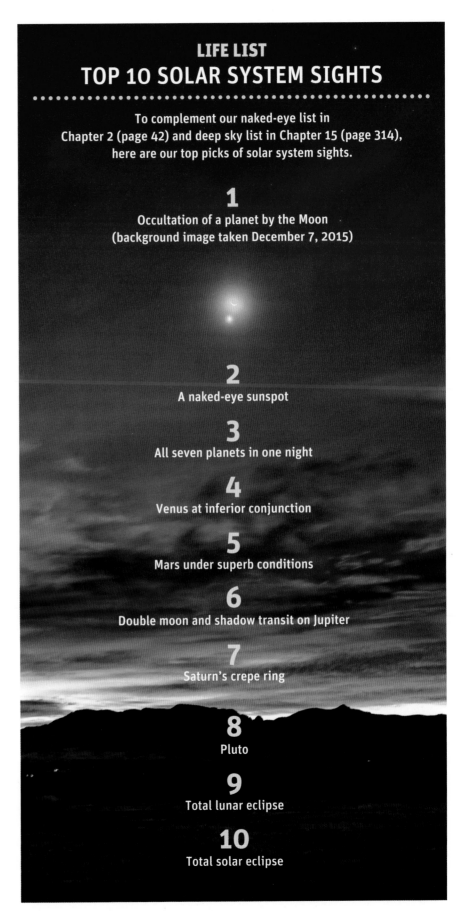

LIFE LIST
TOP 10 SOLAR SYSTEM SIGHTS

To complement our naked-eye list in Chapter 2 (page 42) and deep sky list in Chapter 15 (page 314), here are our top picks of solar system sights.

1
Occultation of a planet by the Moon
(background image taken December 7, 2015)

2
A naked-eye sunspot

3
All seven planets in one night

4
Venus at inferior conjunction

5
Mars under superb conditions

6
Double moon and shadow transit on Jupiter

7
Saturn's crepe ring

8
Pluto

9
Total lunar eclipse

10
Total solar eclipse

CHAPTER 15

Exploring the Deep Sky

Professional astronomers at mountaintop observatories do not look through telescopes. They use giant cameras to record starlight onto electronic detectors. Seeing the subtle light from distant galaxies and nebulas "live" through an eyepiece has become the exclusive domain of amateur astronomers. Today's backyard stargazers share a common bond with the great visual observers of the 18th and 19th centuries, who made their discoveries during all-night sessions at the eyepiece.

A cluster of galaxies might appear only as a field of faint fuzzies at the threshold of vision through an amateur telescope. Unimpressive at first glance, until you realize that each of those indistinct spots is another Milky Way, filled with stars, planets and, perhaps, curious minds like ours. Deep sky observing is done as much with the mind as it is with the eye. So with that "in mind," we now venture into the realm of the deep sky, where targets can be spectacular...or subtle.

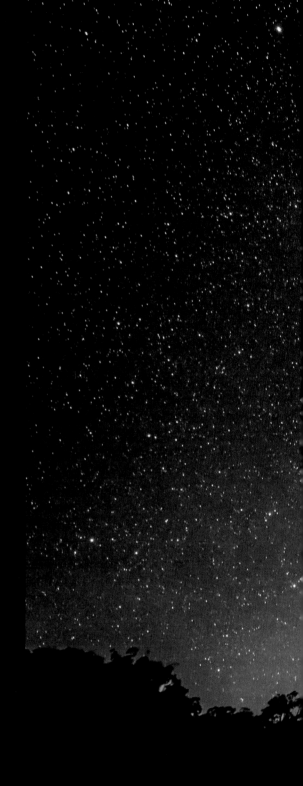

Observing in deep sky paradise, as the Dark Emu rises in the east, author Dyer enjoys viewing the great southern sky at the OzSky Star Safari, in Australia. To make use of ideal sites like this, the best telescope is a big-aperture Dobsonian. And they don't get much bigger than this 30-inch Obsession! Nor do the skies get much darker —note the glow of gegenschein to the left of the Milky Way.

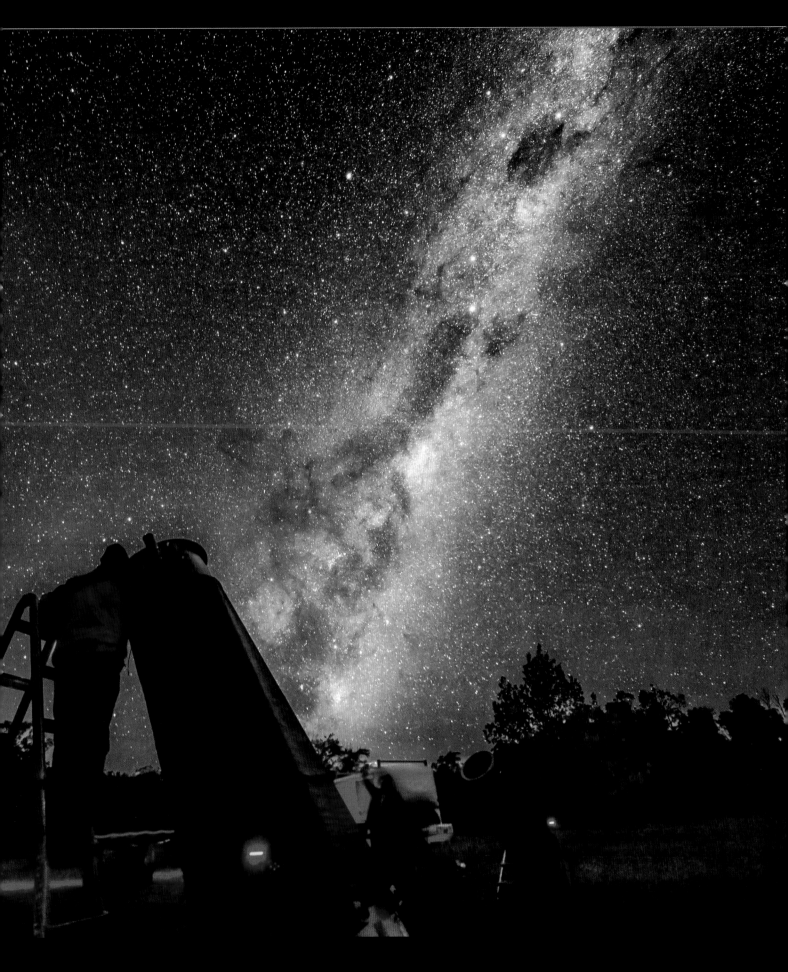

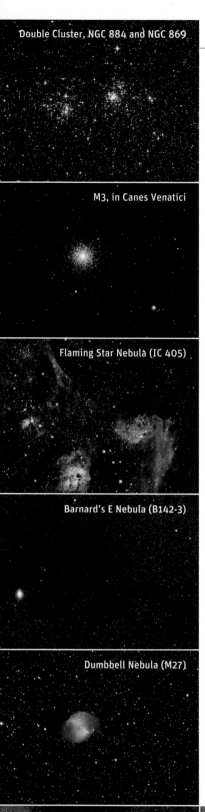

Double Cluster, NGC 884 and NGC 869

M3, in Canes Venatici

Flaming Star Nebula (IC 405)

Barnard's E Nebula (B142-3)

Dumbbell Nebula (M27)

THE DEEP SKY MENAGERIE

The deep end of the sky officially starts at the edge of the solar system and extends out to clusters of galaxies and enigmatic quasars. Taken literally, it encompasses everything in the universe except our Sun and its family of attendant worlds. The deep sky also includes the many types of stars that make up the constellations. And yet when amateur astronomers speak of deep sky objects (DSOs), they are usually referring to extended objects: the star clusters and nebulas of our own Milky Way Galaxy and the many types of galaxies that lie beyond the Milky Way.

Of the thousands of DSOs within reach of our telescopes, each can be classified into one of a few species in the deep sky menagerie.

OPEN STAR CLUSTERS
These are collections of a few dozen to a few hundred stars all gravitationally bound and usually recently formed from a collapsing cloud of dust and gas. Some, such as the Double Cluster, are bright enough to be naked eye.

GLOBULAR STAR CLUSTERS
The name comes from their spherical shape. Globulars like Messier 3 are intrinsically much larger than open clusters and contain hundreds of thousands of stars. They are spectacular in a moderately sized telescope.

BRIGHT NEBULAS
These are interstellar clouds of gas (mostly hydrogen) and dust (mainly carbon) in which new stars form. Nebulas, such as the Flaming Star, glow either by emitting their own light or by reflecting the light of nearby stars.

DARK NEBULAS
Made of obscuring dust, these objects appear as black patches against a bright background of stars. Dark nebulas, such as B142-3, require a dark sky to see. The biggest appear to the naked eye as "holes" in the Milky Way.

PLANETARY NEBULAS
These are misnamed, as they have nothing to do with planets. Planetary nebulas, such as the Dumbbell, typically appear as a compact shell of gas cast off by a Sun-like star at the end of its life. They represent one product of star death.

SUPERNOVA REMNANTS
While only a handful of supernova remnants are visible in amateur telescopes, they are among the most famous and intricate of nebulas. An example is the Vela supernova remnant, which looks like fragments of glowing explosion debris.

THE MILKY WAY
This is the name we give the galaxy in which we live, and it is best seen with the naked eye. Simply look up on a dark, moonless night (see page 43). You need a telescope only when you want to see objects *in* the Milky Way.

OTHER GALAXIES
Thousands of galaxies lie beyond the Milky Way. A handful can be seen with the naked eye and a few dozen more with binoculars. But most require a moderate-aperture telescope. Spiral galaxies, like the Leo Trio, are iconic examples.

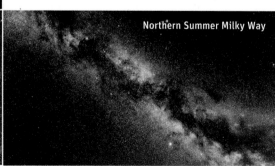

Vela Supernova Remnant

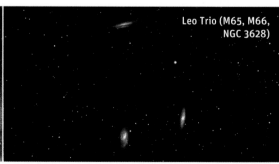

Northern Summer Milky Way

Leo Trio (M65, M66, NGC 3628)

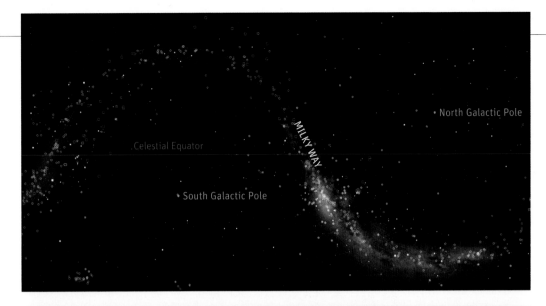

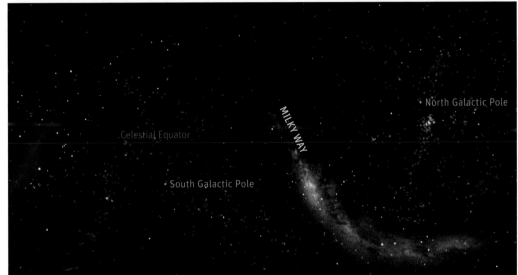

ALONG THE MILKY WAY
Most of the open star clusters (yellow) and nebulas (green) lie along the band of the Milky Way, formed by the disk of our galaxy, where new stars are born and old stars die. Globular clusters (orange) orbit the Milky Way in a halo centered on the bright galactic core. They are mainly found around Sagittarius and Scorpius.

REALM OF THE GALAXIES
The dense foreground of our galaxy's dusty spiral arms blocks our view of galaxies behind the Milky Way, so most of the galaxies we see (orange, red and blue) are found away from the Milky Way. The compact collection at right in this photo, toward the north galactic pole, is the Coma-Virgo supercluster. The region around the south galactic pole at left, in Sculptor, Fornax and Eridanus, is also richly endowed with galaxies.

MAKING SENSE OF THE SKY

The term "Milky Way" can be confusing. Everything we see in the night sky with unaided eyes (except the Andromeda Galaxy and the Magellanic Clouds) belongs to our spiral-shaped galaxy. We call our entire galaxy the Milky Way (*Via Lactea* in Latin). But in its original sense, the term referred only to the gray band of light arching across the sky in summer, fall and winter. It took Galileo with his first telescope to discover that this milky band is composed of stars much fainter than those obvious to the naked eye.

When we look at the band of the Milky Way, we are gazing into the spiral arms of our disk-shaped galaxy, toward the densest parts of the galaxy. It's within the spiral arms that

stars are born and die, so we see most nebulas and star clusters along the Milky Way. Globular star clusters are the exception. Most of those live in a halo thousands of light-years across that surrounds the core of the Milky Way. From our vantage point halfway to the edge of the galaxy, we look toward its center around Sagittarius and see that region of sky populated with globulars, like bees buzzing about a distant hive.

Galaxies beyond our Milky Way inhabit the parts of the sky where the Milky Way isn't. We see few galaxies embedded along the Milky Way band, not because they aren't there but because they are either dimmed or hidden by the mass of star-stuff that comprises our galaxy.

WHAT'S A LIGHT-YEAR?
Beyond the solar system, distances are so vast, we measure them in units of how far light travels in a year moving at 300,000 kilometers per second. One light-year is 10 million million kilometers. The nearest star beyond the Sun is 4.3 light-years away.

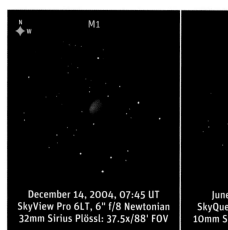

M1

December 14, 2004, 07:45 UT
SkyView Pro 6LT, 6" f/8 Newtonian
32mm Sirius Plössl: 37.5x/88' FOV

M3

June 26, 2008, 06:00 UT
SkyQuest XT8, 8" f/6 Newtonian
10mm Sirius Plössl: 120x/24' FOV

M8/NGC 6523, NGC 6530

August 20, 2006, 05:45 UT
SkyView Pro 6LT, 6" f/8 Newtonian
32mm Sirius Plössl: 37.5x/88' FOV

M104

June 22, 2008, 04:30 UT
SkyQuest XT8, 8" f/6 Newtonian
10mm Sirius Plössl +2x Barlow:
240x/12' FOV

SKETCHING TO SEE MORE

Expert sketcher Jeremy Perez provides examples of what can be done at the eyepiece and later at home, often with the aid of image-processing software to add finishing touches digitally. But producing artwork isn't the main goal—forcing your eye to really see is the objective, as well as creating a personal record of what you observed and the viewing conditions that night.

DEEP SKY STATION

A camping table for laying out accessories and star charts, an observing stool for seated viewing when the eyepiece height allows and a camp chair for relaxing coffee breaks all make for an enjoyable session of deep sky viewing under the stars.

DIVING INTO THE DEEP SKY

You'll never run out of things to look at in the realm of the deep sky. From objects so large they can be seen with the naked eye to objects so small and faint they require a giant 24-inch telescope, the universe has much to offer. However, it is hard to discount the need for lots of aperture.

Bigger telescopes resolve globular clusters

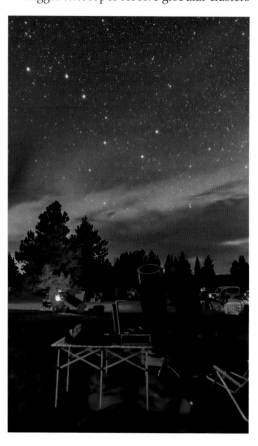

into swarms of pinpoints. More aperture makes nebulas appear brighter, almost resembling their photographs, and turns galaxies from ill-defined spots into unmistakable spirals mottled with dust lanes. Even so, sheer brute-force aperture is not the sole requirement for deep sky exploring. Just as important is the honing of key observing skills.

OBSERVING TIPS

No matter what telescope you use to explore the deep sky, a few techniques will help you see more than you might think possible.

◆ **Cultivate Night Vision** Becoming dark-adapted is essential. Each eye's pupil dilates to its maximum aperture in 10 to 15 minutes. But over another 15 to 20 minutes, a chemical reaction in the eye kicks in that further boosts its sensitivity. Once your eyes have become dark-adapted, avoid any white or bright lights.

◆ **Practice Jiggle Vision** Another trick is to jiggle the telescope. The slight motion in the field can reveal dim targets that might otherwise fade into the background.

◆ **Hit the Road** The best accessory for any telescope is a dark sky. Away from city lights, even an 80mm refractor can show all the brightest members of the Coma-Virgo galaxy cluster.

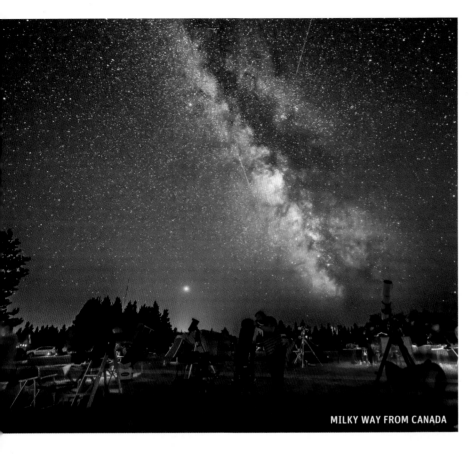

MILKY WAY FROM CANADA

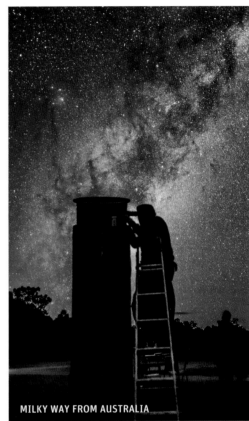

MILKY WAY FROM AUSTRALIA

◆ **Don't Give Up on the City** The brighter Messier objects, especially star clusters, are visible even through the murk of urban sky glow. GoTo telescopes can help you find them.

◆ **Drawing Upon Experience** The best way to learn to see is to draw what you see. Over time, you'll be amazed at the improvement in your visual acuity. If you're interested in sketching, The Royal Astronomical Society of Canada has an excellent resource page at rasc.ca/astrosketchers-group.

◆ **Log the Sky** You can record your impressions and the sky conditions in writing or as voice memos. Logging your observations helps you learn to see.

AVERTED VISION

The most common trick for seeing faint fuzzies is to employ averted vision. The technique is simple. Look slightly away from the object under study while continuing to concentrate on it. Averted vision is most effective if you look at a point halfway from the center to the edge of the field. If you observe with your right eye, look to the right of the object.

This method works because the cells of the eye's retina off-center are more sensitive to dim light. The gain achieved can be as much as a magnitude. While averted vision can reveal an object, you might not consider a sighting definite unless you see the target with direct vision.

LIMITING-MAGNITUDE FACTORS

How faint can you see? It depends on much more than just telescope aperture. Factors include seeing, the transparency of the atmosphere, the quality and cleanliness of the telescope's optics, the type of telescope, its magnification, the use of averted vision and the kind of celestial object being viewed. But most important is the observer's experience.

An experienced observer can typically see a magnitude fainter than can a novice. Hundreds of hours of observing through a telescope train the eye to detect threshold detail. While visual acuity varies from person to person, the difference seldom amounts to more than half a magnitude. Young people's eyes

ADAPTING TO THE DARK
Whether you are at a star party, left, or out on your own, follow the "Red Lights Only Rule" when deep sky viewing to preserve your night vision. Even then, make sure lights are dim and, if observing with others, not aimed into their eyes. At very dark sites, as above, even the glowing core of the Milky Way can be a detriment to staying fully dark-adapted. Here, for detecting the faintest fuzzies at the threshold of vision, an observer has a hood on to block out stray light.

RUNNING THE MESSIER MARATHON

Seeing all 110 objects in Charles Messier's catalog in one night seems an impossible feat. And yet that's just what some avid observers attempt to do.

The period between March 5 and April 12 is prime season, with the ideal nights being March 30 to April 3 if the Moon is new. The early-evening targets on marathon night are the autumn Messiers, and participants hastily pick out M74, M77, M33 and M31, plus its companions, in the twilight. The race then turns to easier winter targets. After a midnight breather, the marathoners move on to Heartbreak Hill: the multitude of spring-sky galaxies. From there, it's a downhill run to the dawn sky and the congestion of the final mile in Sagittarius. M30, in Capricornus, is the elusive prize, rising just before dawn. *The Year-Round Messier Marathon Field Guide* by Harvard Pennington (Willmann-Bell, 1997) and *The Observing Guide to the Messier Marathon* by Don Machholz (Cambridge, 2002) serve as excellent guides.

BIGGER IS BETTER

The more aperture, the more you'll see. These illustrations simulate the view of the Whirlpool Galaxy (M51) in a small-, moderate- and large-aperture telescope. Spiral arms only hinted at in a small aperture become obvious and nearly photographic in a big telescope.

generally have slightly more sensitivity to objects at the threshold of vision, but veteran observers who are in their fifties or older can usually come within two-tenths of a magnitude of eyes 30 years younger.

The ability of a youthful observer's eyes to dilate to 7mm or 8mm, compared with 5mm or less for more senior eyes, has no bearing when viewing through a telescope. The higher magnifications employed on a scope result in exit pupils much smaller than 7mm anyway.

One of the long-standing assumptions of backyard astronomers is that faint deep sky objects are best seen at low magnification operating at maximum exit pupil. While this does apply to some large, diffuse nebulas, it is untrue when viewing more compact objects. Boosting magnification darkens the sky and enlarges an object enough to make it more obvious. Small, faint galaxies invisible at 50x may pop into view at 150x.

While transparent skies are paramount in deep sky observing, bad seeing—the bane of planetary observers—can remove a full magnitude from the limit of a steady-air night.

Do different types of telescopes have different magnitude-penetration limits? Yes, but there's not much variation. It depends more on the quality of the optics than on the type of telescope. High-quality optics yield pinpoint star images instead of the tiny puffballs that never quite come into focus in mediocre telescopes. Quality can win out over sheer aperture—but only to a point in deep sky viewing.

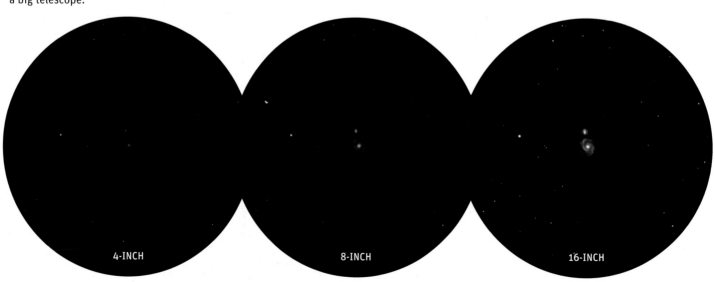

4-INCH 8-INCH 16-INCH

INVENTORIES OF THE SKY

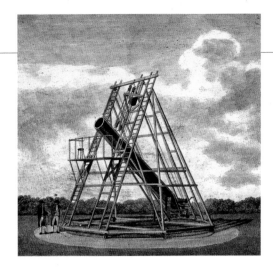

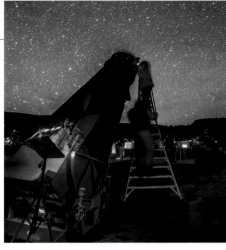

Using computerized telescopes, backyard stargazers can now call up thousands of deep sky objects from a variety of catalogs. These inventories of the sky are the result of 300 years of meticulous observations. In the 18th and 19th centuries, explorers of the sky hunted down and listed everything within reach of their often crude telescopes. The result was a hodgepodge of celestial catalogs, complete with baffling nomenclature, that are still very much in use today.

MESSIER'S CATALOG

This most famous of deep sky catalogs provides backyard astronomers with a ready list of the best and brightest targets. Ironically, it was compiled as a catalog of things *not* to look at.

In the late 1700s, Charles Messier did not set out to find deep sky targets. To him, they were merely nuisance objects he kept bumping into during searches for his intended targets —comets. He published lists of the fuzzy noncomets so that he and his comet-hunting colleagues would not be fooled by them. Today, Messier's comet discoveries are largely forgotten. It is his list of nuisance objects that is remembered, as Messier, or M, objects.

Current versions of Messier's catalog contain 110 objects, including M104 to M109, discovered by an associate, Pierre Méchain, and reported to Messier but not listed in a published version of his catalog. NGC 205, one of the Andromeda Galaxy's companions, was apparently logged by Messier but never added to his catalog. Modern-day observers have dubbed it M110.

From a rural site, all the Messier objects can be seen with an 80mm telescope. The larg-

DEEP SKY OBSERVING THEN AND NOW

Most of the targets we view today were discovered by 18th- and 19th-century astronomers using ungainly telescopes, such as William Herschel's 40-foot reflector (that's the tube length not aperture), above left. What these astronomy pioneers would have given to have a modern Dobsonian, like the 36-inch Obsession, above, Barbara Mitchell is observing with at the Texas Star Party.

CHARLES MESSIER, 'FERRET OF COMETS'

On September 12, 1758, French astronomer Charles Messier was tracking a comet he had found when he encountered something unexpected in the sky. He called it "a nebulosity above the southern horn of Taurus. It contains no stars; it is a whitish light, elongated like the flame of a taper." Messier wasn't the first to see the object; English astronomer John Bevis had logged it 27 years earlier. But Messier's rediscovery of what eventually became known as the Crab Nebula (M1) inspired him to inventory more "comet masqueraders," objects he and others might mistake for the real celestial prize of the day: a comet.

From a rooftop observatory at the Hôtel de Cluny in Paris, Messier found 13 comets between 1760 and 1798, winning him the title of "ferret of comets" from Louis XV, the king of France. Messier's first *Catalogue of Nebulae and Star Clusters*, published in 1771, contained 41 objects that he and his colleagues had discovered. For good measure, Messier added four well-known objects— the Orion Nebula complex (M42 and M43), the Beehive cluster (M44) and the Pleiades (M45)— bringing his first list to a tidy 45 objects. Messier published revised versions of his catalog in 1783 and 1784, bringing the total inventory of Messier objects to 103. Subsequent additions bring the total to 110.

The Messier numbers follow a haphazard sequence across the sky, because the objects are numbered in the order in which Messier located them or learned of them. Although he intended to, he never did publish a list with the entries renumbered in order of right ascension, west to east, across the sky. Illness, old age and the French Revolution intervened.

MR. NGC

From 1874 to 1878, John Louis Emil Dreyer surveyed the sky with the 72-inch Leviathan telescope (then the largest in the world) at Ireland's Birr Castle. He went on to complete the *New General Catalogue* that is still in use today.

MASTER REFERENCE WORKS THEN AND NOW

In the late 1970s, *Burnham's Celestial Handbook* by Robert Burnham, Jr. set a benchmark for completeness. Updating the science was the series *Annals of the Deep Sky* by Jeff Kanipe and Dennis Webb, now sadly out of print.

est telescope Messier himself used was an 8-inch reflector, though its metal mirror had the light-gathering power of a modern 4-inch. Tracking down the Messiers over the course of a year or two is a rewarding endeavor. In the process, you'll become familiar with the sky, learn how to see faint objects through your telescope and gain enough credits to graduate to the level of an experienced observer.

THE NGC AND IC

Most deep sky enthusiasts complete the Messier list. Then what? The next goal is collecting NGC objects. NGC stands for *New General Catalogue*, which was originally compiled by Danish-born astronomer John Louis Emil Dreyer under the aegis of the Royal Astronomical Society in England. Published in 1888, Dreyer's *New General Catalogue of Nebulae and Clusters of Stars* contained observations of 7,840 objects from dozens of observers and replaced all previous lists and catalogs. Even the Messier objects were assigned NGC numbers. The NGC listed every nebula and cluster known in 1888.

Unlike the random nature of the Messier catalog, NGC objects are all neatly ordered by right ascension. The numbering starts at 0 hour right ascension (or what was 0 hour in 1888) and increases from

west to east across the sky. However, successively numbered NGC objects can be separated by many degrees north or south in declination.

Soon after the NGC was printed, it required revision. A supplementary *Index Catalogue* (IC) was published in 1895, followed by another one in 1908. The first IC contains 1,529 objects discovered visually. The second IC offers another 3,856 entries, many found through the then new technique of photography. Most of these later IC objects (with numbers higher than 1529) are too faint to detect visually. They are "I-don't-see" objects.

The brightest NGCs are easy targets for an 80mm telescope. But a 5- to 8-inch telescope, at a minimum, is needed to dive deeply into the NGC list.

HERSCHEL'S CATALOG

Avid deep sky observers wanting to venture beyond the Messier catalog can tackle 400 of the best Herschel objects. Prompted by a suggestion from author James Mullaney in the 1970s, members of the Ancient City Astronomy Club, in St. Augustine, Florida, embarked on a project to sort out the core objects of the NGC, the 2,477 entries from William and Caroline Herschel's original 1786 *Catalogue of Nebulae and Clusters of Stars*. From this, the club sifted out the 400 best, the so-called Herschel 400. All are known by NGC numbers but also carry now obsolete Herschel numbers. For example, NGC 4565 is also H V-24, the 24th entry in the Herschels' Class V type of object.

DEEP SKY LIBRARY

Observing guides abound, but we consider these volumes essential additions to any deep sky library. *The Night Sky Observer's Guide* (four volumes) by Kepple, Sanner, Cooper and Kay (Willmann-Bell; now out of print) compiles descriptions of thousands of objects from many observers. Stephen O'Meara's *Deep-Sky Companions* series (Cambridge) is an excellent guide to the Messier and Caldwell lists and to his favorite lesser-known targets. Ronald Stoyan's *Atlas of the Messier Objects* (Cambridge) is a beautiful coffee-table guide to Monsieur Messier's catalog.

CALDWELL CATALOG

In 1995, a new deep sky best-of list was introduced to the hobby, largely through the promotion of *Sky & Telescope* magazine. Patrick Moore, Britain's best-known astronomy author, presented his list of 109 of ostensibly the most notable non-Messier objects, selected primarily from the NGC. He titled his list after his full last name, Caldwell-Moore. Caldwells are arranged from north to south in order of decreasing declination and include southern-hemisphere targets.

Many GoTo telescopes offer Caldwells as target choices. However, a fair number of the Caldwells (and, indeed, some of the Messiers) are visual duds. Be warned: Caldwells aren't necessarily the best of the non-Messiers. For those, we suggest author Dyer's listing of the 110 Finest NGC Objects, published annually in the RASC *Observer's Handbook*.

BEYOND THE NGC

Even with its several thousand entries, the *New General Catalogue* ignores an entire class of object: dark nebulas. It was left to American astronomer Edward Emerson Barnard to compile the first catalog of these "B" objects. Barnard's "Catalogue of 349 Dark Objects in the Sky" was included in his 1927 work *A Photographic Atlas of Selected Regions of the Milky Way*. Other dark nebulas carry an "LDN" designation, from Beverly Lynds' 1962 *Catalogue of Dark Nebulae*.

Within the class of emission nebulas, advanced observers pursue elusive objects having prefixes such as Ced (S. Cederblad's 1946 list), Sh2 (Sharpless), Mi (Minkowski), vdB (van den Bergh) and Gum (Colin Gum's 1955 nebula survey).

Detailed star atlases plot open clusters with such prefixes as Be (Berkeley), Cr (Collinder), Do (Dolidze), H (Harvard), K (King), Mel (Melotte), Ru (Ruprecht), St (Stock) and Tr (Trumpler). Many of these non-NGC clusters were missed by earlier eyepiece surveys, since they are either very large or so sparse they don't stand out from the background.

Thanks to the advent of nebula filters, experienced amateur astronomers routinely pick off non-NGC planetary nebulas once thought to be invisible. Some are from George

Abell's list of 100 large, faint planetaries that he discovered by examining photos taken with the Palomar Schmidt telescope in the 1950s.

Abell also cataloged many clusters of faint galaxies. Deep atlases also plot galaxies with designations such as PGC (the 1989 *Catalogue of Principal Galaxies*), UGC (the 1973 *Uppsala General Catalogue of Galaxies*), MCG (the *Morphological Catalogue of Galaxies*, compiled from 1962 to 1974) and ESO (the European Southern Observatory's 1982 catalog of faint southern-sky galaxies).

HERSCHEL GUIDES

For specialists wishing to pursue the Herschel 400 list, Stephen O'Meara's and Mark Bratton's guides (both by Cambridge) will help you in your quest.

THE HERSCHEL DYNASTY

Few families have had as significant an impact on science as the Herschels' influence on astronomy. In the 1770s, William Herschel, a musician by profession, took up the craft of telescope making. His Newtonian reflectors, all with speculum metal mirrors, proved so superior to any of the day that Herschel became the equivalent of a millionaire just from telescope sales. On March 18, 1781, Herschel used his 6.3-inch reflector to sweep up what he initially thought was a comet. It proved to be Uranus, the first planet discovered in historic times. England's King George III appointed Herschel his private astronomer. Set for life, Herschel built ever larger reflectors, culminating in 1789 with a 48-inch telescope, which he used to survey the sky.

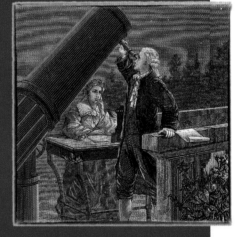

Herschel's principal assistant on his night shifts was his sister, Caroline. In her own explorations of the sky, Caroline Herschel discovered eight comets and is credited with finding M110, one of the companions to the Andromeda Galaxy. Caroline was also instrumental in the publication of the catalogs of nebulas and clusters that the brother-and-sister team had found and logged.

William's only son, John, continued the dynasty, discovering more than 2,000 deep sky objects, many during a stay in the southern hemisphere. In 1864, the younger Herschel published a compilation of the family's lifework, the *General Catalogue of Nebulae and Clusters of Stars*, an exhaustive listing of 5,000 nebulas and clusters. The master of visual astronomy, John Herschel became one of the pioneers of photography. The first photo ever taken on a glass plate is John's 1839 image of his father's soon-to-be-dismantled 48-inch telescope on the grounds of their British country home.

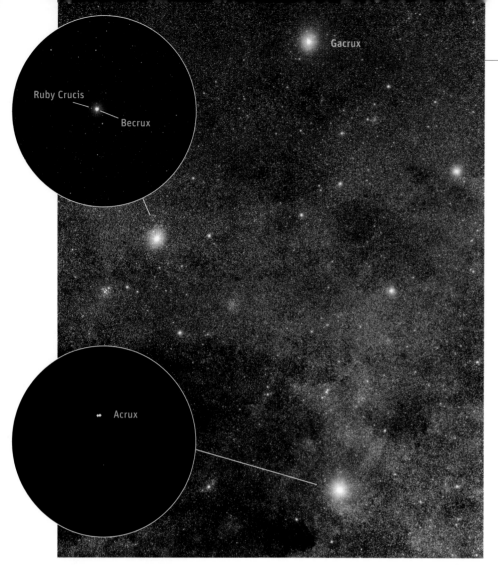

COLORS IN THE CROSS
Gacrux, the red-giant star (spectral class M) at the top of the Southern Cross, has a cool surface temperature of 3,600 K, compared with the other stars of Crux (spectral class B), at more than 20,000 K, making them appear white or blue-white. At the bottom of Crux is one of the sky's best double stars, Acrux, with its pair of closely matched white stars four arc seconds apart. The very red carbon star Ruby Crucis is in the same low-power field as brilliant blue Becrux.

THE STARS

Dark skies are not a prerequisite for all deep sky targets. From the confines of a city, some of the best sights are the many types of stars.

DOUBLE STARS: STELLAR JEWELS

The majority of stars (estimates suggest as many as a third) belong to systems of two or more stars orbiting one another, the result of a common origin in a spinning cloud of gas and dust.

Many double stars have measured orbital motions, though it may take centuries for the stellar partners to dance around each other. Some doubles are merely traveling together through space (dubbed CPM, or Common Proper Motion). A famous example is Zeta (ζ) Ursae Majoris, better known as Mizar, the middle star in the handle of the Big Dipper. Its naked-eye companion, Alcor, isn't orbit-

ing Mizar but is traveling with it. However, Mizar itself is a true gravitationally bound double whose components are resolvable in any telescope. (See Ken Hewitt-White's telescope Tour 7 on page 328.)

Some double stars don't belong together at all; they are merely coincidental lineups in the sky. The showpiece double Albireo, or Beta (β) Cygni, might be an example, but distance measurements to the pair aren't precise enough to confirm whether they are gravitationally connected or just a line-of-sight coincidence.

In our opinion, the best double stars fall into one of two categories: strongly colored pairs (often yellow and blue, such as Albireo) and pairs with close stars of nearly equal brightness (usually white or blue-white) that look like a pair of distant headlights.

Double stars have also been compiled into catalogs. The master list is the *Washington Double Star Catalog* (WDS), which has a whopping 100,000 entries. A more practical list is the *Aitken Double Star Catalogue* (ADS), published by Robert Aitken in 1932. It contains 17,180 entries. Famed double-star observers Wilhelm Struve, his son Otto and, later, Sherburne Burnham compiled earlier lists in the 19th century. Some stars are still best known by their Struve (Σ or OΣ) or Burnham (β) numbers. We encountered Σ747 in Ken's binocular Tour 1 on page 115.

In historic guidebooks, the colors attributed to double stars read like an artist's palette of pastel hues (azure, lilac, aquamarine, cerulean blue, rose) or a jeweler's tray of gems and minerals (gold, silver, turquoise, emerald, topaz). Be warned, these tints are subtle and subjective. Only a few doubles show obvious colors, such as Delta (δ) Cephei and Gamma (γ) Andromedae. Most exhibit pale tints at best but are still attractive.

In addition, the colors of faint companions, called secondary stars, are often illusory, an effect of contrast with the brighter primary

NU DRACONIS

DELTA CEPHEI

MATCHED VS. CONTRASTING

Nu Draconis (aka Kuma, or the "dragon's eyes"), in Draco, is a classic "headlight" double with matching white stars 63 arc seconds apart, wide enough for binoculars. Delta Cephei is a showpiece colorful double with yellow and blue components 40 arc seconds apart.

FAMOUS DOUBLES

In Ursa Major, dimmer Alcor is separated from Mizar by 708 arc seconds. Mizar itself is a double with a 14-arc-second gap. Epsilon Lyrae, the Double-Double in Lyra, has two matched pairs, each 2.1 to 2.4 arc seconds apart, separated by 210 arc seconds.

MIZAR AND ALCOR

EPSILON LYRAE

GAMMA ARIETIS

THETA SERPENTIS

'HEADLIGHT' DOUBLES

Gamma Arietis boasts identical white stars (the "ram's eyes") 7.5 arc seconds apart, impressively close but easy. The type A white components of Theta Serpentis are wider and look like piercing eyes in the sky.

EAGLE-EYED DAWES

"Using a capital little refractor of only 1.6 inches aperture…I worked away almost every night, when uncertain health would permit, and found and distinctly made out…Castor, Rigel, ε^1 and ε^2 Lyrae, σ Orionis, ζ Aquarii and many others."

Such dedication earned England's William Rutter Dawes the reputation of being one of the finest observers of the mid-1800s—that and his eagle eyes. Try splitting those double stars with a 1.6-inch refractor, and you'll appreciate Dawes' remarkable acuity. And yet for all his eagle-eyed ability at the telescope, Dawes was so nearsighted that legend has it he could pass his wife on the street and not recognize her.

In today's amateur circles, Dawes is best known for his rule on resolving power: "I thus determined…that a one-inch aperture would just separate a double star composed of two stars of the sixth magnitude, if their central distance was 4.56"…Hence, the separating power of any given aperture, a, will be expressed by the fraction 4.56"/a."

We still use this rule of thumb today for calculating the resolving power of a telescope. But keep in mind that this empirical rule was devised for stars of equal and moderate brightness. Double stars whose components exhibit a wide range in brightness will be harder to split.

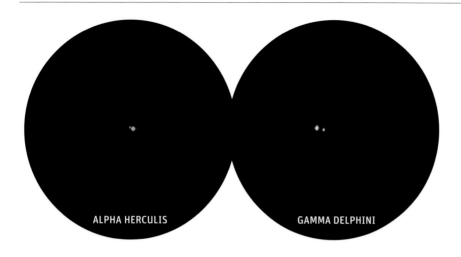

ALPHA HERCULIS GAMMA DELPHINI

Some stars show significant orbital motion over several years. Sirius is becoming easier to resolve after the 1993 minimum separation (called periastron) of 2.5 arc seconds between Sirius and its faint white-dwarf companion, Sirius B. Maximum separation of 11 arc seconds is (or was) in 2022. Gamma (γ) Virginis, aka Porrima, reached periastron in 2008, when the stars swung around each other only 0.4 arc second apart. The gap is slowly increasing, and from now and into the 2030s, Porrima will be easy to split in a moderate-aperture telescope.

COLORFUL DOUBLES

A northern summer favorite is Alpha Herculis (Rasalgethi), with its orange primary star and fainter turquoise secondary. Gamma Delphini's stars are described as yellow and light emerald or lilac.

star. For example, the companion of Antares isn't really green; it just appears that way next to its bright yellow-orange primary.

Stars with separations between one and two arc seconds will tax the resolving power of telescopes under 4 inches aperture, and stars less than one arc second apart will test 8-inch and larger telescopes. In less-than-ideal seeing conditions, telescopes of any size seldom resolve stars closer than 0.5 arc second apart. Doubles that feature dim companions orbiting brilliant primary stars (such as Antares and Sirius) can be difficult to resolve in any backyard telescope.

CARBON STARS: COSMIC COOL

Variable stars pulsate in brightness over hours, days or weeks. Some variables feature two stars eclipsing each other, such as Algol, nicknamed the Demon Star, in Perseus. But most variables are single stars physically pulsating in size and brightness over a period of several days. Delta Cephei is the classic example, for which Cepheid variables are named. Cepheids are key to measuring cosmic distance scales using a period versus luminosity relation called Leavitt's Law, after its discoverer Henrietta Swan Leavitt, who published her findings in 1908.

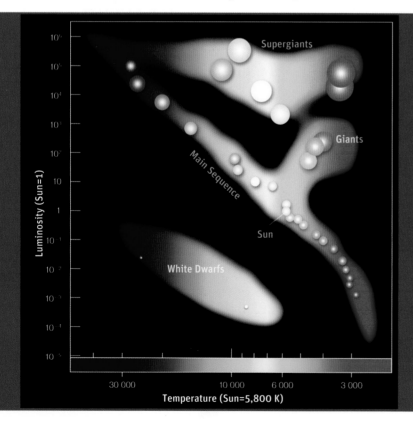

STAR COLORS

Astronomers class stars by an arcane sequence of spectral letters, easily remembered from hot to cool by the mnemonic: Oh Be A Fine Guy/Girl Kiss Me. (All temperatures are in Kelvin, with zero Kelvin equal to absolute zero at −273°C.)

SPECTRAL CLASSES	TEMPERATURE
O = Blue	47,500 K–31,000 K
B = Blue-white	30,000 K–10,000 K
A = White	9,800 K–7,300 K
F = Yellow	7,200 K–6,000 K
G = Yellow-orange	5,900 K–4,900 K
K = Orange	4,800 K–3,900 K
M = Red	3,800 K–2,200 K

Our Sun is an average G-type star with a surface temperature of 5,770 K.

In 1603, Johannes Bayer published *Uranometria*, a set of star charts in which he labeled stars with Greek letters. He typically called the brightest star in a constellation Alpha (α), the second brightest Beta (β), and so on, down the 24-letter Greek alphabet to Omega (ω). We still use these Bayer letter designations today. For example, Sirius is Alpha (α) Canis Majoris.

By tradition, the constellation name in such designations takes the Latin genitive, or possessive, case. Thus it is Gamma Arietis (not Gamma Aries), meaning Gamma of Aries.

A French edition of John Flamsteed's 1729 *Atlas Coelestis* introduced the system of numbering stars from west to east across a constellation, the so-called Flamsteed numbers. Most naked-eye stars carry a Flamsteed number. Sirius is 9 Canis Majoris. Both Bayer letters and Flamsteed numbers are used on our tour charts in Chapters 6 and 16.

The first computer-generated star atlas, published by the Smithsonian Astrophysical Observatory in the 1960s, catalogs 260,000 stars down to ninth magnitude. Sirius, for instance, is designated SAO 151881.

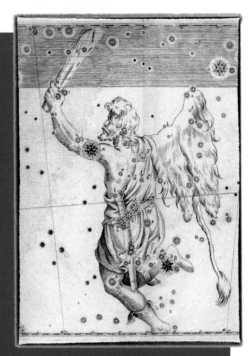

A colorful subset is the long-period variables, which are often red and take months to cycle up and down in brightness. A famous example is Betelgeuse, which dipped to a record dim magnitude of 1.6 in early 2020.

Many red stars are also classed as carbon stars, among the coolest known, with surface temperatures of less than 3,000 K. In addition, their atmospheres are cool enough to support sooty carbon compounds that absorb blue light, contributing to the stars' deep red tints.

When checking the data for carbon stars, you'll find a color index. This is an objective method of measuring a star's color that subtracts a star's brightness in the visual yellow-green, or V, band of the spectrum from the star's brightness in the blue, or B, band. This B-V color index value has been set to 0 for blue-white stars such as Vega. Bluer stars have a slight negative color index. Moving the other way down the spectrum, our yellow Sun's color index is +0.65. Red giants, such as Betelgeuse and Aldebaran, have color indices around +1.5 to +2.0 but look more yellow-orange than red.

By comparison, carbon stars have color indices of 5 or higher and look like glowing-red coals. The depth of the color varies with aperture; carbon stars are sometimes more intensely red in a small telescope than in a large one. Carbon stars can slowly pulse in a range of up to five magnitudes over hundreds of days and often look reddest when faintest.

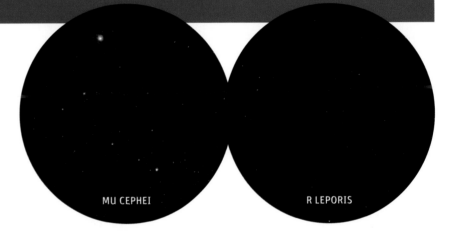

GARNET AND CRIMSON
The red supergiant star Mu (μ) Cephei, with a color index of +2.35, was dubbed the Garnet Star by John Herschel. Hind's Crimson Star (R Leporis), discovered in 1845 by John Hind, is a ruby-red carbon star, with a color index of +5.74.

LA SUPERBA AND TX PISCIUM
Dubbed La Superba in the 19th century by Angelo Secchi, the carbon star Gamma (Y) Canum Venaticorum varies between magnitude 4.8 and 7.3. At about fifth magnitude, TX, or 19, Piscium is visible to the naked eye and appears very red in binoculars.

STAR CLUSTERS

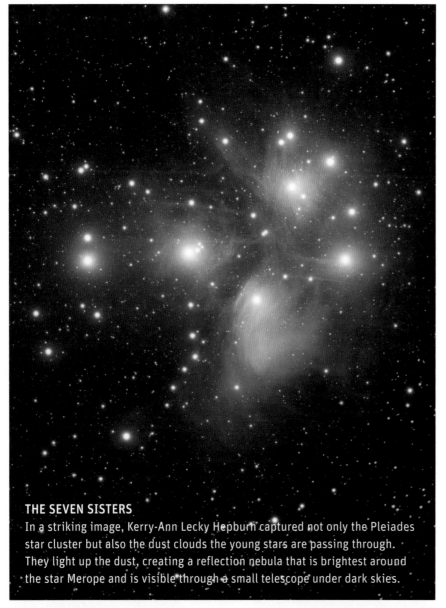

THE SEVEN SISTERS
In a striking image, Kerry-Ann Lecky Hepburn captured not only the Pleiades star cluster but also the dust clouds the young stars are passing through. They light up the dust, creating a reflection nebula that is brightest around the star Merope and is visible through a small telescope under dark skies.

Astrophotographers can make a good case that the full glory of a nebula or a galaxy can be seen only in images. But it's tough for a photograph to capture a star cluster's visual quality of glittering diamond dust.

OGLING OPEN CLUSTERS

The word "open" refers to the resolvability of this class of star cluster. In the best cases, all the members of an open cluster can be seen individually, unlike the partially resolved glow of most globular clusters. Open clusters range from brilliant eyepiece-filling star fields down to faint smudges resolvable with moderate to high magnification.

The stars in an open cluster were all born at the same time from a nebula. Roughly 1,900 open star clusters have been cataloged in our Milky Way Galaxy. Some 10 to 25 light-years across in the prime of their lives, open clusters eventually disperse, scattering their member stars along our galaxy's spiral arms. The clusters we see today are "only" tens to hundreds of millions of years old.

How well an open cluster shows in the eyepiece depends on several factors. One is size. Large clusters (more than 30 arc minutes in apparent diameter) require a wide field and low power. For example, the Pleiades and Beehive clusters, the destinations of two binocular tours in Chapter 6, can look better in an 8x

WILD DUCK CLUSTER
One of the finest open star clusters, the Wild Duck Cluster (M11) is embedded in the Scutum Star Cloud.

E.T. CLUSTER
Gaze at NGC 457, in Cassiopeia, and you'll see the stellar outline of "E.T. the Extra-Terrestrial." It is also called the Owl Cluster.

JEWEL BOX
Named by John Herschel, the Jewel Box Cluster (NGC 4755), in Crux, contains a ruby-red star in a field of blue diamonds.

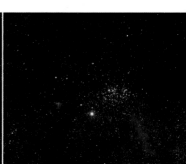

FOOTBALL CLUSTER
NGC 3532, the Football Cluster in Carina, is also called the Black Arrow Cluster, for the dark lane bisecting its rich mass of stars.

finderscope than they do in a long-focal-length telescope. To fully appreciate, say, M35, in Gemini, you need a field of view at least twice the cluster's ½-degree size so that M35 appears distinct from its background. Conversely, a small cluster (less than five arc minutes across) requires high power to resolve.

Magnitudes of open clusters range from 1.5 (the Pleiades) to fainter than 12. You would think that the brighter the cluster, the better it would look. Not necessarily. A cluster's magnitude is a measure of the total brightness of all its member stars. If it contains merely a handful of bright stars, a cluster's appearance may be disappointing despite a high magnitude rating.

What makes a cluster interesting is its richness (the number of member stars in a given area) and the contrast between the cluster and the surrounding star field. The best clusters usually contain 100 or more members, earning them the official designation of "rich."

GLORIOUS GLOBULARS

Like miniature spherical galaxies, globular star clusters contain hundreds of thousands of ancient suns packed into a space 25 to 250 light-years wide. Approximately 180 globulars have been found that belong to our Milky Way, the majority being suitable targets for amateur telescopes. Most are ancient, having formed 9 to 11 billion years ago as by-products of the creation of the galaxy itself. The nearest globulars lie several thousand light-years away, toward the core of our galaxy.

Seeing globulars in all their glory requires sharp, well-collimated optics as well as aperture. A good 4-inch telescope will begin to resolve the best northern globulars, such as M3, in Canes Venatici; M5, in Serpens (see Tour 8 in Chapter 16); and M13, in Hercules (Tour 9). It will also reveal southern-sky wonders M22, in Sagittarius (Tour 12); NGC 6397, in Ara; and NGC 6752, in Pavo.

Not all globulars are as dazzling as those showpieces. Globular clusters range in size from 1 to 20 arc minutes across. The largest ones are best—Omega Centauri being the biggest of all (see Tour 20 in Chapter 16). Small globulars are more difficult to resolve, appearing as fuzzy spheres. But also important is

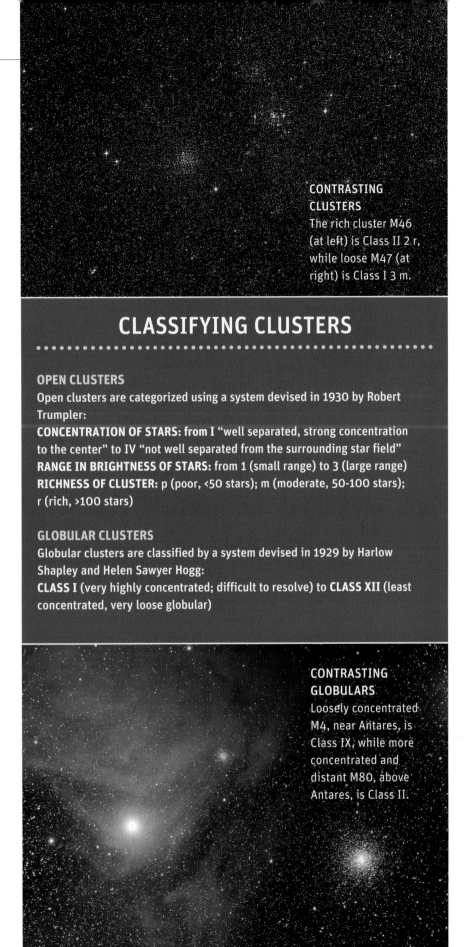

CONTRASTING CLUSTERS
The rich cluster M46 (at left) is Class II 2 r, while loose M47 (at right) is Class I 3 m.

CLASSIFYING CLUSTERS

OPEN CLUSTERS
Open clusters are categorized using a system devised in 1930 by Robert Trumpler:
CONCENTRATION OF STARS: from I "well separated, strong concentration to the center" to IV "not well separated from the surrounding star field"
RANGE IN BRIGHTNESS OF STARS: from 1 (small range) to 3 (large range)
RICHNESS OF CLUSTER: p (poor, <50 stars); m (moderate, 50-100 stars); r (rich, >100 stars)

GLOBULAR CLUSTERS
Globular clusters are classified by a system devised in 1929 by Harlow Shapley and Helen Sawyer Hogg:
CLASS I (very highly concentrated; difficult to resolve) to **CLASS XII** (least concentrated, very loose globular)

CONTRASTING GLOBULARS
Loosely concentrated M4, near Antares, is Class IX, while more concentrated and distant M80, above Antares, is Class II.

their degree of concentration. Some globulars are so compressed, they are difficult to resolve in even a large-aperture telescope.

At the other end of the scale, a few globulars are so loosely concentrated, they take on the appearance of rich, finely resolved open clusters. Good examples are NGC 288, in Sculptor; NGC 5466, in Boötes; and NGC 5897, in Libra. In fact, the relatively loose globular M71, in Sagitta, was classified as an open star cluster for many years.

MESSIER 13
The Great Globular Cluster in Hercules (Class V) is a showpiece of the northern summer sky, yet it ranks below southern globulars for spectacle.

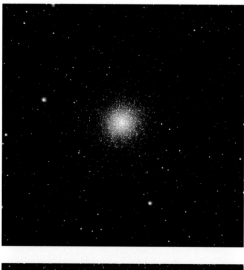

NGC 2419, in Lynx, is called the Intergalactic Wanderer, as it is 300,000 light-years away. Your reward is simply detecting it. If you live below 40 degrees north latitude, try NGC 1049, an 11th-magnitude blur only 0.6 arc minute across that resides in a dwarf elliptical galaxy called the Fornax Dwarf. Although the galaxy is too faint to be seen in most amateur telescopes, this one globular stands out, shining from a distance of 460,000 light-years.

But NGC 1049 is not the distance champ.

MESSIER 22
Because of its low altitude in Sagittarius, M22 (Class VII) is often ignored by northern observers, despite its outclassing northern M13.

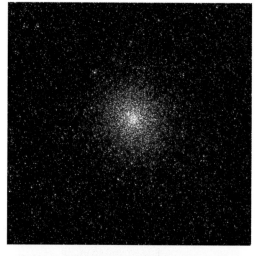

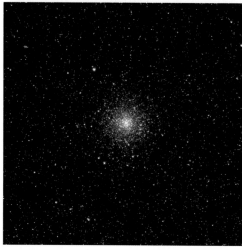

NGC 6397
This southern object in Ara is the fourth brightest globular in the sky, and being Class IX, it is easily resolved in a small telescope.

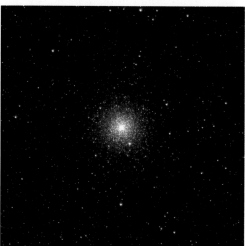

NGC 6752
This globular cluster (Class VI) in Pavo is also easy to resolve. Some observers rank it #3 after the globulars Omega Centauri and 47 Tucanae.

Owners of big scopes can go after tiny, starlike globulars surrounding the Andromeda Galaxy, 2.5 million light-years away. Another challenge is to hunt down the 15 Palomar globulars, most of which are buried in the Milky Way and dimmed by intervening dust. When you finish those, you can attempt the even more obscure globulars (all 11 of them) in Agop Terzan's *Catalogue of Globular Star Clusters*.

ASTERISMS, THE NONCLUSTERS

Every observer encounters asterisms—interesting alignments of stars that we perceive as familiar shapes, instead of just random patterns. Yet that's exactly what they are—chance arrangements of stars. Asterisms are not true clusters and remain unlabeled on most star charts (the *interstellarum Deep Sky Atlas* is an exception).

A well-known example lies in the dim constellation Camelopardalis: Kemble's Cascade. Named for Canadian observer Father Lucien Kemble, this asterism is a two-degree-long chain of fifth- to eighth-magnitude stars.

A binocular field southwest of M52, in Cassiopeia, you'll find a three-degree-long chain of stars that resembles a number 7 on its side. Three degrees southwest of the cluster M50, near the Monoceros-Canis Major border, is the asterism Pakan's 3, first noted by Canadian Randy Pakan.

Polaris forms the sparkling jewel of a 45-arc-minute-wide semicircle of faint stars dubbed the Engagement Ring by Robert Burnham Jr. The one-degree-long Little Fish swims in a rich Milky Way "sea" in Auriga, near M38. Ken Hewitt-White noted it in his binocular Tour 2, on page 115.

Finally, the sprawl of stars surrounding Alpha (α) Persei, or Mirfak, looks as though it should be an asterism or an official cluster. It even carries the designation Melotte 20. But this group is classed as an OB Association, a collection of hot young stars that, in this case, formed together 50 million years ago and are now only loosely bound in the nearby Perseus Arm of the Milky Way.

For a comprehensive list of asterisms suitable for binoculars and telescopes, the Astronomical League (www.astroleague.org) offers one as part of its many observing programs.

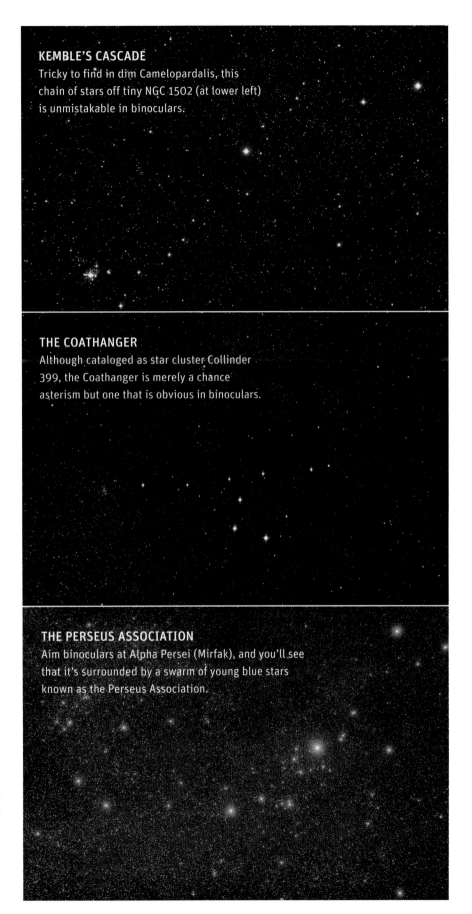

KEMBLE'S CASCADE
Tricky to find in dim Camelopardalis, this chain of stars off tiny NGC 1502 (at lower left) is unmistakable in binoculars.

THE COATHANGER
Although cataloged as star cluster Collinder 399, the Coathanger is merely a chance asterism but one that is obvious in binoculars.

THE PERSEUS ASSOCIATION
Aim binoculars at Alpha Persei (Mirfak), and you'll see that it's surrounded by a swarm of young blue stars known as the Perseus Association.

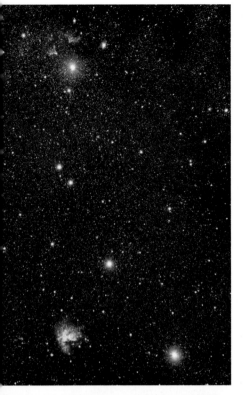

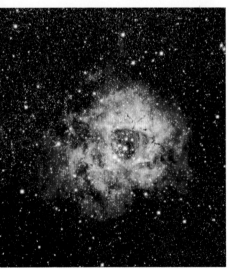

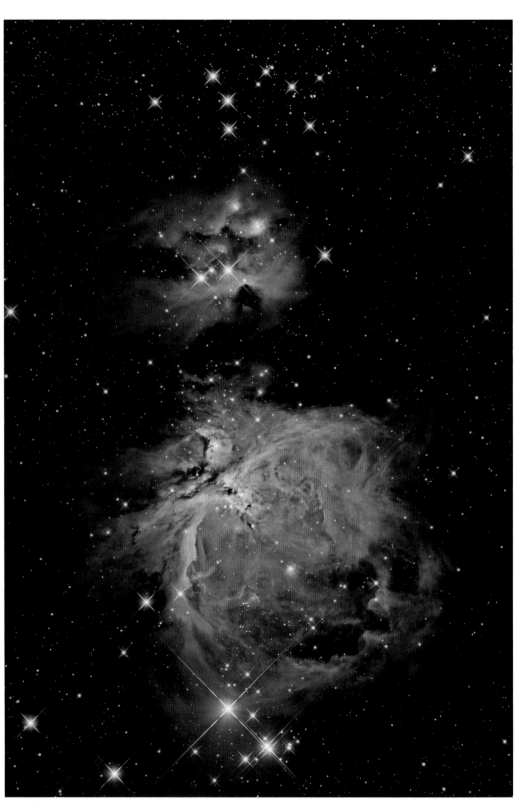

PACMAN AND ROSETTE

Top: North of the Pacman Nebula (NGC 281), in Cassiopeia, are the dim reflection nebulas IC 59 and IC 63, near blue Gamma Cassiopeiae.
Above: The Rosette Nebula is visible even in binoculars as a ghostly glow around the star cluster NGC 2244, in Monoceros.

ORION NEBULA

Ron Brecher's superb composite of many exposures captures both the bright inner core and the faint outer wisps of the Orion Nebula (M42). Above it is the blue reflection nebula called the Running Man. M42's core can look green to the eye, and large telescopes show a hint of the outer pinks. But your eye can certainly see much of this complex structure and mottling, even through a small-aperture telescope.

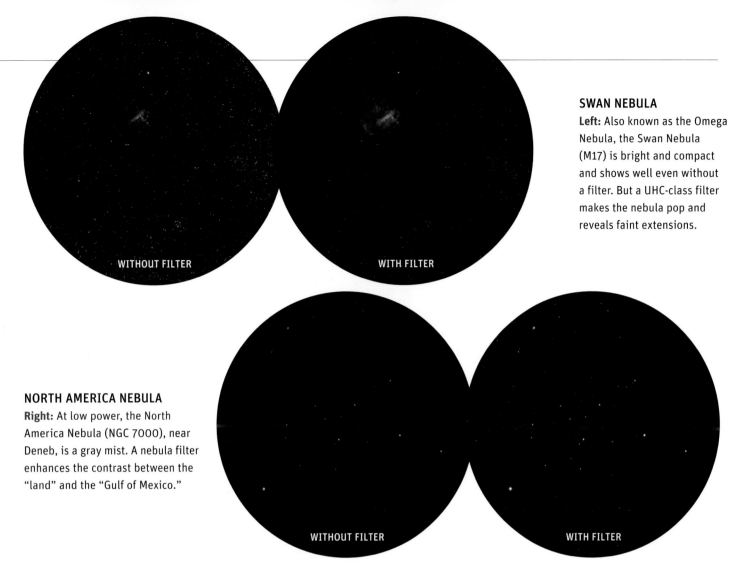

SWAN NEBULA
Left: Also known as the Omega Nebula, the Swan Nebula (M17) is bright and compact and shows well even without a filter. But a UHC-class filter makes the nebula pop and reveals faint extensions.

WITHOUT FILTER

WITH FILTER

NORTH AMERICA NEBULA
Right: At low power, the North America Nebula (NGC 7000), near Deneb, is a gray mist. A nebula filter enhances the contrast between the "land" and the "Gulf of Mexico."

WITHOUT FILTER

WITH FILTER

WHERE STARS ARE BORN

The anticipation of seeing nebulas in Technicolor entices many newcomers to a telescope, and unfortunately, the views inevitably disappoint. The human eye is simply not sensitive enough to pick up the colors that cameras record in long exposures. As we simulate in our circular eyepiece views, these clouds of celestial smoke appear in monochrome gray. Only a few (the Orion Nebula, the core of the Carina Nebula and some planetaries) are bright enough to excite the eye's color receptors.

Despite the limitations, a 6- to 12-inch telescope can show a wealth of detail in the brightest nebulas, producing views that look almost photographic, albeit in black and white. Some nebulas look better in the eyepiece than they do in photos because the eye can capture the full range of detail, from bright to dim, along with stars embedded within the nebula that can be washed out in long-exposure images.

GLOWING GAS CLOUDS

Stars form from interstellar clouds of dust and gas. Cold, dark clouds of hydrogen and complex molecules line the spiral arms of the Milky Way, where shock waves from nearby supernovas can trigger their collapse into a nebula. Most nebulas stretch a few dozen light-years across space. The Tarantula Nebula holds the record for the largest, spanning a mind-boggling 900 light-years.

The iconic example is the Orion Nebula, Messier 42, surely one of the first deep sky objects every amateur astronomer observes. Appropriately, M42 is the target for Ken's first telescope tour in Chapter 16. M42 is an emission nebula—a nebula that glows with its own unique light.

Embedded within every emission nebula is a very hot blue star newly formed out of the surrounding cloud (more often, there is a group

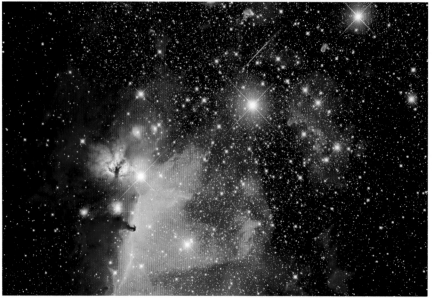

DUAL DARK HORSES

Top: To the naked eye, the large dark lanes in Ophiuchus look like a black horse. The southern half is known as the Pipe Nebula (B78). At center lies the tiny Snake Nebula (B72), a telescopic target for dark nights. The photo's field of view is about 15 degrees wide.

Above: Located below Orion's belt, the Horsehead Nebula (B33) requires an 8-inch or larger telescope and a UHC filter or, better yet, a Hydrogen-beta filter to bring out the faint emission nebula IC 434, the backdrop to B33's tiny silhouette. This field of view is about four degrees wide.

of these stars, such as the four Trapezium stars at the heart of M42). The stars emit ultraviolet light into the heart of the nebula, pumping up the neutral hydrogen atoms. The resulting energy jolt tears the atoms apart, creating a sea of free electrons and protons, a process called ionization, which turns the neutral hydrogen into singly ionized hydrogen atoms called H II. Emission nebulas are often called H II regions. As the wayward electrons are recaptured, they give up their excess energy as visible light in a series of narrow wavelengths.

In photographs, emission nebulas look red, the result of light emitted at a wavelength of 656.3 nanometers, the hydrogen-alpha spectral line deep in the red end of the spectrum. In the eyepiece, however, emission nebulas, if they show any color at all, appear greenish, as the eye is more sensitive to green than to red. Again, M42 is a good example. Its green color is produced in part by the hydrogen-beta emission line at 486.1 nanometers but pri-

marily by a pair of lines at 500.7 and 495.9 nanometers, generated by oxygen that has lost two of its eight electrons. Doubly ionized oxygen is called O III.

The fact that nebulas emit light at these discrete wavelengths makes nebula filters possible—they allow the select wavelengths to pass while rejecting all others, improving the contrast between object and sky. Most emission nebulas don't have published magnitude figures, so you might be surprised at what you can see, especially with a filter.

MISTY REFLECTION NEBULAS

Most nebula filters do little to enhance the view of reflection nebulas, which do not emit their own light but shine because the light of a nearby star, or stars, scatters off dust particles embedded in the nebula. "Dust" is a catchall term for any interstellar matter larger than molecules. The dust inside nebulas is thought to be graphite coated with ice. The spectrum of a reflection nebula is the same as the continuous spectrum of a star. Since newly formed stars are usually bluish, reflection nebulas are often blue as well.

Reflection nebulas are less common than emission types. The Messier catalog lists only one, M78 (see Tour 2 in Chapter 16). Most are faint and difficult to see, often washed out by the glare of the nearby source star.

One hazard when seeking reflection nebulas is that dew or dirt on the eyepiece or the main optics can produce a pale glow around any bright star. A humid atmosphere also creates hazy star images. Hunting reflection nebulas is best left for dry, transparent nights with clean optics.

DARK NEBULAS: SILHOUETTES ON THE SKY

Although composed of the same mixture of gas and dust as bright emission and reflection nebulas, dark nebulas lack any embedded or nearby stars to warm or illuminate them. They appear as nearly starless voids—cold, black patches obscuring whatever lies behind them.

Some dark nebulas can be spotted with the unaided eye. The black rifts and lanes that split the Milky Way in Cygnus are dust clouds lining the arms of our galaxy about 4,000 to 5,000

light-years away. The five-degree-wide Coal Sack, near the Southern Cross, is a dense mass of dust roughly 600 light-years away (see our binocular Tour 9 on page 119).

Not all dark nebulas are so large. Many of them fit nicely into a telescope's low-power field. But how do you observe an object that gives off no light? The trick is to use a wide field (one degree or more) to see the dark area framed by the surrounding star field. A large telescope is not needed—a short-focus 90mm refractor is fine, as are 70mm or 80mm binoculars. Dark nebulas often carry an "opacity rating" of 1 to 6, with 6 being the darkest and most obvious, appearing even darker than the background sky.

Unfortunately, most GoTo telescopes don't include dark nebulas (B or LDN objects) in their databases. To track them down, turn to printed works such as the *Pocket Sky Atlas*, *SkyAtlas 2000.0* or the *interstellarum Deep Sky Atlas*. In mobile apps, try SkySafari or Luminos. With these, you can locate dark nebulas such as B86 and B92, in Sagittarius, both small patches silhouetted against rich Milky Way star fields.

A dark sky is imperative. Unless the Milky Way is a shining river of light, forget about hunting for this elusive class of object.

DISCOVERY OF THE HORSEHEAD

In 1881, Edward C. Pickering, the director of the Harvard College Observatory, in Cambridge, Massachusetts, was unhappy with the work being done by his male employees analyzing stacks of photographic plates, declaring the work was so easy that even his maid could do it. So he hired her, one Williamina Fleming.

Fleming became one of the first of the famous "Harvard computers," women hired to do the tedious job of data reduction. In the group photo below, Pickering is at left and Fleming is standing. Among the "computers" were Henrietta Swan Leavitt, Annie Jump Cannon and Antonia Maury. Cannon, Maury and Fleming devised the stellar spectral-classification system in use today. Leavitt found a way to measure the distances to galaxies.

While looking at Plate #B2312 in 1888, Fleming noticed an odd nebula below Alnitak, in Orion's belt. Can you see it in the negative image here? It's what she would have looked at. The object became known as the Horsehead Nebula. However, in compiling his *Index Catalogues* of photographic discoveries, John Louis Emil Dreyer credited Pickering, overlooking Fleming.

AROUND THE GALACTIC CENTER

Accessible to northern- and southern-hemisphere observers, the Milky Way in Sagittarius and Scorpius provides a rich hunting ground with any optical aid.

Binoculars net you three Messiers in one field. The nebulas really shine in a telescope.

M20 Trifid Nebula

M21

M8 Lagoon Nebula

M23

In 1764, Charles Messier discovered this cluster sparkling west of M24.

Sagittarius

M24 Small Sagittarius Star Cloud

NGC 6645

The Small Sagittarius Star Cloud (M24) contains the dark nebula B92, with the star cluster M18 and the emission nebulas M16 and M17 above.

M16 Eagle Nebula

B92

M17 Swan Nebula

M18

M24 Small Sagittarius Star Cloud

M25

Although logged by Messier, M25 was never included in Herschel's catalog. Its number is IC 4725.

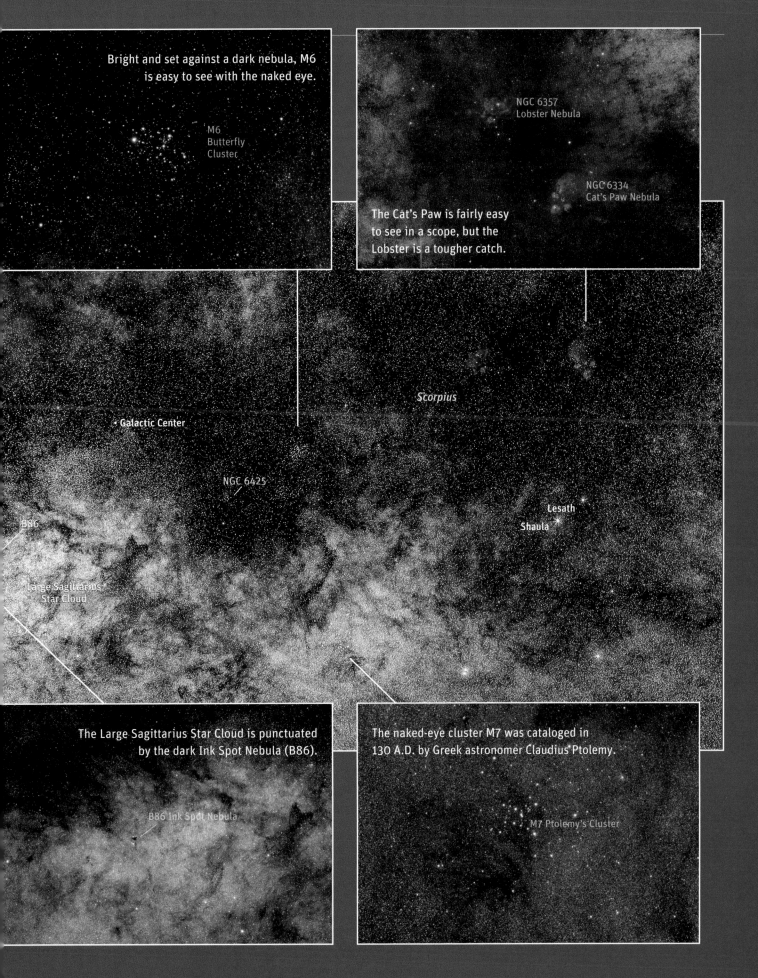

Bright and set against a dark nebula, M6 is easy to see with the naked eye.

M6 Butterfly Cluster

NGC 6357 Lobster Nebula

NGC 6334 Cat's Paw Nebula

The Cat's Paw is fairly easy to see in a scope, but the Lobster is a tougher catch.

Scorpius

Galactic Center

NGC 6425

Lesath

Shaula

B86

Large Sagittarius Star Cloud

The Large Sagittarius Star Cloud is punctuated by the dark Ink Spot Nebula (B86).

B86 Ink Spot Nebula

The naked-eye cluster M7 was cataloged in 130 A.D. by Greek astronomer Claudius Ptolemy.

M7 Ptolemy's Cluster

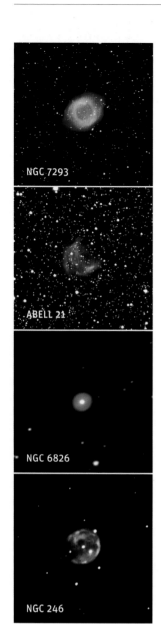

NGC 7293

ABELL 21

NGC 6826

NGC 246

PLANETARY VARIETY
The Helix Nebula (NGC 7293), in Aquarius, is huge but is viewable in small scopes. The Medusa Nebula (Abell 21), in Gemini, is a challenge for big scopes. The Blinking Planetary (NGC 6826), in Cygnus, appears when you use averted vision but winks out if you stare at the central star. The Skull Nebula (NGC 246), in Cetus, shows mottled structure.

WHERE STARS DIE

Not all nebulas are areas of star formation. Some are sites of stellar death. At the end of their lives, stars cast off material that is eventually swept up by star-forming nebulas, where it goes on to enrich a new generation of stars as part of a grand galactic recycling program.

In fact, all the elements that are heavier than helium, including carbon, oxygen, iron and every other element critical for life, were forged inside stars. When you look at a planetary nebula or a supernova remnant, you are seeing where the stuff that makes you came from.

SMOKE-PUFF PLANETARIES

Planetary nebulas are not sites of planet formation. William Herschel, who discovered Uranus, called them planetary nebulas because many reminded him of the appearance of a round but dim planet. The name stuck.

We know now that a planetary nebula is a shell of gas expelled by a Sun-like star during an unstable phase near the end of its life. The process takes thousands of years and often involves several episodes of stellar belching, which creates complex structures as fast-moving gas runs into older, slower-moving shells. The aging star then shrinks to a hot white dwarf the size of a small planet. About 3,000 planetary nebulas have been cataloged no more than a few thousand light-years away, all in our sector of the galaxy.

For the deep sky observer, planetary nebulas fall into one of three broad categories: large and bright; bright but starlike; and large and faint. The differences are partly intrinsic and partly due to distance.

The classic Ring Nebula (M57) is an example of a large, bright planetary. It's described in detail in telescope Tour 10 in Chapter 16. The Dumbbell Nebula (M27), in Vulpecula (Tour 11), exhibits a classic double-lobed structure shared by many planetaries, such as the Spiral Planetary (NGC 5189), in Musca, arguably the southern sky's best planetary nebula.

Most planetaries fall into the category of "bright but starlike." With disks 20 arc seconds

or less in diameter, they are difficult to distinguish from stars at low power. At high power, however, they often show blue-green disks.

At the opposite end of the planetary-nebula scale are large (more than 60 arc seconds), dim objects. The Helix Nebula (NGC 7293), for example, spans half the diameter of the Moon, but its low surface brightness makes it elusive under average sky conditions. Two others in this class are NGC 6781, in Aquila, and the Skull Nebula (NGC 246), in Cetus. These faint, diffuse planetaries can be difficult to see without a nebula filter. Yet when viewed with a filter in 10-inch or larger telescopes under dark skies, they become showpiece objects.

EXPLODING SUPERNOVA REMNANTS

Very massive stars end their lives abruptly. In a matter of minutes, 90 percent of a star's mass is blasted into space, while the remaining core collapses into a superdense neutron star or, perhaps, a black hole. In the process, the star gives off as much energy as an entire galaxy, a dramatic finale to a star's life, but a rare one. Only a few of the most massive stars are supernova candidates.

The best-known supernova remnant is the Crab Nebula (M1), in Taurus, the remains of a supernova witnessed by humans nearly 10 centuries ago, in 1054 A.D. However, because the Crab is about 6,500 light-years away, the explosion itself took place 6,500 years before the light of the explosion reached us.

IC 443 appears as a crescent-shaped arc near the star Eta (η) Geminorum. Extremely faint, it is a challenge for even an experienced observer using a filter-equipped 12-inch telescope. In the southern sky, we've traced the brightest fragments of the Vela supernova remnant using a 10-inch.

Thor's Helmet (NGC 2359), in Canis Major, and the Southern Crescent (NGC 3199), in Carina, are examples of nebulas created not by supernovas but by the intense stellar winds of hot Wolf-Rayet stars.

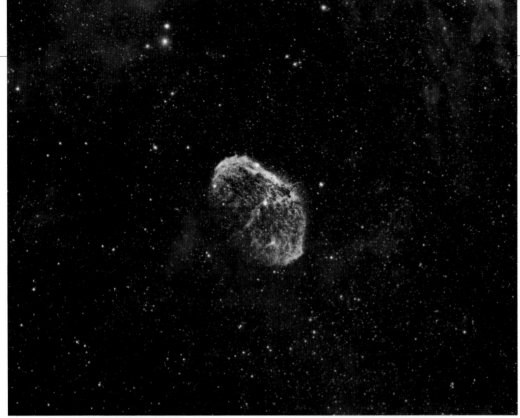

CRESCENT NEBULA

Sometimes wrongly labeled as a supernova remnant, the Crescent Nebula (NGC 6888), in Cygnus, is actually a shell blown away from a rare type of superhot sun called a Wolf-Rayet star. This detailed view is by Trevor Jones (astrobackyard.com).

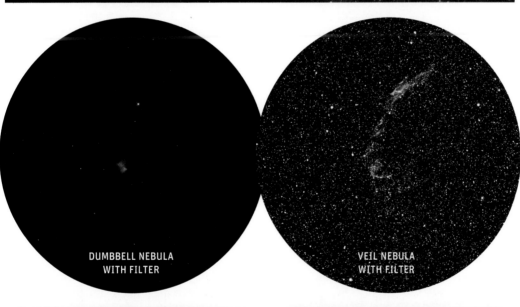

DUMBBELL NEBULA WITH FILTER

VEIL NEBULA WITH FILTER

STELLAR GRAVEYARDS

While obvious without a nebula filter, the Dumbbell Nebula (M27) reveals more of its faint extensions with a filter, looking less like an apple core and more like a sphere. The Veil Nebula supernova remnant, in Cygnus, really blossoms with a nebula filter, becoming a showpiece of twisted lacework.

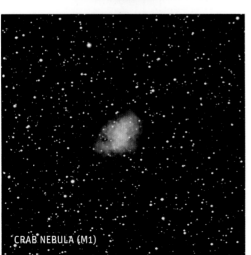

CRAB NEBULA (M1)

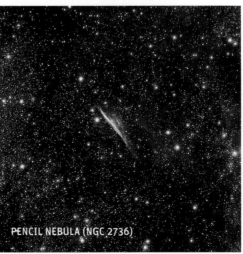

PENCIL NEBULA (NGC 2736)

SUPERNOVA REMNANTS NORTH AND SOUTH

Visually, the Crab Nebula (M1) resembles an amorphous blur. The wispy filaments that gave it its name can be seen only in large-aperture telescopes. In the southern constellation Vela, the Pencil Nebula (NGC 2736) is the brightest fragment of the big Vela supernova remnant.

ANDROMEDA GALAXY
Looking at M31 through a telescope for the first time can be disappointing for beginners. Expecting an eyepiece view like this beautiful time-exposure image by Lynn Hilborn, they see, instead, a featureless smear. But with careful observation, you can identify structure, such as the dark lanes.

FACE-ON SPIRALS
Many face-on spirals, such as the Pinwheel Galaxy (M101), in Ursa Major, are diffuse and hard to spot despite a high magnitude (7.9 for M101). M83, in Hydra, is magnitude 7.5 and a showpiece for southerly latitudes and large apertures.

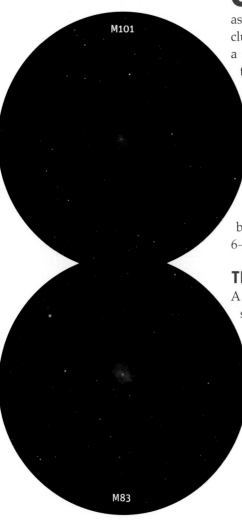

M101

M83

BEYOND THE MILKY WAY

Our Milky Way is but one of tens of billions of galaxies. In fact, the stars we think of as countless are really just a scant foreground clutter between us and the real universe— a space tangled with galaxies that clump together into clusters.

Several thousand galaxies shine brighter than 13th magnitude, the effective dividing line between moderately bright galaxies and those which are barely perceptible blurs. While bright Messier galaxies are within reach of a small telescope—even binoculars—the best recipe for galaxy hunting is to combine a dark sky with aperture. Use at least a 6-inch telescope.

THE GALAXY ZOO

A small telescope might not reveal detailed structure in most galaxies, but it does show their overall shape, a characteristic that depends on a galaxy's type and orientation to our line of sight. For galaxy types, the classification scheme Edwin Hubble devised in 1926 remains in use.

◆ **Elliptical Galaxies** Andromeda's two close companion galaxies, M32 and M110, are examples of elliptical galaxies. Although common, ellipticals are the least interesting to observe. Most elliptical galaxies have no visible internal structure—no dust lanes,

mottling or arm structure. They appear as amorphous glows that fade from bright cores into the darkness of space.

Depending on their degree of ellipticity, the ellipticals can vary from perfectly spherical to strongly elongated patches. In the Messier catalog, many of the brightest members of the Virgo swarm of galaxies (namely, M59, M60, M84, M85, M86 and the giant M87) are ellipticals, all at about ninth magnitude, bright enough for small telescopes, even binoculars.

◆ **Spiral Galaxies** When people hear the word galaxy, the image that comes to mind is of a spiral, its graceful curving arms the epitome of deep sky grandeur. While the majority of bright nearby galaxies are spirals, not all reveal their signature pinwheel structure. It depends in part on whether the galaxy appears edge-on, face-on (the best orientation for seeing spiral arms) or tilted, which is usually the case.

The finest spiral galaxy for backyard astronomers is M51, the Whirlpool Galaxy (see Ken's Tour 7 in Chapter 16). How big a telescope you need to clearly reveal its face-on spiral arms is debatable. However, as we illustrated earlier, most observers will see the "suggestion" of spiral arms through an 8-inch telescope.

A variation of the spiral is the barred

spiral, in which the arms start not from a central core but from a long stellar bar protruding on either side of the core. The effect is obvious in photographs but subtle at the eyepiece. M95, in Leo, is a barred spiral, but it looks more like an elliptical in most telescopes. Even one of the best barred spirals, NGC 1365, aka the Fornax Propeller, requires at least a 10-inch telescope to reveal its barred structure.

Because their light is concentrated into a compact form, edge-on galaxies are more obvious than spirals that appear face-on. While most edge-ons are spirals, members of a transition type, called S0 spirals, also produce fine edge-ons. The Spindle Galaxy (NGC 3115), in Sextans, is a prime example. For the best edge-on galaxy, take Ken's Tour 6 in Chapter 16 to slender NGC 4565, the Needle Galaxy, in Coma Berenices.

When selecting candidates for observing, consider galaxies whose cataloged dimensions are asymmetrical—for example, 10 arc minutes by 1 arc minute. This is an indication of an edge-on galaxy that is sure to be an interesting sight.

◆ **Oddball Galaxies** Irregular galaxies are a minority group whose members have unusual shapes or contain chaotic details, such as patches of nebulosity, mottled dark lanes or straggling appendages. The best example is the Cigar Galaxy (M82), in Ursa Major. M82 is erupting with fountains of material ejected by a chain-reaction burst of star formation. NGC 4449, in Canes Venatici, looks oddly rectangular. The Antennae (NGC 4038 and NGC 4039), in Corvus, and The Mice (NGC 4676), in Coma Berenices, are examples of close pairs of colliding galaxies.

Observers looking for twisted galaxies in abundance can turn to Halton Arp's 1966 listing of 338 of the sky's most peculiar galactic denizens. Other less deviant galaxies have distinguishing characteristics. M77, in Cetus, for example, is a spiral with a starlike center. It is the brightest example of a Seyfert galaxy, a class of galaxy with an energetic nucleus one step away from being a quasar.

CLASSIFYING GALAXIES

Galaxies are officially classified by a system first devised by Edwin Hubble

Elliptical: E0 (circular) to E7 (very flattened)
Spiral: Sa (tightly wound arms, large central hub) to Sd (loose arms, smaller central hub)
Barred Spiral: SBa to SBd (same as spiral but with a central bar)
Lenticular: S0 (a cross between a flattened elliptical and a spiral)
Irregular: Irr (with a ragged appearance)

Although this classic "tuning fork" diagram implies galaxies evolve from one form to another, that's not the case. However, spirals can collide, lose their arms and merge into a giant elliptical.

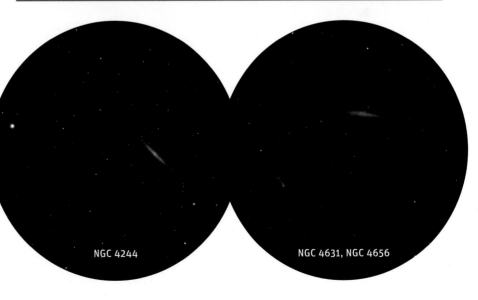

EDGE-ON SPIRALS
A good hunting ground for edge-on spiral galaxies is Canes Venatici, where you'll find NGC 4244, the Silver Needle, and the pair NGC 4631 and NGC 4656, known respectively as the Whale and the Hockey Stick.

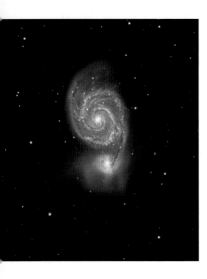

THE WHIRLPOOL

Images of the Whirlpool Galaxy (M51), such as this one by Kerry-Ann Lecky Hepburn, capture the galaxy's spiral arms, its odd companion galaxy, NGC 5195, and even faint outlying star structures. Compare this image with the eyepiece sketch on the facing page made by the Earl of Rosse using his Leviathan telescope.

MARKARIAN'S CHAIN

The heart of Coma-Virgo's "realm of the galaxies" lies around M84 and M86, twin ellipticals that are the brightest members of Markarian's Chain, a remarkable string of galaxies. South of the chain is another elliptical, M87, the monster "black hole galaxy."

◆ **Quasars** Quasars are the luminous cores of young galaxies energized by matter pouring into a massive black hole. Shining at approximately 13th magnitude (its brightness varies), quasar 3C 273, in Virgo, is the brightest member of this unusual class of objects. (The next brightest quasars are roughly 14th to 16th magnitude.) All that can be seen, however, is a faint "star." But at an estimated two to three billion light-years away, 3C 273 is one of the most distant objects visible in an amateur telescope.

THE LOCAL GROUP

Galaxies are gregarious creatures, living their cosmic lives in groups. Our Milky Way belongs to a small gathering called the Local Group (a term coined by Edwin Hubble), whose two largest members are the Milky Way and Andromeda. The only other prominent member in the northern sky is M33, the large spiral galaxy in Triangulum, just south of M31. In the southern hemisphere, the two Magellanic Clouds are naked-eye companion galaxies to the Milky Way and are so rich in objects, they each earned a telescope tour in Chapter 16.

Beyond those galaxies, the "Locals" become faint and challenging. The Local Group comprises more than 50 galaxies (new members are discovered almost yearly). The irregular galaxies NGC 6822 (aka Barnard's Galaxy), in Sagittarius, IC 1613, in Cetus, and IC 10, in Cassiopeia, carry relatively high magnitudes (about 10th) but are so diffuse, they are notoriously difficult to see even in the darkest skies.

Dwarf ellipticals in the Local Group are just plain faint. Using large-aperture scopes, amateurs have tracked down Andromeda II, Leo I, the Draco Dwarf and the Sculptor Dwarf, but they're all barely perceptible glows, more imagined than seen.

GALAXY GROUPS

The sky contains other families of related, sometimes interacting, galaxies that are not populous enough to be called clusters but provide interesting fields containing three or more members.

One of the best is the Leo Trio: Two bright spirals, M65 and M66, form a triangle with the large edge-on galaxy NGC 3628. A much fainter clump, located seven degrees southeast

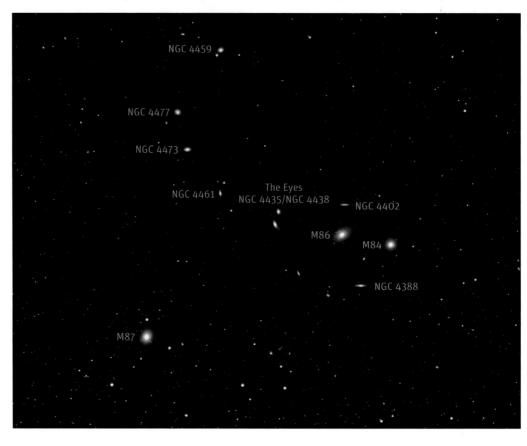

of the Whirlpool Galaxy, is the NGC 5353 group. Owners of 10- to 12-inch telescopes will find a high-power field containing five 12th- to 14th-magnitude galaxies. In the southern sky lies the mutually interacting Grus Quartet of NGC 7552/82/90/99.

The primary listing of galaxy groups is Paul Hickson's 1994 *Atlas of Compact Groups of Galaxies*, a catalog of 100 tightly knit families of four or more galaxies each. Most groups consist of faint 13th- to 16th-magnitude members, making hunting for "Hicksons" big-aperture work.

GALAXY CLUSTERS

In northern spring, as we showed in Chapter 4, we are looking straight out of the disk of our Milky Way Galaxy toward its north galactic pole, which lies in Coma Berenices. That sight line passes through the least amount of galactic dust, allowing us to see into the throngs of distant galaxies.

The crowd of hundreds of galaxies in the Coma-Virgo area is a galaxy cluster, the nearest such grand-scale gathering. The center of the cluster lies 54 million light-years away, only a stone's throw on the galactic scale. In fact, because of this cluster's proximity, member galaxies are scattered over a huge swath of sky, from Ursa Major south to Virgo. Our Local Group lies on the outskirts of this cluster.

If you enjoy observing the individual Coma-Virgo galaxy members, you might want to attempt more remote galaxy clusters. These objects are at the top of the cosmic hierarchy, but they are among the most challenging deep sky targets. Because of their great distances, each is contained within an area only one to two degrees wide at most.

A good target to start with is Abell 1656, the Coma Berenices galaxy cluster. Its brightest members are a pair of 12th-magnitude galaxies, NGC 4874 and NGC 4889, both 360 million light-years away. We have seen these galaxies in a 5-inch telescope. Surrounding the two giant ellipticals are about 50 mostly tiny 13th- to 16th-magnitude galaxies that require at least a 12-inch instrument.

In the constellation Leo, Abell 1367 is centered around the 13th-magnitude elliptical NGC 3842. Five dozen galaxies brighter

THE LEVIATHAN OF PARSONSTOWN

There was a time when the largest telescope in the world sat in misty Ireland, owned not by a government or university but by a wealthy individual. William Parsons, the third Earl of Rosse, constructed the Leviathan, a 72-inch reflector slung on cables between two brickwork walls at his family estate, Birr Castle, in Parsonstown.

Lord Rosse began observations in 1845 and immediately discovered that Messier 51 had a spiral shape. He and his assistant observers, among them John Dreyer of NGC fame, saw spiral structure in dozens of other nebulas, recording their observations in drawings that today's visual observers praise for their accuracy and beauty (the Whirlpool Galaxy, at right, is an example). The late 1800s was the golden age of visual observing, and for several decades, the Leviathan dominated the discoveries. Many of the names of deep sky objects so familiar today, such as the Crab Nebula and the Whirlpool Galaxy, were coined by Lord Rosse and his assistants.

than 16th magnitude reside in this rich cluster. The distance record holder for accessible galaxy clusters is Abell 2065, the Corona Borealis cluster. With a 14-inch telescope under pristine skies, amateur astronomers have observed this cluster as a grayish mottling of the sky. Abell 2065 is at least one billion light-years away, nearly 400 times more distant than the Andromeda Galaxy. With the exception of a few of the brightest quasars, Abell 2065 marks the edge of the backyard astronomer's universe.

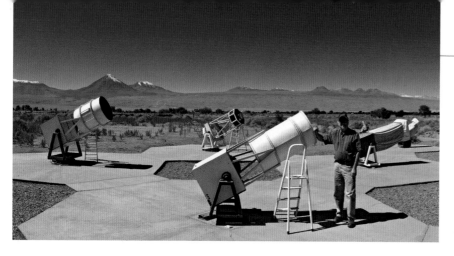

ASTRONOMY PARADISE
Observing conditions just don't get any better than this, as author Dyer prepares for a night of big-scope southern-sky viewing at the Atacama Lodge, near San Pedro de Atacama, Chile.

THE OTHER SIDE OF THE SKY

There's a saying attributed to astronomer Bart Bok that God put all the astronomers in the north but all the best celestial targets in the south. Until you've ventured below the equator, you can't appreciate how true that adage is. From 45 degrees north latitude (northern Europe, the northern U.S. and southern Canada), any object south of –45 degrees declination is out of sight, forever below your horizon. Some of the finest sights the heavens have to offer lie beneath that horizon: top-tier nebulas, clusters and galaxies—they're all there, in the great southern sky.

WHEN AND WHERE TO GO

In Chapter 4, we presented charts showing the Milky Way throughout the year. For the best of what the southern sky has to offer, we suggest traveling between March and May—austral autumn. It's when we usually head south.

The prime destinations lie in a latitude band about 30 degrees south, where ocean currents and trade winds create desert climates around the globe. Choice areas include Australia, Chile and southern Africa, all locations with astronomical meccas, such as major observatories and star parties.

The Atacama Desert and Andean foothills in central and northern Chile take the prize for the best skies and are home to many of the world's major observatories. New megascopes are also located here, such as the United States' Vera C. Rubin Observatory, the multinational Giant Magellan Telescope and Europe's 39-meter Extremely Large Telescope. We've had the privilege of observing

at the Las Campanas Observatory, north of La Serena, and it was heaven on Earth. The sky there is stunningly dark, and the seeing is so rock-steady that stars and planets appear without a shimmer. It is like being beyond the atmosphere.

Chilean-bound astronomers often make for the Elqui Valley area, north of La Serena, two hours by air north of Santiago and the nearest town to the cluster of American and European observatories.

Another popular tourist destination is the more remote San Pedro de Atacama, in northern Chile (sanpedroatacama.com/en/). Astronomer Alain Maury runs a public observatory and lodge (spaceobs.com) near San Pedro. We have both stayed there and highly recommend it. Access to San Pedro is by air into nearby Calama, where you must then rent a vehicle.

In South Africa and Namibia, several rural retreats and guesthouses cater to amateur astronomers and have become popular with stargazers from Europe. We have yet to try them, but colleagues rave about their experiences.

While we love Chile, our destination of choice since 2000 has been Australia—Oz. We can speak the language (sort of!), drive a rental car (sort of!—driving is on the left) and find ample places to stay and set up safely, often in the company of friendly local amateurs. On most Oz trips, we've averaged about 50 to 65 percent clear nights.

Australia has a sparse population, clean air and little light pollution. We've found it unnecessary to "go bush" (travel deep into the outback) for dark skies. Superb conditions can be found two to three hours from Sydney, Brisbane or Melbourne. In our experience, the skies in those areas are just as dark and the chances for clear nights just as good as those at outback locations such as "the Alice" or Uluru. For climate statistics, check Australia's Bureau of Meteorology (bom.gov.au).

For the driest, clearest skies within easy driving distance of Sydney or Brisbane, head over the Great Dividing Range, which runs along the eastern coast, to sites away from coastal humidity and into the Central West or New England districts of New South Wales or

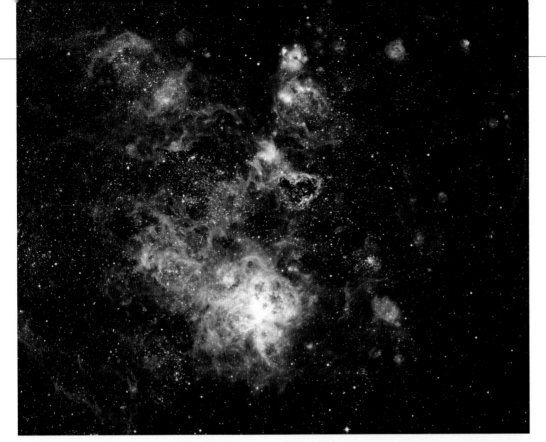

TARANTULA NEBULA

One of the spectacles of the southern sky is the Tarantula Nebula and its complex surroundings in the Large Magellanic Cloud, captured here by Peter Ceravolo using a robotic telescope in Chile and masterfully processed by Debra Ceravolo.

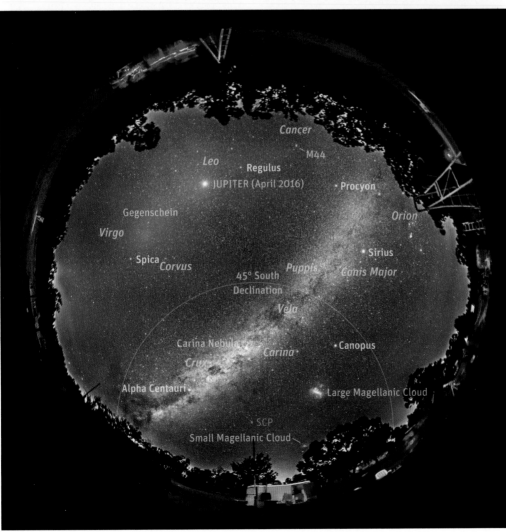

WHAT LIES BENEATH

This view looks due south in April from the OzSky Star Safari, in New South Wales, Australia. (See ozsky.org for details about this exclusive star party Down Under.) Anything within the 45-degree circle is forever below the horizon from 45 degrees north latitude. That region around the south celestial pole (SCP) includes some of the sky's best deep sky objects.

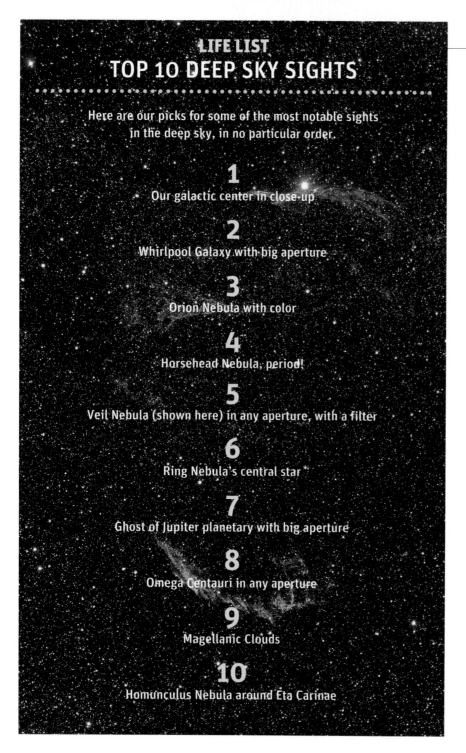

LIFE LIST
TOP 10 DEEP SKY SIGHTS

Here are our picks for some of the most notable sights
in the deep sky, in no particular order.

1
Our galactic center in close-up

2
Whirlpool Galaxy with big aperture

3
Orion Nebula with color

4
Horsehead Nebula, period!

5
Veil Nebula (shown here) in any aperture, with a filter

6
Ring Nebula's central star

7
Ghost of Jupiter planetary with big aperture

8
Omega Centauri in any aperture

9
Magellanic Clouds

10
Homunculus Nebula around Eta Carinae

Astrofest (August, near Linville) and the Vic-South Desert Spring Star Party (October or November, near Nhill, Victoria).

To find out more, Google the star party's name or look up the websites of the major astronomical societies that host the events in New South Wales, Queensland, South Australia or Victoria. You'll find a list of Australian and New Zealand clubs at astronomy.org.au.

Our favorite destination in Oz is Coonabarabran (coonabarabran.org), at the junction of the Newell and Oxley Highways, which bills itself as the Astronomy Capital of Australia—and for good reason. Australia's major optical-telescope complex, the Siding Spring Observatory (sidingspringobservatory.com.au), is just down the Timor Road, while the radio telescopes of the Australia Telescope Compact Array (narrabri.atnf.csiro.au) and Parkes Observatory (parkes.atnf.csiro.au) are up and down the Newell Highway at Narrabri and Parkes.

WHAT TO TAKE

For even the most experienced northern observers, heading Down Under is like starting over. Identifying constellations requires going back to basics, using star-dome charts or a planisphere made for southern latitudes.

Take at least binoculars. Many southern splendors are large and bright enough to show well in binoculars. The next step up would be a 60mm to 80mm apo refractor with a red-dot finder on a light but solid tripod with a smooth panning head or a small altazimuth mount. All you need are two eyepieces: a low-power 20mm to 24mm and a higher-power 6mm to 10mm. Don't forget your red flashlight. But leave laser pointers at home. Their import is illegal in many countries.

While an equatorial mount is not essential, a small GoTo mount is wonderful if you want to see lots in a short time. The little Sky-Watcher AZ-GTi we showed in Chapter 7 would be ideal. Power is from internal AA batteries. If you plan to do photography, take one of the small trackers we discuss in Chapter 17 for wide-field shooting. All have polar scopes with reticles (the AZ-GTi doesn't) that make it less difficult (though still not easy!) to polar-align in the southern hemisphere.

Now consider how much you can take. The

into southern Queensland. Sites north of Melbourne, toward the Riverina/Murray River country, and north of Adelaide, in the Flinders Ranges, are also superb.

In these areas, you'll find annual star parties you can attend to meet austral astronomers and gaze through big scopes. Events include the Snake Valley Astro Camp (March, near Ballarat, Victoria), the South Pacific Star Party (April or May, near Mudgee, New South Wales; the largest star party in the southern hemisphere), the Queensland

weight limit for international air travel is tight, even more so for domestic flights, such as from Santiago to Calama in Chile. Tripods are the most awkward items to pack. Pad gear well in checked luggage—protruding bits, such as knobs on focusers and tripod legs, can be bent or snapped off. Remove them. We usually pack scopes in checked bags (refractors are by far the most durable), leaving cameras, key lenses and any laptop we take for carry-on. Lithium batteries might also need to go in carry-on and be limited to low-capacity units.

TRAVELING THE OTHER WAY?

Of course, if you are a resident of the southern hemisphere, you are already familiar with the wonders of your own night sky. What you want to witness are the mythical sights of the northern sky, objects always low or below your northern horizon. The Andromeda and Whirlpool Galaxies are your exotic targets.

If you plan to head north, the best locations in North America are Arizona, New Mexico and Texas, where major observatories, astronomy resorts and star parties give you access to big telescopes. The best time is either March to May, if you are seeking northern galaxies, or September to November, if you are after the clusters and nebulas of the northern Milky Way from Cygnus to Auriga. June to August tends to be the monsoon period in the American Southwest.

Wherever you live, if you think you have seen it all from your hemisphere but are considering spending $3,000 or more on a new telescope, think, instead, about spending that money on a trip to the other side of the world. Step out under a foreign night sky and look up. When you realize you don't recognize a thing, you'll break out in a big smile!

SOUTHERN-SKY GUIDES

The *Atlas of the Southern Night Sky* by Steve Massey and Steve Quirk (New Holland Publishers) and the classic Hartung's are both excellent, though the latter is out of print. *The Southern Sky Guide* (Cambridge) by David Ellyard and Wil Tirion is a fine readily available beginner book.

HERSCHEL AT THE CAPE

Imagine being the first person in the world to explore an entire sky, among the darkest in the world, with an 18-inch telescope. Imagine having that sky at your disposal every night from your backyard. A dream for observers today, but from 1834 to 1838, this was how John Herschel spent his time, scanning the southern skies from South Africa. "Whatever the future may be," wrote Herschel, "the days of our sojourn in that sunny land will stand ... as the happy part of my earthly pilgrimage."

To extend his father William's catalog of the sky, John, his wife Margaret and their three children packed their belongings and an 18.25-inch reflector telescope and sailed off to the Cape of Good Hope. The Herschels became celebrated citizens of Cape Town's European colony, making the social rounds by day and exploring the sky by night. During this time, John Herschel discovered 2,100 double stars and more than 1,300 nebulas and clusters. In 1837, he recorded the rare explosive flaring of the star Eta Carinae, as it briefly shone as one of the brightest stars in the night sky.

The years at Cape Town marked the height of Herschel's astronomical endeavors. Back in England, he rose to such positions as Master of the Mint, but he rarely looked through a telescope again, and the 18-inch mirror sat tarnished in a cellar. "With the publication of my South African observations," concluded Herschel, "I have made up my mind to consider my astronomical career as terminated."

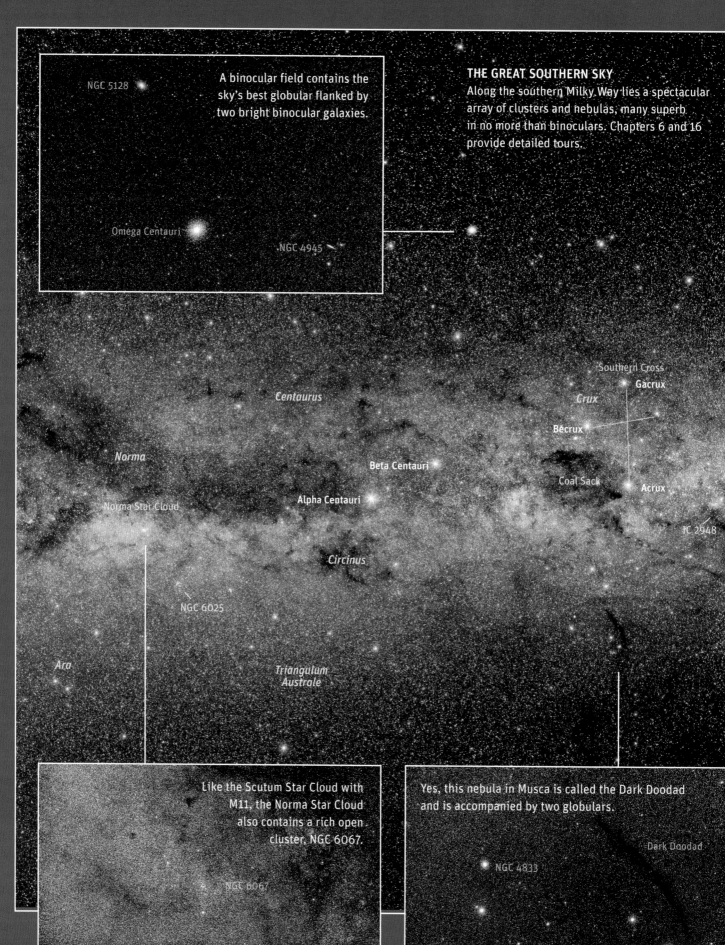

A binocular field contains the sky's best globular flanked by two bright binocular galaxies.

NGC 5128

Omega Centauri

NGC 4945

THE GREAT SOUTHERN SKY
Along the southern Milky Way lies a spectacular array of clusters and nebulas, many superb in no more than binoculars. Chapters 6 and 16 provide detailed tours.

Southern Cross
Gacrux
Crux
Becrux
Coal Sack
Acrux
IC 2948

Centaurus

Norma

Beta Centauri

Alpha Centauri

Norma Star Cloud

Circinus

NGC 6025

Ara

Triangulum
Australe

Like the Scutum Star Cloud with M11, the Norma Star Cloud also contains a rich open cluster, NGC 6067.

NGC 6067

Yes, this nebula in Musca is called the Dark Doodad and is accompanied by two globulars.

Dark Doodad

NGC 4833

NGC 4372

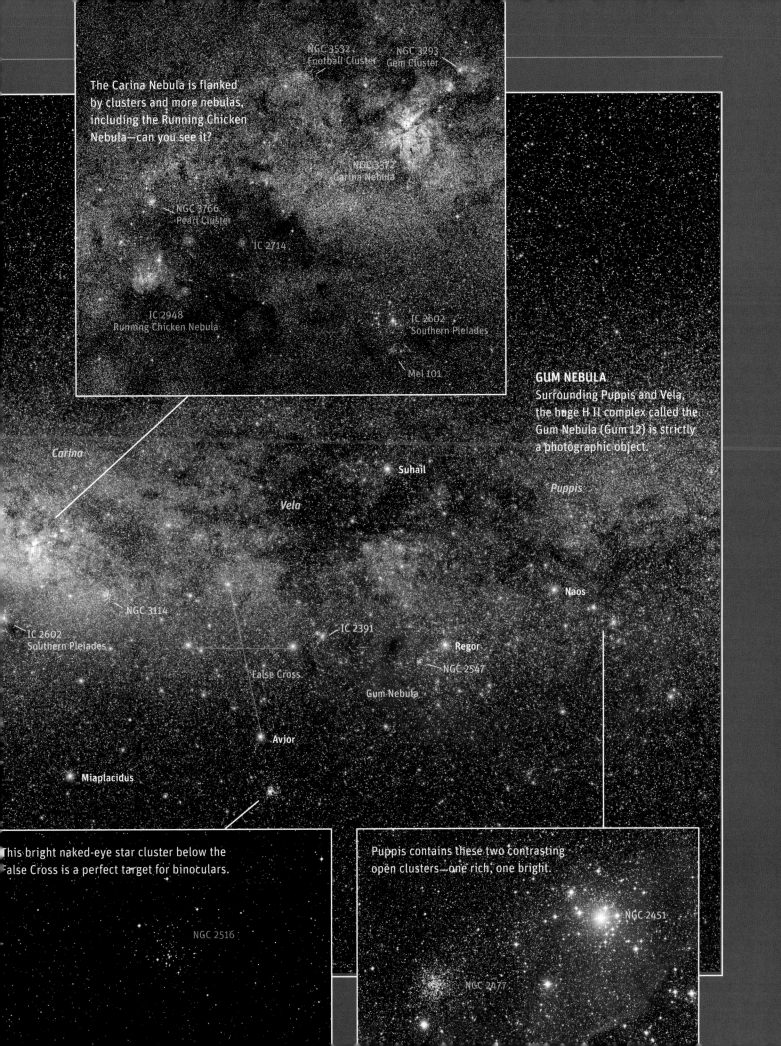

The Carina Nebula is flanked by clusters and more nebulas, including the Running Chicken Nebula—can you see it?

NGC 3532
Football Cluster

NGC 3293
Gem Cluster

NGC 3372
Carina Nebula

NGC 3766
Pearl Cluster

IC 2714

IC 2948
Running Chicken Nebula

IC 2602
Southern Pleiades

Mel 101

GUM NEBULA
Surrounding Puppis and Vela, the huge H II complex called the Gum Nebula (Gum 12) is strictly a photographic object.

Carina

Suhail

Vela

Puppis

NGC 3114

IC 2602
Southern Pleiades

IC 2391

Naos

Regor

NGC 2547

False Cross

Gum Nebula

Avior

Miaplacidus

This bright naked-eye star cluster below the False Cross is a perfect target for binoculars.

Puppis contains these two contrasting open clusters—one rich, one bright.

NGC 2516

NGC 2451

NGC 2477

CHAPTER 16

Telescope Sky Tours

We finish this section's guide to the telescopic sky by putting our telescopes to work to find some of the sky's finest sights. Once again, our tour guide is Ken Hewitt-White, who has crafted 16 tours of the northern heavens. Ken has chosen some of his favorite targets, including a sampling of double stars, open and globular clusters, emission and reflection nebulas and galaxies. After that, author Dyer takes us Down Under for a selection of southern-sky splendors.

Many of the tours are suburban sky-friendly, but your views of nebulas and galaxies will benefit from being at a dark site well away from city light pollution. All our tour objects are suitable for small telescopes, though globular clusters, nebulas and galaxies always look better in bigger optics.

While a GoTo telescope could take you directly to many of the tour targets, we encourage you to hop through the stars to become more familiar with the sky and appreciate the object's location and context. Let the tours begin!

Globular star clusters, such as Messier 13, in Hercules (see Tour 9), can look as good in the eyepiece as they do in photographs. This wonderful image of M13 by Kathy Walker captures the sparkling beauty of a top-tier globular star cluster.

**AIMING AT
THE MILKY WAY**

A laser pointer mounted
on a telescope is one way
to aid your star-hopping,
but only where laser use is
not illegal or discouraged. It
works best under a dark sky.
Any of the finder aids we
discussed in Chapter 9 will
assist you in completing our
telescope tours.

OUR SAMPLE TELESCOPE TOURS
BY KEN HEWITT-WHITE

Welcome to our second set of deep sky tours—this time using telescopes. These simple scoping activities represent the next step after our binocular tours in Chapter 6. Again, we're applying the star-hop method introduced in Chapter 4, but in more detail. Our telescopic explorations will illustrate the value of broadband and narrowband filters (see Chapters 9 and 15) and will stress the importance of viewing techniques, such as averted vision (see Chapter 15). But never mind the technical aspects. Above all else, our night sky rambles have been designed with one thing in mind: to inspire you to get outside with your telescope.

SUBURBAN SKYWATCHING

Our yearlong observing project originated in an average suburban yard—mine! I reside at 49.2 degrees north latitude, on the north side of a small city (population 90,000) in southern British Columbia, Canada. The local light pollution is very noticeable, especially toward the center of town. With my unaided eyes, I can see stars down to fourth or fifth magnitude, depending on the direction I'm facing—north isn't bad, but my low south is terrible. Gazing high overhead on the clearest summer evenings, I can barely detect the portion of the Milky Way that runs the length of the Northern Cross.

Fortunately, my light-blighted backyard doesn't stop me from probing the heavens. I'm amazed at the number of celestial objects I can at least detect and, in some cases, genuinely enjoy from my humble stargazing post. My at-home telescope sessions require certain "containment" tactics, such as setting up a portable slide-projection screen to block a nasty porch lamp, pulling a hoodie over my head to block glare from inside houses (one fluorescent kitchen light aims directly at my yard), working upwind of chimney smoke or hiding from the blinding beams of nearby motion-sensor security lights that activate on the slightest provocation. Nighttime breezes can be a problem, of course, but so can nocturnal wanderers, such as raccoons and possums—even my own two cats! Still, I'm out there, often after midnight, when the neighborhood is a bit darker.

MY TELESCOPES

I have nine telescopes (at last count), but it wouldn't have been practical to deploy all of them for this project. I chose two: a 4-inch f/6.5 achromatic refractor on an equatorial mount and an 8-inch f/6 Newtonian reflector on a Dobsonian mount. The 4-inch to 8-inch range in aperture is typical of backyard astronomy today. If you own a scope smaller than my refractor, you'll still be able to sight many of the listed objects. If your optics are larger than my reflector, then nearly everything I describe will look better.

I employed a variety of eyepieces, from 32mm focal length (low power) to 5mm focal length (high power), which resulted in a lot of odd-numbered magnifications, so I've rounded off the values. For my little refractor, I cite essentially four steps of 25x, 50x, 75x and 100x. For my larger reflector, I go up to 175x—no higher. As explained in Chapter 7, extreme magnification rarely works.

A word about computer-operated telescopes: Most of my selections exist in the databases of GoTo scopes. The rest (mainly double stars) can be programmed in. Automated scoping is fun—I have one GoTo mount myself—but star-hopping gives you a feel for the night sky. Better yet, with star-hopping you see more.

THE TOURS

Truth to tell, I used to practice "gawk 'n' go" astronomy. I'd find a cluster or nebula, stare at it, then chase down another one. Later, though, I began exploring areas around my chosen targets. I was amazed at how much I could discover in relatively small regions of sky when I took the time to check my charts and star-hop slowly. The informal telescopic excursions I've assembled here are intended as meandering drives through the celestial countryside. We look around as we go and stop at some major "tourist attractions."

The tours are arranged in seasonal groups of four journeys each, plus a special Down Under set of southern-hemisphere tours by author Dyer. In total, we sample nearly 100 treasures. And they're not all easy catches; we've included a few challenge objects too.

Admittedly, the tough stuff, such as wispy nebulas and galaxies, is better appreciated from dark country sites, but virtually everything here is visible in a city sky. Indeed, less sensitive fare, like open clusters and double stars, don't look bad from town. I hope to demonstrate that city-based astronomy is not a lost cause.

KEN'S SCOPES
Observing mostly from his suburban backyard and occasionally from darker rural locations, author Ken Hewitt-White compiled all the northern-sky tours and eyepiece impressions using a 4-inch f/6.5 refractor and an 8-inch f/6 Newtonian reflector. Many of the tours are illustrated with circular-field images, like the one of Messier 31 below, to simulate what an object will look like in the eyepiece of a moderate-aperture (6- to 8-inch) telescope.

WHERE WE ARE GOING

The tours feature mostly short star-hops. Each session begins with a naked-eye star, progresses to fainter stars visible in optical finderscopes (a 6x30 is fine; an 8x50 is better) and encounters a variety of deep sky objects along the way.

Every tour is accompanied by a star chart. Each chart covers an area of sky between 15 and 30 degrees wide. The red circles represent the five-degree fields of most finderscopes. Five degrees is the distance between the "Pointer" stars in the bowl of the Big Dipper, as shown in Chapter 4.

You can locate the star-hop areas via the identifying index charts on the next page, which are overlaid on a version of the seasonal star maps presented at the start of Chapter 4. To find an area, it's helpful to use those seasonal charts first (or an aid such as a planisphere or mobile app) to pick out the major constellations and bright stars within them.

The text and charts employ the same nomenclature we used for the binocular tours in Chapter 6 (M and NGC, Greek letters, Struve binaries, object classifications, etc.). In every instance, explanations and definitions can be found in Chapter 15.

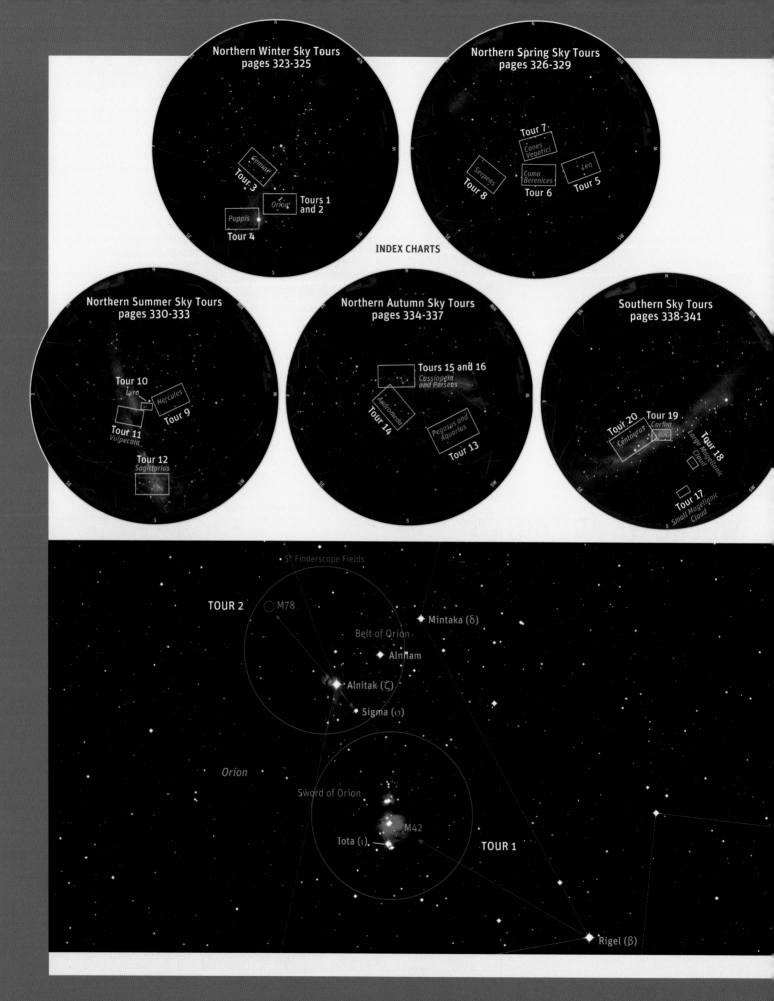

Northern Winter Sky Tours
pages 323-325

Tour 3
Gemini

Orion

Tours 1 and 2

Puppis

Tour 4

Northern Spring Sky Tours
pages 326-329

Tour 7
Canes Venatici

Leo

Serpens

Coma Berenices

Tour 8

Tour 6

Tour 5

INDEX CHARTS

Northern Summer Sky Tours
pages 330-333

Tour 10
Lyra

Hercules

Tour 9

Tour 11
Vulpecula

Tour 12
Sagittarius

Northern Autumn Sky Tours
pages 334-337

Tours 15 and 16
Cassiopeia and Perseus

Andromeda
Tour 14

Pegasus and Aquarius
Tour 13

Southern Sky Tours
pages 338-341

Tour 20
Centaurus

Tour 19
Carina

Tour 18
Large Magellanic Cloud

Tour 17
Small Magellanic Cloud

5° Finderscope Fields

TOUR 2
M78

Mintaka (δ)

Belt of Orion

Alnilam

Alnitak (ζ)

Sigma (σ)

Orion

Sword of Orion

M42

Iota (ι)

TOUR 1

Rigel (β)

NORTHERN WINTER SKY

TOUR 1 ORION'S NURSERY

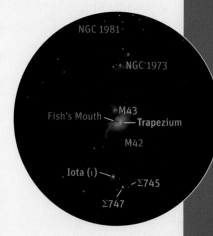

Orion the hunter is full of telescopic treasures. Our first tour explores the southern part of the constellation, beginning at zero-magnitude **Beta (β) Orionis**, or **Rigel**, on the southwest corner of Orion's hourglass figure. Apply high magnification on this sapphire sun and see whether you can detect a dim companion amid the primary's brilliant glow. The 6.8-magnitude speck lies only 9.5 arc seconds south of Rigel. My 4-inch refractor nabs it at 100x (provided the atmosphere is rock-steady), and my 8-inch reflector does so easily at 125x.

Northeast of Rigel is the sword of Orion, a two-degree-long streak of stars and nebulosity that's simply dazzling in low-power fields. The sword's marquee attraction is the Orion Nebula, **M42**, a spectacular emission nebula 1,300 light-years away. In my smaller scope at 50x, M42 is an irregular mist enveloping a 20-arc-second-wide quadrilateral of fifth- to eighth-magnitude stars called the **Trapezium**. The youthful foursome heats the nebula to fluorescence. Upping to 75x accentuates this intense inner region. Curving wings of nebulosity spanning more than half a degree curl eastward and westward from the luminous core. Between the wings, a dark wedge dubbed the **Fish's Mouth** intrudes into M42 almost to the Trapezium. North of the Fish's Mouth is **M43**, a much dimmer nebula surrounding a seventh-magnitude star. All these details are eye-catching in my 8-inch scope through the same range of magnification.

Half a degree south of the main nebula, 2.7-magnitude **Iota (ι) Orionis** holds a 7.0-magnitude attendant 11.3 arc seconds away. My 4-inch needs at least 50x to "split" Iota. Southwest of Iota is a breezy-easy double, **Σ747**, whose 4.7- and 5.5-magnitude stars lie 36 arc seconds apart. Farther westward is **Σ745**, with 8.4- and 9.4-magnitude points separated by 28 arc seconds. The three doubles are satisfying additions to the already amazing field containing M42.

TOUR 2 BELTWAY STAR-HOP

Our second excursion begins at 2.4-magnitude **Delta (δ) Orionis**, or **Mintaka**, at the western end of the three-star belt of Orion. Delta comes with a 6.8-magnitude companion, almost one arc minute northward. The mini-Mintaka shows in my little scope at 25x. At the other end of the belt is 1.7-magnitude **Zeta (ζ) Orionis**, or **Alnitak**, which also has a wide northward companion. The 8.5-magnitude blip is hard to see in Alnitak's glare, even when I double the power.

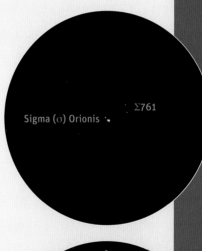

Below Alnitak is an intriguing multiple system centered on 3.7-magnitude **Sigma (σ) Orionis**. A 6.3-magnitude star 42 arc seconds northeast of Sigma and another of similar brightness three times closer to Sigma on the same side are low-power pickups. Increased magnification teases out an 8.8-magnitude member less than 12 arc seconds southwest of Sigma. And barely three arc minutes northwest of that strung-out foursome is a slender triangle called Σ761, outlined by eighth- and ninth-magnitude stars. An attractive field!

A sweep of the telescope (slowly, at low to medium magnification) northeastward for almost one degree from Sigma to Alnitak, then another 2½ degrees reaches **M78**, a diminutive reflection nebula. Rather than being heated to fluorescence, reflection nebulas contain dust grains that reflect the light of one or more nearby stars. M78 features two embedded stars of magnitude 10.2 and 10.6, nearly one arc minute apart. The surrounding haze, about eight arc minutes across, is iffy in my 4-inch refractor. However, my 8-inch Newtonian working at 50x picks up M78 right away. At 100x, the nebula presents a sharp northern edge (next to the star pair), but its fanlike southern portion fades into the sky.

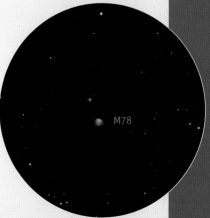

Admittedly, M78 is a tough city-sky target. A broadband light-pollution filter (not a narrowband nebula filter) improves the view. So does a dark country sky!

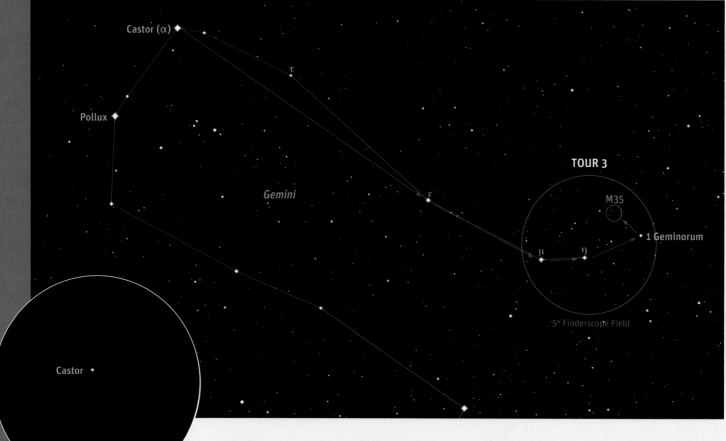

TOUR 3 FROM CASTOR TO CLUSTER

In **Gemini** the twins, we start our tour at **Alpha (α) Geminorum**, or **Castor**, an alluring multiple star. My 4-inch refractor needs at least 75x to comfortably split bluish white Castor into its 1.9- and 3.0-magnitude A and B components, as the gap between them is currently just 5.2 arc seconds (but slowly widening). A 9.8-magnitude red-dwarf star, Castor C, flickers 71 arc seconds to the south. The fiery hue of Castor C isn't obvious, but it's there.

From Castor, we descend southwestward along Gemini's rectangular constellation pattern, past the third-magnitude orange stars **Epsilon (ε)**, **Mu (μ)** and **Eta (η)** to fainter **1 Geminorum**. There, in Castor's western "foot," is **M35**, an open cluster 2,800 light-years from Earth. M35 glows at magnitude 5.6 and is almost half a degree in diameter. The refractor working at 25x resolves this prominent patch into stars, with the possible exception of a grainy arc of light in the north part of the cluster. Doubling to 50x teases out at least nine closely spaced beads in a celestial necklace. An 8.2-magnitude star anchors the western end of the necklace, while the eastern end is decorated by a double called **OΣ 134**—its 7.4-magnitude yellow sun and 9.1-magnitude bluish companion lie 30 arc seconds apart. At 75x, I count upwards of four dozen cluster members down to 10th magnitude. Fabulous object!

An "extra" for the eagle-eyed lurks beside M35—an open cluster named **NGC 2158**. Although packed with stars, NGC 2158 is nearly five times more distant than M35. It's only magnitude 8.6 and barely five arc minutes wide. In my 4-inch at 50x, I perceive it as a wee wisp southwest of the big Messier cluster. My 8-inch reflector at 125x resolves the miniature fog into very faint stars.

TOUR 4 TWO CLUSTERS AND A DUSKY DONUT

Canis Major the big dog is emblazoned by **Alpha** (α) **Canis Majoris**, or **Sirius**, shining at magnitude −1.4. Heading eastward from Sirius, we zigzag for a dozen degrees, past **Iota** (ι) and **Gamma** (γ) and into neighboring **Puppis** the stern (of the mythical ship Argo) to the reddish variable star **KQ Puppis** and, finally, two open clusters of contrasting appearance.

M47, about 1,600 light-years away, is a half-degree-wide scatter of several dozen stars. The fourth-magnitude object is unmistakable in my refractor at 25x. Numerous tandem suns populate M47. The best of them is **Σ1121**. Its well-balanced seventh-magnitude stars, separated by 7.4 arc seconds, split tightly at about 50x.

A degree east-southeast of M47 is **M46**, a cluster roughly three times farther away and nearly two magnitudes dimmer. M46 is about as large as M47 and holds more stars; unfortunately, except for one 8.7-magnitude outlier, none are brighter than 10th magnitude. In my small backyard scope at 25x, the cluster is a grainy haze. At around 50x, a few dots speckle the haze; 75x coaxes additional faint stars into view.

Thankfully, M46 offers a bonus—a ring-shaped planetary nebula seemingly embedded in the cluster. Actually, **NGC 2438** lies in front of M46. The 10.8-magnitude, 75-arc-second-wide "smudge" emerges at 75x, provided I use a narrowband nebula filter. The filter reduces M46 to a few dull pinpricks, plus the oddly placed smudge. My 8-inch reflector at 125x turns the smudge into a dusky donut.

One degree east of M46 are **4** and **2 Puppis**. Dimmer 2 Pup is a fine double. Its 6.0- and 6.7-magnitude components are separated by 16.6 arc seconds. And a fifth-magnitude orangey star lies half a degree southwest of M46. Having trouble finding the cluster? Stare at the shallow triangle formed by 4-2 Pup, M47 and the orangey star—M46 is in there somewhere!

We end our tour 1½ degrees south-southeast of 2 Pup at an attractive low-power pairing called **Knott 4**. The nearly identical sixth-magnitude stars, 128 arc seconds apart, have the luster of a rosé wine.

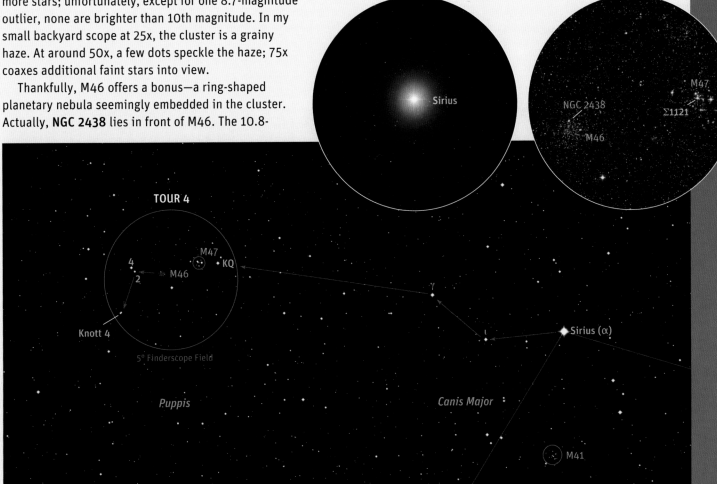

TOUR 5 CELESTIAL SICKLE TOUR

Algieba

NGC 2903

The most recognizable part of **Leo** the lion is the **Sickle**. A large asterism of six stars, the Sickle neatly outlines the lion's huge head. At the base of the Sickle, 1.4-magnitude **Alpha (α) Leonis**, or **Regulus**, shines with a blue-white tint. Regulus is accompanied by an eighth-magnitude orangey yellow star widely spaced to the northwest.

From Regulus, we ascend the Sickle to **Gamma (γ) Leonis**, or **Algieba**. Golden Gamma is a showcase binary. The 2.4- and 3.6-magnitude suns, 4.8 arc seconds apart, are tightly split in my refractor at 75x. I like comparing Algieba to Castor (Tour 3)—the Castor tandem is marginally brighter and wider, but Algieba is more colorful.

Above Algieba is 3.4-magnitude **Zeta (ζ) Leonis**, or **Adhafera**, the brightest of four stars in a half-degree-long crooked line. The sixth-magnitude stars **35** and **39 Leonis** flank Adhafera, and an eighth-magnitude star is close by. A few fainter stars are scattered around. Viewed at lowest magnification, the Adhafera group is almost clusterlike.

Rounding the top of the Sickle, we head westward to 4.3-magnitude **Lambda (λ) Leonis**. A degree south of Lambda is a 7.5-magnitude star (ignore its 6.9-magnitude neighbor to the west), and 20 arc minutes farther south is the barred spiral galaxy **NGC 2903**. Measuring 12 by 6 arc minutes and glowing at ninth magnitude, NGC 2903 compares favorably to several better-known Messier galaxies in Leo.

Light pollution isn't kind to galaxies. Even so, NGC 2903 is accessible in my suburban sky. My reflector at 50x reveals a teensy, diffuse cloud elongated north-south. At 125x, its fuzzy footprint approaches four by two arc minutes, the "foot" being brighter in the middle. Upping to 150x stretches the wisp. The refractor cranked up to 100x shows the bright middle and little else. Away from city lights, though, NGC 2903 is a winner.

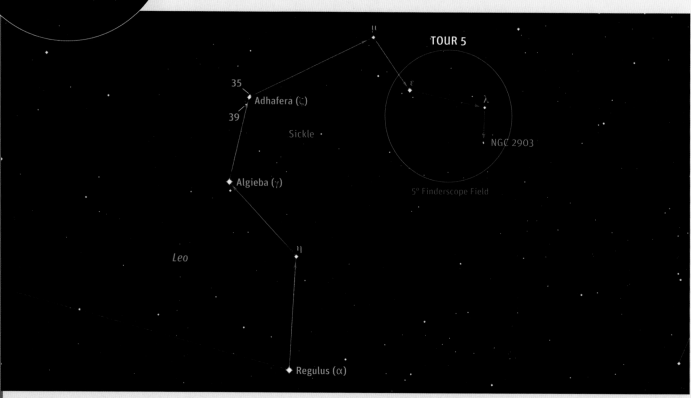

TOUR 5

35
Adhafera (ζ)
39
Sickle
λ
NGC 2903
Algieba (γ)
5° Finderscope Field
Leo
η
Regulus (α)

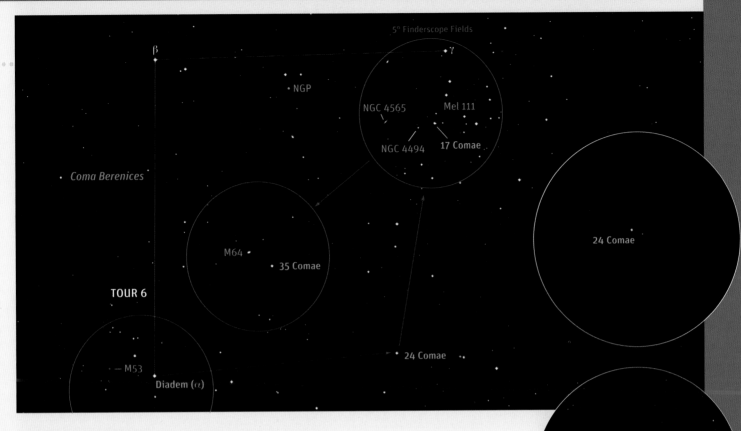

TOUR 6 COMBING BERENICE'S HAIR

The inconspicuous constellation between Leo and Boötes is **Coma Berenices**, Berenice's hair. "Combing" the queen's curly locks pulls out deep sky targets aplenty.

We begin at 4.3-magnitude **Alpha** (α) **Comae**, or **Diadem**, in southeastern Coma Berenices. A degree northeast of Diadem is the 7.6-magnitude globular cluster **M53**. Although M53 is hardly top-notch, it's 12 arc minutes across and easily snared in the same low-power field as Diadem.

Eight degrees west of Diadem is **24 Comae**—an absolutely gorgeous double, red and blue, magnitude 5.1 and 6.3, spaced 20 arc seconds apart. Heading northward another eight degrees brings us to a five-degree-wide star cluster known as **Melotte 111**. Optical finderscopes can sweep up almost two dozen stars in Mel 111. On its eastern edge, 5.3-magnitude **17 Comae** stands out from the crowd because it sports a wide 6.6-magnitude companion.

Just east of 17 Comae is an eighth-magnitude star and a tiny yet distinct 10th-magnitude galaxy named **NGC 4494**. Two dimmer stars a bit northeast of NGC 4494 helpfully point farther eastward to a coveted prize: the faint but fantastic Needle Galaxy, **NGC 4565**. A "prototype" edge-on, the Needle measures 16 by 2 arc

minutes. Light from the 10th-magnitude object is partly blocked by a bisecting dust band. In my 4-inch refractor at 25x, I see a roundish blur—the galaxy's central bulge. Patiently staring at 75x, I perceive extensions to either side. My 8-inch reflector under a dark sky captures the entire Needle, complete with its threadlike dust lane. Exquisite!

We complete our triangular tour by meandering southeastward back toward Diadem. En route, we encounter 5.0-magnitude **35 Comae** (it has a wide, 9.8-magnitude co-star) and, less than a degree northeast, the Black Eye Galaxy, **M64**. Measuring 10 by 5 arc minutes, this ninth-magnitude Messier is a quick catch, though its "black eye" (a broad dust lane) is tricky. In my 8-inch at 175x, I see an oval cloud brightening toward the middle. Patient staring "grows" the diffuse cloud and reveals a dim star off its east side. The side facing the star is scarred by a vague, dusky patch—M64's cosmic shiner.

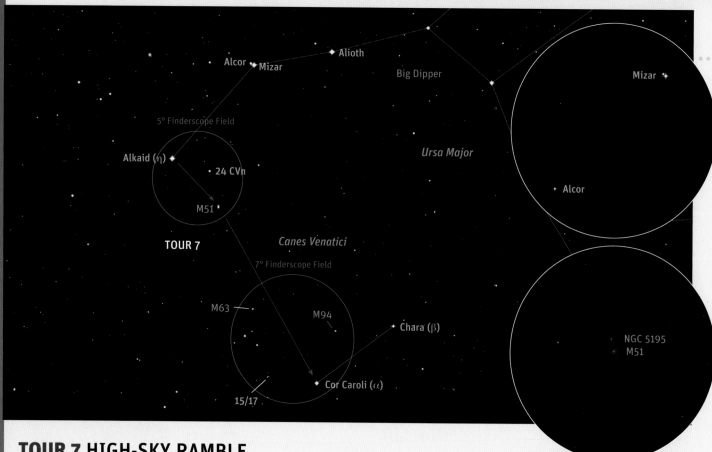

TOUR 7

5° Finderscope Field

Alcor • Mizar • Alioth Big Dipper Mizar •

Alkaid (η) • Ursa Major

• 24 CVn Alcor •

M51 •

TOUR 7 Canes Venatici

7° Finderscope Field

M63 — M94 NGC 5195
M51

Chara (β) •

Cor Caroli (α) •

15/17

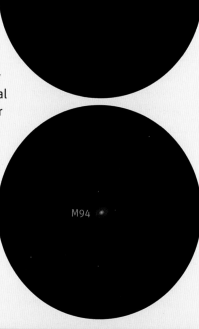

Mizar •

NGC 5195
M51

Cor Caroli •

M94 •

TOUR 7 HIGH-SKY RAMBLE

On spring nights, the **Big Dipper** hangs high. "Bending" the Dipper's handle is second-magnitude **Mizar**, a superb binary star comprising a 2.2-magnitude primary and a 3.9-magnitude secondary, 14 arc seconds apart. Don't miss Mizar and its wider companion Alcor.

The handle's end point is 1.8-magnitude **Alkaid**. From there, we shift two degrees west into **Canes Venatici** the hunting dogs to 4.7-magnitude **24 Canum Venaticorum** (CVn). From 24 CVn, a southwestward hop centers the Whirlpool Galaxy, **M51**, an eighth-magnitude face-on spiral 28 million light-years from Earth. In truth, there are two galaxies here. The binary blob is roughly 11 by 7 arc minutes in extent.

In my city-based 8-inch reflector at 50x, I see slightly unequal side-by-side lumps. The more prominent lump is the hub of M51 itself, while the adjacent smudge is M51's armless, misshapen neighbor, **NGC 5195**. At between 100x and 150x, the brighter lump is surrounded by a tenuous, round halo—M51's face-on disk. Sadly, no "whirlpool" is evident. The keys to seeing the elusive spiral pattern are aperture and darkness: If you have a 10-inch or larger scope far from city lights, M51 will welcome you with open arms.

Canes Venatici's Alpha star, **Cor Caroli**, is a dandy

double. The 2.9- and 5.6-magnitude stars are 19 arc seconds apart. From Cor Caroli, we hop eastward 2¾ degrees to the sixth-magnitude set of **15/17 CVn**, then 3¾ degrees northward (past a triangle of stars) to the Sunflower Galaxy, **M63**. The ninth-magnitude spiral, 26 million light-years away, measures 13 by 7 arc minutes. My 8-inch at 100x reveals an elliptical mass enveloping a barely brighter oval core. A ninth-magnitude star attends M63 just westward.

Three degrees north-north-west of Cor Caroli is the tightly wound spiral galaxy **M94**. Only 16.4 million light-years distant, M94 is similar to M63 in size but is brighter. My reflector produces a compact fuzzball, diffuse at the edge and brilliant in the middle. Easy stuff!

TOUR 8 SERPENT CRAWL

Our exploration of **Serpens Caput** ("head of the serpent") starts at 3.7-magnitude **Beta** (β) **Serpentis**, an extremely unequal double. The puny partner is magnitude 10.0, but lying 31 arc seconds from Beta, it is obvious in any scope. Close by is 6.7-magnitude 29 Serpentis, seven arc minutes northeast of Beta. Six degrees southward, **Delta** (δ) is a deluxe binary featuring 4.2- and 5.2-magnitude components only 4.0 arc seconds apart. My 8-inch Dob nails it at 125x.

Farther southward is 2.6-magnitude **Alpha** (α), or **Unukalhai** ("serpent's neck"). Orangey Alpha is our staging point for visiting **M5**, a top-tier globular cluster 26,000 light-years away. Finding M5 requires an eight-degree star-hop. Alpha and dimmer **Epsilon** (ε) form the baseline of a six-degree-long isosceles triangle aiming southwestward. At the triangle's vertex is fifth-magnitude **10 Serpentis**. From there, we hop westward to similarly bright **5 Serpentis**, which guards our prize ⅓ degree to the northwest. The star (magnitude 5.1) and cluster (magnitude 5.7) are close friends in my 8-power finderscope.

M5 and 5 Serpentis shine together in my 4-inch refractor at 25x. Measuring 17 arc minutes in diameter, the globular has a compact, well-defined core enveloped in a dim halo that fades into the surrounding sky. At 75x, the periphery is flecked with faint stars. My larger scope at 125x resolves M5 into countless pinpoints. One particular pinpoint, in the southwestern part of M5, often stands out on its own. It's a "cluster variable" that fluctuates in and out of sight every few weeks.

Before you leave, concentrate on 5 Serpentis, as it's another strongly unequal binary star. Its 10.1-magnitude attendant is separated by 11.4 arc seconds—much less than the Beta Serpentis example noted earlier. It's a tough nut, but my 8-inch cracks it at 125x.

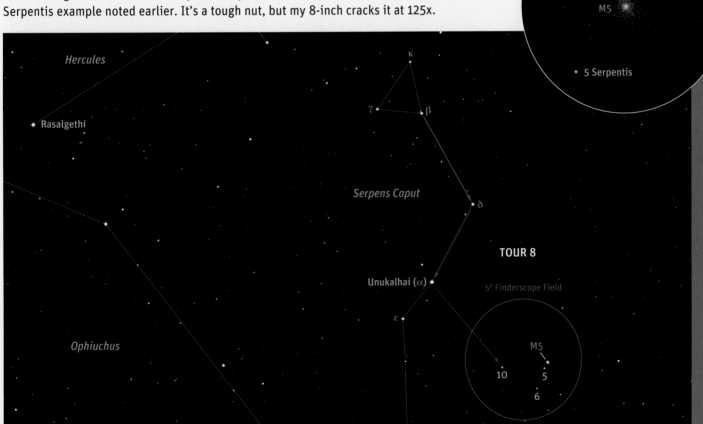

TOUR 9 CHANDELIERS OF SUNS

The H-shaped constellation **Hercules** contains the **Keystone**, a tidy asterism outlined by four third- and fourth-magnitude stars. You'll find the Keystone two-thirds of the way from zero-magnitude Arcturus to equally bright Vega.

The Keystone houses the famous Hercules Cluster, **M13**, arguably the best globular visible from midnorthern latitudes—though M5, in Serpens (Tour 8), gives M13 a run for its money. M13 sits two-thirds of the way from 2.8-magnitude **Zeta** (ζ) **Herculis** to 3.5-magnitude **Eta** (η), on the west side of the Keystone. Some 21,000 light-years away, M13 is a 5.8-magnitude object almost 17 arc minutes in diameter. Like M5, it's finderscope-friendly.

In my refractor at 25x, M13 is a hazy sphere with a broad, bright middle and a diffuse halo. The little fuzzball is flanked by a 6.8-magnitude orange star 15 arc minutes to the east and a 7.3-magnitude white star a similar distance to the southwest. At 75x, the view is impressive; patient staring teases out pinprick flecks of light—individual stars—across the cluster. My larger scope working at 125x resolves M13 into a chandelier of suns, despite my light-polluted sky. By the way, an 11.6-magnitude galaxy called **NGC 6207** lies half a degree northeast of M13. The tiny, oval fuzz challenges city-based scopes, but it's a slam dunk away from town.

Eta Herculis, mentioned earlier, establishes the Keystone's northwest corner. A line from Eta to 3.8-magnitude **Iota** (ι) **Herculis**, 12½ degrees to the northeast, grazes another fine globular cluster, **M92**. More distant (26,000 light-years), dimmer (magnitude 6.4) and smaller (11 arc minutes) than M13, M92 can't quite match the glory of its Keystone cousin. In the refractor at 75x, M92 is strongly condensed and resists resolution. In my reflector, though, M92 is lightly salted with very faint stars.

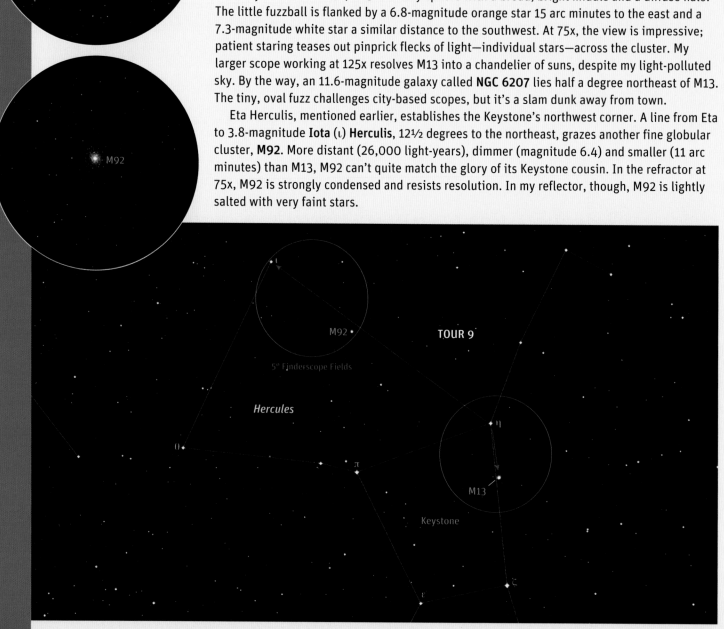

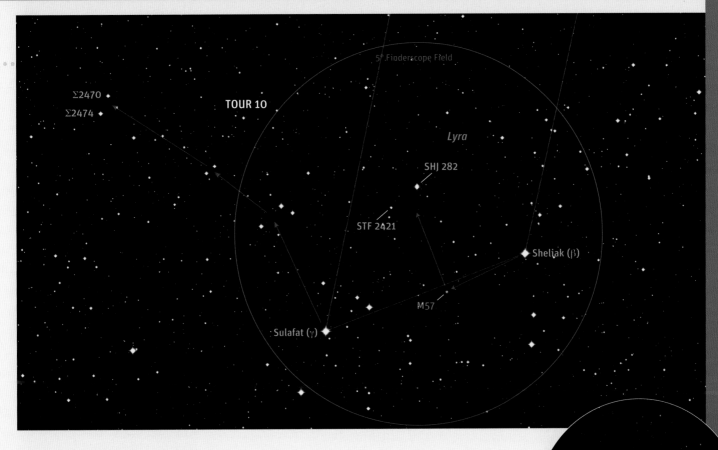

Σ2470
Σ2474

TOUR 10

5° Finderscope Field

Lyra

SHJ 282

STF 2421

Sheliak (β)

M57

Sulafat (γ)

M57

TOUR 10 RING STUDY

The south end of the parallelogram of medium-bright stars forming **Lyra** the harp is home to the remarkable Ring Nebula, **M57**. Formed by the ejected debris of a dying star, the iconic Ring is a picture-perfect planetary nebula, 2,000 light-years from Earth. The region also features several pretty star combinations.

The brightest one is **Beta** (β) **Lyrae**, or **Sheliak**. Beta Lyrae is a well-known eclipsing binary star that varies in brightness between 3.3 and 4.4 magnitude in regular 12.9-day cycles. Sheliak is attended by a 6.7-magnitude star 46 arc seconds southeastward and a wide pair of unrelated 10th-magnitude stars northward. Viewed at low magnification, it resembles a multiple-star system.

The Ring sits two-fifths of the way from Sheliak to 3.3-magnitude **Gamma** (γ) **Lyrae**, or **Sulafat**. I can fit Sheliak and Sulafat, plus M57, in the 25x field of my refractor. But the low-power view is underwhelming. Of moderate brightness (magnitude 8.8) and size (80 by 60 arc seconds), the Ring is a minuscule gray disk at 25x. If I look right at it, the disk disappears. Doubling to 50x, M57 becomes a diminutive donut or Cheerio. In my reflector at 125x, the Ring is clearly oval, with brighter sides and darker ends. At higher magnifications, though, the swollen gray annulus starts to fade into my gray suburban sky.

Less than one degree northeast of the Ring are two easy doubles. The wider tandem, **SHJ 282**, has stars of magnitude 6.0 and 7.6, 45 arc seconds apart. Eighteen arc minutes southeast of SHJ 282 is **STF 2421**, with 8.1- and 9.3-magnitude stars 24 arc seconds apart. Both pairs (and the Ring!) fit in my refractor's low-power field.

We end with a "double duo" just under three degrees northeast of Sulafat. Σ**2474** holds 6.8- and 7.9-magnitude stars 15.8 arc seconds apart, while 10 arc minutes northwest, Σ**2470** has 7.0- and 8.4-magnitude stars 13.6 arc seconds apart. The refractor resolves both pairs at 50x. Check our chart for a star-hop route past successive pairs of stars to this delightful duet.

TOUR 11 BIG, BRIGHT BARBELL

Our tour originates in **Cygnus** the swan, whose head is marked by **Beta (β) Cygni**, or **Albireo**. (Albireo is also part of the well-known Northern Cross.) Albireo is an exceptional double star comprising 3.1-magnitude (orange) and 5.1-magnitude (blue) suns 35 arc seconds apart in a rich Milky Way star field. Albireo's colorful gems are without rival—any size scope operating at low magnification is all you need to appreciate them.

From Albireo, we slide southeastward into inconspicuous **Vulpecula** the fox and follow an eight-degree-long string of stars formed by fifth-magnitude **10, 13** and **14 Vulpeculae**. The latter guards the Dumbbell Nebula, **M27**, a planetary nebula 1,200 light-years from Earth. A shorter star-hop begins in adjacent **Sagitta** the arrow, to the south. From 3.5-magnitude **Gamma (γ) Sagittae**, we jump 3¼ degrees directly north to M27. The 7.3-magnitude nebula, about eight by six arc minutes in size, shows dimly in my 8x50 finderscope.

A planetary nebula such as M27 or M57 (Tour 10) develops when an aging, shriveled star sheds its outer layers to create an expanding gaseous shell. In the case of M27, the shell displays a bipolar structure because

we're viewing it side-on. Triangular lobes fanning northward and southward form the "dumbbell" (most observers see an hourglass or apple-core shape), which materializes in my refractor at 75x, provided I use a narrowband nebula filter. Under a rural sky (or using my bigger scope), I perceive tenuous nebulosity filling the area between the lobes, which morphs the Dumbbell into a ghostly planet adrift in space.

A bonus for those with wide-field scopes is **Collinder 399** (Cr 399), a 1.5-degree-wide asterism better known as the **Coathanger**. Formed by 10 stars ranging between fifth and seventh magnitude, the Coathanger is upside down—but will appear upright in telescopes (and optical finderscopes) with inverted fields of view. You'll find the Coathanger roughly eight degrees west of Gamma Sagittae and the same distance south of Albireo. Don't miss the eye-catching Coathanger!

TOUR 12 TEAPOT TREASURES

The distinctive **Teapot**, in **Sagittarius** the archer, can guide us to several excellent deep sky objects.

The Teapot's lid is topped by 2.8-magnitude **Lambda (λ) Sagittarii**. Here, 2½ degrees northeast of Lambda, is the Great Sagittarius Cluster, **M22**, 10,000 light-years away. Magnitude 5.1 and almost half a degree in diameter, M22 is visible without optical aid from a rural site. My refractor at 25x makes M22 a ball of hazy glitter; more magnification resolves the glitter. In my reflector at 100x, M22 is a glorious pincushion of stars.

A line from second-magnitude **Sigma (σ)** through Lambda Sagittarii (past the little globular **M28**) reaches the 5,100-light-year-distant Lagoon Nebula, **M8**, above the Teapot's spout. A showcase emission nebula, M8 floats amid a loose string of fifth- to seventh-magnitude stars. The ¾-degree-wide nebulosity is divided by a curvy lane—the "lagoon"—into two parts: a filamentary portion embracing the open cluster **NGC 6530** and a bright western portion dominated by a sixth-magnitude star. The nebula/cluster combo is a low-power delight. However, adding a narrowband nebula filter and increasing the magnification will reveal tenuous filaments all around.

Just over a degree above M8 is the delicate Trifid Nebula, **M20**. A two-part object, M20 measures about 30 by 20 arc minutes, stretching north-south. The south half (pink in photos) is a tri-petal emission nebula surrounding an eighth-magnitude binary star. A narrowband nebula filter increases the contrast of this pale celestial flower and defines the intersecting dust lanes. Adjacent to the Trifid northward is a blue reflection nebula illuminated by a 7.5-magnitude star. My filter can't enhance reflection nebulas, but at a dark rural site, both of my scopes detect the ghostly glow—and the Trifid beside it—without filters.

The two embedded stars in M20 are part of a chain curving northeastward to sixth-magnitude **M21**, a modest open cluster. M20 and M21 "chained" together are a pleasing sight in a low-power eyepiece.

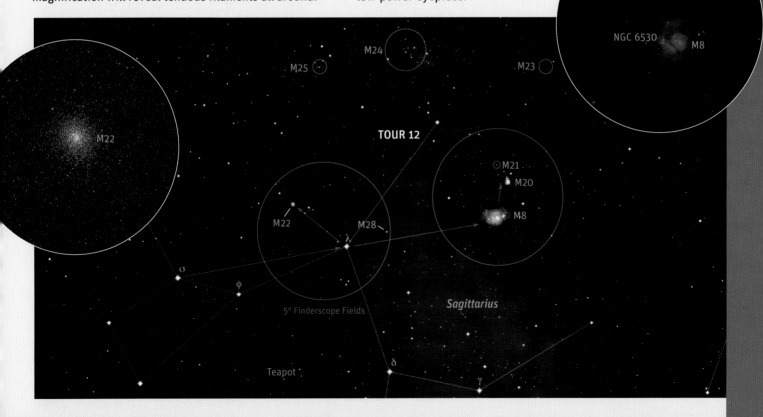

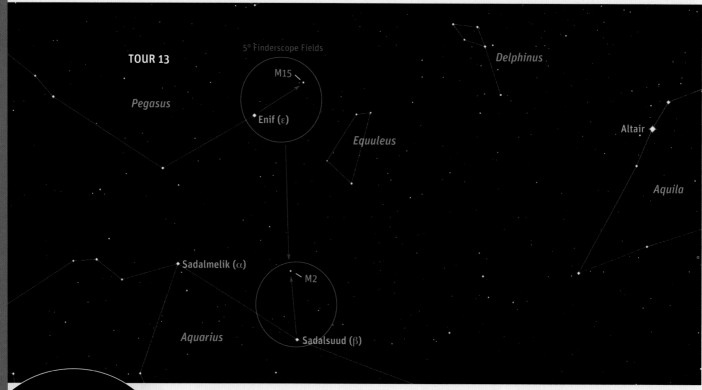

TOUR 13 BATTLE OF THE GLOBULARS

This tour focuses on the globular clusters **M2** and **M15**. Both are sixth-magnitude, 12-arc-minute-wide spheres of stars. But they're not twins.

The head of **Pegasus** the winged horse is marked by 2.4-magnitude **Epsilon (ε) Pegasi**, or **Enif**. Yellow-orange in hue and bearing a wide, ninth-magnitude companion, Enif is our gateway to M15. Look for the cluster four degrees northwest of Enif, just west of a sixth-magnitude star. The Pegasus globular is 34,000 light-years from Earth.

The brightest members of M15 are magnitude 12.6. The majority are about three magnitudes dimmer, so M15 isn't a blaze of pinpoints in backyard scopes. In my 4-inch at 25x, M15 is a well-defined circular haze that grows brighter toward the center. At 50x, the cluster's tenuous outskirts materialize as a dim halo. At 75x, a few halo stars are perceptible, and 100x pulls in several more. My 8-inch at 125x resolves many stars, plus a nuclear core. In fact, M15 possesses an exceptionally dense middle. While 175x can produce radiating chains of stars, M15's cramped center remains a bright knot—as in "not" resolved!

Our second globular, M2, lies 13 degrees south of M15, in **Aquarius** the water carrier. Look for it seven-tenths of the way from Enif to 2.9-magnitude **Beta (β) Aquarii**, or **Sadalsuud**. Some 40,000 light-years away, the Aquarius cluster appears a bit dimmer than its northern cousin. M2's brightest stars are only magnitude 13.1 (beyond the reach of my smaller scope), and most are three steps fainter. My reflector at 125x gives me a slightly elliptical mist, partially resolved into stars, that brightens smoothly and gently toward the middle. At 175x, the resolution improves dramatically.

Of the two clusters, M2 might be more richly concentrated overall. But M15 strikes me as the worthier specimen because of its incredibly compact, gleaming core.

TOUR 14 CELESTIAL ROYALTY OBSERVED

The constellation **Andromeda** the princess is outlined by a slender, V-shaped star pattern. At its eastern end is **Gamma (γ) Andromedae**, or **Almach**, an excellent binary. The 2.1-magnitude, yellow-orange primary sun is accompanied by a 5.4-magnitude blue star 10 arc seconds away. My 4-inch scope resolves the colorful couple at 50x. Lovely set!

Let's slide southwestward to 2.1-magnitude **Beta (β) Andromedae**, or **Mirach**. Turning to the northwest, we jump 3½ degrees to 3.8-magnitude **Mu (μ)**, then hop over 4.5-magnitude **Nu (ν)** to the majestic Andromeda Galaxy, **M31**. Some 2½ million light-years from Earth, M31 is the nearest major spiral galaxy to our own.

And it's huge. The oval object measures three by one degrees, slanted northeast-southwest. Officially, it's magnitude 4.3, but most of the light is concentrated in the galaxy's central bulge. Viewed in my suburban 4-inch scope at 25x, the bulge resembles an unresolved globular cluster. The slender disc (M31 is inclined on an angle) is dimmer; I need extra magnification to pick up "wings" on either side of the bulge. The northwest edge

of the galaxy seems unnaturally sharp due to an outer lane of obscuring dust.

M31 hosts two ninth-magnitude "dwarf" satellite galaxies. **M32** stands 24 arc minutes south of the parent's bright hub. At low power, M32 resembles a fuzzy star. At high power, it gains a halo—again, like an unresolved globular with a starlike center. **M110** floats northwest of the hub a bit farther out. It's larger than M32, strongly elliptical but poorly concentrated. At best, M110 is a thin sheen.

Viewed under a country sky, all three galaxies shine, especially Messier 31. In my 8-inch scope at 50x, M31's sharp northwest edge resolves into two parallel dust lanes—an almost three-dimensional effect. The Andromeda system is truly a royal trio.

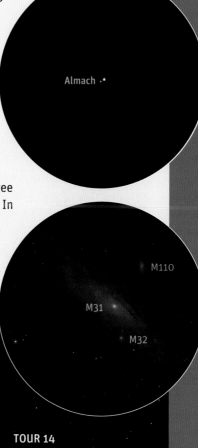

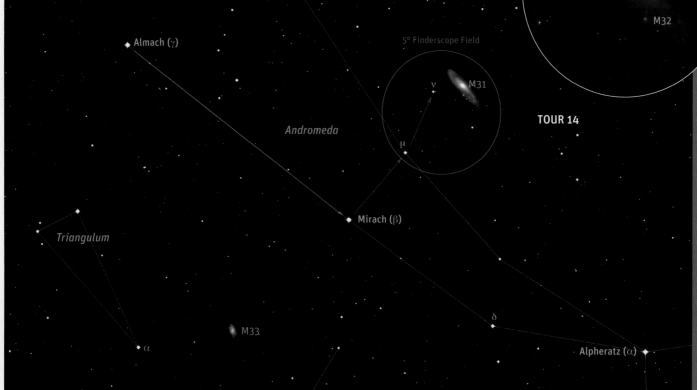

NORTHERN AUTUMN SKY

TOUR 15 COSMIC NEIGHBORS

Hail, **Cassiopeia** the queen. We start at 2.2-magnitude **Alpha** (α) **Cassiopeiae**, or **Schedar**, the brightest and southernmost point in the constellation's W-shaped star pattern. Schedar glows orange and has a wide, ninth-magnitude attendant.

From Schedar, we first shift 1¾ degrees northeastward to 3.5-magnitude **Eta** (η) **Cassiopeiae**, or **Achird**. Yellowy Eta, only 19.4 light-years away and a near twin of our Sun, protects a 7.5-magnitude red dwarf 13.4 arc seconds to the northwest. This pretty pair is a must-see in any scope!

Back to Schedar. A line from Schedar to 2.3-magnitude **Beta** (β) **Cassiopeiae**, or **Caph**, extended northwestward six degrees reaches **M52**, a 6.9-magnitude, ¼-degree-wide open cluster. (Helpfully for star-hoppers, a fifth-magnitude reddish orange star, **4 Cassiopeiae**, stands just north of M52.) About 4,600 light-years from Earth, M52 contains perhaps 200 blue-white suns, the brightest being 10th magnitude. On its southwest perimeter is an 8.3-magnitude yellow-orange star. In my 4-inch scope at 25x, I see that prominent outrigger along with a few flecks of starlight atop a faint, mottled mass; 75x pulls in more stars and helps separate the cluster from its surroundings. My 8-inch resolves M52 into dozens of dots.

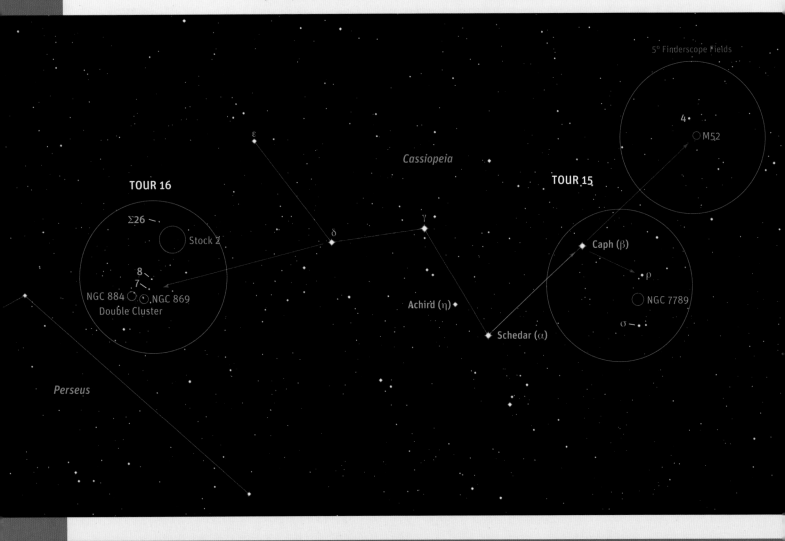

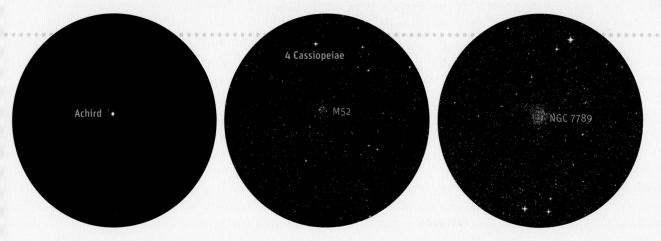

If we return to Caph and shift 2½ degrees southwestward, we come to 4.5-magnitude **Rho** (ρ) **Cassiopeiae**. Nearly two degrees south of Rho is 4.9-magnitude **Sigma** (σ) **Cassiopeiae**, a binary star whose 7.2-magnitude secondary component is set off by only 3.2 arc seconds. My 8-inch splits Sigma nicely at 135x.

Roughly halfway between Rho and Sigma is **NGC 7789**, sometimes called Caroline's Rose, after Caroline Herschel, who discovered it in 1783. A rich cluster at least half again as far away as M52, NGC 7789 is officially magnitude 6.7. However, NGC 7789 appears dimmer—its members are faint and spread over a larger area than M52. At 25x, my refractor struggles to do better than several dim stars atop a granular haze. Staring intently in my 8-inch at 100x, I can see countless faint stars overlaying the haze.

TOUR 16 DOUBLE CLUSTER TRIO

For our final northern tour, we slide south of the Cassiopeia W into northern **Perseus**, the rescuer of Andromeda. Here, we find the side-by-side open clusters **NGC 869** and **NGC 884**, popularly known as the **Double Cluster**, roughly 7,000 and 8,000 light-years away, respectively. Each about half a degree wide, the clusters overlap on most charts, though in telescopic views, they're separate, not only in the eyepiece but in space as well. Together, they span almost one degree of sky, oriented east-west. Simply put, they're low-power beauties.

The closer western cluster, NGC 869, shines at fifth magnitude and is packed with dozens of young blue-white stars. A pair of 6.6-magnitude stars, 2.4 arc minutes apart, stand out—one in the cluster's core and the other northeast of center. (A similar set, Σ**25**, just west of NGC 869, features 6.5- and 7.4-magnitude stars 1.7 arc minutes apart.) The more distant cluster, NGC 884, is almost one magnitude dimmer than NGC 869, has somewhat fewer stars and is less concentrated. Its core contains two triangular clumps of eighth- and ninth-magnitude stars.

A chain of stars dominated by sixth-magnitude **7** and **8 Persei** curls northwestward away from NGC 869 to a 6.4-magnitude star, then veers northward into Cassiopeia, where we find an obscure cluster called **Stock 2**. Only about 1,000 light-years distant, yet much less prominent than the Double Cluster, Stock 2 is a degree-wide spill of about 100 stars fainter than magnitude 7.5. The coarse collection fans broadly to the northeast, where a double named Σ**26**, comprising 6.9- and 7.2-magnitude stars 63 arc seconds apart, aims back at Stock 2's strongest concentration. In terms of brightness and slant, Σ26 is similar to Σ25 and also to the pair inside NGC 869.

Faint and loose, yes, but Stock 2 is visible in my refractor amid a rich Milky Way star field. Indeed, we're treated to a trio of clusters in a three-degree swath of sky. The entire field is stunning at low power in any short-focus, wide-field scope.

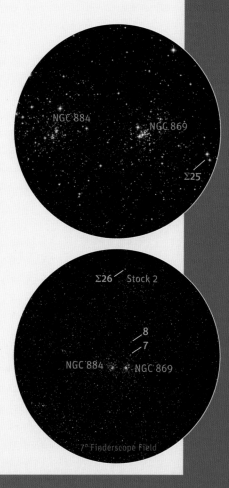

SOUTHERN-HEMISPHERE SKY

TOUR 17 GREAT BALL OF STARS

The two Magellanic Clouds are the showpieces of the southern sky. First plotted on 16th-century star maps as Nubecula Major and Nubecula Minor, these expansive objects didn't become known as the Magellanic Clouds (after the 16th-century global explorer Ferdinand Magellan) until the 19th century. Even the noted French astronomer Nicolas-Louis de Lacaille, writing in 1756, called them simply *le Grand Nuage* and *le Petit Nuage*. The Large Magellanic Cloud (LMC) is 163,000 light-years away, while the **Small Magellanic Cloud** (SMC) is about 40,000 light-years more distant. They had once been considered irregular galaxies but are now classified as barred spirals.

We haven't provided finder charts for the Clouds, as both are naked-eye objects in a dark sky and are plotted on our seasonal charts in Chapter 4. September to March is the best time for seeing them highest in the south—from well below the equator.

While the LMC is richer in terms of content, consider tackling the SMC first, as it contains only a few clusters and nebulas and sets sooner. The brightest nebula in the SMC is the elliptical glow of **NGC 346**. To the south is the compact cluster **NGC 330**; to the north is the looser cluster **NGC 371**. Together, this trio makes a fine telescopic field of contrasting objects.

The most spectacular sight seemingly a part of the SMC doesn't belong to the galaxy at all. **NGC 104**, or **47 Tucanae**, a foreground object "only" 13,000 light-years away, is arguably the best globular cluster in the heavens. It boasts a tightly compressed core, but at half a degree across, this impressive cluster resolves well in any telescope.

The globular **NGC 362**, also on the periphery of the SMC, is twice the distance of 47 Tucanae and smaller, but don't neglect it. With sufficient magnification, NGC 362 holds its own as a fine and similarly compressed globular—a "mini 47 Tuc."

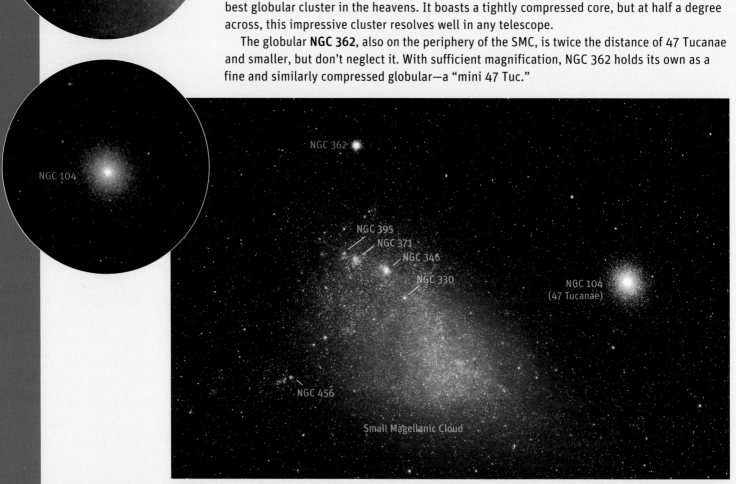

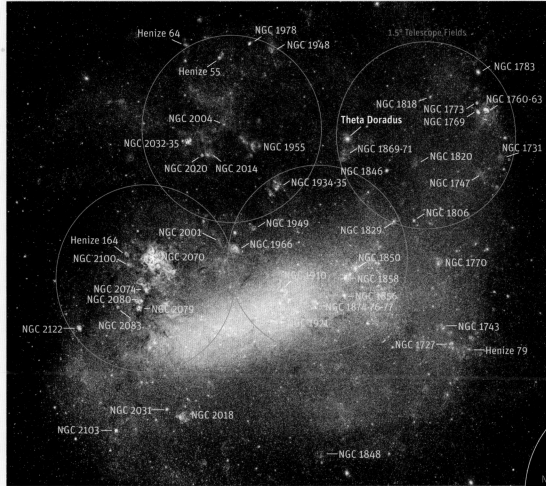

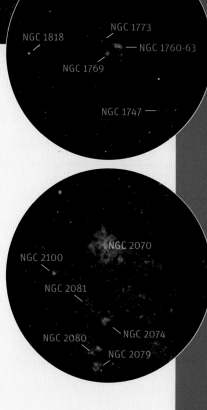

TOUR 18 THE LMC UNIVERSE

With the **Large Magellanic Cloud** (LMC), you can peer into the heart of another galaxy to sweep across field after field of clusters and nebulas. The trick is figuring out what each fuzzy bit is! Many LMC star clusters seem nebulous but are not marked as nebulas on charts. Yet they respond to nebula filters. Conversely, objects marked as nebulas can look like star clusters. The distinction between open and globular clusters is also fuzzy in the LMC—due to the great distances involved, every cluster is tiny. Some of our labels might be wrong, as no two sources agree on every object's identity (we've used the *interstellarum Deep Sky Atlas* as our main guide).

You can spend several nights scanning the LMC. Each red circle is a 1.5-degree field of a low-power telescope eyepiece. Most of the pink and cyan nebulas in the photo show up visually, especially with a filter. The second best nebulous field in the LMC is often missed, as it lies far to the west. Brisbane-based observer Gregg Thompson dubs bean-shaped **NGC 1760** the LMC Lagoon. It forms a tight triangle with the nebulas **NGC 1769** and **NGC 1773**.

However, the showpiece of the LMC—visible even to the unaided eye—is **NGC 2070**, the Tarantula Nebula. It is an emission nebula so vast that if it were as close as the Orion Nebula, it would spread across some 30 degrees of sky. Despite its distance of 163,000 light-years, the Tarantula displays more structure than most nebulas inside our Milky Way. From binoculars to giant Dobsonians, every instrument trained on the Tarantula has something remarkable to show. Even without a filter, complex wisps and arcs of nebulosity spray out as appendages. Two large loops of gas around dark cavities resemble a skull. The entire field is strewn with faint nebulosity. A nebula filter reveals even more structural detail. Incredible!

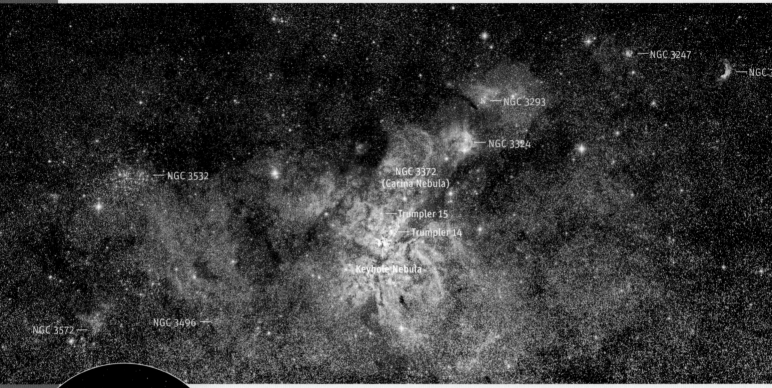

NGC 3247

NGC 3

NGC 3293

NGC 3324

NGC 3532

NGC 3372
(Carina Nebula)

Trumpler 15

Trumpler 14

Keyhole Nebula

NGC 3572

NGC 3496

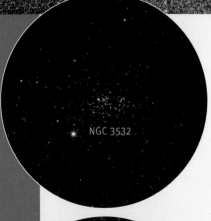

NGC 3532

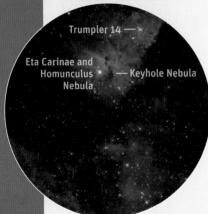

Trumpler 14

Eta Carinae and
Homunculus
Nebula

Keyhole Nebula

TOUR 19 CARINA CLOSE-UP

We took you to the wonders of Carina the keel in our binoculars Tour 10 in Chapter 6. If you have a telescope, the region is well worth a revisit. East of the main nebula is **NGC 3532**, an open cluster that 19th-century astronomer John Herschel called "the most brilliant object of the kind I have ever seen." You might well agree. Footy-mad Aussies have dubbed it the Football Cluster. It's also called the Black Arrow Cluster for the dark arrow-headed channel that bisects its length.

To the west of the Carina Nebula sits a Wolf-Rayet shell called **NGC 3199**, the Southern Crescent. A 4-inch scope will show it as a pale crescent, and it is obvious in an 8-inch, even without a filter. A narrowband O-III filter really makes it pop.

On the northern edge of the Carina Nebula is **NGC 3293**, the Gem Cluster, another of the southern sky's colorful star clusters. A single ruby-red star is set in a field of blue diamonds.

With or without a filter, the Carina Nebula appears as a beautiful painting of light and shadow. Dark lanes sculpt the bright tri-lobed emission nebula known as **NGC 3372**, which also contains an assortment of subtle star clusters. The entire object is sometimes called the **Keyhole Nebula**; however, that name properly applies only to a small region close to the supernova-candidate star **Eta Carinae**. Look for a tiny, dark feature—the "keyhole"—though it might be obvious only in larger apertures.

Indeed, examine Eta Carinae itself. It should appear golden yellow and fuzzy. Bump the magnification up to 200x or more, and under steady seeing conditions, the **Homunculus Nebula** should come into view. A bright but tiny hourglass-shaped nebula, it is the remnants of an outburst of Eta Carinae in the 1840s. In a large telescope, it is absolutely one of the finest and most unusual sights the deep sky has to offer.

TOUR 20 CENTAURUS SPECTACLES

This field in **Centaurus** the centaur lies far enough north that low-latitude northern observers should be able to see it on spring nights. However, our chart assumes that you are south of the equator, so it uses **Alpha Centauri**, itself an impressively bright and close double star (with a 5.6-arc-second separation), and **Crux**, the Southern Cross, to triangulate north to naked-eye **Omega Centauri**. But Omega is not a star!

Any optics will show Omega as a fuzzy glow. While officially classed as the sky's largest globular cluster, Omega might actually be the core of a dwarf galaxy 15,800 light-years away. Some 10 million stars are contained within the 150-light-year-wide cluster. Also called **NGC 5139**, Omega is stunning. Telescopes show it as a uniform ball of stars resembling a giant pile of sugar. No wonder observers call it "Oh-My-God" Centauri. Rippling seeing conditions make the stars appear to sparkle.

If that's not enough for you, just 4½ degrees to the north (within a binocular or finderscope field) lies **NGC 5128**, the Hamburger Galaxy. At magnitude 6.8, it is one of the brightest galaxies in the sky—and one of the oddest. Also known as the radio source **Centaurus A**,

NGC 5128 is likely the result of a collision with a smaller spiral galaxy. The dark, curving lane across the middle of this spherical giant might be evidence of the absorbed galaxy. The dusky lane represents the hamburger patty. Large telescopes at high power reveal a thin line of starlight crossing the patty—the "lettuce" on the hamburger!

Four degrees southwest of Omega is 9.3-magnitude **NGC 4945**. Well-known American observer Stephen O'Meara dubs this edge-on barred spiral the Tweezers Galaxy. Others know it as the Gold Dollar Galaxy. In small scopes, it appears as an elongated haze, but larger apertures reveal more of its dark mottling and internal structure. This trio exemplifies the southern sky's remarkable splendors.

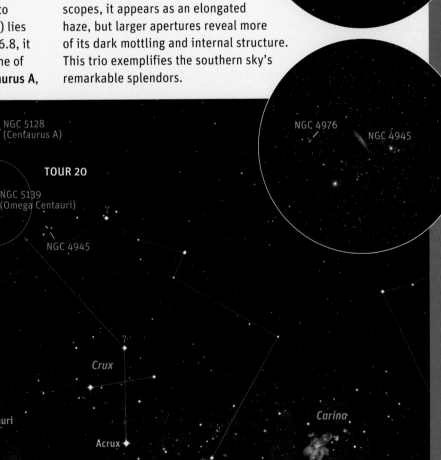

NGC 5139 (Omega Centauri)

NGC 5128 (Centaurus A)

NGC 4976 NGC 4945

NGC 5128 (Cenfaurus A)

Centaurus

5° Finderscope Field

TOUR 20

NGC 5139 (Omega Centauri)

NGC 4945

Alpha Centauri

ε

Crux

Carina

Beta Centauri

Alpha Centauri

Acrux

CHAPTER 17

Photographing the Sky

Capturing fabulous images of the night sky is so much easier in the digital age than it was during the last century with film. You see instant results, which makes the effort more gratifying and the learning process less painful. But there's a lot to learn!

In our tutorials, we emphasize two key philosophies: (1) Keep It Simple and (2) Take It One Step at a Time. All too often, we see newcomers dive into the deep end of advanced astrophotography, buying complex gear they see experts using on YouTube, only to struggle, if not fail, to get decent results for all the expense and effort. We advise learning the basics first and using the gear you might already own before embarking on a buying spree.

As such, Part Four on astrophotography is geared to using good-quality, interchangeable-lens cameras you can buy at any camera store. The possibilities they provide are endless and are enough to keep you busy for a lifetime of shooting. They have for us!

One of the most popular targets for aspiring deep sky photographers is the Andromeda Galaxy (M31). This is a stack of nine images taken with one of the setups shown later in the chapter (page 359), the Orion ED80T refractor on a Celestron AVX mount, a good entry-level system. The processing steps for this image are shown in the tutorial in Chapter 18 on page 382.

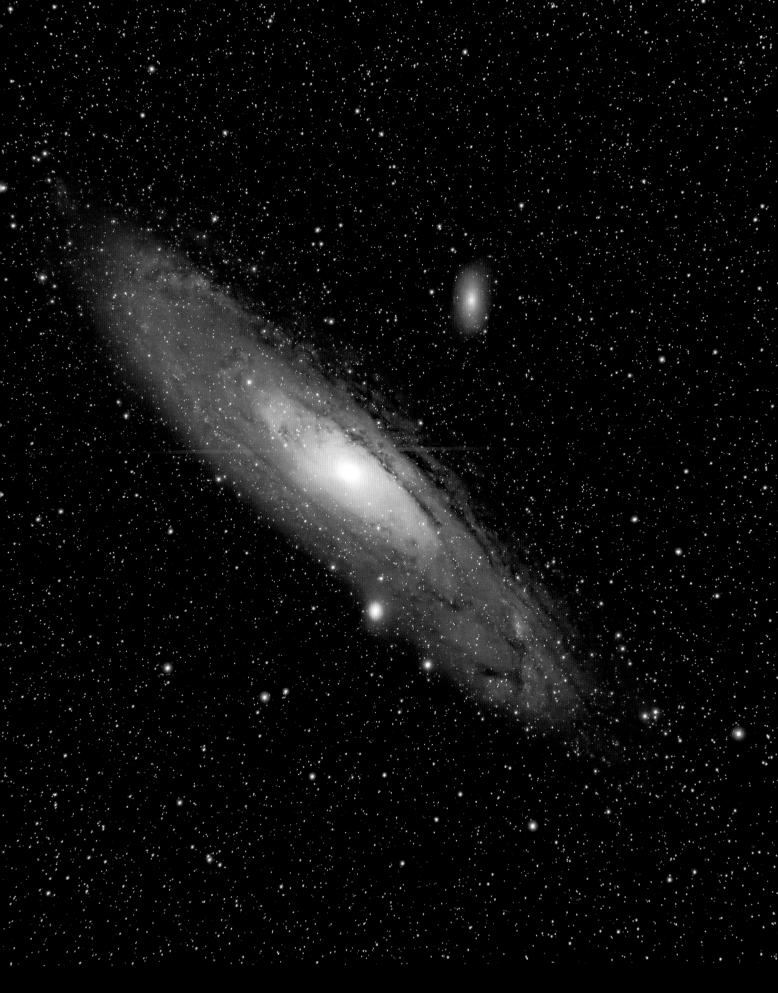

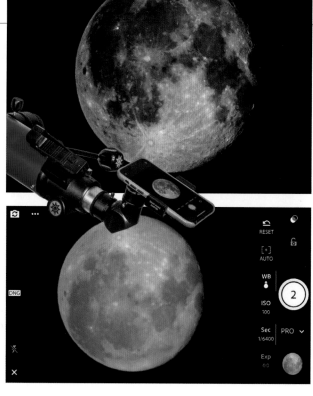

GETTING STARTED: PHONE PHOTOGRAPHY

How can you get into astrophotography? You may have a camera in your pocket that is surprisingly capable. As of 2019, smartphones from Apple, Google, Huawei and Samsung, among others, feature cameras with advanced "night modes" that increase sensitivity and reduce noise when shooting low-light scenes.

SHOOTING NIGHT SCENES

The cameras in phones use very small sensors with individual pixels only 1 or 2 microns across (explained in "Decoding Camera Specs" on page 346). Because tiny pixels cannot collect many photons of light during a given exposure, images shot in low light will be very grainy, or "noisy." The secret to phone cameras working at all at night is their clever use of computational photography, made possible by the powerful computers in modern phones.

The cameras shoot multiple images and then internally stack them on the fly to average, or smooth out, the random elements of the images—the speckles of noise—while building up the image content you want.

Results vary and will improve with every annual upgrade of phone models. However, despite comparisons you might see on the web claiming a phone can match a DSLR, that's far from true for long exposures of the night sky. The in-camera processing can do only so much to overcome the limitations imposed by physics and the inability of small pixels to collect enough photons. That said, you can still have a lot of fun with your phone.

SHOOTING THROUGH A TELESCOPE

Even older phone cameras can be put to use taking shots of the Moon through any telescope, a great project for kids to try. Indeed, many beginner scopes now come with adapters for clamping a phone to a telescope eyepiece.

The Moon is bright, requiring exposures so short you don't even need a telescope with a tracking motor. A telescope on an altazimuth or Dobsonian mount will work, though you will have to keep nudging the scope to keep the Moon centered. Depending on how large the Moon appears in the camera field, you might need to tap on the Moon's image to force the camera to set the exposure correctly and to auto-focus on the Moon. Take lots of shots, as some will be sharper. Images can then be processed with the camera's photo app and shared to the world.

CHOOSING A DSLR OR DSLM CAMERA

We take all our astrophotos with either a digital single lens reflex (DSLR) camera or, increasingly, a digital single lens mirrorless (DSLM) camera. We think these are the best cameras for learning astrophotography. Unlike specialized astro-cameras, DSLR and DSLM cameras don't require a computer and complex software to run or an external power source. They are easy to attach to a telescope, operate and focus. And they can also be used to take scenic nightscapes, star trails and Milky Way panoramas. So our tutorials focus on using either a DSLR or a DSLM. It's all we ever use. And it's what you might already own.

CROPPED OR FULL FRAME?

If you're purchasing a camera, your budget may restrict your choice to a cropped frame camera. With prices starting at $400, these cameras are more affordable than full frame cameras, which start at $1,000. A cropped frame camera can work very well, providing a tighter field of view than a full frame camera when on a telescope, good for framing small deep sky objects.

But as a rule, cropped frame cameras have smaller pixels (about 4 microns for a typical 24-megapixel cropped frame camera) than all but the highest-megapixel full frames. That means more noise. We prefer full frame cameras in the 20- to 30-megapixel range (as of 2021), with pixels about 6 microns across.

Camera models change much more frequently than do telescopes and eyepieces, so whatever we'd recommend for cameras would soon be outdated. Our general advice is to get the latest model, rather than an older one or a used camera. Noise performance almost always improves with every generation of camera. Unless your budget is very tight, buying an old Canon Rebel T3i, to name but one model, isn't what we would recommend.

When buying a new cropped frame camera, buy the furthest up the line you can afford, again because sensor noise is often less in the better cameras. In a full frame camera, the opposite is true: Lower-end, lower-megapixel cameras have larger pixels, hence lower noise,

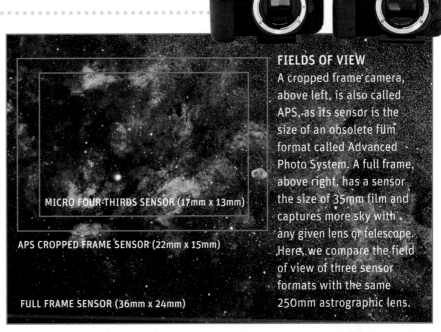

FIELDS OF VIEW
A cropped frame camera, above left, is also called APS, as its sensor is the size of an obsolete film format called Advanced Photo System. A full frame, above right, has a sensor the size of 35mm film and captures more sky with any given lens or telescope. Here, we compare the field of view of three sensor formats with the same 250mm astrographic lens.

MICRO FOUR-THIRDS SENSOR (17mm x 13mm)

APS CROPPED FRAME SENSOR (22mm x 15mm)

FULL FRAME SENSOR (36mm x 24mm)

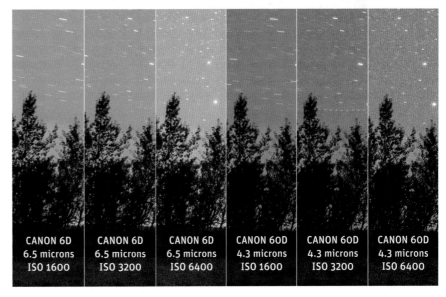

| CANON 6D 6.5 microns ISO 1600 | CANON 6D 6.5 microns ISO 3200 | CANON 6D 6.5 microns ISO 6400 | CANON 60D 4.3 microns ISO 1600 | CANON 60D 4.3 microns ISO 3200 | CANON 60D 4.3 microns ISO 6400 |

than their top-of-the-line 45- to 60-megapixel brethren. And for most astrophotography, low noise, not resolution, is paramount.

DSLR OR DSLM?

Either type of camera can do a fine job. But we think it's safe to say the future lies with mirrorless, as manufacturers are investing less on developing new DSLRs. Canon, Nikon and Sony all have superb DSLM cameras, though most are full frames. If you are on a budget, a cropped frame DSLR might be the best choice.

NOISE COMPARISON
Here, we compare noise at three ISOs between two similar-vintage Canon cameras, the full frame 6D and the cropped frame 60D, the latter with smaller but noisier pixels (4.3 microns versus 6.5 microns). The cropped frame camera has about one stop higher noise than the full frame camera.

DECODING CAMERA SPECS

BAYER ARRAY The pixels in all consumer digital cameras (with rare exceptions) are each covered by a tiny red, green or blue filter arranged in a Bayer color filter array (CFA), above, named for Kodak's Bryce Bayer, who invented the system. Each pixel records a monochrome but filtered image. To create a color image, the camera takes the data from each pixel and blends it with the data from the surrounding pixels. This decoding is called debayering.

DARK FRAME Most cameras have a Long Exposure Noise Reduction (LENR) option. When it is turned on, the camera takes a second exposure with the shutter closed that is equal in length to the actual exposure. This "dark frame" records nothing but noise, which the camera subtracts internally from the main exposure, eliminating hot-pixel thermal noise in long exposures. Thermal noise is an addition to the overall graininess seen in the images below.

DYNAMIC RANGE This is a measure of a camera's ability to record the widest range of detail, from bright highlights to dark shadows. Shooting with a bit depth of 14 bits, not 12 bits, increases dynamic range, useful for shadow details.

ISO SPEED A digital camera can be set to boost its sensor's gain using ISO settings similar to those applied to film emulsions. Doubling the ISO records objects in half the exposure times but at the expense of doubling the noise, as the photos below demonstrate.

JPG (or JPEG) IMAGES A file format set by the Joint Photographic Experts Group compresses image data to reduce file sizes. It irretrievably throws away data, as JPGs are 8-bit. JPG is increasingly being replaced by HEIF (High Efficiency Image File Format).

LOW-PASS FILTER Sensors are covered by a filter which blocks infrared light that the lens can't focus. In most cameras, another "anti-alias," low-pass filter smooths jagged pixelation.

MEGAPIXELS A sensor with an array of 6,000 by 4,000 pixels

has 24 million pixels, or 24 mega-pixels. Sensors with more pixels use smaller pixels, yielding greater resolution.

MICRON Pixel size, or pitch, is given in microns (1 micron = 1/1,000 millimeter). Each pixel in a typical camera is from 4 to 8 microns across. While small pixels provide sharper detail, large pixels exhibit lower noise because they can collect more photons.

PIXEL Each photosensitive element in a digital sensor is more correctly called a photosite but tends to be referred to as a pixel.

RAW IMAGES All good-quality cameras can be set to record images in raw format, retaining the full range of data untouched by compression, processing or noise smoothing. For maximum detail and dynamic range, all astronomical images should be shot in raw format.

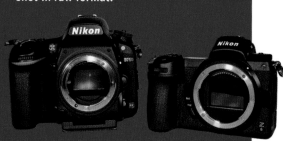

ISO 800

ISO 1600

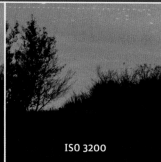

ISO 3200

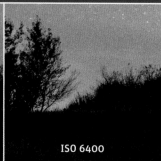

ISO 6400

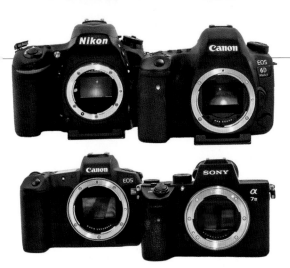

DSLR VS. DSLM

DSLRs, top, use a reflex mirror to direct light to an optical viewfinder, just as with film cameras. While most DSLMs, above, have an eye-level viewfinder, it shows the same electronic image displayed on the rear LCD screen.

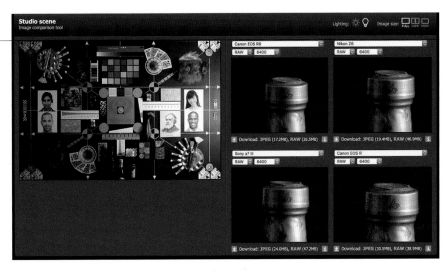

COMPARING CAMERAS

Tests of cameras for astrophotography are not common, but DPReview.com has comparisons of the relative noise levels of hundreds of cameras. Go to the full review of any camera, select Image Quality and Low Light. Pick the camera and ISO speed under Raw.

CANON, NIKON OR SONY?

For astrophotography, these are the big three. Pentax fans like the Astrotracer function that is unique to Pentax. It slowly shifts the sensor to follow the stars, allowing longer exposures without star trailing—in theory. In tests, we found it hit-and-miss, often adding more trailing. We also suggest avoiding cameras with Micro Four-Thirds (MFT) sensors. While great for video, they are too noisy for our purposes.

For astrophotography, Canon established itself as the leader early on, but in recent years, Nikon has matched, if not exceeded, Canon in long-exposure performance. Nikons, like Sonys, have "ISO invariant" sensors more forgiving of underexposure than many Canon DSLRs, exhibiting less noise when shadows are brightened, a characteristic that is good for nightscapes.

From 2014 on, Sony mirrorless cameras came on strong, prompting Canon and Nikon to develop their own mirrorless lines, the Canon EOS R and Nikon Z series. Sony Alphas are excellent for nightscapes and for low-light videos of auroras. However, in our tests of a Sony α7 III, it exhibited odd edge glows in long deep sky exposures. For that most demanding of tasks, we suggest Canon or Nikon.

CHOOSING LENSES

The common characteristic of a quality camera for astrophotography is that the lens is removable so that the lensless camera body can be attached directly to a telescope. But for many forms of astrophotography, we do use a lens, and it must be a good one.

As with daytime landscape photography, wide-angle lenses are needed for nightscapes, with focal lengths from 10mm to 24mm. They're also good for tracked Milky Way images. To frame photogenic star fields along the Milky Way, a telephoto lens from 85mm to 200mm works well. Just as with telescopes, no one lens can do it all.

While Sigma, Tamron and Tokina make some excellent zoom lenses, we both prefer fixed-focal-length "prime" lenses for their better optical quality and faster speed. Fortunately, manual-focus lenses are much less expensive than lenses with auto-focus, a function we don't need for astrophotography anyway. Manual lenses from Irix, Rokinon/Samyang and Venus Laowa all offer excellent optical quality for $300 to $900. For optical quality that rivals or exceeds top lenses from the camera brands, we love the Sigma Art series. But they are auto-focus lenses and are more costly than no-frills manuals.

CROPPED VS. FULL FRAME LENSES

Some lenses, like Rokinon's fast 16mm f/2 (left), are only for cropped frame cameras and will not illuminate a full frame sensor, unlike Rokinon's popular and low-cost 14mm f/2.8 (right).

ADAPTING LENSES

The selection of "native" lenses for mirrorless cameras and third-party offerings from brands such as Sigma is growing. However, lenses made for DSLRs, such as this Sigma 14mm Art, can be attached to a DSLM body with a lens adapter. You will likely need one to attach a DSLM to a telescope.

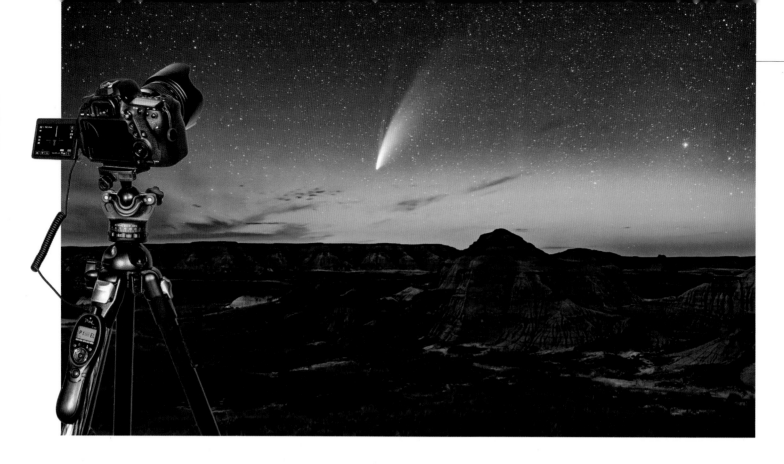

STEP ONE: CAPTURING NIGHTSCAPES

COMET NEOWISE AND AURORA

A camera on a tripod is all you need to start. Using a Canon 6D Mark II and a 35mm lens, author Dyer shot a single untracked 20-second exposure at f/2.5 and ISO 3200 for the sky and six 2-minute exposures at ISO 1600 for the ground, stacked to smooth noise, as explained on page 380.

F-STOPS

Lenses are marked in f-stops: f/1.4, f/2, f/2.8, f/4, f/5.6, etc. Each jump of one f-stop halves or doubles the amount of light the lens collects.

Before diving into the deep end of deep sky imaging, hone your skills by shooting and processing nightscapes using no more than a camera on a tripod. This will teach you how to manually set and focus your camera at night, no small feat if all you've shot up to now are daytime scenes, likely with your camera on auto-exposure (AE) and auto-focus (AF).

And lest you think this form of astrophotography is just for beginners, a number of our colleagues in the field make their living shooting nothing but still-image nightscapes. Author Dyer has also written an extensive e-book just on shooting nightscapes and time-lapses (see amazingsky.com).

GETTING STARTED

While you need a good camera, don't skimp on the tripod. Flimsy travel tripods are not suitable for the long exposures we shoot. Budget $200 to $400 for the tripod. We use models from Manfrotto, but there are many fine brands.

If all you have is an 18mm-55mm kit zoom lens, use it. It can work well for bright scenes in twilight and moonlight. But dark, moonless scenes with the Milky Way require a fast wide-angle lens, such as a 14mm f/2.8 or 24mm f/1.4.

You'll also need a remote camera release or, better yet, an intervalometer ($50 and up), as shown above. Be sure the intervalometer fits the remote port on your camera, as the style of port varies even within a camera brand. A spare battery is a good idea too, especially with older cameras with poorer battery life.

MOONLIT SCENES

Nightscapes are easy, but don't leap into Milky Way shots at dark sky sites. Start with urban skylines at twilight. Or head to a scenic site when a bright Moon is out. Its light will illuminate the landscape below a blue sky filled with stars.

While it is possible that auto-focus and even auto-exposure might work under moonlight, the point is to learn not to depend on them. Switch your camera to Manual (M), and set the shutter speed, lens aperture and ISO speed based on your judgment, not the camera's.

So which exposure is best? Choose an ISO no higher than necessary for an image well exposed to the right (ETTR), as on page 351.

High ISOs are noisier than low ISOs and have a lower dynamic range. On moonlit nights, start with ISO 800, then try 400. Or go higher, if needed. Decreasing the ISO requires either lengthening the shutter speed or opening up the aperture, or both. Increasing the ISO allows shorter shutter speeds or smaller apertures.

While shooting with the lens "wide open" at f/1.4 to f/2 might work, lenses exhibit more aberrations when wide open. Stars look soft across the frame and distorted at the frame corners. Stopping down the lens by one or two f-stops (to f/2.8 or f/4) might be needed. A smaller aperture also provides more depth of field so that the foreground as well as the stars can all be in focus.

THE 500 RULE

It's better not to shoot at high ISOs if they aren't necessary or with the lens wide open. But for nightscapes, there's a limit on the shutter speed due to the rotation of Earth. The 500 Rule says that the maximum exposure time before stars begin to trail is: 500 ÷ focal length of the lens. So the limit for a 50mm lens would be 500 ÷ 50 = 10 seconds. This is true whether you shoot cropped or full frame.

Those with high-megapixel cameras who wish to be more finicky can opt for the stricter 300 Rule. In practice, however, a little star trailing can be difficult to see, especially on Instagram!

THE MILKY WAY

Images with the Milky Way over a scenic landscape are the iconic nightscapes. Your kit zoom lens with its maximum aperture of f/5 won't do the job. This is where you must have a fast and wide lens. With the 500 Rule or stricter 300 Rule limiting the exposure time to 15 to 40 seconds, there's no choice under moonless skies but to open the lens aperture to f/2.8 or f/2 and to boost the ISO to 3200 or even as high as 12,800. This is where the quality of your camera becomes apparent. Lesser cameras won't perform well over ISO 1600.

With wide apertures and the sky in focus, the foreground will be out of focus. One technique is to shoot one image for the sky and one for the ground, the latter with the lens stopped down, as smaller apertures yield

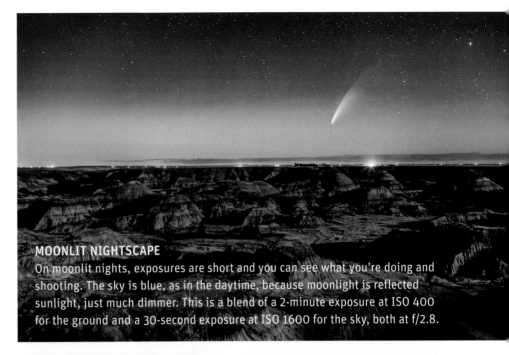

MOONLIT NIGHTSCAPE
On moonlit nights, exposures are short and you can see what you're doing and shooting. The sky is blue, as in the daytime, because moonlight is reflected sunlight, just much dimmer. This is a blend of a 2-minute exposure at ISO 400 for the ground and a 30-second exposure at ISO 1600 for the sky, both at f/2.8.

OFF-AXIS ABERRATIONS
When used wide open, even top-quality lenses exhibit coma and astigmatism at the corners, as well as vignetting that darkens the corners. Stopping down to f/4 cleans up most flaws, but a speed of f/2 or f/2.8 is often the best compromise.

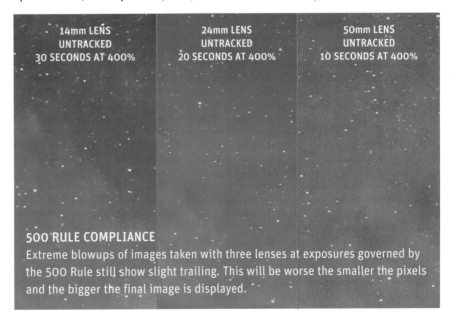

14mm LENS
UNTRACKED
30 SECONDS AT 400%

24mm LENS
UNTRACKED
20 SECONDS AT 400%

50mm LENS
UNTRACKED
10 SECONDS AT 400%

500 RULE COMPLIANCE
Extreme blowups of images taken with three lenses at exposures governed by the 500 Rule still show slight trailing. This will be worse the smaller the pixels and the bigger the final image is displayed.

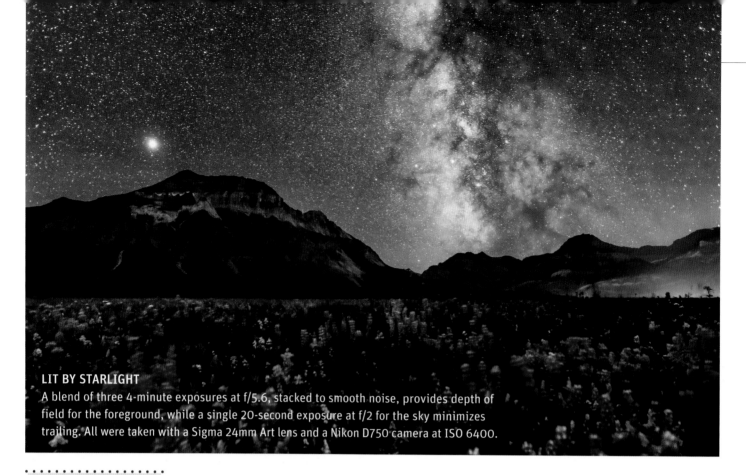

LIT BY STARLIGHT
A blend of three 4-minute exposures at f/5.6, stacked to smooth noise, provides depth of field for the foreground, while a single 20-second exposure at f/2 for the sky minimizes trailing. All were taken with a Sigma 24mm Art lens and a Nikon D750 camera at ISO 6400.

more depth of field. The two are blended later in processing.

CALCULATING EXPOSURES

Shutter speed, aperture and ISO are all reciprocal. Increase one, and you can decrease one of the others. Doubling the ISO allows either halving the shutter speed or stopping the lens down by one f-stop—say, from f/2.8 to f/4. The penalty of the higher ISO is increased noise.

Take our Milky Way example: Suppose we found that an exposure of 30 seconds at f/2 and ISO 3200 worked well for the scene. But for the foreground to be in focus, the lens must be stopped down to f/5.6. That's going from f/2 to f/2.8 to f/4 to f/5.6, three f-stops. Each stop is a difference of two in light. So to make up for the loss of light, the exposure time has to lengthen, from 30 to 60 to 120 to 240 seconds, three doublings. The ground exposure must be 4 minutes long. If you also want to shoot the dark ground at ISO 800 for lower noise, then that's a loss of another two stops, a factor of

EXPOSURE SUGGESTIONS

TWILIGHT SCENES
◆ 1 – 8 seconds
◆ f/2.8 – f/5.6
◆ ISO 100 – 200

NOCTILUCENT CLOUDS
◆ 2 – 10 seconds
◆ f/2 – f/2.8
◆ ISO 400 – 800

MOONLESS NIGHTSCAPES
◆ 20 – 40 seconds
◆ f/2 – f/2.8
◆ ISO 3200 – 12,800

AURORAS
◆ 4 – 30 seconds
◆ f/2 – f/2.8
◆ ISO 800 – 1600

MOONLIT NIGHTSCAPES
◆ 5 – 15 seconds
◆ f/2.8 – f/5.6
◆ ISO 400 – 1600

STAR TRAILS/TIME-LAPSES
◆ 50 to 300 images
◆ expose as with other subjects
◆ at 1-second intervals

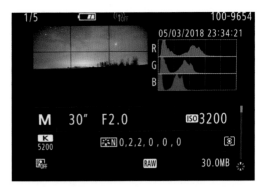

EXPOSE TO THE RIGHT

To maximize signal and minimize noise, the cardinal rule for nightscapes is expose to the right (ETTR). Use the camera's histogram to judge exposure. It should not be piled up to the left, underexposed, but stretched to the right, even if that requires using a higher ISO, as it did here.

four difference. The ground exposure would have to be 16 minutes long!

We cannot tell you what the best exposure is for any subject, as it will vary with the scene and sky quality. Getting it right requires learning how to balance the trade-offs in setting: shutter speed (to avoid trailing), aperture (for maximum light while minimizing lens aberrations) and ISO (for minimum noise without underexposing). This is just the kind of field experience that will serve you well when it comes time to shoot deep sky objects.

AURORAS

Auroras are a special case, as we are shooting a subject that is moving quickly and likely changing in brightness a lot over just a few seconds if a substorm occurs. For a bright, fast-rippling display, use shutter speeds of no more than 1 to 3 seconds at ISO 400 to 3200 with the lens aperture wide. Faint displays that are barely visible to the eye can still look great to the camera in exposures of 30 seconds at

ISO 1600 or more, again with the lens wide.

Mirrorless cameras can even capture real-time 4K videos of bright auroras, but only with f/2 or faster lenses and ISOs as high as 51,200. The Sony α7S series, with their big 8-micron pixels, are the masters of low-light video.

PANORAMAS

These are relatively easy to shoot. Instead of a single image, you take a series, shifting the camera about 30 to 45 degrees between images, usually moving from left to right. Two factors are critical: leveling the tripod and camera and allowing a 30 to 50 percent overlap, enough for the stitching software to identify common features to align and blend the segments. Use the same exposure for all the segments to avoid banding and unevenness in the sky.

Some nightscapers even shoot panoramas with multiple rows to cover the entire sky. Advanced software, such as Microsoft's Image Composite Editor (free) and PTGui ($150), can handle the complex stitching.

THE BIG PICTURE

A panorama captures the arch of the Milky Way and an aurora over Alberta's Red Deer River. It is a stitch of six segments taken using a Nikon D750 with a Rokinon 12mm fish-eye lens, in landscape orientation. Each frame was untracked for 45 seconds at f/2.8 and ISO 3200.

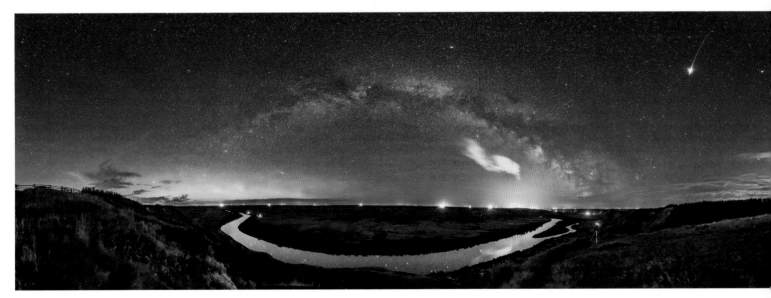

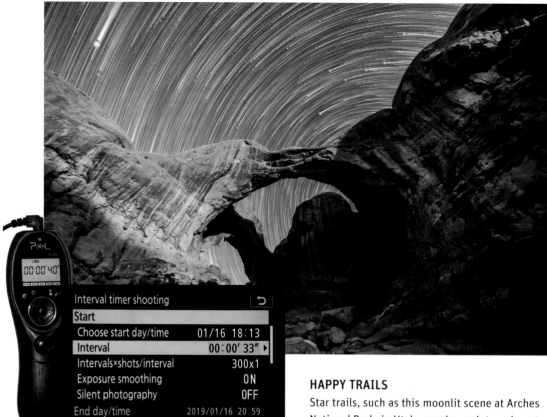

STAR TRAILS

If you can shoot one good exposure of a scene, it's easy to shoot dozens or even hundreds. The key is an intervalometer to fire the shutter automatically, using an interval of no more than one second between exposures. As soon as the shutter closes, it opens again for the next image. Any longer, and you'll see gaps in the star trails. Specialized programs, such as StarStaX (free), can stack the images into the equivalent of a single multiminute or multihour exposure.

MOTION CONTROL

The Star Adventurer Mini (Orion's StarShoot CAT is identical) can be set up so that it turns horizontally to shoot a time-lapse with the camera panning as the sky moves. Programming the angle of turn, the interval and the number of frames is done via WiFi using an app.

HAPPY TRAILS

Star trails, such as this moonlit scene at Arches National Park, in Utah, require an intervalometer. Many cameras have one built in, but the interval must be two to three seconds longer than the shutter speed: 33 seconds for a 30-second exposure, for example. Outboard intervalometers vary. For an interval of one second, some can be set to one second; others must be set to the exposure time + one second. Test before a critical shoot!

TIME-LAPSES

If you have a set of images taken for a star-trail stack, you can also string them together to assemble a time-lapse movie of the sky turning. Typically, at least 300 images are required. While Photoshop can create movies from a folder of images, the usual practice is to use a dedicated assembly program, such as TimeLapse DeFlicker or the advanced time-lapse processing software LRTimelapse.

Serious time-lapsers use devices that automatically pan, tilt or slide a camera during a shoot. These motion controllers are available from Dynamic Perception, Edelkrone, eMotimo, Syrp, Radian and Rhino, some of the brands author Dyer has used. As readers of our book are also likely to be interested in a sky tracker, we can recommend Sky-Watcher's Star Adventurer 2i and Star Adventurer Mini, both programmable via WiFi to perform simple motion-control time-lapses and to serve as a traditional polar-aligned tracker.

File Format

For astrophotography, always shoot in raw format, not JPG, and in the largest size (not RAW S). Shoot raw + JPG, if you wish, but that only takes up more card space.

Raw Options

Many cameras offer options for raw quality. For the widest dynamic range, always shoot 14-bit (not 12-bit) and Uncompressed. (This is a Nikon screen.)

Long Exposure Noise Reduction

The camera takes a dark frame after exposures longer than 1 second. Except for star trails and time-lapses, we recommend this, especially on warm nights.

CAMERA SETTINGS FOR ASTROPHOTOGRAPHY

Picture Style or Picture Control
This does *not* affect raw images, only JPGs. However, to have the preview image best resemble the final raw file, set this to Neutral.

Live View
DSLMs are always in Live View, feeding an image from the sensor to the viewscreen at all times. DSLRs have a Live View switch, but sometimes Live View has to be Enabled.

Mirror Lockup (for DSLRs only)
Use this for lunar imaging. It shouldn't be needed for deep sky, but with Canons, turning it on and using the 2-second self-timer flips the mirror up, then fires the shutter.

Custom Button Assignments
Many cameras have Custom or Multifunction buttons or dials. Assign them to functions you always use to quickly access at night. This is a Nikon Z 6.

Color Temperature
Auto White Balance (AWB) works well. But to ensure consistency from frame to frame, set the white balance to a fixed 5,200 kelvin.

Exposure Simulation
This boosts the brightness of the Live View image, making it easier to frame and focus. It can be well hidden and might not appear if Live View is turned off.

Display Brightness
Turn it down for astro use. If the image is too bright at night, it will provide a false impression of how well exposed the image is.

My Menu
All cameras have a My Menu that you can populate with commands scattered over many screens. Cameras also offer customizable Quick Menu or "i" screens.

Color Space
While this affects only JPGs, it is best to set the Color Space to Adobe RGB, not sRGB, so that the camera records the widest gamut of colors.

Silent LV Shoot
You can use the electronic shutter to start exposures. Disable it. The mechanical shutter will ensure that images are taken in 14-bit for maximum dynamic range.

Screen Info Settings
You can select what information is displayed when previewing and playing back images. Adjust this for an uncluttered view with the histogram visible.

Hidden but Critical Options
The Canon EOS R series, for example, has this Release Shutter w/o Lens option. If it is OFF, the camera shutter will not fire if it is attached to a telescope!

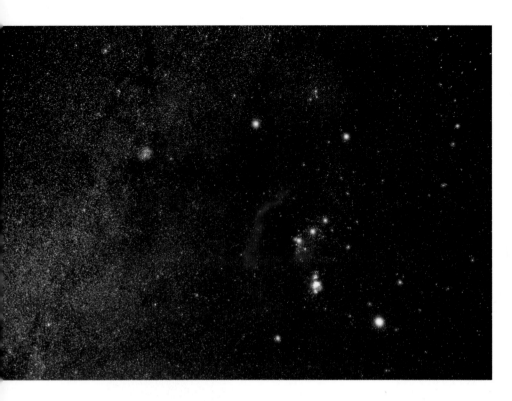

STEP TWO: TRACKING THE SKY

SKYGUIDER PRO TRACKER

The iOptron SkyGuider Pro ($450) has tracking accurate enough for a good percentage of untrailed 2-minute exposures with up to 200mm lenses. Its rechargeable lithium battery lasts for many nights.

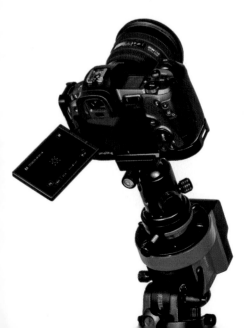

The next step circumvents both the 500 Rule and the 300 Rule because now we place the camera onto a small motorized tracker ($200 to $500) that can turn to follow the sky's rotation. Exposures can be several minutes without trailing. Lens apertures can be stopped down to f/2.8 or f/4 for the sharpest images, while ISO speeds don't need to be higher than 800 or 1600. Yet we get the Milky Way richly recorded because light can build up on the sensor, allowing the camera to record stars and nebulas far fainter than your eye can see—and in vivid color. You'll be hooked!

TRACKER SUBJECTS

The usual subjects for trackers are wide views of the Milky Way, constellation portraits, telephoto close-ups of Milky Way star fields and even large deep sky objects, such as the Andromeda Galaxy and Magellanic Clouds. So tracker shooting gets you into the realm of deep sky imaging in a relatively easy step up in complexity.

We can also use a tracker when photographing nightscapes. Take the sky image with

the tracker motor on, then turn it off for the landscape so that the tracker's motion doesn't blur the ground (or take the untracked image first). The two images are blended in processing. In those cases, it is still best to keep the tracker image no longer than 1 to 2 minutes (for each image if you are stacking several). The ground shot can be any length you want, as per the examples in the previous section.

POLAR ALIGNMENT

In shooting nightscapes, you get to know how to set your camera. With a tracker, you learn a new skill: polar alignment. A tracker must be aligned so that its rotation axis points at the celestial pole. We describe the steps in the Appendix. All trackers have a small polar-alignment scope with an illuminated reticle that shows where to place Polaris, in the northern hemisphere, or a pattern of stars in Octans, in the southern hemisphere. With a little experience, the process takes only a minute—OK, 10 minutes in the southern hemisphere!

The battery-powered tracker, set to the sidereal rate, turns to follow the stars. If the polar alignment is inaccurate, there will be some trailing in long exposures, especially with telephoto lenses. But the main cause of trailing will be errors in the small drive gears, a flaw more visible the longer the lens.

TRACKER CHOICES

In the old days, we had to do this type of photography by mounting the camera with its lens onto a telescope; this was known as piggyback photography. Now, there are a variety of dedicated sky trackers available that are compact enough to fit into a camera bag and great for taking to dark sky sites by car or by plane. Of the trackers we have tested and owned, we can recommend the iOptron SkyGuider Pro and the Sky-Watcher Star Adventurers.

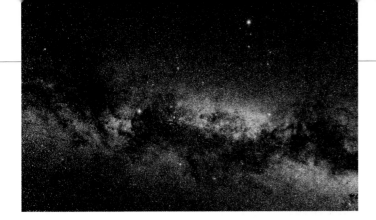

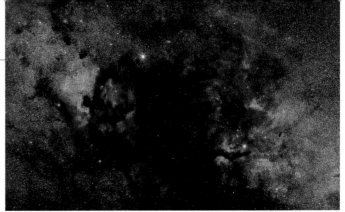

They each have an angled accessory head that bolts to any headless camera tripod. Adjustments on the tracker's head make it easy to precisely aim its polar axis at the pole. You then need a solid ball head to go onto the tracker to hold the camera. As with the tripod, don't scrimp. A light ball head will shift under the weight of the camera, especially with a heavy lens attached, causing more star trails.

HOW LONG CAN YOU GO?

The longer the lens, the more your images will be prone to trailing. We've found that the practical limit for most trackers is a fast 135mm to 200mm lens, in exposures of no more than 2 to 3 minutes. Take lots of images at those focal lengths, as some (often up to half) will be trailed to a certain extent. What many beginners want to do is mount a monster 600mm wildlife lens onto a small tracker. Don't. We have better options for you later.

Wide-angle lenses are far more forgiving, so exposures can be longer, perhaps 4 to 6 minutes. ISO speeds can then be lower. Wide-angle lenses are the worst offenders for off-axis aberrations, which become readily apparent when your subject is nothing but points of light. Stop down for the cleanest image. Which f-stop you use depends on the quality of your lens, which you will soon discover.

WHAT CAN POSSIBLY GO WRONG?

Facebook is filled with pleas for help from beginners struggling to find Polaris or targets of choice, like the Andromeda Galaxy. These are invariably from people attempting to shoot deep sky objects with trackers without first learning the sky, as we advised in Part One.

But you can get the tracker aligned and pointed and still make dumb mistakes, like setting the intervalometer incorrectly so that it misfires your exposures. Or bumping the lens, throwing it out of focus. Or forgetting to check batteries, so the camera or tracker dies partway through a shoot. Or...the list goes on! Welcome to astrophotography.

CHOOSE YOUR LENS
The sky has something for every lens. A 35mm lens takes in the dark lanes winding through Cygnus, left, while a 135mm telephoto used with a filter-modified camera frames regions of the Milky Way, such as the rich nebulosity in Cygnus, right. Both are stacks of several 3- to 4-minute exposures at f/2.8 and ISO 1600.

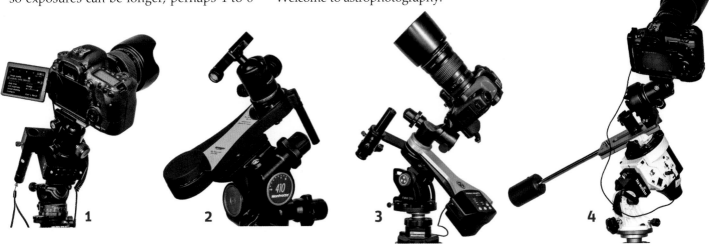

TRACKERS GALORE

1. The Move Shoot Move (MSM) Rotator ($200) is low-cost and compact but is good for wide-angle lenses only. **2.** The mechanical Omegon MiniTrack ($190) uses a clockwork sector drive, but it, too, is just for wide-angle lenses, and it cannot be turned off at will for nightscape images. **3.** At the high end, the Fornax LighTrack ($1,000) also uses a sector drive and tracks well enough for long lenses and small telescopes. **4.** A leading choice is the Sky-Watcher Star Adventurer 2i ($400), which can be configured with a declination bracket and counterweight, as shown. The 2i can control a camera shutter and be programmed with a WiFi app for time-lapse and tracked sequences.

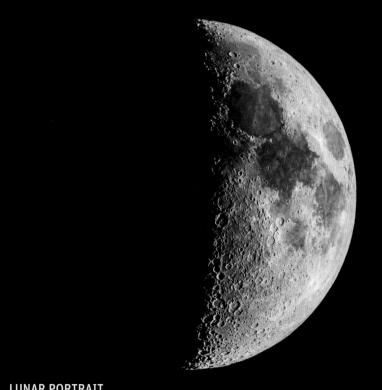

LUNAR PORTRAIT
With a small telescope, a Barlow lens might be needed to enlarge the Moon's image enough to reveal impressive detail. This photo was taken using a 130mm f/6 refractor and 2x Barlow for 1,600mm of focal length and 1/30 second at ISO 100 with a Canon 60Da. Can you see the Lunar X and Lunar V?

USING PLANET CAMS

The challenge when taking high-magnification images of the Moon and planets is the blurring effect of turbulence in our atmosphere, known as bad seeing. To combat it, planetary photographers shoot movies, capturing hundreds of frames, as some will be sharper than others, the essence of "lucky imaging." To shoot movies, the tool of choice is the dedicated planetary camera feeding a video stream directly into a computer via a wired high-speed connection.

The amazing lunar and planetary photos we feature in Chapters 12 through 14 by master imagers Robert Reeves and Damian Peach were taken with just such high-speed cameras. Planetary cameras from Celestron (shown), The Imaging Source, Orion, QHYCCD and ZWO are popular.

Software such as the Windows programs AutoStakkert! by Emil Kraaikamp (autostakkert.com) or RegiStax by Cor Berrevoets (astronomie.be/registax/) extracts only the best frames from the movie, then stacks and aligns them to reduce noise. Further processing with "wavelet" sharpening filters brings out far more detail than even the eye could see at the eyepiece, producing images that rival what Hubble can take.

STEP THREE: THROUGH A TELESCOPE

For the next step up in complexity, we attach a camera to the telescope to use the scope as the lens of the camera. It is possible to shoot the Moon through a Dobsonian reflector without any tracking, but for any other form of imaging through a telescope, you will need one with tracking motors. While planets can be shot using a GoTo scope on an altazimuth mount, long exposures of deep sky objects require a polar-aligned equatorial mount.

To be successful, you should know how to set up your telescope, including polar-aligning it, just as we did with a tracker, and then how to align its GoTo system, as per Chapter 11.

ATTACHING A CAMERA

If you want to shoot impressive frame-filling images of the Moon, couple your camera to a telescope with a focal length of 800mm to 1,600mm. To do that, you'll need an adapter for connecting the camera body to what is called the telescope's prime focus.

Some telescopes need a specific adapter for their focusers; in other cases, a generic adapter will work, which is inserted into the focuser like an eyepiece. While some beginner scopes have threaded focusers that will accept a T-ring, the Newtonians we tested did not rack in far enough to reach focus with a DSLR unless used with a Barlow and a nosepiece adapter. Refractors are better for providing ample focus travel.

The critical part is the T-ring that goes between your camera's lens mount and the generic M42 or wider M48 threads on the camera adapter or focuser. Telescope dealers carry these. DSLM cameras also need a lens adapter, as the T-rings are typically made to fit the Canon EF and the Nikon F lens mounts used by Canon and Nikon DSLRs, not their mirrorless RF and Z lens mounts, which are much wider.

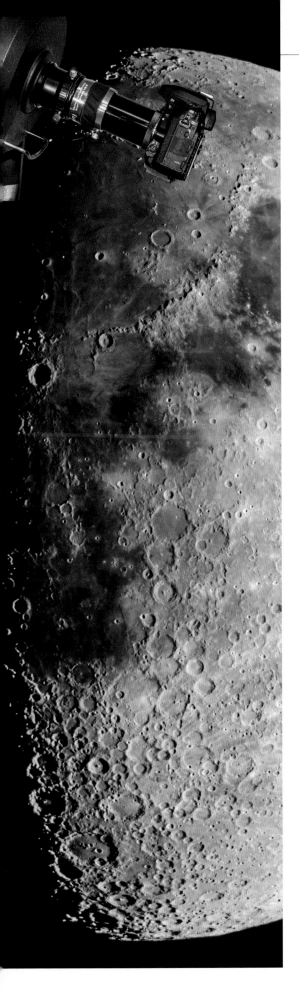

LUNAR CLOSE-UPS

With a Schmidt-Cassegrain and Barlow, the camera frames only a portion of the Moon. A set of overlapping images (three in this case) can be stitched in Photoshop to create a panorama or high-resolution mosaic. These images were taken with a Celestron C9.25, 2x Barlow and Canon 60Da. **Inset:** Incorporating a Barlow into the light path of a Schmidt-Cassegrain might require using a standard nosepiece adapter and a visual back.

Sony users should be able to find T-rings for the Sony E lens mount. For T-rings for all camera brands, see telescopeadapters.com.

SHOOTING THE MOON

Using Live View, you can focus on the limb of the Moon or on bright rims or central peaks of craters. Or you can slew to a bright star and focus on it, perhaps using a Bahtinov mask (see page 358).

For exposure settings, the Moon is bright, so ISO 100 works fine. Even then, exposures are just fractions of a second. After all, the Moon is a bright, sunlit rock. The correct exposure will depend on the focal ratio of your telescope, the clarity of the sky and the altitude and phase of the Moon. Try 1/4 second for a thin crescent, 1/30 second for a quarter Moon and 1/250 second for a full Moon. Expose long enough that the dark terminator is not underexposed but not so long that the rest of the bright lunar disk is overexposed.

MORE POWER!

Close-ups of the Moon or shooting the planets requires more power. A favored method is to employ a Barlow lens, inserted between the telescope and the camera. It can double or triple the effective focal length of the telescope. For example, an 8-inch f/10 Schmidt-Cassegrain has a focal length of 2,000mm, but with a 2x Barlow, it becomes an f/20 system with 4,000mm focal length, good for resolving the smallest details with 3- to 4-micron pixels. However, exposures must now be four times as long, or the ISO increased by a factor of four. To reduce vibration at such focal lengths, DSLR users should activate Mirror Lockup, while DSLM users can switch to Electronic First Curtain Shutter, or Silent Shooting.

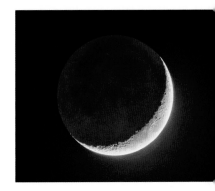

CAPTURING EARTHSHINE

Photographing the faint Earthshine on a crescent Moon requires an exposure of several seconds, normally overexposing the bright crescent. Here, blending in a shorter exposure retains the view as the eye saw it. For Earthshine exposures, set the telescope drive to the Lunar rate.

CAMERA ADAPTERS

Schmidt-Cassegrains need a unique T-adapter, top, while generic 1.25-inch, above, and 2-inch nosepiece adapters slide into any focuser. Both types require a camera-specific T-ring.

HIDDEN MENUS
Nikon hides its Exposure Preview option, top, under the "i" menu. Sony's Bright Monitoring, above, isn't even in a menu and can be accessed only by assigning it to a Custom Button. But when it is on, the Milky Way shows up in Live View —wonderful for framing nightscapes.

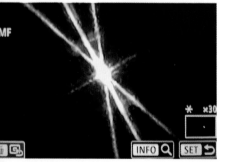

FOCUSING THE CAMERA

While good exposure is important, we can sometimes fix poor exposure in processing. But not poor focus. It is critical to get it right. Newcomers are always surprised by the challenge. Just seeing anything in the viewfinder at night to frame can be tough, never mind focusing the image.

USING LIVE VIEW

With many DSLRs, the optical viewfinder might provide the brightest view for framing a scene. To critically focus, however, you must use Live View (sometimes indicated as LV on DSLRs) to feed the rear LCD screen a video signal from the sensor. (Mirrorless cameras are always in Live View mode.) First, make sure the lens is on Manual Focus (MF). Then aim at a distant bright light or a bright star and move the overlay box over the light or star. Hit the "+" button to zoom up the image to maximum, then manually adjust the focus of the lens until that point of light is as tiny and sharp as possible. This must be done because even lenses that are marked with a distance scale are usually not in sharpest focus for the sky when set to infinity (∞).

ENHANCING THE VIEW

Brightening the Live View image makes it easier to find a target to focus on and to frame the scene. Turning on Exposure Simulation (on Canons) or Exposure Preview (on Nikons) electronically brightens the image. Opening the lens to maximum aperture and increasing the shutter speed might also help. But Nikons can go dark if put on Bulb. As a rule, DSLMs have a brighter Live View image than DSLRs, and full frame DSLRs are often brighter than cropped frames.

FOCUSING AIDS

A unique aid to focusing is called a Bahtinov mask. It creates a diffraction pattern on bright stars that makes it easy to nail focus when in Live View. It is indispensable for use on telescopes when shooting deep sky images. It also works on telephoto lenses when shooting tracked images of star fields.

Versions of Bahtinov masks in the form of etched plastic filters are sold for nightscape shooting, but we've found these ineffective—when used with wide-angle lenses, the diffraction pattern is too small to be usable.

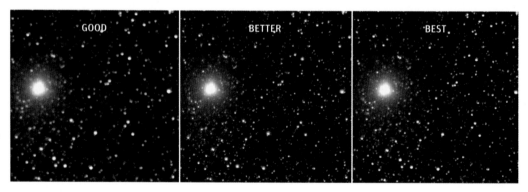

NAILING FOCUS
Above: Missing focus makes stars look soft and cyan-tinted. Getting better makes stars sharper but perhaps still surrounded by colored halos from chromatic aberration. With the best focus—in this case, with a telephoto lens—the stars are colorless.

FOCUSING MASK
Left: When placed over a telephoto lens or telescope, a simple Bahtinov mask adds diffraction spikes to bright stars. The optics are in focus when the central spike is precisely in the middle of the two side spikes, taking the guesswork out of judging focus visually.

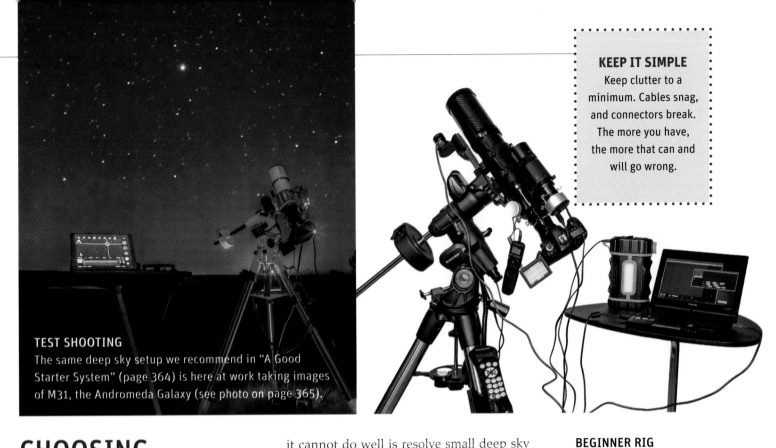

TEST SHOOTING
The same deep sky setup we recommend in "A Good Starter System" (page 364) is here at work taking images of M31, the Andromeda Galaxy (see photo on page 365).

KEEP IT SIMPLE
Keep clutter to a minimum. Cables snag, and connectors break. The more you have, the more that can and will go wrong.

CHOOSING DEEP SKY GEAR

Now we start spending! To keep costs reasonable, we concentrate on fitting you out with a good entry-level deep sky rig for less than $3,000. So this is not a shopping list for advanced users seeking a dream "retirement" system.

OUR FIRST-CHOICE TELESCOPE
We feel that the best telescope for starting out in deep sky photography is an apochromatic refractor with about 80mm aperture and an f/ratio of f/5 to f/7. Prices start at $1,000 for the optical tube.

The advantages are many: The speed is fast enough to keep exposures short while providing an evenly illuminated field with corner-to-corner sharpness; the tube is small and light, so it matches well with a small mount for portability and affordability; and the short focal length is forgiving of less-than-perfect polar alignment and auto-guiding.

Yet the telescope's focal length of 400mm to 560mm is enough for impressive close-ups of the larger classes of deep sky objects: nebulas, open star clusters and big galaxies, like Andromeda and the Magellanic Clouds. What

it cannot do well is resolve small deep sky objects, such as most planetary nebulas, globular star clusters and galaxies. Those require a focal length of 800mm to 2,000mm.

GOING SMALLER: ASTROGRAPHS
A class of instrument popular in recent years is the astrograph. Many astrographs are refractors with only 50mm to 70mm apertures. That sounds small, but what distinguishes astrographs is that they are not designed to be used visually. Think of astrographs in this size as first-class lenses with more precise focusing mechanisms and sharper optics than a

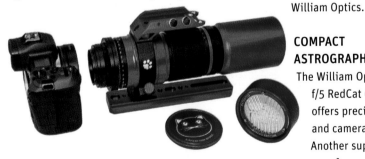

BEGINNER RIG
Here's another good entry-level rig, one author Dyer used to take the M31 image on page 343: Celestron's AVX mount and Orion's ED8OT refractor, with a StarShoot auto-guider. In small apos, we can also choose from APM, Astro-Tech, Explore Scientific, iOptron, Lunt, Omegon, SharpStar, Sky-Watcher, Starwave, Stellarvue and William Optics.

COMPACT ASTROGRAPHS
The William Optics 51mm f/5 RedCat (top; $750) offers precise focusing and camera rotation. Another superb performer is Meade's 70mm f/5 Astrograph (bottom; $1,200). Similar small astrographs are available from Askar/SharpStar, Borg/Astro Hutech and OPT/Radian.

POPULAR BUT PROBLEMATIC

We do not recommend a small astrograph such as the RedCat on a tracker like the SkyGuider Pro, although this is a popular combination. The latter lacks precise declination adjustments, making aiming and framing difficult. Use a full German equatorial mount for such an astrograph.

telephoto and fittings more amenable to secure mounting and attaching auto-guiders.

A small astrograph can still cost $1,000. Someone starting out might be better served by a good photo-visual telescope, rather than one specialized for imaging.

GOING LARGER

Serious beginners could step up to a 100mm apo refractor. Many are f/5.5 to f/7 with either doublet or triplet ED lenses and focal lengths up to 700mm, better for resolving small deep sky targets but still providing a generous field of view. Prices for the optical tube alone range from $1,500 to $4,000, so a complete system with mount will break our $3,000 entry-level budget.

WHAT ABOUT REFLECTORS?

We prefer refractors for their image quality and freedom from collimation concerns. Plus, with the exception of specialized astrographs, refractors work equally well both visually and photographically, which is generally not the case with reflectors.

However, a reflector can produce stunning results, with the advantage of providing fast speed and long focal lengths at a very reasonable price. For example, Sky-Watcher's Quattro 200P yields 800mm of focal length at f/4, a combination few, if any, refractors can match, certainly not at the $1,000 price point of the Quattro. The downsides are the critical collimation and the need for a hefty mount.

Celestron's Rowe-Ackermann Schmidt Astrograph (RASA) series offers unmatched speeds of f/2. Author Dyer tested the RASA 11 ($3,500) and loved its image sharpness, but not its weight. The 8-inch RASA, while compact, works only with cropped frame DSLM or cooled CMOS cameras.

What about a Schmidt-Cassegrain? Celestron's EdgeHD and Meade's ACF systems, with their field-flattening optics, are designed for imaging. Their long focal lengths (1,400mm with the f/7 reducer on a Celestron 8-inch) are great for capturing galaxies, globular clusters and planetary nebulas. But they demand windless nights and steady seeing. We don't recommend them for beginners.

CHOOSING A MOUNT

The primary choice of most astrophotographers is a German equatorial mount (GEM). Solid GEMs with the accurate tracking needed for long exposures start at $800 for a lightweight mount. Such a mount is also the minimum if you are set on shooting with that 600mm telephoto, certainly with any telescope. The GoTo functions and dual-axis motions make it easy to find and frame objects, not true for trackers.

GEMs are easy to polar-align, are not as prone to vibration as fork mounts and accept a variety of tube assemblies. A solid GEM is the literal foundation of an astrophoto system, so the usual wise advice is to invest most in the mount. Placing too heavy a telescope on too light a mount

BIGGER APOS

Moving to a 100mm (4-inch) apo gets you a very capable visual telescope that is still highly portable. Two units we've tested and can recommend are the Sky-Watcher f/5.5 Esprit 100, top, and Explore Scientific's f/7 FCD100 (above).

PREMIUM 4-INCH

At $4,000, Tele Vue's NP101is (for "imaging system") is among the more costly choices in the 4-inch class. But it certainly performs well, both visually and photographically at f/5.4. We show it here on the popular Sky-Watcher HEQ5 mount ($1,200).

is asking for endless trouble, thus our proscription against mounting a big telephoto on a small sky tracker. That said, overbuying can get you a mount that, while capable of handling a larger telescope in the future, might be so heavy, you are discouraged from using it.

We primarily show Sky-Watcher light and middleweight mounts, as those are the models we've had the chance to test in recent years. But there are many good mounts under $3,000 from Celestron, iOptron, Losmandy, Meade and Orion.

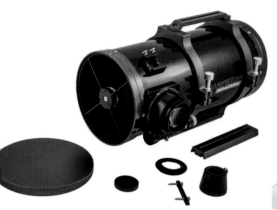

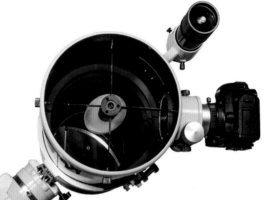

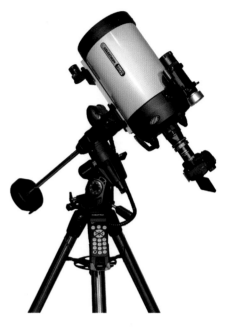

ASTROGRAPHIC REFLECTOR

SharpStar's 150mm HNT ($2,000) is an f/2.8 "hyperbolic" Newtonian with a corrector lens built into the focuser. While it can be used with an eyepiece for collimation, this is a photo-only instrument, with images sharp across a full frame.

PHOTOGRAPHIC NEWTONIAN

Astrographic Newtonians, like this Sky-Watcher Quattro 200P, feature oversized secondary mirrors for full-field illumination and well-baffled tubes for maximum contrast. The size and mass of the Quattro's tube requires a middleweight mount.

SCHMIDT-CASSEGRAIN PACKAGE

Celestron's compact but solid AVX mount can just handle the 8-inch EdgeHD tube. However, the long focal length of any Schmidt-Cassegrain demands accurate polar alignment and auto-guiding, as well as windless nights to keep images steady and sharp.

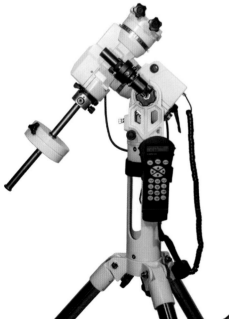

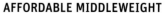

VERSATILE LIGHTWEIGHT

The Sky-Watcher AZ-EQ5 ($1,500) can be set up as an altazimuth mount for visual use or equatorially for imaging. It's a good match for an 80mm or a light 100mm refractor.

VERSATILE MIDDLEWEIGHT

The Sky-Watcher AZ-EQ6 ($2,200) can also be used as an altazimuth or equatorial mount and is ideal for handling a larger apo refractor such as this Astro-Physics 130mm f/6.

AFFORDABLE MIDDLEWEIGHT

For a 5-inch apo, like Tele Vue's NP127is, we like the middleweight Sky-Watcher EQ6-R. At $1,600, it is affordable for its weight class and capable of handling many scopes.

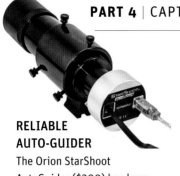

RELIABLE AUTO-GUIDER

The Orion StarShoot AutoGuider ($300) has long been a popular choice for its high sensitivity. Here, it is coupled to a repurposed 50mm finderscope.

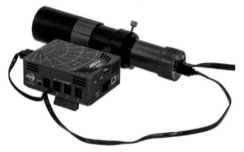

WIRELESS AUTO-GUIDER

ZWO's ASIAIR Pro sets up a local WiFi network for controlling a GoTo telescope, an imaging camera and the auto-guider (here on a ZWO 30mm mini-guidescope). It works great. Similar units include the StellarMate and PrimaLuceLab's Eagle Core.

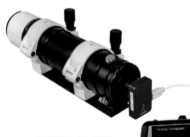

STAND-ALONE GUIDER

Ideal for use with a DSLR, Lacerta's MGEN-3 ($800) is a stand-alone auto-guider with a small guide camera that can attach to any guidescope. It also works great, guiding on dozens of stars and controlling a camera shutter to do dithering.

FIELD FLATTENERS

Astrographic Newtonians need a coma corrector to eliminate the principal aberration of all fast Newtonians: off-axis coma. The main accessory required for most apo refractors is the field flattener, to compensate for the refractor's curved focal plane, which throws the corners out of focus. This is particularly crucial when using full frame cameras that take in the entire field of the telescope.

Some field flatteners are also reducers, typically providing a 0.8x reduction in effective focal length and an increase in speed of nearly one stop, shortening exposures by nearly half, always a plus. The downside of any reducer is that it always introduces more vignetting—a darkening of the field toward the corners. This might be correctable in raw development but, if severe, will need the fuss of flat field frames, described on page 368.

AUTO-GUIDING

As with sky trackers, all telescope mounts exhibit some level of drive errors that make the mount wander back and forth in right ascension as it tracks from east to west. This can be a regular periodic error dictated by the rotation rate of the main driving gear. Or it can be random fluctuations from irregular errors in the gear machining.

These errors, plus any drift north or south in declination from imperfect polar alignment or atmospheric refraction, can be counteracted by auto-guiding. The auto-guider, a small, dedicated camera attached to a guidescope, looks at the star field around your target. It monitors the position of a guide star (or multiple stars), detecting its shift with sub-arc-second accuracy. When the guide star moves, the software sends pulses to the mount to jog it the other way to compensate. These corrections happen every few seconds, ensuring that stars do not trail. The longer the focal length you shoot with, the more critical it is that the auto-guiding be accurate.

All astrophoto-capable mounts come with auto-guider ports to accept the correction pulses from any guider. These ports are usually configured in the "ST-4" standard, named after the first auto-guider to be introduced, the Santa Barbara Instrument Group (SBIG) ST-4, back in the early 1990s.

A few stand-alone auto-guiders have been offered over the years, notably Celestron's poor and insensitive NexGuide and SBIG's superb but discontinued SG-4. However, most auto-guiders are just cameras and must work through external software running on a laptop or netbook. The usual choice is the excellent and free program PHD2 Guiding (openphdguiding.org).

CHOOSING FILTERS

Don't fuss with filters. Not to start. But for more advanced work, a nebula filter can bring out details in emission and planetary nebulas and in supernova remnants. It can cut light pollution enough that good images of emission nebulas are possible even from light-polluted backyards.

Broadband filters reduce light pollution and enhance nebulas. Narrowband filters make nebulas pop even more by letting through only a few nanometers of bandwidth around the green O-III and H-beta and the red H-alpha and Sulfur-II emission lines. While these filters work great with DSLRs and DSLMs, the camera must be "filter-modified" for the maximum benefit.

STOCK OR MODIFIED?

You can shoot a lot with an off-the-shelf DSLR or DSLM. These cameras are great for star clusters and galaxies. Over the years, however, Canon has sold several astronomical "a" models: the 20Da (2005) and the 60Da (2012), both cropped frame DSLRs, and the EOS Ra (2019), a full frame mirrorless camera. In 2015, Nikon introduced its superb but now discontinued D810A.

All feature a sensor filter that cuts out infrared without sacrificing the deep red visible wavelength at 656 nanometers emitted by hydrogen atoms, the H-alpha line. This deep red light is only palely recorded by stock cameras. Some photographers claim that through aggressive processing, nebula images from a stock camera can be made to match those from a modified camera. We've never found that to be the case.

An alternative to a Canon or Nikon "a" model is to buy a stock DSLR or DSLM and have it modified or purchase it modified from

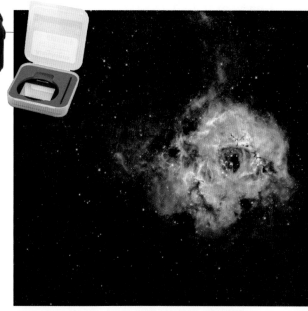

a specialty company, such as Astro Hutech (hutech.com) or Spencer's Camera & Photo (spencerscamera.com). The latter has a thorough list of cameras that work well when filter-modified.

While a factory-modified "a" camera can work well as a daytime camera, third-party modified cameras shift the color balance strongly pink. Although that can be partly corrected with a Custom White Balance, the colors will never be accurate for normal use. A third-party modified DSLR or DSLM is a camera you dedicate to astrophotography.

MONOCHROME FILTER

This image was shot in moonlight with a deep red H-alpha filter. It was taken with the SharpStar 15028HNT astrograph using an EOS Ra and a 12nm Astronomik clip-in filter. Clip-ins allow the filtered camera to be used on any scope or lens but are good for only that camera.

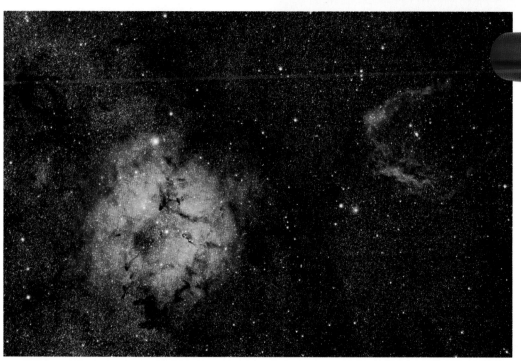

ENHANCING NEBULAS

Many adapters and focusers accept 48mm (2-inch) filters, such as the Optolong L-eNhance used on the 51mm RedCat with the EOS Ra to shoot faint nebulas in Cepheus, left. The final photo is a stack of filtered and unfiltered images. But filtered images of nebulas require a modified camera.

STOCK VS. MODIFIED

Here, we compare unprocessed images of the North America Nebula through: a stock Canon EOS R; the factory-modified EOS Ra; a third-party modified 5D Mark II; and the older 60Da. Red nebulas are weakly recorded in stock cameras, while the Ra does better than the 60Da. The Ra also has a 30x zoom in Live View for precise focusing.

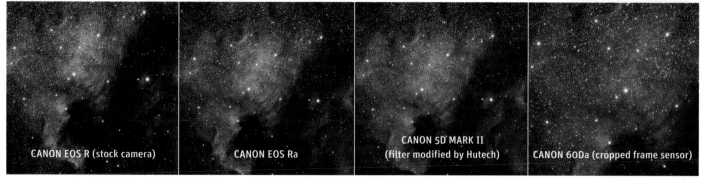

CANON EOS R (stock camera)

CANON EOS Ra

CANON 5D MARK II (filter modified by Hutech)

CANON 60Da (cropped frame sensor)

A GOOD STARTER SYSTEM

Here's a sample setup based on equipment we've used and can recommend. The core is a short-focus apo refractor on a solid but portable German equatorial mount. The total cost of the gear shown here, without the main camera and tablet, is about $2,800.

1 APO REFRACTOR We're showing a 76mm SharpStar EDPH refractor here, but there are many choices, usually f/5 to f/7. An alternative is an astrograph, such as a William Optics RedCat. Approx. $1,000.

2 GERMAN EQUATORIAL MOUNT For a small apo, the Sky-Watcher EQM-35 works well for good tracking, GoTo and dual-axis auto-guiding capability. But there are other choices. $800 to $1,500.

3 POLAR-ALIGNMENT SCOPE Most mounts, even trackers, have this for quick and easy polar alignment.

4 FIELD FLATTENER AND T-RING Apo refractors usually require a field flattener and/or reducer lens. Also needed is a camera-specific T-ring. $150 to $300.

5 GUIDING CAMERA For viewing a guide star (or stars) for accurate tracking, this little ZWO ASI120MM CMOS camera is one of many choices. $150 to $350.

6 MINI-GUIDESCOPE With sensitive guide cameras, a 30mm-aperture guidescope is adequate, with no need for adjustable guidescope rings. Approx. $100.

7 CAMERA CONTROLLER BOX (optional) A ZWO ASIAIR Pro connects to the auto-guider and sets up a WiFi node so that the tablet can be connected to perform the auto-guiding. Through its USB ports, it can also control an imaging camera and a GoTo mount. $300.

8 TABLET OR PHONE A tablet or smartphone runs the auto-guiding software; in this case, the ASIAIR app, which uses a version of PHD2 Guiding. The alternative is to wire a laptop directly to the auto-guider camera via USB.

9 IMAGING CAMERA This could be a DSLM, but we're showing a DSLR with a flip-out screen, very useful when on a telescope. We wouldn't buy a camera without one! $400 to $3,000.

10 INTERVALOMETER While the ASIAIR and other WiFi controllers can control select DSLRs, we usually use and recommend a reliable intervalometer. Approx. $50.

11 GOTO CONTROLLER Other than small trackers, mounts for astrophotography are all GoTo, which is essential for finding and framing targets in a telescope.

12 BATTERY While the camera will be good for two to three hours on its internal battery, the mount and guider gear require 12-volt power. Use a large-capacity lithium battery. Approx. $250.

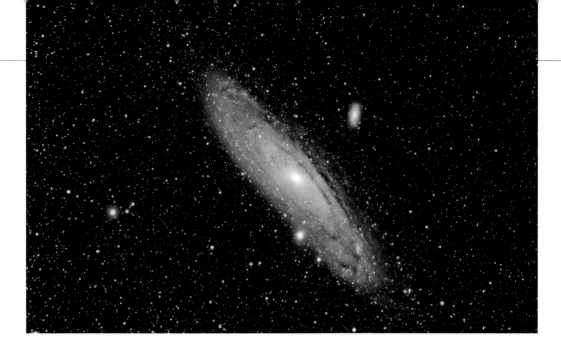

STEP FOUR: USING DEEP SKY GEAR

ANDROMEDA WITH STARTER SETUP
Taken with our starter system, facing page, this image is the result of the planning and exposures described below. This is a stack of sixteen 4-minute sub-frames shot with a Canon 60Da. When set up with Field of View Indicators for your camera and telescope, planetarium programs such as Stellarium or Starry Night, shown below, are invaluable for planning what to shoot and how to frame it.

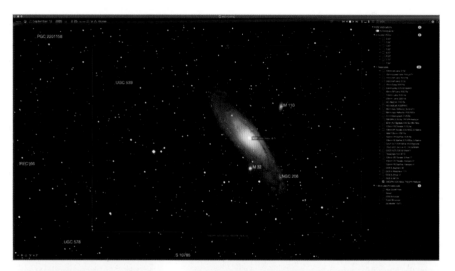

With the basics learned and all the right gear acquired, we are at last ready to shoot nebulas and galaxies. Wait. Don't head to your dark site and attempt to get it all going at once. It's too much. Set up and use your equipment at home first to become familiar with polar-aligning the mount and aligning its GoTo system. Then learn to find things visually. When you've done that, shoot from your backyard, despite light pollution. You just want to get stars that are focused and well tracked, a major accomplishment.

FOCUSING AND FRAMING

Before performing a final focus, always allow the warm telescope to cool down. Even then, the focus can shift slightly as the night cools. Tweaking focus through the night is a best practice. To focus, slew to a bright star and use a Bahtinov mask in LiveView. Without a mask, choose a moderately bright star and focus to make its image as tight as possible.

Now slew to your deep sky target. Make it a bright one, such as M13, M31 or M42. Boost the ISO way up, to 25,600. Take a 15-second shot. You simply want to see the field. Use the mount's direction buttons to adjust the framing. Just remember to lower the ISO after framing!

QUICK-AND-EASY SHOOTING

Whether at home or at a dark site, don't worry about auto-guiding on your first nights out. Most mounts of merit can track for 30 to 60 sec-

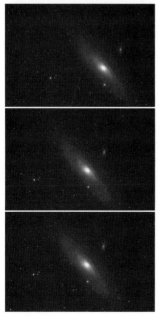

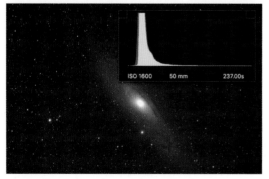

FRAMING AND JUDGING EXPOSURES

Left: Once on target, take several short exposures at ultrahigh ISOs to get the framing right, with the best composition not always with the object dead center. **Above:** Always ETTR (expose to the right). Shift the histogram to the right. Make the background sky bright, not black. Underexposing makes noise worse.

GETTING GUIDING GOING

An auto-guider (the ASIAIR app is shown) jogs the mount east and west, then north and south to calibrate the corrections needed. It then begins guiding. Use 2- to 3-second exposures.

GUIDING UNDER WAY

Laptops for guiding are best set up in a shelter, like this little tent, to keep its light away from others at star parties and to prevent dew from forming on it. Once guiding, this is the type of graph you want to see.

onds without auto-guiding, at least with short-focal-length scopes. Use the intervalometer to take two to three dozen short exposures at a high ISO, perhaps 6400. As with sky trackers, some images will be trailed. Toss them. Stacking the rest (see page 378) can smooth the noise. The result is a satisfying first image. Hooray!

BEST PRACTICES: AUTO-GUIDING

By taking quick-and-easy shots for a few nights, you'll learn to set up your gear, polar-align, focus, find and frame objects and program an exposure sequence. That's a lot!

For the best results, however, you need to shoot multiminute exposures at a lower ISO, and that means auto-guiding—ideally from a dark site, but practice first at home. Enter the required information, such as the focal length of your guidescope. It's essential to focus the guidescope using looping images from the guide camera. Then lock the focus, and never touch it! Get the guiding under way, wait a minute for oscillations to settle, and start the exposure sequence. But at what settings?

BEST PRACTICES: EXPOSE TO THE RIGHT (ETTR)

Just as with nightscapes, use the histogram to judge the correct exposure. You want an image with the main hump pushed over to the right, to the point where the sky looks bright, even from a dark site. With the f/ratio of a telescope fixed, you have two ways to affect exposure: shutter speed and ISO. Since exposures are limited at the quick-and-easy stage, boost the ISO up as high as it needs to be for a good ETTR histogram.

With auto-guiding, however, you can shoot for as long as you want and at lower ISOs for lower noise and a wider dynamic range. To judge the best settings, use the high-ISO framing shots as a guide. Let's say a 15-second framing image at ISO 25,600 looked good with a well-placed ETTR histogram. With most cameras, we prefer to shoot at no higher than ISO 1600, which is four stops ($2^4 = 16$x) slower than ISO 25,600.

Getting the equivalent exposure at ISO 1600 that you had for the high-ISO framing shots requires an exposure of 15s x 16 = 240 seconds, or 4 minutes. What combination of ISO and shutter speed you actually use depends on the sky brightness, the quality of your camera and the amount of time you wish to spend shooting any one target, because the best practice is to shoot not one, but many sub-frames to stack later.

BEST PRACTICES: STACKING

Images are stacked not to increase the effective exposure time but to reduce noise. Newcomers often think stacking will cure all ills, especially underexposure. No. Each sub-frame must still be well exposed. Even in our quick-and-easy test, we expose each frame properly, using a high ISO to do it. Here, with autoguiding, we shoot at a lower ISO for a longer duration but for an equivalent good ETTR exposure. Then we stack those shots for even lower noise.

BEST PRACTICES: DARK FRAMES

Stacking images smooths forms of noise, called shot noise and read noise, that make high-ISO shots look grainy. It does not reduce thermal noise, which gets worse the warmer the camera and produces lots of bright and colored pixels that speckle an image.

The solution is a dark frame, an exposure taken at the same ISO, for the same length as the light frame but with the lens capped. The conventional practice is to take eight or more dark frames at the end of the night to average together into a "master dark," which is subtracted later in processing.

We don't follow convention. In numerous tests, we've found that the camera's own dark frame routine, called Long Exposure Noise Reduction (LENR), always does a better job eliminating thermal noise than separate darks.

The reason is that in an uncooled camera like a DSLR or DSLM, the sensor is constantly changing temperature. So its thermal noise is not the same when taking dark frames at the

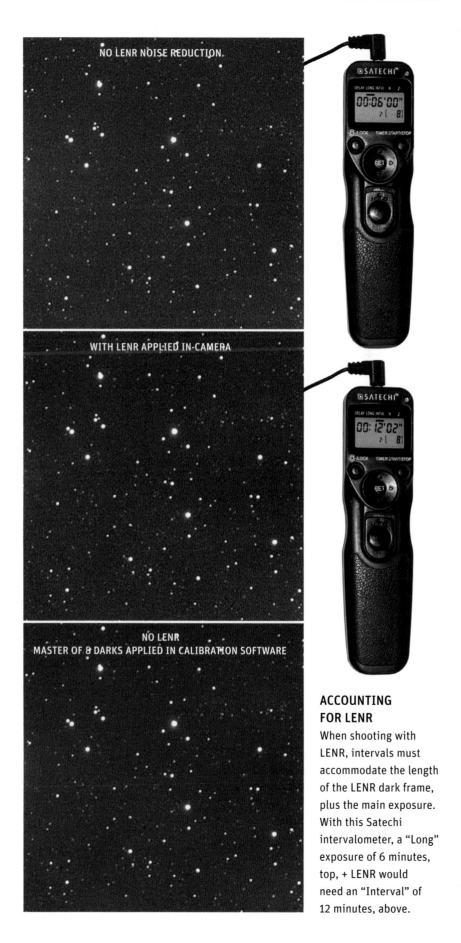

LENR VS. DARK FRAMES

Nothing is more controversial. But in test after test we see the same result: At top, on a warm summer night, without Long Exposure Noise Reduction frames are peppered with tiny hot pixels. With LENR, they are gone. Applying a "Master Dark" made of eight dark frames taken at the end of the night and subtracted in calibration software eliminates some hot pixels, but leaves lots of dark holes and colored spots. This was with Starry Sky Stacker, but calibrating the same images with PixInsight and Nebulosity showed the same results. LENR works better.

ACCOUNTING FOR LENR

When shooting with LENR, intervals must accommodate the length of the LENR dark frame, plus the main exposure. With this Satechi intervalometer, a "Long" exposure of 6 minutes, top, + LENR would need an "Interval" of 12 minutes, above.

LAPTOP CAMERA CONTROL

By connecting to a camera through its USB port, the popular Windows programs Astro Photography Tool, left, and BackyardEOS, right, offer advanced control functions, such as scripted sequences with various exposure times and ISO speeds. But to keep things simple and reliable, we suggest using just an intervalometer for camera control. It's all we ever use.

FLAT FIELDS

A "flat" from an 11-inch Celestron RASA shows its very "unflat" field, with lots of light falloff across a full frame sensor. Taking flats is best done with a light box that provides a consistent source of uniform illumination. While flats can remove dust spots, it's better not to have them at all by cleaning the camera sensor.

end of the night as it was when shooting the actual images. Subtracting even a master dark results in either hot pixels not being removed or the opposite—a frame that's pocked with dark holes.

Yes, employing LENR means it takes twice as long to acquire a set of images, but the results are better. In winter, however, with nature providing ample cooling, it might not be necessary to employ dark frames at all. Test!

And owners of Canon full frame DSLRs can take advantage of a little-known dark frame buffer unique to those cameras: Turn LENR on, and you can fire three, four or five images (the number depends on the camera model) before the dark frame kicks in and locks up the camera. The one dark frame gets applied internally to each of the preceding light frames. There is no menu command to turn this on; just fire the shutter again as soon as the previous image finishes.

But this works only when operating the camera from the remote shutter port via an intervalometer, not when controlling the camera through the USB port with a computer. Nor does it work if Live View is on, so mirrorless Canon EOS R models do not have this dark frame buffer. Pity!

FLATS AND BIAS FRAMES

Flats are images of a uniformly illuminated screen. Or they can be of the twilight sky taken through a diffusion cloth, such as a white T-shirt, over the telescope aperture. They map the unevenness of the telescope's illumination of the frame. Applying flats at the calibration stage in processing brightens the dark corners, making the frame appear evenly illuminated. This is needed for fast reflectors prone to vignetting, especially when you're going after faint nebulosity barely above the sky background. But for most objects with the f/6-class apo refractors we recommend, we have not found flats essential, simplifying the processing workflow.

Bias frames are very short shots (1/4,000 second). While easy to take, they are not necessary with CMOS sensors (all DSLRs and DSLMs), certainly not if you shoot with LENR on. Even makers of cooled CMOS cameras suggest that bias frames are not needed. They are a holdover from CCD cameras for use in "scaling" dark frames taken at different durations and saved to a library.

Yes, this advice is contrary to what you will find elsewhere, so we suggest you test for yourself. We have found bias frames, master darks and even flats unnecessary or ineffective for the gear and ETTR-based settings we are recommending. Keep it simple.

ADVANCED TECHNIQUE: DITHERING

This popular technique requires operating the camera with a computer or a WiFi controller. When the control software finishes an exposure, it communicates to the guiding software or module, which then shifts the pointing of the telescope mount at random by a few pixels, then resumes guiding. Once the mount

settles, the control software starts a new exposure, and so on, through the sequence.

Stacking the dithered frames aligns them to match up the stars. The hot pixels then move around and so average out. Dithering reduces the worst effects of thermal noise without dark frames. It does work but requires a more complex camera-control arrangement and, to be effective, at least 8 to 12 exposures.

ADVANCED TECHNIQUE: USING FILTERS

Introducing a filter into the light path always requires refocusing, unless it is placed over the front of a lens. That likely means slewing to a bright focus star (as the filtered Live View will be dim), then returning to the object or to the field's central right ascension and declination coordinates to reframe the image. The framing should be the same as any unfiltered shots if you intend to combine the two later. Having a filter drawer in the focuser makes it easy to insert filters without having to remove and shift the camera, but even many astrographs lack one.

A narrowband filter can absorb as much as three stops of light. Exposures might need to be 8 to 16 minutes and ISOs raised to 3200, requiring more sub-frames for noise reduction. That means lots of exposure time! Fast f/2.8 to f/4 astrographs come into their own when shooting through filters.

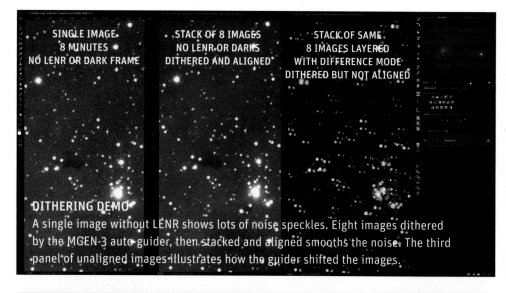

DITHERING DEMO
A single image without LENR shows lots of noise speckles. Eight images dithered by the MGEN-3 auto-guider, then stacked and aligned smooths the noise. The third panel of unaligned images illustrates how the guider shifted the images.

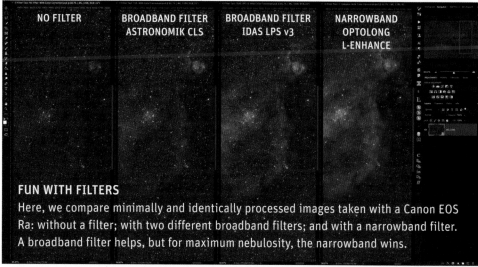

FUN WITH FILTERS
Here, we compare minimally and identically processed images taken with a Canon EOS Ra: without a filter; with two different broadband filters; and with a narrowband filter. A broadband filter helps, but for maximum nebulosity, the narrowband wins.

BEATING THE GUIDING GREMLINS

Despite the wonders of auto-guiders, an occasional bad image can occur and is often unexplainable. But if stars are routinely trailed, here are some common causes. The PHD2 Guiding website (openphdguiding.org) also offers useful tips for avoiding strange guiding behaviors.

Every Star Looks Double The telescope was inadvertently bumped, and the guider chose another guide star.

Trailing in Right Ascension (East-West) The drive might have gear errors too large for the auto-guider to compensate for. If a mount is too well balanced, it can also chatter back and forth. Try unbalancing it slightly so that the mount wants to fall back east, keeping the gears meshed and in contact.

Trailing in Declination (North-South) If the guiding oscillates in declination, back off the aggressiveness of the auto-guider or reduce the mount's backlash compensation. But if the mount seems to run away in declination when guiding, increase the aggressiveness and/or mount backlash.

Rotation Around the Guide Star Stars trailed in arcs indicate that the mount was not accurately polar-aligned. This effect will be worse with fields closest to the celestial poles.

Trailing for No Apparent Reason Guidescopes can shift in their mountings. With Schmidt-Cassegrain telescopes, the primary mirror itself can shift; avoid exposures that will cross the meridian.

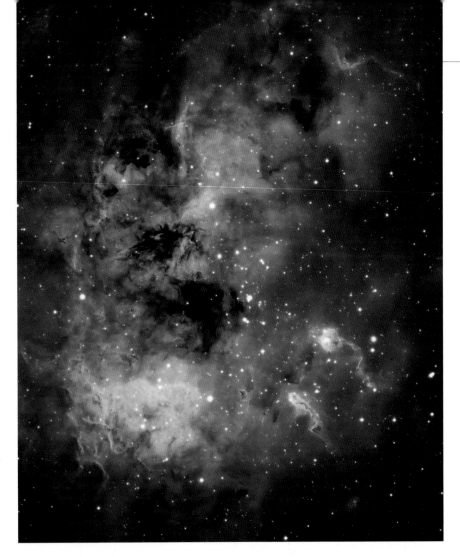

ADVANCED ASTROPHOTOGRAPHY

THE TADPOLES OF IC 410
Featured on NASA's Astronomy Photo of the Day (APOD) site, Trevor Jones captured this stunning image of star-forming features in the nebula IC 410, in Auriga, using "SHO" false color. This is a combination of nine exposures with a Sulfur-II filter, 60 frames (5 hours!) in H-alpha and 16 frames in O-III, all five minutes long. Trevor used a Starlight Xpress Trius SX-694 monochrome camera shooting through a Sky-Watcher Esprit 150 refractor on an EQ8-R mount.

We like DSLRs and DSLMs, but with the prices of cooled astro-cameras coming down and prompted by YouTube influencers, many beginners are tempted to leap into advanced technology. It's not what we would recommend to start, but for the technically minded, it can work.

COOLED ASTRO-CAMERAS

In years past, the step beyond a DSLR was to a cooled camera with a CCD (charge-coupled device) sensor. Chip makers have stopped, or will soon stop, manufacturing CCDs. Companies are moving to cooled cameras with CMOS (complementary metal-oxide semiconductor) sensors, often the same ones used in consumer cameras, though always with filters modified for astronomy.

But the big difference is that the sensors in dedicated CMOS astro-cameras are electrically cooled, typically to 35 Celsius degrees below ambient air temperature. This reduces thermal noise. The cooling is essential, as CMOS cameras lack any of the internal signal-processing magic of DSLRs and DSLMs, such as Canon's Digic and Nikon's Expeed firmware.

The cooling and camera operation requires a 12-volt power source and an external computer to focus, set exposures, fire a sequence of images and save them. Popular control software includes Astro Photography Tool (APT), Voyager or the free open-source N.I.N.A. (Nighttime Imaging 'N' Astronomy), all Windows-only programs capable of controlling many devices. Alternatively, ZWO's ASIAIR Pro WiFi box, shown on page 362, can control ZWO's devices through a tablet app.

With the switch to cheaper CMOS chips, costs have come down; entry-level cameras from QHYCCD, ZWO and others start at $800. At that price, you are getting a sensor smaller than an APS-format cropped frame, usually a micro four-thirds (17mm x 13mm) or a one-inch (13mm x 9mm) sensor. A small, high-resolution sensor (most have 3- to 4-micron pixels) has the benefit of nicely framing and resolving small targets but is not amenable to capturing wide-field images.

Moving up to an APS-format sensor (22mm x 15mm) can cost $2,000, far more than a cropped frame DSLR, though with all the advantages of a cooled camera made for astronomy. Should you wish to go full frame (36mm x 24mm), expect to spend $3,500 to $6,000, more than a filter-modified DSLR or a DSLM, such as the Canon EOS Ra. However, the results can be spectacular, and costs will likely come down.

ONE-SHOT COLOR OR MONOCHROME

When choosing a camera, you can pick a one-shot color (OSC) model, with pixels covered with the same Bayer-array RGB filters in your DSLR. OSC cameras can be used with narrow-band filters for suppressing light pollution and enhancing nebulas. But the addition of a filter and the presence of filters on the pixels themselves mean a lot of light is lost. Exposures are long, and images can be noisy.

The alternative is to choose the monochrome version of a camera, with each pixel

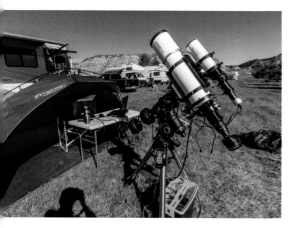

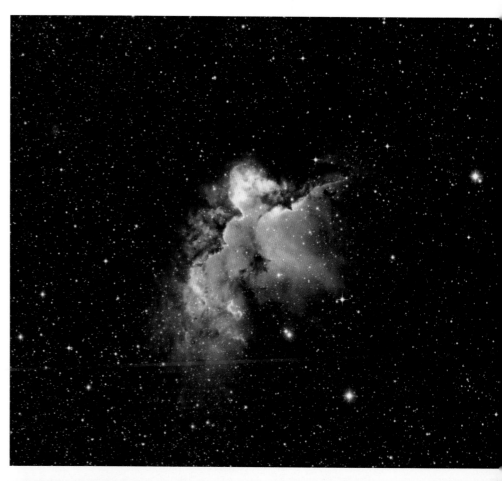

GETTING SERIOUS IN THE FIELD

A rig for advanced imaging requires computers, cables, a big power source and a workstation. It's a major commitment to set up at a dark site. **Right:** Kimberly Sibbald cornered the Wizard, aka NGC 7380, in Cepheus, using a SharpStar 140mm refractor on a Celestron CGEM II mount with a ZWO ASI1600MM Pro monochrome camera. For the sequence, she took five images in Sulfur-II, nine in H-alpha and five in O-III, each 20 minutes long, for a total of 6.3 hours of images. She then combined them using the popular Hubble palette, assigning Sulfur-II to the red channel, H-alpha to green and O-III to blue.

recording the full spectrum of light. Coupling such a camera with a narrowband H-alpha filter is the preferred method for capturing the deepest, richest sweep of nebulosity.

Creating a full-color image requires using a motorized filter wheel with broadband R, G and B filters to shoot an automated sequence of red-, green- and blue-filtered images, as well as a full-spectrum L (Luminosity) image for later merging into a natural-color image. Another option is to shoot through deep red Sulfur-II, red H-alpha and green O-III narrowband filters to create false-color images resembling Hubble photographs. A set of filters can be $1,000 or more, not to mention the cost of the filter wheel itself.

Monochrome cameras may be more efficient, but acquiring all the images through the various filters can take hours of shooting. Collecting enough data for an image to compete with the best photos often requires shooting the same object over many nights. We've not been tempted!

ROBOTIC IMAGING

If you can control a telescope with a computer at the scope, why not control it with a computer in your warm house? Or why not have the telescope far away, where skies are clear and it can slog through the night under robotic control while you sleep? Software can automate all the required functions: the camera, the filter wheel, telescope pointing, object framing using plate solving, even opening and closing the observatory.

Master control programs such as Sequence Generator Pro can orchestrate the subprograms running all the devices. The script then faithfully executes through the night, controlling all the gear while the photographer sleeps, to wake up to a hard drive filled with data—assuming it all works!

A more affordable alternative to owning your own remote dream scope is to rent time on someone else's. Commercial operations range from the novice-oriented slooh.com, for $100 a year, to high-end remote operations, such as itelescope.net, shown here in Australia, whose rates vary depending on the telescope chosen, the length of the booking and the phase of the Moon.

CHAPTER 18

Processing Astrophotos

While much of the hard work is at the camera or telescope, good processing makes the final image. Continuing our philosophy of keeping it simple, we provide processing tutorials using a workflow that stays within the Adobe Photoshop family. Although we'll suggest some alternatives, we feel the modest subscription fee is a small price to pay for a powerful program that most astrophotographers employ at some point in their editing workflows.

Our steps follow the professional techniques of nondestructive processing so that any setting can be changed at any time. You never have to say, "I wish I hadn't done that!" Or be forced to redo lots of steps to rework an image when you look at it later and wonder, "What was I thinking?"

Our tutorials assume a familiarity with Photoshop's layers and masks. If you need a refresher, look for tutorials in Photoshop's Help menu. While we demonstrate Photoshop, many of the techniques apply to other programs we show, particularly Affinity Photo.

Here's a behind-the-scenes look at the image of M31 that opens Chapter 17, showing its content in Photoshop, with image layers, smart objects, smart filters and adjustment layers, all editable at any time. Always save such a layered image as a PSD or PSB master file that can be used to export versions for print and the web.

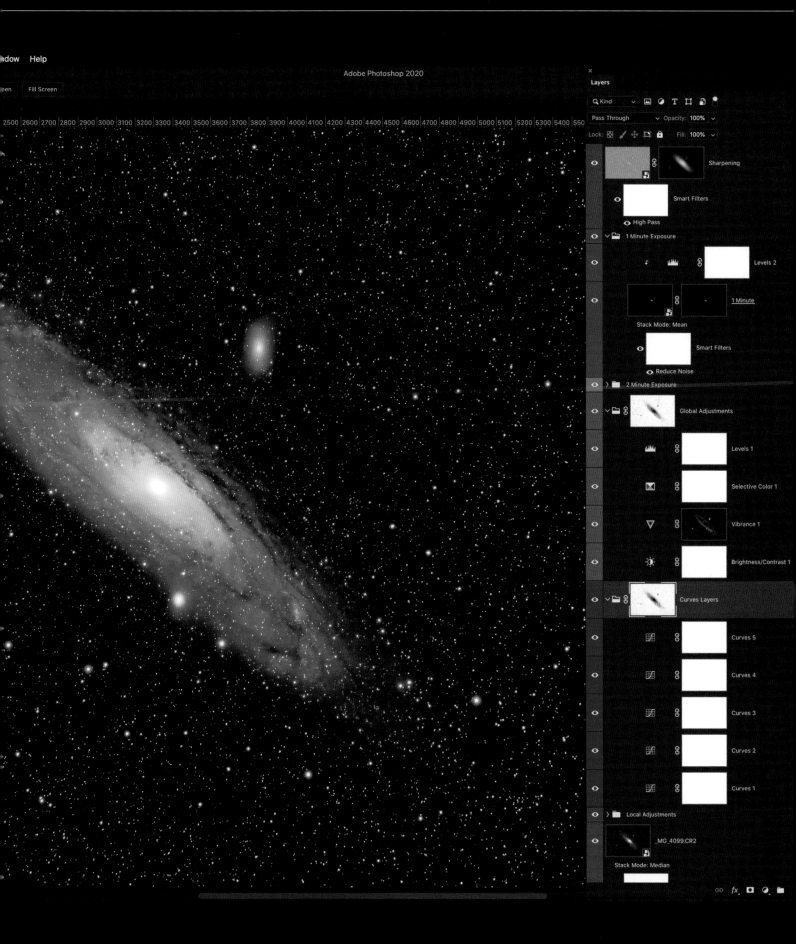

BEFORE AND AFTER
Good processing can turn a deep sky object barely recorded, right, into a dramatic image, below.

BEFORE PROCESSING (out of camera)

OUR WORKFLOW

The workflow we show performs as many adjustments as possible while images are still raw files, when we have access to their full dynamic range. Then we bring the "developed" raw images into Photoshop. All our astronomical images in this book were processed with this workflow.

PHOTOSHOP'S F-WORD

Once in Photoshop, the mantra is to never, ever Flatten. It is the F-word of Photoshop. It is one of the "Five Forbidden Functions" of Photoshop, which include Delete, Erase, Merge and Rasterize. All permanently alter pixels, throwing away information you can never recover. The professional way to use Photoshop is to employ nondestructive adjustment layers, layer masks and smart filters.

In Photoshop tutorials, we see many astrophotographers performing destructive edits, forever altering pixels. Now, if you are someone who never makes a mistake and you never change your mind, fine. But nondestructive methods allow you to see how you edited your image even months later and to make changes to any edit at any time.

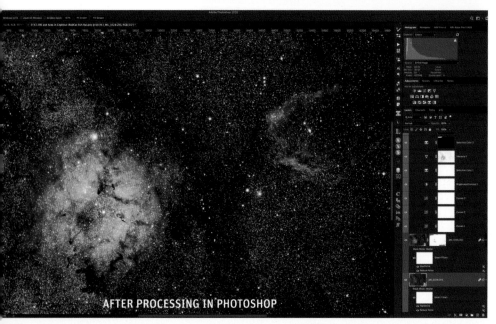

AFTER PROCESSING IN PHOTOSHOP

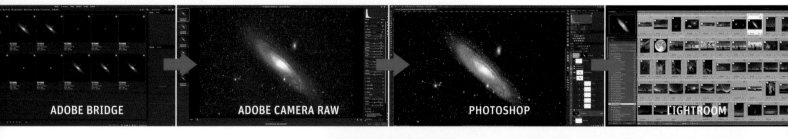

ADOBE BRIDGE

ADOBE CAMERA RAW

PHOTOSHOP

LIGHTROOM

GOOD WORKFLOW...AND BAD!
Above: Our workflow imports images using Adobe Bridge into Adobe Camera Raw for raw development, then to Photoshop for stacking. Final images are cataloged in Lightroom.
Right: The old-school method of using Photoshop is to copy the layer below, apply a destructive adjustment to that new layer, copy it, then apply a destructive edit to the copy, and so on. Yes, the original image is preserved, but there is no way to change any edits without redoing most of the work. And if the layers get flattened, there is no way to make any changes at all.

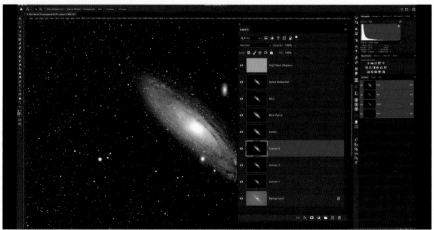

OTHER WORKFLOWS

Adobe Photoshop is a layer-based program that can align and stack images, which is critical for astrophotography. We can use it exclusively in our workflow because we apply dark frames "in camera" using LENR, as we described in Chapter 17. The Optics panel in Camera Raw can provide basic flat fielding for a simpler workflow.

ADOBE COMPETITORS

We've tested many nonsubscription alternatives to Photoshop for the demands of astrophotography. All have limitations, but the three programs at right are among the best. Not shown is RawTherapee, a free raw developer but incredibly complex, and GIMP, a free layer-based program but, as of v3.0, terribly old-school destructive.

Starry Sky Stacker (Mac only/purchase)

DeepSkyStacker (Windows only/free)

Astro Pixel Processor (Mac & Windows/purchase)

DxO PHOTOLAB
This raw developer has excellent noise reduction. Use it with Affinity Photo.

SERIF AFFINITY PHOTO
It can stack, align and average images, with nondestructive adjustment layers.

ON1 PHOTO RAW
Foremost a raw developer, it can also layer and mask multiple images.

CALIBRATION AND STACKING

Left: If you feel your images require the application of separate dark frames and flat fields, PixInsight (see page 385) can perform the initial calibration (as the process is called) and stacking. Or you may opt for a dedicated stacking program, which can read raw files and apply darks and flats. Affinity Photo's easy-to-use Astrophotography Stack function (not shown) can also apply calibration files, then align and stack light frames.

STEP ONE: DEVELOPING RAW IMAGES

The first step in our workflow is to "develop" the raw files, here using Adobe Camera Raw (v12.4). All adjustments are nondestructive. You lock in those settings only when you export the raw file or send it to a layer-based editor, such as Photoshop or Affinity Photo.

DEVELOPING A NIGHTSCAPE

Working with raw files makes it possible to recover shadow details in landscapes illuminated only by starlight. With the adjustment of a few sliders, images can look good enough to be publication-ready in minutes.

1 IMPORT AND SELECT IN BRIDGE

Bridge's Photo Downloader utility can import images, which can then be sorted. Double-clicking opens an image in Adobe Camera Raw (ACR).

2 CAMERA RAW PREFERENCES

Right: In ACR's Preferences (gear icon), set Workflow to Space>ProPhoto RGB and Depth to 16 Bits/ Channel. These are critical onetime settings.

3 OPTICS AND DETAIL PANELS

Left: Under Optics (called Lens Corrections in Lightroom), ACR can remove lens vignetting. In Detail, raise Luminance Noise Reduction to 30 to 50 and Sharpening>Masking to ~75.

4 BASIC PANEL

Right: Boost Shadows. Play with Exposure, Contrast, Highlights, Vibrance and Dehaze. Under Profile, Adobe Landscape works well. Then "Open as Object" into Photoshop.

OPEN AS OBJECT

1 OPTICS AND DETAIL

Under Detail, set Noise Reduction to 40 to 50. Under Optics, brighten dark corners in the Manual tab. Dial in Vignette and Midpoint amounts by eye. This is where we "flat field" images.

2 WHITE BALANCE

Use the Eyedropper tool under White Balance and click/drag on an area of sky that should be neutral. This usually has to be done for each image.

DEVELOPING DEEP SKY IMAGES

Contrary to nightscapes, deep sky objects are often low in contrast, requiring copious contrast boosts, which work because only here do we have access to the full 14-bit raw data from the camera.

3 BASIC PANEL

Under Basic, select a Profile. Boost Contrast to +100. Here, reducing Highlights recovered detail in M31's bright core. Apply Clarity and Dehaze—but don't go overboard!

4 CURVES PANEL

Curves can also boost contrast. Use a Point Curve with presets or the Parametric Curve to draw a custom curve, perhaps for each color channel to further tweak color balance.

5 COLOR MIXER (FORMERLY HSL)

This is another parametric adjustment for boosting or reducing specific colors. Use the Targeted Adjustment Tool to drag over areas you wish to affect.

6 COPY AND PASTE SETTINGS

In Bridge, select the developed image. Right-click to Develop Settings>Copy Settings. Select the other images in the set. Right-click to Paste Settings.

STEP TWO: STACKING IMAGES IN PHOTOSHOP

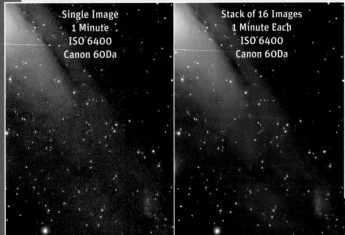

Single Image
1 Minute
ISO 6400
Canon 60Da

Stack of 16 Images
1 Minute Each
ISO 6400
Canon 60Da

Most astrophotos benefit from stacking multiple images. This is done to reduce noise, revealing more details and allowing the contrast of the image to be increased without exaggerating noise.

Stacking four images reduces noise by a factor of two, the equivalent of shooting at half the ISO. Stacking nine images improves noise by a factor of three. It takes stacking 16 images to reduce noise by a factor of four. Even so, stacking does not make up for bad exposure. Indeed, it can introduce artifacts if the original images are poor, as we show below. Always ETTR (expose to the right)!

STACKING HIGH-ISO IMAGES

Above left is a single unguided 1-minute exposure at ISO 6400; above right a stack of 16 images, as per our unguided quick-and-easy method (see page 365). The noise is smoother. But...

STACKING LOWER-ISO IMAGES

At far right is the same stack of 16 images at ISO 6400. It appears low contrast compared with 16 images at ISO 1600 auto-guided for 4 minutes each.

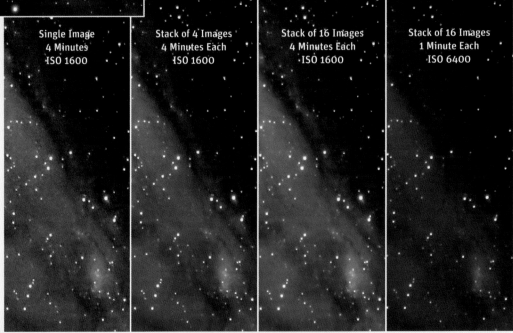

Single Image
4 Minutes
ISO 1600

Stack of 4 Images
4 Minutes Each
ISO 1600

Stack of 16 Images
4 Minutes Each
ISO 1600

Stack of 16 Images
1 Minute Each
ISO 6400

WALKING NOISE

Streaks of noise arise from underexposing (not adhering to ETTR), then cranking levels up after stacking. Dithering doesn't always solve this; good exposure does. The best way to defeat most noise is to prevent it in the first place by exposing well. Give the sensor lots of signal.

1 LOAD INTO LAYERS
In Bridge, select the images and choose Tools>Photoshop> Load Files into Photoshop Layers...

2 ALIGN LAYERS
Select all the image layers, and choose Edit>Auto-Align Layers...Projection>Auto works well.

3 CONVERT A LAYER SET INTO A SMART OBJECT
Choose Layer>Smart Objects>Convert to Smart Object.

4 SELECT STACK MODE
Choose Layer>Smart Objects>Stack Mode, either Mean or Median. Maximum works for star trails.

METHOD 1: THE LONG WAY
Above: In Photoshop, this is the multistep way to stack and align images. Photoshop will align dithered images and those where the camera was rotated between sets, as here. Photoshop can fail to align if images are dark and contain too few stars. That rarely happens with ETTR exposures. Here, this method was needed to align and stack sets of filtered and unfiltered images.

METHOD 2: THE ONE-CLICK WAY
Below: Under File>Scripts, Statistics performs the layering, aligning, conversion to a smart object and application of a Stack Mode in one fell swoop! Old versions of Photoshop (CS6 Standard and earlier) don't have this Script or Stack Modes.

1 FILE>SCRIPTS>STATISTICS
Open all the images to stack, and choose Add Open Files. Check Attempt to Automatically Align. Done in moments!

2 CHANGE STACK MODE
If some images have satellite trails, change the Stack Mode from Mean to Median after stacking.

STEP THREE: PROCESSING NIGHTSCAPES

Before we venture into deep sky processing, we'll illustrate techniques with a challenging nightscape image. We developed a single image from this set earlier. Here, we can make an even better version, blending a single 20-second shot for the sky with a stack of four 2-minute exposures for the ground.

Many astrophotographers use Starry Landscape Stacker (for MacOS) or Sequator (for Windows), two programs that can stack and align the static ground and moving sky separately. Clever, but we find they leave edge artifacts along the horizon. We never use them.

1 LOAD INTO LAYERS
Above: Select the ground exposures in Bridge, then use Tools>Photoshop>Load Files into Layers to bring them into Photoshop. No need to align the layers.

2 CONVERT TO SMART OBJECT
Right: Select the layers. Under Filters choose Convert for Smart Filters. This embeds images within a smart object "container." Any filters applied are nondestructive.

3 STACK MODE
Left: Go to Layers>Smart Object>Stack Mode, and choose Mean. This averages the images to smooth the noise but yields a trailed sky, as shown.

4 PLACE THE SKY IMAGE
Right: Return to Bridge, and choose File>Place...In Photoshop. The short-exposure sky image comes in as a smart object that allows reediting the original raw file.

5 SELECT THE SKY

Move the sky image to the top layer. Use Select>Sky (as of Photoshop 2021) or the Quick Selection Tool to drag across the sky to select it. Then choose Select and Mask...

6 REFINE THE SELECTION

Use Select and Mask and its Refine Edge Tool at left to brush across the horizon and any trees and complex shapes to automatically select around them. Choose Output to Selection.

7 MASK THE SKY

With the "marching ants" selection active, hit the Add Layer Mask button. The mask hides the ground from the short exposure, revealing the ground from the long-exposure stack below.

STITCH A PANORAMA

While specialized programs such as PTGui can stitch panoramas, try Adobe Camera Raw and Merge to Panorama. Options allow warping the scene and filling in blank areas.

EXPORT FOR STAR TRAILS AND TIME-LAPSES

Create TIFFs or JPGs by selecting a set of developed raw images in Bridge. Use Tools>Photoshop>Image Processor to export, resizing as needed. Use those to stack star trails or assemble a movie.

8 ADD ADJUSTMENT LAYERS FOR COLOR AND CONTRAST

Mask adjustment layers by Option/Alt dragging the mask from the sky to the mask for the adjustment layer. Invert it if needed. Or Feather the mask edge nondestructively.

STEP FOUR: PROCESSING DEEP SKY IMAGES

Here, we process a set of images taken with one of the starter systems we showed in Chapter 17, the Orion ED80T on the Celestron AVX mount. The main images are a set of six 8-minute exposures at ISO 1600 with a stock Canon 6D Mark II. Processing Andromeda illustrates the essential techniques for editing deep sky objects in Photoshop.

Third-party additions to Photoshop, such as the Astronomy Tools actions (prodigitalsoftware.com) and Russell Croman's StarShrink and GradientXTerminator filters (rc-astro.com/resources/index.html), applied in this tutorial, can also be very useful.

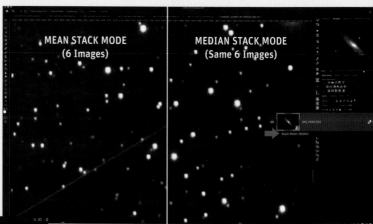

1 MEAN VS. MEDIAN STACKING
Above: Use Mean Stack Mode for the best noise smoothing. Use Median Stack Mode if frames have satellite trails, as here. The more frames, the better this works.

2 ADD SMART FILTERS
Above: Under Filter>Noise, Reduce Noise smooths the sky without erasing stars. Shadows/Highlights, shown at right, can recover more detail in bright cores.

3 ADD CURVES ADJUSTMENT LAYERS
Above: Bringing out faint nebulas and galaxy arms is all about Curves. Use the Targeted Adjustment Tool to drag on an area you want to enhance.

4 CHANGE THE BLEND MODE
Left: Add more Curves layers, each with more subtle boosts. To avoid colors becoming too intense, change the Blend Mode from Normal to Luminosity.

5 GROUP LAYERS

To organize layers, put them into Groups. Masks can be added to a Group so that one mask applies to all adjustments in that Group, as here, to protect the galaxy's core.

6 SELECTIVE COLOR

Selective Color is a precise way to adjust colors. Here, we have also applied Russell Croman's GradientXTerminator and StarShrink as smart filters, indicated at bottom.

7 BRIGHTNESS/CONTRAST WITH MASK

We used a soft-edged black brush to paint on the mask to prevent the adjustment from affecting the core. With masks, black conceals, white reveals. Never erase; use masks to hide.

8 CLEAN UP MIRROR SHADOWS IN DSLR IMAGES

Use the selection tool to draw a rectangle along the bottom. Add a Brightness/Contrast layer. Under Mask Properties, Feather it. Boost the brightness as needed.

9 CREATE A HIGHLIGHTS 'STAR' MASK

Switch to the Channels palette. Command/Control click on the RGB channel. This selects the highlights. A mask added to any layer will have that "luminosity mask" applied.

10 INVERT THE MASK

If you want the mask to reveal and affect everything but the highlights, select the mask and hit Command/Control I to invert the mask. The mask in Step 5 was created this way.

11 ADD A SHORT EXPOSURE FOR THE CORE

From Bridge, we Place a 1-minute exposure into the image stack. Change the Blend Mode to Difference. Use the Move tool and arrow keys to align it, as Auto-Align will likely not work.

12 BLEND IN THE CORE

Change the Blend back to Normal. With the short exposure selected, create a highlights mask as per Step 9. Add a layer mask to the short exposure. Feather as needed.

13 HIGH PASS SHARPEN

Create a "stamped" copy of all the layers below with Command-Option-Shift E (Mac) or Control-Alt-Shift E (Windows). Convert it to a smart object. Apply a Filter>Other>High Pass.

14 NONDESTRUCTIVE FILTER

Now change the Blend Mode to Soft Light. Add an inverted highlights mask to prevent sharpening from affecting stars. Feather it. Every aspect of the sharpening layer is adjustable.

15 CROP FOR COSMETICS AND COMPOSITION

Cropping is here as a finishing step and is nondestructive (uncheck Delete Cropped Pixels). Save the master image as a layered PSD or Large Document PSB. Do not flatten!

16 A FINAL STEP: KEYWORD AND CATALOG

Keyword images in Photoshop under File>File Info (inset box) or in Lightroom (background). Catalog your final images so that you can search by keyword.

ADVANCED DEEP SKY PROCESSING

Dive into deep sky imaging, and you'll soon encounter PixInsight (pixinsight.com). While specialized programs for calibrating and processing deep sky images fade in and out of fashion, PixInsight has been the most popular for the last few years. As of 2021, it costs €230 (about US$280), but it's not uncommon to spend at least that much again on books, videos and workshops to learn how to use it. One of the best written references is the two-volume *Mastering PixInsight* by PixInsight guru Rogelio Bernal Andreo (deepskycolors.com).

PixInsight does not work like any other image-processing program you have ever used. Menu commands and processes (and there are many!) are labeled with arcane mathematical terms. For example, one form of noise reduction is called MultiscaleMedianTransform.

1. DYNAMIC BACKGROUND EXTRACTION

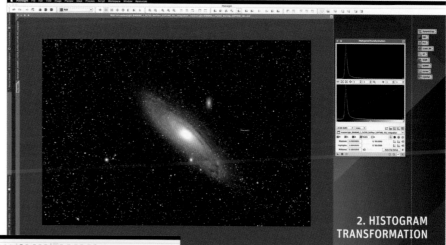

2. HISTOGRAM TRANSFORMATION

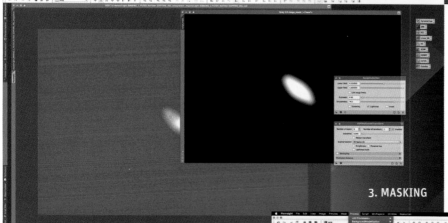

3. MASKING

PIXINSIGHT SAMPLER SCREENS

1 The Dynamic Background Extraction can even out gradients and vignetting.
2 This process stretches the image permanently to reveal the object.
3 Masks are adjusted in separate windows, applied, then discarded.
4 Curves brings out faint structures. All previews are in separate windows.

Dialog boxes are incredibly complex; not turning on one checkbox (of many!) can ruin that function. Nor does PixInsight produce a file with visible layers or adjustments, though it does record the processing steps of a saved Project in its History Explorer, allowing you to redo edits, but only from an earlier state onward.

Once mastered, its power is its ability to bring out the maximum detail and faintest structures in deep sky objects. PixInsight's sole purpose is deep sky processing, and it does that very well. But the learning curve is precipitous!

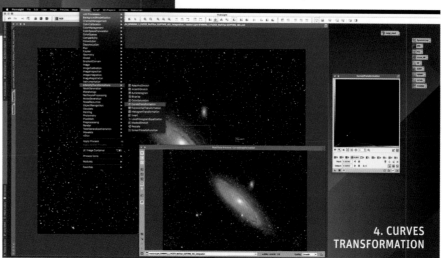

4. CURVES TRANSFORMATION

Exit Strategy

Every August, a band of dedicated skywatchers navigates the tortuous 12-mile road up Mount Kobau, in southern British Columbia, in search of perfect skies. Sometimes, they are rewarded. The weather cooperates, and the black canvas of the sky is painted with the delicate brushstrokes of the Milky Way (facing page). But other years, isolated at the top of a 6,000-foot mountain, the troop of observers have had to wait out a thunderstorm's torrential rains. One year, they were forced to evacuate as a forest fire raged nearby, threatening to cut off their only retreat.

And yet even when conditions turn foul, everyone leaves the Mount Kobau Star Party saying, "See you next year!" They know they will be back. And so it goes at every star party and gathering of amateur astronomers. The great thing about backyard astronomy is that it can extend much farther than your backyard. In your area alone, there are probably hundreds of like-minded lovers of the sky. Perhaps as you pursue your interest in the stars, you will find yourself becoming a part of that community. You, too, might discover a place like Kobau, the Texas Star Party, Stellafane or one of the many other dark sky meccas around the world.

On the other hand, your personal nirvana might never be farther away than your backyard, and your community of fellow skywatchers no larger than your family and friends. No matter. However you observe, it's the same limitless sky overhead, a sky we hope our book helps you explore.

THE SKY FIRST

Throughout this and every edition of *The Backyard Astronomer's Guide*, we focus on aspects of recreational astronomy often glossed over by other guidebooks. For example, we provide specific details about equipment and brand names. We do so because most of the inquiries we receive from beginners are variations on a single question: "What should I buy?" Our emphasis on hardware might lead to the impression that amateur astronomy is nothing more than collecting equipment. For some, this is, indeed, the case. But collectors rarely sustain their enthusiasm for the hobby. Which brings us to our concluding topic, one seldom discussed in amateur-astronomy literature: Why do people lose interest in astronomy?

In Chapter 1, we said you cannot buy your way into the hobby. But some newcomers try. They purchase the best equipment on the market but never get around to investing the time required to learn how to use it properly. Are they backyard astronomers? Not in our view. Even in the era of computerized telescopes, you cannot acquire a full appreciation of the universe without developing the skills to find things in the sky and an understanding of how the sky works. While we have included helpful information in our book, this knowledge stays with you only after you have spent time under the stars with simple star maps in hand. You learn by doing.

Since the first edition of our book, in 1991, equipment for backyard astronomy has evolved at an incredible rate. The high-tech gear is enticing. Yet even in this latest edition, perhaps even more so, our advice remains the same: The primary reason people lose interest in astronomy is that equipment absorbs their

A Kobau devotee gets her grab-and-go refractor ready for stargazing.

attention, and they neglect the stars. The sky never becomes a friendly place. The star patterns remain anonymous, and the locations of the sky's attractions stay hidden. Instruments that are too complex make setting up gear an onerous chore. What could have been a lifelong interest becomes a passing phase.

There are other reasons people lose interest in astronomy. Some leap into the deep end of the pool without first learning how to swim—perhaps by loading up on high-end astro-imaging equipment before trying anything more than simple shots of the Moon or a constellation. But the reality is, many backyard astronomers who are just entering the hobby express an interest in taking astrophotos. That's why two chapters of our book deal with imaging techniques.

However, there have been times when we both gave up astrophotography. Back in the film days, the results were often not worth the time and expense, not until equipment improved, as it certainly has done now.

Even so, despite the ease of use of digital cameras, our advice is to start simply and go slowly. Astrophotography can be much more complex than YouTube gurus would have you believe. We have seen too many frustrated beginners trying to emulate the experts by attempting long exposures of the Horsehead Nebula when they cannot yet point to the constellation Orion.

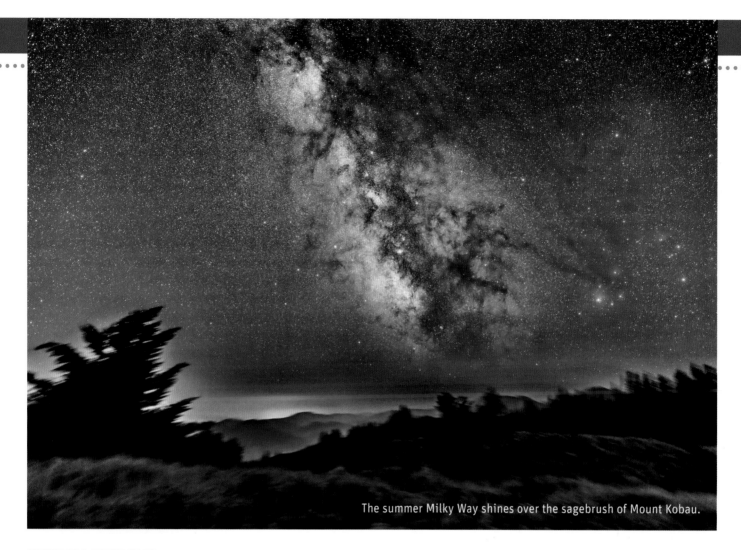

The summer Milky Way shines over the sagebrush of Mount Kobau.

KEEPING INSPIRED

Developing stargazing skills takes time, more time than many people can find. It seems the more leisure hours we have, the more we fill them with demanding activities that are far from leisurely. Finding time to be under the stars is, in our opinion, more a matter of attitude than scheduling. For us, the time spent pursuing this hobby is a quiet respite from life in the fast lane. And backyard astronomy does not have to be a solitary pursuit. Involving the family will make your astro-explorations all the more meaningful.

We also find that after the initial novelty wears off, many amateurs drift away from the hobby for lack of a purpose. To rekindle interest, we suggest taking on a project and working toward a goal, such as observing all the Messier objects, sketching the planets or photographing the constellations. Or schedule your next trip to include a few nights at a dark sky location.

Every now and then, we all need a shot of inspiration. Sometimes, a casual observation of a planetary conjunction or an exceptionally clear night is enough to remind us how wonderful the sky is. Even after five decades in the hobby, we never cease to be amazed at what new wonders the sky offers us each year, if not each night. Keeping abreast of celestial happenings is essential to maintaining your interest as a "naturalist of the night."

Other times, inspiration comes from a group therapy session, such as a star party, a motivating talk at a club meeting or connecting with skywatching friends, in person or on-line. However, while the virtual clubs created by special-interest forums and Facebook groups can be a source of helpful answers to specific questions, we've found such e-groups rife with misinformation and immaturity. We avoid most of them. They are not a true reflection of the great people who populate the community of backyard astronomers.

Like every other leisure pursuit, astronomy can be taken seriously or casually. It is entirely up to you. Our task has been to provide advice on the tools available and an introduction to the techniques of sky observing. Armed with this information, you are ready to explore a hobby—and a universe—that can provide a lifetime of amazement and fun. Welcome to backyard astronomy.

—Terence Dickinson and Alan Dyer

OUR WEBSITE

For updates and support content for this book, visit our website at:
www.backyardastronomy.com

Telescope Maintenance and Learning More

In this final section, we describe how to carry out the essential maintenance that most telescopes require now and then: cleaning optics and collimating reflectors. But before collimating your telescope, you should evaluate the quality of the optics. You must be able to discern the difference between poor collimation, which can be fixed, and poor optics, which likely cannot be fixed. To help you with this evaluation, we've compiled an "Atlas of Optical Aberrations."

The task of polar alignment can seem daunting at first, but with a little practice, it becomes quick and easy. In fact, for most backyard stargazing, polar alignment requires no more than setting the mount down with its polar axis tipped up to the correct angle (your latitude) and aimed in the right direction (due north in the northern hemisphere; due south in the southern hemisphere). That will be good enough for visual use. But astrophotography demands more precise polar alignment, and we offer several methods.

We end by recommending sources where you can learn more—books, magazines and websites.

This time-exposure photo shows how, in the northern hemisphere, a mount's polar axis (in this case, a Sky-Watcher Star Adventurer tracker) must point to the north celestial pole near Polaris, which can be found by using the "Pointer" stars in the Big Dipper's bowl. The sky rotates around this point, so your mount must as well. People who have difficulty with polar alignment often leap into astrophotography without first learning the basics of identifying stars such as Polaris.

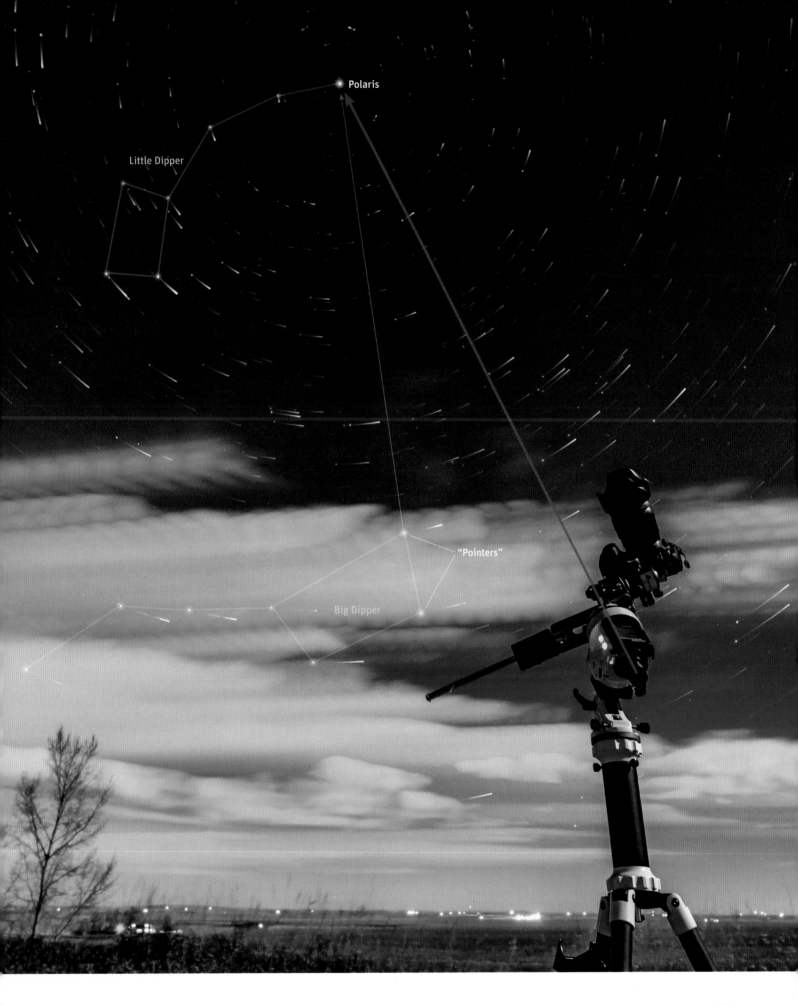

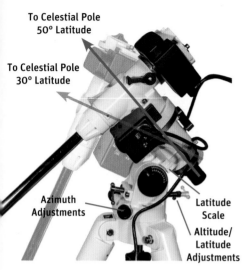

**To Celestial Pole
50° Latitude**

**To Celestial Pole
30° Latitude**

**Azimuth
Adjustments**

**Latitude
Scale**

**Altitude/
Latitude
Adjustments**

AIMING AT POLARIS

If the mount is set to your latitude and leveled, then it should aim close to Polaris when pointed due north (not to magnetic north).

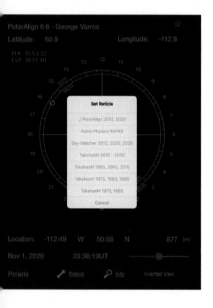

POLAR-ALIGNMENT APP

Apps such as PolarAlign by George Varros offer a choice of reticle patterns. Be sure to select the correct one for your mount. To use an app, just place Polaris where you're instructed to position it on the reticle. Do not try to outsmart the app to put Polaris 180° away, because the view is inverted.

Polar Alignment

Polar alignment is needed for star trackers, German equatorial mounts and fork-mounted telescopes on a wedge.

To polar-align a telescope, use the mount's altitude (i.e., latitude) and azimuth adjustments to aim the polar axis at Polaris by centering the star on the crosshairs of the polar-alignment scope. That will be good enough for GoTo finding and tracking for visual use. With equatorial GoTo mounts, always polar-align first, *then* perform a two- or three-star GoTo alignment as per the instructions in Chapter 11 (pages 216-217).

Astrophotography requires more exacting polar alignment because, as of 2020, Polaris actually lies 0.65 degree (39 arc minutes) from the true north celestial pole (NCP). The demands of how close you must get to the true NCP (or SCP in the southern hemisphere) go up as the focal length of your lens or telescope increases, as well as the length and number of your exposures. For the astrophoto rigs we recommend in Chapter 17, aligning within one to five arc minutes of the true NCP will be more than good enough.

THE EASY WAY TO ALIGN (NORTHERN HEMISPHERE)

Here's how to polar-align using the typical polar-alignment scope found on trackers and German equatorial mounts:

1 Set the mount for your latitude, and level it. Make sure the tripod legs aren't going to slip.

2 Place the mount so that the polar axis aims as close to due north (toward Polaris) as possible. Use the Big Dipper or Cassiopeia to identify Polaris.

3 Some German equatorial mounts require that the declination (north-south) axis be turned 90 degrees to allow a clear view up and through the polar axis.

4 Sight through the polar scope. It may or may not have a source of internal illumination for the reticle. If it doesn't, shine a dim red light into the polar axis.

5 Polaris may be in the field of view. If not, sight along the polar axis as best you can to aim it at what will be the brightest star in the area. A common error is to aim at Kochab, which is similar in brightness.

6 Now turn either the polar scope (some can be rotated independently of the mount) or the whole polar axis so that one of the radial reticle lines (it doesn't matter which one) points toward Kochab, the other bright star in Ursa Minor.

7 Use the mount's altitude and azimuth adjustments (not the right ascension and declination axes) to move Polaris so that it falls on the reticle's circular pattern, at a "clock position" on that radial line *in the direction toward Kochab*. That's the key!

8 Lock down the mount adjustments, making sure the positioning doesn't shift.

9 That's it. You have now polar-aligned well enough for hours of exposures with focal lengths up to 1,000mm. This is how we polar-align. With a bit of practice, the process takes 30 seconds.

FINDER CHARTS: NORTH CELESTIAL POLE

The Big Dipper's "Pointer" stars aim at Polaris, the brightest star in its region of sky. If the Big Dipper lies below your horizon, as it does in autumn from low latitudes, use the W of Cassiopeia to help locate Polaris and Ursa Minor, aka the Little Dipper. Polaris is at the end of the handle of the Little Dipper.

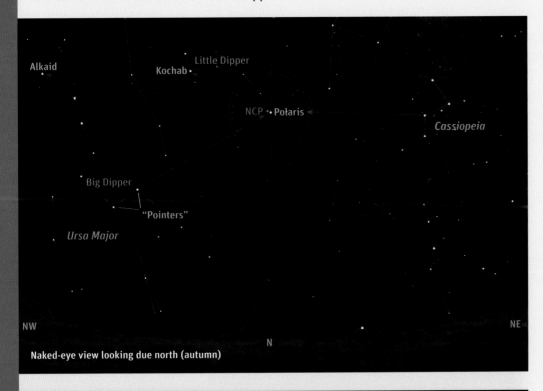

Naked-eye view looking due north (autumn)

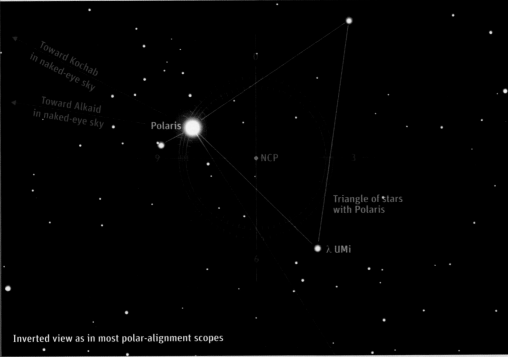

Inverted view as in most polar-alignment scopes

REACHING THE NORTH POLE

The key to polar alignment is to realize that the true north celestial pole (NCP) lies along a line between Polaris and Kochab. A line from Polaris to Alkaid, in the Big Dipper, also passes close to the NCP.

The close-up view below simulates what you would see through a typical polar-alignment scope, which inverts the view. You'll soon get to know the field, with Polaris forming a triangle with two fainter stars; a fourth star is off to one side. The NCP lies within that triangle.

To align, place Polaris on the reticle circle (on the middle circle for 2021) along a line *aimed at Kochab*. In this example, Polaris is at the "10 o'clock" position, but its clock position will depend on the time and date. In an inverting polar scope (as most are), Polaris *always* goes on the side *toward Kochab* in the naked-eye sky. That still applies even if you clip a camera's right-angle viewer to the polar scope, as some like to do to save the neck.

FINDER CHARTS: SOUTH CELESTIAL POLE

Locating the south celestial pole (SCP) is a challenge. It lies in one of the blankest regions of the southern sky, with no bright "South Star" nearby. A line perpendicular to a line joining Alpha (α) and Beta (β) Centauri (called the "Pointers") and another line from the Southern Cross intersect close to the pole in Octans, with bright Achernar on the other side of the pole. The chart below depicts an autumn sky. In spring, the sky is turned 180 degrees, with Octans above the SCP.

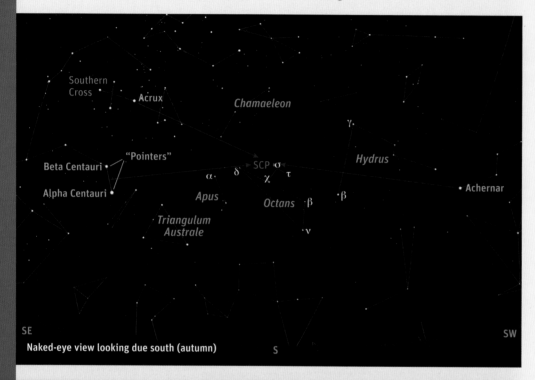

Naked-eye view looking due south (autumn)

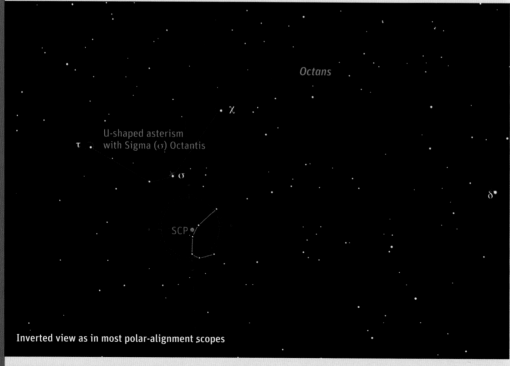

Inverted view as in most polar-alignment scopes

REACHING THE SOUTH POLE

The field that contains the SCP lies off the side of dim, triangular Octans, defined by the fourth-magnitude stars Beta (β) and Delta (δ) Octantis. To get oriented (at other times of the year, the field is rotated compared with this austral autumn view), look for the distinctive pattern of Apus and bright Beta (β) Hydri flanking the pole area.

Aim the mount and polar scope as close as you can to the region near fifth-magnitude Sigma (σ) Octantis, the brightest star in the field near the pole. In the polar scope, look for a wide U-shaped pattern of stars that contains Sigma, as well as fainter Chi (χ) and Tau (τ). After finding it once or twice, identifying the field again becomes easier, as it is a distinctive asterism.

Some polar scopes contain a reticle with that U-shaped pattern marked, as shown on the facing page, top right. Place its stars in the slots, and you're there. The SCP also lies along another smaller and fainter circlet of stars.

POLAR-ALIGNING DOWN UNDER

For those who live in the southern hemisphere, polar alignment will become easier as you get to know where the celestial pole lies from your site and become familiar with the field.

Getting the U-shaped pattern of stars that contains Sigma (σ) Octantis into the field of the polar scope is the first task, then recognizing it in the inverted field. Having a red-dot finder on the polar axis of the mount helps for aiming it into the area.

We present some high-tech options for polar alignment here, but if you are a northerner visiting the southern hemisphere (or vice versa) for a rare trip to shoot exotic skies, we suggest *always* taking a mount or tracker that also has an optical polar scope. Don't depend on a digital option as your only means of polar alignment. If it fails, you will be unable to polar-align and your photo trip will be a waste.

POLAR-ALIGNMENT PATTERNS

As depicted in the Polar Scope Align Pro app, top right, some polar-alignment scopes include the asterism near the south celestial pole that is key to aligning from Down Under. Other polar scopes, right, include hash marks for key alignment stars for both the northern (in red) and southern hemisphere (in blue).

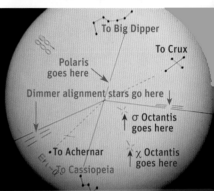

DIGITAL POLAR ALIGNMENT: THE ASIAIR

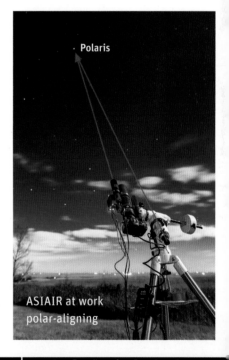

The difficulty of polar-aligning in the southern hemisphere and, for some users, even in the northern hemisphere prompts many to turn to one of the new generation of digital aids. The ASIAIR from ZWO (introduced in Chapter 17 and shown at right) has a polar-alignment function.

The process is fairly quick and very accurate. The app uses the main imaging camera for this, so if you have just a small guide camera attached to the ASIAIR, you must temporarily assign it as the main camera and input the correct focal length for the guidescope so that the app knows the image scale. The process then works very well, providing an accuracy of under four arc minutes, limited mainly by how precisely you can adjust your mount.

ASIAIR STEPS

1 In digital polar alignment, the software matches the actual field to a database of star positions in a process called "plate solving."

2 The ASIAIR can also connect to and control a GoTo mount so that it can automatically perform the required rotation of the mount.

3 The app displays how far the rotation of the polar axis is off the true pole. You then adjust the mount to bring the yellow marker to the center.

4 Once you get close (accuracy here is given as one arc minute), you are rewarded with a fireworks display!

ASIAIR at work polar-aligning

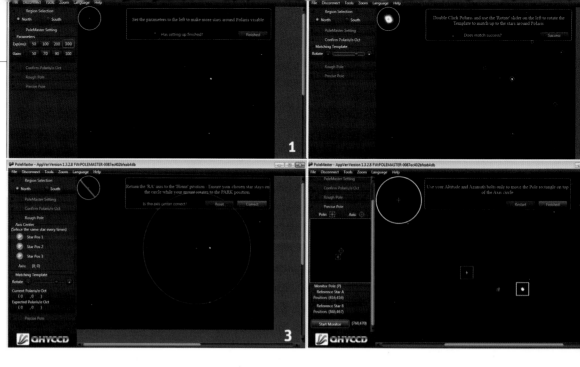

POLEMASTER STEPS 1. The camera exposure time (300 milliseconds is selected here) and Gain of the camera can be adjusted to make stars around the celestial pole more obvious. **2.** Clicking on Polaris in this example brings up an overlay that you rotate using the slider at left to match the template's circles to the pattern of actual stars. **3.** Click on one of the surrounding stars several times as you turn the mount around its polar axis for the software to determine the axis of rotation. **4.** Place Polaris in the open circle by physically adjusting the mount's polar axis in altitude and azimuth. The software switches from Rough Pole to Precise Pole mode (shown here) for a final physical move of the mount to align the green Pole box over the red Axis box.

DIGITAL POLAR ALIGNMENT: POLEMASTER

One of the first digital polar-alignment aids to hit the market, and still one of the most popular, is the PoleMaster from QHYCCD (qhyccd.com). (The iPolar from iOptron is similar.) The PoleMaster is a camera with an 11-by-8-degree field of view that attaches to your mount for the sole purpose of polar alignment. It requires a laptop to display its streaming images using the PoleMaster program (Windows and MacOS).

Like the ASIAIR, the process has several steps, requiring that you first match the actual star field to the software's built-in template of known stars around Polaris or Sigma Octantis. Rotating the mount around its polar axis tells the software where the mount's pole of rotation is compared with where the actual celestial pole is. You then use the mount's altitude and azimuth adjustments to align the former with the latter by aligning markers.

With practice, the process takes only a few

minutes. The software provides helpful on-screen prompts. Our tests of the PoleMaster (and ASIAIR) were confined to the northern hemisphere, so we cannot say how well either will work for you on that special trip to Australia or Chile.

You must first aim the mount's polar axis to within at least a few degrees of the pole to be sure Polaris or Sigma Octantis is in Pole-Master's field. As such, having a traditional optical polar scope is still a good idea, especially if the PoleMaster fails for some reason. If you don't start with the mount's polar axis close to the pole or if you click on the wrong star not realizing it isn't Polaris or Sigma Octantis, the steps of matching the star field to the overlay pattern will never succeed.

The PoleMaster works very well. However, with devices such as the ASIAIR offering a similar function (using gear you might have at the scope anyway), a device dedicated just to polar alignment will become less popular.

MOUNTING OPTIONS

The PoleMaster can be mounted over the aperture of a mount's polar scope using one of the many optional dovetail adapters, allowing both visual and camera use. Alternatively, the PoleMaster can attach to a dovetail rail using a mounting bracket from ADM Accessories, as shown above (admaccessories.com). This arrangement is needed for fork mounts that lack a polar-axis scope.

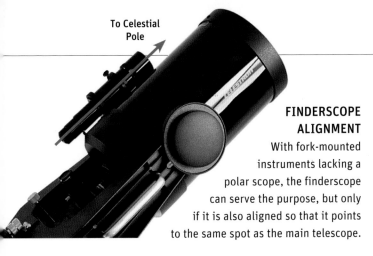

To Celestial Pole

FINDERSCOPE ALIGNMENT

With fork-mounted instruments lacking a polar scope, the finderscope can serve the purpose, but only if it is also aligned so that it points to the same spot as the main telescope.

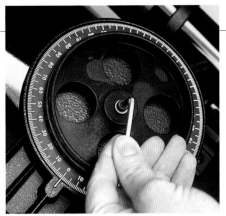

CALIBRATING THE DECLINATION CIRCLE

A fork-mounted tube might not be pointed toward 90 degrees declination even when it is turned to 90 degrees according to the declination circle. To ensure it is, look in the main scope at low power and rotate the scope in right ascension. If the scope is truly at 90 degrees, the field should rotate about the center of the eyepiece. Move the scope in declination until it does. Loosen the declination circle, turn it to read 90 degrees, then lock it down.

POLAR-ALIGNING A FORK-MOUNTED SCOPE

To be polar-aligned, the polar axis—the one the forks revolve around—and, therefore, the fork tines must be aimed at the celestial pole. This requires the optional wedge. The following steps are for a traditional optical alignment.

1 Adjust the angle of the wedge to match your latitude.

2 Place the telescope so that its forks are aimed northward (or southward in the southern hemisphere). Roughly level the tripod.

3 Swing the tube in declination so that it reads 90 degrees on the circles on the side of the tube, and lock it there.

4 Move the scope to place Polaris (Sigma Octantis in the southern hemisphere) in the finderscope. Do this by moving the whole tripod or by using the wedge's azimuth and altitude adjustments.

5 Use the charts on pages 391 or 392 to aim the scope's wedge so that the center of the finderscope lies at the position of the true celestial pole.

THE TWO-STAR DRIFT METHOD

With the advent of digital techniques, the old-school "drift" method is falling into disuse. However, it can be useful when setting up a permanent observatory or for polar-aligning from a site near the equator.

Aim the telescope at a star on the celestial equator due south. Use an illuminated-reticle eyepiece to watch the star carefully. Ignore any drift it makes east or west in right ascension. Watch for a drift north or south in declination.

◆ If the star drifts *north*, the polar axis is aimed too far *west* (it is to the left of the actual pole in the northern hemisphere).

◆ If the star drifts *south*, the polar axis is aimed too far *east* (to the right of the pole).

 Move the mount in azimuth in the appropriate direction, then watch again. Has the drift improved? Now point the telescope at another star on the celestial equator, but one that is rising in the east. Observe it for a while, ignoring any drift in right ascension.

◆ If the star drifts *north*, the polar axis is aimed too *high* (it is above the pole).

◆ If the star drifts *south*, the polar axis is aimed too *low* (it is below the pole).

 For a drift align in the southern hemisphere, substitute *south* everywhere we have said *north*, and vice versa.

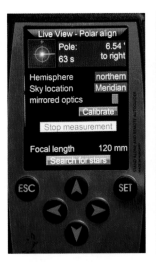
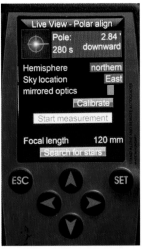

DRIFT ALIGN

The MGEN-3 auto-guider from Lacerta, described on page 362, offers the two-star alignment process. It uses a stream of images from the auto-guider camera to measure how much a star near the celestial equator is drifting.

Cleaning Optics

After an observing session on a cold night, always cap the main optics, focuser and eyepieces first. Then carry the protected optics inside to allow them to warm up gradually. This will prevent condensation from forming on the optics and leaving a filmy residue.

Sooner or later, dust and grime will coat optics. The rule is, clean optics only when absolutely necessary. Vigorous cleaning can scratch optics and coatings, inflicting far more harm than a few dust and dew spots. When dust does accumulate on the optical surfaces, remove it while it is still dust, before a night of heavy dew transforms it into mud.

You can mix your own lens-cleaning fluid: Use a 50-50 ratio of distilled water and isopropyl (rubbing) alcohol. Add a few drops of dishwashing (not dishwasher) liquid, just enough to undo the surface tension that causes beading of the water-alcohol mixture on polished glass.

CLEANING EYEPIECES AND LENSES

LENS-CLEANING TIPS

◆ Do not use cleaning solutions or cloths sold for eyeglass use. They can leave a chemical residue.

◆ Camera lens cleaners can work for small optics such as eyepieces. For larger lenses, use our home-brew formula.

◆ Do not apply lens-cleaning fluid directly to a lens; it can seep into lens cells and the interior of eyepieces.

◆ Never take an eyepiece apart. You might not get it back together correctly.

◆ On some refractors, it is possible to remove the lens in its cell from the tube, as shown at far right. This might be necessary to get at the rear lens surface, where a filmy coating can accumulate. Never take doublet or triplet lenses apart. Always replace the cell in the same orientation on the tube as you found it.

Eyepieces require the most cleaning. The eye lenses pick up oil from eyelashes and from misplaced fingers. In refractors and catadioptrics, the front lens or corrector plate can also gather dust. If dew is allowed to form on these surfaces, a filmy residue can accumulate. Here are the steps for cleaning them:

1 First, blow loose dust and dirt off the exterior lens surfaces with a bulb-blower brush or a can of compressed air. (Be careful: If you tilt the can, some of the propellant may sputter out, spotting the optics with chemical gunk.)

2 Next, use a soft camel-hair brush or LensPen (carried by telescope stores) and light strokes to remove loose specks. Any that remain could scratch the surface when you perform the next step.

3 For eyepieces, moisten a cotton swab (a Q-tip) with a few drops of the cleaning fluid. For a larger lens, moisten a cotton ball.

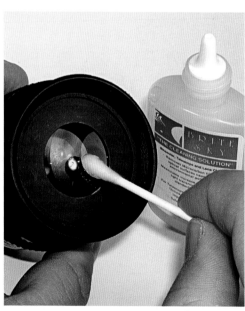
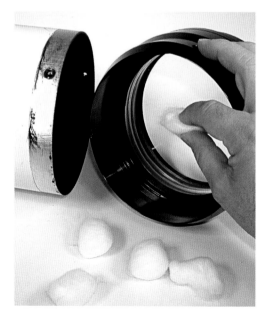

4 Gently wipe the lens. Do not press hard. If the stain is stubborn, use new swabs or cotton balls. Sometimes, softly breathing on the lens can help remove stains.

5 Use a dry swab or cotton ball for a final cleaning of moist areas, plus some more air puffs to blow off the bits of cotton that inevitably remain. There may still be a few smears, but a final polish with a light condensation from your breath will restore the pristine appearance.

With Schmidt-Cassegrains, the front corrector plate, complete with the secondary mirror attached, can be removed from the front of the tube. But use extreme care; the corrector plate is very thin. Getting at the inside surface of the corrector may be required if the interior of the telescope has become contaminated with dust or moisture.

Important: The corrector-plate assembly must be returned in exactly the same orientation you found it.

CLEANING MIRRORS

For most of the lifetime of a Newtonian, the primary and secondary mirrors should require only the occasional blast of compressed air and a few strokes of a camel-hair brush. Aluminized surfaces can scratch easily, and a mirror full of microscopic scratches is far worse than a mirror with a few isolated specks of dust. Wash a mirror only if it develops a thick film of dust or grime. Follow these steps:

1 Remove the cell from the end of the tube, a task that might require some prying. Then loosen the three clips to remove the mirror from its cell.

2 Once the mirror is free from the cell and safely on a towel on a table, use a blower and brush to remove as much dust as possible.

3 Place the mirror on edge in a sink on a folded towel to prevent it from slipping.

4 Run cold water over the front of the mirror to wash off more dirt. Don't worry; this will not remove the aluminum coating.

5 Then fill the sink with warm water, and add a few drops of a gentle liquid soap.

6 Lay the mirror flat on the towel in the sink, submerged under about half an inch of water. Use sterile cotton balls to swab the mirror gently. Always brush in straight lines across the surface. Never rub or use circular motions. Repeat with fresh cotton balls, moving perpendicular to the first swipes.

7 Drain the sink, then rinse the mirror with cool water.

8 Perform a final rinse with distilled water (tap water can leave stains).

9 Let the mirror dry by standing it on edge. The mirror should not have to be subjected to this treatment again for many years.

MIRROR-WASHING TIPS

◆ Removing this mirror from its cell (top left) required pulling it free from dabs of silicone glue.

◆ Place the mirror on a towel in a sink.

◆ Remove any rings from your fingers.

◆ Clean mirrors with the weight of the cotton balls as the only pressure (top right).

◆ Rinse the mirror with distilled water. Stand it on end to let it air-dry (bottom left).

◆ When replacing the mirror in the cell (bottom right), tighten the clips so that they just touch the mirror. Overtightening will pinch the mirror, introducing astigmatism.

◆ Removing and replacing a mirror always requires recollimating the optics.

Remove mirror carefully

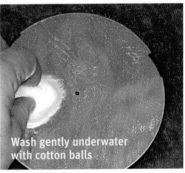
Wash gently underwater with cotton balls

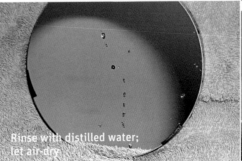
Rinse with distilled water; let air-dry

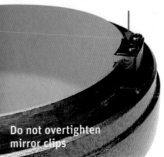
Do not overtighten mirror clips

Collimating Optics

Owners of reflector telescopes must perform a needed maintenance chore now and then: collimation. This involves adjusting the tilt of the mirrors so that light rays hitting the main mirror on-axis form an image in the exact center of the eyepiece. If the optics are out of collimation, images will not be as sharp as they could be. Indeed, optics dismissed as faulty are often simply out of collimation.

To test for poor collimation, slowly rack a bright star at high power out of focus. If the expanding round disk is not symmetrical, there is a problem. On reflectors, the test is easy, because the central dark shadow cast by the secondary mirror should be dead center in the out-of-focus blur circle.

Refractors and Maksutov-Cassegrains usually never need collimation or even allow it. However, if you have a Newtonian or a Schmidt-Cassegrain, collimation can be required, especially after a bumpy road trip.

COLLIMATING SCHMIDT-CASSEGRAINS

These are the simplest telescopes to collimate. The adjustments are done strictly using the three small screws on the secondary mirror cell. (The screws on some models are hidden behind a protective plastic cover that must be pried off to reveal the collimation screws.) Use these screws to adjust the tilt of the secondary mirror so that it projects the light beam straight down the center of the telescope.

On most Schmidt-Cassegrains, the secondary mirror magnifies the focal length by a factor of five. Its collimation is, therefore, extremely critical. Even a slight maladjustment can degrade performance. Always approach collimation with a light hand—a small fraction of a turn might be all that is required. Here are the steps to collimate a Schmidt-Cassegrain:

1 On a night with steady star images, set up the telescope and let it cool to outside air temperature. This may take up to an hour but is important, as the effects of thermal plumes can mimic poor collimation.

2 Aim the telescope at a second-magnitude star high above the horizon. Polaris is a good choice, as it won't move much during the process. Use a medium-power (100x) eyepiece, but if possible, do not use a star diagonal, because it can introduce collimation problems of its own.

3 Place the star dead center, then rack it out of focus until it is a sizable blob. If the telescope is out of collimation, the secondary-mirror shadow will appear off-center.

4 Using the mount's slow motions, move the telescope so that the star image is displaced from the center of the field in the direction that makes the central shadow appear *better* centered.

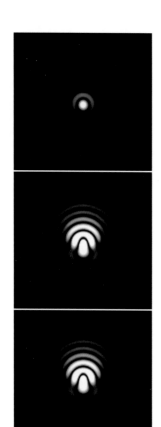

GOOD, BAD AND AWFUL
These illustrations simulate a star at high power in a Schmidt-Cassegrain with, from top to bottom:
- ¼-wave of coma from very slight miscollimation;
- ½-wave of coma from poor collimation;
- 1-wave of coma from severe miscollimation.
The bottom two telescopes would produce blurry images.

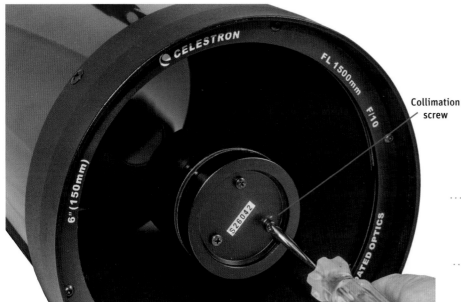

Collimation screw

COLLIMATING SCHMIDT-CASSEGRAINS

Left: When collimating a Schmidt-Cassegrain telescope, take two precautions:

- Do not overtighten the three collimation screws. If they warp the secondary, you'll see astigmatic star images.
- Some cells (not this one) have a central screw. Do not loosen this; it holds the secondary mirror in place!

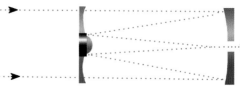

5 Now turn the collimation screw that moves the out-of-focus star image back toward the center of the field. This takes trial and error. Remember to make very small adjustments.

6 If the image is still asymmetrical, repeat Steps 4 and 5. Turning one screw might not be sufficient. A combination of two might be required. If one screw gets too tight, loosen the other two to perform the same move. At the end of the whole procedure, all three screws should be finger-tight.

7 Once you have completed this at medium power, switch to high power (200x to 300x). Any residual collimation error that remains after Step 6 will show up now, especially if you rack the star just slightly out of focus. Perform Steps 4 and 5 again, making even finer adjustments.

You can perform this procedure to a fair degree of accuracy during the day. Sight a distant power-pole insulator or a piece of polished chrome trim. Look for a specular glint of sunlight—it can serve as an artificial star. For the final adjustment, use a star at night.

NEWTONIAN COLLIMATION TOOLS

Above right: The telescope has a simple collimation cap in place in the focuser. A more advanced tool is the Cheshire eyepiece, with a peephole, crosshairs in the barrel and an angled mirror for lighting up the secondary. **Right:** Here's a laser collimator at work. The secondary has been adjusted to center the laser dot on the primary. But the primary still needs adjustment to center the dot on the collimator screen.

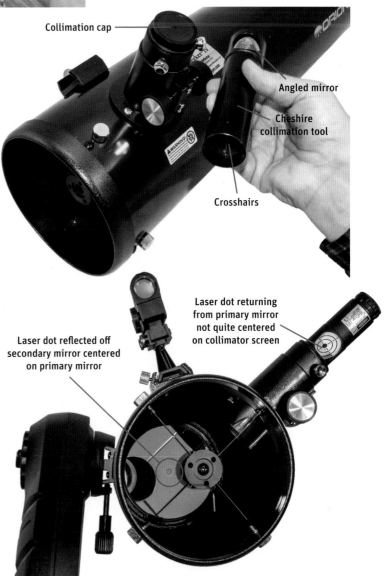

Collimation cap

Angled mirror

Cheshire collimation tool

Crosshairs

Laser dot returning from primary mirror not quite centered on collimator screen

Laser dot reflected off secondary mirror centered on primary mirror

CIRCLES
WITHIN CIRCLES
When viewed through
a Cheshire eyepiece,
the crosshairs and the
secondary's spider vanes
should intersect at the
center of the various
reflections, below. This scope
needs work, as revealed in
the photo of the defocused
star, bottom left, showing
an off-center secondary
shadow. Most mirrors come
with a central dot or circle,
bottom right, a great aid for
collimating Newtonians.

COLLIMATING NEWTONIANS

In a Newtonian, both mirrors may require adjustment, which complicates the process. But you can bring Newtonian mirrors into close collimation indoors by examining the appearance of the various reflections while looking down the focuser. To do this, make a "collimating cap." Drill or punch a pinhole in the exact center of a focuser's plastic dustcap. This simple sighting aid keeps your eye in the center of the focuser tube. An alternative is a collimation tool known as a Cheshire eyepiece, shown on the previous page. It has crosshairs and a reflector to illuminate the secondary.

Although more costly, a laser collimator, also shown on the previous page, works well and allows precise collimation without having to be under the stars. To use one, first adjust the tilt of the secondary mirror so that the laser dot falls in the center of the primary mirror, usually marked with a dot or ring. Then adjust the tilt of the primary mirror so that the laser dot reflects back up on itself, hitting the center of the collimator's angled screen.

To "eyeball" collimation using a collimating cap or Cheshire eyepiece, follow these steps:

1 If the optics have been disassembled and are way off, you might first need to center the secondary mirror in the tube. Adjust the spider vanes so that they are of equal length.

2 Then to get the mirror directly under the focuser, turn the threaded rod on which the secondary mirror holder sits. This moves the secondary up and down the length of the tube. Rotate the diagonal holder to face the mirror directly up the focuser. Sight through your collimation eyepiece to judge whether the secondary mirror is centered on the focuser hole. Do not worry about any off-center reflections in the diagonal mirror; just get the mirror itself positioned. Steps 1 and 2 are rarely required for commercial scopes unless they have been disassembled.

3 This is where most users will need to start. First, adjust the tilt of the secondary mirror. Adjust the three collimation screws on the diagonal holder so that the reflection of the main mirror is precisely centered in the diagonal mirror. Ignore the reflection of the

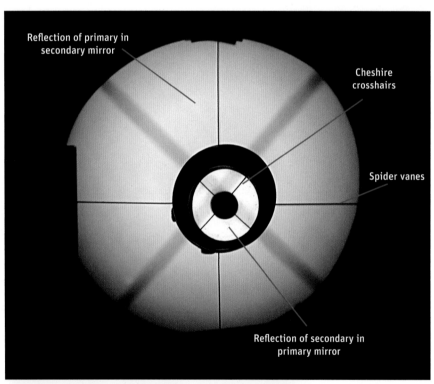

Reflection of primary in
secondary mirror

Cheshire
crosshairs

Spider vanes

Reflection of secondary in
primary mirror

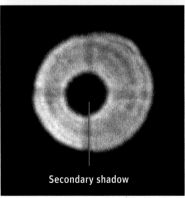

Secondary shadow

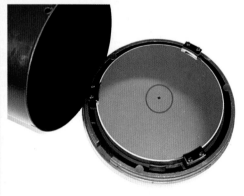

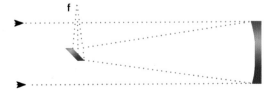

f

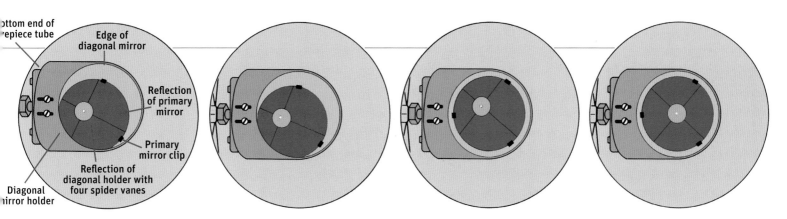

COLLIMATING A NEWTONIAN

These illustrations depict the view down the focuser of a Newtonian. In this case, the mirrors are way out of collimation and the secondary mirror is not centered in the focuser.

First, physically position the secondary. Adjust the length of the spider vanes, and turn the diagonal mirror so that it is centered in the focuser's aperture, as shown here.

Adjust the secondary mirror's three tilt screws. This might take an Allen or a hex wrench. The goal is to center the reflection of the main primary mirror so that the final view looks like this.

Adjust the primary mirror's three tilt screws. Loosening two may be needed to tighten the third. Center the reflection of the secondary in the primary's reflection so that it looks like this.

spider vanes and secondary mirror for now; just concentrate on getting the perimeter of the main mirror nicely lined up with the outline of the secondary mirror.

4 At this point, the main mirror's reflection of the spider vanes and diagonal holder probably looks off-center. To bring them in line, you'll need to adjust the three collimation screws on the main (primary) mirror cell. The dark diagonal-mirror silhouette should end up in the center of the reflection of the primary mirror, which itself is centered in the secondary mirror.

5 Once the coarse mechanical adjustments are made, take the telescope out at night and check the out-of-focus star images. Wait for the telescope to cool down, then follow the procedure outlined under Schmidt-Cassegrains, but with a difference: Use the three collimation screws on the primary mirror cell to do the final fine-tuning with a magnified star image. Do not adjust the secondary mirror. In future, it is usually only the primary that you'll need to adjust.

There's a good tutorial showing Newtonian collimation on Orion Telescopes & Binoculars' YouTube channel (youtube.com/user/oriontelescopes). Once there, search for "Collimation."

> **BREAKING GLASS!**
> Always perform these adjustments with the tube horizontal to avoid the risk of a tool falling down the tube onto the primary mirror.

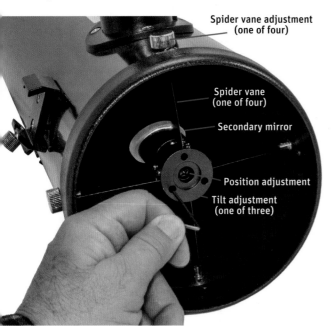

Spider vane adjustment (one of four)

Spider vane (one of four)

Secondary mirror

Position adjustment

Tilt adjustment (one of three)

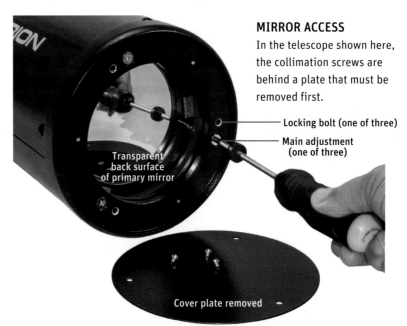

MIRROR ACCESS

In the telescope shown here, the collimation screws are behind a plate that must be removed first.

Locking bolt (one of three)

Main adjustment (one of three)

Transparent back surface of primary mirror

Cover plate removed

APPENDIX D

Testing Optics

Final collimation often requires examining a star at high power, both in focus and out of focus. This is a sensitive test that can also reveal flaws and defects in the optics.

THE IN-FOCUS DIFFRACTION PATTERN

At high power, a star looks like a distinct spot surrounded by a series of concentric rings, with the innermost ring being the brightest and most obvious. This is called the diffraction pattern. The spot in the middle is known as the Airy disk. Any telescope that claims to be "diffraction-limited" must create a good likeness of that pattern. Your telescope may not produce as perfect a bull's-eye as we've depicted. Few scopes do. To see a perfect diffraction pattern, mask your telescope down to a one- to two-inch aperture. Then focus the telescope on a bright star well above the horizon, using a magnification of 100x to 150x. You should see a classic diffraction pattern that can serve as a standard of comparison when testing telescopes.

THE PERFECT IMAGE
Here, we compare
two popular classes
of telescopes:

4-INCH REFRACTOR
When in focus on a bright star, an unobstructed telescope produces a bright Airy disk surrounded by a faint inner diffraction ring (assuming textbook-perfect optics). Out of focus, the image expands to filled-in diffraction disks that look identical both inside and outside of focus.

8-INCH SCHMIDT-CASSEGRAIN
With its larger aperture, this Schmidt-Cassegrain produces a smaller Airy disk in focus but with a brighter first diffraction ring—an effect of the obstructed aperture. Although still identical, the two extra-focal images look more like donuts.

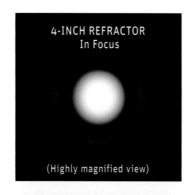

4-INCH REFRACTOR
In Focus

(Highly magnified view)

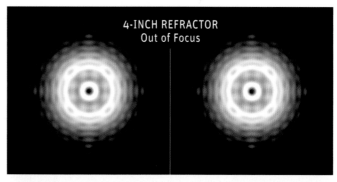

4-INCH REFRACTOR
Out of Focus

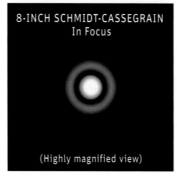

8-INCH SCHMIDT-CASSEGRAIN
In Focus

(Highly magnified view)

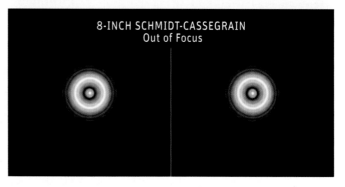

8-INCH SCHMIDT-CASSEGRAIN
Out of Focus

THE OUT-OF-FOCUS DIFFRACTION PATTERN

With the telescope stopped down, slowly rack the star out of focus. You'll see an expanding pattern of rings emerge. Defocus the instrument to the point where four to six rings show. Except for a fat outer ring, the light should be spread more or less uniformly among the rings. Now rack through focus to the same place on the other side of focus. The pattern should look identical, with a uniform distribution of light within the rings.

In an unobstructed telescope, such as a refractor, the out-of-focus pattern will be filled in. In an obstructed telescope (a reflector with a secondary mirror), the out-of-focus pattern will look more like a donut. Examining the appearance of an out-of-focus star image (called the extra-focal image no matter which way it is defocused) is the essence of the star test.

ATLAS OF ABERRATIONS

These "big four" aberrations represent the main optical flaws backyard astronomers are likely to encounter in some combination. All star-test simulations shown in this Appendix were produced using a free astronomy software program called Aberrator by Cor Berrevoets, available for Windows at aberrator.astronomy.net.

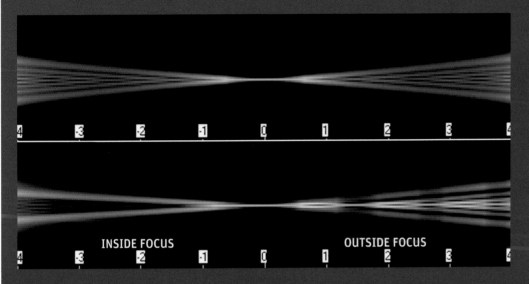

PERFECT OPTICS In perfect optics, the converging and diverging light cones (seen here in profile) contain identical bundles of light rays. Light comes to a sharp focus.

IMPERFECT OPTICS With spherical aberration, light from the perimeter of a lens or mirror does not focus at the same point as light from the center. The result is an asymmetrical light cone and a smeared focal point.

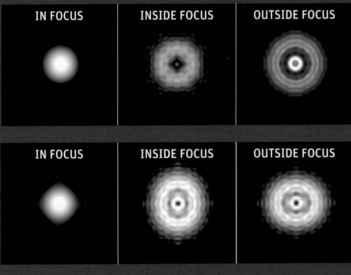

| IN FOCUS | INSIDE FOCUS | OUTSIDE FOCUS |

1. SPHERICAL ABERRATION The basis of the star test is to look at the pattern of a defocused star, effectively slicing through the light cones on either side of focus. In the case of spherical aberration, this pattern can look fuzzy on one side of focus yet tightly defined on the other. In focus (the image at far left), the first diffraction ring looks brighter.

| IN FOCUS | INSIDE FOCUS | OUTSIDE FOCUS |

2. ON-AXIS ASTIGMATISM If the lens or mirror is ground so that it is not rotationally symmetrical, the extra-focal diffraction disk might appear elliptical. Its axis flips 90 degrees from one side of focus to the other. In focus (as at far left), stars always appear vaguely crosslike. Optics that are physically pinched can produce a similar effect.

3. CHROMATIC ABERRATION (LONGITUDINAL) Found only in refractors, this aberration arises when all colors are not brought to the same focal point. The illustrations depict a focused star as seen through a 4-inch f/8 refractor with 0.6-wave (near right) of chromatic aberration and 1-wave (far right). The latter is typical of standard f/6 to f/8 achromatic refractors. While the blue halos are distracting, this aberration does not degrade the image as badly as other flaws.

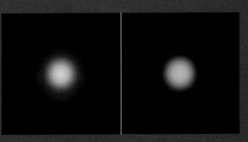

4. OFF-AXIS COMA Coma, an inherent aberration of many reflectors, makes stars that are off-center in the field look flared to one side. The farther the image is from the center of the field of view, the worse the aberration. Coma also becomes more severe in faster optics, with fast f/4 or f/5 Newtonians having much smaller coma-free fields than f/8 instruments. For this reason, collimation of fast Newtonians is critical, or all images will look fuzzy.

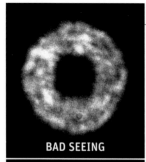

BAD SEEING

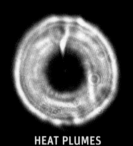

HEAT PLUMES

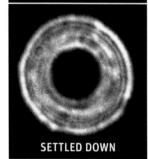

SETTLED DOWN

SETTLING DOWN
A valid star test requires a night of good seeing. If the air is turbulent, the out-of-focus diffraction disk will distort and blur, top. If warm air remains in the telescope tube, rising currents can produce plumes that distort star images, middle. But once the telescope has settled down, you'll see a smooth and uniform diffraction disk when a star is thrown out of focus, bottom. These images are actual photos of defocused stars.

NEEDING COLLIMATION
Right: A telescope that is out of collimation (in this case, a Newtonian reflector) produces a skewed diffraction disk when a star is defocused for testing.

WHAT YOU MIGHT SEE

It is important to keep in mind that star images can be ruined by factors other than the quality of the optics, or you may be blaming your telescope for a defect it does not have. To conduct a star test, use the full aperture of the telescope and a good-quality eyepiece, such as a Plössl. Be sure to do the star test with the image centered in the field of view. If you can, remove any star diagonal so that you are looking straight through the optics (cheap diagonals can mimic the effects of poor collimation).

Note: In the diagrams at right and on the previous and following pages, the in-focus Airy disk pattern is shown at much higher magnification than the out-of-focus diffraction disks. The two types of images are not drawn to the same scale.

TELESCOPE COLLIMATION
A telescope that is out of collimation will likely fail the star test. The out-of-focus diffraction pattern will look like a striped, tilted cone as viewed from the pointy end. If your scope offers up poor images, poor collimation is the first suspect. Follow the directions in Appendix C before conducting a star test. The optics may be fine, just poorly collimated.

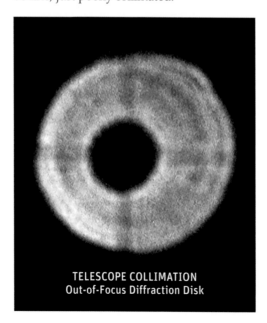

TELESCOPE COLLIMATION
Out-of-Focus Diffraction Disk

TUBE CURRENTS
Slow-moving currents of warm air inside a telescope can introduce defects that mimic permanent errors on the glass. Diffraction patterns look flattened or flared. Such image-distorting currents occur when a telescope is taken from a warm house into the night air or when outside air is rapidly cooling after sunset. When star-testing, always allow the telescope, eyepiece and even the star diagonal to cool down. A warm eyepiece inserted into a cold telescope can also introduce heat plumes. Expect to wait an hour or more, especially on cold nights.

ATMOSPHERIC TURBULENCE
On nights of poor seeing, turbulent air churning above the telescope (sometimes many miles above) can turn the view into a boiling confusion. When this happens, don't bother testing or collimating. Because it looks through a greater volume of air, a large telescope is affected by this problem much more than a small one, making it difficult to find a good night to test a big instrument. Even so, on nights of bad seeing, a small telescope may look sharper. But when the seeing is good and given good optics in both, a big telescope will always show as much, if not more, detail.

PINCHED OPTICS
Badly mounted optics create unusual diffraction patterns. Most common for a Newtonian telescope is a six-sided spiking or flattening (depending on which side of focus you are on). This occurs if the clips holding a primary mirror in its cell are too tight. Loosening the clips requires removing the mirror and cell from the tube. Secondary mirrors and star diagonals glued onto holders can also suffer from pinching. Back off the bolts that hold the secondary mirror. The main lenses in refractors can also be pinched in their cells. If there are screws around the cell, back each off slightly.

NONOPTICAL PROBLEMS

This series of simulations demonstrates the effect of various problems that can blur images which are not the fault of the optics. On the left is a magnified view of a star in focus. At right is the simulated appearance of the extra-focal disks seen on either side of focus.

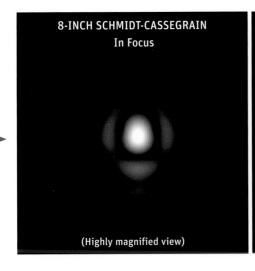

8-INCH SCHMIDT-CASSEGRAIN
In Focus

(Highly magnified view)

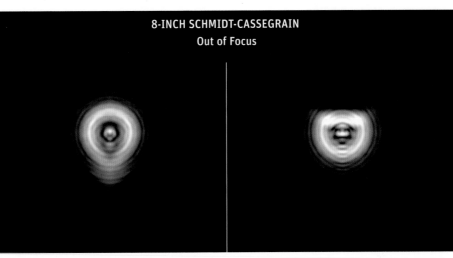

8-INCH SCHMIDT-CASSEGRAIN
Out of Focus

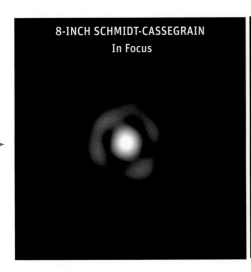

8-INCH SCHMIDT-CASSEGRAIN
In Focus

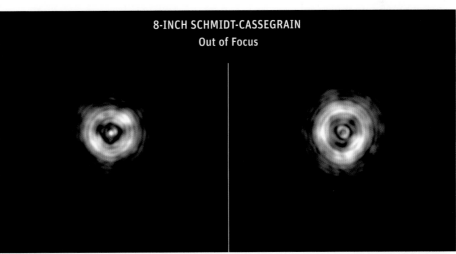

8-INCH SCHMIDT-CASSEGRAIN
Out of Focus

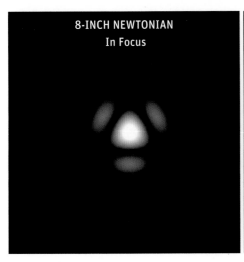

8-INCH NEWTONIAN
In Focus

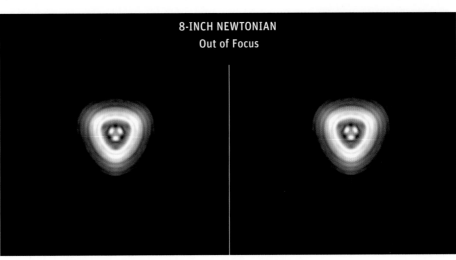

8-INCH NEWTONIAN
Out of Focus

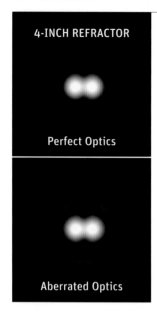

4-INCH REFRACTOR

Perfect Optics

Aberrated Optics

THE DOUBLE-STAR MYTH

A persistent myth is that splitting close double stars is a good test of optics. Above is a 4-inch refractor; below, an 8-inch Schmidt-Cassegrain. In each pair, the top image depicts perfect optics, while the lower image is the same scope with bad spherical aberration. Notice that the double star is still well resolved, but the poor optics surround the stars with a glow from overly bright diffraction rings. The Airy disk pattern is not clean.

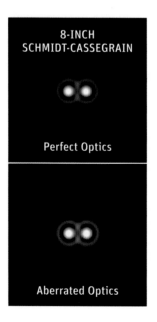

8-INCH
SCHMIDT-CASSEGRAIN

Perfect Optics

Aberrated Optics

WHAT YOU DON'T WANT TO SEE

Now on to determining whether there is a defect in the optics themselves. Errors on the optical surface are divided into categories. What you see is likely a combination of two or more defects. However, the most common flaw, present to some degree in all but the finest optics, is spherical aberration. Purchasing a slower f/8 Newtonian or an f/11 to f/15 refractor is one way to avoid this aberration, as fast lenses and mirrors are difficult to make well. This is a prime source of the adage, even myth, that slow focal-ratio telescopes are best for the planets. This was once a good rule of thumb, but today, superb optics can be found at all focal ratios, though at a price. It is optical quality, not focal ratio per se, that determines a telescope's suitability for its most demanding task: revealing subtle planetary detail.

ZONES

Zones are small figuring errors that often result from harsh machine polishing. Most commercial optics suffer to some extent from zones. Severe cases degrade image quality noticeably. To check for zones, defocus the image more than is usual in the star test. On one side of focus or the other, you may notice that one or more of the rings look weak.

With reflectors, be careful in any star testing not to be confused by the secondary mirror's central shadow. The important point is that the pattern should be the same on both sides of focus.

ROUGH SURFACES

This defect, often present in mass-produced optics, appears as a lessening of contrast between the rings plus the appearance of spiky appendages to the rings. Do not confuse these spikes with diffraction from spider vanes—spider diffraction is spaced regularly. A velvety smooth ring system indicates that you do not have trouble with surface roughness. The telescopes we recommend in Chapter 7 are likely to be largely free of surface roughness.

SPHERICAL ABERRATION

The most common of all optical flaws, spherical aberration can occur when a mirror or lens is undercorrected, resulting in light rays from the perimeter focusing closer than rays from the center. Inside of focus, the diffraction pattern has an overly bright outer ring; outside of focus, the outer rings are faint and ill-defined. The opposite pattern, with a fuzzball inside of focus and a donut outside of focus, results from overcorrection. Either error leads to fuzzy images; stars and planets never snap into focus; and planetary disks look gauzy.

ASTIGMATISM

A lens or mirror ground asymmetrically makes a star image look like a stubby line or an ellipse that flips over at right angles as you rack from one side of focus to the other. The best focus looks vaguely crosslike. The easiest way to detect astigmatism is to rock the focuser quickly back and forth. Mild astigmatism may show up with only three rings visible, when the star is just out of focus, and it will soften planetary images and blur the Airy disk of stars. Again, there is no crisp, snappy focus point. This flaw is sometimes seen in refractors or can be from warped star diagonals.

MIXED ABERRATIONS

A more common situation is a telescope suffering from a blend of maladies. These views simulate a mix of tube currents, coma, spherical aberration and astigmatism. If, after careful testing and a second opinion, you feel your optics are truly defective, contact the dealer or manufacturer.

These illustrations are adapted with permission from "Test Drive Your Telescope" in the May 1990 issue of *Astronomy* magazine. For more details, the star-testing bible is *Star Testing Astronomical Telescopes* by Harold Richard Suiter (Willmann-Bell, 1994), now out of print.

FLAWS IN THE OPTICS

This series of simulations demonstrates the effect of various aberrations that originate in the optics themselves. On the left is the magnified view of a star in focus. At right is the simulated appearance of the extra-focal disks seen on either side of focus.

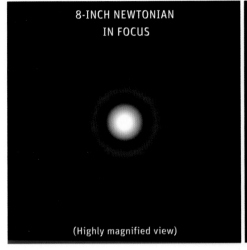

8-INCH NEWTONIAN IN FOCUS

(Highly magnified view)

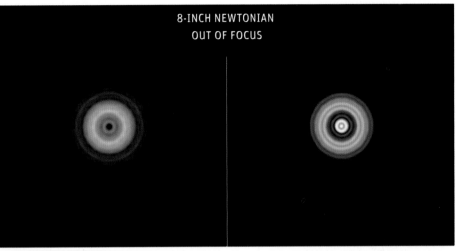

8-INCH NEWTONIAN OUT OF FOCUS

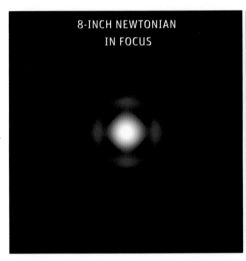

8-INCH NEWTONIAN IN FOCUS

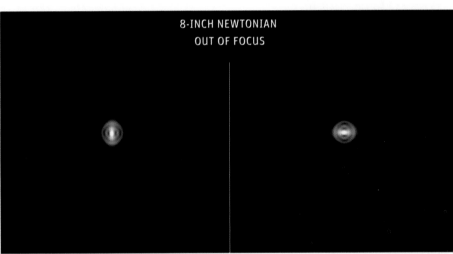

8-INCH NEWTONIAN OUT OF FOCUS

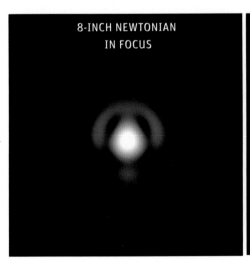

8-INCH NEWTONIAN IN FOCUS

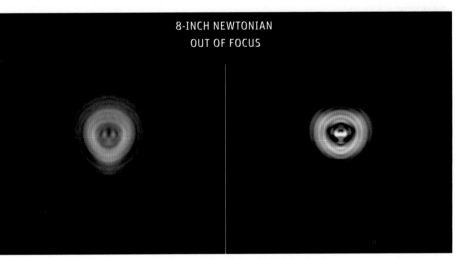

8-INCH NEWTONIAN OUT OF FOCUS

APPENDIX E

Learning More

Throughout this book, we've shown guidebooks and star atlases we've used. Here, we offer a list of other books we can recommend if you wish to learn more about the various chapter topics. Our emphasis in this bibliography is on practical observing guides.

Note: In late 2020, the astronomy publisher Willmann-Bell closed, so its array of excellent books will be hard to find or may become available through another publisher.

CHAPTER 1
INSPIRATION FOR STARTING OUT IN ASTRONOMY

Ultimate Guide to Viewing the Cosmos by David Dickinson (Page Street Publishing; Salem, MA; 2018). A good guide to stargazing by the editors of the universetoday.com website.

Seeing in the Dark by Timothy Ferris (Simon & Schuster; New York; 2003). A first-rate science writer examines the realm of the scientific amateur astronomer.

Starlight Nights: The Adventures of a Star-Gazer by Leslie C. Peltier (Sky Publishing; Cambridge, MA; 1999). May be hard to find but worth it! This wonderful book chronicles Peltier's heartwarming and inspiring odyssey in backyard astronomy.

CHAPTER 2
NAKED-EYE ASTRONOMY

General Naked-Eye Guides

Night Sky With the Naked Eye by Bob King (Page Street Publishing; Salem, MA; 2016).

Wonders of the Night Sky You Must See Before You Die by Bob King (Page Street Publishing; Salem, MA; 2018).

The 50 Best Sights in Astronomy and How to See Them by Fred Schaaf (Wiley; New York; 2007).

Firefly Planisphere: Latitude 42°N by Robin Scagell and Wil Tirion (Firefly Books; Richmond Hill, Ontario, Canada; 2018).

Atmospheric Phenomena

Some of these titles are long out of print but are worth searching for as classic reference works.

Rainbows, Halos, and Glories by Robert Greenler (Cambridge University Press; Cambridge. MA; 1980).

Sunsets, Twilights, and Evening Skies by Aden and Marjorie Meinel (Cambridge University Press; Cambridge, MA; 1983).

Light and Color in the Outdoors by Marcel Minnaert (Springer; London; 1993).

Aurora

Auroras: Fire in the Sky by Dan Bortolotti, with photographs by Yuichi Takasaka (Firefly Books; Richmond Hill, Ontario, Canada; 2018).

How to Photograph the Northern Lights by Patrick J. Endres (self-published e-book; available on Apple Books; 2016).

The Aurora Chase by Adrien Mauduit (self-published e-book; available on Apple Books; 2021).

Aurora: In Search of the Northern Lights by Melanie Windridge (William Collins; London; 2016). The best popular book on the science of auroras.

Meteors and Meteorites

Meteor Showers: An Annotated Catalog by Gary W. Kronk (Springer; Berlin; 2014).

Field Guide to Meteors and Meteorites by O. Richard Norton and Lawrence Chitwood (Springer; Berlin; 2008).

CHAPTER 3
YOUR OBSERVING SITE

Light Pollution: Responses and Remedies by Bob Mizon (Springer; Berlin; 2012).

Stars Above, Earth Below: A Guide to Astronomy in the National Parks by Tyler Nordgren (Springer-Praxis; New York; 2010). The author helped establish many U.S. national parks as dark sky preserves.

Urban Astronomy: Stargazing from Towns & Suburbs by Robin Scagell (Firefly Books; Richmond Hill, Ontario, Canada; 2014).

Dark Skies: A Practical Guide to Astrotourism by Valerie Stimac (Lonely Planet; Oakland, CA; 2019). See the supporting website at spacetourismguide.com.

Astronomy Adventures and Vacations by Timothy Treadwell (Springer; Berlin; 2017).

CHAPTER 4
GETTING TO KNOW THE SKY

Observer's Handbook (The Royal Astronomical Society of Canada; Toronto; rasc.ca). This indispensable annual guide to the year's celestial events is always on our desks. Available in Canadian and U.S. editions.

1001 Celestial Wonders to See Before You Die by Michael E. Bakich (Springer; Berlin; 2010).

Go-To Telescopes Under Suburban Skies by Neale Monks (Springer; Berlin; 2010).

50 Targets for the Mid-Sized Telescope by John A. Read (self-published; available through Amazon; 2017). *50 Things to See With a Small Telescope* (rev. 2017) also available.

100 Things to See in the Night Sky and *100 Things to See in the Southern Night Sky* by Dean Regas (Adams Media; New York; 2017).

CHAPTERS 5 AND 6
CHOOSING AND USING BINOCULARS

The Complete Star Atlas: A Practical Guide to Viewing the Night Sky by Michael E. Bakich (Kalmbach Books; Waukesha, WI; 2020).

Turn Left at Orion, 5th Edition, by Guy Consolmagno and Dan M. Davis (Cambridge University Press; Cambridge, MA; 2019). Expanded and revised spiral-bound edition. Highly recommended!

Touring the Universe through Binoculars by Philip S. Harrington (John Wiley & Sons; New York; 1990).

Night Sky Atlas by Robin Scagell and Wil Tirion (Firefly Books; Richmond Hill, Ontario, Canada; 2017).

Stargazing With Binoculars by Robin Scagell and David Frydman (Firefly Books; Richmond Hill, Ontario, Canada; 2014).

Discover the Night Sky through Binoculars by Stephen Tonkin (BinocularSky Publishing; London; 2018). An excellent self-published guide to binocular astronomy.

CHAPTERS 7 THROUGH 11
CHOOSING AND USING TELESCOPES AND ACCESSORIES

The NexStar Evolution and SkyPortal User's Guide by James L. Chen (Springer; Berlin; 2016).

Building a Roll-Off Roof or Dome Observatory by John Stephen Hicks (Springer; Berlin; 2016).

Choosing and Using a New CAT by Rod Mollise (Springer; Berlin; 2020).

Choosing and Using Astronomical Eyepieces by William Paolini (Springer; Berlin; 2013).

The NexStar User's Guide II by Michael Swanson (Springer; Berlin; 2017).

CHAPTERS 12 AND 13
OBSERVING THE SUN, MOON AND ECLIPSES

The Moon

Moon Observer's Guide by Peter Grego (Firefly Books; Richmond Hill, Ontario, Canada; 2016).

Sketching the Moon: An Astronomical Artist's Guide by R. Handy, D. Kelleghan, T. McCague, E. Rix and S. Russell (Springer; Berlin; 2012).

The Telescopic Tourist's Guide to the Moon by Andrew May (Springer; Berlin; 2017).

Observing the Moon: The Modern Astronomer's Guide, 2nd Edition, by Gerald North (Cambridge University Press; Cambridge, MA; 2007).

Mapping and Naming the Moon: A History of Lunar Cartography and Nomenclature by Ewen A. Whitaker (Cambridge University Press; Cambridge, MA; 1999).

The Sun

Sun, Earth and Sky by Kenneth R. Lang (Springer; Berlin; 2006). About the science of the Sun.

How to Observe the Sun Safely by Lee Macdonald (Springer; Berlin; 2012).

Observing the Sun with Coronado Telescopes by Philip Pugh (Springer; Berlin; 2007).

Eclipses

21st Century Canon of Solar Eclipses and *21st Century Canon of Lunar Eclipses* by Fred Espenak (Astropixels Publishing, astropixels.com/pubs/index.html or available through Amazon; 2016 and 2020).

Fred Espenak's Road Atlases for 2023 and 2024 Eclipses (Astropixels Publishing; Portal, AZ; 2017 and 2018).

Totality: The Great American Eclipses of 2017 and 2024 by Mark Littmann and Fred Espenak (Oxford University Press; New York; 2017).

Being in the Shadow: Stories of the First-Time Total Eclipse Experience by Kate Russo (self-published; available through Amazon; 2017).

Total Addiction: The Life of an Eclipse Chaser by Kate Russo (Springer; Berlin; 2012).

Atlas of Solar Eclipses: 2020 to 2045 by Michael Zeiler and Michael E. Bakich (self-published; available at greatamericaneclipse.com; 2020).

CHAPTER 14
OBSERVING THE SOLAR SYSTEM

Planets

Visual Lunar and Planetary Astronomy by Paul G. Abel (Springer; Berlin; 2013).

Astronomical Sketching: A Step-by-Step Introduction by R. Handy, D. B. Moody, J. Perez, E. Rix and S. Robbins (Springer; Berlin; 2007).

Observing the Solar System by Gerald North (Cambridge University Press; Cambridge, MA; 2012).

Planets & Perception: Telescopic Views and Interpretations, 1609-1909 by William Sheehan (The University of Arizona Press; Tucson, AZ; 1988). Now out of print.

Planetary Astronomy: Observing, imaging and studying the planets edited by Christophe Pellier. Privately published; available at planetary-astronomy.com. Very comprehensive.

Mars: The Lure of the Red Planet by William Sheehan and Stephen James O'Meara (Prometheus Books; New York; 2001). Now out of print.

Jupiter by William Sheehan and Thomas Hockey (Reaktion Books; London; 2018).

Saturn by William Sheehan (Reaktion Books; London; 2019). Both are excellent histories of their respective planets.

Comets

Comets! Visitors from Deep Space by David J. Eicher (Cambridge University Press; Cambridge, MA; 2013). A popular look at the history of comets by the editor of *Astronomy* magazine.

Hunting and Imaging Comets by Martin Mobberley (Springer; Berlin; 2011).

Atlas of Great Comets by Ronald Stoyan (Cambridge University Press; Cambridge, MA; 2015).

CHAPTERS 15 AND 16
DEEP SKY OBSERVING

Stars and Constellations

Star Names: Their Lore and Meaning by Richard Hinckley Allen (Dover Publications; New York; 1963). The classic authoritative guide to the origin of star names.

An Anthology of Visual Double Stars by Bob Argyle, Mike Swan and Andrew James (Cambridge University Press; Cambridge, MA; 2019).

Double Stars for Small Telescopes: More Than 2,100 Stellar Gems for Backyard Observers by Sissy Haas (Sky Publishing; Cambridge, MA; 2007).

The Cambridge Double Star Atlas, 2nd Edition, by Bruce MacEvoy and Wil Tirion (Cambridge University Press; Cambridge, MA; 2016). A specialized version of the *Cambridge Star Atlas.*

Deep Sky Objects

Deep Sky Observer's Guide by Neil Bone (Firefly Books; Richmond Hill, Ontario, Canada; 2005). A pocket-sized guide to 200+ double stars and deep sky objects.

The Backyard Astronomer's Field Guide: How to Find the Best Objects the Night Sky Has to Offer by David Dickinson (Page Street Publishing; Salem, MA; 2020). No relation to our book or author Terence Dickinson but a good guide to deep sky targets.

Deep Sky Observing: An Astronomical Tour, 2nd Edition, by Steven R. Coe (Springer; Berlin; 2016).

Cosmic Challenge: The Ultimate Observing List for Amateurs by Philip S. Harrington (Cambridge University Press; Cambridge, MA; 2019).

Astronomy of the Milky Way: Observer's Guide to the Northern Sky, 2nd Edition (2017), and *Astronomy of the Milky Way: Observer's Guide to the Southern Sky,* 2nd Edition (2018) by Mike Inglis (Springer; Berlin).

Celestial Harvest: 300-Plus Showpieces of the Heavens for Telescope Viewing and Contemplation by James Mullaney (Dover Publications; New York; 2012).

CHAPTERS 17 AND 18
ASTROPHOTOGRAPHY

Nightscapes

How to Photograph & Process NightScapes and TimeLapses by Alan Dyer (self-published; available on Apple Books and as PDFs from amazingsky.com; 2018).

Notes from the Stars: Ten Nightscape Master Classes by Ten World-Class Night Photographers edited by Rogelio Bernal Andreo (self-published; 2018; available from deepskycolors.com/books.html).

The Complete Guide to Landscape Astrophotography by Mike Shaw (Routledge; New York; 2017). Best print book on the topic.

Creative Nightscapes and Time-Lapses by Mike Shaw (Routledge; New York; 2019).

The World at Night by Babak Tafreshi (White Lion Publishing; London; 2019). An inspiring collection of nightscape images from around the world.

Primarily Deep Sky Imaging and Processing

The Deep-sky Imaging Primer, 2nd Edition, by Charles Bracken (self-published; available through Amazon; 2017). Contains excellent PixInsight tutorials.

Digital SLR Astrophotography, 2nd Edition, by Michael A. Covington (Cambridge University Press; Cambridge, MA; 2018).

Imaging the Southern Sky by Stephen Chadwick and Ian Cooper (Springer; Berlin; 2012).

Guide to Affinity Photo; Guide to Deep Sky Stacker; Guide to Photoshop Astrophotography (3-volume set) by Dave Eagle (self-published; available through Amazon; 2018 to 2021).

Inside PixInsight by Warren A. Keller (Springer; Berlin; 2018).

The 100 Best Astrophotography Targets by Ruben Kier (Springer; Berlin; 2009).

Astrophotography by Thierry Legault (Rocky Nook; Santa Barbara, CA; 2014).

Astrophotography is Easy! Basics for Beginners by Gregory I. Redfern (Springer; Switzerland; 2020).

Shooting Stars II: The New Ultimate Guide to Imaging the Universe by Nik Szymanek (Pole Star Publications; Tonbridge, UK; 2019). Well-illustrated processing tutorials; published by *Astronomy Now* magazine.

Astrophotography: The Essential Guide to Photographing the Night Sky by Mark Thompson (Firefly Books; Richmond Hill, Ontario, Canada; 2015).

FAVORITE PERIODICALS

These are the major English-language magazines we recommend. All are available in print and digital editions, and all have social-media feeds.

North America

Astronomy: astronomy.com

Sky & Telescope: skyandtelescope.org

SkyNews: skynews.ca

U.K. and Australia

Astronomy Now: astronomynow.com

Sky at Night: skyatnightmagazine.com

Australian Sky & Telescope: skyandtelescope.com.au

Home-Published Periodicals

Amateur Astronomy: amateurastronomy.com A print and digital quarterly with a mix of hobby features, interviews and star party tales.

Amateur Astrophotography: amateurastrophotography.com A digital-only periodical covering all forms of astrophotography.

Astronomy Technology Today: astronomytechnologytoday.com A digital-only periodical reviewing astronomy hardware and software.

TOP 10 WEBSITES

Our book's own website is backyardastronomy.com. For information about observing and astrophotography, here are our favorite websites:

astrobackyard.com Trevor Jones' blog with astrophoto tutorials and reviews. Also subscribe to his popular YouTube channel at youtube.com/c/AstroBackyard

astrobin.com Searchable galleries of astrophotos from contributors worldwide.

astrogeartoday.com Professionally written and edited reviews of astronomy gear.

astronomy.tools Useful on-line calculators for various astronomy needs.

cloudynights.com Peer reviews of equipment, with an active forum.

eclipsewise.com Solar and lunar eclipse information from "Mr. Eclipse," Fred Espenak.

heavens-above.com Predictions of ISS, Starlink and other satellite passes for your site.

in-the-sky.org Information about upcoming sky events.

spaceweather.com Predictions of solar and auroral activity, with extensive photo galleries.

The World at Night (twanight.org) Inspiring nightscape images from around the world.

CREDITS

CONTRIBUTORS: All astrophotos not otherwise credited are by Alan Dyer or Terence Dickinson. Images from other photographers are as follows, in alphabetical order:
Photo © Brett Abernethy/brettabernethy.com, 34
Photo © Ron Brecher/astrodoc.ca, 300 (right)
Photo © Debra and Peter Ceravolo/ceravolo.com, 313 (top)
Photo © Rainee Colacurcio/fineartamerica.com/profiles/rainee-colacurcio, 234
Photo © Monika Deviat/monikadeviatphotography.com, 41 (bottom)
Photo © Fred Espenak/MrEclipse.com, 236 (bottom)
Digital paintings © Edwin Faughn/edwinfaughn.com, 261, 266, 269, 273, 276
Photo © Lynn Hilborn/nightoverontario.com, 308 (top)
Photos © Trevor Jones/astrobackyard.com, 307 (top), 370
Photos © Kerry-Ann Lecky Hepburn/weatherandsky.com, 7 (bottom left), 296 (top), 310 (top)
Photos © Christoph Malin/christophmalin.com, 53 (center pair)
Photo © Jack Newton/JackNewton.com, 236 (top)
Photos © Damian Peach/damianpeach.com, 6 (top right), 261, 263 (Venus) by T1M Pic du Midi/Damian Peach et al., 264 (top), 266-267 (top), 267 (bottom), 268 (top and middle), 269, 270, 271 (top), 272, 273 (bottom), 274-275, 276 (left pair)
Sketches © Jeremy Perez/perezmedia.net, 286
Photos © Robert Reeves, 228 (bottom), 230-231 (all), 232 (libration pair), 242-243, 246-257
Photos © Lynda Sawula, 113, 321
Photo © Gary Seronik/garyseronik.com, 142 (LX65 telescope)
Photo © Kimberly Sibbald/spacepaparazzi.com, 371
Photo © Yuichi Takasaka/blue-moon.ca, 23 (top right)
Photo © Kathleen Walker/hallsharbourobs.ca, 318-319
Map © Michael Zeiler/GreatAmericanEclipse.com, 240

OTHER SOURCES: Chapter 2: 27 (sidebar) NASA; 28 (twilight chart) © TWCarlson—Own work, CC BY-SA 3.0; 40 (sunspot chart) SILSO, Royal Observatory of Belgium, Brussels; 43 (NGC 891) Robert Gendler, NAOJ, HST/NASA, Adam Block; 44 (Milky Way map) NASA/JPL-Caltech/R. Hurt (SSC/Caltech). **Chapter 3:** 52-53 (Earth at night) NASA/Goddard Space Flight Center; 52 (Calgary from ISS) NASA; 52-53 (lighting fixtures) International Dark-Sky Association/darksky.org; 59 (light-pollution maps) DarkSkyFinder.com; 59 (dark sky meter) © Unihedron/unihedron.com; 60-61 (sky charts) Simulation Curriculum/starrynight.com. **Chapter 4:** 67-81 (all-sky charts) Stellarium/stellarium.org; 82-89 (sky-motion diagrams) Simulation Curriculum; 87 (ecliptic chart) Stellarium; 91 (Milky Way) NASA. **Chapter 6:** 114 (charts) Stellarium; 115-119 (charts) Simulation Curriculum. **Chapter 7:** 122 NASA/JPL/Hubble STScI; 123 (Saturn images) Simulation Curriculum; 125-127 (old ads) courtesy *Sky & Telescope*; 128 (eVscope) Unistellar; 142 (CPC8) Celestron International; 147 (equatorial refractor trio) Celestron International, Meade Instruments, Orion Telescopes. **Chapter 8:** 177 (filter charts) © Astronomik/Gerd Neumann. **Chapter 9:** 187 (dolly) Farpoint/Farpoint Astro.com; 191 StarSense Celestron International. **Chapter 10:** 197 (chart) Simulation Curriculum. **Chapter 12:** 228-229 (lunar phase series) Moon Globe app/MidnightMartian/appadvice.com; 229 (Hevelius map) Wikimedia Commons; 235 (Galileo drawing) Wikimedia Commons. **Chapter 13:** 246-256 (small Moon disks) Moon Globe app/MidnightMartian. **Chapter 14:** 271 (Shoemaker-Levy 9 impact) NASA/Hubble STScI; 280 (Comet Donati art) Wikimedia Commons. **Chapter 15:** 285 (Milky Way maps) Stellarium; 289 (Herschel telescope, Messier) Wikimedia Commons; 290 (Dreyer portrait) Wikimedia Commons; 290 (*Annals* covers) Willmann-Bell, Inc.; 291 (William and Caroline Herschel) Wikimedia Commons; 293 (William Dawes portrait) Wikimedia Commons; 294 (Star Colors diagram) European Southern Observatory; 295 (*Uranometria*) Wikimedia Commons; 303 (Harvard computers and plate) Wikimedia Commons; 309 (Hubble chart) NASA/ESA/Hubble STScI; 311 (sketches by 3rd Earl of Rosse) Wikimedia Commons; 315 (John Herschel portrait and Table Mountain sketch) Wikimedia Commons. **Chapter 16:** 322 (charts) Stellarium; 322-341 (charts) Simulation Curriculum. **Chapter 17:** 346 (Bayer array) Wikimedia Commons; 356 (Skyris) Celestron International; Appendix: 391-392 (sky charts) Simulation Curriculum/skysafariastronomy.com; 402-407 (star tests) Aberrator/aberrator.astronomy.net

TERENCE DICKINSON became fascinated with astronomy at age 5, when he saw a brilliant meteor from the sidewalk in front of his home in Toronto. This early interest soon became the defining characteristic of Dickinson's life and led him to a career as one of Canada's best-loved amateur-astronomy writers, renowned for unraveling and explaining the mysteries of the cosmos. After becoming a member of The Royal Astronomical Society of Canada in the 1960s, Dickinson worked as a staff astronomer at two major planetariums. His down-to-earth style has made him a best-selling author of 14 astronomy books and hundreds of articles on the subject. In 1994, he cofounded *SkyNews*, Canada's national astronomy magazine. He has received several national and international awards, among them the Royal Canadian Institute's Sandford Fleming Medal for achievements in advancing public understanding of science. A recipient of the Order of Canada, he has also received honorary doctorates from Queen's University in Kingston, Ontario, and Trent University in Peterborough, Ontario. He and his wife Susan live under the dark rural skies of eastern Ontario.

ALAN DYER is now happily retired from many rewarding years producing planetarium shows for theaters in Winnipeg, Edmonton and Calgary, Canada. Occasionally, they still let him onto the Digistar system in Calgary to have fun programming a presentation. A former editor on staff with *Astronomy* magazine in the early 1990s, Dyer is a regular contributor to *SkyNews* and *Sky & Telescope*. He is the author of several e-books, including *How to Photograph & Process NightScapes and TimeLapses*. His astrophotos and videos have appeared on spaceweather.com, NASA's Astronomy Picture of the Day, *Forbes*, Universe Today, *National Geographic*, *TIME*, NBCNews and CBS News. He is a member of the exclusive The World At Night photo group (twanight.org). In 2018, Canada Post featured one of his photos of the northern lights on a stamp commemorating the 100th anniversary of The Royal Astronomical Society of Canada. Since his first "TSE," in February 1979, Dyer has traveled the world to see 16 total solar eclipses. The main belt asteroid 78434 is named for him. He can be reached through his website at amazingsky.com, where there are links to his social-media pages.

KEN HEWITT-WHITE developed a passion for astronomy as a child over 50 years ago, and he has been observing the night sky ever since. His enthusiasm for describing his myriad telescopic explorations began when he was a teenager and hasn't waned. After a 20-year career as a show producer and presenter at the MacMillan Planetarium, in Vancouver, British Columbia, Hewitt-White turned to writing full time. His award-winning body of work includes a documentary TV series, two books and countless magazine articles. He and his wife Lynda live in southern British Columbia close to the mountains, where they go stargazing every summer.

ACKNOWLEDGMENTS

Terence Dickinson and Alan Dyer would like to thank the many readers of the first three editions of *The Backyard Astronomer's Guide*, who richly contributed to this new edition through their insightful comments and questions. A work of this magnitude can be brought to fruition only by a team of dedicated professionals. Without Susan Dickinson, Dickinson's intrepid partner in all things, and Firefly Books publisher Lionel Koffler, an equally loyal professional partner, this project would never have left Earth. Our special thanks go to our talented and tireless art director Janice McLean, for her central role in this comprehensive revision of the original book, first published back in the predigital era. For this edition, Dyer shouldered new responsibilities with grace and energy, and contributor Ken Hewitt-White brought his skills and warm style to the final pages and even stepped up to create our Index. Thanks, too, to Tracy C. Read, for acting as a liaison and sounding board.

Dyer appreciates the assistance of Bev and Ken From of All-Star Telescope (allstartelescope.com), without whom several chapters would have been deficient in equipment photos and buying advice. Many thanks also to the staff of other fine telescope dealerships in Canada for their assistance in supplying equipment that made its way into the book. And Dyer thanks the staff of the Rothney Astrophysical Observatory, the organizers of the Saskatchewan Summer Star Party and the Calgary Centre of The Royal Astronomical Society of Canada, whose events made many of the images possible.